Worldly Goods

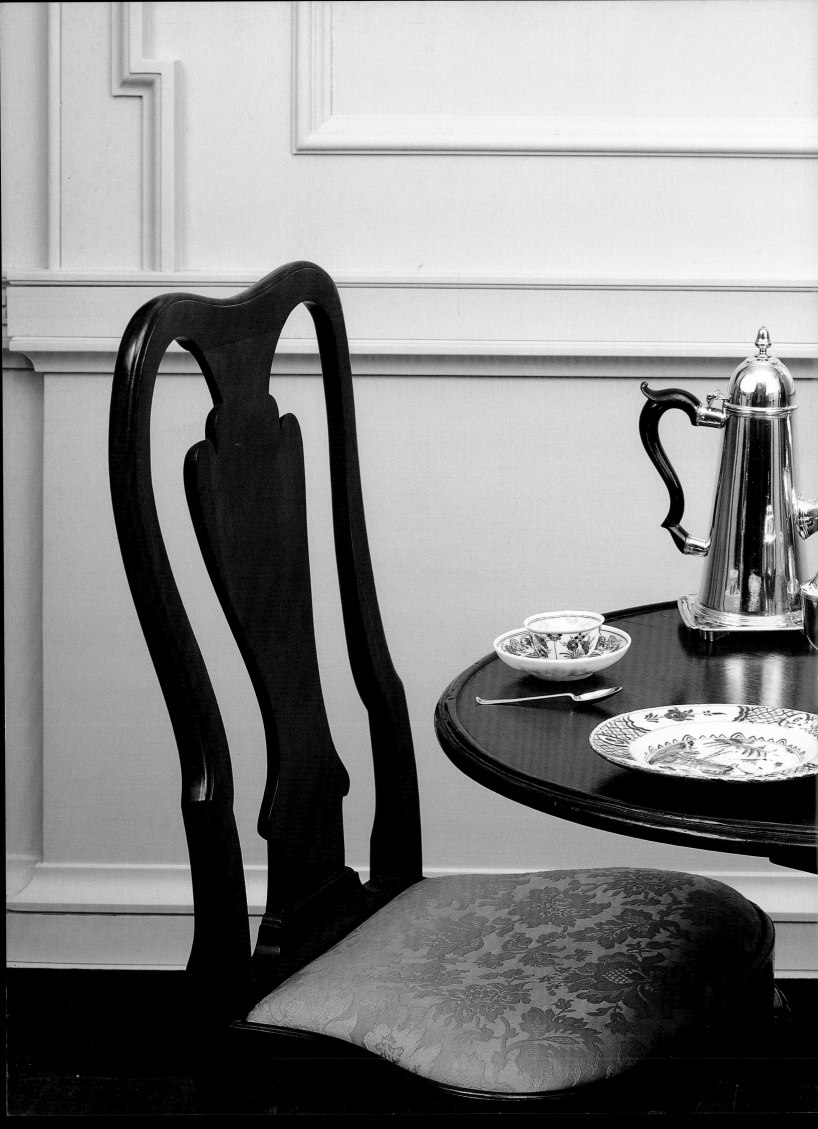

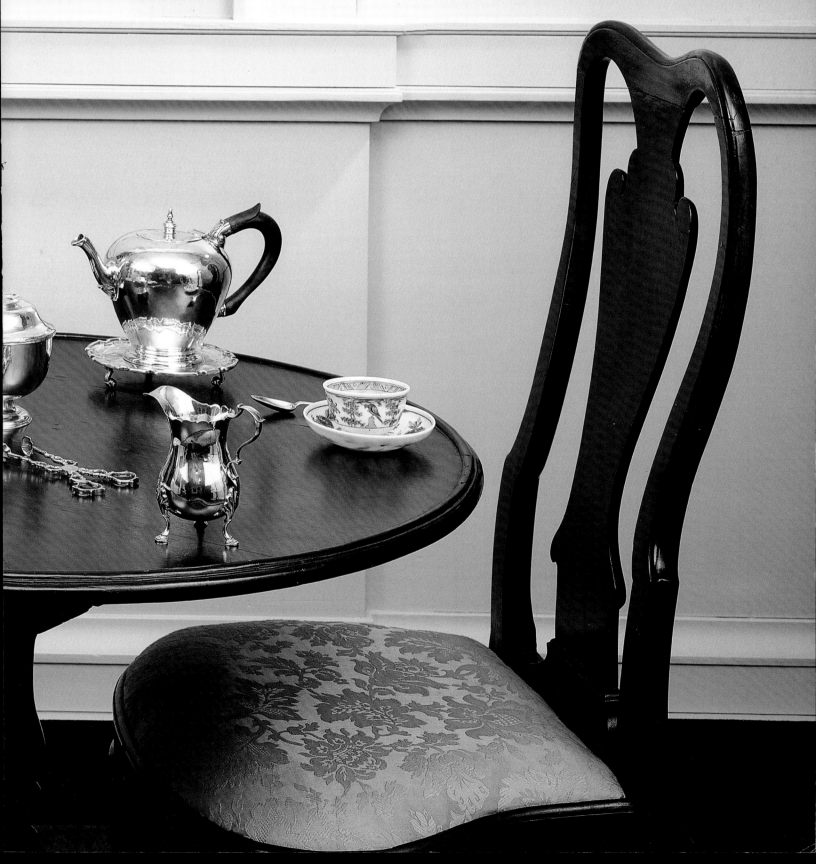

Made possible by J. P. Morgan

Additional support has been provided
by The William Penn Foundation, The
Pew Charitable Trusts, the Robert
Montgomery Scott Endowment for
Exhibitions, the National Endowment
for the Arts, The Women's Committee
of the Philadelphia Museum of Art, and
Kathleen C. and John J. F. Sherrerd.
Support for the catalogue was provided
by The Chipstone Foundation and by
Lulu C. and Anthony W. Wang. The
accompanying symposium was made
possible through the generous contri-
butions and joint sponsorship of
Christie's and Sotheby's.

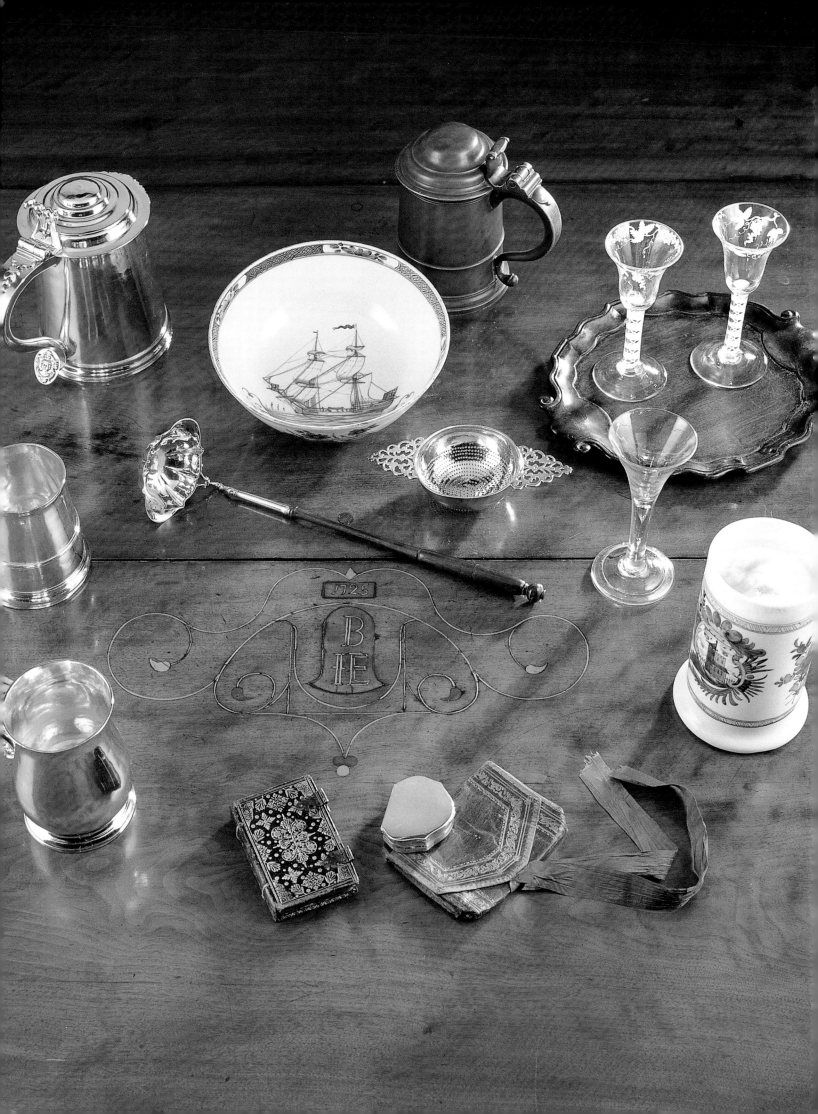

Worldly Goods

THE ARTS OF EARLY PENNSYLVANIA, 1680–1758

Jack L. Lindsey

Essays by Richard S. Dunn, Edward C. Carter II, and Richard Saunders

PHILADELPHIA MUSEUM OF ART

This publication accompanies the exhibition *Worldly Goods: The Arts of Early Pennsylvania, 1680–1758* at the Philadelphia Museum of Art, October 10, 1999, to January 2, 2000.

Cover/jacket illustration: The front cover is compiled from objects in the checklist of the exhibition. These are, clockwise from the upper left: nos. 287, 396 (detail), 366, 71, 422, 385, 246, 288 (reverse), 52 (detail of top), 330, 450; center: no. 50, set with no. 358, acc. no. 1921-3-4, and other objects in the collection of the Philadelphia Museum of Art.

Page i: Detail of high chest, no. 40.

Pages ii–iv, vi–vii: Tableaux of objects from the exhibition.

Page x: Front hall of Stenton mansion, Germantown, Pennsylvania.

Copyright 1999 Philadelphia Museum of Art

Produced by the Department of Publishing
Philadelphia Museum of Art
Benjamin Franklin Parkway at Twenty-Sixth Street
P.O. Box 7646
Philadelphia, PA 19101-7646

Edited by Kathleen Krattenmaker, with the assistance of Morgen Cheshire and Holly Smiles
Production by Richard Bonk and William Rudolph

Designed by Mariana Canelo
Color separations by Professional Graphics, Inc., Rockford, Illinois

Printed and bound by CS Graphics, PTE, Ltd., Singapore

Library of Congress Cataloging-in-Publication Data

Lindsey, Jack L.
 Worldly goods: the arts of early Pennsylvania, 1680–1758 / Jack L. Lindsey; with essays by Richard S. Dunn, Edward C. Carter II, and Richard Saunders.
 p. cm.
 Includes bibliographical references.
 ISBN 0-87633-130-4 (hardbound: alk. paper).—
 ISBN 0-87633-129-0 (softcover: alk. paper)
 1. Art, American—Pennsylvania Exhibitions.
 2. Art, Colonial—Pennsylvania Exhibitions.
 3. Art, American—Delaware River Valley (N.Y.–Del. and N. J.) Exhibitions. 4. Art, Colonial—Delaware River Valley (N.Y.–Del. and N. J.) Exhibitions.
 I. Dunn, Richard S. II. Carter, Edward Carlos, 1928– . III. Saunders, Richard H., 1949– .
 IV. Philadelphia Museum of Art. V. Title.
 N6530.P4L55 1999
 709'.748'07474811—dc21 99-37645
 CIP

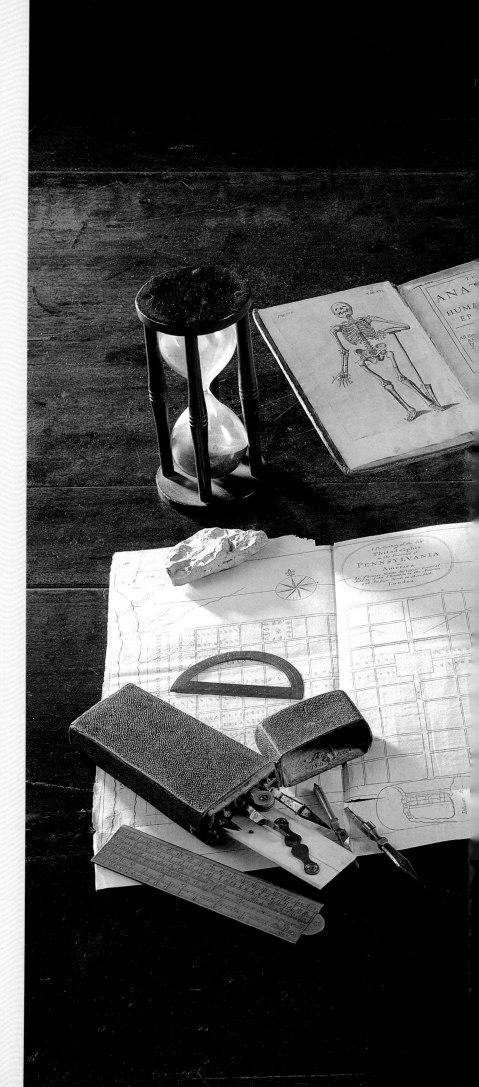

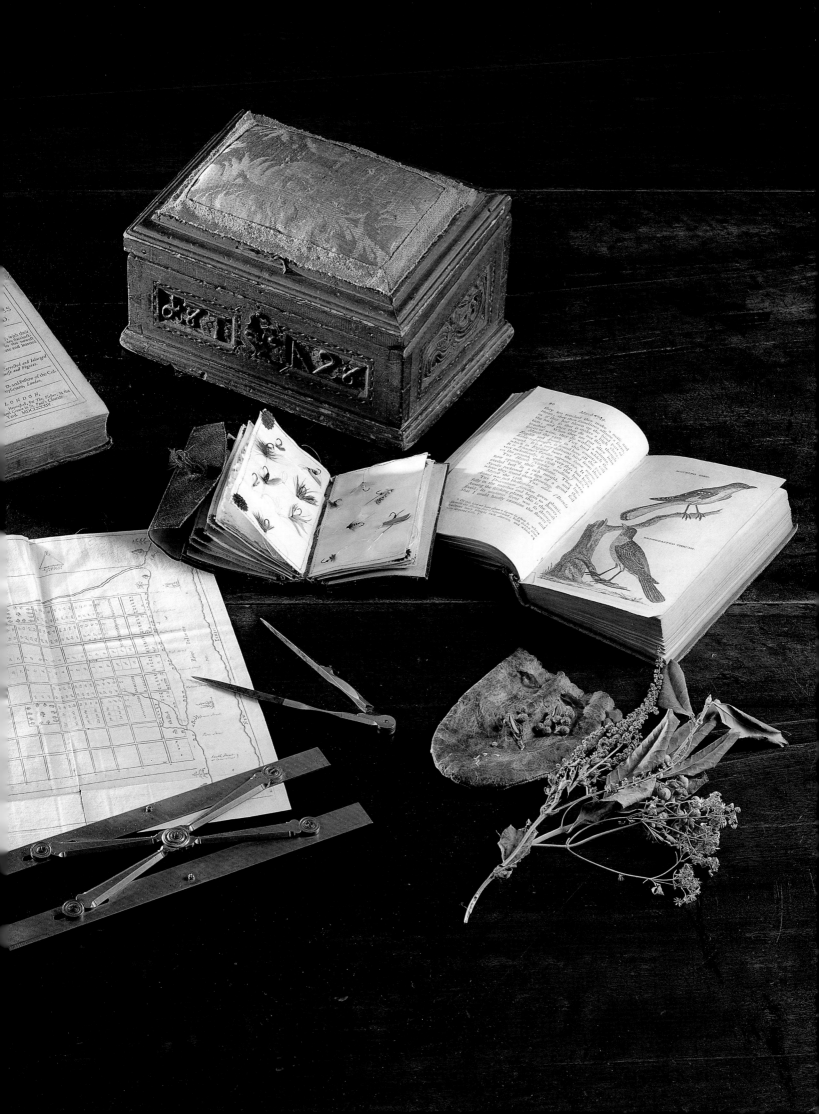

Contents

Checklist of the Exhibition

Appendixes

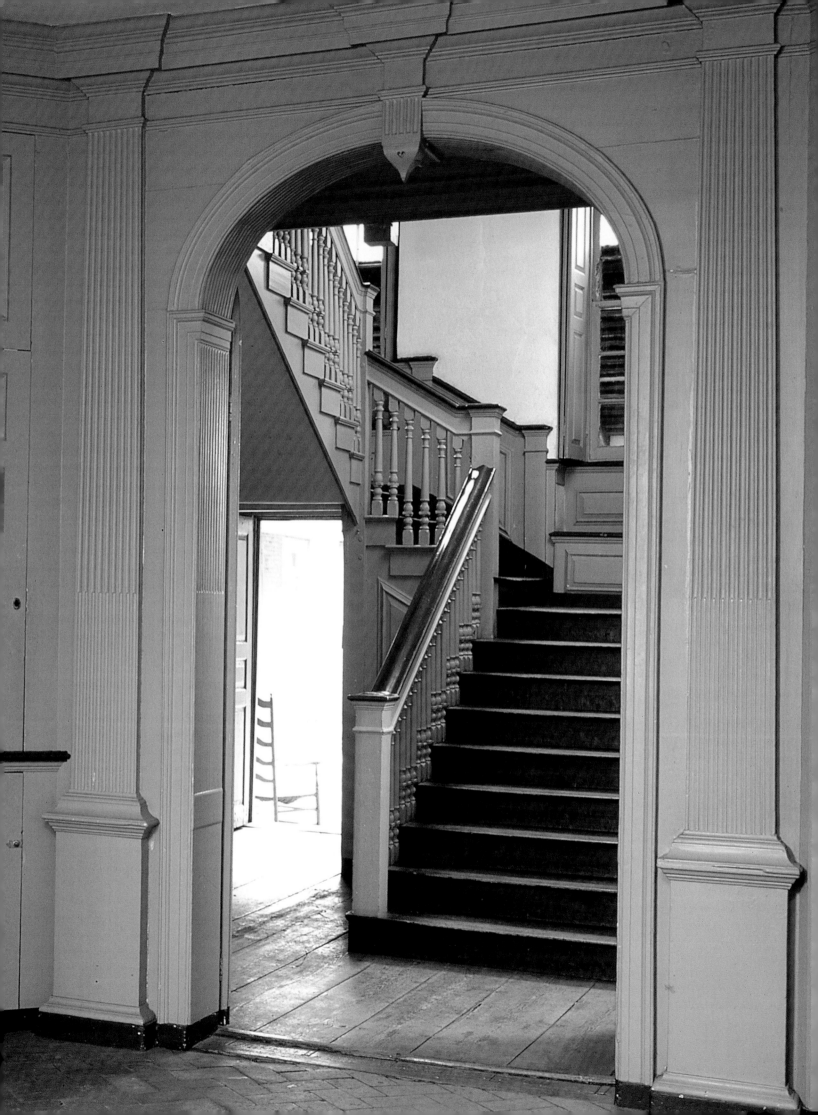

Foreword

The latest in a sequence of major exhibitions organized by the Philadelphia Museum of Art to explore, document, and celebrate the achievements of Pennsylvania artists and artisans over more than three hundred years, *Worldly Goods: The Arts of Early Pennsylvania, 1680–1758*, throws light upon particularly difficult terrain—remote in time, apparently sparse in evidence. Yet the vast wooded landscape of William Penn's colony and the regular streets of his "greene Country Towne" of Philadelphia prove to have nourished the arts as hospitably as they received new settlers. The wealth and variety of objects encompassed by this exhibition and catalogue, many of them shown to the public for the first time, leave late twentieth-century viewers in no doubt of the degree to which early Pennsylvanians expended labor, precious income, and love upon the works of art and fine objects with which they sought to enhance their lives. Thanks to the remarkable scholarship, keen eye, persistence, and persuasive powers of Jack L. Lindsey, Curator of American Decorative

Arts and *primum mobile* of the exhibition, it reveals a far richer cultural landscape than had hitherto been surmised.

Without the extraordinarily generous cooperation of the more than fifty lenders to the exhibition, both public institutions and private collectors, such a project would not have been possible, and we are deeply in their debt. We are grateful to the three distinguished scholars, Edward C. Carter II, Richard S. Dunn, and Richard Saunders, for their contributions to this catalogue, which discuss the development of painting and set forth the broader milieu in which the growth of intellectual and cultural life in early Pennsylvania took place.

Elsewhere in this book Jack Lindsey salutes the myriad colleagues, mentors, lenders, and Museum staff whose help has been invaluable in many ways; his thanks are here most warmly seconded. We would also like to thank John Blatteau of the architecture department of the University of Pennsylvania and Ahmad Suleiman for their assistance in re-creating a paneled wall from Stenton in the installation of the exhibi-

tion. In particular, our heartfelt gratitude goes to H. Richard Dietrich, Jr., William B. Dupont, and Joseph A. McFalls for their enthusiastic support and spectacular assistance. Robert L. McNeil, Jr., in his inimitable devotion to the art and history of Philadelphia throughout many decades of publications and philanthropy, has been an inspiration to this project.

No exhibition and catalogue of this ambitious scale can be achieved without generous financial support, and *Worldly Goods* has benefited from the keen interest in Philadelphia's late twentieth-century cultural life taken by The Pew Charitable Trusts and The William Penn Foundation. The Women's Committee of the Museum helped to fund initial research for the exhibition, and The National Endowment for the Arts provided support for its implementation. Christie's and Sotheby's have enthusiastically sponsored a three-day symposium. The Chipstone Foundation of Milwaukee made a handsome grant to the catalogue, and individual donors made especially generous

contributions, including Kathleen C. and John J. F. Sherrerd of Philadelphia and Lulu C. and Anthony W. Wang of New York.

Our warmest thanks, in conclusion, go to J. P. Morgan for their munificent corporate sponsorship. We look forward to their increased presence in the Philadelphia community and congratulate them on their long and distinguished history of support for cultural projects worldwide.

This book concludes with illustrated checklists of all the objects in the exhibition, grouped by medium and form.

Especially in the field of furniture, the checklist constitutes a kind of visual dictionary enabling the reader to follow and enjoy the intricate patterns of influence and individuality and the cross-currents of tradition and innovation that flowed through the arts of late seventeenth and early eighteenth-century Pennsylvania in such abundance. The Philadelphia Museum of Art is fortunate to have in its permanent collections a handsome share of the illustrated objects, thanks to the continuing generosity of many generations of donors, including most recently Martin Battestin,

Daniel Blain, Jr., and the heirs of Kathleen Maier. According to his daughter's recent memoir, Henry Francis du Pont once advised a young relative at an antiques show "to look at the individual chairs as if they were people." This exhibition and its catalogue will have succeeded in their purpose if visitors and readers gain a more familial sense of the diversity and character of the works of art included, and through them a more vivid understanding of the extraordinary decades of William Penn's "holy experiment" during which they were created.

Anne d'Harnoncourt

THE GEORGE D. WIDENER DIRECTOR
AND CHIEF EXECUTIVE OFFICER

Preface

During the planning stages for the exhibition and catalogue *Worldly Goods: The Arts of Early Pennsylvania, 1680–1758,* two questions were raised repeatedly during various discussions with collectors, curators, and scholars: just how large was the surviving body of decorative and fine arts produced in the Delaware Valley prior to 1758, and how would one go about locating and documenting important material, given the relative paucity of published scholarship on this early period? A small number of pre-1758 objects from Pennsylvania were well known because they were associated with prominent original owners or because they had appeared often in earlier advertisements or auction catalogues. The widespread interest in and scholarship surrounding the initial settlement of Pennsylvania; the near deification of early pivotal figures such as William Penn, James Logan, and Benjamin Franklin; and Philadelphia's prominence in the development of commerce, theology, politics, and culture in colonial America had result-

ed in the identification and preservation of many of the known surviving artifacts from this early period in Pennsylvania as historical icons. Ours was the somewhat daunting task of determining how much more was out there. That we were able to gather such an abundant, rich, and diverse body of material is a tribute to the enthusiasm, generosity, and support of many friends and colleagues, who met my every inquiry with encouragement backed by their own knowledge, experience, and keen observation. The result was a cooperative effort that supplied the project with the direction and guidance it needed.

At serendipitous moments during our search documents and artifacts came together, suggesting a history, name, or place for a patron or craftsman: a diary recorded the use of a treasured silver teapot; a book inscription bore witness to a craftsman's access to a certain technology or design; and an original receipt tucked away deep in the drawer of a treasured spice box confirmed its descent within a particular family. One find suggested the route to

another, and as a result, the exhibition evolved. In a number of cases, private collectors had identified and ensured the survival of pivotal early pieces, along with their documentation, long before institutions had begun to collect them. Most gratifying was the surfacing of several important new discoveries, presented here for the first time, which came to light through the cooperation and participation of these scholar-collectors.

As objects surfaced, they were examined for authenticity, condition, quality, and importance. Newly discovered documentation and innovations in conservation and analytical techniques together enabled a deeper, more accurate process of evaluation. As a result, several early pieces, long held forth as the best or the only examples of their type, were found to have been overly restored, wrongly identified, or significantly altered. Further complicating the puzzle, early alterations or repairs have often acquired the patina characteristic of original, untouched materials. In several cases, important pieces that had been deemed unscathed in prior examinations and

held up as our most perfect windows to an understanding of past aesthetics, were found to have been altered and subsequently no longer can be counted on to provide an accurate picture of the aesthetics and craftsmanship of the period.

Our ideas about the past have also been skewed by the types of objects that have survived. The survival of historical artifacts is dependent on a number of factors, not least of which are accident, chance, and benign neglect. Many of the extant objects owe their survival to the vagaries of human sentiment, kept in some cases because of their expense or because they were imbued with symbolic significance by their association with certain people or events. Most of the simple, utilitarian objects necessary for daily life, however, have not survived, having deteriorated through regular use and subsequently been discarded. It is thus easier to document the evolution of tall case clocks than it is that of the toothbrush, and we are left with a somewhat random, inaccurate cross section of what was actually present in or typical of a given time period, culture, and place.

The rich history of craftsmanship and artisanry in the Delaware Valley during the eighteenth century has inspired a fairly extensive published body of research focusing on the region's decorative and fine arts, most of which has tended to concentrate, however, on the period 1760–85, characterized by the rococo style. The furniture, silver, architecture, and interiors created during this "golden age" in Philadelphia by a superbly talented group of craftsmen have long been held forth by scholars, collectors, and connoisseurs as representing the zenith of American colonial achievement. This focusing of attention on the Philadelphia rococo style has resulted, until very recently, in a gap in scholarship on the earlier period in Pennsylvania. Indeed, most of the existing scholarship on early colonial craftsmanship in America has typically concentrated on the regional traditions present in New England, the Dutch traditions in New York, or the early Tidewater culture of Virginia and Maryland. Publications and exhibitions that have examined the years prior to 1758 in Pennsylvania have tended to be limited in scope—studies, for example, of early localized regional styles, individual craftsmen, or groups of objects similar in form, decoration, or construction.

Worldly Goods: The Arts of Early Pennsylvania, 1680–1758 brings together for the first time a large and remarkably diverse group of objects from this important initial period in the history of Pennsylvania and is the first attempt at a broader and more complete investigation of the presence and lingering influence of the earlier European baroque style on the decorative and fine arts of the Delaware Valley. Architecture, objects, public and private gardens, and rural landscapes all reflected aspects of traditional patterns, construction, and forms from the diverse memories and experiences of the colony's immigrant population. Surviving artifacts, both those produced locally and imported examples with documented histories of ownership in the Delaware Valley, illustrate the evolution of a distinct visual and intellectual culture in Pennsylvania and the surrounding region. While William Penn's efforts to found a colony based on religious toleration fell short in some areas, his policies did result in the creation of a flourishing and diverse community of craftsmen and patrons. The predominant decorative-arts traditions transplanted to the colony from the British Isles were mixed and distilled with stylistic inspirations emanating from Holland, France, Portugal, Germany, the West Indies, and the Orient to produce the new hybrids in design and style presented here.

The unfortunate lack of concrete historical documentation detailing the routes through which these multiple stylistic traditions converged in the Delaware Valley presents a frustrating dilemma. Fewer than fifteen period references to specific published design sources used in Pennsylvania during its early years have been found, and there are even fewer surviving imported pattern books that can be documented to ownership in pre-1758 Pennsylvania. A trustworthy chronology outlining the development of designs and forms in the Delaware Valley remains elusive in the face of the vernacular interpretations and variant forms produced by local artisans. A widely held idea in traditional scholarship on the decorative arts—that an object produced within a particular area can be accurately dated based on its style, construction, and form—does not hold true for colonial Pennsylvania, where stylistic movements did not follow a clear sequential order and where aesthetic principles from a number of different cultures were mixed and interpreted in multiple ways. The "style = date" premise also operates on the assumption that the elements of a style—its effects on design, form, and decoration—were embraced and practiced uniformly by all craftsmen while it held predominance in a particular region. In reality, the dynamics that

facilitated awareness of a particular style, and that promoted or deterred its acceptance, were particularly variant in a society such as colonial Pennsylvania, where the aesthetic principles on which the majority of styles were based were not native born but transferred either directly or indirectly from other cultures.

William MacPherson Hornor, Jr., who in 1935 published one of the first extensive recordings of early Pennsylvania furniture, his *Blue Book of Philadelphia Furniture: William Penn to George Washington,* aptly observed in his notes for the preface of the original subscribers' edition (Museum Archives): "Furniture speaks no dialect. The grain of the wood, the method of dovetailing, the width of the seat, the piercing of the stiles by tenons, the stroke of the carving, the poplar sides and oak bottoms, the pitch of the pediment, the contour of the moldings, the sort of blocks, and all the rest of the well worn arguments of experts are unfortunately for them, more subject to the exception than is comfortable to admit. There are no cut and dried or infallible rules to follow." The experiences gathered while preparing this catalogue and the exhibition it commemorates have tended to corroborate Hornor's statement. It is hoped, however, that bringing together this assemblage of important regional artifacts will help clarify our understanding of this early period in the Delaware Valley by providing a larger body of documented material for more detailed scrutiny and observation. The scope and size of the project has required a broader, more contextual examination using surviving examples as points of access to wider historical contexts. The information gleaned remains incomplete—glimpses of the period seen through the filter of a select group of decorative arts, paintings, and documents that happen to have survived the ravages of time and changing taste. It is hoped that the ideas presented here will inspire further interest and debate and encourage the continued growth of the body of knowledge on this important period.

Jack L. Lindsey

Acknowledgments

A project such as *Worldly Goods: The Arts of Early Pennsylvania, 1680–1758* is realized only with the interest and help of countless individuals. The total number of contributors is regrettably too large to thank each individually. I am deeply indebted to the private and institutional lenders who made the exhibition and catalogue possible. Universally, they greeted both the idea of this exhibition and the invasion of their homes and galleries with enthusiasm and good humor. Several rearranged living spaces or exhibition schedules to accommodate my requests, and the results are all the richer for their generous participation.

At the Philadelphia Museum of Art, I am indebted to the director, Anne d'Harnoncourt, for her ongoing support, encouragement, and confidence. The members of the American Art Advisory Committee of the Museum have supplied valuable friendship, suggestions, support, and guidance through every stage of the project. My colleagues in the Department of American Art all con-

tributed to the effort. The multiple talents and work ethic of Andrew Brunk, the assistant curator and research associate for the exhibition, were essential to the process. He compiled and maintained the checklist of the exhibition and created order from my chaos, coordinating the diverse tasks of historical documentation, scheduling of photography, and arranging loans and conservation while providing research and insight during the cataloguing and selection process. Martha C. Halpern, the assistant curator of the Fairmount Park houses, pitched in to manage the American wing while I worked on this catalogue and shared her great experience and research expertise in working with Philadelphia records, wills, and inventories. Her architectural and genealogical scholarship made very valuable contributions to the project. Beatrice B. Garvan, curator emerita, acted as both a therapist and a sounding board for ideas while adding her characteristic thoroughness and brilliance to the selection and documentation of silver. Darrel L. Sewell, the

Robert L. McNeil, Jr., Curator of American Art, offered keen advice on the selection of paintings. Miriam E. Mucha, curatorial associate for the American glass collection, coached me through countless questions on glass and cartography with knowledge and humor. Jennifer Zwilling, curatorial intern, also contributed much with her intelligence and enthusiasm. Mike Hammer and W. Douglass Paschall helped hold down the fort in the department during the entire process. Other colleagues on the Museum's curatorial staff generously provided the benefit of their expertise and kindly granted access to their collections, including Dilys E. Blum, Donna Corbin, Felice Fischer, Kristina Haugland, John Ittmann, Ella Schaap, Pierre Terjanian, and Dean Walker.

In typical fashion, the entire staff at the Museum rallied to accomplish the endless preparatory tasks with characteristic expertise and dedication. Suzanne Wells, the Museum's coordinator of special exhibitions, kept everyone on an even keel. Alice Beamesderfer, Mari

Jones, and Kim Sajet, as well as Sandra Horrocks and Linda Jacobs, provided information and offered their myriad talents and expertise in matters of administration, coordination, and installation of the exhibition, and in grant writing. In the Registrar's office, Elie-Anne Chevrier and Sara Loughman organized and handled all loan arrangements with their usual aplomb, while Kim Liddle, Clarisse Carnell, and Nancy Baxter kept track of the comings and goings of numerous treasures. Conna Clark, Marisa Sánchez, and Terry Murphy ensured that hundreds of photographs were identified and there when needed, while Allen Townsend and Lilah Mittelstadt in the Library tracked down rare books and references and granted requests for research materials. Danielle Rice, Elizabeth Anderson, Marla Shoemaker, and the entire staff of the education department along with the Museum guides supplied their interpretive expertise and advice to all aspects of the exhibition and the accompanying symposium.

The complicated and detailed design and installation of the exhibition were accomplished by Jack Schlechter, Andrew Slavinskas, Joe Mikuliak, Martha Masiello, Michael Macfeat, and the Museum's talented staff of carpenters, art handlers, and mount makers. Gary Hiatt in Prints and Drawings designed and executed the installation of a number of important books and documents. Special thanks are owed to Sarah Thrower for her design of the floor cloths used in the exhibition. Maia Wind and Diane Gottardi brought my scrap-paper ideas of how the exhibition might look into a cohesive, beautiful, finished design, handling the extensive labeling and graphics for the exhibition with patience and flair. The Museum's conservation staff lent their many talents, performing analysis and treatments and appropriately stabilizing or restoring the damages wrought by time and use on many of the objects illustrated here, and I thank David DeMuzio, Behrooz Salimnejad, Christopher Swan, Christopher Storb, Kate Javens, and Clarissa DeMuzio in furniture conservation; P. Andrew Lins, Melissa Meighan, Sally Malenka in objects conservation; Mark Tucker in paintings conservation; Nancy Ash and Faith Zieske in paper conservation; Sara Reiter in costume and textile conservation; and Joe Mikuliak, conservation photographer. Working miracles, they transformed objects and, indeed, the entire appearance of the exhibition. I thank Matthew Pimm and Paula Cyhan, in Editorial and Graphic Design, for the fine design for the brochure for the symposium. In the Museum's publishing department George Marcus, Kathleen Krattenmaker, Richard Bonk, William Rudolph, Morgen Cheshire, and Holly Smiles edited and supervised the production and design of this catalogue. With patience and skill, they have greatly improved its final form, creating wonders from my initial manuscript. In particular, Kathleen's detailed editing and sensitive analysis has provided clarity and accuracy in the essays, while Morgen's work on the checklist has improved it greatly. To Mariana Canelo, the talented designer of the catalogue, I owe special thanks for her beautiful results. The skillful and sensitive photographs of Graydon Wood and Lynn Rosenthal of the Museum, and those of Gavin Ashworth of New York, were accomplished by a willingness to adapt to a variety of situations in the field. Their talent, dedication, and eye for detail have produced a lasting and handsome visual record of the exhibition.

I am particularly appreciative of the contributions of the guest essayists, who have added immeasurably to an understanding of the diverse and complicated society of early colonial Pennsylvania: Dr. Richard S. Dunn, Director of The McNeil Center for Early American Studies at the University of Pennsylvania, Philadelphia, and Dr. Edward C. Carter II, Librarian of the American Philosophical Society, Philadelphia, have each supplied essays that effectively ground objects and art in a broader historical context. Dr. Richard Saunders, Director of the Middlebury College Museum of Art, Middlebury, Vermont, joined the effort with his expertise in the development of early portraiture and painting in Philadelphia, and through his essay and advice during the selection process added valuable insights into the dynamics of patron, painter, and style during the first half of the eighteenth century.

I am also indebted to colleagues and friends at a great number of libraries, historical societies, historic houses, archives, and other museums who have shared information, provided photography, or granted access to their collections. At the Dietrich American Foundation, Philadelphia, H. Richard Dietrich, Jr., with characteristic generosity and trust, supplied immeasurable help, while his curators, Debbie Rebuck and Jacqueline DeGroff, shared the Foundation's rich archives and collections and generously accommodated my every request. At the Barra Foundation in Wyndmoor, Pennsylvania, Robert L. McNeil, Jr., and Susan Detweiler provided important additions to the exhibition along with helpful insights. At the Chipstone Foundation, Milwaukee, its

board of directors and its executive director, Luke Beckerdite, supplied their generous support, enthusiasm, and advice. In addition, I am grateful to the following individuals and their institutions: Ellen Smith at the American Jewish Historical Society, Waltham, Massachusetts; Margaretha Talerman at the American Swedish Historical Museum, Philadelphia; Scott DeHaven and Roy Goodman at the American Philosophical Society, Philadelphia; Herbert C. Kraft at the Archaeological Research Center, Seton Hall University Museum, South Orange, New Jersey; Judith Barter and Hsiu-ling Huang at the Art Institute of Chicago; Jeffrey Ray at the Atwater Kent Museum, Philadelphia; Bruce Gill at Christ Church, Philadelphia; Ward Childs in the Register of Wills and Don Watson at the Archives, City of Philadelphia; Kris Kepford and Elizabeth Laurent at Cliveden, a co-stewardship property of the National Trust for Historic Preservation, Philadelphia; Gretchen Worden at the Mütter Museum, College of Physicians of Philadelphia; Ronald Hurst and Jonathan Prown at Colonial Williamsburg, Inc., Virginia; Ruth Hoffman at Congregation Mikveh Israel, Philadelphia; Gail Serfaty at the Diplomatic Reception Rooms, Department of State, Washington, D.C.; James W. Tottis at the Detroit Institute of Arts; James L. Crawford and Richard P. Smith at the Episcopal Academy, Merion, Pennsylvania; Carol Faill at Franklin and Marshall College, Lancaster, Pennsylvania; Bengt Kylsberg and Karin Sheri at Skokloster Castle, Hallwyl Museum, Skokloster, Sweden; Jim McMahon, Jr., at the Hershey Museum, Hershey, Pennsylvania; Donald R. Friary, Penny Leverett, and Philip Zea at Historic Deerfield, Inc., Deerfield, Massachusetts; Kristen Froehlich at the Historical Society of Pennsylvania, Philadelphia; Dr. Marit Jentoft-Nilsen at the J. Paul Getty Museum, Los Angeles; Jim Green, John van Horne, Phil Lapsansky, Erika Piola, and Sarah Weatherwax at the Library Company of Philadelphia; Cory Aimsler at the Mercer Museum, Doylestown, Pennsylvania; Morrison H. Heckscher, John K. Howat, Peter M. Kenny, and Francis Gruber Safford at the Metropolitan Museum of Art, New York; Mark A. Trudo at the Moravian Historical Society, Nazareth, Pennsylvania; Jan Ballard at the Moravian Museum of Bethlehem, Pennsylvania; Jonathan Fairbanks and Gerald Ward at the Museum of Fine Arts, Boston; Kristina Eriksson, Johanna Fries, Tomas Lidman, and Gudrun Oettinger at the Royal Library, National Library of Sweden, Stockholm; Deborah Warner at the National Museum of American History, Washington, D.C.; Ulysses G. Dietz at the Newark Museum, Newark, New Jersey; Rebecca Streeter at the New Jersey Historical Society, Trenton, New Jersey; Debbie Coutavas and Kathleen Stuart at the Pierpont Morgan Library, New York; Sewell Biggs, Karol Schmiegel, and Roxanne Stanulis at the Sewell C. Biggs Museum of American Art, Dover, Delaware; Jean Burks at the Shelburne Museum, Shelburne, Vermont; Steve Warfel at the State Museum of Pennsylvania, Harrisburg; Margo Burnette, Margaret Richardson, and Nora Wetherall at Stenton mansion, Philadelphia; Martha Asher and Beth Weiss at the Sterling and Francine Clark Art Institute, Williamstown, Massachusetts; G. Frederic White, III, at Trinity Episcopal Church, Wilmington, Delaware; Nancy Richards, Joanna Ruth, and Kay Williams at Tryon Palace Historic Sites and Gardens, New Bern, North Carolina; Mark Anderson, Wendy Cooper, Kathy Coyle, Pat Halfpenny, Charles Hummel, Brock Jobe, Greg Landrey, Dwight Lanmon, Susan Newton, and Neville Thompson at the Winterthur Museum, Winterthur, Delaware; Meg Schaefer at Wrights Ferry Mansion, Columbia, Pennsylvania; Marigene Butler, Jeff Groff, and Betsy Solomon at Wyck, Germantown; and David Barquist and Patricia Kane at Yale University Art Gallery, New Haven.

Many other individuals lent support and valuable assistance in a variety of ways, including Kathy and John Sherrerd, who seem to always be there when American Art needs them; Joanne Thalheimer, who looked at a fragment and stitched a showstopper; Anthony and Lulu Wang, whose confidence and generous support made the difference; Sandy Cadwalader, who stood up for freedom of speech; Bill Dupont, who delayed construction and let me send a truck; Joseph McFalls, gentleman historian and one-man preservation act; Skip Chalfant, who searched and found a spoon and *the* table; Fred and Anne Vogel, who opened up their home and encouraged and advised me on period fabrics, thus transforming this aspect of the exhibition; Tom and Karen Helm, who surrendered basic comforts with a smile; Martin Battestin, Philip Bradley, Michael Brown, Mr. and Mrs. Kilborn Church, Tom Crane, Amy Freitag, Betsy Garrett, Lee Ellen Griffith, Clifford and Ralph Harvard, John Hays, Don and Trish Herr, Joan and Victor Johnson, Leigh Keno, Leslie Keno, Joseph Kindig III, Susan Kleckner, Eric Kondratieff, Mary Louise Krumrine, Deanne Levison, Jack Levy, Sandy Lloyd, Alan

Miller, Dennis Moyer, Robert Nix, Ruth Nutt, Bruce Perkins, Betty Ring, Albert Sack, Harold Sack, Ann Sickles, Jeanne Sloan, Jay Stiefel, Jonathan Trace, Robert Teitelman, and many others. Finally, my family and several good friends have been there when I needed them and nudged me, nurtured, encouraged, fed, and dealt with me at my worst and ignored me when they should have. In particular, thanks are owed to Bob, Dallas, and Cobi, who regularly did all of the above.

In the early 1750s, Gottlieb Mittelberger, a German visitor who traveled extensively in the region, observed in his *Journey to Pennsylvania in the Year 1750* that Pennsylvania had become a "heaven for farmers, paradise for artisans, and hell for officials and preachers." This book is gratefully dedicated to all those whose support helped assure that my task was harvesting and creation, and who helped me avoid the inferno.

Jack L. Lindsey

Lenders to the Exhibition

The American College of Physicians, Mütter Museum, Philadelphia

American Jewish Historical Society, Waltham, Massachusetts, and New York

American Philosophical Society, Philadelphia

American Swedish Historical Museum, Philadelphia

The Art Institute of Chicago

The Atwater Kent Museum, Philadelphia

The Brinton 1704 House, Dilworthtown, Pennsylvania

Chester County Historical Society, West Chester, Pennsylvania

Christ Church, Philadelphia

City of Philadelphia, Archives and Register of Wills

Cliveden, a co-stewardship site of the National Trust for Historic Preservation, Philadelphia

The Colonial Williamsburg Foundation, Williamsburg, Virginia

Commissioners of Fairmount Park, Philadelphia

Congregation Mikveh Israel, Philadelphia

The Corning Museum of Glass, Corning, New York

The Detroit Institute of Arts

The Dietrich American Foundation, Chester Springs, Pennsylvania

Diplomatic Reception Rooms, Department of State, Washington, D.C.

The Episcopal Academy, Merion, Pennsylvania

Hershey Museum, Hershey, Pennsylvania

The Historical Society of Pennsylvania, Philadelphia

Historic Deerfield, Inc., Deerfield, Massachusetts

The Library Company of Philadelphia

Library of the College of Physicians of Philadelphia

The Mercer Museum of the Bucks County Historical Society, Doylestown, Pennsylvania

The Metropolitan Museum of Art, New York

The Moravian Historical Society, Nazareth, Pennsylvania

The Moravian Museum of Bethlehem, a member institution of Historic Bethlehem Partnership, Bethlehem, Pennsylvania

Museum of Fine Arts, Boston

National Portrait Gallery, Smithsonian Institution, Washington, D.C.

The Newark Museum, Newark, New Jersey

The New Jersey Historical Society, Newark, New Jersey

Old Swedes Church of Trinity Episcopal Parish, Wilmington, Delaware

The Pierpont Morgan Library, New York

Rothman Gallery, Franklin and Marshall College, Lancaster, Pennsylvania

The Royal Library, National Library of Sweden, Stockholm

The Ryerson and Burnham Libraries (The Art Institute of Chicago), Chicago

Saint Paul's Church, Philadelphia

The Schwarz Gallery, Philadelphia

Sewell C. Biggs Museum of American Art, Dover, Delaware

Skokloster Castle, Hallwyl Museum, Skokloster, Sweden

The State Museum of Pennsylvania, Pennsylvania Historical and Museum Commission, Harrisburg, Pennsylvania

Stenton, the National Society of the
Colonial Dames of America in the
Commonwealth of Pennsylvania,
Philadelphia

Sterling and Francine Clark Art Insti-
tute, Williamstown, Massachusetts

Tryon Palace Historic Sites and
Gardens, New Bern, North Carolina

Von Hess Foundation: Wright's Ferry
Mansion, Columbia, Pennsylvania

Winterthur Museum, Garden & Library,
Winterthur, Delaware

Wyck, Germantown, Philadelphia

Yale University Art Gallery, New Haven,
Connecticut

Jeff Applegate

Mr. and Mrs. Daniel Blain, Jr.

Philip H. Bradley

H. L. Chalfant

H. Richard Dietrich, Jr.

William K. Dupont

Edward A. and Judi V. Eckenhoff

Robert A. Erlandson

Mr. and Mrs. Thomas B. Helm

Mr. and Mrs. William S. Hyland

Veronica Anderson MacDonald

Donald McCoy and Frances Genovese

Joseph and Jean McFalls

Mr. and Mrs. Robert L. McNeil, Jr.

Dr. and Mrs. Richard A. Mones

Robert Murphy

The Ruth J. Nutt Collection

Bruce C. Perkins

Mr. and Mrs. John S. Price

Mr. and Mrs. Robert L. Raley

Valerie Anderson Readman-Story

Dr. and Mrs. Louis E. Sage

Charles and Olenka Santore

Mr. and Mrs. Herbert F. Schiffer

Joseph B. and Sharon L. Shelanski

Mr. and Mrs. E. Newbold Smith

Jay and Terry Snider

Mr. and Mrs. Clarence Spohn

Jay Robert Stiefel

J. Anthony Stout

Charlene Sussel

S. Robert Teitelman

Mr. and Mrs. Frederick Vogel, III

Tom Ward

Katrina Wetzels

Mr. and Mrs. William West Wilson, Jr.

Mr. and Mrs. Roy J. Zuckerberg

and fifteen private lenders

Note to the Reader

All numbers preceded by "no." refer to objects in the Checklist of the Exhibition, pp. 127–246.

Figure captions for objects in the checklist supply basic information (artist or maker, object name, date) and the checklist number of the object, directing the reader to full information on the piece.

The checklist of the exhibition is grouped by medium or material: wood (furniture), silver, base metals, ceramics, glass, textiles, and paintings and works on paper. Furniture is further arranged into broad types (case furniture, tables, etc.) and finer types (boxes, chests, etc.) and chronologically thereafter. Silver is arranged by type (tankards, canns, etc.) and chronologically thereafter. All other mediums are arranged chronologically.

The order in the checklist entries is as follows: name of object or work of art; artist or maker, place of birth, and life dates, where known; place and date of manufacture; inscription, if applicable; medium(s) or material(s); dimensions; credit line; provenance, where known, or additional information about the piece.

Within the checklist of furniture, primary woods precede secondary woods and other materials, which are listed alphabetically.

Only materials and inscriptions original to a piece are listed.

Dimensions are given in both inches and centimeters in the order height by width by depth, unless otherwise specified.

Provenance information lists only original owners, where known, or a line of descent.

When objects and works of art in the checklist have been illustrated in the text, a figure reference will direct the reader to the illustration.

The Arts of Early Pennsylvania, 1680–1758

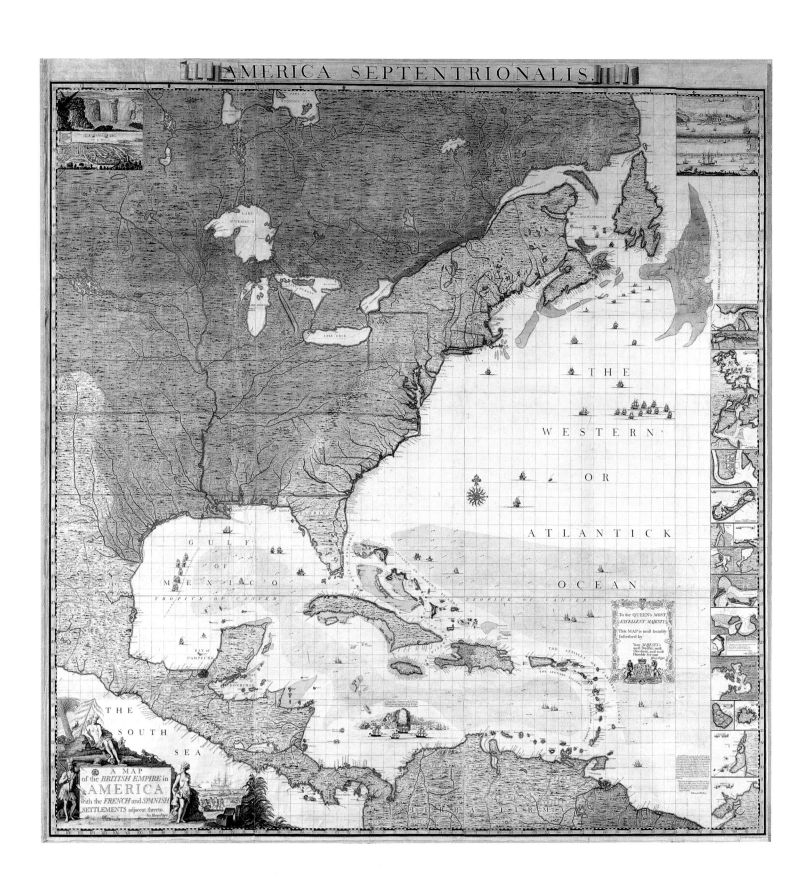

Worldly Goods

Jack L. Lindsey

D uring the late seventeenth and early eighteenth century concepts of worldly order and balance emerged as important topics of deliberation in Europe and Britain. As exploration and colonization expanded, the realization of humanity's broader potentials and responsibilities in a vast new world called for increased civic order and a systematic way to designate the position of all individuals in it. In Europe, growing challenges to the hierarchical social orders established during the late Renaissance and enforced by crown, court, and state religion threatened the established systems, which had bound diverse populations into relationships of superior and inferior and leader and subordinate and provided controlled parameters of behavior for individuals within each prescribed class. In what is often referred to as the "Age of Absolutism," the monarchy, followed by the clergy, struck a balance of power with the court aristocracy and landed gentry (fig. 3). At the top of the hierarchy, they were followed, in descending order, by wealthy merchants, smaller shopkeepers, artisans and craftsmen,

yeoman farmers, laborers, peasants, and slaves in a system deemed "natural" and perceived by most as ordained by the word of God.[1]

Scientific inquiry—astronomical and mathematical calculations and investigations into "natural philosophy"—altered concepts of this "natural" order, suggesting forces and balances much more powerful than any system established by hereditary rule or military conquest. Revolutionary thinkers such as Galileo, René Descartes, Voltaire, Thomas Hobbes, Sir Isaac Newton, and John Locke, in their searches for more rational government and empirical systems of balance in the universe, broadened concepts of humanity's role on a diverse planet. Ancient Greece and Rome, and even earlier civilizations, provided models of what many felt had been humankind's greatest moments (fig. 2). The Royal Society of London for Improving Natural Knowledge, established in 1662, was one of several learned organizations serving as early clearinghouses and sounding boards for controversial and revolutionary scientific ideas and discoveries. As people's knowledge

Fig. 1 (opposite page)
Henry Popple, *America Septentrionalis*, 1733, no. 492. The legend at the bottom right of Popple's map of the American colonies, written by the astronomer Edmond Halley, praises it for showing "the Position of the different Provinces & Islands in that Part of the Globe more truly than any yet extant."

Fig. 2
Euclid's *Elemental Geometry*, printed 1594, no. 481. James Logan's library at his Philadelphia house, Stenton, included the writings of the great scientific thinkers of ancient Greece and Rome, annotated by Logan in Greek, Latin, or Arabic.

Fig. 3
Medal of Charles II, King of England, Pieter van Abeele, c. 1660, no. 282. Presentation medals were often awarded by the court to agents of the crown as a sign of favor.

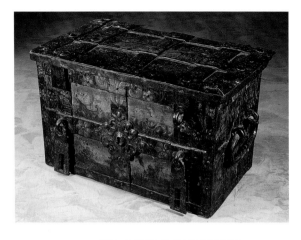

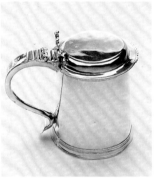

Fig. 4
Chest, c. 1650–70, no. 16. This chest, which a Swedish immigrant carried with him to New Sweden, is typical of those brought to the Delaware Valley by newly arriving wealthier immigrants.

Fig. 5
Tankard, Cesar Ghiselin, c. 1684–90, no. 185. This tankard, one of the earliest known to have been produced in Philadelphia, shows the influence of French, Dutch, and English silversmithing traditions. Cesar Ghiselin, a French Huguenot, incorporated a cut-card and wire-worked foot band and cast, figural thumbpiece.

of the universe widened and they were enlightened to its greater potentials as well as its dangers, they sought for ways to order and describe it more accurately;[2] the act of naming and classifying things, planetary calculations, and cartography took on a new importance. It was from this evolving world in Europe and Britain, with its emphasis on rational understanding and order, that many of the early colonists who settled in the Delaware Valley had come. And it was the model to which they referred in establishing the intricate social order that would mold colonial Pennsylvania's early political and cultural life.

Exploration and colonization provided opportunities to experiment with new systems of government and commerce and also offered for some a means of escape from persecution based on their religion, politics, or philosophy. In Pennsylvania William Penn sought to establish a new social order founded on religious liberty and personal freedom. Penn had experienced firsthand the intolerance of seventeenth-century England. He also remembered London's overcrowding and social chaos; these conditions, many felt, had culminated in the disastrous human miseries in the city during the 1660s: the massive outbreaks of bubonic plague in 1665 and the great fire of 1666. In establishing the colony of Pennsylvania in 1681, Penn envisioned "a greene Country Towne, w[ch] will never be burnt, and allways be wholsome."[3]

In theory, the harsh conditions of initial settlement in Penn's new colony left little time to devote to domestic creature comforts. While early immigrants may have brought along a few cherished items for nostalgic reasons or to provide liquid assets, surviving inventories suggest that most of the earliest households

were sparsely equipped with locally produced objects necessary for day-to-day life (fig. 4).[4] Some wealthier householders did possess a wider range of domestic objects, including such luxuries as fine textiles, glass, and precious metals. Slowly, conditions improved for a greater portion of the population (fig. 5). The export of agricultural products and raw materials and the import of manufactured goods —lucrative activities of colonial ports and countinghouses—provided the stability essential for Pennsylvania's fragile developing economy. Those fortunate enough to have arrived with liquid capital and connections gained early market advantages during the initial period of settlement and growth. An influential and elite merchant class evolved, and in most cases assumed the positions of political and cultural leadership. Urban and rural economies became increasingly interdependent as they recognized the coordinated regional efforts necessary to realize the enormous profits that were possible through accessing larger, diversified markets abroad.[5] Waves of continued immigration supplied a steady source of both common labor and highly skilled talent.

Once the chaos occasioned by relocating to a new country receded, people began to order their lives in very particular ways. Undifferentiated patterns of domestic room usage slowly evolved to the point where distinct areas of the house were used for specific functions. Furniture forms developed to provide for multiple interior divisions and orderly storage (fig. 7). As domestic rituals and social activities were elaborated, specific decorative and functional serving forms became necessary. Their amount of ornament, stylishness, and cost soon came to denote the rank, wealth, and social

position of the owner (fig. 8). Growing prosperity brought with it disposable income and an increased demand for the luxury fruits of hard labor and success. Once they were able, people in almost every level of colonial society made efforts to improve the signals sent to their neighbors and peers by their personal appearance and possessions. The house and its furnishings and decorations, as well as a person's dress and deportment, became visible symbols of social status,[6] and craftsmen and merchants scrambled to provide the range of goods necessary to fill demands. Epitomizing the highest of style, the unified interior, complete with its furniture en suite in coordinated colors and repeated decorative motifs, became a model for all Pennsylvanians to emulate (fig. 9).

Most of the stylistic movements present in early colonial America were complicated hybrids of European and English styles brought to the region by immigrant craftsmen or through trade (fig. 10). The varied economic conditions and regional preferences in the early Delaware Valley sparked numerous vernacular reinterpretations of these aesthetic traditions and imported designs. Some traditional elements and decorative forms continued relatively unchanged, however, for immigrant craftsmen developed their own conservatism in response to new conditions.[7] Within the craft community apprentices were usually expected to follow fairly specific methods of construction, and they absorbed many of the practices and aesthetic preferences of the shop master. Once independent and in their own shops, they were often reluctant to give up the tried-and-true methods they had learned. Hence a style or form that might have evolved more freely in response to changing

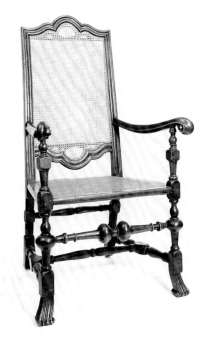

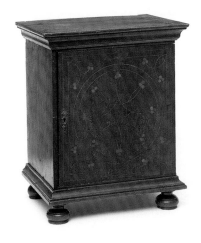

outside stimuli often lingered longer as a result of habit and training (fig. 11). Competition and imitation among rival craftsmen scrambling to secure commissions could also serve to both speed and slow stylistic change. While many patrons sought to acquire "the latest fashion" to demonstrate their taste, artists who wandered too far, too quickly, from the accepted models risked a loss of business or even ridicule.

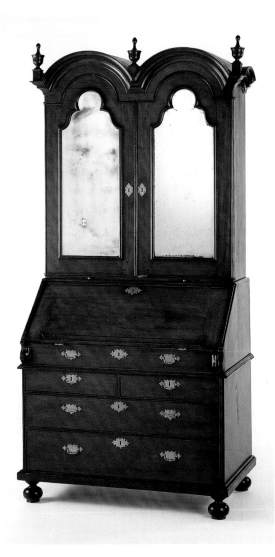

Fig. 6
Armchair, 1690–1720, no. 137. Caned furniture like this locally made armchair was promoted during the late seventeenth and early eighteenth centuries for its health advantages, such as better ventilation and lack of the types of vermin that found a home in the stuffing and fabric used in early upholstery.

Fig. 7
Spice Box, c. 1745–60, no. 11. "Spice boxes"—small cabinets with multiple drawers in their interiors that could be locked—were used for storing valuables and were particularly popular in Pennsylvania. Forms such as these reflect the growing emphasis many of the colony's residents placed on order and organization.

Fig. 8
Secretary Desk and Bookcase, c. 1710–20, no. 70. Ornate "scritores," or writing desks, were symbolic of authority and wealth. The imported shaped and beveled mirrored plates in the upper doors of this desk were the most costly components in its design.

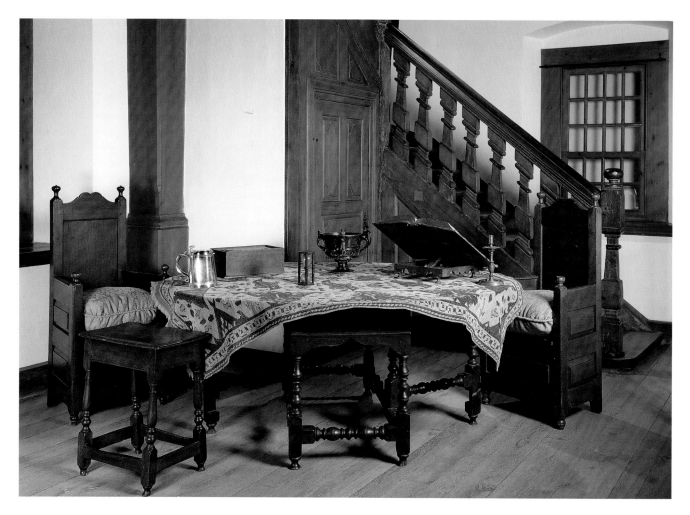

Fig. 9
Early Pennsylvania furnishings (nos. 77, 107, 139, 375) placed in the Millbach House (built c. 1753), as installed at the Philadelphia Museum of Art. The costliness of fine textiles, silver, and richly paneled or turned furniture such as those seen here was widely recognized, and their ownership conveyed important messages of power and authority.

Fig. 10
Settle Bench, c. 1725–40, no. 109. Furniture forms such as this high-backed settle bench combine traditional English, Germanic, and northern European forms and construction techniques. It is one of the few settle "couches" from the period to have retained its original upholstery.

Fig. 11
Spoon, c. 1680–94, no. 263; Spoon, Johannis Nys, c. 1710–20, no. 269. Imported spoons like the stipple-engraved example on the left, owned by the Philadelphia merchant Jonathan Dickinson, may have served as inspiration for similar spoons from the shops of several of the city's earliest silversmiths, such as Johannis Nys. Nys, a French Huguenot, may also have been familiar with such styles through his earlier training.

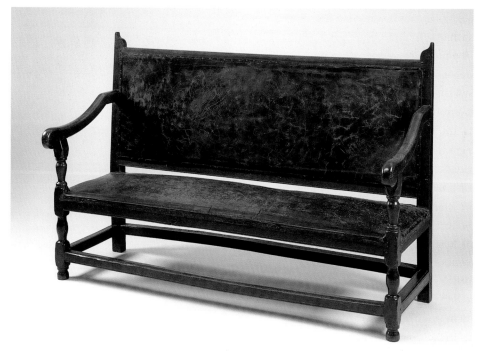

 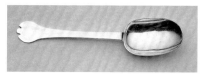

The documented frequent immigration of foreign-trained craftsmen and the volume of prototypes imported into busy colonial ports such as Philadelphia secured the claim made by many local craftsmen of being able to supply work "in the latest and best London manner."[8] There is little evidence to support the common theory of a time lag in the transferral of motifs and forms from foreign shores to the cities of colonial America. As the furniture scholar Benno Forman noted, "unless specific causes can be adduced to explain a delay in the transmission of ideas—a war in progress, religious or political scruples against being fashionable, lack of money with which to buy new fashions, export items consisting of old stock shipped to the colonials to be got rid of—we have no reason to assume that a customer in a seaport town who wanted a piece of furniture in the newest fashion was hampered by anything but the time it took a ship to bring a model or a maker from Europe."[9]

Stylistic changes and variations resulted from no single impetus but from many things occurring simultaneously. The gradual formation and assimilation of a new style provided time for experimentation. Some ideas were rejected while others advanced to result in a new decorative form or motif. Aesthetic shifts rarely took place in the distinct historical sequences suggested by many earlier scholars and art historians. Nor did the introduction of new stylistic ideas always begin in sophisticated urban areas and then "trickle down" to rural craftsmen or patrons who had an imperfect understanding of them. Transitional or regional interpretations of a style more often reflect the conscious choices or preferences of individual craftsmen and their patrons rather than accident, misunder-

standing, lack of training, or the inaccessibility of suitable materials and prototypes.[10] Change was most often gradual, with decorative elements of a new style cautiously applied to earlier forms, requiring no abrupt shift in mind-set, for transitional experiments toward a new mode of decoration or a new form could continue to carry the symbolic significance of older styles (fig. 12).[11] As a result, individual experiments with proportion, materials, or the placement of decorative ornament could—in the hands of adventurous craftsmen or at the insistence or whim of an idiosyncratic patron—provide any number of variations in historical patterns that now serve to cloud our efforts to track any provable chronology or predictable rate of change in the shift from one prevailing style to another (fig. 13).

The terms that have been adopted for the different styles and periods in the history of the American decorative arts have also recently undergone scrutiny. Nomenclature has traditionally derived from the name of the reigning English monarch or the most prominent designer active during a given period. The styles that held sway in colonial America and, more specifically, in Pennsylvania prior to 1750 have usually been called "William and Mary" and "Queen Anne." Because in America the aesthetic principles that define these styles both predate and persist after the reigns of William and Mary (1689–1702) and Queen Anne (1702–14), the terms are slowly being replaced by "Early Baroque" and "Late Baroque."[12] These broader terms more properly suggest the numerous international influences that informed the aesthetic and philosophical motivations of the styles prominent in early colonial America and particularly Pennsylvania. However,

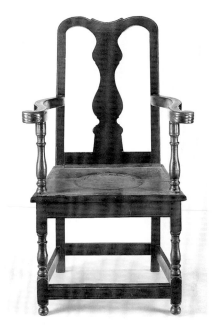

Fig. 12
Armchair, c. 1740–55, no. 160. Chairs such as this armchair by a Germanic maker illustrate the idiosyncratic solutions individual craftsmen arrived at in wrestling with design choices and construction techniques during a period of stylistic transition. Its base turnings and seat frame reflect aspects of earlier wainscot-chair construction, while its baluster-shaped back splat and scooped crest rail relate to later compass-seat, cabriole-leg chair design.

Fig. 13
Wardrobe, c. 1745–60, no. 44. The intricate shaped paneling, bold molding profiles, relief-carved polychrome floral insets, and inlays decorating this remarkable walnut kas represent a local amalgamation of earlier seventeenth-century motifs from low country Dutch and northern Germanic traditions.

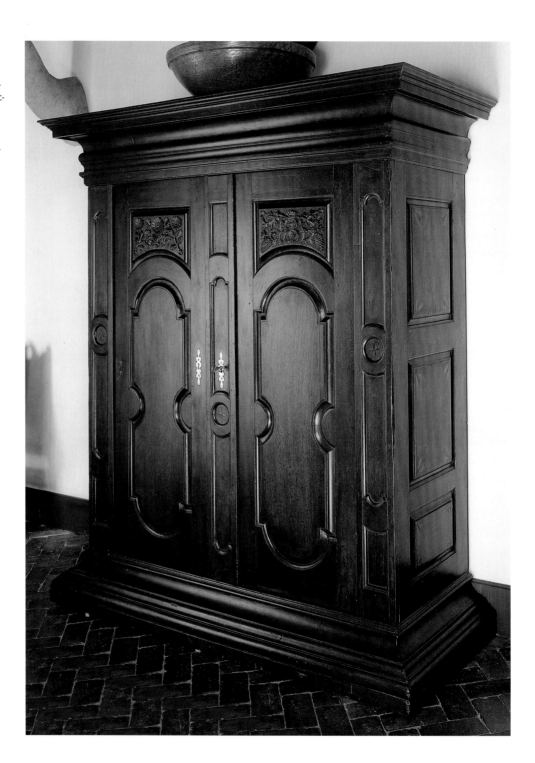

a recent approach that identifies a group of decorative styles has the advantage of allowing for tracing often long-lived motifs and the substantial national and regional variations and combinations that defy a single stylistic category.[13]

The style with the greatest impact in the American colonies was the prevailing northern European classicism of France, Holland, and Britain that flourished in the second half of the seventeenth century. Drawing on ancient classical motifs

revitalized in Italy during the later Renaissance, the movement was formed during the reign of King Louis XIV, the Sun King (1643–1715). The court style of France, as achieved most fully at Versailles, became the model for most of the leading courts of Europe. The style gained enthusiastic support and underwent further adaptation in Holland after 1672 under William III's reign as stadtholder (1672–1702), and it spread with equal vigor to England after William's marriage to his cousin Mary (1662–1695) in 1677, developing further upon their ascendency to the English throne in 1689.[14]

Patronage of European royal courts was crucial to the evolution of late seventeenth-century design principles, but it was the talent and imagination of legions of highly skilled designers, *ébénistes,* cabinetmakers, metalworkers, and tapestry weavers who brought refined brilliance to the style and popularized it among the wealthy merchant families involved in the Dutch East and West India companies and in wider speculative colonial investments. The majority of these craftsmen were of French Huguenot descent, forced to flee France in increasing numbers after the revocation of the Edict of Nantes in 1685.[15] Forbidden to follow their Protestant faith, persecuted and displaced from their shops, master craftsmen and apprentices alike relocated to Holland, England, and the American colonies. Having been trained in diverse, specialized crafts, most of them were welcomed with enthusiasm.[16] In London, for example, a building boom to repair the devastation left by the great fire of 1666 provided widespread employment for craftsmen of every type and at every level of skill. Cosimo III de' Medici, grand duke of Tuscany, noted

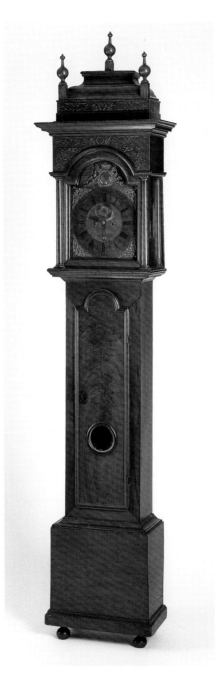

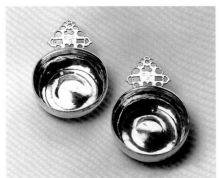

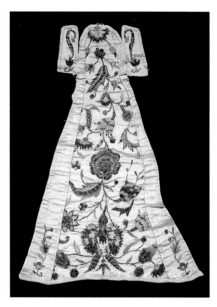

Fig. 14
Tall Case Clock, Peter Stretch, c. 1720–30, no. 58. This clock, whose blind fretwork frieze and cast brass spandrels are similar to English and northern European prototypes, was produced by Peter Stretch in his shop at the corner of Front and Chestnut streets in Philadelphia. One of the city's leading craftsmen, active in civic and Quaker affairs, Stretch, along with his sons Thomas and William, established one of the most respected clockmaking businesses in the city.

Fig. 15
Stomacher, c. 1690–1735, no. 377. Ornate personal accessories such as this fine needlework stomacher, which would have been worn as a part of the bodice of a stylish lady's dress, were copied from the clothing styles of European and English courts.

Fig. 16
Pair of Porringers, Johannis Nys, c. 1710–25, no. 257. French Huguenot talent and traditions heavily influenced the silversmithing profession in Philadelphia. Both Cesar Ghiselin and Johannis Nys, the city's earliest practicing silversmiths, were Huguenots.

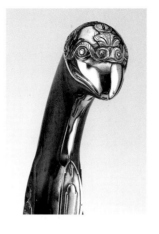

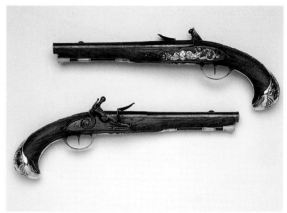

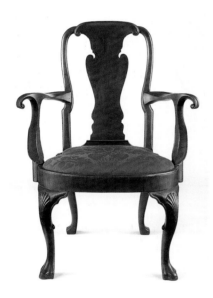

upon a visit to England in 1668 that "the French make fortunes in London, for being more attentive to their business, they sell their manufactures at a lower price than the English."[17]

One of the figures most responsible for the development and dissemination of the French styles as an international movement was the architect and designer Daniel Marot (1661–1752). His published designs combined decorative elements from the ancient architectural orders with a new bold and curvaceous symmetry. Typical of the style are strong, meticulously balanced three-dimensional forms in richly worked materials and with surfaces embellished by intricate patterns, so-called auricular ornament (curving forms like the interior of a shell or the lobes of an ear), acanthus scrolls, and other naturalistic motifs (fig. 17). Marot also brought the formulation of the unified interior (a room conceived together with its decorations and furnishings) to its fullest development. He prescribed that architecture, gardens, furnishings, and interior decoration share color, fabric, and motifs as a coordinated and balanced whole. Ornate furniture, precious silver, exotic porcelain, and rich decorative textiles in orchestrated assemblages related by pat-

tern and color created lavish domestic interiors en suite.[18]

Marot had trained in France and thus had intimate knowledge of the work of the painter Charles Le Brun (1619–1690), the leading decorator of Versailles and the person who had the most influence on the customs and fashions of the court of Louis XIV. A Huguenot, Marot fled France for the Hague in 1684–85 and, aided by his diverse talents, quickly established important contacts that led him to the Dutch court of William and Mary. There he became absorbed in the building and decorating of Het Loo, the monarchs' residence near Apeldoorn, until William's death in 1702. During the protracted improvements there he followed the monarchs to England in 1689–90, where he joined the many highly skilled Huguenots who enjoyed influential patronage within the English court and from the landed gentry and wealthy merchant classes. Marot's itinerary and multifaceted career, together with the diaspora of large numbers of craftsmen like him who were forced to flee the turmoil and political disruptions of wars and prejudice in seventeenth-century Europe, helped spread European and English baroque classicism to the colonies and

serve to explain its influence during the period (fig. 18).[19]

The art and artifacts illustrated here demonstrate the richness and ingenuity of the aesthetic traditions and craftsmanship that made their way to the Delaware Valley and flourished there during the early colonial period, a time when status and personal identity became intertwined with fashionable behavior and objects, as well as decorative motifs and style. William Penn had from the beginning realized the necessity of attracting skilled craftsmen to Pennsylvania, and he made special efforts to entice a full range of talents and skills to support the needs of individual householders and commerce. The approximately 120 craftsmen practicing their various trades in Philadelphia by 1690, together with those producing goods in the surrounding rural communities, became, as a group, a mainstay of the region's economy.[20] In turn, the thriving economy and diverse cultural dynamics of the Delaware Valley brought unprecedented support and demand for the decorative arts. Competition among rival craftsmen resulted in improved quality, increased innovation, and inspired imagination. The resulting artistic output, produced to satisfy multiple cultural and aesthetic preferences, emanated with equal brilliance from both urban and rural workshops and helped to determine the content and character of most households during the period.

The rapid development and early success of Penn's colony, with Philadelphia at its economic and cultural core, can be attributed to a number of factors. Since ancient times Native Americans had recognized the natural abundance of the Delaware Valley and had hunted and prospered there. In their earlier attempts at colonization, Dutch and Swedish trad-ers had failed to gain a strong and lasting position in the region.[21] By contrast, William Penn's intention in 1681 to found "a large Towne or Citty in the most Convenient pla[ce] upon the River for health & Navigation" was quickly realized.[22] His success where others had failed was largely due to the economic and investment potentials provided by the physical characteristics of the site his surveyors chose and his commitment to the idea that the colony of Pennsylvania would become a haven of religious tolerance, civil liberty, and personal opportunity. Philadelphia's location on a wide peninsula between two rivers would prove to be one of the most important factors in its development. Penn's investors were quick to realize that the Delaware River provided a deep, commodious port capable of being expanded and of accommodating a large sea-going trade. In addition, the Schuylkill, flowing from the west, would in time provide valuable access to the vast undeveloped agricultural hinterland surrounding the city Penn and his surveyors envisioned.

Penn's open, symmetrical layout for the city of Philadelphia shows his desire for orderly development (fig. 20).[23] His plan prescribed placing the major public buildings around open squares or along the wide main streets:

"The City, . . . consists of a large Front-street *to each River, and a* High-street *(near the middle) from Front (or River) to Front, of one hundred Foot broad, and a* Broad-street *in the middle of the City, from Side to Side, of the like breadth. In the Center of the City is a* Square *of ten* Acres; *at each Angle are to be Houses for* publick Affairs, *as a* Meeting-House, Assembly *or* State-House, Market-House, School-House, *and several other*

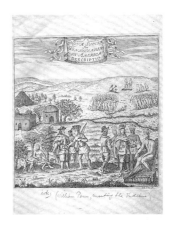

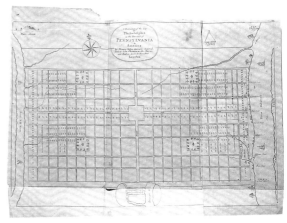

Fig. 19
Tomas Campanius Holm, *Kort Beskrifning om Provincien Nya Swerige . . .*, 1702, no. 489. While few lasting settlements were established along the Delaware River prior to Penn's arrival, the profitable trade in furs and relatively peaceful relations the earliest Dutch and Swedish settlers had established with the Delaware Indians paved the way for the later English settlers.

Fig. 20
William Penn, *A Letter from William Penn . . . to the Committee of the Free Society of Traders*, 1683, no. 484. Penn's surveyor, Thomas Holme, in this 1683 map depicted Philadelphia's uniform grid of streets, relieved by a main central square and four flanking subsidiary squares. The map was included with Penn's letter to the Free Society of Traders.

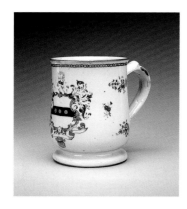

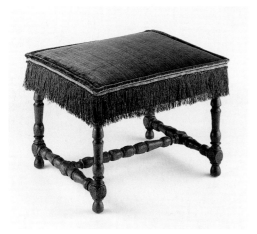

Fig. 21
Cann, c. 1725–40, no. 353. By the mid-1690s, it was felt that Penn emulated too closely the lifestyles of the English court. This elaborate Chinese porcelain cann, bearing the family crest used by William Penn's sons and grandsons, suggests the extent to which later generations of the Penn family had moved away from the tenets of Quaker simplicity.

Fig. 22
Stool, c. 1670–1700, no. 105. This turned-joint stool was owned by Francis Daniel Pastorius, who founded the settlement of Germantown in 1683, site of Pennsylvania's earliest printing operation, linen manufactory, and paper mill. William Penn encouraged the establishment of such ethnic enclaves.

Buildings for Publick Concerns. There are also in each Quarter of the City a Square of eight Acres, to be for the like Uses, as the Moore-fields in London."[24]

With its balanced grid of pleasant streets, public squares, and green uncrowded vistas, the plan reflects the influence of European and English baroque town planning, and the careful placement of major public buildings followed the prescriptions of such architects as the Englishman Sir Christopher Wren (1623–1723), who suggested that "handsome Spires or Lanterns, rising in good proportion above the neighbouring houses . . . may be of sufficient Ornament to the Town."[25]

The speed and direction of Philadelphia's early development seem to have taken even Penn and his initial investors by surprise. In December 1683 Penn boasted to the Marquis of Halifax: "I must, without vanity, say that I have led the greatest colony into America that ever any man did upon a private credit, and the most prosperous beginnings that ever were in it are to be found among us!"[26] While the growing power of a prosperous merchant class would eventually bring it into conflict with Penn's restrictive proprietary rule, its economic leadership laid the groundwork that ensured the city's continued growth and diversification. A burgeoning international trade developed, founded upon the export and distribution of Pennsylvania's rich raw materials and agricultural produce. Philadelphia gained a virtual monopoly on the movement of goods along the Delaware early on; exports reached the equivalent of £3,400 by 1697 and grew steadily thereafter. In 1723 the number of vessels cleared by the city's ports was eighty-five; by 1749 that number had

increased to at least four hundred.[27]

Penn's widespread promotion of Pennsylvania coincided with a long period of turmoil in Europe. A century of devastating wars, beginning with the Thirty Years War (1618–48) and continuing with little relief through the outbreak of Queen Anne's War in 1702, had repeatedly devastated local economies, disrupting whole villages and destroying Middle European agricultural output and the remnants of feudal order. Penn's promise of religious toleration and personal liberty offered the hope of escape from misery and political persecution. Such propagandistic tracts as Penn's own *Some Account of the Province of Pennsilvania,* printed in 1681 in English, Dutch, and German, tempted potential immigrants by describing anticipated development as reality, painting a picture of unlimited opportunity and utopia. While the economic and cultural assets he described as already in place would not be fully established for another fifty years, the image he portrayed of the region's promise held in the minds of many, bringing waves of hopeful immigrants. Jonathan Dickinson, a leading and influential Philadelphia merchant who had invested extensively in the growing triangle trade with the West Indies and England, understood how essential continued immigration was to the steady, uninterrupted growth of the colony.[28] In 1719 he commented on the diverse groups arriving in the city: "We are daily expecting ships from London which bring over Palatines [middle Germans], in number about six or seven hundred. . . . Some few came from Ireland lately, and more are expected thence. This is besides our common supply from Wales and England."[29]

While most immigrants sought to escape the hardships and restrictions of

their former lives, many still hoped to reestablish in some degree a familiar sense of their former identity in their new surroundings. Earlier occupations, customs, and stylistic preferences were resurrected and transformed as immigrants simultaneously looked back to tradition and forward to the new demands of assimilation and adaptation.[30] The varying responses of different national groups working communally gave early Pennsylvania cultural sophistication and a cooperative ethos. The prediction made by John Jones, one of Penn's "First Purchasers," in 1699, that Philadelphia would in time become the "Metropolis of America," was quickly shown to be prescient.[31]

Prosperity and expansion set the stage for widespread support of the arts at almost every level of society. The desire for stylish luxuries fueled the demand for imported goods and inspired both urban and rural artisans to develop the skills to rival foreign craftsmanship. The race to fill demands helped broaden the already rich artistic traditions in the Delaware Valley. Andreas Rudman, the first pastor of the city's Swedish congregation at Gloria Dei (or Old Swedes' Church), noted in 1700: "If anyone were to see Philadelphia who had not been there [before], he would be astonished beyond measure [to learn] that it was founded less than twenty years ago. . . . All the houses are built of brick, three or four hundred of them, and in every house a shop, . . . so that whatever one wants at any time he can have, for money."[32] By 1743, Benjamin Franklin, Philadelphia's leading cultural and intellectual figure, was able to write: "The

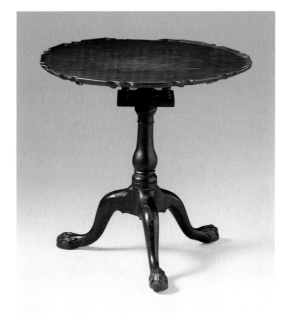

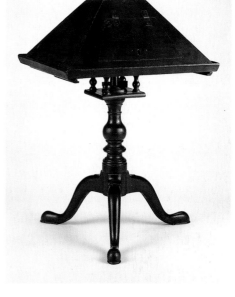

first Drudgery of Settling new Colonies . . . is now pretty well over; and there are many in every Province in Circumstances that set them at Ease, and afford Leisure to cultivate the finer Arts, and improve the common Stock of Knowledge."[33] As he wrote in a letter to a friend in 1748, he too was "taking the proper measures for obtaining leisure to enjoy life and my friends."[34] Franklin hoped that the city's cultural and intellectual character would continue to develop. He would later ask, somewhat whimsically: "Why, I say, should that little Island [England] enjoy in almost every Neighbourhood, more sensible, virtuous, and elegant Minds, than we can collect in ranging 100 Leagues of our vast Forests? But 'tis said the Arts delight to travel Westward."[35] This exhibition catalogue celebrates the glories of those rich traditions of artisanry and craftsmanship that did indeed "travel westward" and that continue to enrich our lives.

Fig. 23
Tea Table, c. 1730–40, no. 84. Imported furniture inspired the patterns and forms found in the work of local craftsmen. This Irish tea table is among the earliest cabriole-leg furnishings that can be documented to ownership in Philadelphia.

Fig. 24
Music Stand, possibly William Savery, c. 1745–55, no. 179. Benjamin Franklin, who originally owned this revolving music stand, may also have designed it. With its unique features, it reflects both his love of music and his inventive ingenuity. In addition to playing several instruments, including the viola and harmonium, Franklin composed original scores and hosted concerts for friends and associates in his Philadelphia house.

Notes

1. For one of the best, pioneering works on the theories of cultural order and their effects on artisanry, objects, and the history of aesthetics, see George Kubler, *The Shape of Time: Remarks on the History of Things* (New Haven: Yale University Press, 1962).

2. For an in-depth discussion of these early efforts at classification and ordering in the field of botany, see Joyce E. Chaplin, "Mark Catesby: A Skeptical Newtonian in America," in *Empire's Nature: Mark Catesby's New World Vision*, ed. Amy R. W. Meyers and Margaret Beck Pritchard (Chapel Hill, N.C., and London: University of North Carolina Press, 1998), pp. 34–90.

3. Richard S. Dunn and Mary Maples Dunn, eds., *The Papers of William Penn*, vol. 2, *1680–1684* (Philadelphia: University of Pennsylvania Press, 1982), p. 121; for a discussion of the early years in Philadelphia and Penn's plans for the city, see Dunn and Dunn, "The Founding, 1681–1701," in *Philadelphia: A 300-Year History*, ed. Russell F. Weigley (New York and London: W. W. Norton and Company, 1982), pp. 1–32.

4. An excellent extensive and quantified examination of early regional inventories is Margaret B. Schiffer, *Chester County, Pennsylvania, Inventories, 1684–1850* (Exton, Pa.: Schiffer Publishing Company, 1974).

5. For the dynamics of Pennsylvania politics in the early years, see Frederick B. Tolles, *Meeting House and Counting House: The Quaker Merchants of Colonial Philadelphia, 1682–1763* (1948; repr. New York: W. W. Norton and Company, 1963), pp. 3–29; for Quaker business dealings, see pp. 45–63.

6. Clothing and textiles were particularly lucrative markets because of their high cost. For the import of English textiles into the American colonies, see Florence M. Montgomery, *Printed Textiles: English and American Cottons and Linens, 1700–1850* (New York: The Viking Press, 1970), pp. 36–46.

7. Carl Bridenbaugh, *The Colonial Craftsman* (1950; repr. Chicago and London: The University of Chicago Press, 1966), pp. 33–45, discusses rural craftsmen and their experiences in the northern colonies.

8. See Benno M. Forman, *American Seating Furniture, 1630–1730: An Interpretive Catalogue* (New York and London: W. W. Norton and Company, 1988), p. 13.

9. Ibid.

10. Extensive research on regional craftsmanship, aesthetic choice, and the maintenance and dissemination of regional styles is available in Lee Ellen Griffith, "Line and Berry Inlaid Furniture: A Regional Craft Tradition in Pennsylvania, 1682–1790" (Ph.D. diss., University of Pennsylvania, 1988).

11. For traditional Germanic furnishings and objects in Pennsylvania, see Beatrice B. Garvan, *The Pennsylvania German Collection*, Handbooks in American Art, No. 2 (Philadelphia: Philadelphia Museum of Art, 1982), pp. 10–55.

12. For the recent (post 1990) use of the terms "Early Baroque," "Late Baroque," "Rococo," and "Federal" or "Neo-Classical" in scholarship on American furniture, see Morrison H. Heckscher and Leslie Greene Bowman, *American Rococo, 1750–1775: Elegance in Ornament* (New York: The Metropolitan Museum of Art, 1992), and Wendy A. Cooper, *Classical Taste in America, 1800–1840* (New York, London, and Paris: Abbeville Press for The Baltimore Museum of Art, 1993).

13. Alain Gruber, ed., *The History of the Decorative Arts: Classicism and the Baroque in Europe* (New York: Abbeville Press, 1996). The author wishes to thank Dean Walker, The Henry P. McIlhenny Senior Curator of European Decorative Arts and Sculpture, Philadelphia Museum of Art, for this reference and for his observations and suggestions in clarifying this discussion.

14. See Reinier Baarsen, "The Court Style in Holland," in Reiner Baarsen et al., *Courts and Colonies: The William and Mary Style in Holland, England, and America* (New York: Cooper-Hewitt Museum, 1988), pp. 12–35.

15. Ibid., p. 38. For the influence of foreign styles on colonial American silver, see *Spanish, French, and English Traditions in the Colonial Silver of North America*, 14th Annual Winterthur Conference (Winterthur, Del.: The Henry Francis du Pont Winterthur Museum, 1968).

16. Baarsen, "The Court Style in Holland," pp. 15–17.

17. *Travels of Cosimo the Third, Grand Duke of Tuscany, through England, during the Reign of Charles the Second* (1669; repr. London, 1821), p. 398; quoted in Gervase Jackson-Stops, "The Court Style in Britain," in *Courts and Colonies: The William and Mary Style in Holland, England, and America* (New York: Cooper-Hewitt Museum, 1988), p. 38. See also Peter Thornton, *Seventeenth-Century Interior Decoration in England, France, and Holland* (New Haven and London: Yale University Press, 1978), pp. 10–38.

18. One of the best compilations of Marot's numerous published designs and unpublished drawings is André Bérard, *Catalogue de toutes les estampes qui forment l'oeuvre de Daniel Marot, architecte et graveur français* (Brussels: A. Mertens, 1865). See also *Das Ornamentwerk des Daniel Marot in 264 Lichtdrucken nachgebildet*, introduction by Peter Jessen (Berlin: E. Wasmuth, 1892). Several reproductions of various drawings and etchings for Marot's architectural and decorative-arts designs are reproduced in *Courts and Colonies*.

19. Baarsen, "The Court Style in Holland," pp. 15–16, 31–32. See also Gervase Jackson-Stops, "Daniel Marot and the First Duke of Montagu," *Nederlands Kunsthistorisch Jaarboek*, vol. 31 (1980), pp. 244–62.

20. Dunn and Dunn, "The Founding," pp. 20–21.

21. See Charlotte Wilcoxen, *Dutch Trade and Ceramics in America in the Seventeenth Century* (New York: Albany Institute of History and Art, 1987), pp. 90–93.

22. Dunn and Dunn, *The Papers of William Penn*, vol. 2, p. 98.

23. Unfortunately, Penn's plans for orderly development were soon thwarted. Penn had allotted the most desirable land along the Delaware River exclusively to the largest investors, but the spacious town lots, meant to be the site of gentlemanly gardens and orchards, were quickly subdivided and resold as more people sought to establish themselves near the riverfront. The many smaller streets that were built to access the subdivided lots destroyed the earlier grid and the spacious arrangement Penn had envisioned.

24. William Penn, "A Short Advertisement upon the Scituation and Extent of the City of Philadelphia," in Penn, *A Letter from William Penn . . . to the Committee of the Free Society of Traders* (London, 1683); see no. 484 in the checklist.

25. See Peter Kidson, Peter Murray, and Paul Thompson, *A History of English Architecture*, 2nd ed., rev. (Middlesex, England, and New York: Penguin Books, 1979), pp. 193–94; see also Eduard F. Sekler, *Wren and His Place in European Architecture* (New York: Macmillan, 1956), pp. 71–109.

26. John F. Watson, *Annals of Philadelphia, and Pennsylvania, in the Olden Time*, enl. and rev. Willis P. Hazard, vol. 1 (Philadelphia: Edwin S. Stuart, 1887), p. 19.

27. Theodore Thayer, "Town into City," in *Philadelphia: A 300-Year History,* ed. Russell F. Weigley (New York and London: W. W. Norton and Company, 1982), p. 74.

28. In its triangle trade with England and the West Indies, the colonies traded such raw goods as pork, flour, and barrel staves for the rum, sugar, and mahogany of the West Indies. These goods were then carried to England, where some of them were traded for the English and European goods and luxury items so much in demand in the colonies.

29. John Fanning Watson, *Annals of Philadelphia, and Pennsylvania, in the Olden Time,* enl. and rev. Willis P. Hazard, vol. 2 (Philadelphia: Leary, Stuart, and Company, 1927), p. 254.

30. One of the most extensive examinations of the survival and adaptation of English furniture forms in America is John T. Kirk, *American Furniture and the British Tradition to 1830* (New York: Alfred A. Knopf, 1982).

31. See William MacPherson Hornor, Jr., *Blue Book of Philadelphia Furniture: William Penn to George Washington* (1935; repr. Washington, D.C.: Highland House Publishers, 1977), p. 1.

32. Ruth L. Springer and Louise Wallman, "Two Swedish Pastors Describe Philadelphia, 1700 and 1702," *Pennsylvania Magazine of History and Biography,* vol. 84 (1960), p. 207.

33. Benjamin Franklin, *A Proposal for Promoting Useful Knowledge among the British Plantations in America* (Philadelphia, 1743); see Leonard W. Labaree, ed., *The Papers of Benjamin Franklin,* vol. 2 (New Haven: Yale University Press, 1960), p. 380.

34. Benjamin Franklin to Cadwallader Colden, September 29, 1748; see Carl Van Doren, ed., *Benjamin Franklin's Autobiographical Writings* (New York: Viking Press, 1945), p. 55.

35. Benjamin Franklin to Mary Stevenson, March 25, 1763; see Albert Henry Smyth, ed., *The Writings of Benjamin Franklin,* vol. 4, *1760–1766* (New York: Macmillan, 1906) p. 194; quoted in Thayer, "Town into City," p. 68.

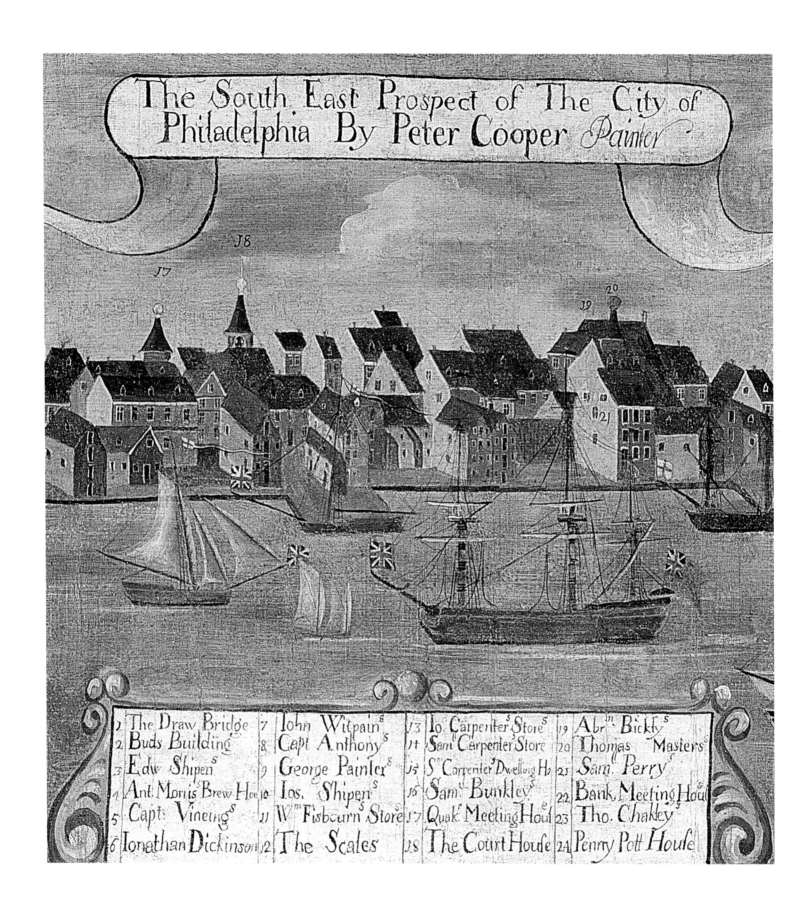

The South East Prospect of The City of Philadelphia By Peter Cooper Painter

1 The Draw Bridge	7 John Witpains	13 Io. Carpenters Store	19 Abrm Bickly
2 Buds Building	8 Capt Anthonys	14 Saml Carpenter Store	20 Thomas Masters
3 Edw Shipen	9 George Painter	15 Sl Carpenters Dwelling Ho	21 Saml Perry
4 Ant Morris Brew Hou	10 Ios. Shipen	16 Saml Bunkley	22 Bank Meeting Hou
5 Capt Vineing	11 Wm Fisbourn Store	17 Quak Meeting Hou	23 Tho Chakley
6 Ionathan Dickinson	12 The Scales	18 The Court House	24 Penny Pott House

Religion, Politics, and Economics:

Pennsylvania in the Atlantic World,

1680–1755

Richard S. Dunn

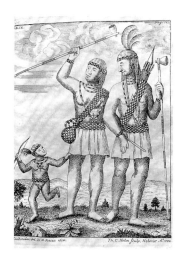

For seventy-five years—from 1680, when William Penn petitioned King Charles II of England for a colony in America, to 1755, when the Quakers abandoned their control of the legislative Assembly—Pennsylvania was a very distinctive place. It was the only British colony in America founded on truly visionary principles. It was the only pacifist colony, with no armed forces or military defenses, and it was the only colony committed to peace with the Indians. It was one of only two colonies (Rhode Island being the other) in which religious radicals were in charge and religious liberty was fully practiced. It was, too, a place remarkable for the extreme heterogeneity and ethnic diversity of its population, with colonists from England, Wales, Scotland, Ireland, Holland, Germany, France, Sweden, and Finland and slaves from West Africa living in propinquity with one another and with the Native Americans. Early Pennsylvanians engaged very actively in the traffic of people and goods and customs from Europe to America. They were citizens of the Atlantic World (figs. 25, 27).

Pennsylvania had another distinction: it was the fastest-growing colony in eighteenth-century North America. Although founded comparatively late —the eleventh of the original thirteen colonies—by 1690 Pennsylvania had passed New Jersey in population; by 1730, New York; by 1750, Connecticut; by 1760, Maryland; and by 1770, Massachusetts. When the first Federal census was taken, in 1790, Pennsylvania was the second most populous state in the Union, after Virginia.[1] Comparison with New York is particularly instructive. Both Pennsylvania and New York were Mid-Atlantic seaboard colonies, with similar climates, soil conditions, and topographical characteristics. Both were settled by a mix of colonists from Britain and western Europe, and both were ethnically diverse and religiously pluralistic. New York would seem to have had important advantages over Pennsylvania, for it was founded nearly sixty years earlier; its chief port, New York City, had a far better natural harbor for sea-going vessels than Philadelphia; and the Hudson River was a much more navigable avenue into the interior

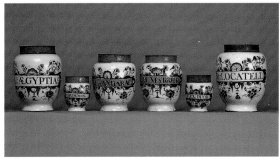

Fig. 25 (opposite page)
Peter Cooper, *The South East Prospect of the City of Philadelphia*, c. 1720, no. 444, detail. The buildings at the left in this detail of Cooper's view of Philadelphia are the Quaker Meeting House and the Court House.

Fig. 26
Tomas Campanius Holm, *Kort Beskrifning om Provincien Nya Swerige . . .*, 1702, no. 489. Dutch and Swedish traders were the first Europeans to establish relations with the Native Americans in the Delaware Valley.

Fig. 27
Apothecary Jars, c. 1740–43, no. 367. These Dutch, tin-glazed apothecary jars, part of a larger set, furnished the first apothecary of the Moravian Brethren at Bethlehem, Pennsylvania.

Fig. 28
Wolf Head Ornament, c. 1640–53, no. 415. This ornament is one of several ceremonial gifts presented by the Delaware Indians to Johan Printz, governor of the colony of New Sweden (with headquarters in Wilmington, Delaware) from 1642 to 1653, shortly before his return to Europe and the capture of his colony by the Dutch.

Fig. 29
Helmet, c. 1650–80, no. 290. Few traces of the earliest small, isolated towns and forts established prior to 1681 have survived. This Swedish military helmet was excavated at a site near Philadelphia.

his charter from Charles II, European efforts to settle the Delaware Valley had been quite feeble—much more feeble than European colonization in the Hudson Valley. The Dutch first sailed into Delaware Bay in 1609, intruding into a region that had been occupied for many centuries by the peoples of two major Eastern Woodland Indian nations: the Lenni-Lenapes, or Delawares, along the Delaware River and the Susquehannocks farther west in the Susquehanna River basin (figs. 26, 28). The Dutch traded with the Delawares for furs but found that the Iroquois had far better access to animal pelts. Then in 1638 a small Swedish expedition arrived on the Delaware and planted a colony in the vicinity of Philadelphia (fig. 29). In 1655 the Dutch seized control of this Swedish outpost, and in 1664 the English conquered New Netherland (renaming it New York) and took over control of the Delaware Valley from the Dutch. English Quakers started settling in southern New Jersey in the 1670s and were established in Upland, now Chester, Pennsylvania, by 1680. But all these colonizing efforts were on a very small scale. In 1680 the total European population in what is now Pennsylvania, Delaware, and southern New Jersey was less than three thousand.

William Penn (1644–1718) quickly changed all that (fig. 30). The son of an ambitious and worldly English naval officer, Penn had converted to Quakerism in his youth, spending considerable time in prison because of his radical religious beliefs. In England the Quakers were seen as dangerous incendiaries and were very harshly persecuted. During the late 1660s and 1670s Penn was an ardent apostle for his despised sect. He published nearly fifty pamphlets in defense of Quakerism, agitated at the royal court and at Parlia-

than the Delaware, Schuylkill, or Susquehanna rivers. But New York was hobbled by ineffectual leadership, bitterly partisan internal political and religious divisions, and an entrenched elite of great landholders and merchants who monopolized the best land and the top government posts. Furthermore, the militant Six Nations of the Iroquois occupied the interior of the colony, blocking expansion into the backcountry, while to the north the French in Canada constantly threatened to attack. Consequently, between 1680 and 1755 New York developed much less vigorously than Pennsylvania.

Throughout most of the seventeenth century, before William Penn obtained

ment against Quaker persecution, and undertook extensive missionary travels in England, Ireland, Holland, and Germany. His best-known religious tract, *No Cross, No Crown*, was published in Dutch under the title *Zonder Kruys Geen Kroon* (fig. 31). Then in 1680 Penn abruptly turned his attention in a new direction and asked Charles II to make him the proprietor of a huge tract of land in America, grounding his petition on a claim that the crown owed his father a debt of £16,000. The king's colonial advisers strongly objected to handing over strategic territory in the heart of English settlement to a Quaker agitator, but Penn's court connections were so strong that he was able to obtain a royal charter for the new colony of Pennsylvania in 1681.[2]

Founding a Colony

Penn had ambitious public and private goals for his colony. He wanted to create a haven for his persecuted fellow Quakers, but he wanted non-Quakers to come as well, so he announced that he was offering religious freedom, participatory government, and economic opportunity to everyone who chose to join him in Pennsylvania. In letters to fellow Quakers in 1681 Penn said that God would bless his colony and make it "the seed of a nation" and "an holy experiment."[3] While not expecting to remake the world, he did have utopian aspirations for Pennsylvania. He believed that his colonists would experience moral regeneration and that they would learn to live together in brotherhood and peace. At the same time, Penn hoped to make a lot of money so that he could pay off his sizable debts. Accordingly, he circulated a series of shrewdly calculated promotional pam-

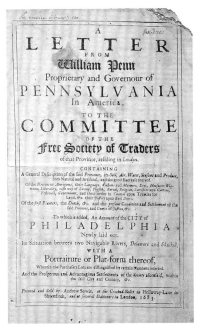

phlets, offering to sell land in Pennsylvania at attractive prices (fig. 32).[4] He took particular pains with his system of government, drawing up a constitution for the colony, the Frame of Government,

Fig. 30 (above)
Francis Place, *Portrait of William Penn*, c. 1696, no. 440. This portrait of Penn was drawn in London by the English artist Francis Place around the time of Penn's marriage to his second wife, Hannah Callowhill.

Fig. 31 (above, left)
William Penn, *Zonder Kruys Geen Kroon*, 1687, no. 486.

Fig. 32 (left)
William Penn, *A Letter from William Penn . . . to the Committee of the Free Society of Traders*, 1683, no. 484. This was Penn's most informative and effective promotional tract for his colony. It contains a detailed description of Native American life and culture.

which he published in 1682. The Frame
of Government instituted a bicameral
system in which a very large council ad-
ministered the colony and proposed leg-
islation, to be accepted or rejected by an
even larger assembly. Penn bestowed
very little direct authority on the propri-
etor, or governor, in this scheme; he evi-
dently expected to guide the colonists by
personal persuasion rather than by pre-
scriptive powers. By engaging a large
number of people in governmental deci-
sion making he was also trying to insti-
tutionalize a Quakerlike search for con-
sensus and political harmony.5

Penn's promotional efforts were high-
ly successful. Nearly fifty ships carried
immigrants and cargo to the new colony
in 1682–83. Some seven thousand people
migrated to Pennsylvania between 1681
and 1685—a very large number consid-
ering that few Britons were emigrating
to any of the other American colonies
at this time. Penn distributed 715,000
acres to nearly six hundred purchasers,
some of them from Holland and Ger-
many, and received about £9,000 from
these sales of land.6 Having made a last-
ing peace settlement with the local Dela-

ware Indians (fig. 33), buying their land
under what he considered to be gener-
ous terms, Penn laid out the capital city
of Philadelphia—his city of brotherly
love—on an expansive scale, and mer-
chants and artisans flocked to live there.
He helped to organize a network of
Quaker meetings, and he permitted the
German and Welsh settlers to form sep-
arate communities in Germantown and
the Welsh Tract, to the west of the city,
where they could preserve their ethnic
identities (see fig. 34). He also achieved
a temporary political union between the
three lower counties (the present state
of Delaware—also part of his domain),
which were dominated by non-Quakers,
and the three upper counties (Chester,
Philadelphia, and Bucks), which were
dominated by Quakers. In short, he
played the difficult role of benevolent
patriarch with real success.7

It should be emphasized that while
William Penn had many grand plans for
his holy experiment, he had no plan for
actively promoting the arts. He valued
books and the free circulation of ideas
(he himself published more than one
hundred thirty titles in his lifetime), and

so he encouraged the establishment of a printing press in Philadelphia and chartered a public school. He was a wealthy gentleman who enjoyed the attendance of a retinue of servants on his 350-acre Sussex estate named Warminghurst Place, and in Pennsylvania laid out a second country estate for himself named Pennsbury Manor on the Delaware River north of Philadelphia (in Bucks county), but Penn had little appreciation of aesthetics, and considerable hostility toward luxurious ostentation. In *No Cross, No Crown* he inveighed at length against excesses in apparel, costly furniture, stage plays, balls, cards, dice, and bowls (or tenpins). He described Warminghurst Place as "a pleasant place, but more by nature than Art. The house is very large, but ugly."[8] And in a farewell letter to his wife Gulielma and their three children written just before he sailed to America in 1682, he beseeched Gulielma to retain her love of "plain things" and her aversion to "the pomp of the world" and urged young Springett, Laetitia, and Billy to pursue useful knowledge and to avoid "the vain arts

and inventions of a luxurious world."[9]

Penn's Quaker conception of the good life is most clearly articulated in his plans for Philadelphia. Before he came to America, he announced his intention to lay out "a large Towne or Citty" on the Delaware River, with the houses surrounded by gardens and orchards, "that it may be a greene Country Towne, w^ch will never be burnt, and allways be wholsome"—unlike the crowded cities of Europe and in particular London, which in the 1660s had experienced both the bubonic plague and the great fire (1666).[10] After his arrival, Penn chose the site for the town and directed his surveyor, Thomas Holme, to draw up a street plan that was very large in scale yet strikingly simple in design (figs. 35, 36). Penn's town stretched for two miles between the Delaware and Schuylkill rivers, and unlike all other British American port towns, it was unfortified and thus totally vulnerable to attack. His gridiron design accommodated large lots for houses and gardens, his east–west streets were named for trees, and his north–south

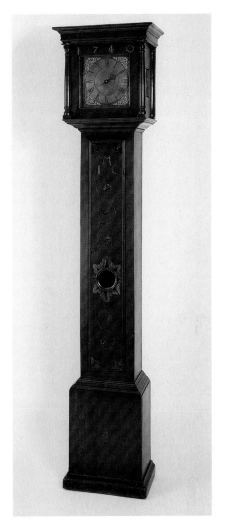

Fig. 34
Tall Case Clock, 1740, no. 63. The inlaid floral motifs, ornament, and form of this clock, which incorporates a European lantern-clock mechanism into a case produced locally, are typical of the stylistic preferences and craftsmanship preserved within the Germanic communities of Pennsylvania.

Fig. 35
Surveyor's Compass, James Ramsay, c. 1670–80, no. 291. This compass was brought to the colony by John Ladd, surveyor-assistant to Thomas Holme, and was used in 1682 to plot and lay out the symmetrical grid for Penn's city.

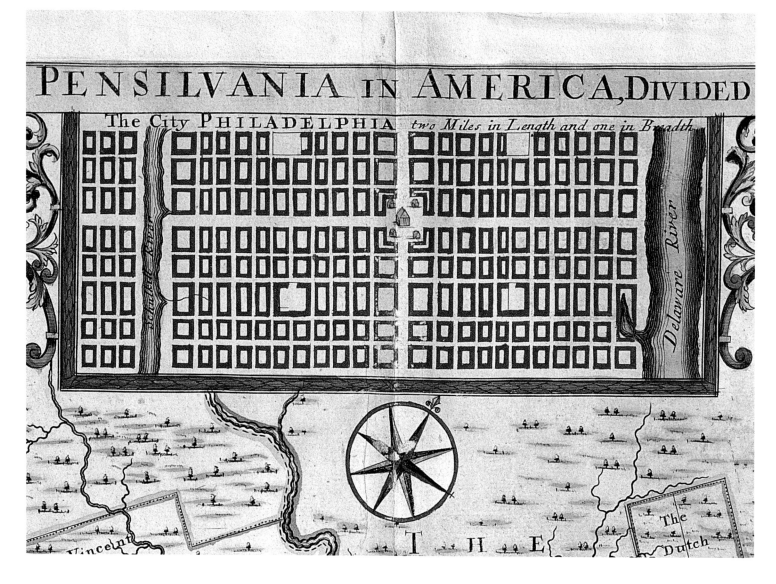

Fig. 36
Thomas Holme, *A Mapp of Ye Improved Part of Pensilvania in America*, c. 1700, no. 487, detail. Thomas Holme, William Penn's surveyor-general, helped select the site for Philadelphia. After it was approved by Penn, Holme drafted in 1682 the first "grid" map of the city, published in London in 1683 as *Portraiture of Philadelphia*. This hand-colored engraving was made some years later.

streets numbered for simplicity, and the few public buildings were so hidden away that there was no possibility of the bravura baroque vistas of Bernini's Rome or the architectural display of Sir Christopher Wren's London. It is revealing to compare Penn's plan for Philadelphia with royal governor Francis Nicholson's plan for Williamsburg, the new capital of Virginia, which was laid out a decade later, in the 1690s. Nicholson named his town after the English king, and he named two streets—Francis Street and

Nicholson Street—after himself. More important, he sought to achieve as much grandeur as was possible in a provincial setting. In Williamsburg, the Wren Building housing the College of William and Mary and the Capitol building face each other a mile apart on the principal street, with the Governor's Palace dramatically situated between them on a side avenue. Nicholson's plan was country baroque; Penn's was Quaker plain (figs. 37, 38).

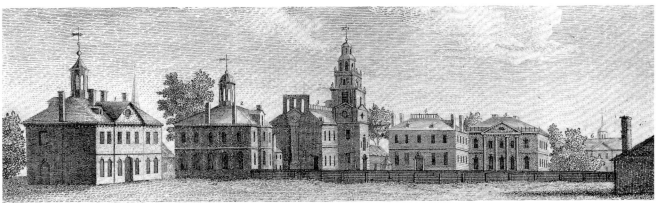

Politics

Several features of Penn's holy experiment were challenged early on. The colonists complained that the proprietor was granting them less land than he had pledged, and they criticized his Frame of Government, asserting that the Council and the Assembly were far too large and that the Assembly had far too little power. It is possible that Penn could have converted the colonists to his way of thinking had he stayed in America, but in 1684 he returned to England in order to battle the proprietor of Maryland, Charles Calvert, the third Lord Baltimore, over the boundary between the two colonies. Instead of appointing a deputy-governor to manage Pennsylvania in his absence, he delegated authority to a group of leading Quakers, apparently expecting them to work together in consensual harmony. He then stayed in England for the next fifteen years, until

1699. As soon as he left Pennsylvania the colonists began to drift into disaffection and disorder. The Quakers quarreled with the non-Quakers, who soon formed a majority within the colony. The colonists refused to pay taxes to the proprietor and ignored instructions from the English crown until William and Mary decided in 1692 to commission Governor Fletcher of New York to govern Pennsylvania, which he did for two years. Meanwhile, a bitter theological schism broke out between the supporters and the adversaries of a reforming Quaker minister named George Keith, shattering the unity of the Quaker community. The Pennsylvania Quakers were inexperienced at government and had strongly anti-authoritarian instincts because of their long persecution in England, but they clung tenaciously to power. During the 1680s and 1690s they adopted an extraordinarily fractious and confrontational political style completely

Fig. 37
Artist unknown, *The Bodleian Plate*, c. 1740, copper plate, 10 x 13¹/₂" (25.4 x 34.3 cm), detail, The Colonial Williamsburg Foundation, 1938-196. The buildings illustrated are, from left to right, the Brafferton Building, the Wren Building, and the President's House.

Fig. 38
James Trenchard (active 1777–1793), after Charles Willson Peale (1741–1827), *View of Several Public Buildings*, c. 1790, engraving, 4⁷/₈ x 8¹/₄" (12.4 x 21 cm), The Library Company of Philadelphia. The Pennsylvania State House (Independence Hall) was constructed between 1732 and 1753 (see fig. 116), but the other buildings in this view were all erected in the 1770s and 1780s. A century after the founding of the Quaker city, Philadelphia could boast the largest and most impressive set of public buildings in America.

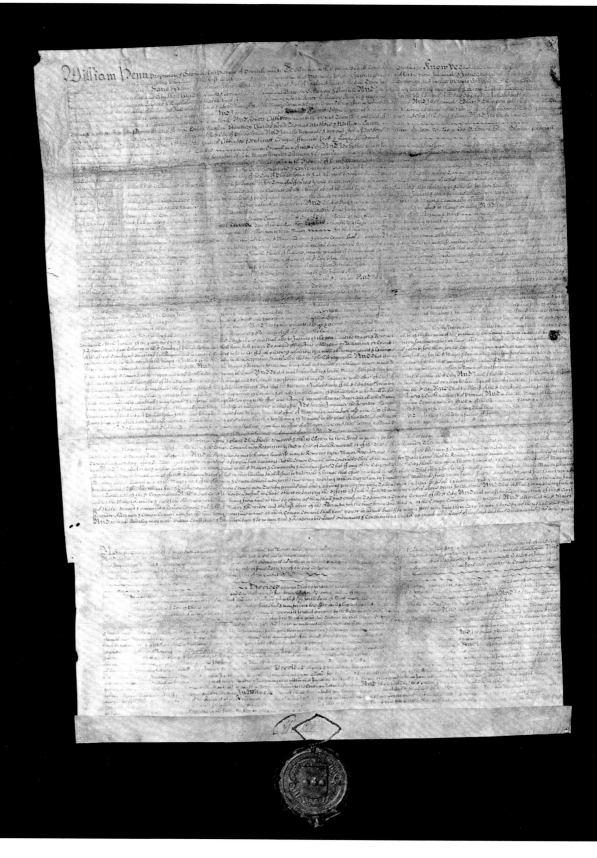

at odds with the loving harmony Penn had tried to foster in his plans for the colony.

By the time Penn returned to Pennsylvania in 1699 with his second wife, Hannah, the colonists were by no means altogether pleased to see him, and he had lost his ability to shape events. He had to accept a permanent division between the three upper counties and the three lower counties (present Delaware) because the Quakers in Pennsylvania refused to share power any longer with the non-Quakers in Delaware. Penn was also forced to discard the Frame of Government he had established in 1682 and accept a new constitution, the Charter of Privileges, drawn up in 1701 by his chief critics in the colony. Under this new arrangement, the governor (aided by his council) had executive authority, and a unicameral assembly had lawmaking authority. This Assembly, unchecked by an upper house, became the most potent legislative body in America. The losses Penn suffered in 1701 were considerable because the Charter of Privileges invited conflict between the executive and legislative branches of government. The Quakers who drew up the Charter focused from 1701 onward on holding as many assembly seats as possible. In fact, by rigging the electoral districts so that the counties with large Quaker populations were overrepresented, they were able to control the Pennsylvania Assembly until 1755.

In 1701 William Penn returned to England to fight efforts by the royal government to take away his charter and impose direct royal rule. He averted this challenge, but he never came back to Pennsylvania, and he was unable to control his colony from overseas. When Penn suffered an incapacitating stroke

in 1712, his wife Hannah (fig. 40) was equally ineffectual as an absentee proprietor, and after her death in 1726, so were their four sons—especially when they abandoned Quakerism and joined the Church of England.

The Penns did have a very able agent, James Logan (1674–1751), the most learned man of his day in Pennsylvania, who worked tirelessly to support the proprietary interests and to build his own private fortune. But despite his efforts, the Quaker-dominated Assembly kept expanding its powers during the first forty-five years of the eighteenth century. Viewing the Penn family as grasping landlords, interested only in selling and renting their huge reservoir of Pennsylvania real estate, the assemblymen took on the role of champions of popular liberty. They exerted control over finances, held the proprietary governors hostage by refusing to pay their salaries unless they approved the legislation passed by the Assembly, and secured as much autonomy for Pennsylvania as possible from the royal government. There were many factional spats, but the Quaker assembly leaders were consistently successful at keeping the Penns and the proprietary governors who were appointed by them on the defensive. Only in the late 1740s did the situation begin to change. Thomas Penn (1702–1775), who was more aggressive than his brothers, became chief proprietor in 1746 and actively searched for allies against the Quakers. The steady influx of new immigrants brought many people to the colony who disapproved of the Quaker peace policy. The outbreak of war with France, and the subsequent invasion of Pennsylvania's western frontier by the French and Indians in 1753–55, increased the demand for military

Fig. 39 (opposite page)
William Penn, Charter for the City of Philadelphia, 1701, no. 488. This charter, drawn up at the same time as the Charter of Privileges, placed the management of the city in the hands of a non-elected, self-perpetuating corporation. But the mayor and aldermen had no taxing power, so that Philadelphia city government was minimal until the Revolution, and all civic improvements had to be carried out by private enterprise.

Fig. 40 (above)
Francis Place, *Portrait of Hannah Penn*, c. 1696, no. 440. Hannah Penn was twenty-five years old when this portrait was drawn, around the time of her marriage to William Penn, whose companion portrait is shown in figure 30 above.

action. At last the Quakers gave way. In 1755 those legislators who could not in conscience abandon their pacifism withdrew from the Assembly, and those who remained supported the war effort. The Assembly remained anti-proprietary, but the Quaker policy of peace and friendship with the Indians was gone.[11]

Economics and Immigration

The new colony of Pennsylvania quickly earned a reputation as a mecca for small farmers. Penn and his sons endeavored to settle the land in an orderly way by granting tracts in contiguous units. While this system often broke down, allowing speculators to acquire large blocks of land, real estate was far more evenly distributed in Pennsylvania than it was in New York to the north or Maryland and Virginia to the south, where the most favored planters acquired enormous acreage. By 1750 most properties in Pennsylvania were between 100 and 500 acres—much larger than individual peasant holdings in Britain or Europe. The land was fertile and well suited to small-scale grain and livestock production. A typical mid-eighteenth-century farmer with 125 acres would cultivate a mix of wheat, rye, oats, barley, buckwheat, Indian corn, flax, and hay crops as well as vegetables and fruit

trees on 50 acres, leaving the rest of his land in woodland and pasture, where he grazed about thirty head of cattle, horses, swine, and sheep (he also kept poultry and hived bees).[12] Most farmers and their wives and dependents were artisans on the side, pursuing such crafts as blacksmithing, carpentry, masonry, or weaving to enhance self-sufficiency and add to the household income. Wheat immediately became the principal cash crop in Pennsylvania, and about one-third of the wheat produced in the colony was exported. Bread and flour were shipped to the West Indies, and wheat and flour were sent to Portugal and Spain (fig. 42).

Pennsylvania's booming economy generated a strong demand for imported labor. Thousands of indentured servants were shipped in from Britain and Germany; they usually contracted to work for four years without pay. The first slave ship from West Africa arrived as early as 1684, and by mid-century there was a sizable black population in permanent servitude (see fig. 43). Both William Penn and Benjamin Franklin were slave owners; not until the 1750s did the Quaker abolitionist leaders John Woolman and Anthony Benezet persuade the Yearly Meeting to call on all Quakers to stop buying and selling slaves. Meanwhile, Pennsylvania's

Fig. 41
Weather Vane, 1699, no. 295. William Penn's critics regularly accused him of putting his own personal interests before those of Pennsylvania. One of his investments was a joint venture with his close associates Samuel Carpenter and Caleb Pusey to establish the first grist- and sawmill on Chester Creek, south of Philadelphia. This weather vane stood atop that mill.

Fig. 42
Bartholomew Penrose, Ship Manifest, 1735–56, no. 493. Philadelphia's exports to the West Indies supplied one leg of the lucrative triangle trade between the West Indies, England, and the American colonies. This page of the manifest records that Penrose was shipping pork and flour to Barbados. These goods would be exchanged for sugar and rum to be sold in London or Bristol. English and European manufactured goods were then purchased for Philadelphia markets.

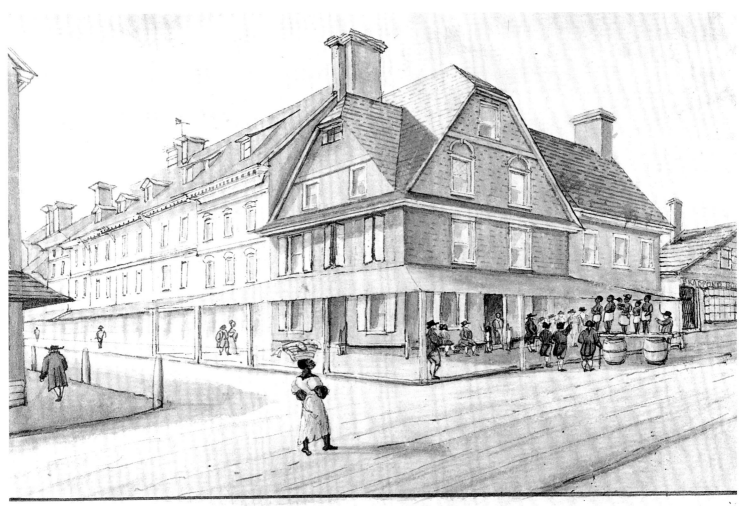

Old London Coffee House S.W. cor. Front & High Sts.

Fig. 43
Attributed to David Johnston Kennedy, *Old London Coffee House*, c. 1836–70, no. 479. This public house, designed for the accommodation of the leading merchants in town, opened in 1754 at Front and Market streets. Coffee and liquor were served on the ground floor, and a merchant's exchange occupied the second floor. It became a favored site for slave sales until slavery was abolished in Philadelphia in the 1780s.

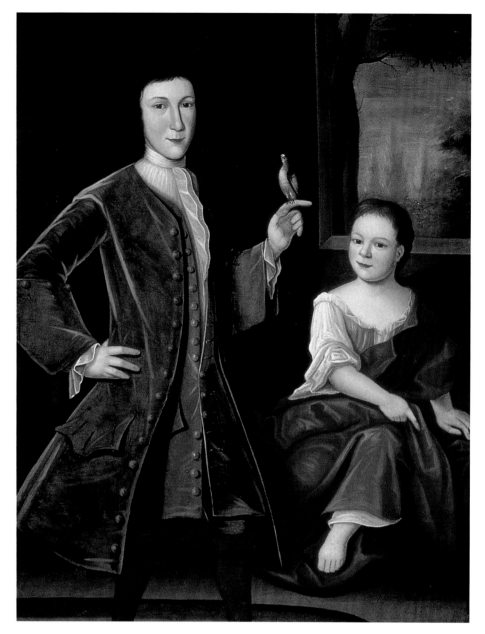

Fig. 44
List of Yehidim, c. 1750–70, no. 504.
The small number of Jews present
in early Philadelphia were viewed by
the larger population with a combination of curiosity, respect, and derision. This list of the Yehidim, or
elders, within Congregation Mikveh
Israel is one of the earliest records
of the city's leading patriarchs.

Fig. 45
Portrait of David and Phila Franks, c.
1735, no. 454. This portrait of the siblings David and Phila Franks was
painted in New York shortly before
David moved to Philadelphia. A member of the Jewish faith, David became
one of the most prominent and influential merchants in the city.

Fig. 46
Armorial Plaque of William and Mary,
c. 1695–1710, no. 419. This plaque
decorated the pew used by the governor of Pennsylvania when he attended
services in Christ Church. As Philadelphia's earliest Anglican church, Christ
Church, along with its parishioners,
enjoyed the direct patronage of the
English crown.

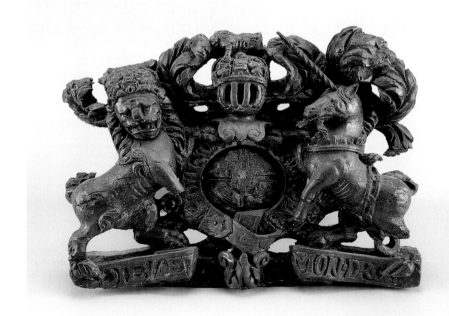

reputation for agricultural prosperity and religious toleration drew voluntary immigrants from all over Britain and northern Europe, where high rents were driving farmers off the land. Philadelphia became the leading American port for Scotch-Irish arrivals from Northern Ireland, Catholic Irish arrivals from Southern Ireland, and German arrivals from the Rhine Valley. About three-quarters of all German immigrants to the thirteen colonies landed in Philadelphia; the peak period was between 1749 and 1754, when some thirty-seven thousand Germans flooded into the city. Many of these German newcomers moved on to Maryland, Virginia, the Carolinas, and Georgia, while those who stayed in Pennsylvania tended to settle in ethnic clusters with other Germans, especially in the backcountry counties of Lancaster, York, Berks, and Northampton.[13] The Scotch-Irish, who started to arrive in large numbers in the 1720s, similarly gravitated toward segregated Scotch-Irish neighborhoods, generally located farther west on the frontier than the English or German settlements. By mid-century a good many Pennsylvanians of English stock were worried about the large number of strangers in their colony. They resented the Germans because of their foreign language and the Scotch-Irish because of their reputedly disorderly lifestyle. However, nothing was done to discourage further immigration, and by 1755 the groundwork was laid for extreme ethnic diversity in Pennsylvania.[14] The federal census of 1790 revealed that only about 35 percent of Pennsylvanians were of English descent, while 33 percent were German, 11 percent were Scotch-Irish, and 9 percent were Scottish. No other state had such a mixed population.

Religious Tensions

Ethnic diversity encouraged religious pluralism and the separation of church from state. The colonists of English heritage were divided into Quakers, Anglicans, Baptists, and Presbyterians; the colonists of German heritage were divided into Lutherans, Calvinists, and radical Pietists; and the colonists of Scotch-Irish or Scottish heritage were mainly Presbyterians. The first Catholic chapel in Philadelphia was opened in 1734, and a small number of Jewish families also came to the colony (figs. 44, 45). William Penn had made liberty of conscience a cardinal feature of his design for Pennsylvania, and the Quakers who dominated the colony's government into the 1750s supported Penn's position and granted legal equality to all Protestant religious denominations. But although there was no established church as in other colonies, religious liberty was sometimes severely tested. In the 1740s the revival movement known as the Great Awakening broke out in Pennsylvania, creating ferment in most of the denominations and sharpening the division among English churchgoers between revivalist Presbyterians and non-revivalist Anglicans, as well as the division among German churchgoers between evangelical Moravians and orthodox Lutherans and Calvinists.

Adding to the religious tension, the Anglican clergy—who had always been the leading opponents of Quakerism, both in England and America—kept asking the home government to bar all Quakers from public office and to establish the Church of England as the state religion in Pennsylvania (see fig. 46). The Quakers could always count on the German pietist sects—the Mennonites,

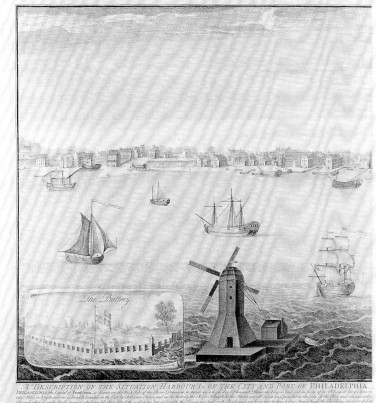

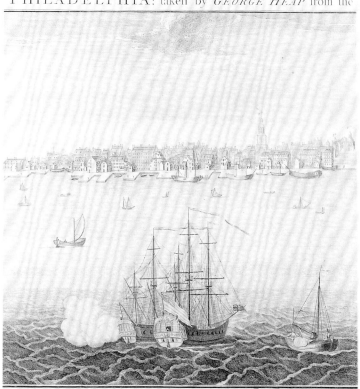

Amish, Moravians, Dunkers (or Brethren), and Schwenkfelders—to support their peace testimony, but the Scotch-Irish Presbyterians and German Lutherans and Calvinists became increasingly restive, calling for military protection against the French and the Indians. In the war crisis of 1755, when General Braddock's redcoats were defeated by the French and Indians in the Battle of the Wilderness near the site of Pittsburgh, the Quakers finally had to give up political power, but their non-Quaker allies, led by Benjamin Franklin, retained control of the Pennsylvania Assembly and sustained the Quaker program of popular liberty. Religious freedom for all colonists was fully preserved.[15]

The Growth of a City

The city of Philadelphia exhibited in microcosm most of the developments described above. The town grew rapidly, from a population of about 2,000 in 1690 to 5,000 in 1720, 13,000 in 1750, and 20,000 in 1770. By 1760 Philadelphia had passed Boston and was closing in on New York; on the eve of the American Revolution, with about 25,000 inhabitants, it was probably the largest town in British America.[16] As the city grew, it evolved away from Penn's "greene Country Towne" design. The inhabitants refused to spread out in spacious lots from the Delaware to the Schuylkill as Penn had intended. Instead they subdivided the original grid lots and crowded

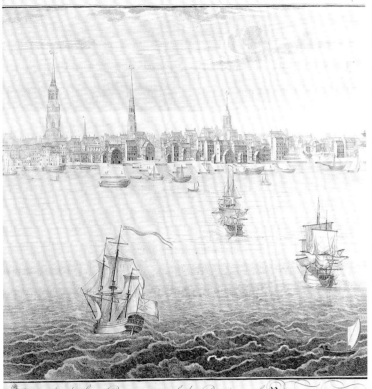

and absolute Proprietors of the Province of PENNSYLVANIA *this Perspective View is humbly Dedicated by* Nicholas Skull.

THE DESCRIPTION CONTINUED REFERENCES

into the area closest to the merchant wharves along the Delaware. Here they built three-story brick row houses and shops along the principal streets, with more modest tenements to accommodate the poorer people lining a network of interior alleys. When Peter Cooper painted his view of Philadelphia in 1726 (see fig. 115), it was a simple town with no notable buildings. George Heap's engraved view on four plates, commissioned by Thomas Penn three decades later, shows a considerably more impressive place. The tallest spire is the tower of Christ Church, the principal Anglican structure, built in baroque style to repudiate Quaker simplicity. In the inset in the lower left corner (fig. 47) appears an un-Quakerlike fort with a battery of twenty-seven cannons that protected the riverfront and its shipping from French attack. Shortly after Heap drew his view, the Pennsylvania Hospital opened at Eighth and Pine streets, located on what was then the edge of settlement to insure that "the sick and miserable" who were confined there would not infect the rest of the population (see fig. 65). Drinking establishments were easier to find. By 1756 there were one hundred one taverns to service a population of sixteen thousand.[17]

Philadelphia's growth and prosperity were generated by the shrewd merchants and skilled artisans who lived and worked there. Penn drew an impressive cadre of Quaker merchants from England, Ireland, the West Indies, and other

Fig. 47
George Heap and Nicholas Scull, *An East Prospect of the City of Philadelphia,* c. 1751–53, no. 469. This ambitious portfolio print, commissioned by Thomas Penn, William Penn's son and the chief proprietor of the colony from 1746 to 1775, is a symbol of his pride in Pennsylvania's achievements. Five hundred images were made in the first printing. The view proved so popular that an additional two hundred and fifty were issued to fill the demand.

Fig. 48
Stool, c. 1700–1720, no. 106. Following the forms of northern European and English *"tabourettes,"* this Philadelphia version of these turned-joint stools is probably one of the two listed in the 1722 inventory of Jonathan Dickinson, one of the city's wealthy merchants.

Fig. 49
Benjamin Franklin, *Poor Richard Improved,* 1750, no. 502. Franklin's almanac combined astronomical data, planting schedules, and weather predictions with pithy aphorisms, social satire, reports on current events, and accounts of curiosities. Franklin used this and his other popular publications to mold political opinion in Philadelphia.

North American colonies between 1682 and 1700, and a second group, which included many Quakers, arrived between 1710 and 1740.[18] By mid-century the Biddles, Carpenters, Dickinsons, Drinkers, Emlens, Jameses, Logans, Mifflins, Morrises, Norrises, Pembertons, Powells, Richardsons, Shippens, Whartons, Willings, and Wistars were all doing business in Philadelphia. These Quaker merchants established a network of commercial alliances with Friends in other Atlantic port towns, and they earned a reputation for scrupulous honesty and hard work. Using ships built in Philadelphia shipyards, they traded up and down the North American Atlantic seaboard and also sailed to the West Indies, Portugal, the Wine Islands (Madeira and the Canaries), Newfoundland, Ireland, and England. They imported fashionable furniture, textiles, silver, and ceramics— "of the best Sort, but Plain," as one Quaker merchant wrote to his London supplier[19]—and commissioned paintings and decorative-art objects from local craftsmen, many of whom are represented in this catalogue (fig. 48).

From the outset, Philadelphia was well supplied with skilled artisans— men who worked with their hands for a living. The best known of these is, of course, Benjamin Franklin (1706–1790), who came to Philadelphia from Boston in 1723 as a seventeen-year-old runaway apprentice. His craft was printing, which combined hard physical labor with intellectuality, and in 1748, when he had made enough money from publishing *The Pennsylvania Gazette* and *Poor Richard's Almanack* (fig. 49) and assorted books, pamphlets, broadsides, and job-printing orders, he retired from active business and devoted the rest of his long career to public service. From the 1730s to the 1780s he instigated numerous civic improvements in his adopted home town. He helped to found the Junto (a collaborative self-help society formed in 1727), the Library Company (the first lending library in America), the American Philosophical Society, the Academy and College of Philadelphia, and Pennsylvania Hospital—all conceived before 1755. In some respects Benjamin Franklin was the opposite of William Penn. He worked from the bottom up rather than from the top down, and he devised secular self-improvement schemes rather than religiously inspired utopian plans. But both men were social activists who tried to improve the quality of life by persuading the people of Pennsylvania to live harmoniously and cooperate fruitfully. And both promoted the religious freedom, economic opportunity, and participatory politics that made this eighteenth-century colony, in Penn's prophetic words, "the seed of a nation."

Notes

1. U.S. Bureau of the Census, *Historical Statistics of the United States, Colonial Times to 1970*, vol. 2 (Washington, D.C., 1975), p. 1168.

2. The negotiation of the Pennsylvania charter is documented in Richard S. Dunn and Mary Maples Dunn, eds., *The Papers of William Penn*, vol. 2, *1680–1684* (Philadelphia: University of Pennsylvania Press, 1982), pp. 21–78.

3. Ibid., pp. 83, 108.

4. Penn's promotional tracts for Pennsylvania are described in Edwin B. Bronner and David Fraser, *The Papers of William Penn*, vol 5, *William Penn's Published Writings, 1660– 1726: An Interpretive Bibliography* (Philadelphia: University of Pennsylvania Press, 1986), pp. 264–76, 282–84, 298–309, 320–23, 327–29, 332–35.

5. For a much more critical interpretation of the Frame of Government, see Gary B. Nash, "The Framing of Government in Pennsylvania: Ideas in Conflict with Reality," *The William and Mary Quarterly: A Magazine of Early American History*, 3rd ser., vol. 23 (1966), pp. 183–209.

6. Penn's land sales are documented in Dunn and Dunn, eds., *The Papers of William Penn*, vol. 2, pp. 630–64. Of the 531 purchasers whose geographical origins can be identified, 88 percent lived in England, 5 percent in Ireland, 4 percent in Wales, 1 percent in Scotland, and 1 percent in western Europe.

7. For two contrasting interpretations of the initial settlement of Pennsylvania, see Edwin B. Bronner, *William Penn's "Holy Experiment": The Founding of Pennsylvania, 1681–1701* (New York and London: Temple University Publications, 1962), pp. 21–69; and Gary B. Nash, *Quakers and Politics: Pennsylvania, 1681–1726* (Princeton: Princeton University Press, 1968), pp. 48–88.

8. Richard S. Dunn and Mary Maples Dunn, eds., *The Papers of William Penn*, vol. 3, *1685–1700*, ed. Marianne S. Wokeck et al. (Philadelphia: University of Pennsylvania Press, 1986), p. 432.

9. Dunn and Dunn, eds., *The Papers of William Penn*, vol 2, pp. 270–71.

10. Ibid., pp. 98, 121.

11. For discussion of Pennsylvania politics from 1701 to 1755, see Alan Tully, *William Penn's Legacy: Policy and Social Structure in Provincial Pennsylvania, 1726–1755* (Baltimore and London: The Johns Hopkins University Press, 1977); and Tully, *Forming American Politics: Ideals, Interests, and Institutions in Colonial New York and Pennsylvania* (Baltimore and London: The Johns Hopkins University Press, 1994), pp. 27–44, 68–85, 106–16, 145–50.

12. James T. Lemon, *The Best Poor Man's Country: A Geographical Study of Early Southeastern Pennsylvania* (Baltimore and London: The Johns Hopkins University Press, 1972), pp. 152–53.

13. For a general discussion of eighteenth-century German migration to Pennsylvania, see Aaron Spencer Fogleman, *Hopeful Journeys: German Immigration, Settlement, and Political Culture in Colonial America, 1717–1775* (Philadelphia: University of Pennsylvania Press, 1996).

14. Sally Schwartz, *"A Mixed Multitude": The Struggle for Toleration in Colonial Pennsylvania* (New York: New York University Press, 1987), pp. 36–204.

15. See J. William Frost, *A Perfect Freedom: Religious Liberty in Pennsylvania* (Cambridge and New York: Cambridge University Press, 1990), pp. 10–59.

16. Gary B. Nash, *The Urban Crucible: Social Change, Political Consciousness, and the Origins of the American Revolution* (Cambridge, Mass., and London: Harvard University Press, 1979), pp. 407–8.

17. Peter Thompson, *Rum Punch and Revolution: Taverngoing and Public Life in Eighteenth-Century Philadelphia* (Philadelphia: University of Pennsylvania Press, 1999), p. 27.

18. Gary B. Nash, "The Early Merchants of Philadelphia: The Formation and Disintegration of a Founding Elite," in *The World of William Penn*, ed. Richard S. Dunn and Mary Maples Dunn (Philadelphia: University of Pennsylvania Press, 1986), pp. 337–62.

19. Frederick B. Tolles, *Meeting House and Counting House: The Quaker Merchants of Colonial Philadelphia, 1682–1763* (Chapel Hill: University of North Carolina Press, 1948), p. 128. Tolles's book remains the best account of Quaker business life and culture.

A Passionate Avocation:

The Foreshadowing of a Philadelphia

Scientific Community, 1682–1769

Edward C. Carter II

Saturday, June 3, 1769, was a beautiful, clear day in Philadelphia—perfect for viewing the heavens, as *The Pennsylvania Gazette* reported June 8: "The Weather was extremely favorable, and the Observations at the three several Places, were completed greatly to the Satisfaction of the Observers." What were these "Observations," and who were these "Observers"? The occasion was the last of three times in the eighteenth century that the planet Venus would pass across the face of the sun, thus affording observers the opportunity to measure the distance of the earth from the sun. The transit of Venus occurs only four times in 243 years at irregular intervals. If a serious international effort had not been successful on June 3, 1769, the world's scientific community would have had to wait until 1874 to take full advantage of this astronomical phenomenon.

The major European scientific nations were part of an international collaborative effort to execute precise observations of the transit that saw expeditions being dispatched to various parts of the globe. In British North America, Philadelphia

played the major role in these efforts under the direction of the recently unified American Philosophical Society.[1] The prime mover of the Society's Venus observation, however, was David Rittenhouse (1732–1796), the ingenious young Quaker surveyor and maker of clocks and mathematical instruments. He made his initial reputation as an astronomer by assembling or making all the instruments used at the observatory on his family farm at Norriton, northwest of the city, and carrying out those transit observations, and the astronomical calculations before and after the event, that went into the final report. He also contributed the best American calculation of the sun's parallax, which was published in the first volume (1771) of the *Transactions of the American Philosophical Society* along with the findings of all American and selected European philosophers who had participated in the transit of Venus observations.

What was the significance of the Philadelphia observers' contribution to this event—a scientific effort that drew high praise from European men of science—and what had they hoped to achieve?

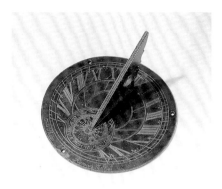

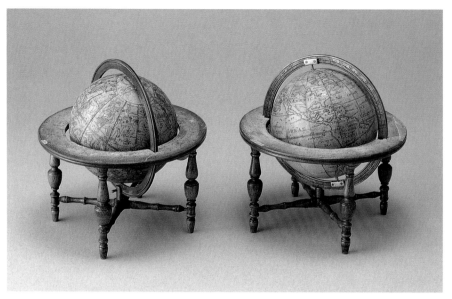

The challenges and rewards of preparing for and recording the transit of Venus have been summarized by historian Raymond P. Stearns:

The object was to determine the solar parallax, i.e., the angle subtended by the radius of the earth at the sun. To determine this angle, a method had been devised by Edmond Halley in 1716, to use observations of the time in which Venus was seen to cross the sun's disk. It was hoped that, by comparing the results of several such observations, made at several widely separated locations on the earth, the solar parallax could be established. From this, astronomers could compute the distance from the earth to the sun and the distances of the planets from the sun. Hitherto, astronomers had been able to express the distances of the planets from the sun only in relative terms, i.e., not in actual miles but rather in terms of their distance from the sun compared with the earth's distance from the sun. Moreover, knowledge of the actual distances in miles between the sun, the earth, and other planets would make possible a more accurate concept of the size of the solar universe. . . . *The necessary preparations involved, beside the astronomical apparatus, exact knowledge of the latitude and longitude of the observation points in order to determine the distance between them. The duration of the transit, that is, the time of contact of Venus with the sun either upon ingress or egress (preferably both), required a fine timepiece whose rate of "going" had been determined precisely. Moreover, the observers had to be skillful in the use of all the instruments employed and thoroughly familiar with the "drill," or the exact order in which every move took place, in order to execute them efficiently and without delay.[2]*

Eighteenth-century scientists hoped that successful international observations of the transit of Venus and the attendant computations would yield results useful for astronomy as well as navigation, surveying, and cartography[3]—practical results that might be of interest to those engaged in subduing and settling a continent (figs. 51, 52). In 1766 there seemed to be no prospect of Philadelphia participating productively during

the next transit of Venus; five years later the scientific world acknowledged that Rittenhouse and his colleagues had carried out highly professional surveys and reported their findings in an equally skillful fashion. It is worth considering how it was that a group of Philadelphians came to make such a significant contribution to this important event.4

Philadelphia's First Men of Science

Three men dominated the history and shaped the direction of Philadelphia science in the first half of the eighteenth century and, in the case of the latter two, well beyond this period: James Logan, John Bartram, and Benjamin Franklin.5 These men had much in common, and they knew each other well, had respect for one another, and were generally cooperative when their interests overlapped. The similarities of their scientific careers and accomplishments are striking. All three were self-educated in the sciences yet made major contributions to their disciplines. They were recognized internationally for their achievements; they corresponded extensively with leading scientists and advocates of science in England, Europe, and the colonies, which resulted in the publication of their findings in learned journals; and they were determined in the promotion of the projects and findings of their fellow Americans if they appeared meritorious or promising. Logan, Bartram, and Franklin could be characterized as "accelerators" of science in Philadelphia, and in America.

James Logan (1674–1751), son of a Scottish Quaker schoolmaster, was born in Lurgan, Ireland, and later moved to Bristol, England, where he was his father's teaching assistant while study-

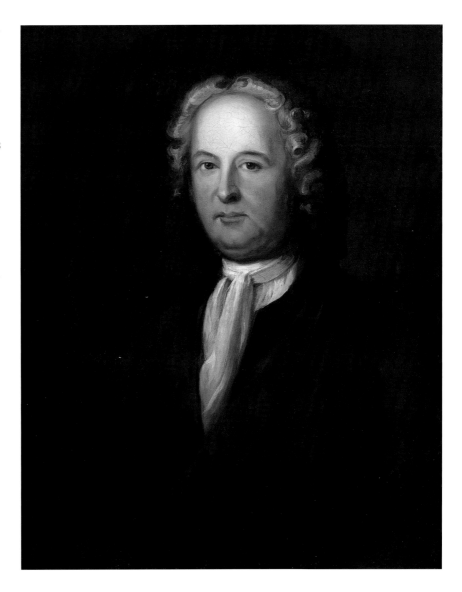

ing Greek, Latin, and several other languages, including Arabic and Italian (fig. 53). There he taught himself mathematics and commenced his study of natural philosophy. Later he was to make solid contributions in optics and astronomy, and impressive ones in botany. Today Logan is not well known, but he was the most proficient, wide-ranging colonial scientist before Franklin.

Logan accompanied William Penn to Philadelphia as his secretary in 1699, and except for several trips to England, he remained in Pennsylvania for the rest

Fig. 53
Attributed to Gustavus Hesselius, *Portrait of James Logan*, c. 1728–35, no. 448. The significance and influence of James Logan's diverse interests and accomplishments placed him as a leading cultural and intellectual force in colonial Philadelphia. Along with his scientific pursuits, Logan studied classical history, languages, mathematics, and aesthetics.

Fig. 54
Sir Isaac Newton, *Philosophiæ Naturalis Principia Mathematica*, 1687, no. 485. Logan's copy of Newton's treatise on mathematics is the earliest to be documented in colonial America. It is extensively annotated by Logan in Latin.

Fig. 55
Plan of John Bartram's House and Garden, 1758, ink on paper, 10³/8 x 10¹/4" (41.5 x 26 cm), private collection. During the fifty years Bartram spent on his farm on the Schuylkill he developed extensive collections of rare plants and experimented with the hybridization of many species.

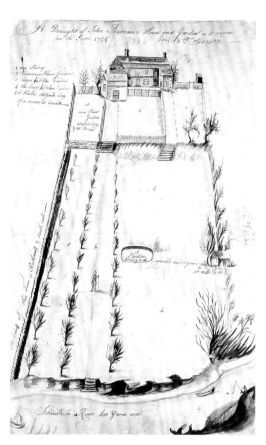

of his life. He was a faithful supporter of Penn and his heirs, serving as a high official in both the provincial and city governments. James Logan is now best known for the great library he assembled (in his time, the finest in America), and for Stenton, the beautiful country house he began building in 1730 in Germantown, in a chaste but elegant and restrained Georgian style. The Logan library is the only collection of its kind preserved virtually intact and is particularly rich in works of ancient and contemporary mathematics, astronomy, and natural history.[6] Logan made his collection of books and manuscripts available to scientifically interested artisans and gentlemen alike, thereby advancing their work. It is reputed that Logan's copy of Sir Isaac Newton's *Principia Mathmatica* was the first to enter America, and he allowed

the young glazier Thomas Godfrey (1704–1749), later the inventor of an improved mariner's quadrant, to study it (fig. 54).

Logan's scientific reputation rests not on his lifelong devotion to the mathematical sciences but on his work in genetics, acclaimed by eighteenth-century natural historians. His work was experimental in nature and not the descriptive or taxonomic work typical of the time. For example, Frederick B. Tolles has observed that Logan's "admirably designed, carefully controlled, lucidly reported experiments with Indian corn proved conclusively that the pollen was the male element and that it was necessary for the production of viable seed."[7] Although Logan's experiments and findings did not stir much excitement in scientific circles in England when they were published in 1735 in the Royal Society's *Philosophical Transactions,* the Dutch botanist Johann Friedrich Gronovius and the Swedish naturalist Carolus Linnaeus lavishly praised the American's work for what it was—a pioneering step toward systematic plant hybridization.

The scientific achievements of John Bartram and Benjamin Franklin are far better known than are those of James Logan. John Bartram (1699–1777) was born into a Quaker family on his father's farm near Darby, just west of Philadelphia. After some preliminary schooling and reading in natural-history subjects, including botany and also medicine and surgery, Bartram settled into his life's calling when in 1728 he purchased a 102-acre farm at Kingsessing on the western banks of the Schuylkill and established his botanical garden while farming most of the acreage (fig. 55).

Bartram, although self-educated, became America's, and the world's, greatest

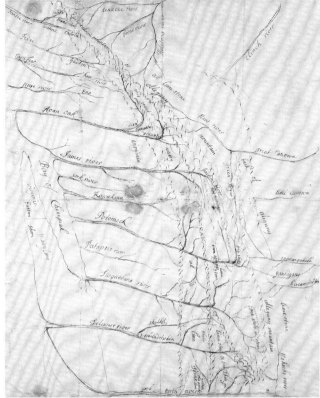

"natural" botanist (as he was called by Linnaeus), if not the colonies' most proficient "formal" one (the latter designation is usually bestowed on John Clayton [1694–1773] of Virginia). Bartram had a superb talent for scouting out plants, both locally and on his wide-ranging expeditions. He grew these specimens in his garden or on plots of ground nearby, harvesting their seeds, which he shipped to collectors abroad and throughout America. Over the years, Bartram also developed a method for sending living plants and bushes and dampened roots to his clients. With the assistance of Logan, he learned the Linnaean system of plant classification and the rudiments of Latin, allowing him to carry on taxonomic work of his own. Bartram's contribution to the field was considerable, as described by a recent biographer:

Of the 8000 species of plants that grew in eastern North America, only 6 reached Europe before 1600, another 50 in the next half-century, and by 1734, when John Bartram began collecting, about 300 had already been sent. Between 1734 and 1776, when the American Revolution interrupted this lucrative trade in plants, the number of "new" finds doubled to 600 and John Bartram was personally responsible for about half of this increase, or one quarter of all the plants identified and sent to Europe during the colonial period.

Fig. 56
Attributed to John Bartram, *Drawing of a Bird*, c. 1748, no. 459. In 1748 Bartram presented this drawing to Nereus Mendenhall, a prominent Chester County Quaker, as a token of his gratitude for Mendenhall's aid in his explorations along the Susquehanna River.

Fig. 57
John Bartram, Map of the Allegheny Ridge, c. 1745–47, no. 501. Bartram presented this map and several fossil fragments to his friend Benjamin Franklin, who wrote on the reverse of the map, "Mr. Bartram's Map very curious."

Fig. 58
Fossil collected by John Bartram and given to Benjamin Franklin, limestone with calcined shells, length 3 3/8" (8.6 cm), private collection.

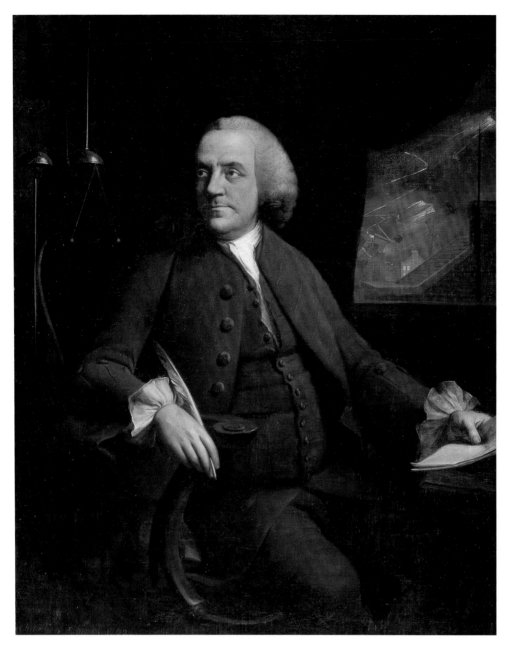

Fig. 59
Mason Chamberlin, *Portrait of Benjamin Franklin*, 1762, no. 476. Along with his own experiments and advocacy of scientific pursuits in the colonies, Franklin's insistence on the importance of building Philadelphia's intellectual and craftsmen's communities, his highly respected diplomacy, and his outspoken political and moral beliefs positioned him as one of the most important figures in early Pennsylvania.

It would be difficult to overstate the significance of this one man's accomplishment in his life's endeavor.[8]

Botany was not Bartram's sole natural history interest (fig. 56). While he felt that the products of nature were to be developed and used for the happiness and profit of men, he had a strong sense of the interrelationship of flora and fauna in the natural world and the appropriate environmental milieu for each species. Bartram was opposed to the over-harvesting of nature's products and thus in a certain sense was an early environmentalist. A forceful, articulate, and on occasion humorous correspondent, he carried on long, extensive exchanges with European and American colleagues. John Bartram was interested in projects that promoted scientific inquiry in America and offered several of his own, such as a geological survey and map of the land east of the Allegheny Mountains (figs. 57, 58).[9] His interests extended to homeopathy, leading him to correspond with Elizabeth Coates Paschall, who was one of the earliest female practitioners in both homeopathy and botanical sciences.

Benjamin Franklin (1706–1790) made his reputation in quite a different field (fig. 59). He was the first American to win an international reputation in science and the first scientist to be renowned for work done solely in electricity.[10] Franklin's work in electricity, carried out in the 1740s and early 1750s and published as *Experiments and Observations on Electricity* (London, 1751; reprinted with additions, 1753), was an impressive contribution to science—much more profound and far-reaching than the 1769 transit of Venus reports—and won him instant international celebrity.[11] Franklin was the premier colonial scientist. He was elected (without having applied) to the Royal Society of London, awarded that body's Copley Medal, and received honorary degrees from Harvard and Yale universities and the College of William and Mary in America and St. Andrews and Oxford universities in England. It is ironic that the two most renowned early American scientific achievements —Franklin's work in electricity and the transit of Venus observations—were in natural philosophy (or the physical sciences, as they are known today), which overall was the weakest, most neglected area of colonial science. The achievements of Franklin and the members of

the American Philosophical Society, although impressive, were really solitary, isolated efforts within a community focused on natural history.

Between retirement from his printing and publishing business in 1748 and his second departure for England in 1757, Franklin devoted himself to study and experiments that had commenced a few years earlier, and for the first time his great ability to construct often brilliant hypotheses and to check them with experiments was revealed, as Brooke Hindle has pointed out.[12] He showed that all electricity, whether natural (like lightning) or man-made by an electrostatic machine, was the same—a "single-fluid." He introduced the terms "negative" and "positive" charge, proposing that the flow of current was from the positive to the negative; his terminology is still used today, although it is now known that electrons flow in the opposite direction. Franklin was also the first to suggest the principle now known as the law of conservation of charge.[13] Finally, his early work on the electrical qualities of pointed bodies led to the highly utilitarian invention of the grounded lightning rod.

Another of Franklin's contributions to science was his founding of the Library Company of Philadelphia in 1731.[14] Its initial subscribers included merchants, craftsmen, and leading intellectuals. The library disseminated valuable information through its holdings of classical texts, pattern books, prints, maps, and philosophical and scientific treatises and became an important repository of knowledge (fig. 63). In addition, its "cabinet of curiosities" exposed people to classical antiquities, natural and botanical specimens, innovative scientific apparatus, and other rarities, including a group of Eskimo tools and a skin parka.[15]

Some critics have claimed that Franklin's scientific work has been overrated, pointing out that electricity was but a sideshow of contemporary physics and suggesting that Franklin, who was not learned in mathematics, with his usual good luck discovered the obvious through a series of kitchen-recipe experiments.[16] This has not been the view of many historians of science or practicing physicists, who have observed that Franklin carefully read the available literature in the field, checking the leading theories by experimentation; developed his own hypotheses and built simple but effective apparatus to test them; proved his theories by experiments and successfully repeated those experiments; and published his results in clear, concise language. Franklin's elegant work altered and significantly increased the fundamental store of scientific knowledge.

Closely allied to Logan, Bartram, and Franklin was Peter Collinson (1694–1768), a London merchant who was a leading member of the Royal Society of London (although not a scientist) and a Quaker, like Logan and Bartram. Remarkably energetic, intelligent, and generous, Collinson was a great promoter of science in the Atlantic World. He did as much as any man in the eighteenth century to establish communications among scientists in England, Europe, and the colonies. While natural history was Collinson's particular interest, he advanced the interests of all the sciences. From his London countinghouse he redirected colonial scientific communications and natural-history specimens to Linnaeus in Sweden, Johann J. Dillenius at Oxford University, and Gronovius at the University of Leiden, among others.[17] Collinson promoted Bartram's seed business by identifying wealthy collector clients and

Fig. 60
Electrical Apparatus, c. 1742–47, no. 432. Franklin engaged local craftsmen to supply the components needed for his electrical experiments whenever possible. He contracted Wistarburgh glassworks in Alloway, New Jersey, to produce the long glass tubes he used. The electrostatic machine shown here lacks its glass components.

by raising financial support from this group for Bartram's wide-ranging botanical expeditions, which extended from northern New York to Florida. He also worked effectively on behalf of Logan and Franklin, for whose Library Company he served as London agent, selecting books and philosophical apparatus for its scientific collection.

The Development of a Scientific Community

As Philadelphia entered the fateful decade leading up to the American Revolution, it might be assumed that a recognizable scientific community had developed to match the city's reputation as the leading center of colonial science. It is true that an American "Royal Society," the American Philosophical Society, was in place and beginning to function, but most scientific efforts were still amateur in nature and quality. Fueled by their passionate avocation, early gentlemen of science focused mainly on gathering and identifying plants and animals and other commentary on natural phenomena. From the time of the city's founding, however, international scientific exchanges took place through an impressive flow of cor-

respondence, publications, and transatlantic visits of interested individuals in both directions, opening new avenues for the exchange not only of ideas but also of goods. Interest in science was so high in the city during the middle decades of the eighteenth century that some sectors of society might even be described as "science mad," but only a handful of individuals derived a modest share of their livelihoods from scientific or technical expertise. It is fair to say that Philadelphia's scientific community was evolving but remained only a regional outpost of European activity, despite the impressive achievements of Logan, Bartram, Franklin, and some of their associates.

The reasons for this are not difficult to discover. There was, first, the paucity of potentially high-quality men of science, as well as the absence of sources of patronage and the scarcity of traditional scientific institutions. In addition, the press of daily business, problems of the city's development, fierce conflicts of provincial politics, the French and Indian War, and the tensions of the Stamp Act crisis seem to have precluded the financial support of Philadelphia's mercantile community, a group that in England did much to support the Royal Society.[18]

A case in point is John Bartram's early attempt to found a society to serve as the focal point for American science. In 1739 Bartram shared with Peter Collinson his idea about establishing such an organization, based in Philadelphia and with corresponding members throughout the colonies. Collinson, who perhaps knew the colonial scientific community better than anyone, warned Bartram against the plan, citing the lack of qualified men of science. He urged the naturalist instead to build his "academy" on the recently created Library Company of Philadelphia. Bartram, not one to be easily discouraged, was soon pushing his plan on Benjamin Franklin, who took the bait and four years later put forward a fully articulated plan for a Philadelphia-based society encompassing all the sciences and useful arts, with membership in all the British colonies in North America and the West Indies. Franklin prefaced his plan by observing that "The first Drudgery of Settling new Colonies, which confines the Attention of People to mere Necessaries, is now pretty well over" and went on to spur his colleagues into action: members were elected, meetings were held, and papers were promised for an American Philosophical Miscellany.[19] Then nothing further happened. Collinson had been right. For all practical purposes by 1746 the first American Philosophical Society was dead, although Franklin later preferred to describe it as dormant.[20]

The British colonies of North America had no significant examples of those foundations upon which contemporary European scientific establishments and progress depended—the patronage and preferment that advanced learned educational and governmental institutions and that sustained research.[21] There were none of those ecclesiastical bene-

fices and governmental positions into which promising men of science might be tucked. Nor was there legislative and executive support of full-scale maritime exploration and royal botanical gardens; military posts dealing with ordinance, navigational, and hydrographic studies; Jesuit colleges and dissenting academies offering the young solid scientific education; or ancient universities with a learned scientific professoriat. Compared to the array of opportunities available to scientists in Europe and England, the occasional if prodigious astronomical and surveying work entailed in determining colonial boundaries was indeed small beer.

Such patronage as did exist in Philadelphia might be termed "referential": colonial scientific activity was referred to those persons willing to assist in its development. This rarely took the form of monetary assistance. Little actual financial patronage was forthcoming during the years 1682–1769. In 1765 Collinson secured for Bartram the title of King's Botanist in North America, which came with a paltry annual stipend of fifty pounds; Bartram basked in the honor of the title and grumbled about the royal meanness, but he pocketed the money. The greatest financial patronage came at the end of this period, when the 1769 transit of Venus effort received £450 from the Pennsylvania Assembly for the purchase of scientific equipment, the execution and study of three observations, and the publication of the results.[22]

The lack of formal institutional support for Philadelphia science was offset by a number of important factors. When Thomas Paine arrived in the city in the fall of 1774, he was delighted to discover a widespread interest in science. "Almost every Philadelphian . . . had some scientific interest or business," he reported,

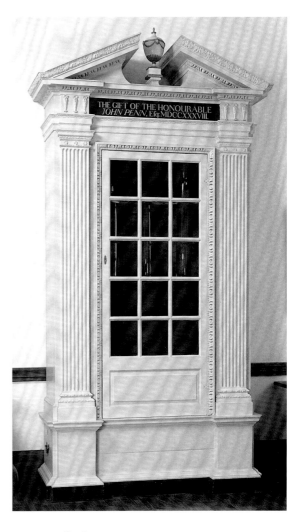

Fig. 64
Water Pump Case, John Harrison, Jr., 1738, no. 181. This case, presented by John Penn to the Library Company in 1738, is the earliest documented use of the Palladian style in Philadelphia. It houses glass scientific instruments used in Benjamin Franklin's electrical experiments and was part of the library's "cabinet of curiosities."

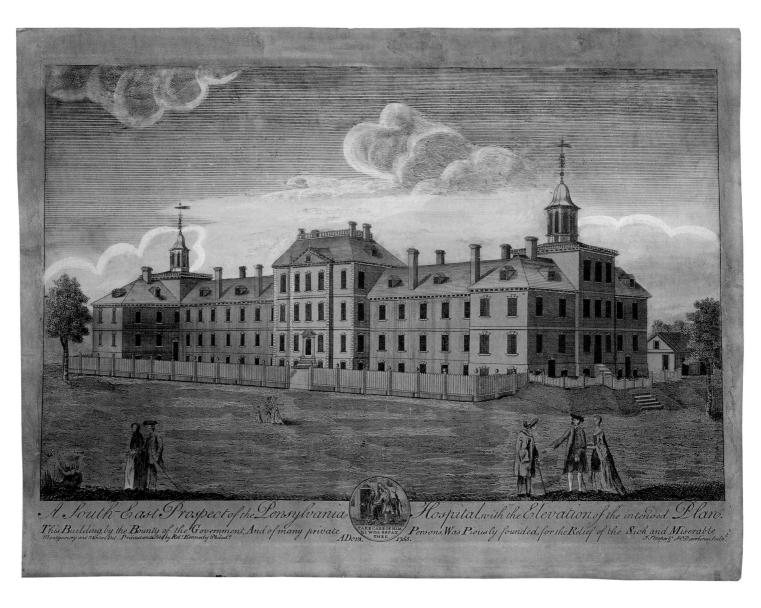

A South-East Prospect of the Pensylvania Hospital, with the Elevation of the intended Plan.
This Building, by the Bounty of the Government And of many private Persons, Was Piously founded, for the Relief of the Sick and Miserable ADom. 1755.

Fig. 65
Henry Dawkins and John Steeper, *A South-East Prospect of Pennsylvania Hospital*, 1761, no. 475. The research and pioneering medical investigations of a distinguished group of the city's physicians culminated in 1751 with the establishment of Pennsylvania Hospital. Founded through private donations as the first public hospital in America, the institution continued to lead throughout the century in the development of effective, science-based medical practices in the colonies.

and as in London, popular lectures on scientific subjects attracted large audiences.[23] Undoubtedly this enthusiasm can be attributed largely to the Society of Friends' acceptance of science as a proper and beneficial pursuit for Quakers. George Fox (1624–1691), founder of Quakerism, and William Penn, a Fellow of the Royal Society, advocated the study of science and the practice of gardening as unostentatious means of learning the secrets of nature and the glory of God, improving one's mind and health, and perhaps even benefiting mankind.[24]

"The Quaker appeal to direct experience rather than to religious authority or tradition, or even the words of the Bible," suggests E. Digby Baltzell, "was closely akin to the spirit of empirical science," which became popular in late seventeenth- and eighteenth-century England.[25] No limits were placed on the range of scientific inquiry appropriate for Friends, although even the most theoretical research was expected to result in practical, utilitarian results. Members of the Quaker commercial class, barred from Oxford and Cambridge universities, often turned

to science and achieved membership in the Royal Society in numbers greatly exceeding their proportion in the general population. This was also true in America, where in 1769 nearly half the Philadelphia members of the newly unified American Philosophical Society were Friends.

The network of the scientifically inclined in Philadelphia included an interesting potpourri of native and foreign-born physicians who received their medical education at Edinburgh University or at universities on the Continent, former members of the Junto (a society created by Franklin in 1727 for the progress and study of science), and a clutch of Germantown mystics. Many doctors involved in the 1751 founding of Pennsylvania Hospital (America's first such institution), and the establishment in 1765 of the Medical School of the College of Philadelphia, had studied botany and chemistry as part of their medical studies in Britain or Europe (figs. 65–67).[26] While none of these men was significantly active in these disciplines, they understood their value to the development of the colonies.

A friend of many of these physicians, and a former Junto member, was Joseph Breintnall (died 1746), a Quaker merchant, scrivener, first secretary of the Library Company, and sheriff of Philadelphia (1735–38), whose friendship Franklin and Bartram treasured. Breintnall was an avid gardener, experimenting with grafting and developing a method of making ink impressions of leaves that resulted in prints so accurate they could be used by scholars, as well as for decorative purposes (fig. 68). He also carried out rather simple experiments on the reflection of the sun's rays on different colors and on the difference between the sun's heating power in summer and winter.[27]

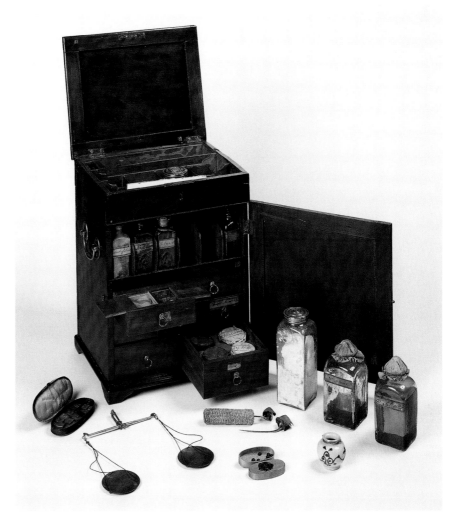

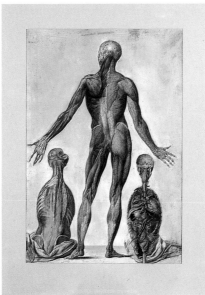

Fig. 66
Medicine Chest and Contents, c. 1740–55, no. 15. The original owner of this medicine chest was Dr. William Shippen, Sr., of Philadelphia, a prominent colonial physician. Among the contents of his case Shippen kept cockspurs, perhaps to hide his interest in cockfighting from disapproving peers and family members.

Fig. 67
Jan van Rymsdyck (Dutch, active London mid-eighteenth century). *Anatomy Studies*, 1755, pastel on vellum, 26 x 18" (66 x 45.7 cm), Pennsylvania Hospital, Philadelphia. This detailed anatomical drawing was one in a series that Dr. John Fothergill, a member of London's Royal Society, presented to Pennsylvania Hospital in 1762 to serve as teaching tools.

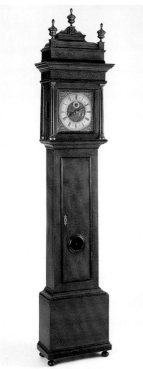

Fig. 68
Joseph Breintnall, *Nature Prints of Leaves*, c. 1731–44, no. 452. Breintnall made this print directly from inked leaves, a technique he pioneered. On this page in his portfolio of botanical specimens, Breintnall noted: "By the best engraver in the Universe."

Fig. 69
Tall Case Clock, Christopher Witt, c. 1710–30, no. 57. Dr. Christopher Witt's many interests and activities included clockmaking.

It was Breintnall who first introduced Bartram to Collinson, and Collinson successfully shepherded papers by Breintnall on rattlesnake bite and the aurora borealis through publication in the *Philosophical Transactions of the Royal Society.*

Another good friend of Breintnall, and also Franklin and Bartram, was the Germantown physician and botanist Dr. Christopher Witt (1675–1765), a "devotee of mystical divinity, natural magic, and astrology."[28] Witt was an accomplished physician and a learned man, although he held theosophic views and had a reputation as a conjurer. He had a fine garden and a botanical exchange with Peter Collinson, as well as a desire to share his knowledge and his books with Bartram.[29] By all accounts, he was, like Breintnall, a charming man and excellent companion. On several occasions Witt bested Bartram on plant exchanges (the older gardener receiving unique specimens in trade for items that Bartram already had in his collections); this did not seem to bother Bartram very much. He liked the older man, respected him for his learning, and enjoyed walking with Witt in his garden, conversing on philosophy and plants, although he did not share his view of the world.[30] As a man of science who based his own work on "observable facts," Bartram found it somewhat silly that an intelligent, learned man like Christopher Witt still clung to medieval beliefs in astrology, folklore, and mystical medicine.

Although English-born, Witt was closely associated with the remnants of the German pietist community that earlier had settled Germantown. The first botanical garden in Pennsylvania was created on the banks of the Wissahickon by the Rosicrucian community known as the Hermits of the Ridge. Featuring

medicinal and other herbs, it adjoined Witt's house and larger garden in Germantown on the southeast corner of High and Main streets.[31] Tradition has it that Witt was the last member of the Germantown Rosicrucians, an esoteric society of moral and religious reformers devoted to psychic and spiritual enlightenment through knowledge of the secrets of nature. It was probably through this connection that the American Philosophical Society received one of its historic treasures, the magnificent double sundial made by Christopher Schissler in 1578, a masterpiece of late Renaissance scientific instrument making (fig. 71).[32] The first mention of this sundial is by an early eighteenth-century traveler in Germany, who located it in the library of Helmstedt University. The rector of the university had once been the tutor of Johannes Kelpius (1673–1708), later the master of the Germantown Rosicrucian community from 1694 to 1708 (see fig. 76). Apparently at his death it passed to Christopher Witt, and then to the American Philosophical Society together with other of Witt's scientific apparatus—all later incorporated into the Society's Cabinet of Instruments.

After 1750 scientific progress in the colony could be detected at the collegiate level. Provost William Smith (1727–1803), who played a major role in organizing the 1769 transit of Venus observations, encouraged the study of science at the College of Philadelphia (established by Franklin in 1755) by inaugurating a program in which nearly 40 percent of the students' classroom time was to be devoted to scientific subjects.[33] Smith taught natural philosophy on a faculty boasting the likes of Glasgow- and Edinburgh-trained Vice-Provost Francis Alison (1705–1779), a brilliant

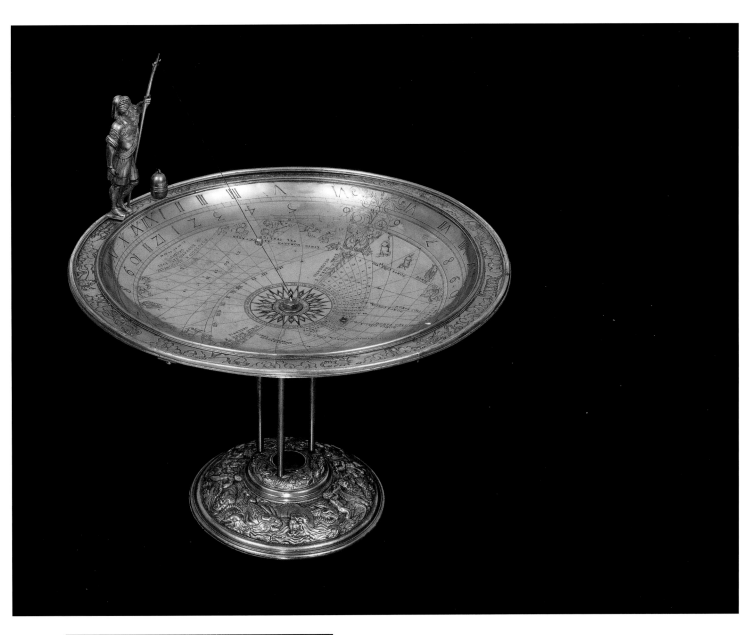

Fig. 70
Thomas Cadwalader, *An Essay on the West-India Dry-Gripes*, c. 1745, no. 500. Dr. Cadwalader's essay on the "dry-gripes," an intestinal ailment thought to be caused by tainted wine, was printed by Benjamin Franklin and was the first medical tract published in America.

Fig. 71
Refractive Sundial, Christopher Schissler, 1578, no. 289. This ornately engraved German refractive sundial had a distinguished line of ownership in the city—Johannes Kelpius, Christopher Witt, Benjamin Franklin, and the American Philosophical Society.

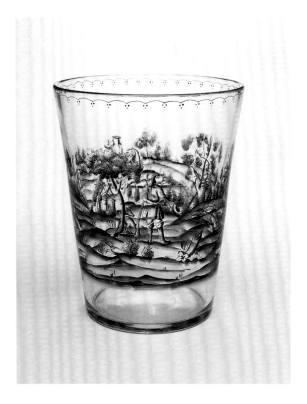

Fig. 72
Whirl Beaker, c. 1745–55, no. 337.
The design of this beaker, a parlor
curiosity imported from Germany,
was based on the scientific prin-
ciples surrounding the viscosity of
oil and water. When oil and water
were rapidly whirled into it, it pro-
duced the effect of a moving hunt-
ing scene. It was owned by Louis
Timothée, the first librarian of the
Library Company of Philadelphia.

classicist and vigorous proponent of nat-
ural history, and Franklin's co-investiga-
tor Ebenezer Kinnersley (1711–1778),
who continued Franklin's research in
electricity after he lost interest. Science
education at the college got an addition-
al boost when Dr. John Morgan
(1735–1789), a student of William Smith
and a member of the college's first grad-
uating class, returned to Philadelphia
from his Edinburgh medical education
and training, and extensive advanced
study in Europe, to found America's
first medical school in 1765. Morgan's
revolutionary curriculum contained
both botany and chemistry and provided
a plan for the formal teaching of science
in the university, following the Scottish
model.[34]

Science and Art

During the time span covered here,
science was only one of several back-
grounds against which the Delaware
Valley's decorative and fine arts devel-
oped and flourished. How is the story
of Philadelphia science and the creation
of its scientific community similar or
related to the achievements of the art-
ists, craftsmen, and collectors celebrated
in this catalogue? Were there scientific
and artistic commonalties? And what
of science and the Baroque?

A common characteristic of colonial
Philadelphia's scientific and artistic en-
terprises was the unrealized nature of
both. Scientists and artists alike during
these years seemed to be in search of an
American style, their quest coupled with
the desire to adhere to the highest Euro-
pean standards. Perhaps the most strik-
ing similarity of the two movements
was their highly international character.
Natural philosophy was closely tied to

and influenced by British science in
much the same way that mid-century
Philadelphia's artistic taste was initially
dominated by the English Georgian
style. As the Dutch, Germanic, and
French Huguenot craftsmen who immi-
grated to Pennsylvania combined north-
ern European traditions and styles in
the objects they created, Philadelphia's
natural historians became increasingly
associated with the learning and intel-
lectual institutions of Holland, France,
Germany, and Sweden. A strong utili-
tarian strain could be found in the craft,
or artisan, aspects of both science and
the arts. Surveying, map-making, and
medical apparatus found their counter-
parts in printed textiles, simple ceramics
and glassware, and kitchen spits and
ironwork. Native artisans in both camps
became increasingly skilled, knowledge-
able, and sought after.

It has been said that there is no ba-
roque science, only baroque scientists.[35]
John Bartram was one Philadelphia sci-
entist—perhaps the sole example—who
was drawn to and actually made use of
the baroque style. Near the end of his
life, Bartram had by 1770 transformed
his square Swedish farmhouse into a
larger if somewhat eccentric structure
by raising its roof, adding dormer win-
dows, and installing three stone Ionic
columns, one of them freestanding, on its
riverside facade. The house and its deco-
rative elements were of Wissahickon
schist, which Bartram himself helped
quarry and roughly carve. Adding a
touch of rustic grandeur are four win-
dows framed with carved volute sur-
rounds that roughly imitate baroque
curves.[36] Fished out of contemporary
architectural design books (perhaps
among those in the Library Company's
collections), these surrounds remain

Fig. 73
John Bartram's house on the west
bank of the Schuylkill, built of
Wissahickon schist, c. 1728, with
additions c. 1765–1815, detail
of windows. Historic Bartram's
Garden, Philadelphia.

today the most striking and surprising
feature of Bartram's house (fig. 73).[37]
What inspired him? Did the king's
botanist and internationally renowned
man of science wish to present a more
exalted architectural facade to those
visiting his garden, thereby enhancing
its grandeur and his own image, or was
this merely a final whimsical gesture on
the part of this complicated, generous
man of genius?[38] Clearly the Baroque
appealed to Bartram. Perhaps it remind-
ed him of the symmetrical curves and
dramatic swirls and colors of the bo-
tanical world he knew so well. Perhaps
he only wanted to be outlandish.

One might conjure up with pleasure
the image of the greatest natural botanist
of the world standing by one of his win-
dows on a cold, clear winter evening
when his trees had shed their leaves, gaz-
ing across the Schuylkill toward the dim
lights of that least baroque of cities—
Philadelphia.

Notes

1. The author wishes to acknowledge the generous editorial and scholarly assistance received from Whitfield J. Bell, Jr., Richard S. Dunn, Darwin H. Stapleton, and John C. Van Horne. Throughout this essay modern usages of the terms "science" and "scientist" have been followed, although in the eighteenth century "science" was understood to be organized knowledge, and the word "scientist" was first coined in 1833 by William Whewelt (1794–1866), the English philosopher of science and physical astronomy.

In part because of the professional challenge of executing the necessary observations in several locations in America, two competing philosophical societies, the American Philosophical Society and the American Society for Promoting Useful Knowledge, had merged into one organization after a good deal of contention and ill feeling. Benjamin Franklin, America's greatest scientist and founder of the original American Philosophical Society in 1743, was elected president of the new organization despite being resident in England.

2. Raymond Phineas Stearns, *Science in the British Colonies of America* (Urbana, Chicago, and London: University of Illinois Press, 1970), pp. 653–54.

3. Daniel J. Boorstin, *The Americans: The Colonial Experience* (New York: Random House, 1958), p. 246.

4. For a clear account of this achievement, see Brooke Hindle, "The Transit of Venus," in Hindle, *The Pursuit of Science in Revolutionary America, 1735–1789* (Chapel Hill: University of North Carolina Press, 1956), pp. 146–65. Some of the instruments used are described and illustrated together with the "Projection of the Transit of Venus over the Sun" in Silvio A. Bedini, "The Transit in the Tower: English Astronomical Instruments in Colonial America," *Annals of Science*, vol. 54 (1997), pp. 184–86, figs. 2, 3, and 10.

5. For concise, balanced accounts of each man's scientific career and contributions, see Frederick B. Tolles, "Philadelphia's First Scientist: James Logan," *Isis*, vol. 47 (1956), pp. 20–30; Whitfied J. Bell, Jr., "John Bartram," in Charles C. Gillispie, ed., *Dictionary of Scientific Biography*, vol. 1 (1970), pp. 486–88; I. Bernard Cohen, "Benjamin Franklin," *Dictionary of Scientific Biography*, vol. 5 (1972), pp. 129–39; for Franklin, see also Stearns, *Science in the British Colonies*, pp. 619–42.

6. Edwin Wolf 2nd, "James Logan," *Dictionary of Scientific Biography*, vol. 8 (1973), p. 460. Since 1792 Logan's collection of books and manuscripts has been at the Library Company of Philadelphia. See Wolf, *The Library of James Logan of Philadelphia, 1674–1751* (Philadelphia: The Library Company of Philadelphia, 1974), with an annotated catalogue containing abstracts of Logan's correspondence with great figures of science.

7. Tolles, "Philadelphia's First Scientist," p. 28.

8. Thomas P. Slaughter, *The Natures of John and William Bartram* (New York: Alfred A. Knopf, 1996), p. 51.

9. Bell, "John Bartram," p. 487.

10. Cohen, "Benjamin Franklin," p. 129.

11. Stearns, *Science in the British Colonies*, p. 679.

12. Hindle, *Pursuit of Science*, p. 77.

13. Hindle, *Pursuit of Science*, pp. 77–78. Briefly, the law of conservation of charge holds that plus and minus charges, or states of electrification, must occur in exactly equal amounts.

14. The Library Company of Philadelphia, often called America's first public library, was actually a subscription institution: books were purchased with money from the subscribers, who thus owned the books though not the knowledge contained therein.

15. In 1754 Logan, Franklin, and other prominent Philadelphians sponsored Charles Swain in his abortive attempt to establish a northwest passage. The Eskimo objects were the only fruits of his efforts.

16. See, for example, Boorstin, *The Colonial Experience*, pp. 252–58. Boorstin, who is not a historian of science, views Franklin's achievements within his thesis that America is a unique, pragmatic civilization not given to flights of theorizing and admiration of learned professionalism.

17. Hindle, *Pursuit of Science*, pp. 18–19.

18. Ibid., p. 74.

19. Benjamin Franklin, *A Proposal for Promoting Useful Knowledge among the British Plantations in America* (Philadelphia, 1743); quoted in Leonard W. Labaree, ed., *The Papers of Benjamin Franklin*, vol. 2 (New Haven: Yale University Press, 1960), p. 380.

20. For an excellent brief review of the American Philosophical Society in the years 1743–75, see Hindle, *Pursuit of Science*, pp. 66–74, 127–45. See also Edward C. Carter II, *"One Grand Pursuit": A Brief History of the American Philosophical Society's First 250 Years, 1743–1993* (Philadelphia: The American Philosophical Society, 1993), pp. 11–17, and Whitfield J. Bell, Jr., *Patriot-Improvers: Biographical Sketches of Members of the American Philosophical Society, Volume One, 1743–1768*, Memoirs of the American Philosophical Society, vol. 226 (Philadelphia: The American Philosophical Society, 1997).

21. I am indebted to Stephanie Grauman Wolf for suggesting that the absence of patronage was a retarding factor on the growth of a Philadelphia scientific community.

22. Hindle, *Pursuit of Science*, p. 140.

23. Eric Foner, *Tom Paine and Revolutionary America* (New York: Oxford University Press, 1976), p. 20.

24. For illuminating discussion of this topic, see Frederick B. Tolles, *Meeting House and Counting House: The Quaker Merchants of Colonial Philadelphia, 1682–1763* (Chapel Hill: University of North Carolina Press, 1948; repr. New York: W. W. Norton and Company, 1963), pp. 205–29, and E. Digby Baltzell, *Puritan Boston and Quaker Philadelphia: Two Protestant Ethics and the Spirit of Class Authority and Leadership* (New York and London: Free Press, 1979), pp. 166–75.

25. Baltzell, *Puritan Boston and Quaker Philadelphia*, p. 169.

26. For a list to 1770 of those doing so, together with institutions of study and American residence, see Stearns, *Science in the British Colonies*, p. 525, note 48.

27. Ronald Kent Esplin, "Franklin's Colleagues and Their Club: The Junto in Philadelphia's Golden Age" (M.A. thesis, University of Virginia, 1979), pp. 36–37. For a fuller account, see Stephen Bloore, "Joseph Breintnall, First Secretary of the Library Company," *The Pennsylvania Magazine of History and Biography*, vol. 59 (1935), pp. 42–56.

28. Leonard W. Labaree, ed., *The Papers of Benjamin Franklin*, vol. 12 (New Haven and London: Yale University Press, 1968), p. 44, note 7.

29. Stearns, *Science in the British Colonies*, p. 577.

30. Slaughter, *Natures of Bartram*, pp. 135–36.

31. John W. Harshberger, "Some Old Gardens of Pennsylvania," *The Pennsylvania Magazine of History and Biography*, vol. 48 (1924), pp. 289–90.

32. A description of the Schissler sundial can be found in Robert P. Multhauf, comp., *A Catalogue of Instruments and Models in the Possession of the American Philosophical Society*, Memoirs of the American Philosophical Society, vol. 53

(Philadelphia: The American Philosophical Society, 1961), pp. 52–53; a paper on the modern history and analysis of this sundial, "When the Shadows Moved Backward: Hezekiah, Schissler, and the APS," was presented by Owen Gingerich at the Autumn General Meeting of the American Philosophical Society (November 1989), much of which has been incorporated into the checklist entry in this catalogue. Schissler, who lived and worked in Augsburg, is today considered to have been one of the two best sixteenth-century German instrument makers.

33. Hindle, *Pursuit of Science,* pp. 90–91. The foresighted curriculum Provost Smith proposed in 1756 can be found in Lawrence A. Cremin, *American Education: The Colonial Experience, 1607–1783* (New York, Evanston, and London: Harper and Row Publishers, 1970), pp. 382–83.

34. Cremin, *American Education,* p. 386. For a sketch of Morgan detailing his amazing career and extraordinary exposure to European culture, learning, and science, see Bell, *Patriot-Improvers,* pp. 327–36.

35. Private conversation with Professor Sigfrido Leschiutta, president of the Instituto Elettrotecnico Nazionale Galileo Ferraris of Turin, Italy, December 4, 1998.

36. For a description of Bartram's house, see John Andrew Gallery, ed., *Philadelphia Architecture: A Guide to the City,* 2nd ed. (Philadelphia: Foundation for Architecture, 1994), p. 28.

37. Richard J. Webster, *Philadelphia Preserved: Catalog of the Historic American Buildings Survey* (Philadelphia: Temple University Press, 1976), p. 194.

38. For discussion of and speculation on the remodeling of Bartram's house, see Slaughter, *Natures of Bartram,* pp. 37–40.

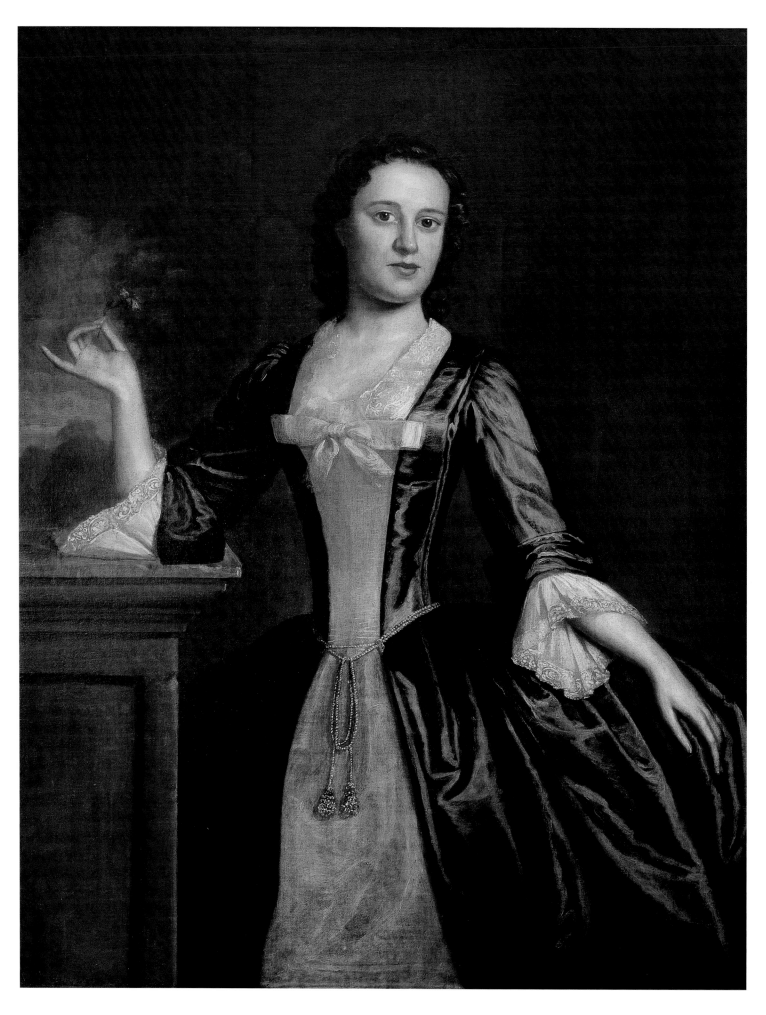

The Development of Painting in Early Pennsylvania

Richard Saunders

Fewer than two hundred paintings were created in Pennsylvania between 1700 and 1750, but this small number is not surprising to anyone familiar with the colony's growth and evolution.[1] A number of factors contributed to the dearth of paintings. First, while Pennsylvania's population increased significantly during these years (from 5,000 in 1700 to 23,750 in 1760),[2] it was only in the second half of the eighteenth century that the colony achieved the critical mass and concentration of wealth necessary to sustain painting at a significant level. In addition, the colony in its early years was dominated by the Society of Friends, and many Quakers eschewed extravagance and considered portraits and other forms of painting self-indulgent or ostentatious. And as most Pennsylvanians were "of the middling sort"—neither tremendously wealthy nor distressingly poor—they rarely commissioned paintings. What painting there was during this period in Pennsylvania, or more accurately, Philadelphia, since painters' studios were almost always located in urban centers, consisted largely of portrait painting. As in other colonial towns, the pragmatic merchants and landowners had little interest in historical paintings, landscapes, and still lifes.

Given the difficult conditions, it is understandable that the first painters active in Pennsylvania and surrounding areas were not trained in the colonies but were instead European immigrants who had learned their skills elsewhere. Those painters who did make their way to America did so less because the colonies promised great opportunity than because they offered a reasonable alternative to the turmoil of European life. The artist Justus Engelhardt Kuhn (died 1717), for example, settled in nearby Annapolis in 1708 as part of a great influx of German immigrants into Maryland and Pennsylvania during the first quarter of the eighteenth century.

In addition to the immigrant painters, who sought to derive an income from their talents, there were educated amateurs who painted for their own fulfillment or amusement. The earliest surviving example of the visual arts in Pennsylvania is an example of this phenomenon. About 1705, Dr. Christopher

Fig. 74
Robert Feke, *Portrait of Elizabeth Branson Lardner*, 1749, no. 460. In 1749 Lynford Lardner wrote of his new wife to John Penn: "Her Complexion is more Brown than Fair, and Her Mind the very Picture of her Face, Pretty and Uniform: Her Person is Small but well Shaped and in the Language of Shakespeare's Lover just as High as my Heart. Her Voice is agreeable and her Tongue can say everything but yes" (Lardner Family Papers, collection of Mary Fowle Dawson).

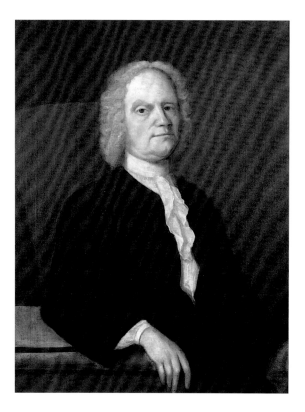

Fig. 75
Gustavus Hesselius, *Self-Portrait,*
c. 1740, oil on canvas, 36¹/4 x 28"
(92.1 x 71.1 cm), The Historical
Society of Pennsylvania, Phila-
delphia.

Fig. 76
Christopher Witt, *Portrait of
Johannes Kelpius,* c. 1705, no. 442.
Kelpius, a man of great learning in
music, the sciences, and languages,
led his group of German mystics to
Philadelphia in 1694. Christopher
Witt depicted him in an armchair of
a type made in the Delaware Valley
in the early eighteenth century.

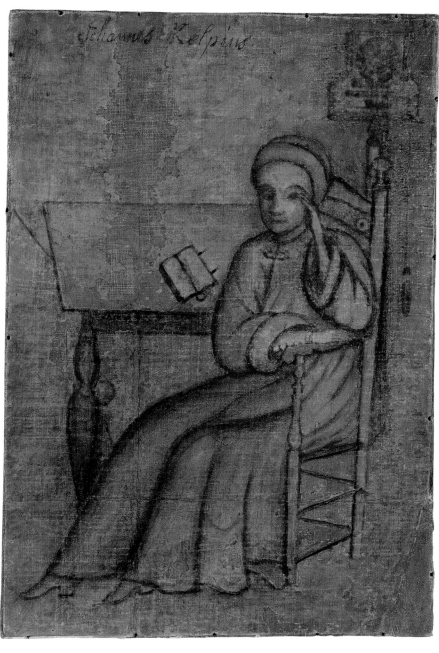

Witt (1675–1765), an accomplished En-
glish physician, painted a diminutive
watercolor portrait of the mystic Johannes
Kelpius (fig. 76). Witt had immigrated to
Pennsylvania in 1704 to join Kelpius's
group of German hermits, who had set-
tled on a picturesque ridge overlooking
Wissahickon Creek in present-day Fair-
mount Park. There Witt began an English
translation of his master's hymns. It
seems likely that this portrait was intended
as the frontispiece to a never-published
volume of Kelpius's work.

The lone painter of note to settle in
Pennsylvania during the early years of
the eighteenth century was Gustavus

Hesselius (1682–1755), who was consid-
erate enough to have left us his self-
portrait (fig. 75). Hesselius was a Swede
who arrived in New Sweden (with head-
quarters in Wilmington, Delaware) in
1712, along with his brother Andreas,
who became the minister of Old Swedes
Church. Later that year Hesselius relocat-
ed to Philadelphia, presumably because
he recognized the limited opportunities
available to him in New Sweden.

As was the case for many immigrant
artists, Hesselius's ambitions and deter-
mination far outstripped his abilities. Pos-
sessing only limited skills as a painter,
he nonetheless had a long career, sug-

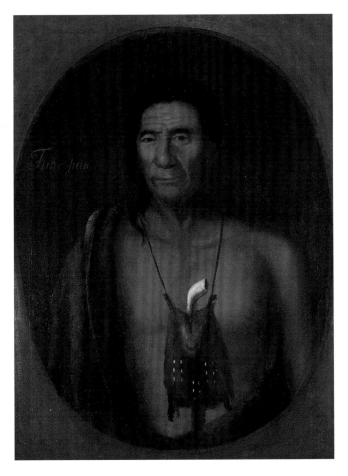

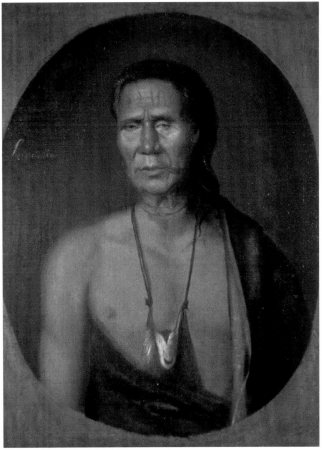

gesting a virtual absence of competition for most of the years he was active. The majority of his surviving portraits, such as that of James Logan (see fig. 53), the wealthy merchant and owner of Stenton mansion, probably painted about 1730, are steeped in the dark palette and rigid painting style that characterized northern baroque portraiture. Hesselius, like most painters of his generation, was taught a systematic and repetitive method of painting that valued consistency over variety. This adherence to consistency is in part why Hesselius continued to paint in a baroque style long after prevailing European fashion had abandoned it for the lighter, brighter rococo palette.

In addition to two remarkable portraits of the Delaware Indians Tishcohan and Lapowinsa (figs. 77, 78), Hesselius is best remembered for the unusually diverse subjects of his oeuvre, which range from the mythological, as in *Bacchanalian Revel* (fig. 79) and its companion piece *Bacchus and Ariadne* (fig. 80), to the religious, as in the *Last Supper,* now lost.3 Unlike his other paintings, Hesselius's mythological paintings descended in his family, indicating that they were painted not as commissions but for his own purposes.

Previous writers have commented on the relative scarcity of paintings by Hesselius, despite his long career in Pennsylvania. One possible reason may have been the reluctance of some potential sitters to have their portraits painted by an artist about whose skills they had

Fig. 77
Gustavus Hesselius, *Portrait of Tishcohan*, 1735–37, no. 455.

Fig. 78
Gustavus Hesselius, *Portrait of Lapowinsa*, c. 1735–37, no. 456.

The portraits of Lapowinsa and Tishcohan, Delaware Indian chiefs and signers of the Walking Purchase treaty, were commissioned by John and Thomas Penn. The treaty, agreed upon in May of 1735 and concluded in 1737, was an attempt to settle a land dispute between the Penns and the Lenni-Lenape tribe.

Fig. 79
Gustavus Hesselius, *Bacchanalian Revel*, c. 1720, oil on canvas, 24⁷/₁₆ x 32⁷/₁₆" (62.1 x 82.4 cm), Pennsylvania Academy of the Fine Arts, Philadelphia, Joseph E. Temple Fund, 1949.14. This elaborate painting and its companion piece, *Bacchus and Ariadne*, are perhaps the earliest mythological scenes to have been painted in America. Their baroque compositions were probably derived from European prints.

reservations. Such was the experience of Logan, a Quaker, who had his own portrait painted by Hesselius but failed to convince his wife or daughters to do likewise. Upon receiving from England portraits of his brother Dr. William Logan and his brother's wife, James Logan expressed regret that he could not respond in kind:

We have a Swedish painter here, no bad hand, who generally does Justice to the men, especially to their blemishes, which he never fails shewing in the fullest light, but is remarked for never having done any to ye fair sex, and therefore very few care to sit to him[.] nothing on earth could prevail with my spouse to sitt at all, or to have hers taken by any man, and our girles believing the Originals have but little from nature to recommend them would scarce be willing to have that little (if any) ill treated by a Pencil the Graces never favour'd, and therefore I doubt we cannot make you the most proper Return for so obliging a Present.4

Painters like Hesselius survived by dint of their wit and flexibility. The tenuous nature of a career as a painter during the colonial period required that any sensible person be prepared to do a variety of tasks. It was the rule, rather than the exception, to find artists such as Hesselius who, although a portrait painter by choice, advertised that he could provide "in the best Manner . . . viz. Coats of Arms drawn on Coaches, Chaises, &c, or any other kind of Ornaments, Landskips, Signs, Shew-boards, Ship and House Painting, Gilding of all Sorts, Writing in Gold or Colour, old Pictures clean'd and mended."5 (He is recorded as having painted the interior paneling of Cedar Grove, a house built by the Quaker widow Elizabeth Coates Paschall in 1748–50.6) In announcing his willingness to take on such diverse work he sounded a refrain colonial painters knew well—that a career as an artist in America was fraught with difficulty.

Residents of Pennsylvania had few options if they sought to commission a portrait in the first third of the eighteenth century. If they were not interested in having a portrait painted by an artist then resident in Philadelphia, they had to either await the arrival of a new painter, travel to another colonial town where a painter resided, or have a portrait painted while in England or Europe. Thomas Lawrence (1689–1754), the New York–born merchant who relocated to Philadelphia in 1720, may have returned to New York to have his portrait painted. Probably executed in the 1720s, his portrait (fig. 81) is here attributed to John Watson (1685–1768), the artist who lived across the Hudson River in Perth Amboy, New Jersey. Watson is responsible for a small but notable group of por-

Fig. 80
Gustavus Hesselius, *Bacchus and Ariadne,* c. 1725, no. 446. Hesselius's depiction of Ariadne, the mythical princess of Crete, as a draped nude is one of the earliest nudes painted in the colonies. Such a depiction was acceptable only through the painting's references to ancient history and the classical world.

Fig. 81
Attributed to John Watson, *Portrait of Thomas Lawrence,* c. 1719–30, no. 450. Watson was a prominent merchant and landowner in northern New Jersey and New York. The merchant Thomas Lawrence also had ties to both New York and New Jersey and had moved to Philadelphia around the time of his marriage to Rachel Lonfield of New Brunswick, New Jersey, in 1719. This portrait was probably painted soon after their marriage.

Fig. 82
John Watson, *Portrait of Sir William Keith*, 1720–30, ink on parchment, 4 x 3¹/8" (10.2 x 7.9 cm), The Historical Society of Pennsylvania, Philadelphia. Sir William Keith built the house Fountain Low, near present-day Doylestown, in 1723–26. Owing to financial troubles Keith was forced to mortgage the house, and it was eventually sold to his son-in-law and renamed Graeme Park.

traits, including those of Governor Lewis Morris of New Jersey and Governor William Burnet of New York, of which the latter is virtually identical in style with Lawrence's portrait. A more capable painter than Hesselius, Watson raised colonial baroque portraiture to a new level by the use of such established motifs as the open window and the table-top still life. Lawrence was not alone in Philadelphia in seeking out Watson. He was joined by Sir William Keith, governor of Pennsylvania from 1717 to 1726, for whom Watson drew one of his distinctive ink-on-parchment miniature portraits (fig. 82).

Determining why a portrait was painted at a particular moment is difficult, but more often than not it seems that significant factors influenced the decision and that few portraits were casual commissions. Important events that might precipitate the commissioning of a portrait included attaining a certain affluence or receiving an inheritance, reaching one's majority, assuming a noteworthy office, and marriage. In addition, portraits were sometimes painted posthumously as memorials; children's portraits were occasionally done prior to their traveling overseas; and portraits of elderly parents or grandparents might be commissioned as a way to honor them. Most of these decisions, however, were influenced by the availability of an acceptable portrait painter.

Another factor contributing to the small number of paintings in the colonies was their cost. Although few records of prices of paintings survive from Pennsylvania, when combined with evidence from other colonies, these figures provide a picture sufficiently clear to allow some assumptions to be made. In Boston during the 1730s, John Smibert, the Scottish

immigrant portrait painter, charged between twenty and twenty-five pounds for a bust-length portrait and twice that amount for a three-quarter-length canvas.[7] Painters like Gustavus Hesselius and John Watson were paid far less. Hesselius received just under five pounds each for two portraits painted in 1722 and eight pounds each for his 1735 portraits of Tishcohan and Lapowinsa.[8] In New York in 1726, Watson was paid four to five pounds each for portraits such as that of Governor Burnet or other works of comparable size and complexity.[9] Surviving furniture and silver prices from this period suggest that the least expensive oil-on-canvas portrait, that is, a bust-length one, cost about as much as a significant piece of case furniture, such as a chest of drawers or a desk, or a moderate piece of silver hollow ware, such as a teapot. For example, in 1712 James Logan paid eight pounds for a chest of drawers that he imported. Ten years later a "Looking Glass Scrutore," presumably a combination desk and bookcase with mirrored doors, owned by the Philadelphia merchant Joseph Redman was appraised for eight pounds.[10] By the 1730s Joseph Richardson, Sr., the Philadelphia silversmith, charged customers just under ten pounds for an average-sized teapot.[11] Portraits were among the most expensive purchases to be made in colonial America, and it seems likely that buying a piece of furniture or silver was considered more important.

After about 1735 subtle changes in Philadelphia life led to a more inviting climate for painters. While it is simplistic to suggest that any single factor precipitated the shift, the increasing prosperity of Philadelphia merchants permitted a refinement of their lifestyle in imitation of the mercantile gentry of

England.[12] Simultaneously, after about 1735 there was a gradual but steady decline in Quakerism and a rise in Presbyterianism and Anglicanism, whose wealthy congregations had far less aversion to the associations connected with high-style painting. In addition, during the 1730s more recent Presbyterian arrivals from Scotland began to play key roles in government, business, and society in general.

The new climate paved the way for the arrival at Philadelphia in 1740 of the Scottish artist John Smibert (1688–1751), who lived in Boston. By this time, Smibert had lived in the colonies for eleven years but had never ventured farther south than Newport, Rhode Island. Most likely aware that both Hesselius and Watson had by this time stopped painting, Smibert must have realized that the situation had created a market for an out-of-town portrait artist that had not existed for much of the preceding decade. Smibert's visit was presumably preceded by the customary letters of introduction, which would have helped to assure him of a sufficient number of commissions. Smibert arrived in Philadelphia in late May or early June and over the course of eight weeks painted fourteen portraits, in each instance raising his price by more than 50 percent, to ten guineas for a bust portrait and twenty guineas for one that was three-quarter length. All the commissions came from eight of Philadelphia's leading families interrelated by marital, commercial, or social ties. His sitters, as one would expect, were some of the city's foremost figures, and several, such as the noted lawyer Andrew Hamilton (1676–1741) and Hamilton's wealthy son-in-law and onetime mayor of the city, William Allen (1704–1780), were,

like Smibert himself, native Scots and also Presbyterians.

The only surviving portrait from Smibert's trip is that of Joseph Turner (1701–1783), a leading Philadelphia merchant and member of the governor's council who for a number of years was partnered with William Allen in the most important commercial firm of the period. His portrait (fig. 83) is an example of Smibert's waning style, by then doggedly conservative. In composition and palette, the portrait differs little from the style in which Smibert learned to paint some twenty-five years earlier at the Great Queen Street Academy in London.

Given the rapid rate at which Smibert took on commissions during his stay in the city, it is likely that he only began each portrait while in Philadelphia—painting the face and sketching in the remainder—and then shipped the portraits back to Boston to be completed and framed. This would explain why he did not receive final payment for the Philadelphia pictures until two years later, as is indicated by James Hamilton's surviving cash book.[13]

Native Talent

Until about mid-century, Pennsylvanians were, for the most part, at the mercy of European-trained painters, whose styles were decades old; by the time they painted in Philadelphia they were artists of only marginal ability. The appearance in the 1740s of painters born and trained in America brought changes to painting in Pennsylvania and elsewhere in the colonies. The transformation arrived abruptly in 1746 with the appearance in Pennsylvania of Robert Feke (c. 1707–c. 1751). Feke was most likely born on Long Island, but after a stint of work in the Boston area he made his home in New-

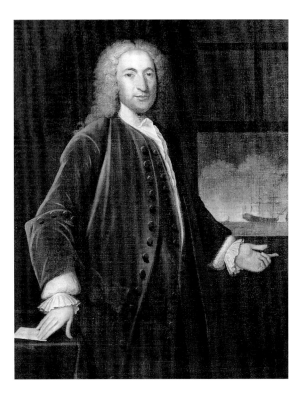

Fig. 83
John Smibert, *Portrait of Joseph Turner*, 1740, oil on canvas, 50 x 40" (127 x 101.6 cm), Cliveden, a co-stewardship property of the National Trust for Historic Preservation, Germantown, Pennsylvania.

port, Rhode Island. While in Philadelphia for what may have been only a few weeks, he painted about a dozen portraits, at least two of which he signed. The crowning achievement of his visit was his portrait of Tench Francis, attorney general in 1741 and undisputed leader of the Pennsylvania bar (fig. 84). Although in its pose and setting the painting retains some of the conventions of baroque portraiture, no one would confuse this portrait with the work of Hesselius, Watson, or Smibert. Feke's decidedly brighter palette, precise definition of form, and appreciation of satiny fabrics must have startled his sitters, who were used to the darker, more rigid style of the older painters.

For reasons that are not entirely clear, Feke departed Philadelphia not long after arriving, but he returned three years later and stayed long enough to allow him to paint another spate of portraits. Among them was the portrait of Elizabeth Branson Lardner (c. 1731–1760; fig. 74), wife of Lynford Lardner (1715–1774), the immensely wealthy attorney for and in-law of the Penn family, who recorded in his daybook on November 15, 1749, "Paid Phyke Face Painter for my own & Wife's Picture."[14] This portrait, along with others painted by Feke that year, established that the women of Philadelphia finally had found an artist to whom they could turn with confidence.

To the younger generation of sitters who made up the lion's share of his patrons, Feke must have arrived like a breath of fresh air. Although he did not possess the sophisticated modeling techniques of a London-trained painter, his portraits undoubtedly dazzled the eyes of Philadelphians. Families tired of the somber-toned palette of Hesselius or Smibert must have found Feke's preference for silver and pastel shades of blue, pink, and yellow quite attractive. Those sitters who rejected the rich, dark tones of their elders' clothing embraced a higher-keyed and lighter palette that was decidedly un-baroque. Although Feke's presence in Pennsylvania was fleeting, his impact on the development of colonial painting was substantial, and his portraits set a new, up-to-date standard by which the work of the next generation of Philadelphia painters would be judged.

Feke's repeated arrivals in and departures from Philadelphia after only short stays are a reminder that for many colonial painters regular travel, or the need to relocate, was a necessity. Most artists were not itinerant in the nineteenth-century definition of the word: they did not travel from town to town, week after week, knocking on doors. Rather, they settled in a town for a few months or longer, if commissions were forthcoming, having first been heralded by letters of introduction, word of mouth, or the occasional newspaper advertisement. The problem was that most colonial cities and towns were simply unable to support a painter over a long period of time.

Throughout the late 1740s and the 1750s Gustavus Hesselius continued to be the only painter resident in Philadelphia, but by this time he seems to have given up portrait painting. As a result, a pattern of short-term residencies by other artists continued. John Hesselius (c. 1728–1778), the son of Gustavus, and John Wollaston (c. 1710–after 1775), an English painter active in America from 1749 to 1759, were both in Philadelphia for periods of time during these years.

One of Benjamin Franklin's account books indicates that by age ten the younger Hesselius was outfitted with paper, presumably for drawing.[15] John

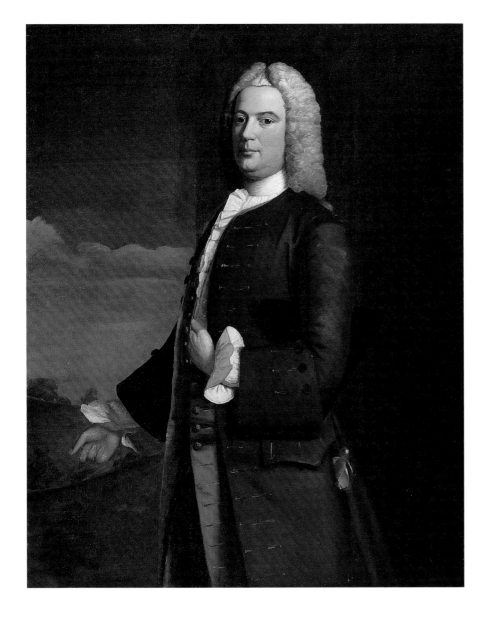

Fig. 84
Robert Feke, *Portrait of Tench Francis*, 1746, no. 457. The Irish-born Tench Francis studied law in London and sometime before 1720 moved to Kent County, Maryland, where he established his legal practice. In 1738 he moved to Philadelphia, where he remained active in the bar and public office until 1755.

Hesselius's signed and dated 1749 portrait of Lynford Lardner is ample evidence that by age twenty-one he had developed a mature style that rivaled, if it did not equal, the abilities of Feke (see fig. 95). Like Feke, the younger Hesselius largely abandoned the baroque palette of his father and replaced it with a brighter and more daring set of colors that undoubtedly appealed to upwardly mobile sitters like Lardner. In the succeeding decade the younger Hesselius returned to Philadelphia on at least one occasion

(in 1751) while simultaneously becoming the major painter in the middle colonies of Maryland, Delaware, and Virginia.

Hesselius was joined by Wollaston in supplying portraits to the residents of this large geographical area. Wollaston made his way to Philadelphia by October 29, 1752, when James Hamilton, then governor of Pennsylvania, made a note in his cash book that he had paid the artist thirty-six pounds for two portraits.[16] Wollaston, whose greatest strength was his ability to capture shimmering sur-

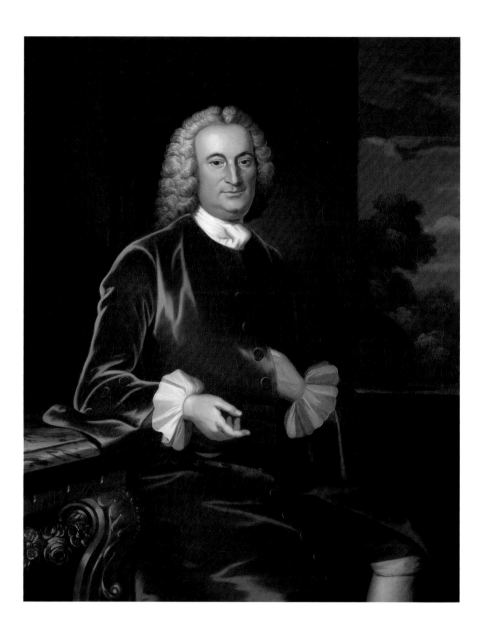

faces, had developed his skills training with a "noted drapery painter"[17]—probably Joseph Van Aken, the best-paid and busiest London drapery painter of the 1740s. Despite this experience, or perhaps because of it, he seems still to fall within the baroque canon of colonial painting, as he never was willing, or able, to shake off the palette and compositional devices that are the legacy of an earlier age. In this sense, Wollaston's presence in Philadelphia was a throwback to an earlier era. While there is probably insufficient evidence to argue that he appealed to slightly older sitters and more conservative families, certainly his *Joseph Turner* (fig. 85) and *Margaret Oswald* (fig. 86), both apparently painted in 1752, have more to do with the baroque style of artists like Smibert and Gustavus Hesselius than with the rococo style of the younger Hesselius or Feke. The paintings are a vivid statement of baroque sensibilities, with their predominantly dark palette and sharply contrasting highlights and with deep space suggested by

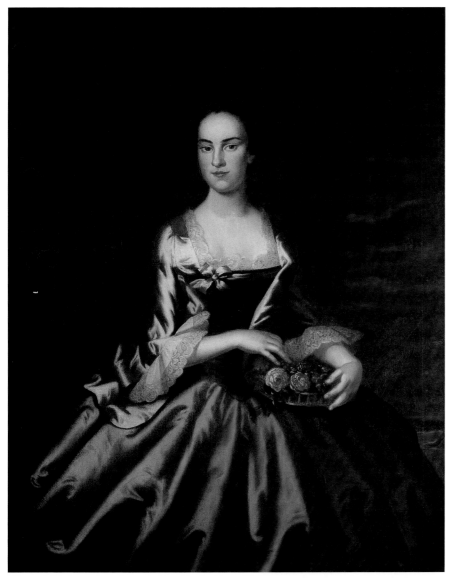

Fig. 86
John Wollaston, *Portrait of Margaret Oswald*, c. 1752, no. 466. Margaret Oswald and her sister Elizabeth (see no. 464), daughters of Mary Turner and James Oswald, were orphaned in 1742. Their uncle Joseph Turner then assumed the responsibility of raising the girls and later commissioned their portraits.

Fig. 87
John Valentine Haidt, *Portraits of Johanna Ingerheidt Schmick and John Jacob Schmick, Sr.*, c. 1754, no. 470. John Haidt, whose trade in Europe was that of a goldsmith, sailed for Pennsylvania in 1754 to join the Moravians in Bethlehem. The Schmicks, also Moravians, were missionaries to the Indians.

vistas. The two portraits are also important in that they represent a rare early effort by a family to document its members: Turner was Oswald's uncle, and the two paintings, along with one of another niece, Elizabeth Oswald, were probably painted together as a single commission.

The 1740s were but a preamble to major shifts in the fashion, nature, and range of Philadelphia painting that were to emerge in the next two decades. The arrival of painters like Wollaston, who came to America for commercial reasons

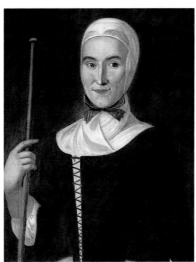
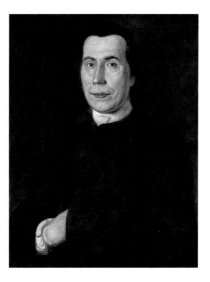

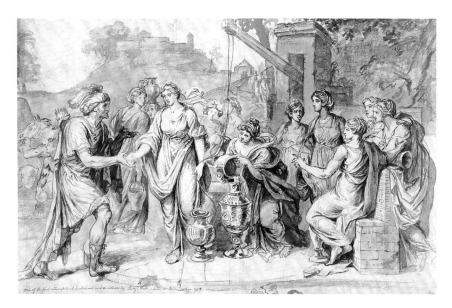

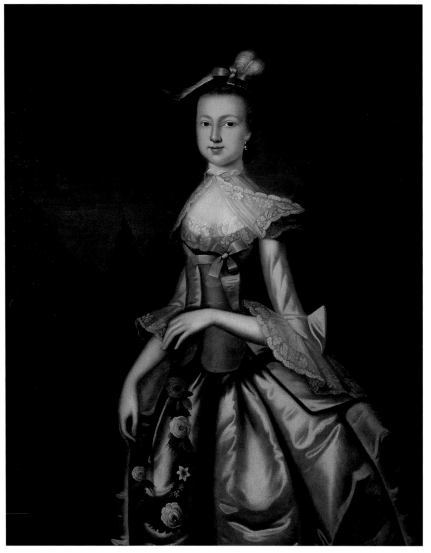

rather than on a mission or to escape religious persecution, is an indication that there was a more favorable climate for painting in the colonies. In fact, after 1750 only one painter, John Valentine Haidt (1700–1780), who joined the Moravian settlement at Bethlehem, Pennsylvania, in 1754, came with a group of settlers whose primary aim was to establish a religious community (fig. 87).[18] But although much had changed, elements of the Baroque continued to linger in the paintings made in Philadelphia and elsewhere in the colonies, for it was not as though Philadelphians awoke one morning to discover that the baroque age was over.

The signs of a stylistic metamorphosis were subtle. The emergence during these mid-century years of an artist such as Benjamin West (1738–1820), who was born in Springfield, Pennsylvania, and began painting by age fourteen, suggests that colonial society had reached a new level of cultural maturity. West's range of abilities and his experiments—from elaborate drawings (fig. 88), miniatures, and landscapes to portraits bedecked with rococo lace (fig. 89) and America's first painting of an ancient history subject, *The Death of Socrates* (fig. 90)—affirm that the seeds sown by various immigrant painters had finally resulted in local growth of considerable potential.

It is significant that West credits William Williams (1727–1791) with inspiring his allegiance to painting. West wrote in 1810 that "had not Williams been settled in Philadelphia I sh[d] not have embraced painting as a profession."[19] Appropriately, it is Williams's work, perhaps more than that of any other Philadelphia artist, that signals the beginning of a new era in Pennsylvania painting. Both con-

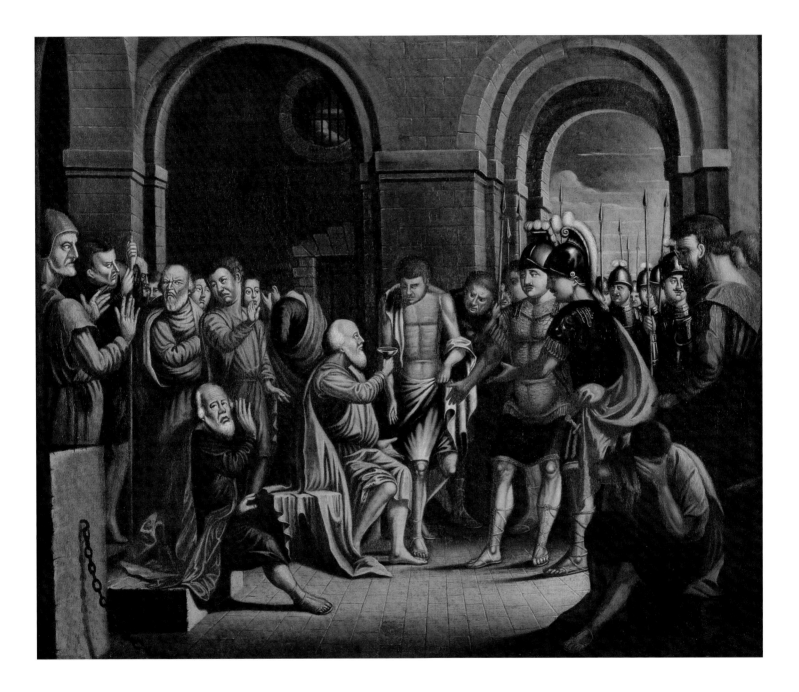

Fig. 88 (opposite page, top)
Benjamin West, *Rebecca at the Well,*
c. 1755–57, no. 472. As the inscrip-
tion indicates, this drawing was one
of Benjamin West's first ventures
into the field of historical composi-
tions. It, along with *The Death of
Socrates,* are among the earliest sur-
viving works by West.

Fig. 89 (opposite page, bottom)
Benjamin West, *Portrait of Jane Gal-
loway (Mrs. Joseph Shippen),* c. 1757,
oil on canvas, 49³/4 x 39¹/4" (126.3 x
99.7 cm), The Historical Society of
Pennsylvania. Jane Galloway was
only about twelve years old at the
time West painted her portrait. In
1768 she married Joseph Shippen,
a judge and secretary of the pro-
vincial council.

Fig. 90
Benjamin West, *The Death of
Socrates,* c. 1756, no. 473. Painted
in Lancaster, Pennsylvania, when
West was about eighteen years old,
this composition was commis-
sioned by William Henry, a suc-
cessful gunsmith, and was loosely
based on an engraving in a book
owned by Henry.

Fig. 91
William Williams, *Portrait of Benjamin Lay*, c. 1750, no. 462. Benjamin Lay, an English Quaker who was an ardent anti-slavery activist, was portrayed by Williams in front of a cave, as he had a cave on his farm that he used for study and meditation. Hannah Logan noted in her diary in 1746 that she and some friends "Had part of the Evening the Comp^y of B. Lay, the Comi-Cynic Philosopher" (Albert Cook Myers, ed., *Hannah Logan's Courtship: A True Narrative*, [Philadelphia: Ferris and Leach Publishers, 1904], p. 81).

Fig. 92
William Williams, *Portrait of Deborah Hall*, 1766, oil on canvas, 71 3/8 x 46 3/8" (180.9 x 118.1 cm), The Brooklyn Museum, Dick S. Ramsey Fund, 42.45. This painting of Deborah Hall, depicted here at age fifteen, was one of three full-length portraits her father, David Hall, commissioned from Williams in 1766, the year he became head of his own printing firm.

versation-piece works of such considerable charm and wit as Benjamin Lay (fig. 91) and portraits of wedding-cake-like delicacy, like that of Deborah Hall (1751–1770; fig. 92), the daughter of David Hall, a printer and onetime partner of Benjamin Franklin, raised the quality of colonial painting to a new level. And the new pictorial style was startlingly different from the baroque style that preceded it.

In just over half a century Pennsylvania transformed itself from an outpost of modest size and importance to a colony of enormous economic, intellectual, and social clout. The surviving paintings of the period from 1700 to 1750 are eloquent testimony to that progression. Because they depict the inhabitants of Pennsylvania—the ambitious people who precipitated its transformation—these paintings not only bear witness to the progression from the Baroque to the Rococo in America but also provide visual testimony to a colony coming of age.

Notes

1. This estimate is based on a combination of evidence. The computer database for the Catalog of American Portraits of the National Portrait Gallery (Smithsonian Institution) contained about 36,000 records as of 1987, representing approximately 40 percent of the written records. Of the computer records, only about 480 were for portraits painted in all the colonies between 1700 and 1750, which would suggest that approximately 1,200 portraits from the period 1700–50 survive. Since statistical information for at least one colonial artist for whom complete records exist (John Smibert) suggests that the survival rate for colonial pictures is about 40 percent, this would mean that about 3,000 portraits were painted in colonial America between 1700 and 1750. These figures, combined with informal surveys of paintings by the approximately twenty artists who were active in Philadelphia between 1700 and 1750 (for whom perhaps sixty paintings survive), suggest that about 150 portraits were painted in Philadelphia during these years. These figures were compiled at the time of an important exhibition devoted to colonial portraits: "American Colonial Portraits, 1700– 1776," National Portrait Gallery, Smithsonian Institution, Washington, D.C., October 9, 1987–January 10, 1988. They are, of course, very rough estimates.

2. Carl Bridenbaugh, *Cities in the Wilderness: The First Century of Urban Life in America, 1625–1742* (New York: Alfred A. Knopf, 1955), p. 143; Carl Bridenbaugh, *Cities in Revolt: Urban Life in America, 1743–1776* (New York: Alfred A. Knopf, 1955), p. 5.

3. Gerald Carr, "Gustavus Hesselius," in Nancy Rivard Shaw et al., *American Paintings in the Detroit Institute of Arts* (New York: Hudson Hills Press, 1991), p. 122, makes the suggestion that these two paintings may be by Hesselius's son, John Hesselius.

4. Logan Papers, Logan Letter Books, vol. 4, p. 331, The Historical Society of Pennsylvania, Philadelphia.

5. *The Pennsylvania Gazette*, September 25, 1740.

6. Receipt book of Elizabeth Coates Paschall, 1741–50, entry for August 14, 1749, Morris Family Papers, no. 721, vol. 26, Hagley Museum and Library, Wilmington, Delaware.

7. Massachusetts Historical Society, *The Notebook of John Smibert* (Boston: Massachusetts Historical Society, 1969), pp. 88–93.

8. John Diggs Accounts, 1722, p. 3, entry for November 17, 1722: "By payed Gus. Hesselius for drawing Mr. Darnalls and his Ladys picture . . . 9.10.8," Manuscripts Division, Library of Congress, Washington, D.C.; quoted in Ellen G. Miles, "Gustavus Hesselius," in Richard H. Saunders and Ellen G. Miles, *American Colonial Portraits, 1700– 1776* (Washington, D.C.: Smithsonian Institution Press, 1987), p. 154.

9. Notebook of John Watson, p. 17, Manuscript Collection, The New-York Historical Society.

10. Cathryn J. McElroy, "Furniture in Philadelphia: The First Fifty Years," in *American Furniture and Its Makers,* Winterthur Portfolio 13, ed. Ian M. G. Quimby (Chicago and London: University of Chicago Press, 1979), pp. 68, 77.

11. Martha Gandy Fales, *Joseph Richardson and Family: Philadelphia Silversmiths* (Middletown, Conn.: Wesleyan University Press for the Historical Society of Pennsylvania, 1974), p. 292.

12. Wayne Craven, *Colonial American Portraiture: The Economic, Religious, Social, Cultural, Philosophical, Scientific, and Aesthetic Foundations* (New York: Cambridge University Press, 1986), p. 375.

13. James Hamilton Papers, Cash Book, 1739–57, entry for September 23, 1742, The Historical Society of Pennsylvania, Philadelphia: I sent by mr. Vassal to be d[elivere]d to Mr. / Smibert at Boston the following Bills of Exchange, viz. / Emerson& Graydon on Mesrs Beckford / & Neat pble to A: H £ 1: – / Joseph Turner on David Barclay & Son / pbl to J: S £ 22: 10 / Joseph Turner on David Barclay & Son / pbl to Jno Smibert 10-10 / William Till on Laurence Williams / pbl to White & Taylor £ 30: – / William Allen on Jno Simpson & Comp / pble to Jno. Smibert £ 31 : 10 / John Sober on David Barclay & Son / pble to Jno. Smibert £7: 17:6 / and ten guineas in gold / James Hamilton / Mr. Smibert acknowledged the receipt of these Bills in a Letter / to me.

14. Lardner Family Papers, Collection of Mary Fowle Dawson; quoted in Jack L. Lindsey, "Lynford Lardner's Silver: Early Rococo in Philadelphia," *Antiques*, vol. 143, no. 4 (April 1993), p. 609.

15. Richard Keith Doud, "John Hesselius: His Life and Work" (master's thesis, University of Delaware, 1963), p. 6; Benjamin Franklin's Shop Book, 1738–39, entry for July 1739: "Mr. Selis, limner Dr for paper by his sun, £ 0..2..0," American Philosophical Society, Philadelphia.

16. See Carolyn Jeanette Weekley, "John Wollaston, Portrait Painter: His Career in Virginia, 1754–1758" (master's thesis, University of Delaware, 1976), p. 16: "pd Mr. Woolaston for 2 Half length pictures 36 - -"; James Hamilton Papers, Cash Book, 1739–57, The Historical Society of Pennsylvania, Philadelphia.

17. Charles Willson Peale to Rembrandt Peale, October 28, 1812, in *The Collected Papers of Charles Willson Peale and His Family, 1735–1885,* ed. Lillian B. Miller (Washington, D.C.: National Portrait Gallery, Smithsonian Institution, 1980), microfiche IIA, 51F14.

18. Ellen G. Miles, "The Portrait in America, 1750–1776," in Saunders and Miles, *American Colonial Portraits, 1700–1776*, p. 28.

19. David Howard Dickason, *William Williams, Novelist and Painter of Colonial America, 1727–1791* (Bloomington, Ind., and London: Indiana University Press, 1970), p. 27.

Pondering Balance:

The Decorative Arts of the Delaware Valley,

1680–1756

Jack L. Lindsey

Late in April 1751 the wealthy Philadelphia attorney Lynford Lardner (1715–1774) was busy with the demands of his office and supervising the final stages of building and furnishing his new country house, Somerset, located on the Delaware River north of the city. The house was a present to his new wife, Elizabeth Branson, and would become the couple's second residence—a river "villa" to provide a counterpoint of country elegance and retreat from their stylish Philadelphia town house on Second Street near Chestnut Street. Apparently feeling the pressures brought on by the demands of his growing obligations, Lardner wrote apologetically to Joseph Galloway, an associate, explaining: "I write with much regret for the absence of word to you concerning affairs at Durham [Furnace]. . . . I remain heavily disposed with the decrees of my Charges, and in pondering the Balance in the Fitting out of Somerset. I am Daily to Frankford to observe the progress of the Cabinetmakers and Workmen."[1] Somerset was finished later that summer, and the elegance and refinement of its interiors, as well as

those of the Lardners' town house, became well known and were recorded by a number of visitors (fig. 94).

Lardner's authority had grown considerably during his tenure as the personal attorney for William Penn's sons Thomas and Richard (fig. 95). His appointment as Keeper of the Great Seal of the Province in 1746 had established him securely among the emerging new political and financial elite. Elizabeth's father, William Branson, who was a mentor to and business partner of Lardner, was also one of the city's leading merchants and an investor in the early iron industry of the colony. Positioned by lineage, wealth, and connections, the Lardners were typical of an influential, aristocratic class of second- and third-generation Philadelphians descended from William Penn's "First Purchasers."[2] Such a position in the social, political, and economic hierarchy of the city required the maintenance of a network of strategic friends and business contacts and appropriate display of the outward signs of success.

Elizabeth's father had earlier expressed his concern that Lardner would undertake the steps necessary to provide for

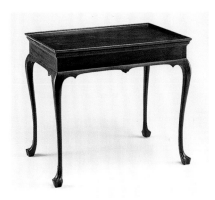

Fig. 93 (opposite page)
High Chest, c. 1740–55, no. 40.
This high chest is one of the most ornately carved "curled" or "figur'd" maple furnishings made in early Pennsylvania that survives. The density and uneven grain of maple would have made the execution of its finely carved pinwheels and shells difficult, and their presence here suggests the work of a highly skilled carver who had access to the very best tools.

Fig. 94
Tea Table, c. 1740–50, no. 88.
This table, which descended in the Branson family of Philadelphia, may have been part of the dowry of Elizabeth Branson, who married Lynford Lardner in 1749. A "squared tea table" was included in the inventory of the Lardners' Second Street town house.

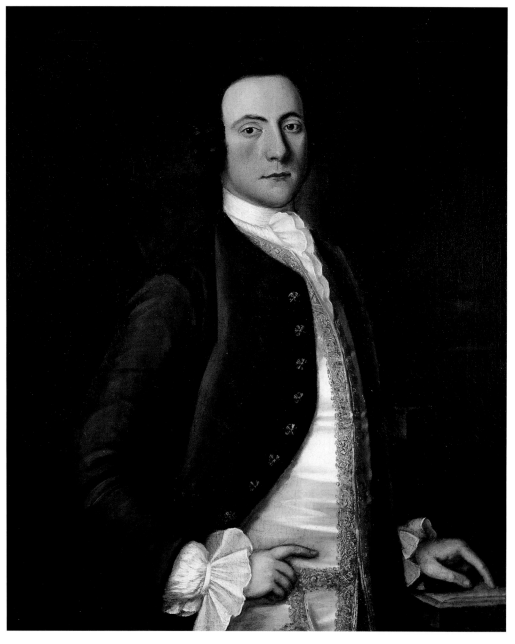

Fig. 95
John Hesselius, *Portrait of Lynford Lardner*, 1749, no. 461. Described as "tall and conscious of Dress," Lardner enjoyed "his farm and garden . . . the relaxation of his books, his Gun, and his fishing rod. Full of Anecdote, he had a happy manner of relating circumstance . . . and might have been said to shine at the Table" (Sketch of Lynford Lardner by John Lardner, February 1, 1805, mss. 421, The Historical Society of Pennsylvania).

Fig. 96
Caster Stand and Casters, Samuel Wood, 1735/36, no. 249. Lardner recorded the purchase of this caster stand from his brother-in-law Richard Penn in his account book on November 19, 1750 (Lynford Lardner Account Book, 1748–52, Rosenbach Museum & Library, Philadelphia).

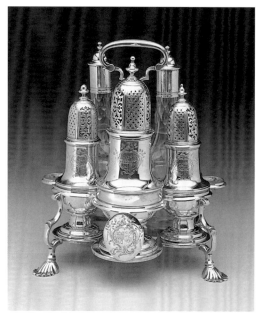

his new wife a "proud residence and security so as to keep her proper manner."[3] He supplied a generous dowry and ensured through additional financial gifts and advice that the couple could live and entertain in the style their social station required, an indication of how important image and the ownership of objects in the latest style had become in a city founded largely by conservative Quakers. Lardner's elite, urbane circle in Philadelphia, which included a number of Quakers, aspired to emulate the behavior and lifestyles of European and English aristocratic society, as well as the refined interiors of their houses. Purchasing agents in London served as conduits and resources for their wealthy clientele in Philadelphia, acquiring for them stylish luxury goods in the most up-to-date fashions. While economic limitations prevented many from purchasing goods from abroad, and the scarcity of pattern books in the new colony affected the degree to which Pennsylvania artisans were able to copy accurately the decorative styles of England and Europe,[4] an elite upper class was able to come very close to achieving their goal of living and dressing in sophisticated comfort and style in the best European fashion (fig. 97).

Those who desired to own elegant furniture and clothing also wished to emulate genteel behavior. Nathaniel Luff, a physician from rural Kent County in Delaware, wrote of the importance of refined manners—"without which, the best finished furniture or finest marble will lose half its lustre, which, when added, decorates and greatly ornaments it."[5] A number of British and French discourses on conduct were imported and widely disseminated, informing and instructing locals on proper attire,

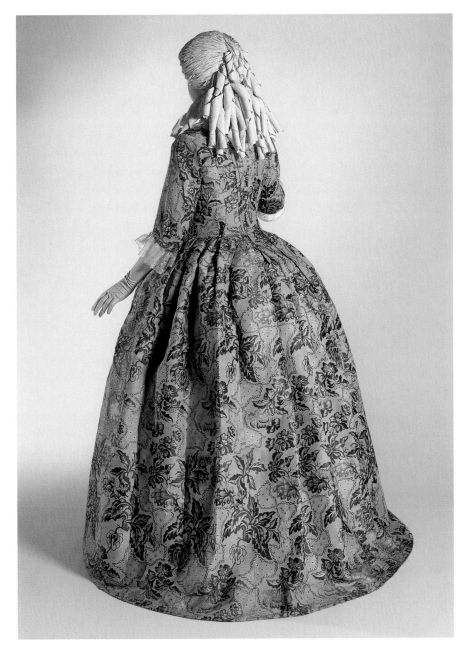

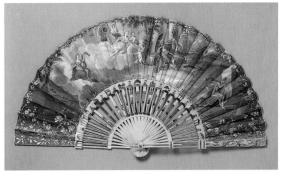

household arrangements, and manners. Through later reprints, Antoine de Courtin's *The Rules of Civility; or, The Maxims of Gentile Behavior As They are Practiced and Observed by Persons of Quality* (1671) became one of the books on manners most referred to in the colonies. John Locke's *Some Thoughts Concerning Education,* published in London in 1693, recommended to readers the proper behavior concerning everything from regulating bowel movements to furnishing the tasteful parlor. He observed that "Good qualities are the Substantial Riches of the Mind, but tis good Breeding sets them off . . . A Graceful Way

and Fashion in Everything is that which gives Ornament and Liking."[6] Henry Peacham, author of *The Compleat Gentleman,* recommended the study of classical antiquities—coins, statues, and inscriptions—as a sound grounding for both aesthetics and polite conversation (fig. 99).[7] Jonathan Swift, the Irish statesman Edmund Burke, and the Scottish philosophers Francis Hutcheson and David Hume were among many who wrote treatises on aesthetics and taste during this period. Benjamin Franklin pirated an English original to produce in 1748 the first example of such a treatise published in America:

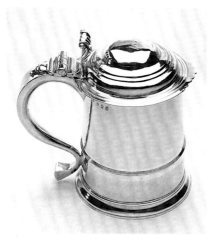

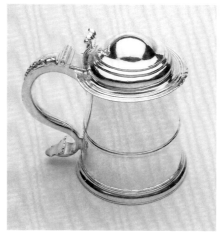

Fig. 100
Tankard, William Penstone, c. 1712/13, no. 186. This early tankard by a London silversmith was brought to Philadelphia by John Cadwalader (1677/78–1734), who arrived in 1697.

Fig. 101
Tankard, Francis Richardson, Sr., c. 1715–20, no. 189. Imported silver pieces probably served as models for Philadelphia silversmiths such as Francis Richardson, Sr., who produced this tankard.

The Instructor, or American Young Man's Best Companion. It instructed novice businessmen in the proper dress, deportment, aesthetics, manners, and even handwriting deemed necessary to advance in polite society.[8] The concern for beauty and refinement in behavior and household fittings reached such a pitch in the first half of the eighteenth century that William Hogarth (1697–1764), English painter and engraver of satirical prints, produced his sharp-edged *The Analysis of Beauty* in 1753 (no. 468). Imported genre prints and treatises on conduct that were circulated in the American colonies helped mold the preferences and choices of an eager, fashion-conscious public. Lardner's pondering of "balance" in his household was symptomatic, it seems, of impulses and considerations weighed by a number of Philadelphians.

A Growing Worldliness

The Delaware Valley benefited from the early convergence of a number of advantageous economic conditions and diverse cultural forces that supported and augmented its early enthusiastic and multi-leveled patronage of the arts. Beginning

in the 1680s, a balance was struck between international trading interests, the personal ambitions of the colony's leading investors, and the region's rich agricultural potential, bringing sustained growth and prosperity to both the city and the surrounding countryside. With only minor periods of economic depression, when local trade and exports experienced slowdowns or disruptions brought about by foreign conflicts, marked growth and economic expansion continued in the region from the time of its founding through the third quarter of the eighteenth century.

Many of the wealthiest people in early Pennsylvania society had immigrated with their extensive financial capital and important social connections relatively intact. A number of Quaker families, socially and economically persecuted in Britain, had been able to reestablish financial interests for themselves or their sons in Holland or the West Indies before coming to Pennsylvania. Others, coming directly from Britain, had been able to withdraw assets and business capital before making the trip.[9] Making use of family networks, past business experience, and international connections, they quickly increased their social standing and influence. Philadelphia's elite merchant class and political leadership flourished as the sons and daughters of the second and third generations built upon the inherited assets of their fathers and grandfathers.

Opportunity, hard work, and the growth of commerce brought the possibility of some degree of upward mobility to most sectors of Pennsylvania society, often within the first or second generation. Alongside the upper classes emerged a growing middle class composed of shopkeepers, artisans, and

successful farmers, who built the most stylish houses they could afford. As the middle class achieved financial security, even small amounts of expendable income provided the opportunity to acquire more material goods. Most common laborers and indentured workers were able to accumulate enough assets over time to gain independence and improve living conditions for themselves and their families. Fresh waves of immigrants, thrilled to have escaped the hardships and shortages of their former lives, seized new opportunities and capitalized on their benefits. Regional satellite towns such as Chester, Germantown, Bristol, New Castle, and Burlington all enjoyed a similar prosperity (figs. 102, 103). While success was not universal among all its citizens, in general there was a gradual and fairly widespread accumulation of wealth across the colony. Only the lowest indentured servants, Native Americans, and African slaves were, as classes, largely disenfranchised.

As people were able to improve their place in the social hierarchy as a result of Pennsylvania's social tolerance and economic opportunity, the traditional types of behavior and visible indications of social class began to blur. Outward signs of refinement, such as expensive attire, leisure pursuits, and stylish household goods, which had earlier served as reliable barometers of class and status, became increasingly available to the lower and middle classes and could no longer be counted on to indicate reliably an individual's overall wealth, education, or social pedigree. The inventories of some middle- and lower-middle-class households during the period document the presence of small amounts of silver, pewter, imported ceramics, and costly textiles. Versions of dressing tables, look-

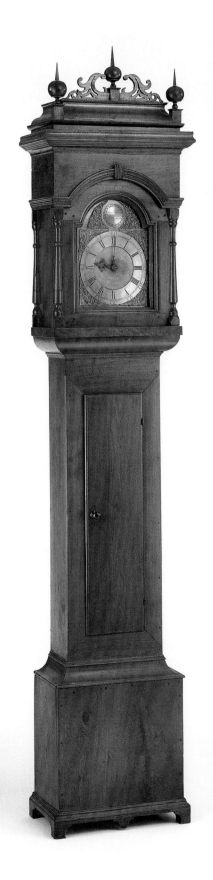

Fig. 102
Tall Case Clock, Isaac Thomas, c. 1751, no. 66. Isaac Thomas settled in Willistown, Chester County, where he not only worked as a clockmaker but also farmed and operated a grist- and sawmill. Many rural craftsmen supplemented their shop incomes through other seasonal labor and business enterprises.

Fig. 103
Plate, c. 1738, no. 365. The desire for stylish imported goods such as this English, tin-glazed plate was also prevalent among the rural Quaker farming families of Chester County. A number of families from London Grove, Sadsbury, Kennett, and elsewhere in Chester County ordered similar plates between 1738 and 1742.

Fig. 104
Gustavus Hesselius, *Portrait of Charles Norris*, c. 1728–35, no. 447. Charles Norris, like many of his contemporaries, demonstrated his status and refined taste through the visible ostentation of his Philadelphia house. Located on Chestnut Street between Fourth and Fifth streets, his three-story brick and stone mansion contained a fine wild-cherry staircase in its central hall and greenhouses heated year-round.

Fig. 105
Easy Chair, c. 1735–45, no. 167. Although a devout Quaker, the Irish immigrant James Logan surrounded himself with an impressive array of stylish household goods and expensive luxuries. This upholstered chair, unusual in its use of cabriole legs at the back as well as at the front, was made in Philadelphia and used at Stenton, Logan's Germantown mansion.

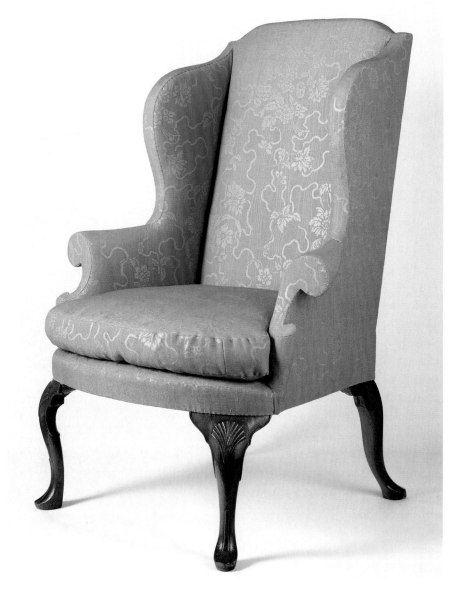

ing glasses, and tea tables—furniture forms that served the hygiene and domestic entertainments of the upper classes—also appeared in many middle-class households.[10]

Upward mobility did not come to the Delaware Valley without social tension. The drive to demonstrate personal achievement and rank through possessions and manners heightened self-consciousness in all classes. Many perceived and feared growing shifts in

power, and their apprehensions served to widen the political and cultural differences already present in the region. Even limited equalizing and casual mixing of social classes could be threatening or uncomfortable, especially to the upper stratum of Philadelphia society.[11] The wealthy merchant Isaac Norris feared that the alarming upward mobility of craftsmen and the lower classes would disrupt the necessary social hierarchy, and that government would even-

tually be taken out of the hands of "ye Wise, ye Rich or the learned," and given over to "Rabble Butchers, porters & Tagrags."[12] To counter the trend toward a blurring of class distinctions, many of those who were descended from the region's "first families" intermarried and increasingly stressed the importance of ancestry and lineage. The growing sense of familial presence or dynasty resulted in a rising demand for painted portraiture (fig. 104) and the use of heraldic devices (see no. 391).[13]

The Quaker leadership of Philadelphia in particular wrestled with the dilemma of class distinctions, visible ostentation, and materialism. In 1698, concerned about the growing taste for stylish goods and its detrimental effect on morals, the Yearly Meeting of Women Friends issued a warning urging "that no superfluous furniture be in your houses, as great fringes about your valances, and double valances, and double curtains, and many such like needless things; which the Truth maketh manifest to the humble minded."[14] James Logan, however, one of the most stylish and educated Quakers of his day, wrote that "Riches have been shewn, to be the natural Effects of *Sobriety, Industry* and *Frugality*."[15] Logan, like many philanthropic wealthy Quakers, felt that his gifts to society in some way sanctioned his level of wealth and comfort; good fortune and prosperity were gifts from God and were acceptable so long as they befitted the owner's social station and were tempered by regular contributions to the greater public good (fig. 105). Unseemly display was vulgar excess, but quiet refinement and elegance, it was felt, afforded the opportunity to educate those less informed and less fortunate than oneself.

As a result, the desire among many of the earliest, most prominent Quaker merchant families to partake of the luxuries and comforts afforded them by the accumulation of wealth caused a gradual undermining of the faith's traditional emphasis on simplicity and plainness (fig. 107). Many sought to rival their non-Quaker peers in the furnishing of their houses and in their personal adornment. Popular recreations such as dancing, music, horse racing, fishing, and card playing were frowned upon by conservative factions, as was frequent "frivolous" socializing, but were practiced nonetheless (fig. 108). Writing in 1760, John Smith of Marlborough noted that in the 1720s "the Society [of Friends] increasing in wealth and in some degree conforming to the fashions of the world, true humility was less apparent, and their meetings in general were not so lively and edifying."[16] The Quakers' own preeminence and success in business and their forays into stylish society now served to diminish their consensus and eventually their numbers. Many were expelled from meetings for their marriage out of the faith or their perceived ostentation, while others left voluntarily to partake of wider worldly goods and pleasures.

Well-off Quakers could and did find ways to enjoy their wealth while still being true to the tenets of their faith. Christopher Sauer, a Germantown printer and clockmaker who lived and worked among a number of Dutch and German Quakers, observed in 1724: "According to appearances, plainness is vanishing pretty much. The dear old folks, most of whom are dead by this time, may have spoken to their children a good deal about plainness. It is still noticeable in the clothes except that the material is

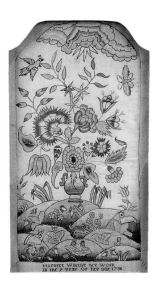

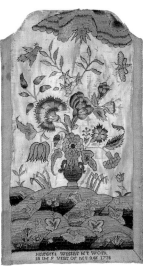

Fig. 106
Pair of Needlework Sconces, Margaret Wistar, 1738, no. 386. Professional tutors helped young women develop skill, self-discipline, and good taste by instructing them in refined needleworking techniques. Margaret Wistar completed this intricately wrought pair of decorative sconce panels in 1738 at the age of nine.

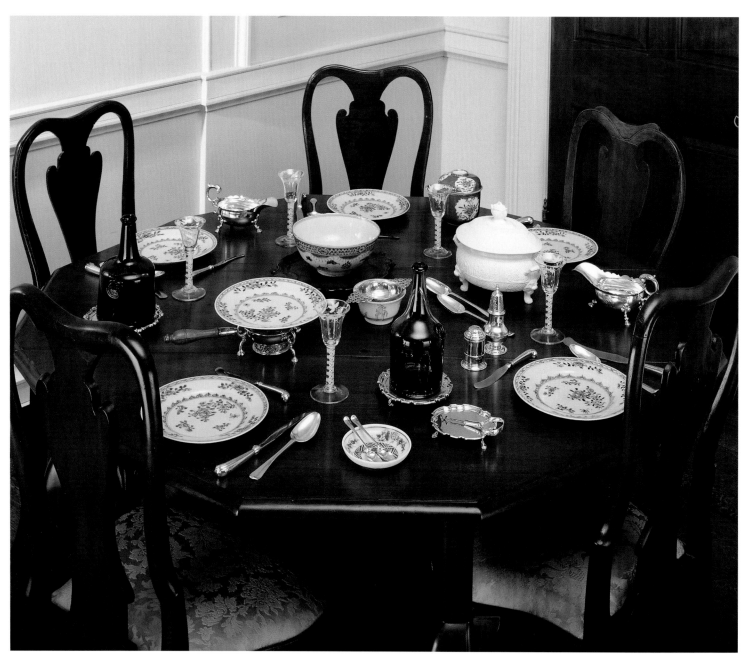

Fig. 107
Drop-Leaf Table, c. 1735–50, no. 81, set with a range of fine tablewares documented to Quaker ownership in Philadelphia during the early eighteenth century. For the chairs, see nos. 118, 120, 122, 123. The table is set with a salver (no. 242) and other objects in the collection of the Philadelphia Museum of Art.

Fig. 108
Fly-Fishing Wallet, c. 1740–50, no. 434. The Colony in Schuylkill, a gentlemen's fishing club, was founded in 1732. James Logan, who owned this wallet of tied fishing flies, was a founding member.

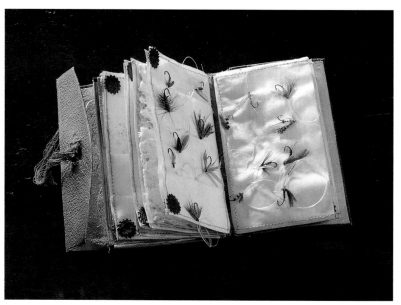

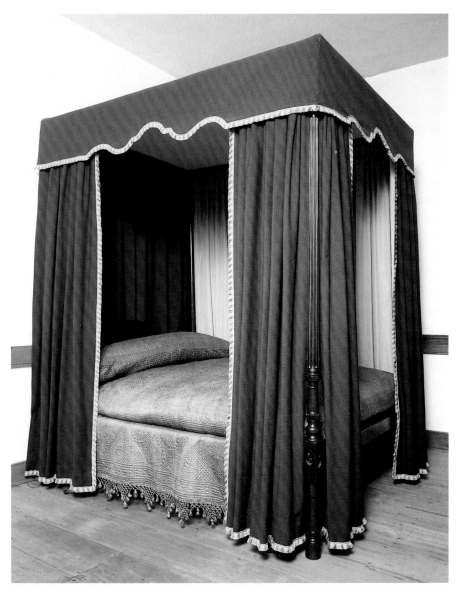

Fig. 109
Salvers, 1740s–50s, nos. 238–242, 245. Silver salvers, small footed trays used under teapots or coffeepots or for serving, often echoed the shape of the round, scalloped-edge tea tables of the period. The bottom salver in this group (no. 238), one of the largest examples from Philadelphia that is known, was made for the wedding of the Quakers Hannah Emlen and William Logan in January 1740.

Fig. 110
Bed with Hangings, c. 1730–45, no. 171. High post beds, complete with their tester frames and expensive textile "furniture," or hangings, were among the most stylish and highly valued furnishings in wealthier households. Simpler low post, hammock, flock, or pallet beds were used by the middle and lower classes.

very costly, or is even velvet."[17] Sauer's observation provides important insight into one aspect of design that would continue to affect the philosophy and motivations behind many of the decorative arts produced in the Delaware Valley during this period. Quaker clients and their craftsmen, whether Quaker or non-Quaker, often chose relatively simple and unadorned forms but employed the richest materials and finest craftsmanship in their making (see no. 93). Rare or more richly grained woods, over-built construction in cabinetmaking, heavier gauges and weights of domestic silver, plainly decorated porcelain, and clothes of fine imported fabrics sewn in simpler, less ostentatious styles could be found in the households of the wealthier Quaker elders and their devout children (figs. 109, 110).

The Quakers' intolerance for vanity and ostentation extended to those outside the faith, but not without criticism. The steadfast, conservative Quaker members refused to recognize the growing preference for current fashions, behaviors, and pastimes. Throughout the first half of the eighteenth century, repeated attempts by the Quaker leadership in

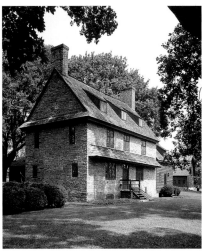

Fig. 111
Caleb Pusey House, c. 1683–96.
Built by Caleb Pusey, who immi-
grated to Pennsylvania in 1682, the
Caleb Pusey house is the earliest
surviving Anglo-American residence
in Pennsylvania. Pusey, in partner-
ship with William Penn and Samuel
Carpenter, established the first grist-
and sawmill in the Delaware Valley.

Fig. 112
Brinton House, 1704–6. Built by
William Brinton II out of local
dressed stone, the engaged brick
end chimneys, pent shed roofs on
gable ends and across the front, and
steeply pitched roofline of the
Brinton House were common archi-
tectural features on both urban and
rural houses in Pennsylvania prior
to 1735.

the Pennsylvania Assembly to impose
strict limits on behavior, entertainment,
lifestyles, and aesthetics only brought
them wider resentment. The refined
and socially prominent Dr. Alexander
Hamilton, who was known for his danc-
ing skills, sportsmanship, and good
taste, observed with impatience in 1744
that the Quakers had become "an obsti-
nate, stiff necked generation."[18] The
Quakers had led Pennsylvania to its
early prominence in international
markets with their business acumen
and adaptability, but "obstinence" and
pious criticisms directed toward grow-
ing class distinctions and "worldliness"
within all levels of society would lead
to their loss of majority and power by
the late 1750s.[19]

Brave Brick Houses

Domestic architecture became one of
the most visible signs of status in Penn-
sylvania. The building boom began
early. While an initial lack of adequate
housing forced even some of the wealthy
among the first arrivals in Philadelphia
to live in crude caves dug into the banks
of the Delaware River, improvements
came quickly for most.[20] The wealthy
English, Dutch, Welsh, and Swedish
farmers who populated West Jersey and
the Delaware and Chester counties of
Pennsylvania often built fine houses of
dressed local stone or of brick, laid in
tight, Flemish bond with decorative,
glazed headers in their end walls, as can
be seen, for example, in the Brinton
House, built about 1704–6 in Chester
County (fig. 112). [21] Vernacular stone
construction was also practiced by early
English, Dutch, and Germanic builders
in the region. A few of these smaller
stone dwellings from the late seven-

teenth and early eighteenth century
survive, giving some idea of the range of
their types and forms: the Caleb Pusey
House (fig. 111), in Upland, Chester
County (built c. 1683–96); the small,
stone "bank house" with pent eave built
on the Brandywine Creek in Chester
County for John Chads (c. 1725); and
the surviving structures and houses
of William Rittenhouse and William
Bradford's mill on Monoshone Creek,
a tributary of Wissahickon Creek, near
Germantown (c. 1690s–c. 1720).[22]

Impervious to fire, brick seems to have
emerged early on as the preferred build-
ing material among those who could af-
ford it—the middle, upper-middle, and
elite classes—supplanting the log and
half-timbered wood constructions of the
earliest settlers.[23] Local brickyards were
established by the mid-1680s, providing
abundant quantities of bricks at afford-
able prices. Like William Penn, many
early arrivals had fresh memories of the
devastation left by the great fire in Lon-
don and feared the possibility of similar
disasters resulting from the widespread
use of wood construction in Philadel-
phia's increasingly close quarters. Richard
Frame set the growing preference for
masonry to verse in 1692: "The best of
Houses then was known / To be of Wood
and Clay / But now we build of Brick
and Stone / Which is a better way."[24]

While speculative overdevelopment
along the Delaware River and the sub-
dividing of lots had muddled William
Penn's spacious and balanced grid plan
for Philadelphia, a number of impressive
public buildings of the type he envisioned
were erected on prominent sites in the
city.[25] The Quakers, who had at first met
in the private houses of members, built
a series of meetinghouses. The third
and fourth—the Great Meeting House

(begun 1695) and the Greater Meeting House (1754)—were located at the corner of Market and Second streets, across from the city's first courthouse and market building, which was erected in 1698–1710 (fig. 113). The Swedish Reformed church Gloria Dei (or Old Swedes' Church) was completed in 1698–1700 in the Southwark section of the city. Built of brick and following an early Anglo-Dutch baroque-classical cruciform plan, it replaced an earlier log church on the site. Most impressive by far was the brick and cut-stone building of Christ Church (1727–44), which served the Anglican congregation and whose construction was overseen by the physician and amateur architect John Kearsley (1684–1772). The elaborate east facade, completed about 1735, included ornate baroque-classical elements such as multiple corniced pediments, an impressive "Venetian window" facing the street, corner pilasters, scrolled corbels, and classical balusters and imported stone urns along the edges of the roof. Its tower was completed about 1739, and the present steeple was added in 1759 (fig. 114). In 1729 Governor Patrick Gordon appointed a committee to oversee the building of the State House, now known as Independence Hall, and work began in 1732 at its site on Chestnut Street between Fifth and Sixth streets (fig. 116). Kearsley also served on this committee, but the Philadelphia lawyer Andrew Hamilton (1676–1741) and the carpenter Edmund Woolley (c. 1695–1771) seem to have been most responsible for the formation of its final design and overseeing its construction. Completed in 1748, with additions in 1753 and 1828, the State House relates in its design to buildings by Sir Christopher Wren and his London followers, as well as to

Fig. 113
Henry Dawkins, *The Paxton Expedition*, 1764, engraving, 9¼ x 13¾" (23.5 x 35 cm), The Library Company of Philadelphia. The Philadelphia merchant Gabriel Thomas noted in 1698 that a "Guild-Hall," market house, and prison had recently been erected in Philadelphia. This early political print provides one of the best surviving images of the complex, which included the courthouse and market head house (center) and the Quakers' Greater Meeting House.

Fig. 114
Charles Willson Peale, *A South East View of Christ Church*, 1787, no. 477. The first Anglican congregation in Philadelphia was organized in 1695. By 1727 the congregation's size and wealth had increased to such an extent that they were able to build one of the city's most important public edifices, Christ Church.

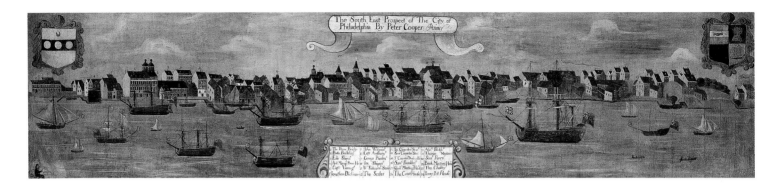

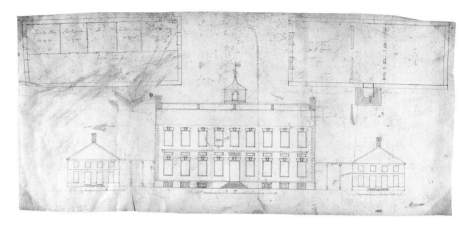

Fig. 115
Peter Cooper, *The South East Prospect of the City of Philadelphia*, c. 1720, no. 444. This detailed depiction of Philadelphia, mounted on board, was possibly intended to be incorporated into a paneled wall above a fireplace mantel. It includes the Penn family's coat of arms and a key to prominent buildings.

Fig. 116
Attributed to Andrew Hamilton or Edmund Woolley, *Elevation of the State House*, 1732, no. 453. Called a "symbol of the age" by the German cartographer Matthew Lotter, the State House provided a central location for the Pennsylvania Assembly, which first held meetings there in 1735. Construction of the interiors and tower continued through 1753.

buildings included in the three-volume *Vitruvius Britannicus* (c. 1715), illustrated by Colin Campbell and available in Philadelphia by 1725.[26] Together with other important public buildings, such as Pennsylvania Hospital (begun 1754–56; fig. 65), Philadelphia's religious and secular buildings brought elements of both European and English baroque-classical architecture to the citizens of Pennsylvania.[27]

Peter Cooper's view of Philadelphia (fig. 115) probably exaggerates the extent to which the city's architecture had developed by 1720, but it does give a sense of the relationship of public and private buildings in Philadelphia, and the extent to which early carpenters and builders utilized forms from German medieval and Anglo-Dutch baroque-classical traditions of construction. Steeply pitched roofs, pent roofs, or prominent molded-brick watercourses on gabled end walls; balustraded second-story balconies; high dormer windows; and door hoods supported by carved brackets were all frequently employed in the earliest, more substantial Philadelphia buildings. Robert Turner, one of William Penn's agents in Philadelphia, writing to Penn in London in 1685, described the city's developing architectural character: "The Town of Philadelphia it goeth on in Planting and Building to admiration, both in the front and backward, and there are about 600 Houses in 3 years time. . . . Brick building is said to be as cheap [as wood]: Bricks are exceeding good, and better than when I built . . . and Bricks cheaper . . . , and now many brave Brick Houses are going up, with good Cellars. . . . all these have Belconies. . . . We build most Houses with Belconies."[28]

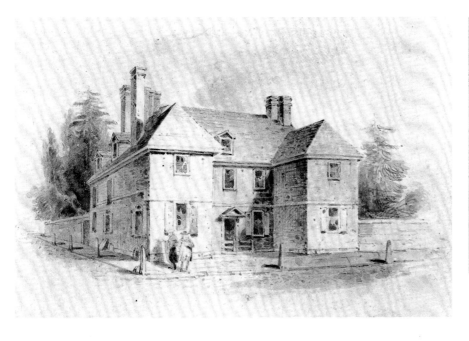

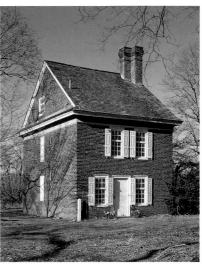

Unfortunately, very few of Philadel-
phia's early smaller houses have survived.
Particularly rare are the simpler lower-
and middle-class single or attached brick
row houses from the late seventeenth
and early eighteenth century. "Budd's
Long Row," a half-timbered row of at-
tached small dwellings (built c. 1690–95)
that ran along Front Street, has complete-
ly disappeared, leaving only scant traces
for archaeologists (see no. 344). These
houses were for the most part occupied
by lesser shopkeepers, artisans, and labo-
rers (fig. 118). Typically narrow in width,
one or two rooms in depth, and two to
two-and-a-half stories high, these houses
often had a pent or gambrel roof that
raised the ceiling and that was pierced
with dormer windows, providing light
and more usable space in the attic garrets.
Surviving tax records suggest that the
working classes were often forced to live
in overcrowded conditions within these
small houses, many of which were built
in the less fashionable Northern Liber-
ties and Southwark sections of the city
to house the growing urban workforce.

On the other end of the economic
spectrum, a surprising number of large,
finely constructed freestanding brick town
houses were built very early along Second,
Third, and Fourth streets, on Chestnut,
High, and Arch streets, and in the area
now known as Society Hill. Samuel Car-
penter, a wealthy merchant who moved
to Philadelphia in 1684 from Barbados,
built the city's first wharf and, on Second
Street, one of the most impressive of
Turner's "brave brick houses"—a large
two-story slate-roofed brick house with
a traditional Anglo-Dutch H-plan with
projecting front wings (figs. 117, 120; see
no. 111).[29] Another early brick house,
unfortunately demolished long ago, that
may have predated Penn's arrival was
the Cannon Ball House (built after the
mid-seventeenth century, with additions
c. 1714–20). Also Anglo-Dutch in form,
it too utilized the early crossed-wing, or
cruciform, plan common in many of
the region's earlier public and private
structures (fig. 119).

A number of other impressive early
houses were built, including those of

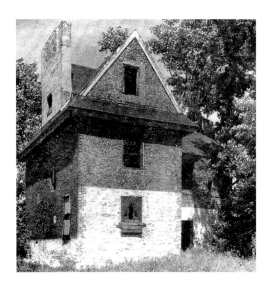

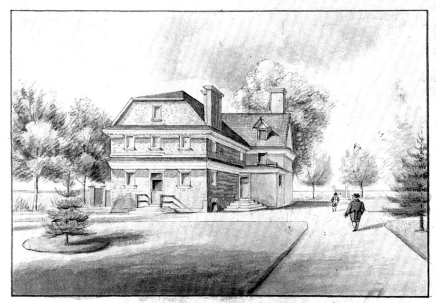

Carpenters Mansion, Ches St

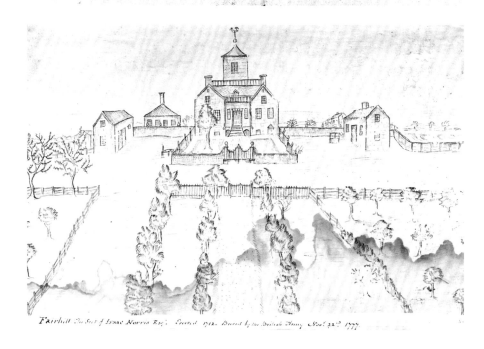

Fairhill the Seat of Isaac Norris Esq. Erected 1712. Burnt by the British Army Nov. 22d 1777

Fig. 119
Cannon Ball House, c. 1714–20. As is true of many of Pennsylvania's late seventeenth- and early eighteenth-century structures, all that survives of the Cannon Ball House are photographs. This one was taken in the 1950s.

Fig. 120
Attributed to David Johnston Kennedy, *Carpenter's Mansion,* c. 1836–70, no. 480. This rear view of the Philadelphia house built by Samuel Carpenter (see fig. 117) shows on its back wing a hipped roof and pent eaves utilized by many of the city's early house carpenters.

Fig. 121
Samuel Norris, *Fairhill: The Seat of Isaac Norris, Esq.,* from the Norris Family Scrapbook, 1761–c. 1860, pencil on paper, 13¼ x 9" (33.7 x 22.9 cm), Winterthur Library: Joseph Downs Collection of Manuscripts and Printed Ephemera. Isaac Norris's Fairhill (built c. 1712–17) provided visible testimony to his wealth and taste. With its extensive gardens and dependency buildings, it was perhaps one of the most thoroughly classically inspired domestic complexes built in Philadelphia in the early eighteenth century and was the site of numerous *fêtes galantes*—gala dinners, parties, and masked balls.

Thomas Fairman, Jonathan Dickinson, Edward Shippen, and Isaac Norris. Following Penn's early hopes and prescriptions, many laid out orchards and extensive gardens alongside their fine houses in the larger town lots. Fairhill, Norris's house, built 1712–17, was located on Germantown Road north of the colo-nial city and was the center of a large working farm plantation (fig. 121). Possibly designed by Norris himself, whose father was a carpenter, Fairhill had the symmetry, steeply pitched roof, and projecting H-form of Samuel Carpenter's earlier house, but its layout was further augmented by flanking "dependency"

buildings and extensive gardens and grounds. Its projecting front and back wings were capped with steep gables intersecting the central entrance wing, which was surmounted by a balcony and an octagonal, domed cupola. In Fairhill, as in many of the region's early residences influenced by baroque classicism, there is an emphasis placed on the materials used in the facades. More expensive materials (in Fairhill's case, brick) were reserved for the front of the house, while rough, unshaped local stone was used for the less visible side walls, which faced onto gardens, and for the back wall, which faced the rear yard.[30]

The high banks of the Delaware and Schuylkill rivers north and west of town and the outlying smaller townships and countryside of Bucks, Chester, and Philadelphia counties continued to be popular locations among the second and third generations of the city's elite for the building of country houses. Many of the earliest Quaker families had been granted large tracts of land northwest of the city in the "Welsh Barony"—a parcel of over 40,000 acres set aside by Penn for Welsh Quakers immigrating to Pennsylvania. Rowland Ellis, a wealthy Quaker farmer who built a fine stone farmhouse called "Bryn Mawr" in 1704, is typical of this group (fig. 122). As Philadelphia continued to grow, many of the wealthy sought to escape the crowds, inconvenience, and summer epidemics that increasingly plagued the city. The breezy high bluffs overlooking the Delaware and Schuylkill rivers provided relief from the summer heat and urban pestilence. Typical of the early eighteenth century were refined country houses like Bush Hill, built on the Schuylkill by Andrew Hamilton between about 1730 and 1740; Belmont Mansion, built about

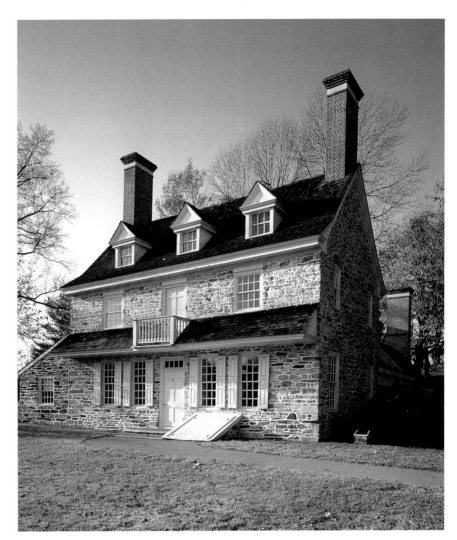

1742–45 by the lawyer William Peters (fig. 123); Bellaire, built about 1714–20 by the Quaker merchant Samuel Preston in Passyunk Township (fig. 124); Hope Lodge, built about 1743–48 by Samuel Morris, a wealthy mill operator and businessman in Whitemarsh Township, Montgomery County (see no. 317); and Fountain Low, later called

Fig. 122
Harriton, 1704. Originally called "Bryn Mawr," this two-and-a-half-story stone farmhouse was later named "Harriton" by Richard Harrison, who bought the house from the original owner, Rowland Ellis. It was built of locally quarried stone—rough, undressed Wissahickon schist—which was the preferred building material for many of the Quaker and Germanic stone houses found in the agricultural communities around Philadelphia.

Fig. 123
Belmont Mansion, detail of parlor ceiling, executed c. 1742–62, The Historic American Building Survey. Library of Congress, survey no. PA-1649. Belmont Mansion, built on a high hill overlooking the Schuylkill River just west of the city, has a rare, ornate, molded-stucco ceiling inspired by baroque-classical designs. While its sculptor is unknown, records indicate that several ornamental plasterers were in Philadelphia during this period.

Fig. 124

Bellaire, c. 1714–1720. Located near the convergence of the Delaware and Schuylkill rivers, Bellaire was one of several fine houses built in the tidewater farmlands of Passyunk and Southwark, just south of what was then Philadelphia's southern boundary.

Fig. 125

Graeme Park, c. 1723–26. Utilizing an early gambrel roof such as is found on both Dutch and English vernacular houses, Graeme Park also retains much of its early interior woodwork. Sometime after 1726 the house, originally called Fountain Low, was sold to Sir William Keith's son-in-law Dr. Thomas Graeme.

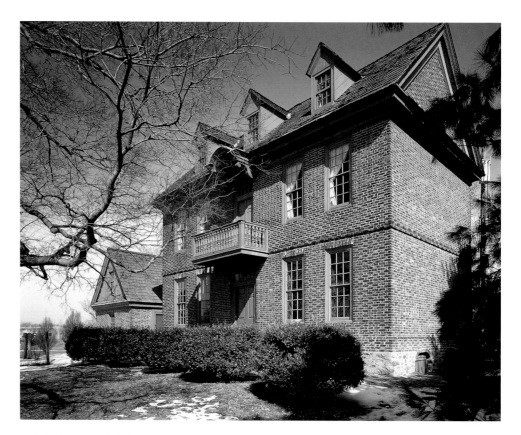

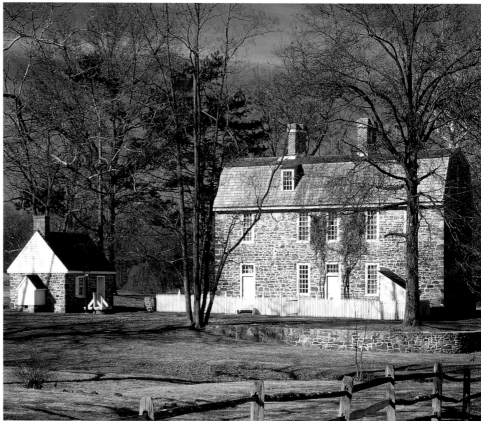

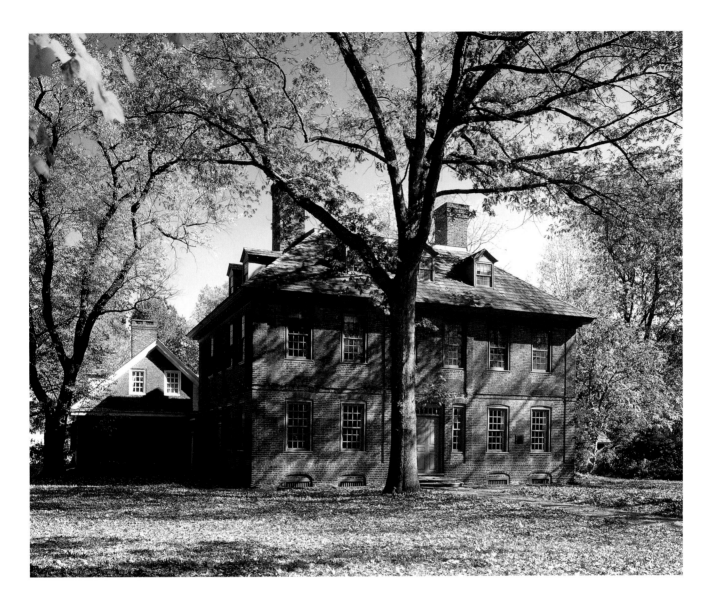

Graeme Park, built about 1723–26 in the rich farmlands of Montgomery County by Sir William Keith, a provincial governor of Pennsylvania (fig. 125).

Stenton, the country house James Logan built about 1727–30 on a large tract of land he amassed near Germantown, exhibits Logan's knowledge of English and Dutch baroque classicism and a familiarity with architectural pattern sources rarely evident during this period. Logan owned an extensive library that included Dutch, English, and Italian illustrated volumes and a few architectural references (no. 482). Intending to build a "plain, cheap farmer's stone house," he explained that the resulting structure had evolved into "a large brick house . . . 51ft. by 40, two good Stories in height, very convenient, & not unsightly. . . . I have proposed to call ye place Stenton after the Village in E. Lothian where [my] father was born."[31] The many carpenters, masons, and laborers employed and closely supervised by Logan during the project created a dwelling of simple elegance and unified design (fig. 126). Following English and

Fig. 126
Stenton, 1727–30. Designed and built by James Logan, William Penn's secretary, Stenton, located in Germantown, was the site of some of the most important political, philosophical, and intellectual inquiry and debate during the early colonial period.

Irish provincial interpretations of
baroque-classical balance and propor-
tions, Logan included six window bays
across the front of the house, allowing
two front rooms of equal dimensions
separated by an ample brick-paved and
richly paneled central entry and recep-
tion hall at the front. Logan's hall also
contained a corner fireplace with mold-
ed surround—a further reflection of ear-
lier Dutch and English baroque style.[32]
The front window bays of Stenton were
accentuated in the facade by shallow,
protruding brick pilasters flanking the
central entrance bay and defining the
outer corners of the house. A molded-
brick watercourse further transects the
facade between the first and second
stories, creating a balanced grid within
which were placed the segmented arched
window openings and the entrance
door, which was originally protected by
an arched hood. The structure also orig-
inally had a hipped roof complete with a
balustraded gallery at the peak, a cupola,

and a weather vane much like that
depicted in the surviving drawing of
Fairhill (see fig. 121).[33]

Stenton's rich interior finishes and
contents, as was the case in many of the
town houses and country estates of the
local aristocracy, reflected even more
directly the wealth and refined tastes of
the owner. Logan's rooms were either
half wainscoted or fully paneled, with
boldly molded ceiling cornices, paneled
doors, windows, and fireplace sur-
rounds. The paneling and trims were
brightly painted in blues, yellows, and
soft putty colors, and the plastered walls
and ceilings kept fresh with periodic
applications of whitewash. In the "Front
Parlour" arched buffet cupboards with
paneled doors flanked the finely molded
fireplace and contained more than 329
ounces of silver, displayed alongside fine
imported ceramics (fig. 128). This richly
furnished room included "10 Black
leather bottom'd Chairs / An Escrtore
with Glass Doors / A large Black framed
Looking Glass / A large Walnut Oval
Table / A Japand Tea Table / A pr of
Andirons with Brass Tops / A Brass
Fender with Fire shovel and Tongs / . . .
a Quantity of China" (fig. 129).[34] Fire-
place and hearth openings in the main
rooms and bed chambers were finished
with imported Dutch tiles or shaped
and molded surrounds of locally quar-
ried marble. Rich imported fabrics of
yellow and blue worsted wools, silks,
and checked cottons created coordinated
decorative treatments for windows,
beds, and seating furniture en suite.
Logan's interest in ancient civilizations
was reflected in his extensive library of
classical literature, housed throughout
the rooms of the house, and in his cabi-
net of curiosities, which included Greek
artifacts sent to him by Peter Collinson,

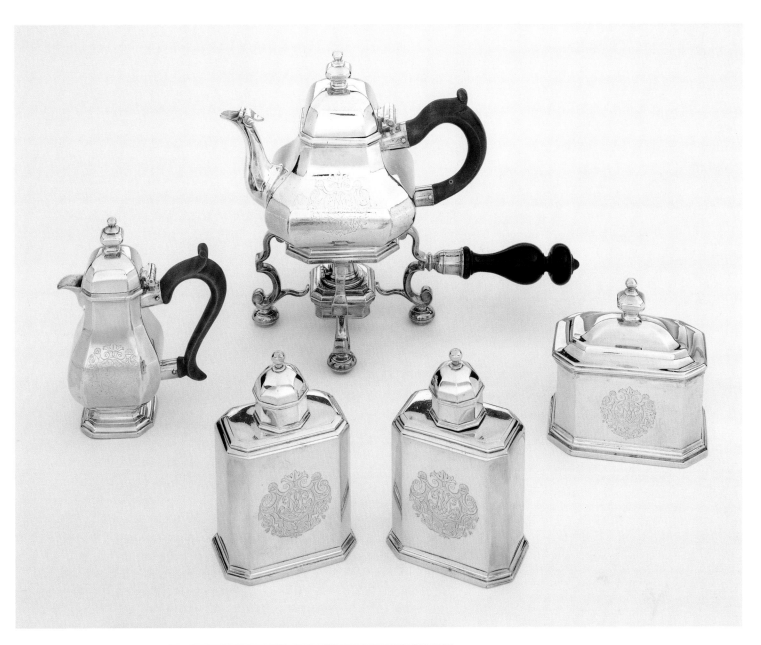

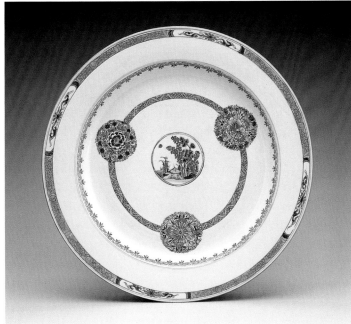

Fig. 128
Tea Service, Peter Archambo,
John Farnell, and Benjamin Pyne,
c. 1720–24, no. 221. This ornate
silver tea service was acquired for
Logan by his London agent and
then engraved with Logan's crest.
Its simplified geometric style was
popularized by French Huguenot sil-
versmiths working in London in the
late seventeenth and early eigh-
teenth century.

Fig. 129
Charger, c. 1680–1720, no. 340.
Chinese export porcelains showing
Japanese and Western design in-
fluences were present in wealthy
Pennsylvania households by the
late 1690s. James Logan, who
owned this example, would have
had access to Dutch and English
suppliers of these exotic porcelains
through his West Indies trade
connections.

Fig. 130
Marble Samples, no. 433. Gathered from ancient sites in Italy and France, James Logan's group of marble samples may have been sent to him by colleagues in London. Each is identified by its Latin name. Several imported marble table tops of the same types of marble can be documented to ownership in early Philadelphia (see no. 95).

Fig. 131
Skyphos, c. 340–320 B.C., no. 338. James Logan's documented ownership of this ancient Greek skyphos (or drinking cup), sent to him by Peter Collinson of London about 1738–40, is the earliest known example of classical pottery in colonial America.

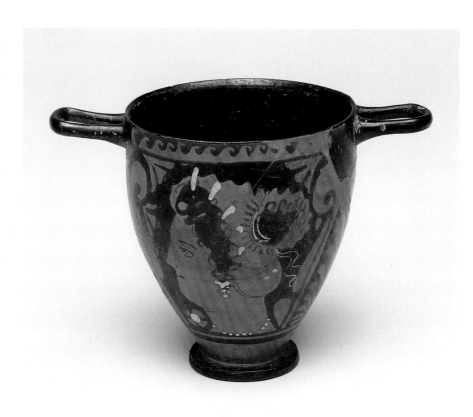

a friend and distinguished member of the Royal Society of London (figs. 130, 131). Logan patronized a number of the area's most accomplished craftsmen in addition to importing large quantities of fine wood furniture, silver, glass, porcelain, and pewter to further embellish his house (figs. 132, 133). His connections with many of Philadelphia's prominent merchants involved in the West Indies trade and his interactions with several London purchasing agents brought him access to the rarest imported fineries (see no. 339). The rich furnishings of the front reception hall, which was used as an impressive area for holding guests, provided access to Logan's office and his ornate parlor. Such an environment conveyed Logan's power and authority to his business associates and peers.[35]

Household inventories provide the best indications as to the nature of early

Delaware Valley interiors.[36] Those recorded for both rural and urban houses show a wide range of objects and materials and a surprising density of furnishings in houses belonging to different classes of Pennsylvania society. The recorded contents of rooms also suggest the variety of activities that took place within the restricted spaces of many early houses. Archibald McNeile's inventory of his Kennett Township house provides one example. Taken in 1742/43, the inventory records that his "lower room" contained "One Bed and Furniture / One eight Day Clock / One walnut Oval Table / Eighteen framed Wooden Chairs / Six black Chairs one of them armed / Two poplar Chests / Eight Table Cloths and five Napkins / Eleven pairs of Sheets / Four loaves of sugar / A quantity of Butter . . . of Cheese / Three pair of old Cards and an old Hackle [for weaving] / . . .

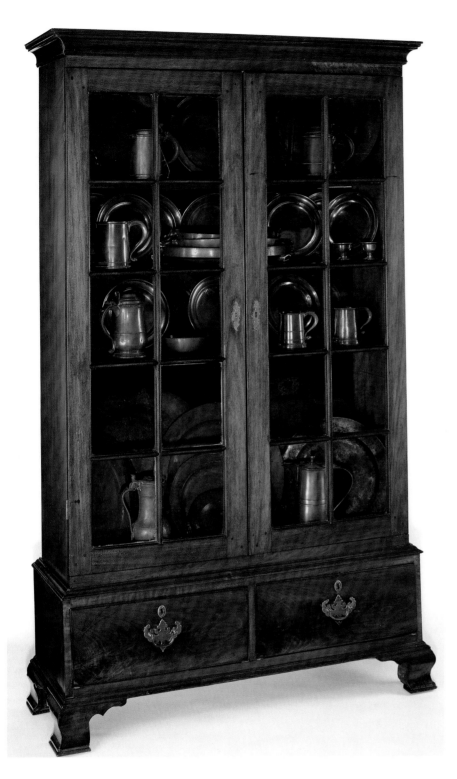

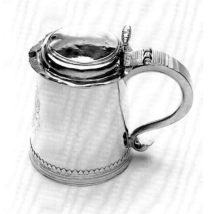

Two Bibles / A Case of Bottles / A quan-
tity of Flax and Cotton."37 This informa-
tion indicates that McNeile and his family
could entertain and seat up to twenty-
four as well as eat, sleep, comb wool or
flax for weaving, read the Bible, and
enjoy a drink in this one room.

Early inventories also give some indi-
cation as to the types of objects that were
most valued and suggest the importance
different objects played in display and
entertaining. The expense of the textiles
used for dining, upholstery, and other
interior decorations made them one of
the most treasured categories of fur-
nishings. For those who could afford
such extravagance, upholsterers could
supply stylish treatments for groups of

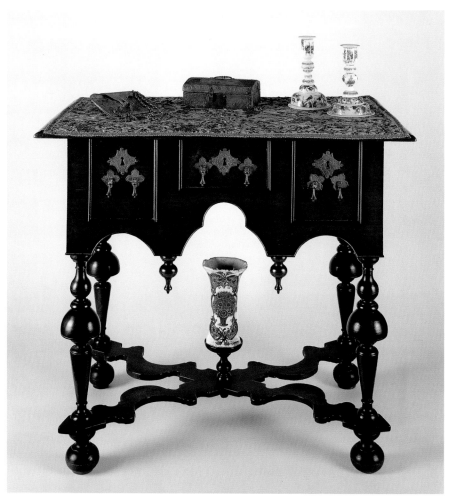

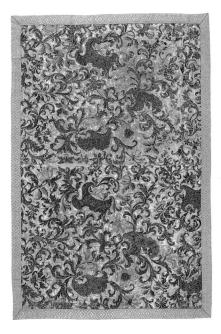

Fig. 134
Silk dressing table cover with needle-work floral decoration, American or English, c. 1710–25, silk brocade and metallic thread, 33³/₈ x 20¹/₈" (84.8 x 51.1 cm), collection of the Philadelphia Museum of Art.

Fig. 135
Dressing Table, c. 1715–25, no. 50, set with objects in the collection of the Philadelphia Museum of Art, including no. 358 and acc. no. 1921-3-4. Finely "wrought" needle-work or simpler "diapered" linen covers were often used in conjunc-tion with early dressing tables. This dressing table also retains a rare china stand on its crossed stretchers.

Fig. 136
Interior of Bellaire, c. 1714–20. Joiners and carpenters produced finely paneled walnut, cherry, and pine interior walls incorporating buffet cupboards and fireplace surrounds for the houses of their wealthy clients. The fireplace wall of Bellaire is one of the best surviv-ing examples.

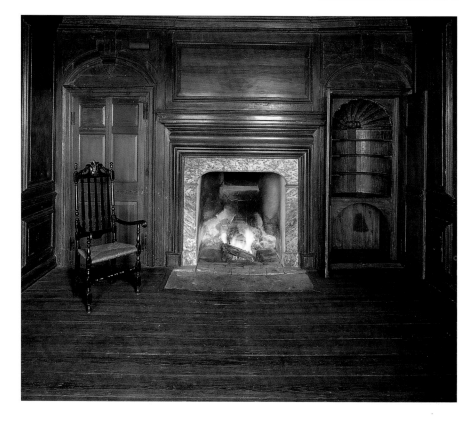

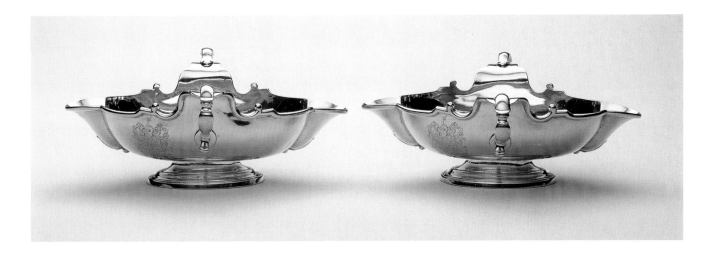

furniture en suite in a parlor or bed chamber. While cherished "wrought" or "turkey-worked" table covers, household linens, and seating covers were brought out for special occasions and for display, more ordinary textiles were used on a daily basis. Inventories also indicate that textiles were stored away in chests or "cases of drawers." Beds were also fitted with hangings and covers made from costly imported wools and silks or, in poorer households, simple linens or cottons (see fig. 110).

Domestic silver was highly treasured because of its intrinsic value. Used prominently and displayed ostentatiously while entertaining, it was stored away or kept in secure cupboards or built-in "bouffert," or buffet, cabinets in the most ornate paneled interiors when not in use (fig. 136). The amount of domestic silver, referred to as "plate," naturally varied widely depending on the wealth of the owner. The inventory of Patrick Gordon, who served as governor of Pennsylvania from 1726 to 1736, included 1,053 ounces of plate. His tankards, salvers, coffeepot, canns, and other ornate serving forms, along with his candlesticks and personal silver and gold dressing articles, were valued at more

than £434 (fig. 137).[38] Many less affluent households in Philadelphia and in rural areas also owned silver, sometimes in substantial amounts. The 1709 inventory of Elizabeth Fishbourn in rural Chester County included a silver tankard, one large and one smaller caudle cup, one tumbler, one porringer, two dram cups, ten spoons, one child's spoon, two pairs of chains for scissors, a thimble, a bodkin, and a pair of silver clasps.[39] As an alternative to expensive silver, imported and domestically produced pewter was also proudly displayed in many households, and in some circles it seems to have been used alongside silver and fine ceramics (see no. 309).

Imported glass and ceramics were also highly prized as ornaments. Jonathan Dickinson, the wealthy Philadelphia and West Indies merchant, displayed "23 pcs. China ware on Mantle peice [sic]," a fashion followed by many.[40] The entablatures over the doors in paneled interiors were also popular places for ceramics, as were the tops of high chests of drawers and the upper interior cases of "scritores," or secretary desks (fig. 138). In 1754 Captain James Russell, a Philadelphia sea captain involved in the triangle trade between England, the West

Fig. 137
Pair of Sauceboats, Charles Le Roux, c. 1725–35, no. 246. These unique, finely cast sauceboats were made for Governor Patrick Gordon and engraved with his crest. Colonial representatives of the crown were allotted £3,000 for the purchase of domestic plate, an indication of how important silver was in establishing the proper image.

Fig. 138
Secretary Desk and Bookcase,
c. 1740–50, no. 75. Few pieces of
domestic furniture offered such
opportunities for symbolic display
as the secretary desk. The "pigeon-
holes," or interior compartments in
the upper case, often held rare por-
celain, glass, or "curiosities." Such
desks were often listed in house-
hold inventories together with their
contents.

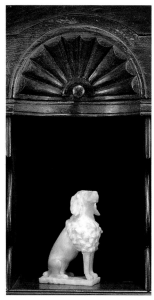

Fig. 139
Figure of a Dog, 1742, no. 431. This
alabaster figure of a dog, displayed
in the "pigeon hole" of a secretary
desk, is inscribed "A.L. 1742." It is
probably similar to the alabaster
"toys" or "images" listed in several
Philadelphia inventories.

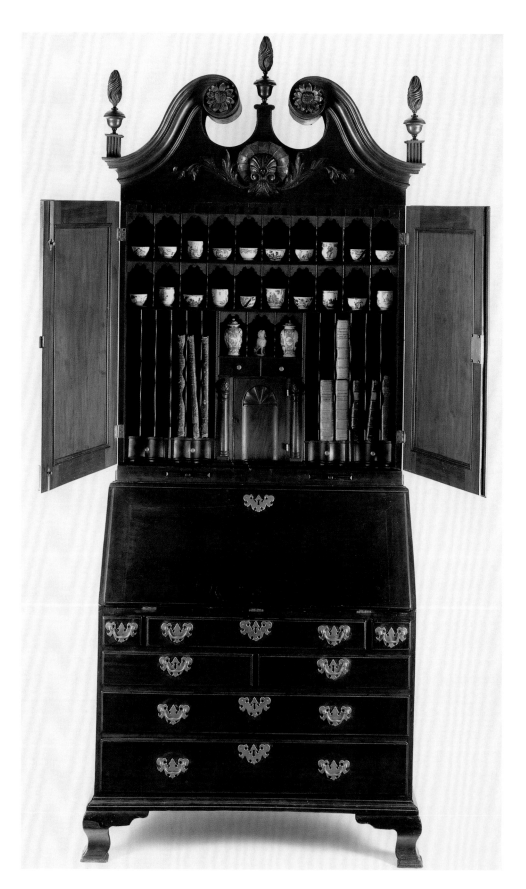

Indies, and the American colonies, displayed a large group of exotic ceramics and decorations in the "2 painted Corner Cupboards" in his city house, including "1 Compleat Sett pencild Dresden China / 1 Sett ditto blew & White / 1 Sett ditto red & White / 7 large China Dishes & 5 doz: China Plates / 50 pieces China Sundry Sorts / 3 doz. Wine Glasses & 3 Decanters / Sundry Alabaster Immages" (see fig. 139).[41] Tall case clocks, musical instruments, paintings, prints, maps, and looking glasses were among other items proudly displayed and highly valued in both urban and rural households, reflecting their high cost and relative scarcity (fig. 140).

Another type of ornate decoration to be found among the furnishings of the most affluent was japanning, a painted finish applied in imitation of the exotic lacquered surfaces of oriental furniture brought into seventeenth- and eighteenth-century France, Holland, and England through the East Indies trade. Simpler japanned furnishings were imported to the American colonies, and domestically produced versions of lacquered or painted furniture, often noted as constructed of pine, are recorded with surprising frequency in local inventories and records. In 1738 John Reynell, a Quaker merchant, ordered through his London agent, Daniel Flexney, "2 raised Japan'd Black Corner Cubbards, with 2 Doors to each, no Red in 'em, of the best Sort, but Plain."[42] Thomas Chalkley, a Quaker preacher, merchant, and active West Indies trader, owned "1 Eight Day Clock with a blew Case figur'd with Gold; to 1 Dyal with a black Case figur'd with Gold."[43] Ralph Assheton's inventory in 1727 listed numerous furnishings with japanned or lacquered surfaces, including chairs, a

cabinet, two card tables, and a tea table.[44] No locally produced Pennsylvania furniture with japanned surfaces has been identified thus far, and only one imported example can now be traced back to ownership in the period before 1750 in the Delaware Valley (see fig. 141). The widely fluctuating climatic conditions in Pennsylvania would have made the delicate gilt and painted surfaces produced by japanning deteriorate if not regularly refurbished, and many early ornamented examples may have been lost through such deterioration and subsequent refinishing.

Of course not all households were well maintained or decorated with the latest and best, even when they could afford to be. Edward Shippen (1639–1712), for example, although one of the wealth-

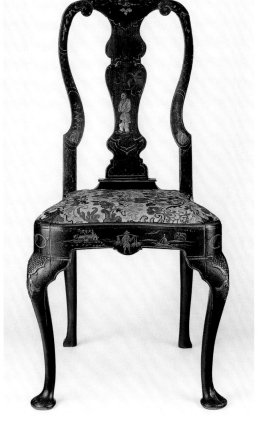

Fig. 140
Pier Glass, c. 1740–45, no. 174. Because the large reflective plates for looking glasses such as this one, which probably was set between two windows, had to be imported, they remained relatively expensive throughout the eighteenth century. This example was originally part of the contents of Port Royal, a house built by the West Indies trader and merchant Edward Stiles, who probably brought it with him when he moved to Philadelphia from the Bahamas around 1740.

Fig. 141
Side Chair, c. 1730–35, no. 117. While no locally produced examples are presently known, a number of household inventories of Philadelphia's wealthier residents refer to "japan'd" or "black'd" furniture and assign to them comparatively high values. Ralph Assheton, one of the city's most successful merchants during the 1730s and 1740s, owned this imported japanned side chair, which retains its original surface and early needlepoint seat.

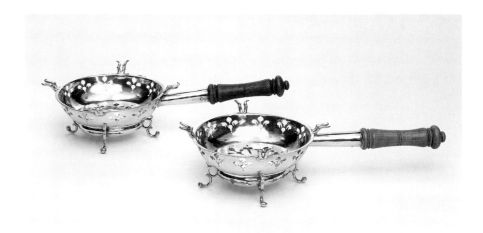

Fig. 142
Pair of Braziers, Johannis Nys, c. 1695–99, no. 261. Johannis Nys, a French Huguenot and one of Philadelphia's earliest practicing silversmiths, produced these ornate braziers, used to keep food warm while serving, for Anthony and Mary Coddington Morris. Their form, cast attachments, and cut-work fleur-de-lis decoration closely follow earlier French and Dutch design traditions.

Fig. 143
Armchair, c. 1725–45, no. 144. International traditions of craftsmanship converged in early Pennsylvania to produce new, hybrid variations on European and English furniture forms. This armchair, probably produced in Philadelphia or Chester County, combines aspects of Welsh, Dutch, and Germanic traditions in its elaborate panel and turned components.

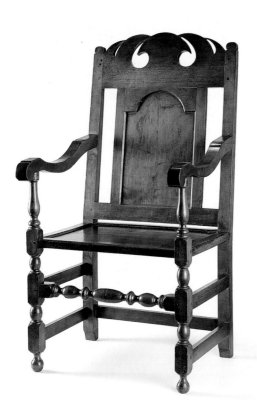

iest men in Philadelphia and the city's first mayor, had in his best parlor many furnishings that were viewed as old, broken, or "much spoiled," at least by those compiling his inventory at the time of his death. The parlor was said to contain "2 old elbow Chairs 6 small Chairs a Child's Chair / a Cane Couch Cushion & Squab all old & much torn / A Clock out of Order & a Case ye Key lost / an old ffashioned glass & a pr of Sconces one broke / An old Scriptore with Some broken China & earthenware / one large & 1 Small oval Table old & rotten / an old Decanter & $1/2$ Dozn broken glasses on ye Mantle ps / 10 glass pictures 2 of wch are broken / 2 old laquer'd fram'd pictures & 4 fram'd pictrs much Spoiled by ye flys & Smoke."[45]

Gardens and Terraced Allées

In addition to having a fine and elegantly furnished house, many affluent Pennsylvanians demonstrated refined taste beyond their front doors by establishing impressive grounds and gardens around their houses (see fig. 121). William Penn wrote, "The *Country* Life is to be *preferr'd;* for there we see the Works of *God;* but in Cities little else but the *Works of*

Men."[46] The proprietor and important guests were at times conveyed from the city to his Pennsbury estate, some twenty-six miles north of Philadelphia, in a barge rowed up the Delaware River by liveried oarsmen.[47] There he had open fields, an orchard, and orderly gardens surrounding his manor house. Mayor Edward Shippen's residence was also prominently situated on the Delaware River slightly south of Dock Creek. Either through published accounts or firsthand experience, men like Penn, Shippen, and many other elite owners of early country residences on the river were undoubtedly familiar with the villas built along the Thames in London during the late seventeenth and early eighteenth century by the aristocracy and wealthy classes. Visitors from the American colonies to London during the period often made the trip up the Thames past houses such as Richmond Hill (built c. 1698–1705) as a part of "The Grand Tour." The "falling garden" (terraced allées, open and symmetrically laid out following the inspiration of Anglo-Palladian scroll-shaped parterres) was an important component of the design of many Dutch, French, and English country houses and villas. Several

of the earliest Pennsylvania river residences followed their inspiration and had open, terraced lawns, fields, or tree-lined allées that provided clear vistas to the river's edge (see fig. 55).[48] Gabriel Thomas, a merchant and close associate of William Penn, noted with wonder in 1696 that there were "very fine and delightful Gardens and Orchards, in most parts of this Countrey; but Edward Shippey [Shippen] . . . has an Orchard and Gardens adjoining to his Great House that equalizes (if not exceeds) any I have ever seen, having a very famous and pleasant Summer-House erected in the middle of his fine and large Garden abounding with Tulips, Pinks, Carnations, Roses, (of several sorts) Lilies, not to mention those that grow wild in the Fields." On the lawn before Shippen's house, which descended to Dock Creek, "reposed his herd of tranquil deer."[49]

Artisans and "Mechanicks"

The expansion and sophistication of Pennsylvania's culture and the colony's support of the arts made the first half of the eighteenth century a heady time for artisans and their patrons. Little is known about the earliest craftsmen who settled in the rudimentary Swedish and Dutch outposts along the Delaware River or in the English settlements in New Jersey and Upland; few traces of their work have been identified (see no. 17). By 1681, however, several highly trained woodworkers, metalworkers, and weavers were among the first immigrant artisans to establish workshops in Philadelphia. These craftsmen are the earliest for whom records survive, providing some information as to their origin and training. While the majority were of English descent, a surprising number were of

Irish, French, Dutch, German, and Scandinavian background. Several had earlier settled in New York, Boston, or the West Indies, where they had completed apprenticeships and practiced their trades before seeking new opportunities in Pennsylvania. These prior work experiences produced a dynamic cross-fertilization of international styles among the earliest craftsmen practicing locally (figs. 142–144). For example, John Tibbye, a "joyner" from London, was one of Penn's "First Purchasers," arriving late in 1681. John Fellow(e)s, Abraham Coffin (Coffen), and Abraham Hooper, all English Quakers, were among those listed as "Cabenett Maker" on the ship passenger lists for 1682, as was John Valecott, a French Huguenot.[50] The silversmiths Cesar Ghiselin, a French Huguenot, and John Pearse, an Englishman, arrived at the port of Chester, just south of Philadelphia, on October 11, 1681 (see nos. 185, 255). Another silversmith, Johannis Nys, also a Huguenot, emigrated from Holland to New York, where he was baptized in 1671; by 1695 he had moved to Philadelphia (fig. 142).[51] William Penn wrote from England on October 6, 1685, to James Harrison, his steward at Pennsbury, that he was sending "a Dutchman, A Joyner and a Carpenter" to help with the building and fitting out of his country residence: "Let him wainscot and make tables and stands."[52] By 1690, Germantown, then five miles northwest of Philadelphia, was described as "a town of Dutch and German people that have set up the linnen manufactory which weave and make many thousand yards of pure fine linnen cloth in a year."[53] Dutch Quakers, German Mennonites, and Pietists established the Delaware Valley's early paper manufactory and printing enterprises in

Fig. 144
Decanters, c. 1720–30, no. 323. Medieval cruciform shapes influenced everything from architecture to glassware throughout the early eighteenth century. Imported English cruciform decanters and bottles were present in Philadelphia by 1725.

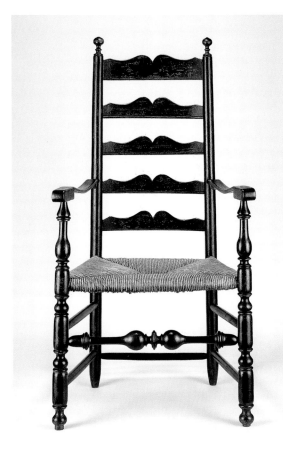

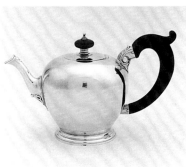

Fig. 145
Armchair, c. 1735–45, no. 153. The scroll-shaped "slats" forming the back of this ladder-back armchair, which become gradually smaller from top to bottom, suggest the prominent role symmetry and balance played in the chair designs of Delaware Valley chairmakers.

Fig. 146
Teapot, Joseph Richardson, Sr., c. 1740–45, no. 216. Experimentation facilitated a craftsman's ability to produce the latest forms and decorations called for by his fashion-conscious patrons. The rounded, spherical body of this 1740s Philadelphia teapot would evolve by the mid-1750s into the inverted baluster, or pear shape.

Germantown, led by the clergyman and industrialist William Rittenhouse (1644–1708) and the German printer, clockmaker, mystic, and inventor Christopher Sauer (1694–1758). Municipal records confirm that by 1690 approximately 120 craftsmen were working in Philadelphia in various trades. While there were fewer full-time professional craftsmen in the region's smaller communities prior to 1720, people in the inland counties of Chester and Bucks, as well as in the older Delaware port towns of New Castle, Burlington, and Chester, could patronize local workshops or obtain locally crafted wares from a number of farmers who practiced crafts on a part-time, seasonal basis (fig. 145; see also no. 80).[54]

News of widespread opportunity brought fresh waves of craftsmen to the colony. Gabriel Thomas published in London in 1696 a glowing account of the opportunity awaiting various professions in Pennsylvania, promising:

Present Encouragements are very great and inviting, . . . Carpenters, both House and Ship, Brick-layers, Masons, . . . will get between Five and Six Shillings every Day constantly. As to Journey-Men Shooe-Makers, they have Two Shilling per Pair both for Men and Womens Shooes: And Journey-Men Taylors have Twelve Shillings per Week and their Diet. . . . And for Weavers, they have Ten or Twelve Pence the Yard for Weaving. . . . Wooll-Combers, have for combing Twelve Pence per Pound. Potters have Sixteen Pence for an Earthen Pot which may be bought in England for Four Pence. Tanners may buy their Hides green for Three Half Pence per Pound, and sell their Leather for Twelve Pence per Pound. . . . Brick-Makers have Twenty Shillings per Thousand for their Bricks at
the Kiln. Felt-Makers will have for their Hats Seven Shillings a piece, such as may be bought in England for Two Shillings a piece. . . . And as to the Glaziers, they will have Five Pence a Quarry for their Glass. . . . And for Silver-Smiths, they have between Half a Crown and Three Shillings an Ounce for working their Silver, and for Gold equivalent. . . . Wheel and Mill-Wrights, Joyners, Brasiers, Pewterers, Dyers, Fullers, Comb-Makers, Wyer-Drawers [wire makers], Cage-Makers, Card-Makers, Painters, Cutlers, Rope-Makers, Carvers, Block-Makers, Turners, Button-Makers, Hair and Wood Sieve-Makers, Bodies [bodice]-Makers, Gun-Smiths, Lock-Smiths, Nailers, File-Cuters, Skinners, Furriers, Glovers, Patten-Makers, Watch-Makers, Clock-Makers, Sadlers, Coller-Makers, Barbers, Printers, Book-Binders, and all other Trades-Men, their Gains and Wages are about the same proportion as the fore-mentioned Trades.[55]

Many craftsmen without introductory letters or sponsors arrived facing the uncertainty of selling their skills by indenture to the highest bidder. On June 2, 1737, the captain of a ship arriving from Ireland announced the sale of the bound indentures of his cargo of carpenters, nailers, joiners, hatters, and shoemakers. David Davis, a captain from Bristol, advertised for sale in June 1739 that he had "Sundry Likely English and Welch Men and Women Servants," among whom were joiners, smiths, shoemakers, tailors, and weavers.[56] Despite the initial uncertainty, the opportunities available allowed many immigrant craftsmen to ascend the economic and social ladder much more quickly than would have been possible within the traditional craft guilds and class systems of Europe or England. Most freed apprentices who

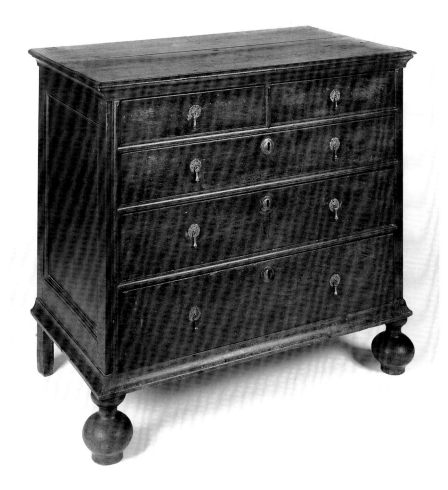

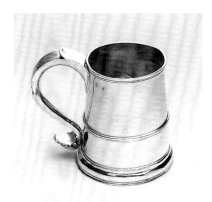

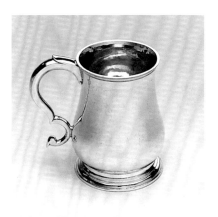

Fig. 147
Chest, William Beake, Jr., c. 1711, no. 26. This is one of two surviving chests of drawers signed by one of Philadelphia's earliest documented cabinetmakers, William Beake, Jr. Typical of early four-drawer chests produced in the region, it follows the traditional patterns for this form, which Beake learned during his apprenticeship to his master William Till, who had trained in England.

Fig. 148
Cann, Francis Richardson, Jr., c. 1730–35, no. 201; Cann, Joseph Richardson, Sr., c. 1740–45, no. 202. Multi-generational craftsman "dynasties" such as that of the silver-smithing Richardsons enjoyed the advantages of longevity, established trust, and the perception of superior talent when seeking patrons.

worked hard and had talent were able to realize their hopes to some degree, usually within one generation, and some even attained the rank of "gentleman" during their careers. Together with their offspring, several, such as the cabinetmaking Claypooles, the Stretch family of clockmakers, and the Richardson and Syng families of silversmiths, achieved multi-generational success as leading craftsman dynasties (fig. 148). For example, Joseph Claypoole, a joiner who arrived in Philadelphia early in 1683, enjoyed a thriving cabinetmaking business with accounts with such influential clients as Isaac Norris, Nathaniel Allen, and the merchant John Reynell. In 1738 he left his business to one of

his sons, Josiah, advertising in *The Pennsylvania Gazette* "That Mr. Joseph Claypoole, Joyner, has left off his trade; and has given his Stock and Implements of Trade to his Son the Subscriber, who has removed from his Shop in Walnut-Street, to the Joyners-Arms in Second-Street . . . where all Persons may be supplied with all Sorts of Furniture of the best Fashion; as Desks of all Sorts, Chests of Drawers of all Sorts, Dining Tables, Chamber Tables, and all Sorts of Tea Tables and Sideboards."57

Among the many craftsmen working in the Delaware Valley a social hierarchy developed that was similar in many ways to that which had existed in the earlier

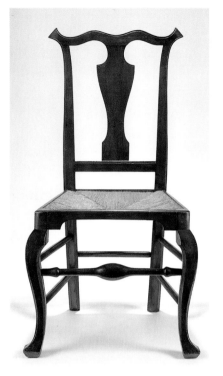

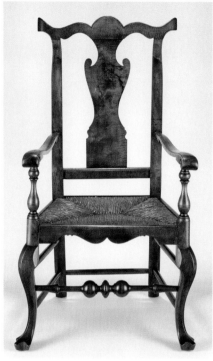

Fig. 149
Side Chair, William Savery, 1745–50, no. 128. This maple splat-back, or banister-back, side chair retains its original printed label on the underside of its finely woven rush seat. Rush or "flag" seats were often painted or stained and varnished yellow, which helped preserve them.

Fig. 150
Armchair, attributed to Solomon Fussell or William Savery, c. 1740–55, no. 156. Maple banister-back or splat-back chairs with square-faced "crook'd" cabriole legs and "matted" or rush seats such as this one became the main production of several large chairmaking shops. Solomon Fussell and his apprentice William Savery expanded the market for inexpensive versions of these chairs, leading to their marketing as venture cargo. They were shipped overland and by sea bundled and unassembled.

craft guilds of England and Europe. R[obert?] Campbell's *The London Tradesman,* published in 1747, described the accepted ranking of craftsmen according to social prestige, education, and the importance of their skill.[58] Colonial Philadelphia's community of craftsmen seems to have been similarly ranked. Many patrons and craftsmen, in practice and in attitude, divided artisans into the "liberal" professions and the mechanical arts. As Campbell described, painting (ornamental painting, portraiture, drawing, engraving, printing, gilding), architecture (carpentry, house building, masonry, stoneworking, joinery), sculpture (silversmithing, metal casting, jewelry making, clockmaking), upholstering, cabinetmaking, chairmaking, and carving were among the liberal arts. Next came the "mechanicks": coopers, cutlers, distillers, dyers, hatters, soapboilers, tailors, tanners, weavers, and all the other tradesmen who according to

Campbell needed a "mechanic head" but not much education.[59]

The apprentice system ensured that master craftsmen maintained a good degree of control over their professions and shops. A typical apprenticeship agreement is one dated September 9, 1746, in which the cabinetmaker George Claypoole, son of the cabinetmaker Joseph Claypoole, took on Thomas Rutter "for six years and four months to be taught the trade of joiner and cabinetmaker."[60] The length of indenture or apprenticeship varied among the different crafts, as did the organization within shops into specialized functions and skills. In larger shops, multiple apprenticeships were initiated in a staged progression to guarantee a useful range of beginners and highly skilled apprentices over the years. Naturally, most journeymen or artisans who had entered into indentures in return for passage or employment had as their main goal obtaining training, financial security, and eventual independence. Unless additional liabilities or debts to the master were incurred, most completed their apprenticeships within four to six years. They would then often remain in the workshops in which they had trained until they could accumulate enough capital to establish themselves independent of their masters. The most fortunate became partners, and many who remained became trusted equals, inheriting the shops, tools, and clientele of their masters. A pattern of intermarriage among craftsman families also served to concentrate assets and talents and ensure continued success. Abel Cottey, for example, an English clockmaker who arrived in Philadelphia in 1682, apprenticed the Irish-born Benjamin Chandlee, Sr., to learn "the art and mystery of clockmaking" soon after

he arrived in Philadelphia in 1702 (see no. 420).[61] Chandlee married Cottey's daughter Sarah in 1710 and, upon her father's death a year later, inherited his Philadelphia shop and the Cottey home in Nottingham Township, Chester County. The couple moved there, and Chandlee trained his four sons in the trade. In turn, his son Benjamin Chandlee, Jr., probably received his father's tools and clientele when Benjamin, Sr., moved to Delaware in 1741 (fig. 151).[62]

Some early craftsmen who trained as apprentices in Philadelphia established independent shops in Delaware, Chester, Bucks, and Montgomery counties of Pennsylvania and in Delaware and New Jersey. Christopher Sauer of Germantown noted this tendency to leave the city, observing: "There is a lack of all artisans, for, when an artisan has collected a sum of money in 3 or 4 years, maybe even in 1 or 2 years, he buys a farm and moves into the country."[63] Many of the early craftsmen who arrived or trained in Philadelphia and later established shops outside the city are now extremely difficult to document. Hendrick Heilig, for example, the Amsterdam-born patriarch of an influential family of Pennsylvania Mennonite clockmakers, arrived in Philadelphia in 1720 aboard the ship *Polly*. He settled in Hanover Township, Montgomery County, as a clockmaker and farmer and married Susanna Rittenhouse, the aunt of the later Philadelphia clockmaker David Rittenhouse. Little is known of Heilig's work, although it is thought that he practiced the trade until his death in 1775.[64]

Welsh Quaker and English rural craftsmen, specifically from the northern English counties of Lancashire and Cheshire, as first identified by the furniture scholar Benno Forman, were concentrat-

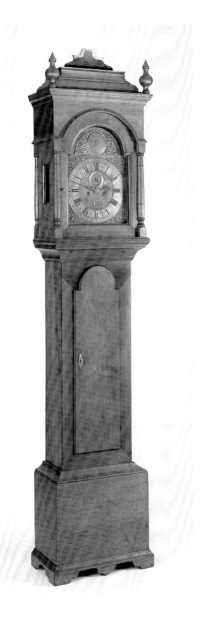

ed in Chester and Delaware counties and, in some cases, in Philadelphia.[65] A Welsh joiner named Llewellin Phillips worked both in Chester County and in Philadelphia, in 1699 and 1704 respectively. In 1732 William Lewis, Jr., a first-generation Welshman who listed himself as a carpenter, owned joiner's and turner's tools, which he left to his sons William and Samuel upon his death in 1737. The early presence of English craftsmen in the region is suggested by two joiners,

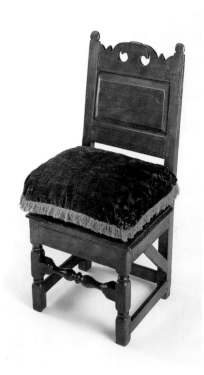

Fig. 151
Tall Case Clock, Benjamin Chandlee, Sr., c. 1730, no. 60. Benjamin Chandlee immigrated to Philadelphia in 1702 and trained with the clockmaker Abel Cottey, later moving to Nottingham Township, Chester County. As was true for many rural clockmakers, the cases built to house his clockworks vary widely in construction and style, and many show a retention of earlier pediment designs, ornaments, and construction techniques.

Fig. 152
Side Chair, c. 1710–30, no. 113. This walnut-paneled side chair retains a diagonal brace under its seat, an element found on several seventeenth-century Germanic and Dutch vernacular seating forms, and was probably made by a northern European joiner or cabinetmaker. The large open space below its paneled back would have been filled with a loose cushion, as shown here.

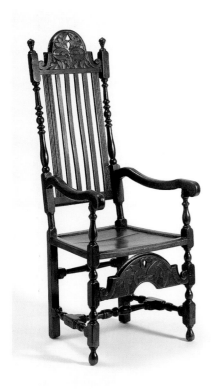

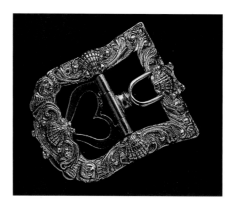

Fig. 155
Buckle, Philip Syng, Jr., c. 1740–50, no. 406. Imported and domestically produced "small work," such as this finely cast and chased gold buckle, suggests the careful craftsmanship and rich ornamentation afforded even the smallest objects of personal adornment. This example was made in the latest style, with symmetrical shells and flanking undulating scrolls.

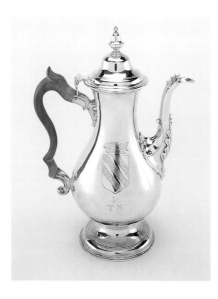

Fig. 153
Armchair, c. 1725–45, no. 146. One of the most ornate carved armchairs from early Pennsylvania that is known, this black walnut "great chair" was probably inspired by early English prototypes and may have required a specialized carver.

Fig. 154
Coffeepot, Philip Syng, Jr., c. 1750–58, no. 213. This coffeepot, made for Thomas Penrose, a wealthy shipping merchant, is engraved with his crest. Its graceful, fully rounded baluster form anticipates the double-bellied or pear-shaped forms that would emerge in the late 1750s and early 1760s.

Richard Clone and John Maddock, who are noted as from Cheshire on passenger lists for the ship *Endeavor*, which arrived in Philadelphia in 1683. Clone worked in Philadelphia, while Maddock is listed in both Ridley and Nether townships, Chester County, in 1698.[66]

The growing number of workmen and divisions of labor within larger craft shops in Philadelphia enabled many apprentices to learn the various specialized skills of their trades more effectively. Beginning apprentices were often assigned repetitive small tasks, such as the cutting of specific joints or the polishing of completed works, in order to absorb the minutia of production. For products requiring multiple parts or several processes, production was often compartmentalized to increase efficiency and quality (see fig. 153). Workers developed specialty skills and particular strengths through the repetitive, often narrow range of their work, such as turning chair legs, carving volutes, or, in the case of silversmiths, casting parts and engraving ciphers. Philadelphia's leading workshops, like those of the chairmaker Solomon Fussell (fig. 150) and the silversmiths Francis Richardson, Sr., and Philip Syng, Sr., had the capital to employ and keep specialized turners, carvers, engravers, and chasers whose

skills, honed over time, greatly augmented the quality and range of finished products they could offer (fig. 154).[67]

Advertisements listing as diverse and plentiful a range of goods as possible, or one's ability to execute various commissions for a client "in the latest fashion," further helped a craftsman lure patrons into his shop. Import merchants and the operators of "vendue sales" (auctions of newly arrived goods), held on the wharf, regularly published extensive lists of exotic fineries available to the public, competing with locally produced goods. Upholsterers, silversmiths, and the makers of looking glasses in particular often stocked a range of imported goods alongside their own products in their shops (fig. 155).[68] Plunket Fleeson, an upholsterer who arrived in the city in 1739, announced that he had "Several Sorts of good Chair-frames, black and red leather Chairs, finished cheaper than any made here, or imported from Boston."[69] Craftsmen also might sell the products of other local artisans in their shops along with their own wares, allowing them to further diversify the range of goods they offered as well as turn a profit on goods that may not have been within their abilities. Peter David (1707–1755), known for his hollow-ware forms, sold in his shop "small work"

purchased from the silversmith Joseph Richardson, Sr. (1711–1784). Richardson's ledger book shows orders from David in 1739 that include "3 sett of Silver Buttons wt 7d– 12Gr. . . . By 3 pr of Small Studs . . . By a pr of Small Sleave Buckels."[70]

The account the cabinetmaker John Elliott, Sr. (1713–1791), kept with his client Charles Norris from 1755 to 1758 suggests the range of services a craftsman had to be prepared to offer his clients in order to keep their patronage (fig. 158).[71] Elliott produced a number of furniture pieces for Norris but in addition to these commissions was called upon to perform various repairs and other duties, including "fixing up 2 Bed Testers," altering the bells, "fixing up the Jack, altering the Multiplying Wheel, [supplying] 2 new pulleys &c," mending the steps, "fixing up 6 Sett of Window Corns & Setting on 2 Desk Locks," mending a corner chair and a stretcher of an elbow chair, "taking out & refixing the feet of an Easy Chair," as well as supplying a "Mop pail & handle," wire, tacks, a looking glass frame, bed laces, a pair of steps, and "3 Mahogy Pier Glasses."[72]

Many shops relied on cooperation and interaction with other craftsmen in the community to produce the different components of a finished design or to meet deadlines for delivery. In 1739 Solomon Fussell, a chairmaker with a large shop who worked in Philadelphia from about 1738 to 1750, supplied orders for the turned wooden handles of "Chaffing" dishes and other small work to the blacksmith John Naylor.[73] In 1743 Fussell's shop also supplied turned elements such as "Clockcase pillors" and "ornament balls" (see fig. 156) for the cases of tall case clocks produced in the shop of cabinetmaker Stephen Armitt.[74] In August 1750 another of the city's joiners, Henry

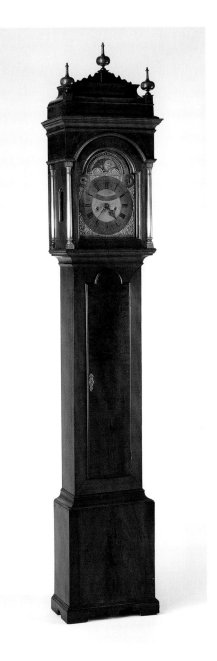

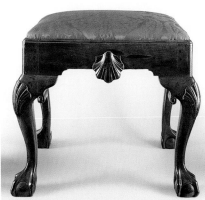

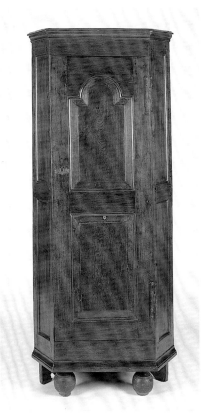

Fig. 156
Tall Case Clock, Joseph Wills, c. 1746, no. 65. The finely cast imported brass columns trimming the upper case of this ornate clock, made for the Quaker Joseph Fox, were an unusual and costly addition. The craftsman who fashioned its turned wood "ornament balls" and case is unknown.

Fig. 157
Corner Cupboard, c. 1730–40, no. 45. The maker of this corner cupboard chose highly figured black walnut for the construction of the panels and frame and added further stylish elements such as shaped interior shelves and turned feet. Early freestanding "bouffert" or corner cupboards such as this one are quite rare.

Fig. 158
Stool, attributed to John Elliott, Sr., c. 1756, no. 108. This stool, one of a rare set of four upholstered stools, was originally owned by Charles Norris, who ordered them from the Philadelphia cabinetmaker John Elliott in 1754 at a cost of £5.4.0.

Fig. 159
Baluster from the exterior of Christ Church, c. 1735–60, pine, painted white, 25³/₄ x 6³/₄" (65.4 x 17.1 cm), Rector, Churchwardens, and Vestrymen, Christ Church, Philadelphia. Architectural balusters were supplied regularly to both public and private building projects by local turners, who conceived their shapes, balance, and decorative detail. The baluster vase form was a prominent design element in all modes of craftsmanship during the period, and regularly affected cabinetmaking, metalworking, and other fields.

Fig. 160
Side Chair, c. 1740–55, no. 127. This simply constructed side chair combines aspects of traditional wainscot chair joinery with a flat sawn baluster, or vase-form splat, in the design of its back.

Fig. 161
Side Chair, attributed to Solomon Fussell, c. 1748, no. 132. One of a set of splat-back chairs commissioned by Benjamin Franklin from the chairmaker Solomon Fussell in 1748, this side chair represents one of several transactions between the two men, who shared similar political sentiments. Fussell may also have been involved in the making of several turned electrical "wheels" for Franklin.

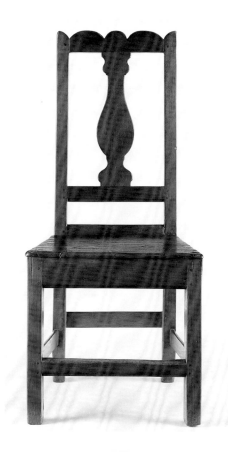

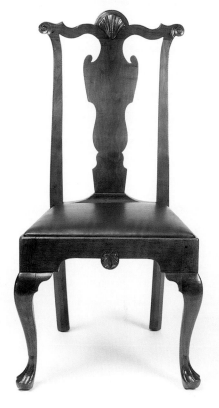

Clifton, bartered a clock case to the Philadelphia clockmaker John Wood and in return received a quantity of "Mehogany Bord, walnut plank & Scantling."[75] Yet another cabinetmaker and carpenter, Daniel Jones, ordered three sets of joint stool legs, four table legs, and two sets of bedposts and turned pins from Fussell in 1739.[76]

Multiple hands were often needed to complete large commissions satisfactorily, and surviving evidence suggests that many artisans, particularly those with specialized skills such as turners, carvers, metal engravers, or silver chasers, often traveled from shop to shop working as independent craftsmen.[77] Architectural joiners producing paneled walls, wainscoted rooms, fireplace surrounds, and "buffet" cupboards utilized the same skills practiced in the furniture shops of those who made panel and framed "wainscot" chairs or case pieces (fig. 157). Interior staircases and exterior balustrades all required multiple turned elements, many of which were supplied by the lathes of chairmakers and other furniture makers. On July 7, 1748, Samuel Powell (1738–1793), a wealthy Philadelphia merchant, paid the joiner and turner John Page for "4 doz & 9 Banisters" for his house on High Street.[78] Benjamin Trotter, a chairmaker, received payment from Doctor Samuel Preston Moore of Philadelphia on two different occasions—the first for "joiner's work" and the second for turning 105 balusters.[79] Such associations resulted in an exchange of skilled workers and a pronounced cross-fertilization between architectural woodworking and the furniture arts, enriching and expanding both (figs. 159, 160).

Gaining strength through their relationships with colleagues, craftsmen

from all trades became involved in fraternal clubs, civic unions, and political organizations. Leading members of the city's building trades were unsuccessful in petitioning the Philadelphia Common Council in 1727 to incorporate their craft in all its branches in order to help regulate the quality of workmanship, trade practices, and prices. Independently, the Carpenters' Company of the City and County of Philadelphia was founded about 1724. While it provided a political and economic voice for craftsmen in this field, it tended to be a somewhat elitist organization made up of the city's wealthier and influential master carpenters as well as those with important political aspirations.[80] During the financial depression of the late 1720s a group of patriotic artisans and craftsmen joined Governor William Keith and Benjamin Franklin to form the Leather Apron Club. The group was largely composed of minor craftsmen, who, among other things, successfully lobbied Philadelphia's unresponsive, patrician legislature to provide protections and support for the region's financially ailing craftsmen and "artificers" (fig. 161). Franklin, publishing under the name "Constant Truman" in 1735, urged craftsmen to speak their minds and defend their rights in the workplace: "Let me tell you, Friends, if you can once be frightened by the Threats and Frowns of great Men, from speaking your Minds freely, you will certainly be taught in a very little Time, that you have no liberty to act freely, but just as they shall think proper to Command or Direct; that is, that you are no longer Freemen, but Slaves."[81] Franklin, the silversmith Philip Syng, Jr., and several other craftsmen joined with several prominent Philadelphia merchants to hold a lottery in 1747, raising funds to

build a battery on the Delaware River in defense of a feared French attack on the city's port. The merchants involved included Joshua Maddox, Edward Shippen, William Branson, and Charles Willing, all of whom went on to commission work from Syng after their joint participation in this defense project (no. 192). Such strategic relationships promoted business and could greatly aid a craftsman's success and upward mobility. The most successful artisans were able to walk a fine line, balancing the political and social biases of their influential clientele, the commercial goals of the community of craftsmen, and their own interests and aspirations.

Furniture Craftsmen and Woodworking

During the first years of settlement William Penn made special efforts to attract woodworkers to Pennsylvania, realizing their crucial role in the development of the colony and in commerce. By 1685 their numbers had increased to the point that he was able to note an abundance of "most sorts of useful Tradesmen, As Carpenters, Joyners, . . . Turners, etc." among those who had immigrated to the colony.[82] Tax lists, advertisements, and other documents record, on average, 172 woodworkers active in the Philadelphia area between 1730 and 1760.[83] Many of these artisans came from small towns and rural areas in Europe and England, where the formal craft guilds held less sway. As a result, the different titles used to distinguish specialized craftsmen, along with the working parameters those titles implied, seem to have been applied less regularly in the Delaware Valley than in Europe and England. John Fellows, for example, listed in his will and inventory as a "Cabinett-maker"

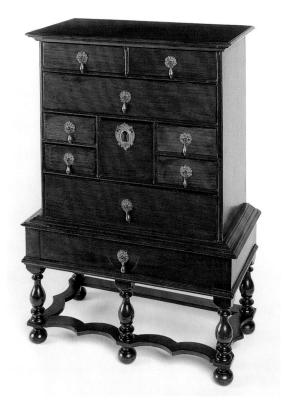

Fig. 162
Miniature Cased Drawers on Stand, c. 1715–30, no. 42. This rare, small-scale drawers on stand, or miniature high chest, includes in its design turned baluster-and-ring legs, found on a number of early Delaware Valley chests, tables, and chairs. Some local turners, in order to save labor and wood, turned the legs in separate passages and then joined these components to form the finished leg and foot elements.

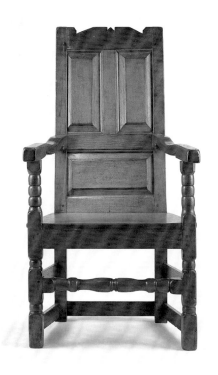

Fig. 163
Armchair, c. 1730–40, no. 150.
Techniques of architectural panel-
and-frame joinery were easily adapt-
ed to cabinetry and chairmaking.
This walnut armchair, which com-
bines traditional English and Welsh
joinery and panel arrangements, is
thought to have originally belonged
to Bartholomew Penrose, a promi-
nent Philadelphia merchant involved
in the West Indies trade.

Fig. 164
Door, c. 1752–53, no. 437. A number
of Germanic cabinetmakers work-
ing in southeastern Pennsylvania
executed complicated shaped and
"double fielded" panels for use in
both cabinetwork and architectural
paneling. This interior door comes
from the Millbach House in Leba-
non County, Pennsylvania.

in Philadelphia, left a number of un-
finished pieces of furniture when he died
in 1694, including a dozen chair frames
and, among his tools, "40 moulding
plains," chisels, files, turning tools, and
a lathe, attesting to the variety of furni-
ture he made.[84] Thomas Stapleford, a
"chairmaker" working in Boston in the
1680s who later moved to Philadelphia,
in 1717 billed his patron James Logan
not for chairs but for "a large oval Table,"
"a large Pine Table," and a "Pallet Bed-
stead."[85]

Despite the apparently common prac-
tice among woodworkers in early Penn-
sylvania of making a variety of furniture
forms, the descriptive titles of carpenter,
joiner, turner, cabinetmaker, and chair-
maker were still used. Many carpenters,
while generally responsible for the fram-
ing of houses and ships, could employ
the same woodworking techniques to
produce furniture. Basic methods of fur-
niture construction, such as lap joinery,

pinned or nailed construction, mortises
and tenons, and the incorporation of
turned elements in design, were all fa-
miliar to house and ship carpenters. In
addition, carpenters regularly made the
structural joints used in frame trussing
and bracing, which were technically
much more complicated than many of
those required in furniture making.
While there are presently no examples
of furniture from the period document-
ed as having been made by craftsmen
calling themselves "carpenter," there is
no reason to think that carpenters did
not regularly produce furniture when
called upon by their clients or by their
own needs to do so.[86]

The "joyner," whose basic technique
for producing furniture was panel-and-
frame, or panel-and-stile, construction,
also had close ties to the architectural
trades (figs. 163, 164). The panel-and-
frame was the main repeated component
in the design of wainscot-paneled interi-
ors. The frame, usually square or rectan-
gular in shape, could be "rabbeted," or
grooved, on its inner face to receive the
central panel; the whole unit was then
held together with four simple corner-
lapped or, more commonly, fully mor-
tised and tenoned joints. In mortise and
tenon joinery the end of one element is
partially cut away to form a thin exten-
sion (the tenon), which is then inserted
into a like-shaped slot (the mortise) cut
into the element to which the first is to
be attached. These joints could then be
glued, pinned, or wedged for further
stability. The basic mortised panel-and-
frame units could be assembled in dif-
ferent configurations to make various
case furniture components, table frames,
"joined" wainscot or panel-back chairs,
chest cases, stools, cabinet doors, and
the heads of beds (see no. 32). Attesting

to the closeness of the professions of carpentry and joinery, *A General Description of All Trades* (London, 1747) observed: "*Carpentry* and *Joinery* . . . are often performed by the same Persons, though the Work of [the Joiner] is much lighter and generally reckoned more curious than that of the *Carpenters;* for a good *Joiner* can often do both well, but every *Carpenter* cannot work at *Joinery*."[87]

The work of the turner can also be found in most branches of furniture making and in aspects of architectural woodworking (fig. 165). The range of equipment the turner needed was extensive, and his tools determined the quality and intricacy of the work he could produce (fig. 166). Using the "pole," "peddle," "spring-pole," or "great wheel" types of lathes, and a variety of handheld chisels or "gouges," the turner fashioned rounded, cylindrical elements of differing diameters by cutting away material from "green," or uncured, wood stock secured at each of its ends in the lathe, which swiftly rotated the stock. Early lathes were activated by turning the wheel or pumping the pole or peddle and often produced an uneven speed of rotation. In addition, each pump of the pole or peddle lathe rotated the wood stock back and forth; only the wheel lathe produced a continuous, one-directional rotation. Strength, a steady hand, and great skill were needed to accomplish the refined passages of turning found on much early furniture. Separately turned elements were used individually or joined together to form the structural components for the bases of case furniture—legs, stretchers, feet, and pendants applied to aprons (fig. 167). The design of most early Pennsylvania chairs included some turned elements, either legs, back stiles, stretchers, feet, or decorative back-stile finials.

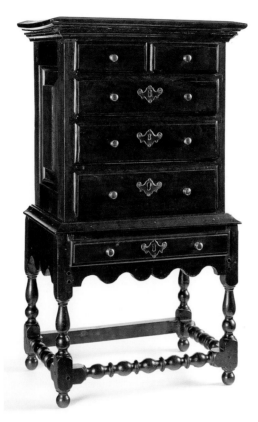

The "crook't foot," or cabriole leg, which grew in popularity in Pennsylvania after 1730, also required offset lathe turning to produce the rounded S-scroll of its curved form. In architecture, turned columns, newel posts, balusters, and decorative pediment and roof finials and urns were all products of the turner's shop. Lathes could also be used to produce

Fig. 165
Miniature Cased Drawers on Stand, c. 1715–30, no. 41. This miniature case of drawers follows the form of the earliest full-scale high chests and incorporates early characteristics such as paneled sides, a single long drawer in its base, a broad waist and pediment moldings, and repeat ball-and-ring turnings. Its construction required both joining and turning skills.

Fig. 166
Joseph Moxon, *Mechanick Exercises; or, the Doctrine of Handy-Works Applied to the Arts of Smithing, Joinery, Carpentry, Turning, and Bricklaying*, 3rd ed. (London: Dan. Midwinter and Tho. Leigh, 1703), p. 168, Winterthur Library: Printed Book and Periodical Collection.

Fig. 167
High Chest and Dressing Table, John Head, c. 1726, no. 38. Although high chests and dressing tables were often produced in pairs in the early eighteenth century, this pair, which may have been made for the marriage of Caspar Wistar and Catherine Johnson, is the only documented pair produced in the Delaware Valley to have survived. Wistar's order, dated April 14, 1726, is entered in the account book of the Philadelphia cabinetmaker John Head.

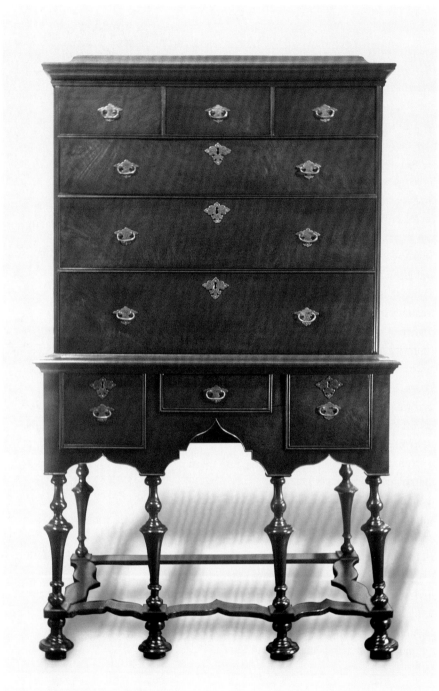

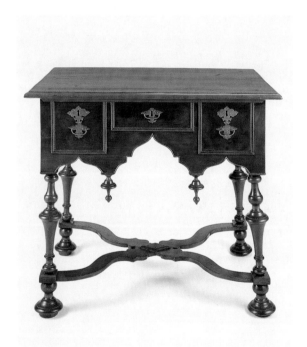

"treen" work: turned blocks and pulleys, trencher plates, bowls, castors, hollow-ware, wooden handles, knobs, and other specialty "small work" (see no. 101). Peter Kalm, a Swedish botanist who traveled extensively in the region in the 1740s, recording much of what he saw, noted that the "burls" or swirl-grained bulges caused by parasitic growths in various local trees were popular among "the Swedes, and more especially the Fin-landers, who have settled here, [they] made [turned] dishes, bowls, etc. . . . These vessels, I am told, were very pretty, and looked as if they were made of curled wood" (see no. 438).[88] Because of the frequent use of turned elements in most branches of furniture making, the in-ventories of many larger woodworking shops included a lathe, and where finances, workload, and space allowed, many shops employed specialized turn-ers on a full-time basis.

In England and in colonial America, the functions and daily work of the cabi-netmaker had grown closer to those of the joiner by the late seventeenth century, although the title "cabinetmaker" contin-ued to denote a different range of work. Not all joiners were qualified for cabinet-making, which, at least in the minds of many patrons, called for more actual design work and a knowledge of archi-tectural proportions (fig. 168). The cabi-netmaker, while using all the techniques of the joiner, also incorporated aspects of board construction—mainly the dove-tail joint. Dovetail joinery was the tech-nique most often used for assembling the corners of chest cases and drawers and consisted of interlocking wedge- or "dovetail"-shaped keys that secured the sides of boards at tight right angles. Campbell's *The London Tradesman* de-scribed the profession thus:

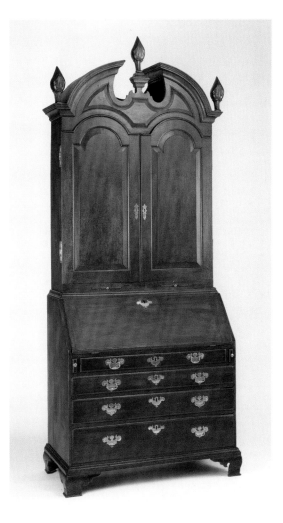

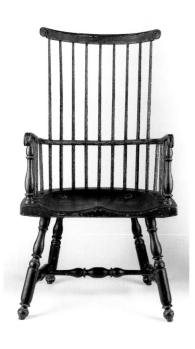

Fig. 168
Secretary Desk and Bookcase, c. 1730–40, no. 72. Complicated case pieces such as this secretary desk, with its broken arched pedi-ment, shaped panels, central mold-ed plinth supporting an early experi-mental carved cartouche, and shell-carved niches and fluted pilasters on the interior, displays an informed knowledge of architectural forms and cabinetmaking techniques.

Fig. 169
Armchair, c. 1745–55, no. 162. The makers of Windsor chairs relied heavily on turned components for both structure and design. Many may have employed a turner full-time or kept a lathe in their shops, while others contracted turners to supply such specialized work. This armchair with boldly splayed legs, broad stance, and crisp turnings is one of the earliest surviving Phila-delphia Windsor chairs.

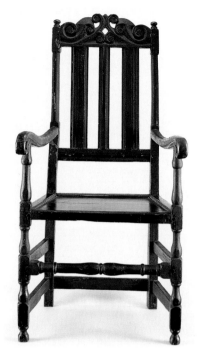

Fig. 170
Armchair, 1690–1710, no. 136. This early armchair from Boston was owned in Philadelphia by Anthony Morris II, a merchant who arrived in Philadelphia from Boston about 1685. Quaker merchantile partnerships probably served as conduits for the marketing of such chairs in Philadelphia.

Fig. 171
Armchair, 1715–30, no. 142. The similarities with the work of Boston chairmakers seen in the pattern of the carved crest and the turned elements of this early Philadelphia armchair suggest the influence that Boston chairs had on the work of local chairmakers.

*The Cabinet-Maker is [the Upholsterer's] right-hand Man; he furnishes him with Mahogany and Wallnut-tree Posts for his Beds, Settees of the Same Materials, Chairs of all Sorts and Prices, carved, plain, and inlaid, Chests of Drawers, Book-Cases, Cabinets, Desks, Scrutores, Buroes, Dining, Dressing, and Card Tables, Tea-Boards, and an innumerable Variety of Articles of this Sort. The Cabinet-Maker is by much the most curious Workman in the Wood Way, except the Carver; and requires a nice mechanic Genius, and a tolerable Degree of Strength, though not so much as the Carpenter; he must have a much lighter Hand and a quicker Eye than the Joiner, as he is employed in Work much more minute and elegant. A Youth who designs to make a Figure in this Branch must learn to Draw; for upon this depends the Invention of new Fashions, and on that the Success of his Business.*⁸⁹

Perhaps because the title earned a higher degree of respect, after 1730 many wood-

workers in Pennsylvania referred to themselves in their legal documents, advertisements, and to their clients as "cabinet-maker," regardless of the actual character of the work carried out in their shops.

The various construction techniques employed in making caned, leather-upholstered, and wainscot-paneled seating furniture required that the chairmaker have access to the multiple talents of the turner, joiner, and upholsterer. The other chairs produced in the early Delaware Valley—slat- or ladder-back, compass-seat, and vase-form splat-back and turned Windsor-type chairs—also varied enough in their construction to warrant cooperation among specialized craftsmen. Again, *A General Description of All Trades* provides some insight into how the designation "chairmaker" was used at this time:

*Though this Sort of Household Goods is generally sold at the Shops of the Cabinet-makers for all the better Kinds, and at the Turners for the more common, yet there are particular Makers for each. The Cane-chair-makers not only make [cane chairs] . . . but the better Sort of matted, Leather bottomed, and Wooden Chairs, of all which there is great Variety of Goodness, Workmanship and Price; and some of the makers, who are also Shop Keepers, are very considerable Dealers. . . . The white Wooden, Wicker and ordinary matted Sort, commonly called Kitchen-chairs, and sold by Turners are made by different Hands, but are all inferior Employs. Those covered with Stuffs, Silks &c. are made and sold by the Upholsterers.*⁹⁰

One of Philadelphia's leading early upholsterers, Plunket Fleeson, for example, advertised on June 14, 1744, that he had at his shop at the sign of "the Easy Chair,

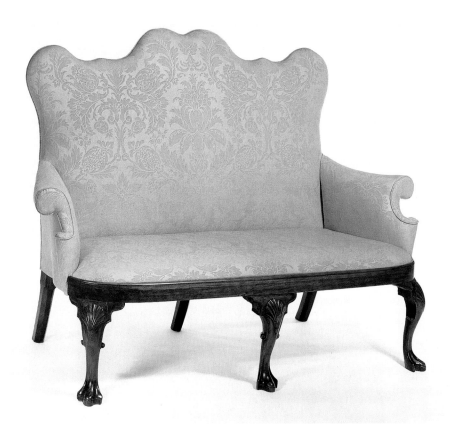

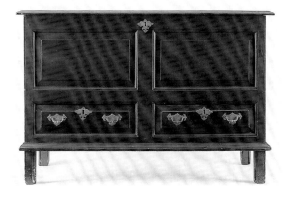

Fig. 173
Textiles Chest, c. 1700–1730, no. 20. If skilled in their craft, early joiners and cabinetmakers needed relatively few tools to accomplish simple but refined forms such as this early wainscot chest. One of a group of surviving paneled chests thought to have been made in West Jersey, near Salem, their simple components could be rived with froe and mallet, shaved smooth with plane and drawknife, and their mortise and tenon joints formed with chisel and auger.

in Chestnut Street, . . . ingaged, and for many Months, employed several of the best Chair-makers in the Province, to the End he might have a Sortment of Choice Walnut Chair Frames; Gives Notice that he now has a great Variety of the newest and best Fashions, ready made, . . . at the most reasonable Rates; and Maple Chairs as cheap as from Boston" (see no. 140 and fig. 181).[91]

Tools of the Trade

The tools used within the different craft shops in the Delaware Valley varied a great deal. Some woodworking tools were produced by local blacksmiths or by the woodworkers themselves, but the higher quality and wider variety of imported tools made them more desirable, despite their high cost and relative scarcity (see

no. 424).[92] Smaller shops, whether rural or urban, needed fewer specialized templates, gouges, chisels, saws, planes, compasses, and clamps to accomplish their work. Many rural craftsmen also learned to use and adapt what tools they had to serve multiple purposes. The basic froe (a cleaving tool), wedges, and mallets for "riving" or splitting rough boards from a log, and the simple saws, drawknives, and planes used to further refine, smooth, thin, and shape could accomplish a great deal in the hands of a trained artisan, but a greater range of quality tools was essential for the execution of finer work and for more efficient use of a craftsman's time. For many craftsmen, tools represented their largest outlay of capital in establishing their practices. Because of their value tools were protected, well cared for, repaired,

Fig. 16. Joiners tools. From Moxon, *Mechanick Exercises* (1703), pl. 4, facing p. 69. (Winterthur Library.)

Fig. 174
Joseph Moxon, *Mechanick Exercises; or, the Doctrine of Handy-Works Applied to the Arts of Smithing, Joinery, Carpentry, Turning, and Bricklaying,* 3rd ed. (London: Dan. Midwinter and Tho. Leigh, 1703), p. 69, Winterthur Library: Printed Book and Periodical Collection.

Fig. 175
Group of Furniture Hardware, c. 1700–1750, brass and iron, private collection. The vast majority of the brass hardware used in colonial Pennsylvania was imported. On rare examples with undisturbed surfaces, some evidence survives indicating that hardware was sometimes color-lacquered or gilded. While England supplied the colonies with most of their brass hardware, Dutch and French sources also provided models for patterns and forms.

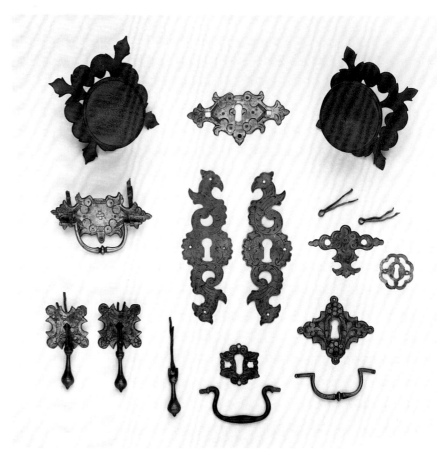

and recycled, and they tended to be passed down to craftsmen's sons or trusted apprentices. The more fortunate apprentices and journeymen working in larger shops were able to acquire a number of their own tools during their service, giving them a good start when they later set up independent shops.

The dispersal of a shop's contents, and the wear on tools from heavy, repeated use, has resulted in the survival of relatively few unaltered craftsmen's implements from the early eighteenth century. Publications and surviving manuscripts, however, supply a good idea of the range of tools that may have been present in local shops. The third edition of Joseph Moxon's *Mechanick Exercises; or, the Doctrine of Handy-Works Applied to the Arts of Smithing, Joinery, Carpentry,*

Turning, and Bricklaying, published in London in 1703, includes illustrations and descriptions of a wide range of tools and describes their purposes and advantages. In Philadelphia Benjamin Franklin owned a copy, as did William Branson and Robert Smith, among others. Moxon's volume may have guided a number of local craftsmen in their selection of tools (fig. 174).93

Craftsmen's tools are itemized in a number of early inventories, indicating that they were a valuable asset. "Twenty one Chisils of divers Cinds" were found in the shop of Joseph Hibbard, a joiner in Darby, Chester County, when it was inventoried in 1737. In 1718 Robert Streeter, a joiner from Chester, owned "3 pair of compasses" and, surprisingly, "a finnering Iron" for veneer work.94 In

Philadelphia the earliest, most extensive inventory documenting the tools and activities in a large cabinetmaking shop is that of Charles Plumley, taken on December 15, 1708. Plumley's extensive collection of sophisticated tools and equipment allowed him to produce most of the products once thought to be specific to the shops of joiners, carpenters, turners, carvers, and chairmakers. He also had a large supply of lumber that included mahogany planks and boards and a "parcell of olive wood and other Veinarys," "6 ffeneaireing [veneering] Screws," a number of "Smoothing plaines," and "76 lb. of Glew" for veneer work, and a large supply of expensive imported brass hardware fittings, including "112 Dropps," "53 Scutcheons" (escutcheons), and many hinges and locks (fig. 175).[95]

Wood Use in Furniture Making

The abundant raw material available in Pennsylvania's forests was crucial to the early development of both the architectural and the furniture-making trades. Many observers and craftsmen marveled at the stands of quality virgin timber in the Delaware Valley, compared to the scarcity and high cost of wood in the areas from which they had come. English, Dutch, Germanic, and French Huguenot craftsmen had been trained where overpopulation and centuries of shipbuilding had decimated the forests, and they had learned to economize on wood use, employing such techniques as using thinner stock for the internal structure of cases and laminations or decorative surface veneers applied over lower-quality woods. While the availability of fine woods locally made most of these traditional construction techniques

unnecessary, they can nevertheless be found in some of the earliest Pennsylvania furniture (see nos. 8, 39, 40).

In furniture construction the use of woods divides into two categories. Primary woods are the main structural woods visible on the surface that are

Fig. 176
Chest-on-Chest, c. 1740–50, no. 34. This finely proportioned walnut chest-on-chest is an example of the continued use in Philadelphia of local woods. The preferred use of local black walnut by many cabinetmakers continued into the late eighteenth century, even with the greater availability of affordable mahogany.

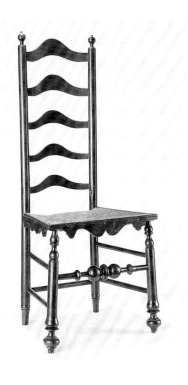

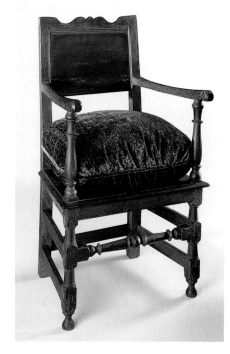

Fig. 177
Side Chair, c. 1725–40, no. 119. A range of mixed hardwoods was used in the construction of chairs such as "arch'd back" or ladder-back chairs, based upon the wood's workability and tensile strength. A dark stain or painted finish would then be applied to unify the finished work.

Fig. 178
Armchair, c. 1700–1715, no. 138. Some of the earliest surviving examples of Pennsylvania turned and joined furniture were constructed entirely of oak. This paneled oak armchair was probably made by one of the English, Welsh, or Irish joiners who immigrated to the colony prior to 1715.

finished (carved or painted); secondary woods are those used for the interior frames, drawer boxes, and structural blocking, or for decorative inlays. In some early, isolated cases, a single wood, such as oak, cedar, or walnut, was employed for the construction of the entire piece. Judging from surviving examples, the primary wood most often used in pre-1755 Pennsylvania furniture was black walnut, while structural secondary woods were usually white and yellow pine, cedar, poplar, and in some regional cases, chestnut or oak, all of which were available locally (see fig. 176).[96] In a 1683 letter to the Free Society of Traders in London extolling the virtues of his new colony, William Penn wrote: "The Trees of most note are, the black Walnut, Cedar, Cyprus, Chestnut, Poplar, Gumwood, Hickery, Sassafrax, Ash, Beech and Oak of divers sorts, as Red, White and Black; Spanish Chestnut and Swamp, the most durable of all."[97] In 1748 the botanist Peter Kalm made a

much more extensive list of local trees and recorded how most were used (see Appendix II). For example, he reported:

The joiners say that among the trees of this country they use chiefly the black walnut, the wild cherry, and the curled maple. Of the black walnut (Juglans nigra) *there is yet a sufficient quantity, but careless people are trying to destroy it, and some peasants even use it as fuel. The wood of the wild cherry tree* (Prunus Virginiana) *is very good, and looks exceedingly well; it has a yellow color, and the older the furniture is, which is made of it, the better it looks. But it is already scarce, for people cut it everywhere without replanting. The curled maple* (Acer rubrum) *is a species of the common red maple, and likewise very difficult to obtain. You may cut down many trees without finding the wood which you want. The wood of the sweet gum tree* (Liquidambar) *is also used in joiner's work, such as tables and other furniture. . . . The pines and the white cedars* (Cupressus thyoides) *are likewise made use of by the joiners for different sorts of work.*[98]

At a surprisingly early date many craftsmen feared, as did Kalm, that oak, cedar, walnut, and poplar were being consumed at too great a rate by Pennsylvania's shipbuilding and house-building industries, carpentry shops, and iron furnaces. Kalm observed: "Many brick kilns had been made hereabouts which require a great quantity of wood. The country is likewise more cultivated than it used to be, and consequently large forests have been cut down for that purpose; and the farms built in those places also consume a quantity of wood. Lastly, people melt iron out of ore in several places about the town, and this work goes on without

interruption. For these reasons it is concluded that in future times Philadelphia will be obliged to pay a high price for wood."[99] As predicted, the forests in close proximity to the city were depleted relatively early of their most desirable timber—oak, walnut, and soft woods such as poplar. In the 1730s, as lumber to fill the growing needs of craftsmen was brought into the city overland from a greater distance, prices rose dramatically.

Despite the cost, the demand for household furniture and interiors made of both imported and local woods grew steadily. Israel Acrelius, a Swedish minister, commented in 1754: "The furniture of the house is usually made of woods of the country, and consists of a dining-table, tea-table, supper-table, bureaus, cabinets, and chairs, which are made of walnut, mahogany, maple, wild cherry, or sweet gum. All these trees are the growth of the country, except mahogany, which is brought from South America."[100] The best craftsmen knew the structural properties of different woods and used them in furniture according to their strength, workability, and decorative aspect (fig. 177). Surviving inventories of the earliest large furniture shops indicate that quite a range of lumber was kept on hand—a significant investment of capital on the part of craftsmen.[101] Wood stocks were often purchased from a lumberman or on the wharves "in the log," that is, unsawn, making them more economical as well as resilient if stored outside. The "logs" were then processed into more usable boards as needed. The 1694 inventory of John Fellows, a Philadelphia joiner, included "17 pine Loggs / 6 1/2 of Round wall-nut Loggs / 754 foot of pine boards / 219 foot of wall-nutt plank / 240 foot of wall-nutt-boards / 64 foot cedar plank

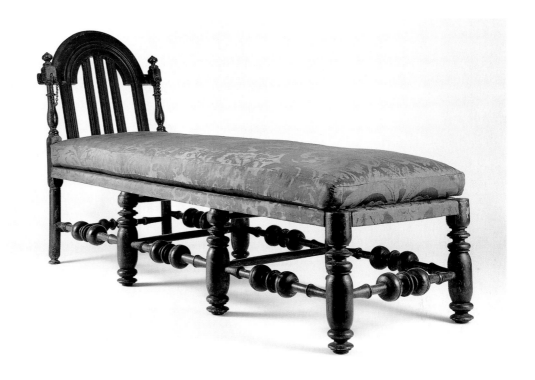

Fig. 179
Daybed, c. 1720–35, no. 168. The craftsman who produced this rare, over-the-rail upholstered daybed used maple for its arched back supports, turned stretchers, and bulbous legs and oak for the rails forming its seat frame. Used in bed chambers as well as other rooms in early households, daybeds were often accompanied by similarly patterned armchairs and side chairs covered with rich, imported fabrics configured en suite with those of the daybed.

/ 60 foot wall nut scantling / 144 foot pyne scantling / 361 foot of wall-nutt & cedar boards / 350 foot of cut boards."[102]

Early household inventories, together with surviving furniture, also help document the woods used in the colony. Oak had long been favored in English and European furniture-making traditions and was also popular in shipbuilding, house building, and carpentry. Local varieties of oak were used fairly extensively as a primary wood by joiners and cabinetmakers using panel-and-stile methods of construction during the earliest period of furniture making in Pennsylvania (fig. 178). The inventory of James Claypoole, a Philadelphia merchant who died in 1687, listed "an Oak Chest of Drawers,"[103] and the inventory of Ralph Fishbourn, taken in Chester County in 1708, listed in the "outward Roome" "1/2 doz of oaken chairs."[104] Moses Key, a yeoman also residing in Chester County, had two oak chairs in his "Common Room."[105] Both in Phila-

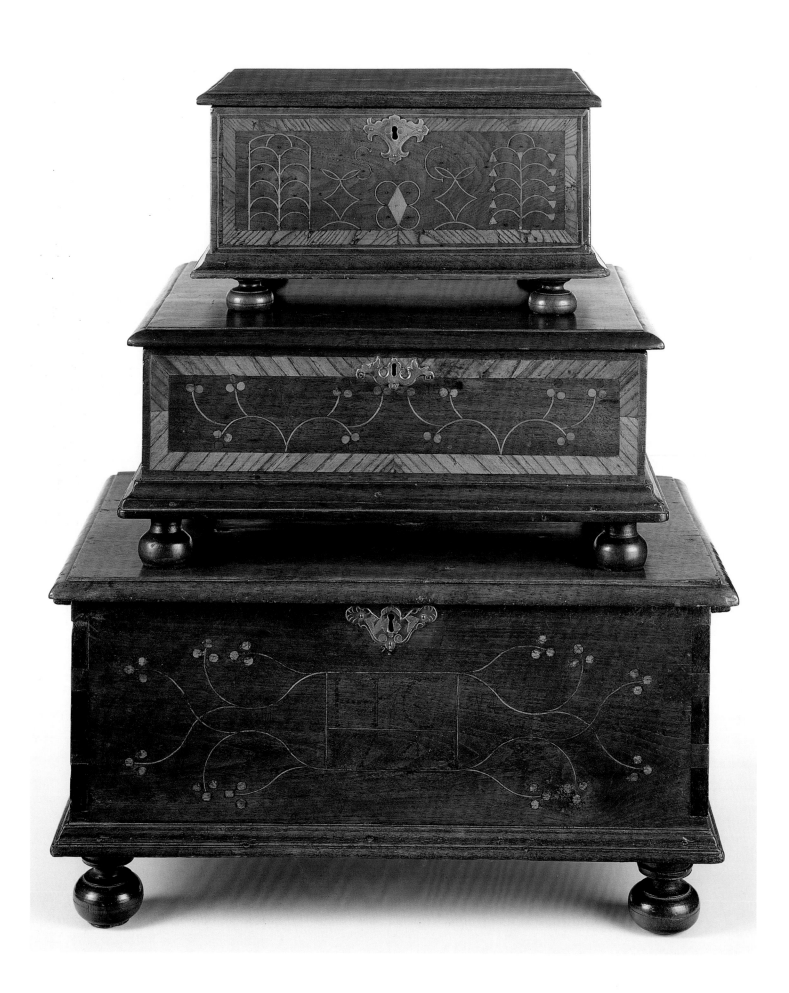

delphia and in rural Chester and Delaware counties the use of oak as a secondary wood persisted in some craftsmen's shops well into the third quarter of the eighteenth century.[106] Oak is also found in the interior structural frames of over-the-rail upholstered seating forms and in case furniture, where it was used for drawer sides and interior blocking (fig. 179). In Pennsylvania both red oak *(Quercus rubra)* and white oak *(Quercus alba)* were plentiful. In some instances, however, particularly in regional practices and for smaller furniture, chestnut *(Fagus castanea)* or hickory *(Juglans alba)*, somewhat similar in appearance and structure to oak, was used in case interiors, or as the turned structural elements in early joined seating furniture, such as Windsor chairs.

Black walnut, the wood most often used as a primary wood, is mentioned regularly in early Delaware Valley inventories. Named for its dark heart veins and deeply figured crotch graining, the tree was plentiful throughout the Mid-Atlantic region and the South. Walnut was ideal for panel-and-frame construction. Carvers liked the wood's even, predictable response to the chisel, and it was noted during the period as being "in great request with the Cabinet-makers for Inlaying, as also for Bedsteads, Stools, Tables, and Cabinets, being rarely infected with Insects, by reason of its Bitterness."[107] Its straight, even grain lent itself to turning and carving, while its density made for a good polished surface. Crotch- or "curled"-grain walnut boards were highly desirable and when finished resembled the darker grades of the finest mahogany; this walnut was rarely covered with a veneer (see no. 145). Walnut had been popular in England, France, and northern Europe, and there

is evidence that some raw walnut lumber may have been exported from Pennsylvania and Virginia to England.[108] In 1713 James Logan asked his London agent, John Askew, to secure "2 finest Virginia Walnut Chairs . . . ye same wth those I had of [Robert] Gam[m]age at ye Crown in Panels . . . with Paws at ye feet designed to suit ye others."[109]

Many Pennsylvania craftsmen's inventories and bills for finished cabinetwork document the early and extensive use of cherry and maple. The interior of Isaac Norris's Fairhill was noted as having a finely turned cherry banister rail running up the central staircase. Cherry was used in both cabinetmaking and chairmaking shops, and although household inventories record many examples of cherry chests, tables, chairs, and clock cases prior to 1750, few seem to have survived (see no. 35).[110] Many more examples of maple case furniture and chairs from the period are known. "Curled" maple, valued for its highly decorative grain as well as its strength and durability, was popular despite the difficulties its uneven density and ribbed grain presented to carvers and turners (see fig. 93). In 1748 Kalm observed that cherry had been largely depleted but that the use of highly figured maple stock continued: "There is a variety of this tree which they call the curled maple, the wood being as it were marbled within; it is much used in all kinds of joiners' work. . . . you frequently find trees whose outsides are marbled but their inside not."[111] Maple's strength made it popular as a structural wood in chairs and occasionally case furniture (see no. 39). Used in early Boston chairs with molded stiles, which were brought to Philadelphia as venture cargo in the years 1730–50, straight-grained hard maple

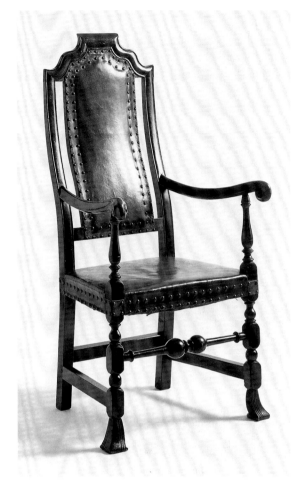

Fig. 180 (opposite page)
Three inlaid document boxes from the 1740s, nos. 2–4. Walnut, the primary wood used in these boxes, lent itself to the compass-scored patterns of inlay decoration such as was produced in Chester County among the English, Welsh, and Dutch Quakers who had settled there. Craftsmen sometimes practiced the designs and patterns by scoring them into shop lumber, leaving traces on the interior faces of drawers, case sides, or backboards.

Fig. 181
Armchair, c. 1735–45, no. 154. On June 14, 1744, the Philadelphia upholsterer Plunket Fleeson advertised in *The Pennsylvania Gazette* that he had for sale "Maple Chairs as cheap as from Boston." The shipment of Boston leather chairs to Philadelphia provided important design and construction prototypes for local chairmakers.

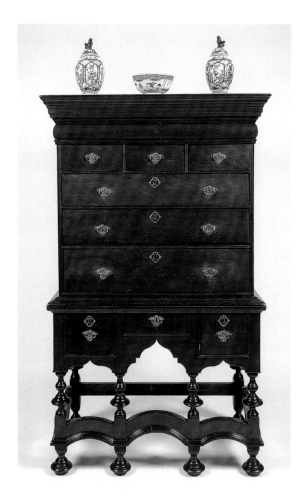

Fig. 182
High Chest, 1695–1720, no. 36. In this rare high chest, perhaps one of the earliest surviving Pennsylvania-made examples, cedar was used for both the primary and secondary wood. Its vertical arched stretcher, bold turnings, and heavy proportions relate it to contemporary Dutch and West Indian chests. The molded cornice conceals a long but shallow "torus" drawer, suitable for holding portfolio maps, charts, or large engraved prints.

lent itself to the lathe and to the refined profiles introduced in the plane-molded back stiles and crest rails of chairs. Judging from surviving examples, maple became the preferred stock of cabinetmakers and chairmakers such as Solomon Fussell, William Savery, and Joseph Armitt for making the economical slat-back or ladder-back rush-seated side chairs and armchairs so common in early Pennsylvania (see figs. 149, 150). Both Fussell and Savery regularly accepted maple lumber from clients as full or partial payment for their finished chairs and other work (see no. 56).[112] Cherry and maple were most often finished with deep red or brown stains, which enriched their figure and color and approximated the look of the finer walnut and mahogany. The character of these early stained surfaces has been largely lost or drastically altered by wear or through later refinishing.

Cedar, both the white (*Thuja occidentalis*) and red (*Juniperis Virginiana*), was used for primary and secondary woods in Philadelphia and Pennsylvania furniture.[113] In the earliest inventories of both city and rural houses, a number of cedar chests, desks, chairs, beds, and tables appear (see no. 67).[114] The 1720 Philadelphia inventory of Martha Waite, for example, lists "Cedar Chest Drawers Table & Cloth."[115] The wood continued to be used by cabinetmakers as a preferred secondary wood for drawer bottoms and case sides and backs throughout the eighteenth century. Although cedar was originally plentiful in the region, because it was resistant to rot, it was used extensively in the shipbuilding industries as well as for houses, so that the largest stands of the tree had been decimated by the 1750s. Cedar's workability with froe, plane, and lathe made

it popular for interior paneling and turned architectural woodwork, particularly among the Swedish craftsmen and English Quakers in West Jersey.[116] The lightness of cedar also made it a very good material for shingles and barrels. Cedar shingles were used in local building, and barrels made from the wood were commonly used for exporting pork and flour. Barrels, barrel staves, and shingles became major staples of the area, along with cedar lumber, and were heavily exported to the West Indies and other areas abroad.

The involvement of Philadelphia's merchants in the triangle trade established close ties with the West Indies. Bermudan and Barbadian red cedar, sometimes called "Maderah," was valued for its rich color, similar to that of mahogany, and it was imported both in its raw state and as finished furniture, made by West Indian craftsmen, prior to 1740.[117] In 1720 Nathaniel Allen, a prominent Philadelphia merchant with trade connections in Bermuda, asked his agent there to send "3 red Sedar Chairs with White Straw Bottoms and of the newest fashion 16 inches high in the seate with Low Backs."[118] In 1716 Joshua Cockfield of Philadelphia owned a "Bermudas Cedar Chest Drawers," and in 1704 Isaac Norris ordered through his Barbadian agent four white cedar chairs with flag seats to match examples he already owned.[119] Norris also had his parlor at Fairhill "wainscoted . . . with boards of red cedar," which may have been imported, given his extensive trade connections.[120] The popularity of cedar soon depleted West Indian sources, as it had in Philadelphia, and its use as a primary wood in furniture largely ceased.

Like the other lumber stocks, cedar was commonly listed in its various

milled states in the inventories of craftsmen.[121] Kalm wrote of local cedar in 1748: "The heart of this cedar is of a fine red color, and whatever is made of it looks very fine, and has a very agreeable and wholesome smell. But the color fades by degrees, or the wood would be very suitable for cabinet work. . . . However, I am told that the wood will keep its color if a thin varnish is put upon it while it is fresh. . . . people put the shavings and chips of it among their linen to secure it against being worm eaten. Some likewise get bureaus, [chests], etc. made of red cedar, for the same reason."[122] So desirable was the tree in the commerce of the early Delaware Valley that as its depletion became obvious, John Bartram experimented with its propagation and encouraged the planting of cedar trees, including instructions for this in the 1749 edition of Benjamin Franklin's *Poor Richard's Almanack*.[123]

A wealth of other local woods was also available for the furniture maker. Poplar or tulipwood, white pine, yellow pine, ash, apple, butternut, sycamore, sweet and red gum, and mulberry are only a few of those used by early craftsmen as both primary and secondary woods in cabinetry and chairmaking (fig. 183). Many of these woods, if used for primary surfaces, were often stained or painted. Of poplar, Kalm observed, "Its wood is here used for . . . all sorts of joiners' work. . . . Some joiners reckoned this wood better than oak, because the latter frequently is warped, while the former is not, and can easily be worked."[124] Elm, holly, pear, and many other woods were used for decorative inlays such as those found in the cabinetmaking traditions of the Welsh and English craftsmen of Chester County (see fig. 180).[125]

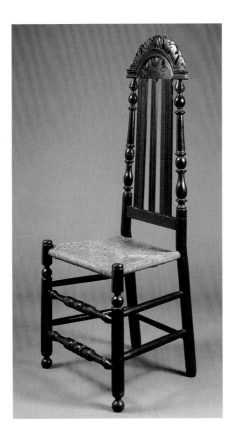

Various imported species of true mahogany, and several other exotic related woods close in appearance, were also available to the Pennsylvania craftsman and his patron surprisingly early, although surviving mahogany furniture from the decades prior to 1720 is quite rare. The extravagant cost of mahogany, an imported luxury, would have kept it from being widely used.[126] The few surviving examples of early mahogany furniture that are known seem to postdate the earliest manuscripts that document the availability of the wood in the region. The refined character of these examples provides further evidence that only the city's wealthiest, most elite class and the craftsmen they patronized had access to mahogany prior to 1750 (fig. 185).

It was the West Indies trade connections of such influential Philadelphia merchants as Samuel Carpenter, Samuel

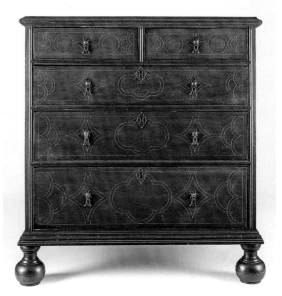

Fig. 183
Side Chair, 1720–40, no. 116. This turned chair makes use of ash, maple, and poplar for its structural and carved components, each chosen by the chairmaker for its particular physical properties. The varied surfaces were originally painted. Local carved-crest chairs such as this are rare and illustrate the multiple influences of Europe, England, and New England on early Philadelphia furniture.

Fig. 184
Chest, c. 1725–50, no. 29. The complicated inlaid patterns of intersecting arches and circles on the drawer fronts and the top of this chest, made in Chester County, required the use of a compass. Patterns such as these relate closely to the geometric designs of French, Dutch, and English baroque-inspired ceilings and formal gardens.

Fig. 185
Secretary Desk and Bookcase, c. 1735–45, no. 74. This richly appointed mahogany secretary desk illustrates an ambitious, accurate, and sophisticated use of classical Palladian and baroque designs from Dutch and English pattern books. Its low, broken-arch pedimented hood, side pilasters, and carved cartouche closely reflect the prevailing Dutch and English classicism of the late seventeenth century.

Fig. 186
Fall-Front Desk, c. 1705–25, no. 68. This fall-front desk, with its scroll bracket and turned base, is one of only four known examples of the form and is one of two versions executed in mahogany. Heavily milled, straight-grained mahogany is used for its case, an extravagant use of what was then an expensive and rare wood.

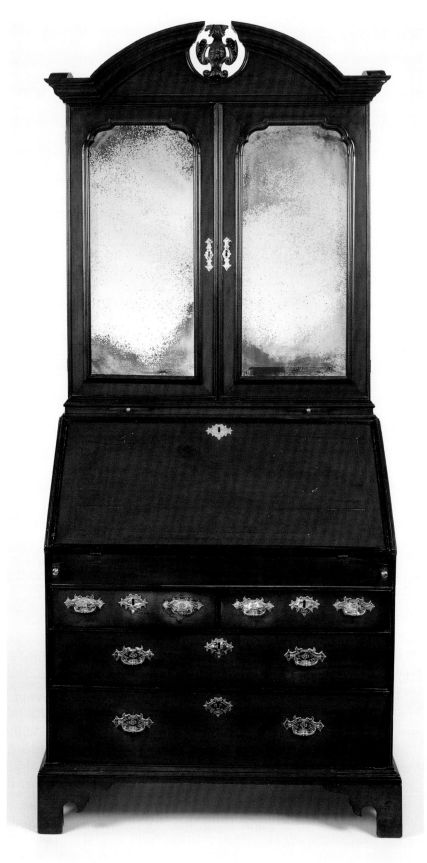

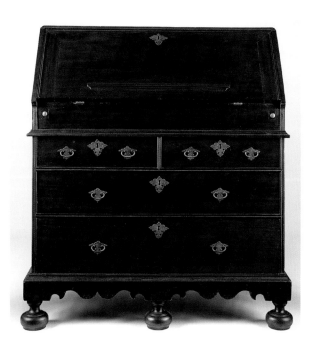

Fig. 187
Dressing Table, c. 1724, no. 52, view of top. Probably the most ornate example of inlaid and marquetry decoration to have survived from early Pennsylvania, this dressing-table top utilizes holly, cherry, walnut, elm, and other woods in its symmetrical yet flowing design. It would usually have been covered during use.

Richardson, Isaac Norris, and Jonathan Dickinson, among others, that brought the first shipments of mahogany to the city's ports (see no. 8). Dickinson's account book documents his importation of "Mohogony" into the city as early as 1698. In that year he writes to his brother and business partner Caleb in Jamaica, asking him to send "A Few fine woods for ye Joyners & Some Mohogony & [?] in board or Plank for Chest of Drawers & Tables & quarters for Frames . . . Lignum Vita for Turners Bastard Lignum Vita & Bully Tree—for Loggs & Round for Millwrights."[127] By 1701 he regularly sold mahogany planks to at least two Philadelphia cabinetmakers, John Johns and Abraham Hooper. Hooper paid Dickinson £18.5.10 for mahogany stock that year.[128] Dickinson's inventory, made upon his death in May 1722, documents his preference for the wood, listing the impressive numbers of seven mahogany chests of drawers, ten mahogany tables, and a "Mohogony Cloaths Press" in his richly furnished house.[129] Showing even more extravagance, Isaac Norris, apparently displeased with the fading of the

color of the red-cedar wainscot paneling he had installed in his parlor at Fairhill, later replaced it with mahogany.[130] By 1708 Charles Plumley, along with a growing number of Philadelphia cabinetmakers, kept mahogany boards or planks on hand.[131] Records of mahogany furniture appear with relative frequency in inventories of the wealthier households by 1720. For example, soon after her marriage to Joseph Paschall in 1721, the account book of Elizabeth Coates records "A Mohogany Chest of drawers & Table" and "A Mohogony Bedsted."[132] While the use of mahogany in chairmaking was rare in comparison to the preference for black walnut, mahogany chairs do appear in local inventories as early as 1734, and the wood is listed in the 1740s account book of Solomon Fussell, one of the leading chairmakers in the city.[133]

Veneering and marquetry techniques had long been practiced in the areas of France, Germany, northern Europe, and England from which many Pennsylvania woodworkers had emigrated, but its use in the colony is quite rare prior to 1735 (fig. 187).[134] Perhaps the plentiful

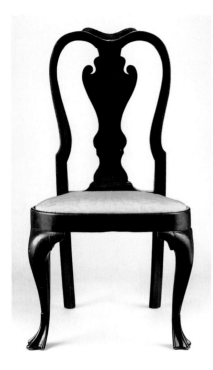

Fig. 188
Side Chair, c. 1735–45, no. 122.
Lamination and veneering were
often used on the frames of cabri-
ole-leg chairs. The lower, inside
edges of the back stiles on many
compass-seat, cabriole-leg exam-
ples have a glued lamination cut
from the corresponding outer edge
of the point of the most pro-
nounced inward curve of the back
stile of the chair. In this way crafts-
men could conserve wood.

supplies of local woods such as walnut
and the additional labor required in ve-
neering and marquetry combined to li-
mit its use in early furniture. Because of
the high cost of mahogany, however, or
the difficulty in acquiring the choicest
figured grain of the wood during the years
it was first imported to Pennsylvania,
some local craftsmen working with the
wood adapted traditional veneering and
lamination techniques. Cabinetmakers
selecting mahogany, walnut, maple, and
other highly figured woods often did so
based upon the grain visible in the exte-
rior face of a log or thick plank, which had
been crudely squared to make its trans-
port and stacking more manageable. If
thick stocks of a desired grain were pur-
chased for a specific use, the cabinet-
maker ran the risk that the natural outer
markings would diminish or "die out"
in the inner grain as the stock was cross-
sectioned and milled into lumber. When
this occurred, in order to achieve the coor-
dinated patterns of the decorative grained
woods often called for in the drawers
and doors of larger case pieces, the rarer,
highly figured wood would often be
milled and used as a thick veneer. Some
cabinetmakers resorted to facing drawer
fronts and larger areas such as door pa-
nels with quarter-inch- to half-inch-thick
layers of a superior grained mahogany
laid over lower-quality straight-grained
mahogany (see no. 73). In other cases, a
figured veneer was laid over a different,
lower-quality secondary wood such as
pine or maple.[135] In addition, to avoid
waste cabinetmakers using mahogany,

walnut, and other primary woods made
use of small laminations glued to a piece
of stock being fashioned into a shaped,
turned, or carved leg, foot, or back stile,
at the outermost projection of the form,
to provide the dimensions necessary for
the turner or carver (fig. 188).

Toward the end of the 1750s increased
importation of mahogany in Philadel-
phia resulted in lower prices. Its greater
availability and the growing taste for the
richly carved surfaces of rocaille orna-
mentation brought an increased
demand for mahogany, and it began to
supplant black walnut as the preferred
wood for fine cabinetry and chairmak-
ing. Throughout the eighteenth century,
however, mahogany, walnut, maple, and
in some cases cherry continued to be
used regularly in most shops, depend-
ing on the preference of the patron and
the cost of the commission.

The furniture craftsmen working in
the Delaware Valley found their way
through the many difficulties of settling
in a new and evolving community to
create an amazingly rich visual testa-
ment to their perseverance and talents.
The period from 1680 to 1758 was one
of intense economic development, rapid
social and technological change, and the
convergence of a variety of international
stylistic traditions. Employing lessons
gleaned from their training, experiences,
and experimentation, the colony's crafts-
men transformed raw materials with
rich creativity to define and shape the
material culture that enriched Penn-
sylvania's early lifestyles and aesthetics.

Notes

1. Lynford Lardner to Joseph Galloway, April 28, 1751, private collection. Transcript in the archives of the Philadelphia Museum of Art, Department of American Art, research file 1992-156-1.

2. See Jack L. Lindsey, "Lynford Lardner's Silver: Early Rococo in Philadelphia," *Antiques*, vol. 143, no. 4 (April 1993), pp. 608–15.

3. William Branson to Lynford Lardner, October 3, 1749, private collection. Transcript in the archives of the Philadelphia Museum of Art, Department of American Art, research file 1992-156-1.

4. While there is currently little documentation to show that Pennsylvania craftsmen or their patrons owned or made use of specific imported pattern books prior to 1750, imported objects, illustrated texts, decorative prints, and descriptive newspaper accounts, widely available in the colony, supplied a wealth of patterns for those seeking the latest foreign fashion in furniture or decorations.

5. Nathaniel Luff, *Journal of the Life of Nathaniel Luff, M.D., of the State of Delaware* (New York, 1848), pp. 12–14; quoted in Richard L. Bushman, *The Refinement of America: Persons, Houses, Cities* (New York: Alfred A Knopf, 1992), pp. 19–27.

6. John Locke, *Some Thoughts Concerning Education,* 5th ed. (London, 1705), §93; see James L. Axtell, *The Educational Writings of John Locke: A Critical Edition with Introduction and Notes* (Cambridge: University Press, 1968), p. 190.

7. Henry Peacham, *The Complete Gentleman, The Truth of Our Times, and The Art of Living in London,* ed. Virgil B. Heltzel (1634; Ithaca, N.Y.: Cornell University Press, 1962), pp. 117, 121.

8. See Bushman, *The Refinement of America,* p. 93. Bushman provides an extensive and thorough examination of early ideas on civility in colonial America.

9. Britain placed restrictions on the amount of assets that many emigrating Quakers could take with them.

10. For examples, see Margaret B. Schiffer, *Chester County, Pennsylvania, Inventories, 1684–1850* (Exton, Pa.: Schiffer Publishing Company, 1974). Schiffer's book, one of the earliest to document the region of Chester County, illustrates and discusses numerous versions of vernacular forms of dressing tables, tea tables, etc.

11. In addition to the upward mobility of the lower classes, there were other factors present in Pennsylvania that blurred the signals of social status projected by dress and by ways of interacting in social situations. The direct manner and relatively simple cut of dress among adherents to simplicity like the Quakers and deistic intellectuals included few visible signs of style, status, or wealth. In addition, the strong traditions of ethnic dress and the festivals and social interactions among immigrant groups such as the Germans and Swedes had their own stratified systems of styles, symbols, and behavior.

12. Isaac Norris to Jonathan Scarth, October 21, 1726, Norris Letter Book, 1716–30, pp. 474–75, The Historical Society of Pennsylvania, Philadelphia; quoted in Gary B. Nash, *The Urban Crucible: Social Change, Political Consciousness, and the Origins of the American Revolution* (Cambridge, Mass., and London: Harvard University Press, 1979), p. 153.

13. Intermarriages within the city's leading families were common. By mid-century most of Philadelphia's elite society was united through a surprisingly close network of intermarriages that often crossed religious but rarely social divisions.

14. Epistle dated September 21, 1698; quoted in Frederick B. Tolles, *Meeting House and Counting House: The Quaker Merchants of Colonial Philadelphia, 1682–1763* (Chapel Hill: University of North Carolina Press, 1948), p. 128.

15. James Logan, *The Charge Delivered from the Bench to the Grand Jury . . .* (Philadelphia, 1723); quoted in Edwin B. Bronner, "Village into Town, 1701–1746," in *Philadelphia: A 300-Year History,* ed. Russell F. Weigley (New York and London: W. W. Norton and Company, 1982), p. 33.

16. See Rufus M. Jones, *The Quakers in the American Colonies* (1911; repr. London: Macmillan, 1923); quoted in Thomas J. Wertenbacker, *The Founding of American Civilization: The Middle Colonies* (New York and London: Charles Scribner's Sons, 1938), p. 200.

17. Christopher Sauer to brothers and friends, December 1, 1724; quoted in R. W. Kelsey, "An Early Description of Pennsylvania," *Pennsylvania Magazine of History and Biography,* vol. 45, no. 1 (1921), pp. 252–53.

18. Carl Bridenbaugh, ed., *Gentleman's Progress: The Itinerarium of Dr. Alexander Hamilton, 1744* (Chapel Hill: University of North Carolina Press, 1948), p. 22.

19. Carl Bridenbaugh and Jessica Bridenbaugh, *Rebels and Gentlemen: Philadelphia in the Age of Franklin* (New York: Reynal and Hitchcock, 1948), pp. 16–17.

20. Francis Daniel Pastorius observed in 1700 that even in the caves some comforts were achieved: "Herein we lived more Contentedly than many nowadays in their painted and wainscotted Palaces," Albert Cook Myers, ed., *Narratives of Early Pennsylvania, West New Jersey, and Delaware, 1630–1707* (New York: Charles Scribner's Sons, 1912), pp. 404–5, note 10.

21. See also Trinity Church in Oxford, Pennsylvania, built c. 1711. For other brick structures that include the use of decorative glazed headers in their construction, see Old Swedes' Church (Gloria Dei) in Philadelphia, built c. 1700, and a series of English Quaker and Swedish brick houses in Salem and Gloucester County, New Jersey, dating c. 1740–55. In Flemish bond, rows of alternating short and long faces of bricks (headers and stretchers) are staggered vertically to avoid adjoining mortar joints in the wall. A "glazed header" refers to the end of a brick that was directly exposed to the most intense heat during firing in the brick kiln and received a deposit of dark wood-ash glaze.

22. The author wishes to thank Martha McCrary Halpern of the Philadelphia Museum of Art, Department of American Art, for her extensive research, experience, and insights on the architectural sections of this essay.

23. In 1683 Thomas Paskel, an English immigrant among the "First Purchasers," noted of the local Finns and Swedes: "In the construction of their houses they use little or no iron. They will build you a house without any instrument other than a hatchet"; see Grant Miles Simon, "Houses and Early Life in Philadelphia," in *Historic Philadelphia from the Founding until the Early Nineteenth Century,* Transactions of the American Philosophical Society, vol. 43, part 1 (Philadelphia: American Philosophical Society, 1953), p. 283. Variations and combinations of log or half-timbered construction, with wattle-and-daub, brick-filled, or clapboard walls, were also practiced by the Germanic populations in the area—the Moravian Brethren, the Schwenkfelders, and the Mennonites in Bucks County and in the sectarian cloistered communities of Ephrata and Bethlehem.

24. See Myers, *Narratives of Early Pennsylvania,* p. 304; quoted in Robert C. Smith, "Two Centuries of Philadelphia Architecture, 1700–1900," in *Historic Philadelphia from the Founding until the Early Nineteenth Century,* Transactions of the American Philosophical Society, vol 43, part 1 (Philadelphia: American Philosophical Society, 1953), p. 289.

25. See *Historic Philadelphia,* pp. 26, 44, 96, 187–89, 210–12, for examples and illustrations.

26. Logan's copy of *Vitruvius Britannicus* has notations with the date 1725. See also Roger W. Moss, Jr., "The Origins of The Carpenters' Company of Philadelphia," in *Building Early*

America: Contributions toward the History of a Great Industry, ed. Charles Peterson (Radnor, Pa.: Chilton Book Company, 1976), pp. 48–49.

27. For further discussions of the examples of early Philadelphia architecture cited here, see Beatrice B. Garvan in Philadelphia Museum of Art, *Philadelphia: Three Centuries of American Art* (Philadelphia: Philadelphia Museum of Art, 1976), pp. 11–13, 32–34, 41–42, 60–61.

28. William Penn, *A Further Account of the Province of Pennsylvania* (London, 1685); reproduced in Myers, *Narratives of Early Pennsylvania,* pp. 269–71. See also John F. Watson, *Annals of Philadelphia, and Pennsylvania, in the Olden Time,* rev. ed., vol. 1 (Philadelphia: Edwin S. Stuart, 1887), p. 49. For the architectural character of the communities around Philadelphia, see the account of Peter Kalm, a Swedish botanist who traveled extensively in the Delaware Valley during the 1740s: *The America of 1750: Peter Kalm's Travels in North America,* English edition, rev. and ed. Adolph B. Benson, vol. 1 (New York: Dover Publications, 1966), pp. 39, 49, 82–84, 87, 99–100, 116–19.

29. Carpenter rose to further prominence as one of the city's leading political and cultural leaders and was noted during the period for his taste and comfortable lifestyle. His business acumen in world trade markets helped place the colony prominently in international circles.

30. Mark Reinberger and Elizabeth McLean, "Isaac Norris's Fairhill: Architecture, Landscape, and Quaker Ideals in a Philadelphia Colonial Country Seat," *Winterthur Portfolio,* vol. 32, no. 4 (Winter 1997), pp. 243–74.

31. Quoted in Roger W. Moss, *Historic Houses of Philadelphia* (Philadelphia: University of Pennsylvania Press, 1998), p. 144.

32. A variety of types of early Delaware Valley houses with corner fireplaces survive. See, for example, the John Chads House in Chadds Ford, Pennsylvania (c. 1725); Pomona Hall in Camden, New Jersey (1726); and Pottsgrove Manor in Pottstown, Pennsylvania (c. 1743–45). Corner fireplaces with ornate over-brackets for the display of ornamental porcelains were popularized and published in Holland and England through the designs and portfolios of the French architect and designer Daniel Marot during the late seventeenth and early eighteenth century.

33. See Moss, *Historic Houses of Philadelphia,* p. 144; I would like to thank Martha McCrary Halpern for her observations on Stenton.

34. See William MacPherson Hornor, Jr., *Blue Book of Philadelphia Furniture: William Penn to George Washington* (1935; Washington, D.C.: Highland House Publishers, 1977), p. 52.

35. Register of Wills, City of Philadelphia, Sarah Logan, 1754, Will no. 121; transcription in research file "Stenton," Department of American Art, Philadelphia Museum of Art.

36. For a thorough examination of regional inventories from the period, see Schiffer, *Chester County, Pennsylvania, Inventories.* Because of their context and variations in their contents, household inventories must be considered with care. Inventories were usually required for estate probate and were taken by executors or trusted friends upon the death of the householder.

37. Schiffer, *Chester County, Pennsylvania, Inventories,* p. 310.

38. Registrar of Wills, City of Philadelphia, Patrick Gordon, 1736, Will no. 1; copy in research file 1991-158-1,2, Department of American Art, Philadelphia Museum of Art. Eighteenth-century colonial representatives of the English crown were authorized to spend £3,000 on silver in the fitting out of their residences in order to be able to make the correct impressions when entertaining. During his tenure as governor, Patrick Gordon and his wife annually held a festive ball at their stylish town house honoring Frederick Louis, the Prince of Wales.

39. Schiffer, *Chester County, Pennsylvania, Inventories,* p. 221.

40. Harrold E. Gillingham, "Notes and Documents: The Estate of Jonathan Dickinson," *The Pennsylvania Magazine of History and Biography,* vol. 59, no. 4 (October 1935), p. 424; see also Hornor, *Blue Book of Philadelphia Furniture,* p. 69.

41. Hornor, *Blue Book of Philadelphia Furniture,* p. 67. Local inventories record that "steps" on boxes and the tops of high chests were also used for display. No documented local examples of such stepped boxes are known to survive.

42. John Reynell to Daniel Flexney, November 25, 1738, Reynell Letter Book, 1738–41; see Tolles, *Meeting House and Counting House,* p. 128; also Arthur W. Leibundguth, "The Furniture-Making Crafts in Philadelphia, c. 1730–c. 1760" (master's thesis, University of Delaware, 1964), p. 36.

43. Thomas Chalkley Account Book, entry for April 26, 1722, Library Company of Philadelphia; quoted by Garvan in *Philadelphia: Three Centuries of American Art,* p. 15.

44. Cathryn J. McElroy, "Furniture in Philadelphia: The First Fifty Years," in *American Furniture and Its Makers,* Winterthur Portfolio, vol. 13, ed. Ian M. G. Quimby (Chicago and London: University of Chicago Press, 1979), p. 69.

45. See Hornor, *Blue Book of Philadelphia Furniture,* p. 14.

46. From William Penn's *The Fruits of Solitude* (1693), maxim 220; see *A Collection of the Works of William Penn,* vol. 1 [Joseph Besse, ed.] (London, 1726), p. 831.

47. For a complete examination of William Penn's philosophy on gardens, and on his plans for Pennsbury, see Carol G. Weener, "Pennsbury Manor: A Study in Colonial Revival Preservation" (unpublished master's thesis, University of Pennsylvania, 1986).

48. Notes taken from a lecture given by Mr. C. Allan Brown on "Villa Culture in England and America," at the University of Virginia, Charlottesville, October 1997, research files, Department of American Art, Philadelphia Museum of Art.

49. See Gabriel Thomas, *An Historical and Geographical Account of the Province and Country of Pensilvania; and of West-New-Jersey in America* (London: A. Baldwin, 1698); reproduced in Myers, *Narratives of Early Pennsylvania,* p. 332. See also Watson, *Annals of Philadelphia, and Pennsylvania,* vol. 1, pp. 39, 72. Given this description, Shippen's "tranquil deer" may have been contained by a hidden garden moat or ditch, known as an "a ha" in English formal gardens of the period.

50. See Benno M. Forman, "The Chest of Drawers in America, 1635–1730: The Origins of the Joined Chest of Drawers," *Winterthur Portfolio,* vol. 20, no. 1 (Spring 1985), pp. 26–27.

51. See Garvan in *Philadelphia: Three Centuries of American Art,* pp. 5, 7–8.

52. J. Francis Fisher Copies, Penn Papers, p. 14, The Historical Society of Pennsylvania, Philadelphia; quoted in McElroy, "Furniture in Philadelphia," p. 62.

53. *Some Letters . . . from Pennsylvania, London, 1691,* The Pennsylvania-German Society Proceedings and Addresses, vol. 9, ed. and trans. Samuel Pennypacker (October 1898), p. 185; see Stephanie Grauman Wolf, *Urban Village: Population, Community, and Family Structure in Germantown, Pennsylvania, 1683–1800* (Princeton: Princeton University Press, 1976), p. 113.

54. See Mary Maples Dunn and Richard S. Dunn, "The Founding, 1681–1701," in *Philadelphia: A 300-Year History,* ed. Russell F. Weigley (New York and London: W. W. Norton and Company, 1982), pp. 20–21.

55. Gabriel Thomas, *An Historical and Geographical Account of the Province and Country of Pensilvania;* see Myers, *Narratives of Early Pennsylvania,* pp. 226–28.

56. *American Weekly Mercury*, no. 910, June 2, 1737; *The Pennsylvania Gazette*, no. 549, June 14–21, 1739; quoted in Leibundguth, "The Furniture-Making Crafts in Philadelphia," p. 40.

57. *The Pennsylvania Gazette*, no. 493, May 18–25, 1738.

58. R. Campbell, *The London Tradesman: Being a Compendious View of All the Trades, Professions, Arts, both Liberal and Mechanic, . . .* (London: T. Gardner, 1747; repr. New York: Augustus M. Kelley Publishers, 1969).

59. See Barbara McClean Ward, "The European Tradition and the Shaping of the American Artisan," in *The American Craftsman and the European Tradition, 1620– 1820*, ed. Francis J. Puig and Michael Conforti (Minneapolis: The Minneapolis Institute of Arts, 1989), pp. 14–15.

60. Account of Servants and Apprentices Bound and Assigned before James Hamilton, Mayor of Philadelphia (1745–46), mss., p. 34, The Historical Society of Pennsylvania, Philadelphia; quoted in Leibundguth, "The Furniture-Making Crafts in Philadelphia," p. 10.

61. See George H. Eckhardt, *Pennsylvania Clocks and Clockmakers: An Epic of Early American Science, Industry, and Craftsmanship* (New York: Bonanza Books, 1955), p. 172. See also James W. Gibbs, *Pennsylvania Clocks and Watches: Antique Timepieces and Their Makers* (University Park, Pa., and London: Pennsylvania State University Press, 1984), pp. 20, 120–21.

62. See *Pennsylvania Clocks and Watches*, pp. 24, 120–21.

63. Kelsey, "An Early Description of Pennsylvania," p. 252.

64. Eckhardt, *Pennsylvania Clocks and Clockmakers*, p. 179.

65. For extensive research on English and Germanic craftsmen and craftsmanship in chairmaking in early Chester, Delaware, and Philadelphia counties, see Benno M. Forman, *American Seating Furniture, 1630–1730: An Interpretive Catalogue* (New York and London: W. W. Norton and Company, 1988).

66. Forman, *American Seating Furniture*, pp. 140– 41, 164.

67. A larger shop could also purchase individual parts in volume to speed production and efficiency.

68. See, for example, Martha Gandy Fales, *Joseph Richardson and Family: Philadelphia Silversmiths* (Middletown, Conn.: Wesleyan University Press, 1974), pp. 211–64.

69. *The Pennsylvania Gazette*, no. 719, September 23, 1742.

70. Joseph Richardson Ledger, 1734–40, The Historical Society of Pennsylvania, Philadelphia; quoted by Garvan in *Philadelphia: Three Centuries of American Art*, p. 45. "Small work" in gold or silver referred to jewelry, buckles, patch boxes, etc. Many of these small objects were imported from England and then struck with local silversmiths' marks and sold as their own productions.

71. Elliott, who often applied a bilingual label in German and English on the backboards of the looking glasses he sold or made, first advertised in the December 30, 1756, edition of *The Pennsylvania Gazette* (no. 1462) that he had for sale "A Neat assortment of looking glasses" and that he supplied "Looking glasses new quicksilver'd, or framed, in the neatest manner" from his shop on Chestnut Street.

72. Family Accounts, Norris of Fairhill, vol. 1, 1740–73, p. 20, The Historical Society of Pennsylvania; quoted in Leibundguth, "The Furniture-Making Crafts in Philadelphia," p. 26.

73. See Leibundguth, "The Furniture-Making Crafts in Philadelphia," p. 19.

74. Ibid., p. 21.

75. See Hornor, *Blue Book of Philadelphia Furniture*, p. 127.

76. Account Book of Solomon Fussell, 1738–50, mss., Stephen Collins Papers, Library of Congress, Washington, D.C.; see Leibundguth, "The Furniture-Making Crafts in Philadelphia," pp. 19–20.

77. The regular movement of specialized carvers, engravers, and other independent craftsmen from shop to shop makes the attribution of undocumented examples to specific craftsmen, based on physical characteristics, difficult if not impossible.

78. Invoice and Day Book of Samuel Powell, Jr., 1747–50, The Historical Society of Philadelphia, Pennsylvania; quoted in Leibundguth, "The Furniture-Making Crafts in Philadelphia," p. 85.

79. Ibid., p. 24.

80. Moss, "The Origins of the Carpenter Company of Philadelphia," pp. 35–53; see also Charles E. Peterson, "Carpenters' Hall," in *Historic Philadelphia from the Founding until the Early Nineteenth Century*, Transactions of the American Philosophical Society, vol. 43, part 1 (Philadelphia: American Philosophical Society, 1953), pp. 96–128.

81. Constant Truman (Benjamin Franklin), *Advice to the Free-Holders and Electors of Pennsylvania* (Philadelphia, 1735), p. 2; quoted in Nash, "A Historical Perspective on Early American Arti-

sans," in *The American Craftsman and the European Tradition, 1620–1820*, ed. Francis J. Puig and Michael Conforti (Minneapolis: The Minneapolis Institute of Arts, 1989), p. 4.

82. Penn, *A Further Account of the Province of Pennsylvania* (London[?], 1685), in Myers, *Narratives of Early Pennsylvania*, p. 261.

83. Leibundguth, "The Furniture-Making Crafts in Philadelphia," pp. 132–36.

84. Register of Wills, City of Philadelphia, John Fellows, 1694, Will no. 104; quoted in Hornor, *Blue Book of Philadelphia Furniture*, p. 8.

85. James Logan Account Book, 1716–21, p. 245, The Historical Society of Pennsylvania; quoted in Forman, *American Seating Furniture*, p. 54.

86. Forman, *American Seating Furniture*, pp. 41–42. Particularly in more rural communities, those practicing the livelihoods of both carpenters and farmers on a part-time basis were regularly called upon to produce household furniture.

87. *A General Description of All Trades, Digested in Alphabetical Order . . .* (London, 1747), p. 124; quoted in Forman, *American Seating Furniture*, p. 42. No comparable American publications from the period that describe the distinctions of craftsmen's trades and practices are known, so that this volume provides the clearest picture of the guild organization that influenced American craft shops.

88. Kalm, *Travels in North America*, vol. 1, p. 221. Specialty turners also supplied small treen, bone, ivory, or hardwood components for other craftsmen, such as silversmiths.

89. Campbell, *The London Tradesman*, pp. 171–72; quoted in Forman, *American Seating Furniture*, p. 45.

90. *A General Description of All Trades*, pp. 57–58; quoted in Forman, *American Seating Furniture*, p. 54. Some of the larger chairmaking shops in Pennsylvania employed craftsmen such as turners on a full-time basis or their masters had turning skills.

91. *The Pennsylvania Gazette*, no. 809, June 14, 1744; reproduced in Alfred Coxe Prime, *Colonial Craftsmen of Pennsylvania: Reproductions of Early Newspaper Advertisements from the Private Collection of Alfred Coxe Prime* (Philadelphia: Pennsylvania Museum and School of Industrial Art, 1925), p. 4. Boston chairmaking enterprises had been established well before those in Philadelphia. There were also many more of such enterprises in Boston, and they produced chairs in greater numbers and of lighter construction, thereby reducing their prices.

92. Available by order through agents or merchants, tools were also sold as venture cargo on the city's wharves.

93. Franklin's copy of Moxon is in the collection of the Library Company of Philadelphia. William Branson's and Robert Smith's copies remain in the libraries of their descendants. Benno Forman notes that many of Moxon's illustrations of tools were plagiarized and reproduced from a 1676 French publication; see Forman, *American Seating Furniture*, p. 46.

94. Lee-Ellen Griffith, "Line and Berry Inlaid Furniture: A Regional Craft Tradition in Pennsylvania, 1682–1790" (Ph.D. diss., University of Pennsylvania, 1988), pp. 21–23.

95. Register of Wills, City of Philadelphia, Charles Plumley, 1708, Will no. 113; Plumley's inventory is published in Forman, *American Seating Furniture*, pp. 371–72; see also pp. 47–49. While these citings documenting the use and availability of veneers in Philadelphia cabinetmaking are the earliest known, few surviving locally produced examples from this period employing veneer have been identified. Possibly because of its scarcity and high cost, mahogany was used as veneer in some of its earliest usages in the city. See, for example, nos. 8, 39, 73.

96. Because so few examples of the earliest, simple utilitarian furniture forms, or the less expensive versions made for the lower classes, survive, it is easy to forget that much of this furniture may have had pine, poplar, cedar, or oak as primary woods. Inventories document a much higher use of these woods during the earliest period of furniture making than surviving furniture would indicate.

97. William Penn, *A Letter from William Penn . . . to the Committee of the Free Society of Traders* (London, 1683); reproduced in Myers, *Narratives of Early Pennsylvania*, p. 227.

98. Kalm, *Travels in North America*, vol. 1, p. 220.

99. Ibid., p. 51.

100. Israel Acrelius, *A History of New Sweden; or, The Settlements on the River Delaware*, Memoirs of the Historical Society of Pennsylvania, vol. 2, trans. and ed. William M. Reynolds (Philadelphia: The Historical Society of Pennsylvania, 1874), p. 157; quoted in Hornor, *Blue Book of Philadelphia Furniture*, p. 40.

101. Wood often made up a sizable portion of the total value assigned to the inventories of larger joiner or cabinetmaker shops during the period.

102. Register of Wills, City of Philadelphia, John Fellows, 1694, Will no. 104; quoted in Hornor, *Blue Book of Philadelphia Furniture*, p. 7. "Plank"

referred to thickly milled stock that was ready to be further milled into thinner "boards." "Scantling" was a term applied during the period to a variety of smaller, thinner stock that was usually riven.

103. Forman, "The Chest of Drawers in America," p. 26.

104. Hornor, *Blue Book of Philadelphia Furniture*, p. 8.

105. Schiffer, *Chester County, Pennsylvania, Inventories*, p. 201.

106. The Welsh and English tradition of using oak as a secondary wood was maintained by Welsh immigrants in Chester and Delaware counties into the 1780s.

107. See Hornor, *Blue Book of Philadelphia Furniture*, p. 42.

108. For a detailed discussion of this debate, see Forman, *American Seating Furniture*, pp. 30–32, where Forman argues convincingly that economics probably prevented large amounts of American walnut from being exported abroad.

109. James Logan to John Askew, March 20, 1712/13, and August 1, 1713, Logan Papers, James Logan Letter Book, The Historical Society of Pennsylvania, Philadelphia; quoted in Forman, *American Seating Furniture*, p. 32.

110. Schiffer, *Chester County, Pennsylvania, Inventories*, pp. 271–72, and Hornor, *Blue Book of Philadelphia Furniture*, pp. 45, 192. Cherry can also be found in random usages as back splats, legs, or stretchers in local ladder-back and splat-back chairs from these early years.

111. Kalm, *Travels in North America*, vol. 1, pp. 88–89.

112. Leibundguth, "The Furniture-Making Crafts in Philadelphia," p. 52.

113. Cedar was probably used alongside white and red juniper, a similar conifer indigenous to the Delaware Valley. Craftsmen's records during the period did not differentiate between the two woods, and Kalm noted their similarities and parallel applications: *Travels in North America*, vol. 1, pp. 62–63, 85. Their appearance and working characteristics are also closely related.

114. Schiffer, *Chester County, Pennsylvania, Inventories*, p. 271.

115. Registrar of Wills, City of Philadelphia, Martha Waite, 1720, Will no. 210; quoted in McElroy, "Furniture in Philadelphia," p. 71.

116. In New Jersey, early Quaker meetinghouses such as "Seaview Friends" (built 1717) in Cape May County and "Rancocas Meeting" in Burling-

ton County (built c. 1745) have cedar interiors. See also "Two Early Letters from Germantown," *Pennsylvania Magazine of History and Biography*, vol. 84, no. 2 (April 1960), p. 200, for further observations on the use of cedar.

117. Furniture made in Philadelphia also made its way to different ports along the West Indies trade routes, and the styles of turned-leg chests and wainscot-paneled and cabriole-leg seating furniture made in Philadelphia demonstrate marked influences from related West Indian, English, and Dutch styles. For cedar furniture from Bermuda, see Bryden Bordley Hyde, *Bermuda's Antique Furniture and Silver* (Hamilton, Bermuda: The Bermuda National Trust, 1971). See also, for example, Dean A. Fales, Jr., *The Furniture of Historic Deerfield* (New York: E. P. Dutton and Company, 1976), p. 146, fig. 306.

118. Richardson Family Papers, Letter Book of Nathaniel and Hannah Allen, 1716–35, entry for September 7, 1720, Joseph Downs Manuscript Library, Winterthur Museum; quoted in McElroy, "Furniture in Philadelphia," p. 64.

119. Hornor, *Blue Book of Philadelphia Furniture*, p. 46.

120. Kalm, *Travels in North America*, vol. 1, p. 302–3.

121. See McElroy, "Furniture in Philadelphia," pp. 61–80; see also Hornor, *Blue Book of Philadelphia Furniture*, p. 46.

122. Kalm, *Travels in North America*, vol. 1, pp. 302–3.

123. *Poor Richard's Almanack*, 1749, pp. 1–3.

124. Kalm, *Travels in North America*, vol. 1, p. 108.

125. For early Pennsylvania inventories that include furniture constructed of these various woods, see Schiffer, *Chester County, Pennsylvania, Inventories*, pp. 267–82, and McElroy, "Furniture in Philadelphia," pp. 62–75.

126. For instance, there are no known mentions of the presence of the wood in the outlying region and in the towns surrounding Philadelphia prior to the 1720s, when it is documented in lumber form in Chester County. Also, early household inventories show the extreme rarity of mahogany furniture outside of Philadelphia; only one tea table of mahogany, in Haverford, Chester County, is documented. See Schiffer, *Chester County, Pennsylvania, Inventories*, p. 274.

127. Jonathan Dickinson Letter Book, 1698–1701, entry for February 25, 1698, The Historical Society of Pennsylvania, Philadelphia; quoted in McElroy, "Furniture in Philadelphia," p. 72.

128. Jonathan Dickinson Ledger, 1699–1701, p. 15, The Historical Society of Pennsylvania, Philadelphia; quoted in McElroy, "Furniture in Philadelphia," p. 72.

129. Register of Wills, City of Philadelphia, Jonathan Dickinson, 1722, Will no. 251; see Gillingham, "The Estate of Jonathan Dickinson," p. 423.

130. Kalm, *Travels in North America,* vol. 1, pp. 302–3.

131. Hornor, *Blue Book of Philadelphia Furniture,* p. 46.

132. Ibid., p. 47.

133. See Leibundguth, "The Furniture-Making Crafts in Philadelphia," p. 59.

134. Marquetry, a veneering technique that employs shaped pieces of wood arranged in geometric or figural patterns laid over or inset into the surface of a piece of furniture, differs from true inlay, which is inset directly into the primary wood of a furniture piece. The shaped elements can be inlaid together with additional materials such as bone or ivory, as is seen occasionally in local decorative treatments.

135. Several examples in the furniture checklist demonstrate this technique; see, for example, nos. 8, 39, 73. For an additional example of a high chest, c. 1735–50, see Sotheby's, New York, "Important Americana: Furniture and Folk Art," January 16–17, 1999, lot 621.

Checklist of the Exhibition

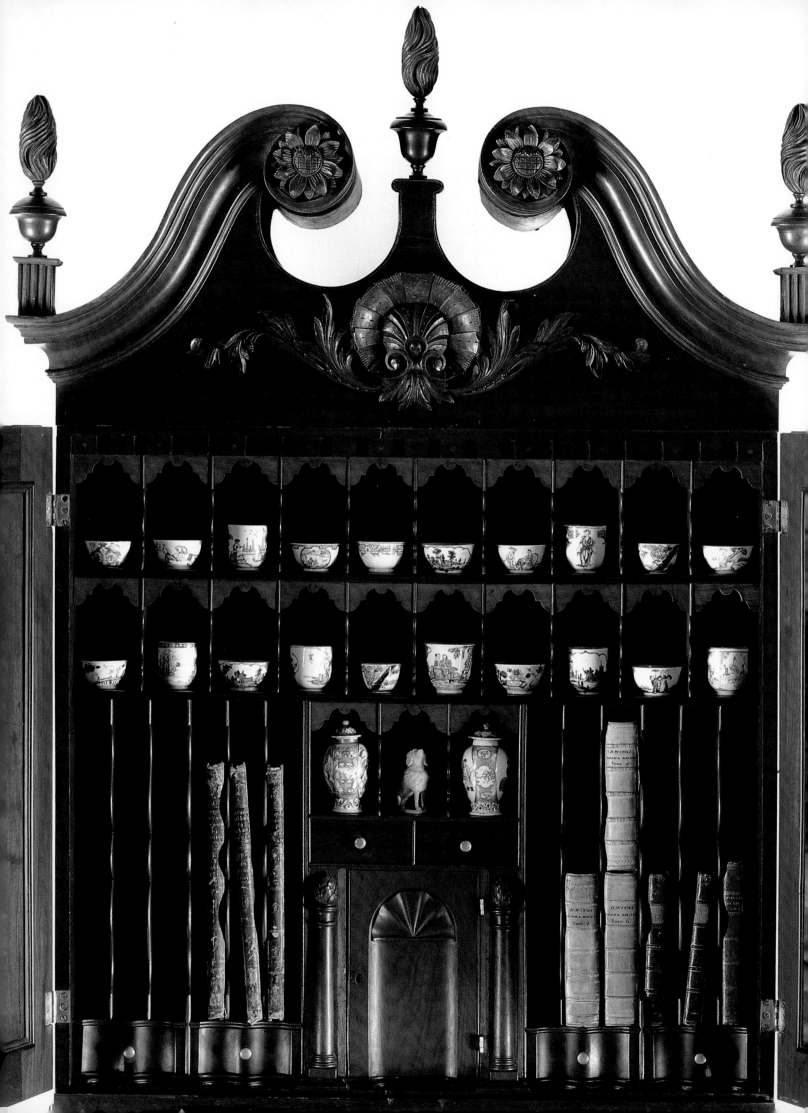

Case Furniture

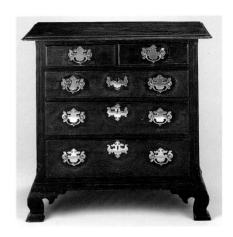

Fig. 189 (opposite page)
Secretary Desk and Bookcase,
c. 1740–50, no. 75, detail of interior.

Fig. 190
Chest, c. 1740–50, no. 31.

The range and popularity of case furniture in the early Delaware Valley are evident from its regular appearance in household inventories and in the numbers of examples that have survived relative to other furniture types. The evolution and the specific stylistic inspirations for most of the forms, which range from simple flat board or panel-and-stile boxes and chests to elaborate desks, chests on stands, and high chests, are nevertheless difficult to document. Small tabletop boxes, many with elaborate joinery and locking mechanisms, are among the earliest surviving household furnishings (see no. 1). Popular throughout the eighteenth century, they were used to hold small valuables, documents, or books and were often part of a woman's dowry, inlaid or inscribed with commemorative dates and the owner's initials (no. 5).[1] The interiors of these boxes were generally left open, with any divisions limited to a small "till," or compartment, set to one side, the divider wall nailed or mortised shallowly into the boards forming the front and

back of the box near the top.[2] Larger versions—chests for the storage of textiles, clothing, or other household goods—were similar in form to these smaller boxes. Imported coffers, trunks, or chests, packed with treasured objects, were often the only furniture that early settlers brought with them and may have served as the prototypes for those made locally (no. 18). The 1718/19 inventory of Bartholomew Coppock of Marple, Chester County, for example, listed "four ould English Chests."[3]

The earliest locally produced chests, few of which have survived, were often simply constructed of six boards of indigenous woods such as cedar, pine, or oak that were butt-nailed or pinned together at their corners (see no. 17). A number of early chests and chests over drawers of the more sophisticated wainscot panel-and-stile type (c. 1710–40) have survived. One distinctive group of these share histories of ownership in the area of Salem, New Jersey. Constructed of yellow pine or oak and originally painted, they exhibit the continuous corner stile and foot characteristic of early Delaware Valley

chests and chests of drawers.[4] Several of these chests have fielded (beveled-edge) paneling and finely executed applied base moldings (see no. 20, fig. 173). A further elaboration of this early form with rectangular wainscot panels can be seen in a rare group of black walnut textile chests and chests over drawers with histories of ownership in Philadelphia and Chester County. Following earlier English and Dutch traditions of geometric paneling, the flat, rectangular inset panels across the front of one such chest (no. 19) have been filled in at their corners and sides with appliques and moldings that create octagons in the side panels and, in the center panel, an X with beveled corners. The two drawer openings below are framed with applied half-round moldings, similar to those found on the drawer divisions of later chests of drawers, dressing tables, and high chests from the region. Constructed of thickly milled black walnut, the sides and back of this chest also have fully inset fielded panels, an example of an early construction feature that persisted in Phila-

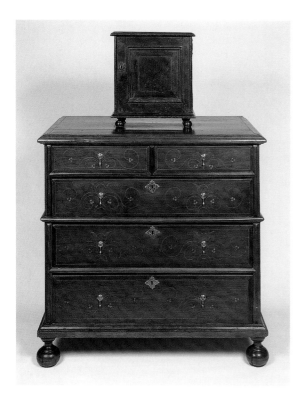

Fig. 191
Chest, c. 1725–45, no. 28; Spice Box,
c. 1710–25, no. 7.

Fig. 192
Chest, c. 1720–35, no. 27, detail
of foot.

delphia and Pennsylvania case furniture through the 1780s.

Philadelphia inventories from the years 1682–1710 list sixty-nine chests of drawers of various unspecified forms and types.[5] Applied patterned moldings in imitation of fully engaged geometric panel decoration survive on one of the earliest chests of drawers from the region, which was probably made in Philadelphia about 1685–1710 (no. 24).[6] It, too, is constructed of heavily milled black walnut, with oak, walnut, white cedar, and white pine used as secondary woods. The boxed, stepped-out corners of the case, created by its applied moldings and the vertical divisions across its facade, relate to Anglo-Dutch stylistic prototypes, particularly to early seventeenth-century English molded-case-furniture traditions from the Norwich District, East Anglia, and to roughly contemporary traditions in Boston.[7] Aspects of its idiosyncratic construction and style suggest its early place in the development of the chest of drawers in Pennsylvania. The staggered, ungraduated arrangement of its drawers would evolve into banks of graduated drawers in slightly later versions, and the large, widely spaced dovetailed joinery and the heavy rails that serve as bottom drawer slides would also be refined and made lighter in later examples. Unlike many earlier Dutch, English, and New England versions, it is not divided into upper and lower case sections, defined by an applied molding across the center of the chest.[8]

Two surviving examples of local walnut chests of drawers with two-part divided cases and four graduated drawers, made about 1725–40, illustrate this earlier tradition and are a testament to the variations in regional craftsmanship during this period (nos. 27, 28). The

cases of both are similarly constructed and both have similar molding profiles and case divisions, indicating they might be from the same workshop. When assembled, the upper case of each is seated on a narrow upward-projecting tenon inset in the side frame of the lower case. The division of the case into two parts would have made it more easily transportable as well as maneuverable up and down the narrow staircases of smaller city houses. The sides of both these chests are similarly configured, with panels-in-stiles set horizontally and positioned one over the other; one (no. 28, fig. 191) has a vertical faux stile applied to the surface of the side panel, dividing it into two rectangles. This chest has turned ball feet while the other has broadly proportioned carved "Spanish," or "brush," feet doweled into the bottom boards of the lower case, a construction similar to the traditional joint for a turned foot (fig. 192). While inlaid scrolled line-and-berry patterns on the drawer fronts and top of one suggest its origins among the Welsh and Dutch Quaker communities in Chester and Delaware counties, the makers of these chests have not been identified.[9]

A number of chests with graduated drawers, ball feet in front, and stile feet at the back survive that are similar in form to an example inscribed by a little-known Philadelphia joiner named William Beake, who is thought to have apprenticed to the joiner William Till (died 1711), also of the city (no. 26, fig. 147). This early chest is constructed of black walnut with yellow pine as the secondary wood.[10] Marked in chalk on the interior of the case side is "William / Beake 1711." Early manifestations of the fully developed chest-on-chest in Pennsylvania retained the turned foot but

added a decorative scroll-cut bracket along the base of the lower case (see no. 33). The continued production of this same basic cabinetry unit for chests, with inset paneled or solid-board case sides, continued into the late 1730s and early 1740s and illustrates the tenacity of earlier construction techniques and aesthetics in many of the cabinetmaking traditions in the colony (see no. 29). Other Pennsylvania cabinetmakers, however, continued to experiment with new designs. Later variations on the chest of drawers adopted the straight or ogee bracket foot and incorporated molded-edge tops with cusped corners, molded lips on the drawer edges, canted case corners, and fluting, which emerged during the 1740s and 1750s (see no. 31, fig. 190).

The first appearance and the early development of the chest on stand, or high chest, in Pennsylvania raise questions of source and chronology. The cabinet on stand, with an upper case of drawers or an escritoire desktop often concealed by a door or fall front, had evolved and enjoyed popularity in the 1640s and 1650s in France and Holland, and in England slightly later, during the 1670s and through the 1690s with the accession of William and Mary. In Holland and France ornately carved, fine wood-and-marquetry cabinets on stands were being produced. In addition, in both Europe and England exotic lacquered or japanned cabinets brought west by the early East Indies traders were fitted with ornately carved or turned lower cases. Late Renaissance southern European "specimen" cabinets of rare marble or with stone mosaic veneers were similarly treated.[11] The wooden stands on which these chests or cabinets rested often had a drawer and included stretchers bridging and bracing the legs. As

the taste for these case forms spread to upper-middle-class English merchants, the upper cabinet gave way to a chest with a full bank of drawers. It was in this form, as a chest of drawers on a turned base, that the high chest first appeared in American merchant-class households, according to surviving records.[12]

The terms used to describe high chests in the earliest Pennsylvania inventories are varied and confusing. The 1700 inventory of Margaret Beardsley's "great Chamber" in her Philadelphia house may be the earliest mention of the form; it notes a "stand chest of drawers."[13] The 1717 inventory of Joseph Fisher of Dublin, Philadelphia County, included a "Standing Chest of Drawers," recorded with the high value of £3.10.0.[14] The few surviving unaltered examples of these high chests with turned bases, along with the spice boxes and miniaturized cases of drawers on stands that are similar in form, exhibit a wide range of designs and construction techniques (see no. 42, fig. 162). The lower cases of examples thought to be among the earliest contain a single long drawer (no. 41, fig. 165). Other early versions include three drawers of varying depths and positions in their lower cases, usually arranged with two deeper, smaller side drawers separated by and flanking a central long shallow drawer. The drawers of these chests became a surface for the display of imported cast and engraved "drops," or brasses, which were often crowded across their front surfaces. The lower cases of early versions with a single long drawer usually incorporate shallow skirt rails that are either straight or have repeating scroll-cuts. Those with three drawers in the lower case most often have deeper aprons, lightened by

cutouts shaped like stepped, rounded arches or facing ogee scrolls that intersect to create pointed arches, the arches positioned under each drawer.[15] These arched cutouts in the apron created a strong silhouette, further elaborated by the complex turnings of the legs. The legs were placed on the case in relation to the arches and the separations of the case between the drawer openings. Deploying them almost like architectural columns, craftsmen placed the legs at the lower corners of the case as well as across the front at the two junctures created by the intersection of the arches across the facade (see no. 37). The exuberant turned patterns of the legs on several examples incorporate abrupt, sizable changes in the diameter of the elements of which they are composed. Several preferred patterns, particularly those incorporating large overturned half balls, or "cups," placed over flaring conical "trumpets," were in some examples turned in sections and then joined by dowels running through the separate elements. These turned legs were often set to flare outward slightly. The flat stretchers that connected the fragile legs and helped to reinforce them were usually sawn in patterns that echoed the shaped cutouts of the case apron. Stretchers were arranged in a boxed format on most high chests of this type and were pierced through at their lapped corners by a round tenon left on the leg post onto which slid the separately turned foot, which was mortised to receive it. These elaborate stands carried the upper case with its bank of drawers and its molded cornices, completing the form.

Dressing or chamber tables were usually made to accompany high chests en suite and were often listed alongside them in early inventories. The matching

high chest and dressing table were no longer fashionable in England by the end of the seventeenth century, but the paired ensemble remained popular in America through the third quarter of the eighteenth century.[16] The earliest surviving pair known from the Delaware Valley, which descended in the Wistar and Morris families, were made by the cabinetmaker John Head around 1726, shortly before the marriage of Caspar Wistar and Catherine Johnson. A later inventory of the couple's Philadelphia town house, located on Market Street between Second and Third streets, lists among the stylish furnishings in the front chamber a "Chest of Drawers & Table, . . . £4.0.0," thought to be this pair (no. 38, fig. 167).[17] Constructed of solid black walnut with yellow pine, white cedar, and poplar as the secondary woods, the ornate, richly swirling crotch-grained lumber used for the drawer fronts creates the effect traditionally accomplished on earlier English and Dutch prototypes by the use of carefully chosen and matched figured veneers. The design of the high chest includes a low molded platform on its top, set above the cornice, thought to have been used for the display of ceramics.[18]

The dressing tables accompanying high chests were generally constructed and designed in the same way as the bases of the high chests but were slightly smaller (see no. 48). Both single- and multiple-drawer versions from Pennsylvania survive. Turned decorative pendants are often applied to the lower edges of the case aprons, replacing the central legs of their larger companion pieces (no. 52). In more ornate versions, a turned finial or a flat stand, possibly also for the display of ceramics, was placed at the central juncture of the crossed stretchers

between the legs (no. 50, fig. 135). The wooden tops of dressing tables were frequently covered with textiles to protect them, and dressing tables are often listed together with their textile covers in inventories. The covers ranged from simple white "diapered" covers to finely "wrought" needlework examples.

Following Dutch and English styles and patterns of use, several early Pennsylvania inventories reflect the placement of high chests and dressing tables in a bed chamber or other room accompanied by a pair of "stands" and a looking glass or dressing box, or occasionally both. The inventories of Elizabeth and John Tatham included "One rich Ollave inlaid Table & 2 Stands," a "Dressing Box being inlaid Olive," and a "good large looking glass" (see nos. 97, 176).[19] The nature and use of these early "stands," which probably held a light source, have largely been overlooked. The few local examples that survive have simple round or octagonal tops fastened to a single turned, baluster-shaped support that is fitted with a platform base and simple scroll-cut legs. These early stands show the same development and decorative variations as the earliest tilt-top tea tables of the 1730s and 1740s. Both Dutch and English examples of these stands are known, and simple imported versions were probably available in Philadelphia. Few locally produced examples of the earliest type, which was probably used in conjunction with a dressing table, survive, and no pairs are known (see nos. 96, 99).

The expense and risk of importing large plates of mirrored glass to the colonies kept the price of looking glasses high; the larger glasses would have been too expensive for most households. While merchants and craftsmen sold or

produced looking glasses in Philadelphia in the early eighteenth century, it was not until 1756 that the cabinetmaker John Elliott advertised that he had for sale "A Neat assortment of looking glasses" and that he could supply "Looking glasses new quicksilver'd, or framed, in the neatest manner" (see no. 177).[20] The dressing box, with its small glass usually mounted in a swinging frame above a box with a fitted interior or a bank of drawers, may have provided an alternative. William Till, a Philadelphia joiner, owned both a "small Swinging Glass" and a "Table and Dressing Box & looking glass" in 1711.[21] Ornate versions would have been found in wealthier households, such as that of Jonathan Dickinson, the prominent Philadelphia merchant, who had a "Swing Glass & drawers" in his richly appointed "Front Chamber" in 1722 (see no. 13).[22] These boxes also would have provided useful storage for combs, powders, and fragrances, since few surviving Pennsylvania dressing tables show evidence of any type of divisions within their drawers.[23]

As craftsmen began to experiment in the early 1730s with incorporating the cabriole leg in the design of familiar case forms such as the dressing table, they found interesting and idiosyncratic solutions to construction problems. On several dressing tables the earlier form and patterning of the case were retained while the turned leg itself was replaced with the S-scroll cabriole leg. The upper post of this cabriole leg was simply notched out to create a saddle joint that was inserted inside the case at its corner, where it was secured with a wooden peg or nail. The exceptional example shown here (fig. 193) incorporates forward-facing rear legs and double

arches and dropped pendants on the sides of the case, design features encountered in Bermudian and colonial West Indian case furniture from the late 1720s through the 1740s. The Delaware Valley craftsman responsible for its construction chose hard maple to give its gracefully attenuated, curved, thinly sawn legs and high scroll-carved "Spanish" feet the necessary durability and strength.

While extremely rare in Philadelphia, the "bureau" table or the diminutive four- or five-drawer chest provided alternatives to the standard chest and dressing table and may have been made by some craftsmen by mid-century as a matching form, produced en suite, for the chest-on-chest. Straight, scroll-cut bracket feet and broadly sawn ogee bracket feet became popular on the cases of later versions (no. 76). Individual craftsmen experimented with case furniture forms, resulting in dressing tables, single chests, and high chests that incorporated numerous adaptations of the scroll-sawn apron and various drawer arrangements, leg and foot designs, pediments, moldings, and carved decoration (nos. 54, 55). The cabriole leg, with or without a carved "cusp" or shell knee and with plain or carved volute knee returns, could terminate in a "pad," Spanish brush, scroll, or trifid foot or, by the early 1740s, a claw-and-ball foot (see no. 39). The flat tops of early double-case chests, clock cases, and cupboards were later elaborated, the simple flat cornice replaced with a double arch, closed or broken arch, ogee scroll, or architectural pitched pediment (see nos. 34, 40; figs. 176, 93). The pediments for many early tall case clocks incorporated a stepped, intricately shaped and molded cap called a "sarcophagus"

top, which, as far as is known, was not adapted for use on larger case pieces in the Delaware Valley (no. 66).

Desks underwent a similar development. The simply constructed tabletop boxes with slanted writing surfaces continued to be produced throughout the eighteenth century (see no. 67). This basic desk box could rest on a table or be placed on a stretcher-based frame with turned legs that could be fitted with a drawer. While they provided an effective writing surface, and the desk section remained easily portable, these smaller desk boxes and desks on frames did not provide the space, multiple compartments, or secure storage the business activities of the merchant class required. The basic form of the single-case chest with graduated drawers was later adapted by replacing the top drawer with a slanted writing surface, hinged to open to a lockable divided interior with hidden compartments (no. 68, fig. 186). Versions of these single-case desks, resting on turned ball or scroll bracket feet, survive in walnut, maple, and mahogany and were adapted in detail and decoration to fit the later styles of the eighteenth century. Sturdy, bail-type handles were often attached to the sides of these desks, so that even with their greater weight they could be transported.

One of the earliest fully developed double-case desks documented is in the form of the escritoire, listed frequently in local inventories and spelled "scitore" or "scritiore" prior to 1730. The escritoire, with a fall-front case that evolved from French, Dutch, Spanish, and English furniture traditions from the late seventeenth century, is best represented in early Pennsylvania by a surviving example made of black walnut and stamped "Edward Evans / 1707" (no. 69, fig.

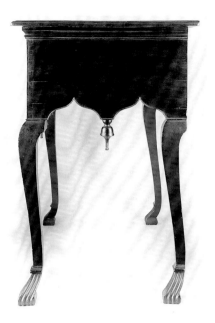

Fig. 193
Dressing Table, c. 1728–40, no. 53, side view.

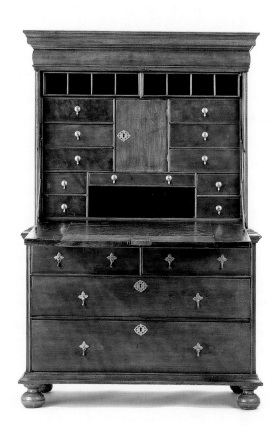

Fig. 194
Escritoire, or Fall-Front Desk,
Edward Evans, 1707, no. 69.

194). Edward Evans (1679–1754) was probably the son of William Evans, a London-trained carpenter who immigrated in 1683 and settled with his family on farmland along the Delaware River in the territory known as West Jersey. Edward, the youngest son, may have been apprenticed to either John or Thomas Budd, two of the earliest documented wood craftsmen working both in Philadelphia and in Burlington, New Jersey, near the Evans farm. Edward completed his apprenticeship in October 1704 and was awarded freeman status in the city records. Possibly through his earlier connection to the Budds, who were active in shipbuilding in Philadelphia and associated with the Penns, Evans enjoyed the influential patronage of the proprietor as early as 1701, while still an apprentice. For work completed, William Penn recorded in his cash book, "By Letitia Penn. pd. Ed. Evans Joyner for a Chest of Drawers she gave Mary Sotcher £7.0.0."[24] Evans was also patronized by other leading merchants in Philadelphia, including Isaac Norris, Andrew Hamilton, James Logan, and the merchant and shipbuilder William Trent. Logan's account books for 1712 record that Evans made a stand and an oval table for him. Evans also purchased imported furniture hardware, particularly brass "drops," from Logan. From 1703 to 1709 he worked regularly as a joiner in Trent's extensive shipbuilding projects in Philadelphia, and he is noted in Trent's records for May 1703 as supplying "Jnº Tucker, merchants" in Bermuda with an "ovell table" as venture cargo.[25]

The Evans desk includes a flat, shallow drawer hidden by a torus molding (a large convex molding) in the upper cornice, a feature found on few surviving Pennsylvania case pieces but a popular

device on English and Dutch cabinets of an earlier date (no. 36, fig. 182).[26] The arrangement of drawers and compartments in the interior of the upper, fall-front section of the Evans desk relates closely to the ornate cabinets on stands made in Holland and England in the 1680s and 1690s.[27] While the desk is well built and solidly constructed of dense black walnut, its plainness and lack of surface graining or other decoration suggests Evans's training as a ship's joiner rather than as a true cabinetmaker, who would have been familiar with inlay or decorative veneers. Evans worked heavily on the *Diligence,* a ship launched by William Trent in 1707. This desk, stamped in the tradition of struck (or branded) makers' marks or signatures, which were most often employed during this early period by ships' joiners, may have been commissioned by Trent for use in his wharf or shipyard office, or by another merchant along the city's busy waterfront.[28]

Several other rare survivals of early types of desks also show strong influences from Anglo-Dutch traditions of design. One example is a black walnut secretary desk with a double-arched pediment form (no. 70, fig. 8). Perhaps one of the earliest of this type, it includes shaped and beveled mirrors in the doors of its upper case. Its lower case of drawers has a slanted fall front that opens to a fitted writing compartment. On the bottom of its upper case is the chalk inscription "D John 6 / 20." Either David or Daniel John, the sons of Philip John (died 1741), a joiner working in Douglas Township, Philadelphia County, could have made and signed the piece, or inscribed it as its owner. The pedimented form of secretary desk with mirrored doors appears in several Philadelphia

inventories, such as that of Joseph Redman, made in 1722, which lists "A Looking glass Screetore 1 glass Broke," and also "Earthen & Glass ware in ye Bowfett & Escreetore head."[29] The case of the John desk exhibits the same solid but elementary cabinetmaking techniques of large mortises and tenons, broad dovetails, heavy interior case stock, and roughly riven lumber seen in much of Pennsylvania's earliest furniture. Its one-piece lower case retains an applied mid-molding positioned where on earlier desks the separate upper desk box joins the lower framed stand or case. Other regional examples of double-arched secretary desks, thought to have been made slightly later, have straight or ogee bracket feet on their lower cases.

A double-case mahogany secretary desk owned by James Logan about 1725–30 is one of the most sophisticated designs by local manufacturers to have survived (no. 71, fig. 195). By far the most ambitious of a small group of desks similar in form and pattern, it includes shaped and beveled mirrored-glass panels in the tympanum and upper doors on the exterior and richly contrasting exotic-wood-inlay pilasters and half-round columns in its interior. The inner faces of the boards forming the back of the upper case are painted with decorative graining to further enrich the interior. In another desk of this style, possibly from the same workshop in light of its closely related design and construction, rare figured Santa Dominican "plum pudding" mahogany is applied as thinly milled boards on the paneled doors and lower drawers (no. 73).[30] These ornate, ogee, pedimented desks were produced alongside other variations. Versions with "broken" (or interrupted) arches, intricately shaped panels,

and blocked, shell-carved interior drawers, such as can be seen on a surviving example that descended in the Gilder family of Philadelphia and New Jersey, are known (no. 72, fig. 168). The Gilder desk's early experimental incorporation of a carved shell on its uniquely shaped pediment ornaments (fig. 196) demonstrates the cross fertilization between carvers decorating case furniture and those working in the shops of chairmakers.

While few desks from the years 1725–50 can be attributed to specific makers, Joseph Claypoole (died 1744), an early joiner who arrived in Philadelphia in 1683, and his sons George and Josiah were all involved in the making of such case forms. The senior Claypoole charged the estate of Captain Richard Hill in September 1729 for the making of one hundred twenty "pidgeon holes" for the estate's papers and business records.[31] Later, Joseph's son Josiah, to whom the father had left his shop and tools, developed a thriving furniture business, frequently participating in the shipping of furniture as venture cargo to the West Indies. Josiah, who by 1740 had advertised his cabinetmaking abilities both in Philadelphia and in Charleston, South Carolina, listed "Desk and Book Cases, with Arch'd Pediment and O.G. Heads, Common Desks of all Sorts, Chests of Drawers of all fashions fluted or plain" among the variety of designs available in his shop (see no. 74, fig. 185).[32]

The cases and pediments of tall case clocks gave Pennsylvania's early cabinetmakers and joiners yet another form with which to experiment. Clocks were among the most highly valued and rare of possessions. Prior to 1700 all the clocks recorded in Philadelphia inventories were owned by members of the city's wealthy merchant class.[33] Costly to acquire in

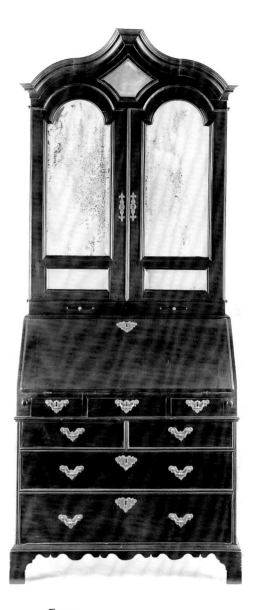

Fig. 195
Secretary Desk and Bookcase,
c. 1725–30, no. 71.

Fig. 196
Secretary Desk and Bookcase,
c. 1730–40, no. 72, detail of upper
case.

comparison to other furniture, clocks also carried symbolic associations, since they marked the mystical orders of time in addition to regulating daily activities. For those who could not afford the luxury of a clock, cheaper, more rudimentary timekeeping devices such as pocket sundials and hourglasses were available (see no. 421).[34]

Some early households, both in Philadelphia and in the surrounding region, owned imported case clocks or cases that were made by local craftsmen to house imported clockworks. Rarely were clockworks and their clock cases made by the same maker. William Penn brought an English tall case clock made by the Bristol clockmaker William Martin (active c. 1670–95) to Pennsylvania for use at Pennsbury in 1699.[35] Another early clockworks in Philadelphia was made by the London clockmaker William Graham (active 1720–30). The cast and elaborately engraved brass clockworks are housed in a case of finely grained mahogany made in the late 1720s or early 1730s in one of Philadelphia's leading cabinetmaking shops. The case is one of the most ornate to have survived and retains its original feet, molded cornice, turned "ball" ornaments, and the applied, sawn fretwork frieze on its elaborate sarcophagus top (no. 59).[36] The decorative fretwork of the most elaborate sarcophagus-type clock cases was applied over the boards of the upper cornice, which were sometimes pierced to allow the chimes to resonate. These piercings were often covered with brightly colored textiles; remnants of red, green, and yellow silk have been found under the fretwork of some Pennsylvania examples.[37] Another clock, made by an unknown German immigrant craftsman, incorporates an early imported brass lantern-clock mechanism into a tall case (no. 63, fig. 34). The decorations of the case, which dates to about 1740, include sophisticated inlaid and shaded floral marquetry stylistically related to a small group of high-quality work thought to have been executed by Alsatian or Dutch craftsmen working in the early Germanic communities of southeastern Pennsylvania.

Unfortunately, little survives of the work of some of the earliest clockmakers working in the Delaware Valley. Evidence of the work of Abel Cottey (1655–1711), for example, who immigrated to Philadelphia in 1682 from England, is very sparse—only one tall case clock, now greatly altered, and the disassociated face of another bearing his signature are known (no. 420). A number of clockworks survive by Peter Stretch (1670–1746), however, one of Philadelphia's earliest and most talented and influential clockmakers. Stretch, who was born in Leek in Staffordshire, England, apprenticed with his uncle Samuel Stretch, a clockmaker specializing in lantern clocks. Peter learned the trade and the manufacture of this type of clock during the 1690s and probably also experimented with the differing mechanisms of tall case clocks (see no. 418). A Quaker, Stretch immigrated with his wife and three sons in 1702 to Philadelphia, where they lived at the corner of Front and Chestnut streets. He quickly gained prominence in the city, serving on the Common Council of Philadelphia from 1708 until his death. His 1717 commission from the Common Council for work on the town clock suggests the level to which he had obtained the confidence of his peers and built his professional reputation. Stretch's earliest clocks were small and finely built, with square dials

and single hands set in simply designed and constructed flat-top cases. His shop offered a number of his own productions, augmented by a range of fine imported wares. While it is not known whether Stretch produced smaller pocket watches (see no. 287), he advertised that he did, and he sold imported examples. An advertisement placed in *The Pennsylvania Gazette,* May 12–19, 1737, states, "Lost or Stolen from Peter Stretch, Watchmaker in Philadelphia . . . a fashionable Silver Watch, made by Stroud, London, having the Graduations for the Minutes arched, and a small Gold Rose between every Hour and the half Hour, a Key and Seal and a Black Silk String. . . . Forty Shillings Reward."[38] Stretch gained a number of influential private patrons during his long career and produced a wide range of engraved brass-faced clockworks with finely cast spandrels and trims set in ornately constructed and decorated walnut or mahogany cases (nos. 58, 62; fig. 14). Two of Peter's sons, Thomas and William, also became accomplished clockmakers, and William received all of Peter's tools, imported clocks, and unfinished clockworks upon his father's death (see no. 64).

Many clockmakers in the Philadelphia region carried on their business alongside other occupations. For Francis Richardson, Jr. (1705/6–1782), the Philadelphia silversmith and merchant, clockmaking probably supplied only a small part of his livelihood. While only one example of his clockworks survives (no. 422), Richardson advertised in *The Pennsylvania Gazette* on September 9, 1736, that he offered "Very neat clocks," which he made, sold, cleaned, and mended at his shop on the corner of Letitia Court in Market Street.[39] As was typical of many rural Pennsylvania

craftsmen, Isaac Thomas (1721–1802) of Willistown, Chester County, was something of a jack-of-all-trades—prolific as a clockmaker but also involved in operating a grist- and sawmill, as well as working as a farmer, surveyor, and joiner.[40] He is one of the few clockmakers who may have been involved in the construction of the cases for his clockworks (see no. 66). We have little information about the cabinetmakers who supplied the cases for most other clockmakers. Solomon Fussell's account book does, however, document his receipt in June 1745 of a case made by Henry Clifton for a clockworks Fussell obtained from John Wood, Sr., the clockmaker.[41]

Regional decorative styles, local preferences for specific forms, or related groups of craftsmen working in a particular tradition ensured continuity and inspired variety in the furniture produced in the communities surrounding Philadelphia. There are a number of surviving high chests, dressing tables, and dining tables in figured maple or walnut from the Swedish settlers and English Quaker families living in and around the towns of Salem, Burlington, and Camden, New Jersey, in the years 1730–50. This furniture most often incorporates exaggerated curvilinear versions of the cabriole leg, with variations of high-ankled, "stockinged" Spanish feet or trifid feet with boldly extended toes. In many of the dressing tables the drawer arrangement consists of four long shallow drawers, positioned two over two, a pattern that differs from the standard in Philadelphia examples. The designs of their aprons incorporate low central sawn profiles, often pierced through with hearts and with scroll-shaped cutouts on the lower end placed opposite one another to form a "whales-

tail." These sawn aprons are further embellished with repeating wavy cutouts or scrolled motifs symmetrically flanking the central element. Many examples also include a narrow beveled or chamfered case corner, sometimes embellished with shallow fluting. While these furniture forms were probably produced by both local joiners and Philadelphia craftsmen who had patrons in these coastal New Jersey communities, the local preference for these particular styles with cabriole legs is demonstrated by their frequency.

The spice box, its interior fitted with a number of small storage drawers, took the same general form and followed the development of larger case furniture. It was more popular in early eighteenth-century Pennsylvania than in any of the other American colonies. It thus developed here to a much higher degree of refinement and decorative sophistication.[42] The earliest known examples of spice boxes, made in the first quarter of the eighteenth century, tend to have a simple board or panel-and-stile framed door hinged to a case elevated on turned feet (see no. 7). Most were constructed of walnut, but mahogany, pine, cherry, and maple examples are also known. Given their size, spice boxes were probably displayed on chests or tables (see fig. 191); in 1720 Martha Waite of Philadelphia instructed that her "Best Bed with it's Furniture and the Wallnut Chest of Drawers and Table which are called her's together with my Spice Box" be given to her daughter.[43] Later, cabriole-leg and bracket-foot examples were often embellished with decorative crotch-grained, inset arched or rectangular panels on their doors and cases (see no. 9). While these boxes may well have held spices, medicinal herbs, or

other expensive foodstuffs, they seem to have been used more often to hold keepsakes and such fineries as jewelry and small valuables. The contents of a spice box owned by Jacob Hibberd of Darby is described in his 1750 inventory: "To one Spice Box Sundreys therein / To 2 links of Gold Sleeve Buttons 2 links of Silver ditto & 2 Silver studds / To a pair of Silver shoe Clasps 1 pr Brass ditto / To 1 Pin Cusshion with a Silver belt and Chain / To a Silver Scizars Chain and thimble of ditto / To a Silver Snuff Box and one Blank ditto / To 2 large Silver spoons 6 Silver Tea spoons and one pair of Silver tongs / To Sundrey Small things."[44] Only one Pennsylvania example has survived with its original contents intact (no. 12), which included such items as cotton gloves, a finely embroidered child's cap, silk and needlework fragments, silver needle cases, a glasses case, pin cushions, buttons, paper valentines, and mementoes such as a lock of hair.[45]

Inlaid decoration is rare on early Philadelphia furniture and is confined largely to simple line or string inlays or shallow crossbanding veneered in mitered surrounds on the drawers of case pieces. The 1708 Philadelphia inventory of James Sandelands, however, lists "a flowered Chest of Drawers" in his best chamber.[46] While figural inlaid decoration is virtually unknown in Philadelphia furniture, a rich tradition of inlay featuring undulating vines, tulips, berries, compass-drawn circles, and geometric shapes survives in a group of finely constructed walnut furniture produced by Welsh, English, and Dutch

joiners and cabinetmakers working in southern Chester County (see nos. 52, 80). Such "line-and-berry" inlay flourished as a regional style in this tightly knit rural community of farmers, shopkeepers, and craftsmen from the 1690s through the 1790s.[47] The patterns created by undulating vines ending in rounded flower-petal or berry motifs, and often emanating from an urn or other central motif, illustrate the cross-fertilization that can occur in a regional style when a number of older decorative traditions intersect. Similar patterns are found in sources ranging from sixteenth- and seventeenth-century Islamic, Persian, and Spanish metalwork, textiles, and inlaid furniture to the scrolled, geometric garden parterre and the designs for the decorative stuccoed ceilings of seventeenth-century France, Holland, and England.[48] The Chester County examples also have very strong ties to the inlay traditions found among slightly earlier Flemish, Dutch, and Welsh furnituremakers.[49] A number of case pieces retain the early patterned use of oak or chestnut as a secondary wood, riven rather than sawn, another reflection of traditional European and British construction techniques (see no. 29).[50]

Several examples of line-and-berry decorated furniture incorporate dates and the initials of owners into their inlaid designs (nos. 2, 4, 5; fig. 180). These dates, once assumed to be commemorative, are now considered in most cases to be the year of the object's manufacture.[51] The inlay on the earliest dated example (1706), a small chest of drawers with turned feet (no. 25), is

simply conceived, while the top of a dressing table with the date 1724 (no. 52, fig. 187) demonstrates an expanded repertoire of inlay patterns and woods employed within this group of furniture. The dressing table's sophisticated construction and the refined pattern and execution of its turnings suggest a possible Germanic influence and perhaps Philadelphia as the place of manufacture, while the overall composition of its inlaid top is close to examples executed by Chester County craftsmen. Either Philadelphia or Chester County could have been the place of manufacture of several of the known examples, for there was frequent trade and movement of craftsmen between the two areas, ensuring similarities in design and a wide distribution of skills and patronage. In addition, a number of early Welsh craftsmen, who were very likely familiar with these inlay traditions, settled permanently in Philadelphia, while some Philadelphia Quaker craftsmen had close business ties to or families in Chester County. Along with the dressing tables, inlaid chests and tall chests with either plain board or paneled sides incorporating upper banks or friezes of small arched drawers under their tops were produced in Chester County (see nos. 22, 32). Inlaid desks, cupboards, tall case clocks, tables, and small tabletop boxes with similar motifs were popular forms as well. The inlay traditions of Chester County constitute one of the most enduring and distinctive regional styles of cabinetmaking in the early Delaware Valley.

1

2

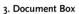

3

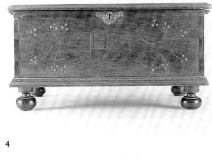

4

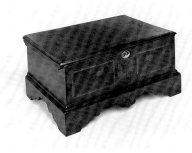

5

Case Furniture

1. Document Box
Philadelphia, c. 1710–25
Walnut
11³/8 x 21⁷/8 x 12¹/8" (28.9 x 55.6 x 30.8 cm)
Private Collection

2. Document Box
Chester County, Pennsylvania, 1740
Inscription: SC (inlaid on front); 1740 (inlaid on top)
Walnut; poplar, mixed wood inlays
7¹/2 x 14 x 9¹/2" (19.1 x 35.6 x 24.1 cm)
Collection of H. L. Chalfant

3. Document Box
Chester County, Pennsylvania, c. 1740–50
Walnut; mixed wood inlays
7¹/2 x 17¹/4 x 14¹/2" (19.1 x 43.8 x 36.8 cm)
Collection of H. L. Chalfant

4. Document Box
Chester County, Pennsylvania, c. 1744
Inscription: HC / 1744 (inlaid on front)
Walnut; pine, mixed wood inlays
11 x 22 x 14" (27.9 x 55.9 x 35.6 cm)
Chester County Historical Society, West Chester,
Pennsylvania. 4BX-4
 Descended in the Carlyle family of London
Township, Chester County.

5. Document Box
Chester County, Pennsylvania, 1746
Inscription: HI / 1746 (inlaid on top)
Walnut; poplar, mixed wood inlays
8¹/2 x 17⁷/8 x 12¹/2" (21.6 x 45.4 x 31.8 cm)
Private Collection

6. Slide-Top Box
Southeastern Pennsylvania, c. 1750–60
Walnut; poplar
5¹/2 x 15 x 8" (14 x 38.1 x 20.3 cm)
Philadelphia Museum of Art. Titus C. Geesey
Collection. 1953-125-16a,b

7. Spice Box
Southeastern Pennsylvania, c. 1710–25
Walnut; oak, pine, poplar
18¹/2 x 17⁷/8 x 10¹/8" (47 x 43.5 x 25.7 cm)
Private Collection
 Based upon surviving inventory listings, spice
boxes were used most often for safekeeping
small valuables and keepsakes, rather than for
the storage of spices or herbal remedies.

8. Spice Box on Stand
Philadelphia, c. 1710–25
Mahogany, mahogany veneer; pine
30 x 18¹/4 x 9¹/2" (76.2 x 46.4 x 24.1 cm)
Private Collection

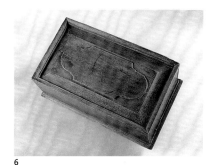

6

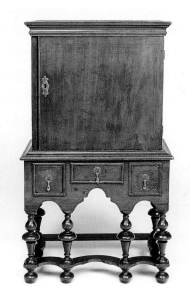

7

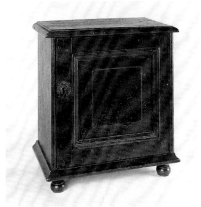

8

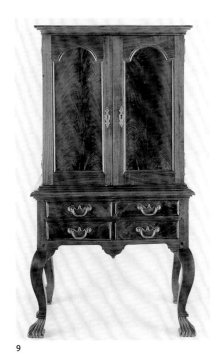

9

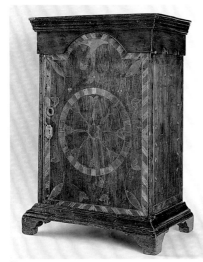

10

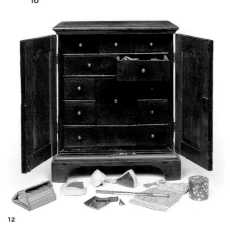

12

One of the earliest surviving examples of Pennsylvania mahogany furniture, this spice box is close in its overall form and interior drawer arrangement to full-scale, late seventeenth-century Dutch and English cases on stands.

9. Spice Box on Stand

Philadelphia or Chester County, Pennsylvania, c. 1735–45
Walnut; chestnut, pine, white cedar
32³/₄ x 18¹/₂ x 11¹/₂" (83.2 x 47 x 29.2 cm)
Chester County Historical Society, West Chester, Pennsylvania. FSPBX-8

10. Spice Box

Chester County, Pennsylvania, 1745–55
Walnut, cherry; oak, pine, poplar, white cedar, mixed wood inlays
23³/₈ x 16¹/₂ x 10³/₄" (59.4 x 41.9 x 27.3 cm)
Chester County Historical Society, West Chester, Pennsylvania. Gift of Bart Anderson. SPB-11

11. Spice Box

Chester County, Pennsylvania, c. 1745–60
Inscription: RM (inlaid on front)
Walnut; chestnut, oak, mixed wood inlays
17⁵/₈ x 14³/₄ x 11¹/₄" (44.8 x 37.5 x 28.6 cm)
Collection of H. Richard Dietrich, Jr.
See fig. 7.

12. Spice Box and Contents

Philadelphia, c. 1745–50
Walnut; cedar, pine, poplar
20³/₈ x 17¹/₄ x 10¹/₄" (51.8 x 43.8 x 26 cm)
Philadelphia Museum of Art. Gift of the family of John R. Shinn in his memory and in memory of his New Jersey Shinn ancestors. 1999-8-1

This spice box is the only known example to have retained parts of its early contents of small keepsakes, jewelry, and needleworks. Originally owned by James Shinn (died 1751), its contents were later inventoried by his heirs, who also identified the eighteenth-century owners of many of the articles kept within the box's drawers.

13. Dressing Box

England, c. 1710–30
Mixed woods; japanned
28¹/₂ x 15 x 9¹/₄" (72.4 x 38.1 x 23.5 cm)
Stenton, Philadelphia. 86.2

James Logan's account book mentions "1 Swinging Glass" that was "brought over by J. Parker" for him in 1712. Although this dressing box was not Logan's, it probably resembles the swinging glass mentioned in Logan's records.

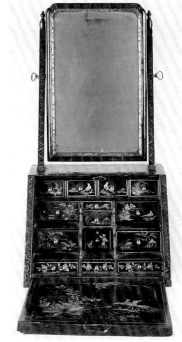

13

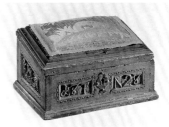

14

17

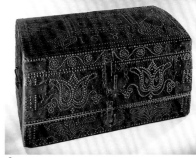

18

14. Sewing Box
America or northern Europe, 1727
White pine; painted, textile cover
6 x 10³/8 x 77/8" (15.2 x 26.4 x 20 cm)
Collection of Joseph and Jean McFalls

15. Medicine Chest and Contents
Probably England, c. 1740–55
Mahogany; oak, white pine
15³/4 x 11¹/2 x 9¹/2" (40 x 29.2 x 24.1 cm)
Mütter Museum, College of the Physicians of
Philadelphia

Originally belonged to William Shippen, Sr.
(1712–1801), of Philadelphia, a leading colonial
physician.
See fig. 66.

16. Chest
Scandinavia, probably Sweden, c. 1650–70
Iron; brass; painted
15¹/8 x 25⁵/8 x 16" (38.4 x 65.1 x 40.6 cm)
American Swedish Historical Museum,
Philadelphia

This chest is thought to have been brought
to New Sweden by Broer Sinnexson in 1683. It
retains much of its original painted decoration.
See fig. 4.

17. Chest
Tidewater, New Jersey, possibly Salem County,
c. 1670–1720
Pine; oak
17¹/8 x 40³/4 x 17¹/2" (43.5 x 103.5 x 44.5 cm)
Private Collection

This chest, which descended in the Goodyn
and Rambo families of New Jersey, is believed to
be one of the earliest surviving chests of Swedish
type made in New Jersey.

18. Chest
Holland or England, c. 1686
Pine; iron, leather, brass nails
22¹/8 x 42 x 23" (56.2 x 106.7 x 58.4 cm)
Philadelphia Museum of Art. Gift of Miss
E. Nixon. 1890-31

This trunk was brought to Philadelphia by
Richard Nixon (died 1749), an early immigrant
from Wexford, Ireland, who was married to
Sarah Bowles in Christ Church in 1727/28.

19. Textiles Chest
Philadelphia, c. 1700–1720
Walnut; oak, pine
33¹/4 x 52¹/2 x 21¹/2" (84.5 x 133.4 x 54.6 cm)
Philadelphia Museum of Art. Purchased with
Museum funds contributed by W. B. Dixon
Stroud. 1993-63-1

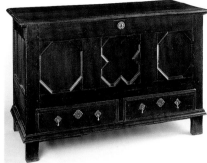

19

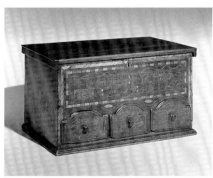

21

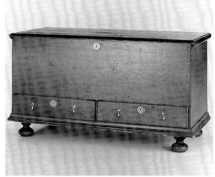

22

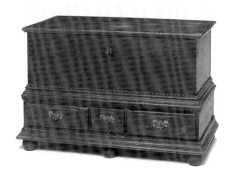

23

20. Textiles Chest
Salem County, New Jersey, c. 1700–1730
Pine; painted
29³/4 x 45¹/2 x 17³/4" (75.6 x 115.6 x 45.1 cm)
Collection of Joseph and Jean McFalls
See fig. 173.

21. Textiles Chest
Southeastern Pennsylvania, c. 1720–40
Inscription: Mr. Graeme's / the governor's
dau[]hter (in chalk under lid)
Pine; painted
28¹/2 x 55 x 23¹/4" (72.4 x 139.7 x 59.1 cm)
Collection of H. Richard Dietrich, Jr.

This chest was probably among the early fur-
nishings of Fountain Low (built 1723–26), later
renamed Graeme Park, located in Horsham,
Montgomery County, Pennsylvania.

22. Miniature Chest
Possibly William Pyle (n.d.) or Abraham
Darlington (1723–1799)
Chester County, Pennsylvania, 1746
Inscription: Hannah : Pyle : was / Born : the
25 : 8ᴍ : 1742 (inlaid on front); 1746 (inlaid
on drawer)
Walnut; pine, mixed wood inlays
11³/4 x 21 x 13" (29.8 x 53.3 x 33 cm)
Private Collection

23. Textiles Chest
Southeastern Pennsylvania, c. 1755–80
Walnut; pine, poplar
32 x 51¹/4 x 27¹/8" (81.3 x 130.2 x 68.9 cm)
Private Collection

24. Chest
Philadelphia, c. 1685–1710
Walnut; cedar, oak, pine
38³/4 x 44¹/8 x 22³/4" (98.4 x 112.1 x 57.8 cm)
Philadelphia Museum of Art. Purchased with
the J. Stogdell Stokes Fund. 1969-133-1

25. Chest

Chester County, 1706
Inscription: IB / 1706 (inlaid on top)
Walnut; pine, poplar
34¹/₂ x 30¹/₂ x 21" (87.6 x 77.5 x 53.3 cm)
Collection of Mrs. Herbert F. Schiffer
 This chest is the earliest known Pennsylvania example that includes inlaid line stringing.

26. Chest

William Beake, Jr. (active c. 1694–after 1711)
Philadelphia, c. 1711
Signature: William / Beake 1711 (in chalk on inside of right side panel)
Walnut; cedar, pine
36³/₄ x 40¹/₈ x 22¹/₈" (93.3 x 101.9 x 56.2 cm)
Private Collection
 William Beake, Jr., of Bucks County, Pennsylvania, was an apprentice to the Philadelphia joiner William Till in 1694 and worked with him until Till's death in 1711.
See fig. 147.

27. Chest

Southeastern Pennsylvania, possibly Philadelphia, c. 1720–35
Walnut; cedar, oak, pine
39³/₄ x 41¹/₄ x 23¹/₄" (101 x 104.8 x 59.1 cm)
Ex-Collection Titus C. Geesey
See also fig. 192.

28. Chest

Southeastern Pennsylvania, probably Chester County, c. 1725–45
Walnut; cedar, oak, pine, mixed wood inlays
41¹/₂ x 42⁵/₈ x 23³/₄" (105.4 x 108.3 x 60.3 cm)
Private Collection
See fig. 191.

29. Chest

Chester County, Pennsylvania, c. 1725–50
Walnut; oak, pine, holly inlays
41 x 38³/₄ x 27" (104.1 x 98.4 x 68.6 cm)
Private Collection
See fig. 184.

30. Chest

Chester County, Pennsylvania, c. 1730–50
Walnut; oak, mixed wood inlays
43 x 42¹/₈ x 22³/₈" (109.2 x 107 x 56.8 cm)
The Dietrich American Foundation

31. Chest

Philadelphia, c. 1740–50
Walnut; poplar, white cedar, white pine
33¹/₄ x 36¹/₄ x 20³/₄" (84.5 x 92.1 x 52.7 cm)
Collection of Mrs. Martha Stokes Price
See fig. 190.

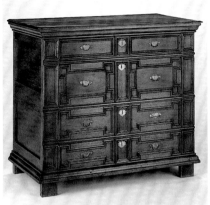

24

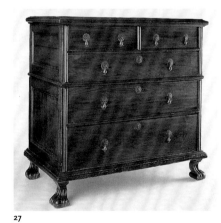

25

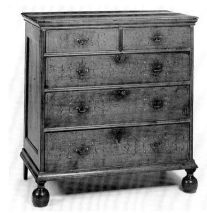

30

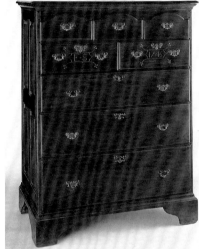

32

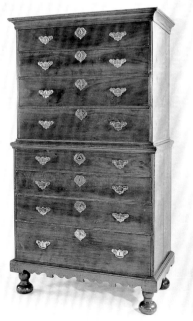

33

27

32. Tall Chest
Chester County, Pennsylvania, c. 1746
Inscription: ES 1746 (inlaid on front)
Walnut; cedar, oak, pine, poplar, mixed wood inlays
52¹/₄ x 41 x 22¹/₈" (132.7 x 104.1 x 56.2 cm)
Collection of H. Richard Dietrich, Jr.

33. Chest-on-Chest
Philadelphia, c. 1715–35
Walnut; red cedar, white cedar, white pine
71³/₄ x 40¹/₄ x 22¹/₂" (182.2 x 102.2 x 57.2 cm)
Von Hess Foundation: Wright's Ferry Mansion, Columbia, Pennsylvania. 78.4

34. Chest-on-Chest
Philadelphia, c. 1740–50
Walnut; poplar, white pine
93 x 42¹/₂ x 23¹/₂" (236.2 x 108 x 59.7 cm)
Private Collection
See fig. 176.

35. Triple Chest
Philadelphia, c. 1735–45
Cherry; cedar, pine, poplar
72³/₈ x 40 x 22" (183.8 x 101.6 x 55.9 cm)
Philadelphia Museum of Art. Bequest of Lydia Thompson Morris. 1932-45-101
 This chest was probably commissioned by Elizabeth Coates Paschall and used at her Philadelphia house, Cedar Grove. It retains its original engraved brasses.

36. High Chest
Philadelphia, 1695–1720
Cedar
70⁷/₈ x 43³/₈ x 23⁵/₈" (180 x 110.2 x 60 cm)
Private Collection
See fig. 182.

37. High Chest
Philadelphia, c. 1700–1720
Walnut; cedar, pine, poplar; holly inlay
64¹/₂ x 41⁷/₈ x 23¹/₈" (163.8 x 106.4 x 58.7 cm)
Lent by the Commissioners of Fairmount Park, Philadelphia
 Descended in the Waln family of Philadelphia.

38. High Chest and Dressing Table
Attributed to John Head (died 1754)
Philadelphia, c. 1726
Walnut; poplar, white cedar, yellow pine
Chest 66⁷/₈ x 42¹/₈ x 23¹/₄" (169.9 x 107 x 59.1 cm)
Dressing table 29 x 33⁵/₈ x 21¹/₂" (73.7 x 85.4 x 54.6 cm)
Philadelphia Museum of Art. Gift of Lydia Thompson Morris. 1928-7-12, 13
 This Philadelphia high chest and dressing table are the only examples known to have survived as

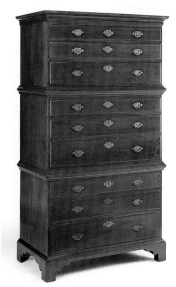

35

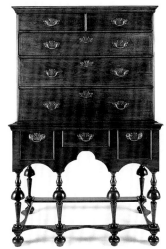

37

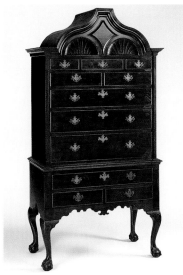

39

a pair. They descended in the Johnson, Wistar, and Morris families and are thought to have been made as a part of the dowry furniture of Catherine Johnson (1703–1786) of Germantown for her marriage to Caspar Wistar on May 25, 1726.
See fig. 167.

39. High Chest
Attributed to Joseph Claypoole (born England, 1677–1744) or his son Josiah (active beginning in 1740)
Philadelphia, c. 1743
Signature: Jos. Claypoole 1743 (in chalk under bottom drawer of upper case along with other partial signatures)
Mahogany, mahogany veneer; cedar, maple, pine, poplar
84¹/₈ x 44¹/₈ x 23¹/₄" (213.7 x 112.1 x 59.1 cm)
Philadelphia Museum of Art. Gift of Martin A. Battestin. 1998-78-1

40. High Chest
Southeastern Pennsylvania, probably Philadelphia, c. 1740–55
Maple; pine
79¹/₄ x 45 x 24" (201.3 x 114.3 x 61 cm)
Private Collection
See fig. 93.

41. Miniature Cased Drawers on Stand
Philadelphia, c. 1715–30
Walnut; oak, pine
24³/₄ x 13¹/₂ x 9¹/₂" (62.9 x 34.3 x 24.1 cm)
Private Collection
See fig. 165.

42. Miniature Cased Drawers on Stand
Philadelphia, c. 1715–30
Mahogany; cedar, white pine
25¹/₂ x 18⁵/₈ x 9" (64.8 x 47.3 x 22.9 cm)
Private Collection
See fig. 162.

43. Wardrobe
Southeastern Pennsylvania, c. 1735–50
Walnut; pine, poplar
78¹/₄ x 69¹/₄ x 24⁵/₈" (198.8 x 175.9 x 62.5 cm)
Von Hess Foundation: Wright's Ferry Mansion, Columbia, Pennsylvania. R97.1
 Wardrobes—*kasten* in Dutch and *Schränke* in German—were derived from northern European antecedents. They were usually constructed of separate large, flat panel-and-frame units that could be easily disassembled for moving.

44. Wardrobe
Southeastern Pennsylvania, c. 1745–60
Walnut; pine, poplar; painted decoration
84 x 77 x 29" (213.4 x 195.6 x 73.7 cm)
Private Collection

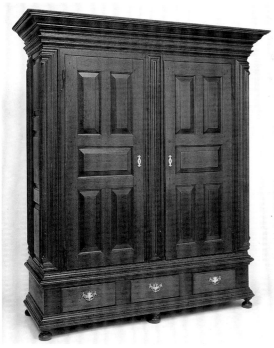

43

46

One of a small group of *kasten* with local histories and of similar craftsmanship, this wardrobe relates closely in its scale and construction techniques to architectural joinery.
See fig. 13.

45. Corner Cupboard
Southeastern Pennsylvania, c. 1730–40
Walnut; poplar
67^1/$_2$ x 28^1/$_2$ x 21" (171.5 x 72.4 x 53.3 cm)
Private Collection
See fig. 157.

46. Wall Cupboard
Lancaster County, Pennsylvania, c. 1733–45
Pine, poplar; cedar
25^1/$_4$ x 19 x 9" (64.1 x 48.3 x 22.9 cm)
Philadelphia Museum of Art. Gift of J. Stogdell Stokes. 1928-10-97
This hanging cupboard was used at Ephrata Cloister in Ephrata, Pennsylvania.

47. Pewter Press
Philadelphia, 1735–45
Walnut; pine, poplar
80^3/$_8$ x 49 x 16^1/$_2$" (204.2 x 124.5 x 41.9 cm)
Philadelphia Museum of Art. Bequest of Mrs. Henry Goddard Leach. 1976-102-1
In 1719 James Logan ordered a press from the Philadelphia cabinetmaker Joseph Harrison (died 1735). This press, listed with the pewter tableware it contained, is included in Logan's 1754 inventory of Stenton.
See fig. 132.

48. Dressing Table
Philadelphia, c. 1700–1715
Walnut; cedar, pine
29^1/$_2$ x 37 x 21^1/$_2$" (74.9 x 94 x 54.6 cm)
Philadelphia Museum of Art. Gift of Lydia Thompson Morris. 1928-7-53

49. Dressing Table
Philadelphia, c. 1700–1720
Walnut
27^3/$_4$ x 39^3/$_4$ x 23^3/$_4$" (70.5 x 101 x 60.3 cm)
Private Collection
According to tradition, this dressing table belonged to Dr. Thomas Wynne, a prominent physician. It descended to Anthony Morris II, one of his patients, and subsequently through the Morris family.

50. Dressing Table
Philadelphia, c. 1715–25
Walnut; cedar, pine
29^3/$_4$ x 33^3/$_8$ x 20^1/$_8$" (75.6 x 84.8 x 51.1 cm)
Philadelphia Museum of Art. Purchased with the Elizabeth S. Shippen Fund. 1925-69-1
See also fig. 135.

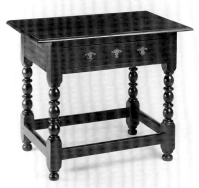

48

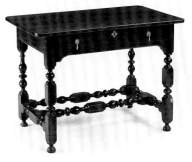

49

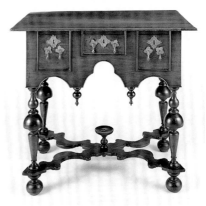

50

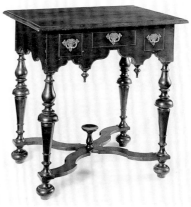

51

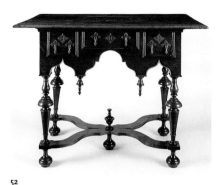

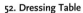
52

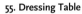
53

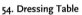
54

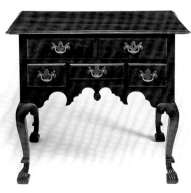
55

51. Dressing Table
Philadelphia, c. 1715–25
Mahogany, cherry; cedar, pine, poplar
27 x 27³/4 x 19³/4" (68.6 x 70.5 x 50.2 cm)
Private Collection

52. Dressing Table
Southeastern Pennsylvania, possibly Chester
County, c. 1724
Inscription: 1724 / EM (inlaid on top)
Walnut; cedar, pine, poplar, mixed wood inlays
30 x 40¹/4 x 23³/8" (76.2 x 102.2 x 59.4 cm)
Philadelphia Museum of Art. Bequest of R.
Wistar Harvey. 1940-16-28
See also fig. 187.

53. Dressing Table
Southeastern Pennsylvania, probably
Philadelphia, c. 1728–40
Mahogany, maple; cedar, pine
30 x 33¹/2 x 20" (76.2 x 85.1 x 50.8 cm)
Collection of Jay Robert Stiefel
See also fig. 193.

54. Dressing Table
Philadelphia, c. 1730–40
Walnut; cedar, pine, poplar
30¹/2 x 34¹/2 x 20¹/2" (77.5 x 87.6 x 52.1 cm)
Private Collection

55. Dressing Table
Southeastern Pennsylvania, c. 1740–50
Walnut; pine
28¹/2 x 35 x 19¹/4" (72.4 x 88.9 x 48.9 cm)
Private Collection

56. Dressing Table
Philadelphia, c. 1745–55
Maple; poplar, white cedar
30 x 35¹/2 x 22" (76.2 x 90.2 x 55.9 cm)
Collection of Jay Robert Stiefel

 This dressing table, which is thought to have
belonged to Benjamin Franklin, is characteristic
of the work of Solomon Fussell and William
Savery. Franklin is known to have patronized
both of these craftsmen in the 1740s.

57. Tall Case Clock
Christopher Witt (born England, 1675–1765)
Germantown, Pennsylvania, c. 1710–30
Signature: Christopher Witt Germantown: fecit
(engraved on bottom of face)
Walnut; pine, poplar; brass and iron works
92⁷/8 x 20³/4 x 9⁷/8" (235.9 x 52.7 x 25.1 cm)
Collection of H. L. Chalfant

 Christopher Witt was one of the first clock-
makers in Pennsylvania to build pendulum-
regulated, weight-driven clocks (or *Wanduhren*),
which were the predecessors of tall case clocks.

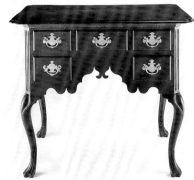
56

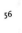

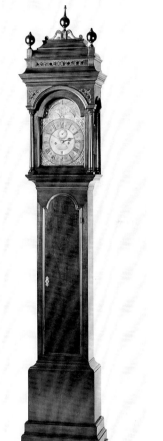
59

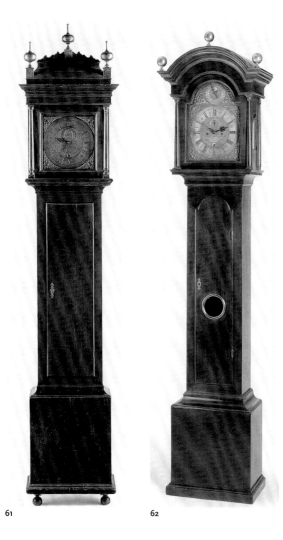

61 62

He later trained the clockmakers Christopher Sauer and Robert Claymore.
See fig. 69.

58. Tall Case Clock

Peter Stretch (born England, 1670–1746)
Philadelphia, c. 1720–30
Signature: Peter Stretch / Philadel (engraved on face)
Walnut; pine, poplar; brass and iron works
101 1/4 x 22 1/8 x 12 1/8" (257.2 x 56.2 x 30.8 cm)
Collection of H. Richard Dietrich, Jr.
See fig. 14.

59. Tall Case Clock

William Graham (active London, c. 1720–30)
Case made in Philadelphia, c. 1725–35
Signature: W^m Graham / LONDON (engraved on face)
London, c. 1720–30
Mahogany; pine, poplar; brass and iron works
108 1/4 x 20 7/8 x 10 7/8" (275 x 53 x 27.6 cm)
Philadelphia Museum of Art. Bequest of Lydia Thompson Morris. 1932-45-82

Descended in the Johnson and Wistar families and may have been part of the furnishings of Caspar and Catherine Johnson Wistar's Philadelphia town house.

60. Tall Case Clock

Benjamin Chandlee, Sr. (born Ireland, 1685–1745)
Nottingham Township, Chester County, Pennsylvania, c. 1730
Signature: B. Chandlee / Nottingham (engraved on face)
Walnut; poplar; brass and iron works
90 1/8 x 20 1/8 x 10 1/2" (228.9 x 51.1 x 26.7 cm)
Chester County Historical Society, West Chester, Pennsylvania. CLX42
See fig. 151.

61. Tall Case Clock

John Wood, Sr. (died 1761)
Philadelphia, c. 1730–40
Signature: John Wood / Philadelphia (engraved on face)
Stamp: No. 3
Walnut; pine, poplar; brass and iron works
100 x 19 1/8 x 9 1/2" (254 x 48.6 x 24.1 cm)
Collection of Joseph and Jean McFalls

62. Tall Case Clock

Peter Stretch (born England, 1670–1746)
Philadelphia, c. 1730–40
Signature: Peter Stretch / Philadelphia (engraved on face)
Inscription: TEMPUS RERUM IMPERATOR [Time is the ruler of things] (engraved on face in banner below signature)
Mahogany; poplar, yellow pine, brass; brass and iron works

94 x 23 1/4 x 11 1/2" (238.8 x 59.1 x 29.2 cm)
Private Collection

Part of the original furnishings of Dawesfield (built 1728), located in Penllyn, in the Welsh tract of Merionethshire, Pennsylvania, this clock descended in the Morris and Lewis families of Philadelphia.

63. Tall Case Clock

Southeastern Pennsylvania, 1740
Walnut; oak, pine, poplar, mixed wood inlays; brass and iron works
Inscription: I ^M C / 1740 (inlaid on front)
89 1/2 x 20 3/8 x 13 1/8" (227.3 x 51.8 x 33.3 cm)
Private Collection

Possibly the work of a Germanic craftsman, this clock incorporates an earlier European lantern clock movement as its mechanism.
See fig. 34.

64. Tall Case Clock

William Stretch (born England, died 1748)
Philadelphia, c. 1735–45
Signature: Wm Stretch / Philadelphia (engraved on face)
Inscription: TEMPUS RERUM IMPERATOR [Time is the ruler of all things] (engraved on face in banner below signature)
Mahogany; pine, poplar, brass; brass and iron works
110 1/2 x 21 3/8 x 10 1/8" (280.7 x 54.3 x 25.7 cm)
Private Collection

65. Tall Case Clock

Joseph Wills (c. 1700–1759)
Philadelphia, c. 1746
Signature: Joseph Wills (engraved on face)
Walnut; pine, poplar, brass; brass and iron works
94 1/4 x 20 3/8 x 11" (239.4 x 51.8 x 27.9 cm)
Philadelphia Museum of Art. Purchased with funds from the sale of deaccessioned works of art and a partial gift from an anonymous donor. 1998-145-1

This clock was first owned by Joseph Fox (1709– 1779), an affluent Philadelphia Quaker, who commissioned it in 1746. The rare, imported brass columns on the upper case are unique among early Philadelphia tall case clock designs.
See fig. 156.

66. Tall Case Clock

Isaac Thomas (born Pennsylvania, 1721–1802)
Chester County, Pennsylvania, c. 1751
Signature: Isaac Thomas / Willis Town (engraved on face)
Walnut; poplar, sycamore; brass and iron works
96 x 19 3/4 x 11 1/4" (243.8 x 50.2 x 28.6 cm)
Private Collection

An enterprising craftsman, farmer, and merchant, Isaac Thomas of Willistown, Chester County, was one of the few clockmakers who may also have made the cases for his clockworks.

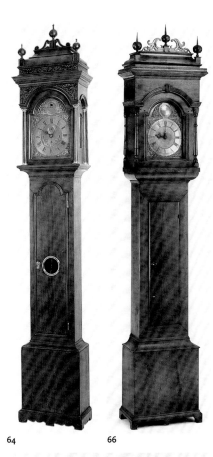

64 66

67

For clockfaces out of their cases, see nos. 420, 422.

67. Tabletop Desk
Philadelphia, c. 1710–20
Inscription: CW (in graphite on inside of drawer)
Cedar
12 x 21¹/₂ x 15" (30.5 x 54.6 x 38.1 cm)
Philadelphia Museum of Art. Gift of James
Shinn Maier, Anthony Morris Maier, and Dr.
James Hollingsworth Maier. 1998-162-1

This desk originally belonged to the glass
manufacturer Caspar Wistar. Its interior re-
tains the original applied moldings on its drawers
and the cast scroll-form drops and pulls, tinted
with orange laquer to approximate the appearance
of gilding.

68. Fall-Front Desk
Philadelphia, c. 1705–25
Mahogany; cedar, pine, poplar
44⁵/₈ x 38⁷/₈ x 23³/₈" (113.3 x 98.7 x 59.4 cm)
Private Collection

This fall-front desk, with scroll-bracket base
and turned feet, is one of only four known sur-
viving local examples of the form.
See fig. 186.

69. Escritoire, or Fall-Front Desk
Edward Evans (born England, 1679–1754)
Philadelphia, 1707
Signature: Edwards Evans / 1707 (stamped
inside bottom drawer centered above open well
in upper section)
Walnut; white cedar, white pine
66¹/₂ x 44¹/₂ x 19⁷/₈" (168.9 x 113 x 50.5 cm)
The Colonial Williamsburg Foundation,
Williamsburg, Virginia. 1958-468
See also fig. 194.

70. Secretary Desk and Bookcase
Philadelphia, c. 1710–20
Inscription: D John 6 / 20 (in chalk on bottom
of bookcase section)
Walnut; pine, poplar, mirror (one pane restored)
90 x 40 x 22³/₄" (228.6 x 101.6 x 57.8 cm)
Philadelphia Museum of Art. Gift of Mrs. John
Wintersteen. 1963-33-1

David John, perhaps an owner or the maker
of this desk, is possibly related to the family of
Philip John, a joiner who died in 1741. The 1722
will of Philadelphian Joseph Redman lists "A
Looking glass Screetore 1 glass broke."
See fig. 8.

71. Secretary Desk and Bookcase
Philadelphia, c. 1725–30
Mahogany; cedar, oak, poplar, unknown exotic
hardwood and mixed wood inlays, mirror
94 x 39³/₄ x 22" (238.8 x 101 x 55.9 cm)
Stenton, Philadelphia. Gift of Mrs. John F.
Doremus. 72.4

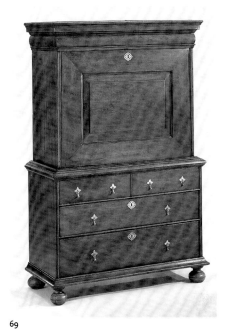

69

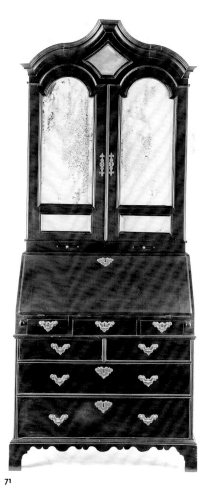

71

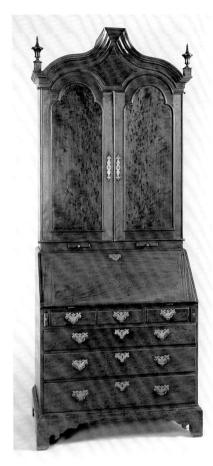

73

This desk originally belonged to James Logan and is listed in the 1754 inventory of the front parlor at Stenton as an "Escritoire with Glass Doors." It includes rare exotic hardwood decorative trim on the interior.
See also fig. 195.

72. Secretary Desk and Bookcase

Philadelphia, c. 1730–40
Walnut, cherry; gum, white cedar, white oak, yellow pine
100¹/₂ x 42 x 23³/₄" (255.3 x 106.7 x 60.3 cm)
The Dietrich American Foundation
 Descended in the Gilder family of Burlington County, New Jersey, and Philadelphia.
See figs. 168, 196.

73. Secretary Desk and Bookcase

Philadelphia, c. 1730–40
Mahogany, mahogany veneer; maple, oak, pine, poplar
96 x 40 x 24¹/₄" (243.8 x 101.6 x 61.6 cm)
Tryon Palace Historic Sites and Gardens. 57.61.4
 The best Hondurian mahoganies, often referred to as "plum pudding mahogany," with their rich spotted grain and dark, almost purple color, are used as thin boards to form the door panels and drawer fronts on this desk.

74. Secretary Desk and Bookcase

Philadelphia, c. 1735–45
Mahogany; pine, poplar, mirror
89 x 41¹/₈ x 24" (226.1 x 104.5 x 61 cm)
Private Collection
See fig. 185.

75. Secretary Desk and Bookcase

Philadelphia, c. 1740–50
Mahogany; cedar, pine, poplar
105 x 41 x 24³/₄" (266.7 x 104.1 x 62.9 cm)
Philadelphia Museum of Art. Gift of Daniel Blain, Jr. 1997-67-3
 This desk descended in the Logan family of Philadelphia and is thought to have been commissioned by William Logan (1718–1776), eldest son of James and a distinguished physician.
See also figs. 138, 189.

76. Bureau Desk or Table

Philadelphia, c. 1750–55
Mahogany; poplar, white cedar
33 x 34¹/₂ x 18¹/₂" (83.8 x 87.6 x 47 cm)
Private Collection
 Lardner family tradition asserts that this bureau was made for Richard Penn (1735–1811) but was given to his brother-in-law and solicitor, Lynford Lardner (1715–1774), in payment of a debt.

75

76

Tables and Stands

Fig. 197
Gateleg Table, possibly made by
James Bartram, c. 1725–40, no. 80.

There were a number of different types of tables in use in early Pennsylvania in addition to the dressing tables discussed with case furniture. In most households, small framed tables or "stands" with turned legs and box stretchers, with and without drawers, served a variety of purposes. However basic the techniques of their joinery, many examples were highly refined in their proportions, turning, and decorative detail (see no. 90). Germanic joiners in Pennsylvania, adapting the profiles of the lathe-turned leg in their designs, often maintained the earlier medieval and Renaissance architectural traditions of square-sawn balusters for the legs of both large and small stretcher-base tables (no. 94). Because the simple stretcher-base table, probably the earliest type of table produced by local joiners and turners, could be used in a number of ways, it continued to be produced throughout the eighteenth century (see no. 49). A survival from medieval Europe, the table "board"—generally a large wooden slab set upon a separate frame that could be disassembled and stored when not in use—was noted in Pennsylvania inventories prior to 1700 and also remained in use, particularly in Germanic communities, through the eighteenth century. Other early listings record the presence of "Spanish," "Dutch," and "Hangore" tables and may refer to origins or types of tables that apparently have not survived or have been incorrectly identified.[52]

"Falling" or "folding" tables, their leaves supported by swinging, turned "gatelegs," have survived in many sizes and variations. While most are constructed of black walnut, examples in oak, cedar, cherry, pine, and mahogany were also produced. Their joined, heavily framed construction, with rails of thickly milled poplar or pine and sturdy oak swing rails framing the gate, was largely hidden by their broad top and leaves when opened, exposing only the interplay of the turned silhouettes of their legs and stretchers (no. 77). Long drawers placed in one or both ends, their bottoms sliding through the table's central frame on an inset mortised support rail, made the tables more useful (no. 80, fig. 197). These tables were often quite large and constructed of heavy stock; the quality and definition of their turnings, composed of separately turned elements such as the baluster vase, reel, ball and ring, and "squares" (blocks), often disguised the thickness of the wood used.[53] The flat-faced "square" blocks of the turnings provided the flat surfaces for the mortises and tenons joining the stretchers and frames (see no. 77). The passages of turning forming the legs and stretchers of gateleg tables closely echo the turning found in architectural balusters of the same time period. Gateleg tables gave their owners the flexibility of the earlier board table but in a form that could be folded and stored against a wall when not in use (no. 79). Such space-saving options were important in the relatively small rooms typical of many early households. Later versions of drop-leaf tables adopted cabriole legs and incorporated other sizes, shapes, and styles of feet (see no. 81).

Specialized table forms evolved to accommodate new and stylish modes of entertaining. As early as 1693 "slate"

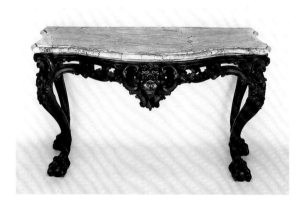

Fig. 198
Pier Table, 1753, no. 95.

tables, their tops impervious to damage from spills or excessive heat, appear in the local records, but so few survive today that little is known of their form or construction.[54] "Slab" and sideboard tables dating from the 1740s and 1750s, with marble or thick wooden tops, accompanied tables for dining, providing additional surfaces for display and serving during meals (no. 92). Toward mid-century these tables were sometimes called "pier slabs" or "pier tables" and were included along with a "pier" glass in inventories of rooms used for dining. The names derive from their placement between two windows, in the wall space known in architectural terminology as a "pier." Marble for these tables was imported or could be obtained from local quarries. In 1748 the traveler Peter Kalm noted the presence of "many kinds of marble, especially a white one with many pale gray bluish spots, that is found in a quarry at the distance of a few English miles from Philadelphia, and is very good for working. . . . People make tombstones and tables, enclose chimneys and doors, and lay floors and flags in front of fireplaces, of this kind of marble."[55] One of the most impressive pier tables from Philadelphia to have survived utilizes imported, highly figured yellow and black Spanish marble known as "Broccatella di Spagna"; it was commissioned about 1751–52 by Joshua Crosby, the first president of Pennsylvania Hospital, and presented to the new hospital building in 1755 (no. 95, fig. 198).[56] Following the designs of French and Dutch console tables inspired by the baroque classicism of the years 1630–50, its deeply carved frame, constructed of mahogany, includes aspects of their symmetrical "auricular" ornament of C-scrolls and foliate motifs,

as well as an impressive central lion-head mask on its front skirt. Few early American furniture pieces are so ambitious and illustrate so direct an influence from the European court style.[57]

The fashionable customs of drinking tea and coffee took root in Philadelphia during the 1720s and 1730s, inspiring a whole range of tables. The earliest versions of round-top tea tables were similar in form to the early candlestands that often accompanied dressing tables. Their flat, scroll-sawn legs were either mortised directly into the lower post of a central turned baluster or set into an intermediate faceted platform upon which the central pillar support was seated (see nos. 82, 83; fig. 199). This configuration of tripod foot, platform, and central column supported the top, which was cut from a flat board or boards and then turned or plane-and-lathe molded to a "dished" profile with a raised edge. Round, octagonal, "scalloped," square, and various other shaped tops were produced (see no. 100). The tops of the earliest tea tables and stands were usually fixed, but tilting tops and the "birdcage" mechanism, which allowed the tops to both rotate and tip up, were produced regularly by the late 1730s. Listings for these "tea table ketches" are often included in craftsmen's and merchants' lists of hardware by this time.[58]

The early, flat-sawn, scroll-shaped legs of tea tables evolved into the fully rounded cabriole leg in a development that began in the mid-1730s. A rare early mahogany tea table (c. 1730–35), thought to have belonged originally to Beulah and Thomas Paschall of Philadelphia, illustrates the transitional form (no. 83, fig. 199). It retains the faceted platform on the base that is found on the earlier

examples with scroll-sawn legs, but this element has been thickened to accommodate the fully rounded mortise joint for the cabriole legs set into its sides. Legs on these earlier cabriole-style tea tables with central platforms employ either the conventional rectangular mortise-and-tenon joint or a dovetail-shaped tenon on the leg, which slid up through a corresponding deep, wedge-shaped mortise cut into the bottom of the central platform or column.[59] The legs on early examples tend to be more heavily milled, broader in their shaped, rounded profiles, and have not yet developed the full height and flowing, curved line of the S-scroll achieved on the best, later examples of cabriole legs on tables, chairs, and case pieces. Its elongated pad foot, while rarely used on cabriole-leg chairs in Pennsylvania, continued as the preferred form of foot for these tables through the early 1750s. The Paschall table's classically inspired, subtly tapered Doric column, or "torus" support stem, rises to a round dished top with a rotating and tilting "birdcage" mechanism. An early walnut candlestand, which belonged to Charles Norris, the prominent Philadelphia merchant, employs a similar foot and torus form of stem and is thought to have been produced in the Philadelphia shop of William Savery (no. 102).

By the late 1740s the fully developed tilt-top tea table with a central baluster stem; shaped, arching cabriole legs; and round or scalloped dished top was being made regularly by a number of local craftsmen. As was the case for earlier furniture components produced by turners, the individual vases, reels, and balls constituting the central "pillar" were combined in different ways, with the baluster-vase-over-ring or the invert-ed-baluster-vase-over-ball-and/or-ring most often employed in local examples. English and Irish tea tables imported to Philadelphia may have inspired decorative variations on the foot or the placement and type of carved motifs such as shells, which appeared on the "knees" of the legs (see no. 84, fig. 23). While the claw-and-ball foot had probably been introduced in Philadelphia by the late 1730s through examples present on imported furniture, the earliest documented reference to this exotic foot is from the mid-1740s. The Philadelphia cabinetmakers Joseph Hall and Henry Rigby made reference to a "Pillar & Claw Table" and "an old Pillar & Claw Mahogy. Table" on January 17, 1745/46, while three years later they record "A Pillar & Claw Tea Table."[60] During the 1750s the relief-carved shells and foliate motifs decorating the legs of these tables, while remaining symmetrical in their layout, grew more fluid in their execution and placement. The reverse-scroll edge of molded scalloped-top tea tables developed a more flowing and refined balance and rhythm. The tripod-base version was by far the tea table most often produced in Pennsylvania, and its basic three-leg form with central stem was adapted to a number of different candlestands, fire screens, and other forms (see nos. 103, 104).

Rectangular tea tables with finely molded edge surrounds on their tops were also produced in the Delaware Valley but are much rarer than the round or scalloped tilt-top tables. Several surviving Philadelphia examples of these "tray-top" tables show strong stylistic influences from Irish prototypes, which are thought to have been among the types of imported tea tables present in the city.[61] The best of these tea tables illustrate the deftness

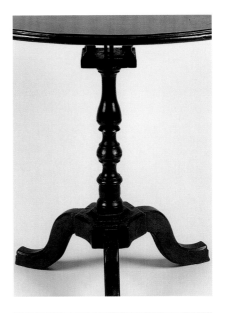

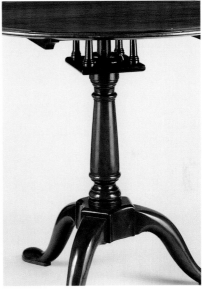

Fig. 199
Tea Tables, c. 1715–35, no. 82; c. 1730–35, no. 83; details.

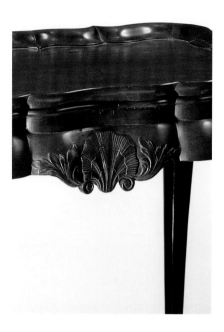

Fig. 200
Tea Table, c. 1748–55, no. 87, detail.

certain craftsmen had achieved by the mid-1740s through their experiments with relationships of proportion, lightness, and verticality in the emerging cabriole-leg style (see no. 88, fig. 94). One of the most accomplished tray-top tea tables descended in the family of Charles Norris and is possibly one of those listed in the 1756 inventory of his Philadelphia town house: "2 Mahogany Tea Tables In the large dining Room on the same [second] floor in front" (no. 87, fig. 200).[62]

The undulating, curvilinear edge of the Norris table's top, which is basically rectangular in form but elaborated around its perimeter with repeating scalloped moldings, is echoed by the complicated laminated block construction of its frame. The lower edges of the apron project outward and are delicately carved with centrally placed scalloped shells and flanking scrolls. Its graceful, high legs with projecting knees have a vertically elongated cabriole shape and are decorated with carved shells and scrolls that diminish in size as they descend from the uppermost, largest shell on the knee to terminate in a "claw'd" foot. One of a group of related early 1750s carved examples, which include several dressing tables, round tea tables, and chairs, it exhibits a structural and decorative sophistication in mid-century Philadelphia that has not

been traced thus far to any particular maker or workshop. Unfortunately, little is known about specialized carvers during this period. Samuel Harding, a carver of pronounced talent working in the city during the 1750s, was certainly one such craftsman capable of producing high-quality carving of this type, and indeed, he may have been responsible for it.[63]

While the card table continued to grow in popularity in the third quarter of the eighteenth century, it seems that few of the tables used for popular games and pastimes in Pennsylvania prior to 1755 have survived.[64] One possible explanation for the relative scarcity of card tables may be Quaker objections to gaming. Early in 1700 the Assembly passed an ordinance enacting a fine of five shillings or five days imprisonment for anyone convicted of "playing at cards, dice, lotteries or such like enticing, vain and evil sports or games."[65] How stringently this law was enforced is not known, and despite these restrictions, the inventories of some wealthier households list either imported or domestically produced backgammon, billiard, and card tables. A 1736 inventory of Governor Patrick Gordon's household goods is one of the earliest known citings of a "card" table.[66] Taverns also offered opportunities for gaming and probably had such tables for their patrons' use.[67]

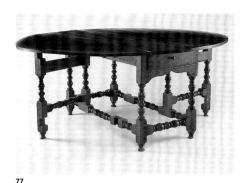

77

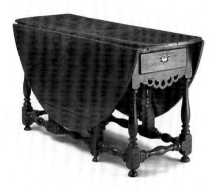

78

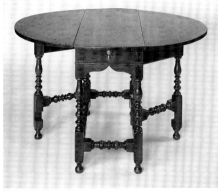

79

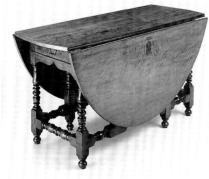

80

Tables and Stands

77. Gateleg Table
Philadelphia, 1685–1700
Walnut; cedar, oak, pine
Open 29¹/8 x 72¹/8 x 54³/4" (74 x 183.2 x 139.1 cm)
Philadelphia Museum of Art. Purchased with the
Thomas Skelton Harrison Fund. 1942-73-1

 This table is thought to be one of the large "fall-
ing leave" tables commissioned by William Penn
for use at Pennsbury Manor, Penn's country home
north of Philadelphia on the Delaware River.

78. Gateleg Table
Philadelphia, c. 1710–30
Walnut; cedar, oak, pine
Open 30³/8 x 72¹/8 x 61¹/8" (77.2 x 183.2 x 155.3 cm)
Philadelphia Museum of Art. Gift of Miss Letitia
Humphreys. 1922-76-1

79. Gateleg Table
Philadelphia, c. 1710–30
Walnut; cedar, pine
Open 28¹/4 x 47³/8 x 36¹/2" (71.8 x 120.3 x 92.7 cm)
Private Collection

80. Gateleg Table
Possibly made by James Bartram
Chester County, Pennsylvania, c. 1725–40
Inscription: 1725 / I ᴮ ᴇ (inlaid on leaf)
Walnut; chestnut, mixed wood inlays
Open 30³/4 x 70 x 60" (78.1 x 177.8 x 152.4 cm)
Mr. and Mrs. William West Wilson, Jr.

 One of the only known gateleg tables produced
in the Delaware Valley to include marquetry deco-
ration, this massive walnut table is thought to have
belonged to James Bartram and his wife Elizabeth.
The brother of the botanist John Bartram, James
Bartram was a cabinetmaker in Chester County.
See also fig. 197.

81. Drop-Leaf Table
Philadelphia, c. 1735–50
Mahogany; chestnut, pine
Leaves down 28¹/2 x 20¹/2 x 60¹/4" (72.4 x 52.1 x
153 cm)
Collection of H. Richard Dietrich, Jr.

82. Tea Table
Philadelphia, c. 1715–35
Walnut
Height 27¹/8" (68.9 cm); diameter 31⁵/8" (80.3 cm)
Private Collection

83. Tea Table
Philadelphia, c. 1730–35
Mahogany
Height 28" (71.1 cm); diameter 29 ¹/4" (74.3 cm)
Philadelphia Museum of Art. Gift of Lydia
Thompson Morris. 1928-7-110

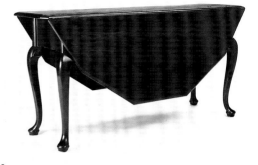

81

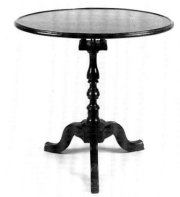

82

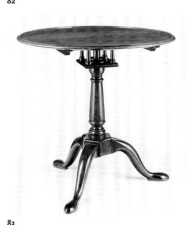

83

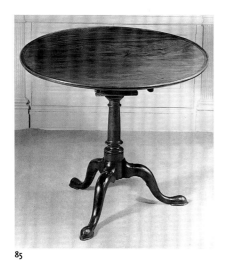

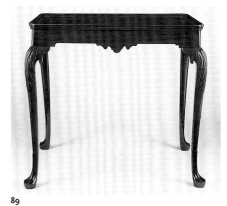

A rare early tea table constructed from mahogany, this table is thought to have originally belonged to Beulah and Thomas Paschall of Philadelphia. *See also fig. 199.*

84. Tea Table
Ireland, c. 1730–40
Mahogany
Height 29¹/₂" (74.9 cm); diameter 31³/₈" (79.7 cm)
Collection of H. Richard Dietrich, Jr.
 This table, owned by the provincial governor of Pennsylvania Sir William Keith (1680–1749), was part of the early furnishings of Fountain Low. *See fig. 23.*

85. Tea Table
William Savery (1721/22–1787)
Philadelphia, c. 1745–55
Walnut
Height 29⁵/₈" (75.2 cm); diameter 34³/₄" (88.3 cm)
Philadelphia Museum of Art. Purchased with the Haas Community Fund and the J. Stogdell Stokes Fund. 1968-174-1
 Typical of the "neat and plain" style preferred by many conservative Quakers, this table bears William Savery's printed label.

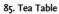

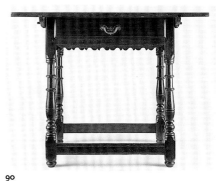
89

86. Tea Table
Philadelphia, c. 1748–55
Mahogany
Height 27" (68.6 cm); diameter 31" (78.7 cm)
Diplomatic Reception Rooms, Department of State, Washington, D.C. 82.72

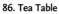

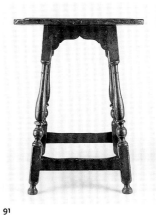
90

87. Tea Table
Philadelphia, c. 1748–55
Mahogany; pine
26¹/₂ x 31¹/₂ x 21¹/₂" (67.3 x 80 x 54.6 cm)
The Historical Society of Pennsylvania, Philadelphia. X-55
 Descended in the Dickinson, Logan, and Novris families of Philadelphia. *See also fig. 200.*

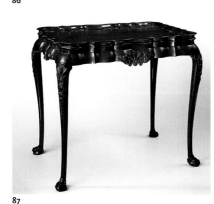

91

88. Tea Table
Philadelphia, c. 1740–50
Mahogany; pine, poplar
28¹/₄ x 32⁷/₈ x 21⁵/₈" (71.8 x 83.5 x 54.9 cm)
Philadelphia Museum of Art. Gift of John F. Haley, Jr., and Anne Rogers Haley in memory of Fred F. Rogers, Jr. 1994-17-1
See fig. 94.

89. Tea Table
Philadelphia, c. 1750–60
Mahogany
28 x 30¹/₈ x 20¹/₄" (71.1 x 76.5 x 51.4 cm)
Philadelphia Museum of Art. Purchased with the John D. McIlhenny Fund. 1962-17-1
 The form and decoration of this table are very similar to contemporaneous Irish tea tables. Its

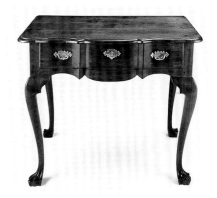
92

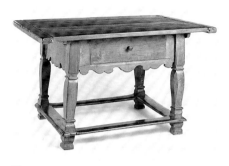

94

96

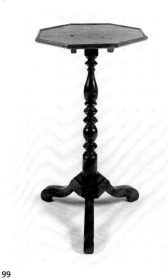

97

decorative carving is similar in pattern and execution to the interior woodwork of the State House (now Independence Hall), which was carved by the Philadelphia craftsman Samuel Harding (died 1758).

90. Table
Southeastern Pennsylvania, c. 1700–1730
Mulberry
28 x 35³/4 x 23¹/2" (71.1 x 90.8 x 59.7 cm)
Private Collection

91. Table
Southeastern Pennsylvania, c. 1730–60
Pine; painted
28¹/2 x 21¹/2 x 17¹/2" (72.4 x 54.6 x 44.5 cm)
Chester County Historical Society, West Chester, Pennsylvania. 1988.927

92. Table
Philadelphia, c. 1735–50
Walnut; pine, red cedar
27¹/2 x 34¹/2 x 22¹/2" (69.9 x 87.6 x 57.2 cm)
Collection of Mrs. Martha Stokes Price

93. Table
Philadelphia, c. 1740–55
Walnut; poplar, white pine
32 x 41³/4 x 19³/8" (81.3 x 106 x 49.2 cm)
Philadelphia Museum of Art. Bequest of R. Wistar Harvey. 1940-16-27.
Not illustrated.

94. Table
Southeastern Pennsylvania, c. 1740–55
Walnut; pine, poplar
26³/4 x 53¹/8 x 35³/8" (67.9 x 134.9 x 89.9 cm)
Philadelphia Museum of Art. Gift of J. Stogdell Stokes. 1924-64-1

95. Pier Table
Philadelphia, 1753
Mahogany; oak, poplar, marble
34¹/2 x 65¹/2 x 29³/4" (87.6 x 166.4 x 75.6 cm)
Philadelphia Museum of Art. Purchased with the J. Stogdell Stokes Fund and the John D. McIlhenny Fund. 1953-28-1
See fig. 198.

96. Candlestand
Holland or England, c. 1680–1710
Ash; pine, walnut, walnut-veneered "oysters."
Height 25³/4" (65.4 cm); diameter 11" (27.9 cm)
Collection of Joseph and Jean McFalls
 Several early Philadelphia household inventories include "ollave" and "oyster'd" (veneered) stands, which may have been imported examples such as this.

97. Candlestand
Delaware Valley, probably New Jersey, c. 1690–1710

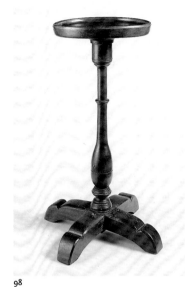

98

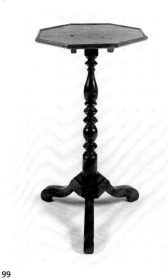

99

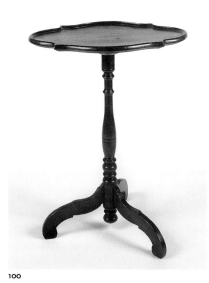

Maple, oak, pine
Height 26" (66 cm); diameter 10¹/₂" (26.7 cm)
Private Collection
 Descended in the Sveng and Rambo families of Salem County, New Jersey.

98. Candlestand
Southeastern Pennsylvania, c. 1710–35
Walnut
Height 28" (71.1 cm); diameter 22¹/₂" (57.2 cm)
Philadelphia Museum of Art. Gift of the heirs of J. Stogdell Stokes. 1952-7-4

99. Candlestand
Philadelphia, c. 1715–35
Walnut
28⁷/₈ x 17³/₄ x 16³/₄" (73.3 x 45.1 x 42.5 cm)
Private Collection

100. Candlestand or Kettle Stand
Philadelphia, c. 1725–40
Walnut
28¹/₂ x 23³/₈ x 18¹/₄" (72.4 x 59.4 x 46.4 cm)
Private Collection
 The scroll-shaped molded top of this rare stand follows the shapes prescribed in earlier northern European designs for garden parterres and decorative molded ceilings.

101. Candlestand
Southeastern Pennsylvania, c. 1730–50
Walnut
Height 27" (68.6 cm); diameter 12⁷/₈" (32.7 cm)
Private Collection

102. Candlestand
Philadelphia, c. 1735–45
Walnut
41⁵/₈ x 15¹/₄ x 117/₈" (105.7 x 38.7 x 30.2 cm)
Philadelphia Museum of Art. Gift of Daniel Blain, Jr. 1997-67-5
 This candlestand is thought to have been owned by Charles Norris of Philadelphia and may have been made in the shop of William Savery.

103. Candlestand with Drawer
Southeastern Pennsylvania, c. 1735–45
Walnut; cedar, oak
49¹/₂ x 20 x 11" (125.7 x 50.8 x 27.9 cm)
Collection of Joseph and Jean McFalls
 Descended in the Wister family of Philadelphia.

104. Pole Screen
Philadelphia, c. 1745–55
Mahogany; pine
63" (160 cm)
Collection of Mrs. Herbert F. Schiffer

100

101

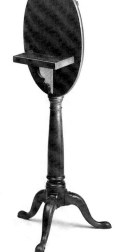

102

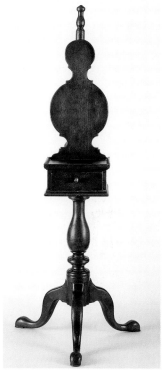

103

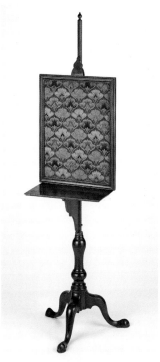

104

Seating Furniture

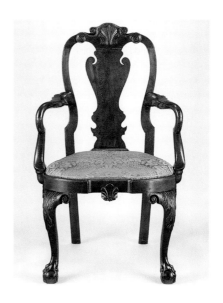

Fig. 201
Armchair, c. 1750–55, no. 164.

eating furniture—chairs, settles, stools, "forms," benches, and settees—was the most varied and plentiful type of domestic furniture produced in colonial Pennsylvania. In the earliest rudimentary households, low chests, simple framed stools, and benches probably served as the only seating furniture. It was not long, however, before various international traditions of craftsmanship combined in the shops of the turners, joiners, and chairmakers in the region, resulting in a greater variety of chair forms. Imported European and English chairs, as well as those from other coastal colonial towns, particularly Boston, influenced and competed with the products of local shops. As in other forms of furniture, certain chairs acquired symbolic associations. The "great chair," with its decorated crest "crowning" the head of its sitter, its imposing arms, and its loose cushion covered in rich materials, denoted power and authority in both domestic and official settings (see no. 146, fig. 153). The taste for comfort and fine imported tex-

tiles was demonstrated in the upholstery treatments, loose slip covers, and cushions used on early chairs. Other seating treatments that softened hard wooden frames can be found in the leather, caned, "flagged," rushed, and "matted" chairs of the period.

Chairs of various forms appeared in surprising numbers in many early households. The household inventory of Christopher Taylor, a Philadelphia merchant who had risen to some prominence before his death in 1685, listed more than thirty chairs, including six caned, six "turkey work," eight wood, two serge, one wicker, one "elboe," and one "close stool case."[68] In 1688 another Philadelphia merchant, James Claypoole, owned ten canvas-bottom chairs, two leather stools, one "Cloath Elbood Chair," one high leather chair and two low ones, eight cane chairs, and one cane couch, accompanied by "10 Cushions £1 & 4 old ones."[69] The pattern of having multiple chairs in a room was not limited to the city. David Lloyd, of Chester, had in his "dining room" at the time of his

death in 1731 eighteen chairs, one armchair, and a couch along with his two tables, tall case clock, and other furnishings, as listed in his inventory.[70] A number of other early inventories from rural Chester, Bucks, and Delaware counties, as well as from households in the river communities of New Jersey and Delaware, show a similar number of chairs kept in chambers and parlors (see no. 114).

One of the earliest surviving Pennsylvania chairs combines the techniques of the joiner and the turner in its construction and incorporates "barlet twist" spiral turnings in its frame (no. 112, fig. 202). Its paneled seat, set into rabbeted channels in the inner faces of its mortised-and-tenoned seat rails, echoes the framing techniques used in earlier wainscot panel chairs made in France, Holland, and rural England. The level of its seat panel and the large space between the seat frame and the lowest horizontal element of its back indicate that it was originally designed to accommodate a high cushion, which would

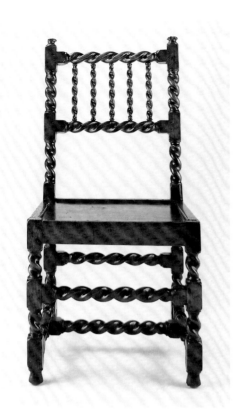

Fig. 202
Side Chair, c. 1690–1710, no. 112.

have been necessary to visually complete and balance the form in addition to making it more comfortable. The double-twist spiral turning used on this chair was variously referred to during the period as "Dutch" or "French" turning, and specialized turning tools and rasping files were usually needed to produce it. The two known chairs of this type, apparently from a once larger set, are of local black walnut and were produced by hand-rasping rather than turning the spirals, a much more laborious process.[71]

One early type of Delaware Valley chair that existed in a number of different varieties used panel-and-stile, or joined "wainscot," construction.[72] The term "wainscot" evolved during the Middle Ages in England and originally referred to fine-quality imported oak lumber; the term later came to describe interior paneling or furniture made of oak. The techniques employed by the joiner in the creation of architectural panels for walls certainly informed the configuration of the panels and the shapes, patterns, and profiles of the beveled-edge treatments used in a number of wainscot furniture forms. The early English term "seiled" or "ceiled," however, was used more directly as a synonym for "joined and paneled" and more accurately describes the method used in the making of wainscot chairs (see nos. 138, 150; figs. 178, 163). In Pennsylvania, both terms were used in inventories of the period to describe paneled wooden chairs that had plank or solid wood seats.[73] The earliest developments and distinctions seen in the large number of surviving examples of Pennsylvania wainscot chairs resulted from the local convergence of stylistically related yet culturally separate English, Welsh, Ger-

manic, Dutch, and Scandinavian traditions of construction and technique (nos. 144, 151; fig. 143).[74]

Welsh, English, and Irish Quaker immigrant farmers and craftsmen settled in Chester and Delaware counties, and in Philadelphia, forming close-knit, culturally homogeneous communities united by a common faith and traditions as well as shared aesthetic preferences.[75] Many of these new immigrants had arrived from the same farming regions abroad and thus shared prior experiences. A pronounced pattern of intermarriage helped to further maintain and encourage the survival of traditions and lifestyles. Among the early arrivals to these Quaker enclaves were a number of professional joiners, carpenters, and cabinetmakers. By the late 1690s the Welsh joiner Llewellin Phillips and the Englishman Richard Clone were working in Philadelphia and in Chester County, while the joiner John Maddock had settled in Ridley Township and established his workshop to supply the varied demands of a small local clientele.[76] It is likely that many of these early wood craftsmen applied their skills in panel and wainscot joinery to both architectural and chairmaking commissions. While some carried on their business year round, others worked by alternating their woodworking with the seasonal demands of agriculture.

As a result of the influence of these various traditions, a wide range of wainscot chairs were produced in Philadelphia, Chester County, Bucks County, and the surrounding region during the late seventeenth and early eighteenth century. The form and construction of a pair of fully paneled black-walnut "closed" armchairs relate them to traditional Dutch and Flemish paneled chairs

of the mid-seventeenth century (see no. 139).[77] One recurring local type of wainscot chair, with a scroll-cut crest incorporating a central arched element flanked by single or repeating comma-shaped cutouts, has contemporary parallels in the late seventeenth-century regional chairmaking traditions of the Cheshire and Lancashire districts in England (see no. 144, fig. 143).[78] Other, heavily proportioned examples incorporating backs with flat straight-sided banisters or turned or flat shaped balusters and cylinder or block legs retain an almost medieval character and may have come from the shops of local Germanic craftsmen (no. 143). Still others display a true mix of international influences, fusing diverse styles and methods of construction (nos. 125, 145). While individual turned elements such as finials, legs, stretchers, or the supports of scroll-cut arms can be related to particular patterns found in earlier ethnic chairmaking traditions, it is important to remember in any attempt to identify and date these chairs that the wide mixing of vernacular traditions that inspired their development over time also served to diffuse and transform those earlier traditions into many different variations. It is thus difficult to identify and prove any kind of stylistic continuum or clear chronological development within the wide range of paneled chair forms. In addition, few known examples are signed or can be linked by documents to their makers or owners, or to a specific region.

Other designs for chairs and seating furniture particularly lent themselves to the richly curvilinear "baroque" style and to the coordinated arrangements en suite popularly prescribed for room settings. In Pennsylvania households of the middle and upper classes, sets consisting of one or two armchairs, up to eighteen side chairs, stools, and a "couch," or daybed, were often configured as a suite in a chamber or parlor (see nos. 149, 168; fig. 179). Stools, or "forms"—both over-the-rail upholstered versions and those with wooden panel seats that would have been softened with a loose squab or cushion—are a rare survival from this early period. Stools were actually used as backless chairs rather than as footstools, as they are now sometimes called (see no. 107). The low upholstered stool was introduced in France and Holland in the second half of the seventeenth century and in England in the early eighteenth century and was called a *tabouret*.[79] The German immigrant Francis Daniel Pastorius, founder of Germantown, owned a Dutch or French version that included cup-and-trumpet turnings on its legs and stretchers (no. 105, fig. 22). The 1722 inventory of the merchant Jonathan Dickinson lists two stools as part of a larger suite of furniture (no. 106, fig. 48).[80] The forms of these stools follow those of English caned examples, while their turnings show both Germanic and northern European influences in their decorative scored lines and the tulip-shaped cup-and-ring turned feet. Later, in 1756, Charles Norris ordered from the cabinetmaker John Elliott a set of four cabriole-leg stools with shell decoration on their skirts and knees and with claw-and-ball feet, the only suite of the form known to have survived (no. 108, fig. 158).[81]

The daybed, or couch, which predates the upholstered settee, or sofa, in Pennsylvania, remained popular throughout the mid-eighteenth century. Daybeds and settees generally followed the decorative development of the chair. Early versions included carved or molded arched crests and caned, banister, vase-splat, or baluster backs, which were framed and fitted to recline on an adjustable chain-and-pin mechanism.[82] These couches, found in both parlors and bed chambers, may have served as extra beds in many rooms, given that they are almost always listed as upholstered or with a squab and pillows that matched the accompanying chairs. In versions from the 1740s and 1750s the arched or bow-crested backs became raked in angle but fixed. In the most ornate versions, highly grained, carefully shaped single or double vase-formed splats developed to match the designs of splat-back chairs, while the earlier forms of turned legs braced by stretchers were replaced with cabriole legs ending in pad, trifid, or claw-and-ball feet (see no. 170).

Quite a range of imported fabrics was available for upholsteries, slipcovers, and loose cushions to those who could afford them, including plush (velvets), cut plush, brocades, wool serges, moreen (a heavy cotton or wool fabric), silks, flowered cottons and chintz, harrateen (an English fabric of wool or linen used for curtains and bed hangings), striped sarcenet (soft, thinly woven silk), and checks.[83] As early as 1685 William Stanley, a Philadelphia merchant, owned "1 doz and 6 new backs & seats of Turkey work for Chairs, 4 wooden chairs . . . , 1 Green serge chaire, 4 Green serge Chairs, 1 Caine Chair, and 6 wrought Covers for Chairs."[84] The 1722 inventory of Jonathan Dickinson designates several of the rooms of his house by the colors of their decorations. Dickinson owned forty-four side chairs and twenty-six armchairs. His "Best Chamber" contained, in addition to several pieces of case furniture and a large bed, an "Easy Chair 12 cushions Couch Squab 3

pillows all flower'd Sattin / Cane Couch / 12 Elbow Cane chairs at 22 / . . . 2 Cane Stools."[85] Given the emphasis placed on imported textiles and coordinated upholsteries in the furnishings of many households, it is surprising how little fully upholstered seating furniture survives from the earliest period of furnituremaking in the Delaware Valley. The effect of time on fragile textiles has left little evidence of the work of colonial upholsterers (but see no. 123). Over-the-frame upholstered forms such as back stools, settees, "sophias," couches, easy chairs, and various forms of bed frames were the specialty of the "upholder," and the raw frames for these forms were often supplied to upholsterers by the joiner. In addition to imported fabric, leather was frequently used for the primary over-the-frame upholstery. Several examples of leather-upholstered settees or settle benches with paneled backs or high-framed leather-covered backs and seats have survived. One of the best preserved, made in either Philadelphia or Chester County about 1725–40, is constructed of heavy black walnut and retains its original marsh-grass, horsehair, and combed-wool foundation stuffings, its linen webbing and understructure, and its original leather seat panel (no. 109, fig. 10).[86]

The earliest written reference in Philadelphia to the profession of upholsterer is a 1693 tax list that describes John Budd as such. The upholsterer Joseph Shippen worked for James Logan between 1712 and 1719, making bed and window hangings, and John Housman, upholsterer, bought 64 yards of "haratine" from Logan.[87] On January 28, 1755, *The Pennsylvania Gazette* advertised that Edward Weyman, upholsterer, "stuffs all kinds of settees, and settee

beds, easy chairs, couches and chair bottoms, either of silk, worsted or leather" at "the sign of the Royal Bed."[88] Despite this documentary evidence, few examples of the framed seating forms that required full attached foundation upholsteries are known. One of the most impressive is a walnut cabriole-leg settee with fully developed scroll-form arms and a shaped, scalloped back crest that was made in Philadelphia about 1735–50; it is thought to have possibly descended in the Logan family (no. 169, fig. 172).[89] Aspects of its construction and design follow both English and Irish prototypes, particularly in the use of a removable framed slip seat, scrolled trifid feet, scrolled moldings on the sides of the legs, and elongated, lobed, shallow-carved shells on the knees.[90]

At present, no examples of stretcher-based, Spanish foot, or turned-foot easy chairs made in the Delaware Valley are known to have survived.[91] However, slightly later easy chairs incorporating different versions of the cabriole leg and either trifid, pad, slipper, or claw-and-ball feet are the most plentiful fully upholstered local seating form to have survived from the period before 1755. One of the earliest documented Philadelphia easy chairs was commissioned by James Logan and includes in its design the same tightly scrolled angular arms, elongated lobes on its carved shell, and scrolls on the sides of the legs that are found on the settee (no. 167, fig. 105). The primary wood of the chair is walnut, while its interior structural frame is of oak, white pine, and poplar. Its elongated, slipper-form foot with carved tab stocking is virtually identical to that found on two surviving upholstered back stools that also originally belonged to Logan (no. 165). Following the pat-

tern of many of Logan's furnishings, these back stools may have been intended to be used with the easy chair en suite. The back crests of all three have similar flat, arched rails with shaped corners and subtly tapering sides.

Many of the earliest imported chairs arriving in Philadelphia had high caned backs with molded or carved crests and caned seats and were of Dutch or English origin. The inspirations for these northern European and British versions came from Italian and Spanish caned chairs of the Late Renaissance. These chairs made their way north through trade and were adapted, refined, and popularized in England and Holland during the 1680s and 1690s. The popularity of caned furniture throughout Europe and in colonial America illustrates the spread of cultures and influences during the period, which followed the patterns of trade established during the seventeenth century by Dutch and Portuguese traders. Enthusiasts for caning praised its "Durableness, Lightness, and Cleanness from Dust, Worms and Moths which inseparably attack Turkey-work, Serge, and other Stuff-Chairs and Couches."[92] The introduction of caned chairs to the American colonial market during the late seventeenth and early eighteenth century came at the height of their popularity in England and just as Philadelphia's economy had begun to prosper (see no. 111 and fig. 203).[93]

Many of the earliest immigrant joiners and chairmakers in Pennsylvania had trained in Germany, Holland, and England, apprenticing within the same traditions of craftsmanship that informed imported furniture. Most who trained in the late seventeenth century would have been familiar with the techniques

involved in the production of caned seating furniture. Once in Pennsylvania, the chairs they produced to compete with imported caned chairs are often so close in pattern, materials, and construction that it is difficult to distinguish the imported from the locally produced examples.94 One of the best-documented Pennsylvania caned, scroll-armed chairs is believed to have belonged originally to Thomas Lloyd, who was deputy governor of Pennsylvania from 1691 to 1693 (no. 137, fig. 6). Tall, with a pronounced rake to its back stiles at the point of intersection with the seat rail, it has elegantly molded stiles and arms and bulbous turned legs and arm supports. It is constructed of black walnut, and its scrolled brush, or Spanish, feet are carved from the solid; no laminated blocks are used in the scrolls or toes as is often the case on examples from Boston or England.95 On the Lloyd chair, and on several other Philadelphia caned armchairs, the ball-and-trumpet turned passages on its arm supports and legs sometimes incorporated small laminations applied at the widest diameter of the balls, probably to allow the turner to use smaller thicknesses of raw turning stock and thus save wood. These wood-saving laminations were probably similar in conception and purpose to the pieced, compartmentalized turning described earlier as found in the turned cup-and-trumpet legs on several types of Pennsylvania dressing tables and high chests.

The close connection between early chairmaking in Boston and Philadelphia (no. 136), which came about as a result of regular trade between the two cities, was probably further fostered by two Boston craftsmen who moved to Philadelphia in the 1690s: Edward Shippen,

an "upholder" who immigrated to Boston around 1669 and moved with his family to Philadelphia in 1693,96 and Thomas Stapleford, a Boston chair-frame-maker who moved to Philadelphia later in the 1690s, probably sponsored by Shippen.97 Cane-back, banister-back, and leather-upholstered chairs made in Boston were popular very early in the Delaware Valley, based on the number of inventories listing "Boston" chairs.98 Local chairmakers and turners were quick to respond to the popularity of imported types.99 Identifying local versions of these chairs depends on small idiosyncratic details of construction rather than on overall elements of design or form (see no. 154, fig. 181). The Philadelphia-produced chairs tend to be constructed entirely of maple or walnut, or occasionally American beech, whereas Boston chairs often employ oak or ash seat and back rails. The arm joint in the rear back stiles on the chairs known to be from Philadelphia tends to be visibly pinned through the mortises, while the Boston-made chairs have half-dovetailed joints left unpinned but held with glue. The turned arm supports on the Boston chairs have no scored lines accentuating their widest diameters, as are often found on Philadelphia examples, and their turnings are usually composed of a ball over a baluster.100 The turned arm supports on Philadelphia versions most often have a ring over a baluster sitting on a spool configuration. Following the regional designs of New England, the legs of Boston chairs employ facing or opposing baluster or vase motifs separated by rings or blocks, while in Philadelphia a different sequence of elements —usually a baluster or vase over a ball separated by blocks—seems to have been preferred.101 Finally, as in other versions

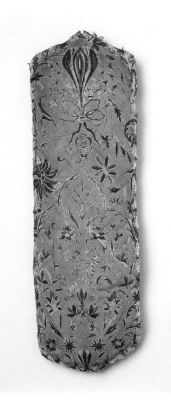

Fig. 203
Back upholstery for caned chair no. 111, c. 1680–1700, added somewhat later.

Fig. 204
Armchair, c. 1715–30, no. 140,
detail of carved crest.

of chairs and case furniture incorporating Spanish or brush feet, these elements tended to be executed from solid stock in Philadelphia, while New England cabinetmakers and chairmakers often applied small laminations to accommodate the outward-projecting decorative elements of the carved foot.[102]

The frequency with which leather, or "Russia," chairs were included in Philadelphia inventories suggests that they were common during the earliest period of chair production in Pennsylvania.[103] "Russia leather" referred to a high-quality imported hide, usually elk, calf, or goat, that was produced in several regions of northern Russia. The tanning process made its surface glossy and durable, and its finely crosshatched grain, which resulted from hammering the hides to make them supple, added decorative effect. More expensive than domestically produced "neat" or "calf" leather, it was nonetheless used frequently in Pennsylvania and other colonial cities.[104] The frames and construction techniques of early Philadelphia leather chairs are similar to those found in local caned chairs, and some Philadelphia chairmaking shops may have produced both varieties. One of the best preserved examples of an early leather armchair produced in the city is a version in cherry made about 1715–30 (no. 140, fig. 204). Its design includes back stiles with molded front profiles, one-piece carved Spanish feet, turned baluster-and-block-form front legs, and a turned front stretcher with a central ball-and-ring. The turned arm supports, executed as "torus" columns, with their tapered sides swelling slightly, are similar in design to early center-stem tea tables and to the turned back stiles on similarly constructed arch-crested banis-

ter-back chairs from the Delaware Valley (see no. 149). The carved foliage on the upper crest under its molded rail (fig. 204) is unique to known leather examples from Philadelphia but relates in its design and execution to the shallow carved foliage on contemporary banister-back chairs with carved crests from the surrounding region (see no. 146, fig. 153). Remarkably, this chair retains an early, possibly original, over-the-rail leather upholstery and its early "blacked" surface finish.[105]

A number of chairs with molded or flat-faced banister backs were produced in Delaware Valley shops (see nos. 142, 148; fig. 171). They had lathe-molded or carved crests and incorporated various turned elements in their legs, stretchers, and arm supports. The arms of these chairs also have a variety of undulating carved and molded profiles. Some have flat, sawn faces and squared, cut contours on their arms, while other examples are fully molded and have rounded, more flowing shapes. Most also include a variation of turned-under, scroll-shaped sawn or carved handholds (see no. 140). Among the most interesting from a technical standpoint are those that incorporate half-round, turned, arched crest rails, which were formed on a lathe as a full-round and then halved to create the arch shape (no. 116). The banisters onto which these crests are joined are placed so that their molded profiles meet, creating a continuous line with the crest. The flat, molded profiles of the banisters and arched crests found on the majority of these chairs are flanked by and contrasted with the rounded forms and crisp profiles of their turned back stiles. Variations of this arched-crest form are found in a number of side chairs, armchairs, and daybeds produced in Penn-

sylvania about 1725–45 (see no. 149).[106] Other variations of the banister-back chair have fully carved decorative elements. One of the most ornate, a relief-carved example, has a panel in a framed seat; an arched, carved back crest and front stretcher; molded scroll arms; turned legs; and back stiles and stretchers similar to those just described (no. 146, fig. 153). In design and conception it is close to the banister-back chairs with carved crests from Boston. Its crest and stretchers are carved with symmetrical foliage and scrolls executed in low relief, relating it to the carved furniture from the Lancashire district in England and to Dutch and Scandinavian vernacular carving traditions.[107]

Elements of traditional English, Welsh, and northern European (Dutch and Germanic) techniques for making wainscot and banister-back chairs also informed aspects of design and craftsmanship found in the various "slat-back" or "ladder-back" chairs. The Delaware Valley ladder-back chair, a widespread and popular early form, remained a staple of chairmaking shops throughout the eighteenth century and is found in both urban and rural inventories, where it is often listed as a rush- or matted-seat chair (see no. 119, fig. 177). Some of the earliest surviving examples from the Delaware Valley, made during the 1720s and 1730s, incorporated design elements such as the outward-splayed turned bulb and spindle-front leg. Finishing the edge of the rush-seat versions, a scroll-sawn applique formed a boxed seat apron, often referred to during the period as a "cased" seat. Fastened to the rounded rush-covered seat rails, they are similar in shape to the aprons found on many early Boston caned and leather chairs. Horizontal "slats" with high central

arches, arranged in vertical rows of either three, four, five, or six, formed the distinctive back, or "ladder," of the chair. The Philadelphia chairmaker Solomon Fussell (c. 1704–1762) wrote in October 1745 that Thomas Kemble purchased from him "6 arch head Chairs & Couch," possibly referring to the arch-shaped slats in the backs of these chairs.[108] Their design could be elaborated further through shaping the slats by decorative sawing of their edges, raking the back stile to slant backward from the level of the seat rail, and adding multiple turnings and finials to the back stiles as well as cabriole legs and decorative pad, trifid, or blocked feet (see no. 153, fig. 145).

While many surviving shop inventories confirm that a number of local joiners and chairmakers were producing the ladder-back chair, Solomon Fussell's ledger covering his years of operation from 1738 to 1751 provides the most detail as to their manufacture and variety. William Savery (1721/22–1787), another important chair- and cabinetmaker of the period, apprenticed with Fussell from about 1735 to 1741 (see nos. 85, 128; fig. 149). The receipt book of John Wistar, which lists expenditures from 1736 to 1745, records "Recei'd Philad[a] December 9th 1741 of John Wistar three Pounds and Eighteen Shillings in full of all accounts to this day. I Say Rece'd for the use of my Master Solomon Fussell by me William Savery."[109] Savery, well connected within Quaker circles in Philadelphia, was established by 1750 in his own shop on Second Street between Chestnut and Market streets and became one of the most influential cabinetmakers in the city. Fussell and Savery together developed mass-production and marketing techniques in their shops

and produced large numbers of simple, low-cost chairs for a growing number of Philadelphia customers (no. 156, fig. 150). Fussell records his prices for the basic three-slat chair in maple at four shillings and adds one shilling for each slat added to the design. While a cabriole leg or the addition of arms raised the price, Fussell's "best Crookt foot arm Chair" is listed in 1744 at the still relatively low price of fifteen shillings. The slat-back chair in all its elaborations remained one of the most inexpensive and popular seating forms available. It was also a chair that, along with the early Windsor-type chairs produced in the city, could readily be sent out in unassembled bundles of parts as venture cargo.[110]

The process of making the different elements of a slat-back chair lent itself to divisions of labor within a shop and compartmentalized assembly, and in many cases both larger and smaller chair-making shops purchased premade elements from other craftsmen and then assembled them into the finished forms. A small shop could buy the turned elements from a specialized turner and avoid the need for a lathe, while a large shop could purchase individual parts in volume to speed production and increase efficiency. Fussell recorded his purchase of cabriole front legs from the joiner Michael Hilton on April 23, 1741, noting payment for "hewing 3 Duz feet." He also had running accounts during 1739–40 with Hugh O'Neal, a turner, and Samuel Hurford, a joiner, to produce large numbers of turned parts—back slats and seat "lists," or stretchers.[111]

A number of other types of chairs were produced in the Fussell shop and later by Savery in his own establishment. Chairs listed with "turned fronts" re-

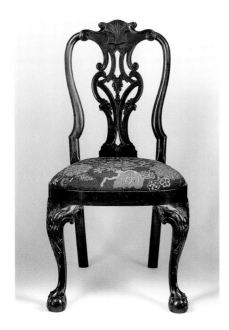

Fig. 205
Side Chair, c. 1750–55, no. 134,
full view and detail of chair back.

ferred to those with a lathe-formed front stretcher bridging the legs. "Yoke shaped" crest rails, with "banester backs" and "crookt feet" probably described the early vase-form splat-back, cabriole-leg chairs that began to be produced in Philadelphia in the early 1740s.[112] The surviving Fussell account book, which begins with entries recorded in 1738–39, has on its front page a balance brought forward "from old book," indicating that it was one volume in a continuing series.[113] Because it is unlikely that this year would have signaled the beginning of their production, cabriole-leg chairs of the type listed in this ledger could have been produced earlier in Fussell's shop, or in other Philadelphia furniture shops (see no. 132, fig. 161).

The cabriole leg was certainly present in Philadelphia on both imported English and Irish chairs by 1730, and could also be found on chairs produced in furniture shops in Boston and brought to the region through coastal trade (see no. 115). The evolution of the fully developed Philadelphia compass-seat chair

from these early prototypes provides one illustration of the experiments and innovations that fueled and benefited the early furniture-making traditions in the city. The form of the cabriole leg, with its continuous S-scroll profile, emerged from the stylistic influences of the late Baroque in Europe and England and slowly replaced the earlier reverse double-C-scroll form of leg. Experiments with the curved profiles and stance of the new leg form resulted in a completely new elaboration of the chair's other structural elements. Components of the leg stretchers, seat frames, back stiles, arms, and crest rails were conceived to echo and elaborate the S-scroll shape of the cabriole leg, creating a more complex series of curves. The earlier, straight back stiles of chairs were curved in relationship to the scroll-shaped sides, shoulders, and volutes of the vase- or baluster-shaped back splats (see no. 126). Chair-back elements also developed subtle S-scrolled profiles that followed the natural curve of the human spine. The straight-sided trapezoidal seat frames of earlier chair design gave way to the curved "compass" seat, created by rounding the front seat rail and flanking it with gracefully curved S-scroll side rails anchored into a straight rear rail (see no. 118). The name derived from the fact that the flowing archs and sinuous lines of the new style required a compass for their successful layout. Balancing the multiple directional flows called for more skilled craftsmanship and specialized joinery to formulate and execute the curved and offset mortises and tenons, sawn profiles, and smooth, uninterrupted joint transitions that were required. The change came gradually, and in many of the regional traditions of cabinetmaking and chairmaking the

cabriole leg and compass seat were never fully embraced (no. 160, fig. 12).

The stylistic influences from Dutch and Irish cabriole- and scroll-leg furniture were pronounced on the earliest cabriole-leg chairs in Philadelphia. By the early 1730s James Logan, who was born in Belfast, owned a number of compass-seat, cabriole-leg chairs, which he obtained from abroad as well as from local craftsmen (nos. 118, 120). Many of the earliest compass-seat chairs produced in the city retain the scroll, slipper, or trifid foot, flanking side scrolls on the upper legs, scooped crest rail, solid vertical splat, and turned back stretcher traditionally encountered in early Irish and provincial English examples (see no. 152, fig. 18). The half-dovetailed mortise joint that secures the front cabriole legs to the front seat rails in these Philadelphia versions is also found on imported Irish examples (fig. 206).[114]

During the 1740s and 1750s the form and the ornamentation of compass-seat chairs were elaborated further. Because of its central placement in the overall form, the "baluster" back splat of the chair grew to be the main focus of its design. Elaborately grained walnut or mahogany was often reserved for use in the back splats, and some examples of ornamental veneered splats are known. The splats were elongated, and there was a greater variety of ornament.

Several shops experimented with the introduction of carved patterns derived from Palladian-inspired sources. The crest rails, back splats, knees, and knee returns often were carved with volutes, shells, and foliate ruffles (nos. 131, 160; fig. 12). Toward the end of the 1750s the solid splats were regularly pierced through with patterned designs, anticipating the lighter proportions and decorative ornamentation of the rococo period (see fig. 205). These carved decorative elaborations continued in the later transformation of the compass-seat chair. Side chairs and armchairs with trapezoidal seat frames, and with increasing amounts of rocaille decorative ornament, appeared regularly by the early 1760s.

Fig. 206
Armchair, c. 1750–55, no. 164, detail of round-dowel front-leg joinery; Side Chair, c. 1735–45, no. 122, detail of half-dovetail front-leg joinery.

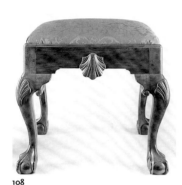

107

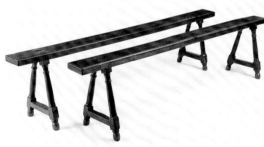

108

110

Seating Furniture

105. Stool

Holland or France, c. 1670–1700
Walnut and other mixed hardwoods; linen
12 5/8 x 18 5/8 x 15 5/8" (32.1 x 47.3 x 39.7 cm)
Philadelphia Museum of Art. Gift of Susanne
Strassburger Anderson, Valerie Anderson
Readman, and Veronica Anderson Macdonald
from the estate of Mae Bourne and Ralph
Beaver Strassburger. 1994-20-45

It is thought that this stool, which retains its
original foundation upholstery, first belonged
to Francis Daniel Pastorius (1651–1719), one of
the founders of Germantown.
See fig. 22.

106. Stool

Philadelphia, c. 1700–1720
Walnut; maple
17 1/8 x 17 1/4 x 14 3/8" (43.5 x 43.8 x 36.5 cm)
The Historical Society of Pennsylvania,
Philadelphia

This stool descended in the Dickinson and
Logan families of Philadelphia. Jonathan
Dickinson's inventory of 1722 lists two cane
stools. Although its upholstery was later altered,
this example is thought to be one of those listed.
See fig. 48.

107. Joint Stool

Southeastern Pennsylvania, c. 1715–35
Walnut
24 x 20 3/8 x 12 1/2" (61 x 51.8 x 31.8 cm)
Collection of Dr. and Mrs. Richard A. Mones

108. Stools

Attributed to John Elliott, Sr. (born England,
1713–1791)
Philadelphia, c. 1756
Walnut, poplar
18 1/2 x 22 1/4 x 17 3/4" (47 x 56.5 x 45.1 cm)
(a, b) Stenton, Philadelphia. Betton Bequest,
1915. 67.12.1–2
(c, d) Winterthur Museum, Winterthur,
Delaware. Bequest of Henry F. du Pont. 61.1532

Charles Norris of Philadelphia commissioned
this set of four stools, which may have been
used en suite with a large set of armchairs that
Norris ordered in 1754.
See also fig. 158.

109. Settle Bench

Southeastern Pennsylvania, possibly
Philadelphia, c. 1725–40
Walnut; leather upholstery
44 1/2 x 68 x 25" (113 x 172.7 x 63.5 cm)
The Dietrich American Foundation

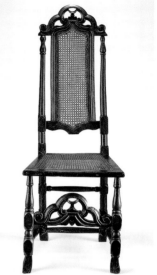

111

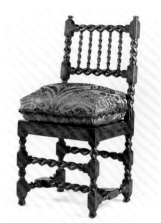

112

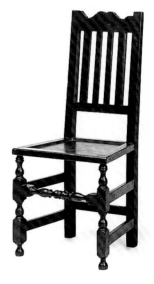

114

This bench retains its original foundation upholstery made of rolled marsh grass, combed wool, curled horsehair, and coarse woven linen under its oxhide cover.
See fig. 10.

110. Pair of Joint Benches

Southeastern Pennsylvania, c. 1735–55
Cherry
20⁷/8 x 91⁵/8 x 15" (53 x 232.7 x 38.1 cm)
Philadelphia Museum of Art. Gift of J. Stogdell Stokes. 1935-36-1a,b

111. Side Chair

England, c. 1680–1700
Beech, maple, mixed hardwoods; painted; caning
46¹/2 x 17³/4 x 14³/4" (118.1 x 45.1 x 37.5 cm)
Philadelphia Museum of Art. The Charles F. Williams Collection. Purchased with subscription and Museum funds. 1923-23-52

Samuel Carpenter first owned this chair; it was probably among the furnishings used at the Slate Roof House (built c. 1687–99), his residence in Philadelphia.
See also fig. 203.

112. Side Chair

Philadelphia, 1690–1710
Walnut
38¹/2 x 18³/4 x 16³/8" (97.8 x 47.6 x 41.6 cm)
Philadelphia Museum of Art. Purchased from the Charles F. Williams Collection with subscription and Museum funds. 1923-23-53
See also fig. 202.

113. Side Chair

Southeastern Pennsylvania, c. 1710–30
Walnut
37 x 17 x 14¹/2" (94 x 43.2 x 36.8 cm)
Philadelphia Museum of Art. Purchased with the Joseph E. Temple Fund. 1926-24-2
See fig. 152.

114. Pair of Side Chairs

Southeastern Pennsylvania, c. 1720–35
Walnut
40³/8 x 18³/8 x 14¹/8" (102.6 x 46.7 x 35.9 cm)
Collection of H. Richard Dietrich, Jr.

115. Pair of Side Chairs

England or Ireland, c. 1720–30
Maple; beech
41⁵/8 x 20¹/4 x 19⁵/8" (105.7 x 51.4 x 49.8 cm)
Collection of Mr. and Mrs. Daniel Blain, Jr.

These chairs were originally owned by James Logan and are thought to have been a part of the early furnishings of Stenton.

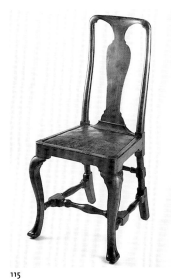

115

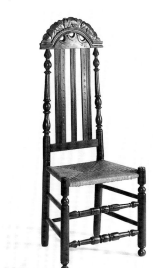

116

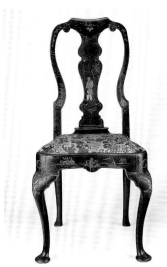

117

116. Side Chair

Delaware Valley, possibly New Castle County, Delaware, c. 1720–40
Ash, maple, poplar; painted
49 x 19¹/2 x 14" (124.5 x 49.5 x 35.6 cm)
The Newark Museum, New Jersey. Purchased with the 1965 Mathilde Oestrich Bequest Fund. 65.236b
See also fig. 183.

117. Side Chair

England or Ireland, c. 1730–35
Maple, walnut; japanned
40¹/8 x 19³/8 x 16" (101.9 x 49.2 x 40.6 cm)
Philadelphia Museum of Art. The Charles F. Williams Collection. Purchased with subscription and Museum funds. 1923-23-16

Originally owned by Ralph Assheton (1695–1745), a wealthy plantation owner and town clerk of Philadelphia from 1716 to 1745.
See also fig. 141.

118. Side Chair

Philadelphia, c. 1730–35
Walnut, walnut veneer; pine
40⁵/8 x 20¹/4 x 17" (103.2 x 51.4 x 43.2 cm)
Philadelphia Museum of Art. Gift of Daniel Blain, Jr. 1997-67-4

The turned back stretcher and the half-dovetailed joinery of this chair are characteristic of the earliest compass-seat chairs produced in Philadelphia. The chair descended in the Logan family of Philadelphia.

119. Pair of Side Chairs

Philadelphia, c. 1725–40
Mixed hardwoods; painted
(a) 45³/4 x 19³/8 x 16" (116.2 x 49.2 x 40.6 cm)
(b) 45⁷/8 x 19¹/2 x 16" (116.5 x 49.5 x 40.6 cm)
Collection of H. L. Chalfant
See fig. 177.

120. Pair of Side Chairs

Philadelphia, c. 1730–35
Walnut, walnut veneer; pine
40⁵/8 x 20³/4 x 20¹/2" (103.2 x 52.7 x 52.1 cm)
Lent by the Commissioners of Fairmount Park, Philadelphia

121. Side Chair
Southeastern Pennsylvania, c. 1730–55
Walnut
43¹/₂ x 19 x 16" (110.5 x 48.3 x 40.6 cm)
Collection of H. Richard Dietrich, Jr.

122. Side Chair
Philadelphia, c. 1735–45
Walnut; pine
41 x 22¹/₂ x 16¹/₂" (104.1 x 57.2 x 41.9 cm)
Philadelphia Museum of Art. The Ozeas,
Ramborger, Keehmle Collection. 1921-34-213
See fig. 188.

123. Side Chair
Philadelphia, c. 1735–45
Walnut; pine, leather
40 x 20 x 19¹/₂" (101.6 x 50.8 x 49.5 cm)
Philadelphia Museum of Art. Gift of Mr. and
Mrs. J. Wells Henderson. 1973-259-1
 This chair retains its original foundation
upholstery, made of linen, wool, and marsh
grass, and its original leather covering.

124. Side Chair
Philadelphia, c. 1735–45
Walnut; pine
39⁷/₈ x 22¹/₄ x 16³/₄" (101.3 x 56.5 x 42.5 cm)
Philadelphia Museum of Art. Gift of Dr. E.
Hollingsworth Siter. 1929-186-1

125. Side Chair
Southeastern Pennsylvania, possibly
Germantown, c. 1735–50
Walnut
42¹/₄ x 18¹/₄ x 14⁵/₈" (107.3 x 46.4 x 37.1 cm)
Private Collection

126. Side Chair
Philadelphia, c. 1740–50
Inscription: IR (in ink on inner face of side
seat rail)
Walnut; pine
40¹/₂ x 22 x 16¹/₂" (102.9 x 55.9 x 41.9 cm)
Collection of Jay Robert Stiefel
 Silversmith Joseph Richardson, Sr., originally
owned this side chair, one of at least six from the
original set that survive.

127. Side Chair
Southeastern Pennsylvania, c. 1740–55
Walnut
39¹/₂ x 18¹/₄ x 14³/₄" (100.3 x 46.4 x 37.5 cm)
Philadelphia Museum of Art. Gift of J. Stogdell
Stokes. 1928-10-99
See fig. 160.

128. Side Chair
William Savery (1721/22–1787)
Philadelphia, c. 1745–50

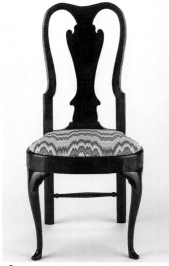

118

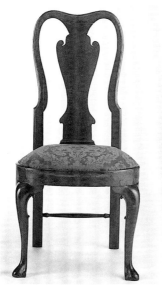

120

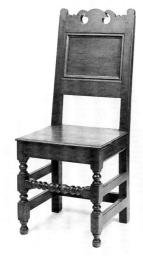

121

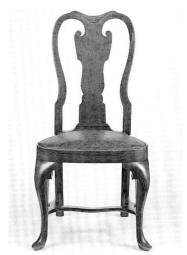

123

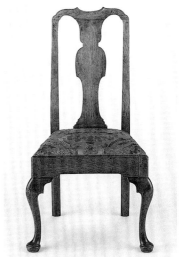

124

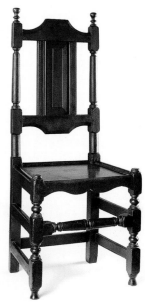

125

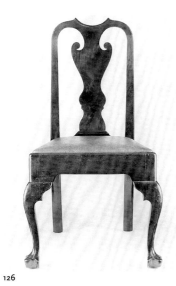

126

Maple; rush seat with printed paper label
attached to underside
36 x 19¹/₂ x 15¹/₂" (91.4 x 49.5 x 39.4 cm)
The Dietrich American Foundation

This chair retains the original yellow ocher
paint on its rush seat.
See fig. 149.

129. Side Chair, or Brettstuhl
Southeastern Pennsylvania, c. 1745–50
Maple, pine, poplar, oak
35⁵/₈ x 18⁷/₈ x 14³/₈" (90.5 x 47.9 x 36.5 cm)
Philadelphia Museum of Art. Gift of J. Stogdell
Stokes. 1928-10-65

Variations of this Germanic "back stool" were
common among the Mennonite and German
Reformed communities in the Delaware Valley.

130. Side Chair
Philadelphia, c. 1745–50
Walnut; pine
41⁷/₈ x 21 x 19³/₄" (106.4 x 53.3 x 50.2 cm)
Private Collection

131. Side Chair
Philadelphia, c. 1745–55
Walnut; pine
42³/₄ x 14¹/₄ x 19¹/₄" (108.6 x 36.2 x 48.9 cm)
Museum of Fine Arts, Boston. The M. and M.
Karolik Collection of Eighteenth-Century
American Arts. 39.119

132. Side Chair
Attributed to Solomon Fussell (c. 1704–1762)
Philadelphia, c. 1748
Walnut; spruce
41³/₄ x 21¹/₄ x 21" (106 x 54 x 53.3 cm)
Private Collection

An original bill of sale from Fussell to Ben-
jamin Franklin, dated 1748, lists this chair along
with several others.
See fig. 161.

133. Side Chair
Philadelphia, c. 1745–55
Walnut; pine
42¹/₈ x 20¹/₈ x 19³/₈" (107 x 51.1 x 49.2 cm)
Philadelphia Museum of Art. Bequest of Adeline
Worrell Fisher. 1938-12-3

134. Side Chair
Philadelphia, c. 1750–55
Mahogany; pine
40³/₄ x 21¹/₄ x 17¹/₄" (103.5 x 54 x 43.8 cm)
Lent by the Commissioners of Fairmount Park,
Philadelphia

Descended in the Waln-Ryerss family of
Philadelphia.
See fig. 205.

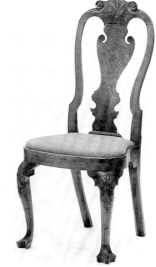

131

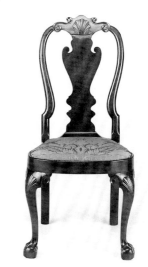

133

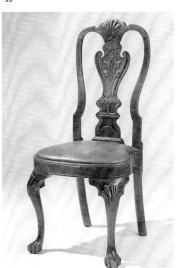

135

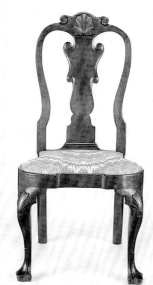

129

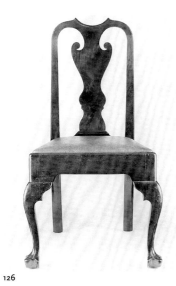

130

135. Pair of Side Chairs

Philadelphia, c. 1750–55
Mahogany; carving possibly later
42¹/₂ x 16⁵/₈ x 20¹/₈" (108 x 42.2 x 51.1 cm)
Private Collection

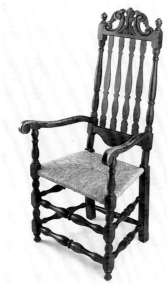

136

136. Armchair

Boston, c. 1690–1710
Mixed hardwoods; painted
49³/₄ x 24 x 15³/₄" (126.4 x 61 x 40 cm)
Philadelphia Museum of Art. Bequest of
Elizabeth Wheatley Bendiner. 1991-79-15

Owned by Anthony Morris II (1654–1721),
a merchant who arrived in Philadelphia from
Boston about 1685.
See also fig. 170.

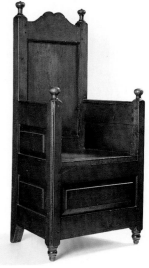

139

137. Armchair

Philadelphia, 1690–1720
Walnut; caning
44 x 25¹/₄ x 23" (111.8 x 64.1 x 58.4 cm)
Winterthur Museum, Winterthur, Delaware. Gift
of David Stockwell. 55.130

It is thought that this chair originally belonged
to Thomas Lloyd (1640–1694), who was deputy
governor of Pennsylvania from 1691 to 1693.
See fig. 6.

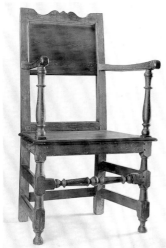

138

138. Armchair

Philadelphia, c. 1700–1715
Oak
42³/₈ x 24 x 20" (107.6 x 61 x 50.8 cm)
Private Collection
See also fig. 178.

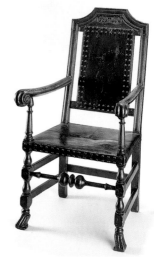

140

139. Pair of Armchairs

Philadelphia, c. 1715–35
Walnut; poplar
Each 47¹/₂ x 23 x 17¹/₂" (120.7 x 58.4 x 44.5 cm)
(a) Philadelphia Museum of Art. Purchased from
the Clarence Wilson Brazer Collection with the
Joseph E. Temple Fund. 1926-24-3
(b) Collection of Joseph and Jean McFalls (Ex-
Collection Clarence Wilson Brazer)

This pair of armchairs descended in the
Pennock family of Chester County, Pennsylvania,
and may have been a part of the early furnishings
of Primitive Hall, the family's residence in West
Marlborough Township, Chester County, which
was built by Joseph Pennock (1677–1771) in 1738.

140. Armchair

Philadelphia, c. 1715–30
Cherry; oak; leather, brass nails
42¹/₂ x 23 x 24¹/₂" (108 x 58.4 x 62.2 cm)
Ex-Collection Titus C. Geesey

This armchair retains its early, possibly original,
leather upholstery and is one of the only examples
that includes carved decoration on its back crest.
See also fig. 204.

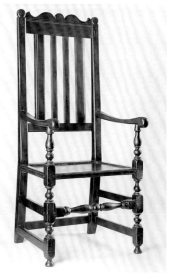

141

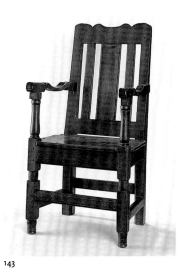

143

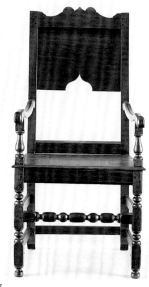

145

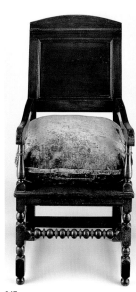

147

141. Armchair
Philadelphia, c. 1715–25
Walnut
49³/4 x 22 x 19⁵/8" (126.4 x 55.9 x 49.8 cm)
Private Collection

142. Armchair
Philadelphia, c. 1715–30
Hickory, maple, red oak; painted
46¹/2 x 22¹/4 x 17¹/4" (118.1 x 56.5 x 43.8 cm)
Collection of Joseph and Jean McFalls
See fig. 171.

143. Armchair
Southeastern Pennsylvania, c. 1720–40
Walnut
40³/8 x 19³/4 x 16" (102.6 x 50.2 x 40.6 cm)
Collection of H. Richard Dietrich, Jr.

144. Armchair
Philadelphia, c. 1725–45
Walnut
44¹/2 x 23 x 21¹/8" (113 x 58.4 x 53.7 cm)
Ex-Collection Titus C. Geesey
See fig. 143.

145. Armchair
Southeastern Pennsylvania, c. 1725–45
Walnut
44¹/8 x 21³/4 x 20" (112.1 x 55.2 x 50.8 cm)
Collection of Joseph and Jean McFalls

146. Armchair
Delaware Valley, c. 1725–45
Walnut
54¹/2 x 23³/4 x 26" (138.4 x 60.3 x 66 cm)
Winterthur Museum, Winterthur, Delaware.
Museum Purchase. 76.173
See fig. 153.

147. Armchair
Southeastern Pennsylvania, c. 1725–45
Walnut
47 x 22³/8 x 21³/4" (119.4 x 56.8 x 55.2 cm)
Philadelphia Museum of Art. Gift of Mr. and
Mrs. Robert Raley. 1997-174-3

148. Armchair
Southeastern Pennsylvania, c. 1725–45
Mixed hardwoods; painted
48 x 21¹/2 x 18" (121.9 x 54.6 x 45.7 cm)
Collection of Mrs. Herbert F. Schiffer

149. Armchair
Philadelphia, c. 1725–45
Mixed hardwoods; painted
49 x 22¹/2 x 18¹/4" (124.5 x 57.2 x 46.4 cm)
Private Collection

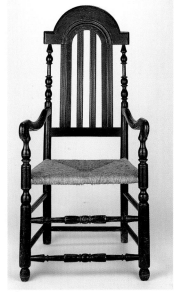

148

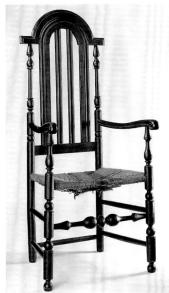

149

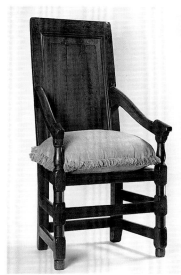

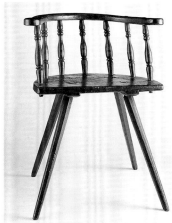

151

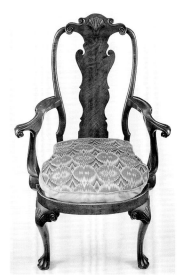

155

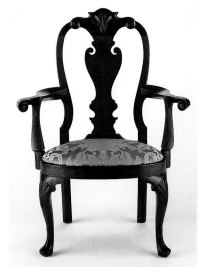

157

150. Armchair
Southeastern Pennsylvania, c. 1730–40
Walnut
42¹/₂ x 24 x 20³/₄" (108 x 61 x 52.7 cm)
Philadelphia Museum of Art. Gift of J. Stogdell
Stokes. 1928-10-60
 Originally owned by Bartholomew Penrose.
See fig. 163.

151. Armchair
Southeastern Pennsylvania, c. 1730–40
Walnut
43¹/₂ x 23 x 19" (110.5 x 58.4 x 48.3 cm)
Philadelphia Museum of Art. Gift of J. Stogdell
Stokes. 1928-10-2

152. Armchair
Philadelphia, c. 1735–40
Walnut; pine
51¹/₂ x 42¹/₂ x 19³/₄" (130.8 x 108 x 50.2 cm)
Private Collection
See fig. 18.

153. Armchair
Southeastern Pennsylvania, c. 1735–45
Mixed hardwoods; painted
44⁷/₈ x 24 x 19¹/₄" (114 x 61 x 48.9 cm)
Collection of H. L. Chalfant
See fig. 145.

154. Armchair
Probably Philadelphia, c. 1735–45
American beech
49 x 24 x 24" (124.5 x 61 x 61 cm)
Winterthur Museum, Winterthur, Delaware. Gift
of Henry F. du Pont. 58.555
See fig. 181.

155. Armchair
Southeastern Pennsylvania, c. 1740–55
Mixed hardwoods; painted
27 x 23¹/₄ x 13¹/₈" (68.6 x 59.1 x 33.3 cm)
Collection of Mr. and Mrs. Joe Shelanski

156. Armchair
Attributed to Solomon Fussell (c. 1704–1762)
or William Savery (1721/22–1787)
Philadelphia, c. 1740–55
Maple
45³/₈ x 25³/₄ x 19³/₄" (115.3 x 65.4 x 50.2 cm)
Private Collection
See fig. 150.

157. Armchair
Philadelphia, c. 1740–55
Walnut; pine
45¹/₄ x 31¹/₄ x 23¹/₂" (114.9 x 79.4 x 59.7 cm)
Philadelphia Museum of Art. Gift of Mrs. G.
Fairman Mullen. 1964-212-1

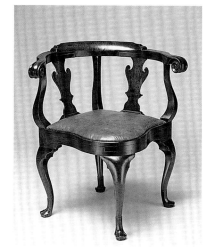

158

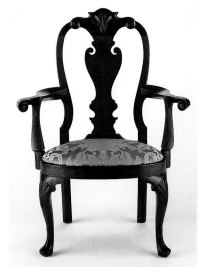

159

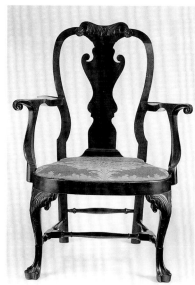

161

158. Corner Chair

Attributed to Joseph Armitt (died 1747)
Philadelphia, c. 1740–55
Walnut; yellow pine
30^1/$_2$ x 28^1/$_2$ x 27" (77.5 x 72.4 x 68.6 cm)
The Metropolitan Museum of Art. Rogers Fund.
1925.115.15

Corner chairs were often used in conjunction with fall-front desks during the mid-eighteenth century. The construction of these chairs required the experimental adaptation of different elements of the more conventional side chairs and armchairs and rarely achieved the balance and sophistication of this example.

159. Armchair

Philadelphia, c. 1740–55
Walnut; chestnut, pine
42^7/$_8$ x 32^1/$_2$ x 23" (108.9 x 82.6 x 58.4 cm)
Philadelphia Museum of Art. Gift of Harriet Martin Ruffin, Sydney E. Martin, Jr., and Crozer Fox Martin in memory of their parents, Mr. and Mrs. Sydney E. Martin. 1971-91-1

It is thought that this chair, which descended in the Norris family of Philadelphia, originally belonged to Charles Norris. Charles Norris owned at least eight of these armchairs, which retain the wide stance, low-arched crest, and well-executed but shallowly carved shell decoration found on earlier Philadelphia and Anglo/Irish examples of the form.

160. Armchair

Southeastern Pennsylvania, possibly Germantown, c. 1740–55
Cherry
41^1/$_2$ x 22^1/$_4$ x 19^1/$_4$" (105.4 x 56.5 x 48.9 cm)
Collection of H. Richard Dietrich, Jr.
See fig. 12.

161. Armchair

Philadelphia, c. 1740–55
Walnut; pine
41 x 30 x 18^3/$_4$" (104.1 x 76.2 x 47.6 cm)
Collection of H. Richard Dietrich, Jr.

162. Armchair

Philadelphia, c. 1745–55
Mixed hardwoods; painted
42^1/$_2$ x 24 x 16" (108 x 61 x 40.6 cm)
Collection of Charles and Olenka Santore
See fig. 169.

163. Armchair

Philadelphia County, c. 1745–60
Maple; painted
46^1/$_4$ x 23 x 22" (117.5 x 58.4 x 55.9 cm)
Collection of Mr. and Mrs. Joe Shelanski

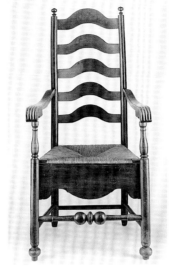

163

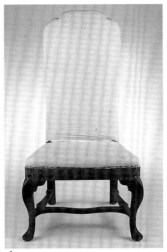

165

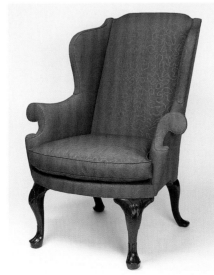

166

The framed rush slip (removable) seat and deep skirt on this chair were designed to conceal a chamber pot set in the frame beneath the seat.

164. Armchair

Philadelphia, c. 1750–55
Walnut; pine
42^1/$_4$ x 25^1/$_2$ x 22" (107.3 x 64.8 x 55.9 cm)
Philadelphia Museum of Art. Purchased with the Thomas Skelton Harrison Fund. 1955-69-1

This armchair descended in the Powell family of Philadelphia; it is thought that it originally belonged to Samuel Powell, Sr. (1673–1756).
See fig. 201.

Upholstered Seating Furniture

165. Pair of Back Stools

Philadelphia, c. 1730–40
Walnut
43^3/$_8$ x 23^1/$_4$ x 22^1/$_4$" (110.2 x 59.1 x 56.5 cm)
(a) Winterthur Museum, Winterthur, Delaware. Gift of Henry F. du Pont. 59.2512
(b) Lent by the Commissioners of Fairmount Park, Philadelphia

Part of the furnishings of Stenton, this pair of rare upholstered back stools was originally owned by James Logan.

166. Easy Chair

Philadelphia, c. 1735–45
Walnut; chestnut, maple, pine, poplar
46 x 37 x 21" (116.8 x 94 x 53.3 cm)
Private Collection

167. Easy Chair

Philadelphia, c. 1735–45
Walnut; oak, pine, poplar
47^1/$_2$ x 33^3/$_4$ x 28" (120.7 x 85.7 x 71.1 cm)
Private Collection

This chair originally belonged to James Logan and was among the furnishings used at Stenton.
See fig. 105.

168. Daybed

Philadelphia, c. 1720–35
Maple, oak, and other mixed hardwoods; painted
38^1/$_4$ x 24^1/$_2$ x 69" (97.2 x 62.2 x 175.3 cm)
Private Collection

Evidence of upholstery tacks and traces of webbing on the frame of this daybed indicate that it was originally upholstered.
See fig. 179.

169. Settee

Philadelphia, c. 1735–50
Walnut; chestnut, pine, poplar
45^3/$_4$ x 62 x 21^1/$_2$" (116.2 x 157.5 x 54.6 cm)

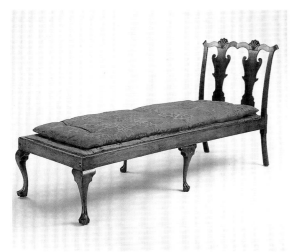

170

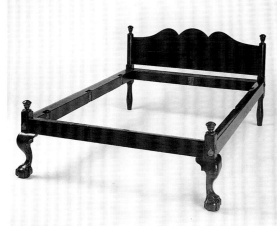

172

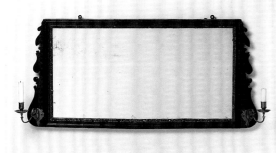

173

The Metropolitan Museum of Art. Rogers Fund.
1925.115.1
See fig. 172.

170. Daybed
Philadelphia, c. 1745–55
Walnut
40⅝ x 32⅝ x 76¼" (103.2 x 82.9 x 193.7 cm)
The Dietrich American Foundation

171. Bed
Philadelphia, c. 1730–45
Mahogany
88 x 59 x 76" (223.5 x 149.9 x 193 cm)
Von Hess Foundation: Wright's Ferry Mansion,
Columbia, Pennsylvania. 80.2
See fig. 110.

172. Bed
Philadelphia, c. 1735–50
Walnut
33 x 56 x 79½" (83.8 x 142.2 x 201.9 cm)
Collection of Mr. and Mrs. Thomas B. Helm

Miscellaneous Furniture Forms

173. Chimney Glass
England or America, c. 1735–50
Mahogany, mahogany veneer; pine, brass, mirror
18½ x 41½" (47 x 105.4 cm)
Philadelphia Museum of Art. Gift of Mr. and
Mrs. Robert L. Raley. 1997-174-12a,b,c

174. Pier Glass
England or America, c. 1740–45
Walnut, walnut veneer; pine
56 x 18" (142.2 x 45.7 cm)
Philadelphia Museum of Art. Bequest of
Walter E. Stait. 1993-76-12
 This glass was originally owned by Edward
Stiles, a Bahamian merchant who moved to
Philadelphia in about 1740 and figured promi-
nently in the city's West Indies trade.
See fig. 140.

175. Looking Glass
England or America, c. 1745–55
Walnut, walnut veneer; pine
49½ x 18¾" (125.7 x 47.6 cm)
Philadelphia Museum of Art. The Charles F.
Williams Collection. 1923-23-98
 Descended in the Barclay family of Philadelphia.

176. Looking Glass
Scandinavia, England, or America, c. 1745–60
Walnut; pine, brass
48 x 19½" (121.9 x 49.5 cm)
Collection of Mrs. Martha Stokes Price

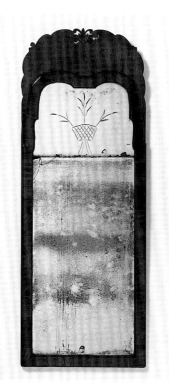

175

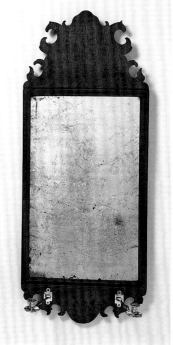

176

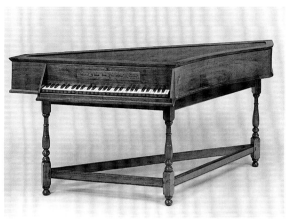

177. Looking Glass
John Elliott, Sr. (1713–1791)
Philadelphia, c. 1750–55
Mahogany; pine
13¼ x 7" (33.7 x 17.8 cm)
Collection of Joseph and Jean McFalls
 Descended in the Sharpless family, prominent Quakers in Chester County.

178. Looking Glass
Philadelphia, c. 1750–55
Mahogany; poplar, white pine, gilt
60 x 29" (152.4 x 73.7 cm)
The Dietrich American Foundation

179. Music Stand
Possibly William Savery (1721/22–1787)
Philadelphia, c. 1745–55
Walnut; poplar
41½ x 28 x 28" (105.4 x 71.1 x 71.1 cm)
The Historical Society of Pennsylvania, Philadelphia
 Originally owned by Benjamin Franklin, this music stand, which revolves by utilizing an adapted "birdcage" mechanism like those found on contemporary tilt-top tea tables, included a storage area for sheet music and candle slides for lighting. Franklin, who occasionally provided his own specialized designs for furniture he commissioned, may have prescribed the form and details of this stand.
See fig. 24.

180

180. Spinet
Johannes Gottlob Clemm [Klemm] (born Germany, 1690–1762)
Philadelphia, c. 1739
Signature: Johannes Clemm fecit Philadelphia 1739 (on front)
Walnut; maple, poplar
33½ x 73¼ x 27" (85.1 x 186.1 x 68.6 cm)
The Metropolitan Museum of Art. Rogers Fund. 1944.149

181. Water Pump Case
John Harrison, Jr. (died 1760)
Philadelphia, 1738
White pine; painted
130½ x 71¼ x 20¼" (331.5 x 181 x 51.4 cm)
The Library Company of Philadelphia
See fig. 64.

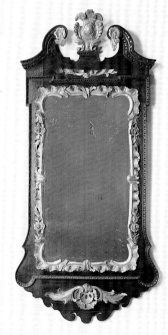

177

178

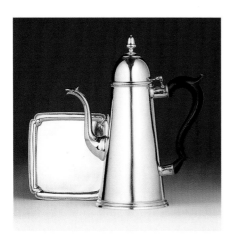

Fig. 207
Coffeepot and Salver, Peter David,
c. 1740–50 (coffeepot), c. 1740
(salver), no. 210.

Silver

Early Philadelphia was home to a thriving silver industry. Changing public and private customs surrounding food and drink inspired a new and expanded range of serving forms, increasing business for silversmiths and leading to experimentation and innovation within their shops. Taverns and parlors were the theaters in which individuals interacted and observed each other, noting the newest and the best (see no. 264). Silversmiths such as Cesar Ghiselin and Johannis Nys, both French Huguenots; the Irishman Philip Syng, Sr.; and the native-born Peter David and Francis Richardson, Sr., provided the creativity and skill necessary to supply local demands for stylish silver. Not everyone, of course, could afford such luxuries. Silver's high cost relative to other necessities and household goods limited accessibility for most. But where it was found—whether quantities of stylish "plate" displayed in an elegant buffet cupboard or a few cherished, well-worn spoons—silver signified stylishness and financial assets.[115]

The early enterprises of Pennsylvania silversmiths were affected by the role precious metals played in the developing economy. The lack of adequate coin for trade and commerce was a constant concern in early Philadelphia and throughout the American colonies. While the issuance of regional paper currency or bartering filled many of the local requirements of exchange, foreign markets offering desirable goods and most sizable investments required gold or silver. A mix of unminted ingots, English crowns and shillings, Spanish reale or "Spanish" dollars, Portuguese pistoles, Dutch guilders, and various French and Mexican coins, brought into the Delaware Valley by immigrants and the growing triangle trade, created a fluctuating and unreliable source of hard currency. Many of these coins had been excessively worn down through use, lessened in weight and value by the fraudulent filing or clipping of their edges, confused or misrepresented in their value, or indeed counterfeited.[116]

Unlike England and Europe, the American colonies had no assay offices or guilds to assure the purity or even the accurate weight of commodity metals. In this environment the silversmith played the essential role of banker and broker as well as artisan (see no. 318). The commissioning of domestic "plate," as solid silver articles were called at the time, allowed patrons to establish the purity of their metal, convert assets or a group of unidentifiable coins into a distinctive form that could be more readily recovered if lost or stolen, and acquire an object that was useful as well as stylish and impressive. Because they were a liquid asset similar to cash, silver objects were generally listed together in household inventories, their value calculated by total weight rather than by form, usefulness, or beauty. While the success of a silversmith certainly depended on his ability to supply quality work in the current styles to his clientele, he was initially more important as an agent handling valuable assets. As such, he had to have a reputation as a fair and honest businessman.

One way for an American silversmith to bolster the public's confidence in the

purity of his metal was through the use of strike marks to identify his work. Many Philadelphia silversmiths adopted marks similar in form to those used in the craft guilds of Europe and England. Several of the city's earliest silversmiths used the traditional heart-shaped or shield-and-crown-shaped emblem enclosing their initials, while most later smiths used the simpler two-initial or initial-and-surname strike mark enclosed in an oval or rectangle.[117] It is important to remember that the marks on most early Philadelphia silver are those representing the master silversmith and owner of the shop. While they controlled business transactions and the quality of the wares leaving the premises, they may not have been directly involved in the design or execution of a particular piece.[118] Further complicating issues of maker identity is the diverse range of goods many early silversmiths offered in their shops (see nos. 284, 287). Silversmiths sold imported silver and the work of other local silversmiths alongside work produced in their own shops, occasionally adding their own marks to those wares. In addition, many "smallwork" objects such as clasps, buckles, patch boxes, buttons, and chains were produced by English makers for export and were sold either unmarked or struck only with initial marks similar to those used in American silver shops. In 1741 Francis Richardson, Jr. (1705–1782), was in London buying goods to be sold by his brother Joseph in his Front Street "goldsmith's" shop. He wrote to his brother in Philadelphia, giving him instructions: "The goods I shall send will be very saleable & a good variety. If thee had not room to expose them to sale let them lye packt up in the chamber till I arive or open & sell what thee conve-

niently can & let the rest lye."[119] American silversmiths and sellers of silver either sold these goods as is or added their own marks. As a result, firmly attributing smaller articles to local smiths is problematic.[120]

The value of their material and the trusting relationships many silversmiths developed with their wealthy clientele tended to raise their status slightly above that of other American craftsmen.[121] Trust and familiarity between silversmiths and their patrons also served to concentrate patronage and often thwarted initial attempts by some highly trained but unfamiliar immigrant silversmiths to establish independent shops and clientele in Philadelphia.[122] Recommendations resulting from a patron's repeat business and satisfaction were an essential component in expanding a craftsman's operations. Family connections and longevity in the trade were also important assets to the silversmith's career. Silversmithing dynasties in early Pennsylvania, such as those established by Francis Richardson, Sr. (1681–1729), Philip Syng, Sr. (1676–1739), and Peter David (1707–1755), and carried on by their sons and apprentices, wielded a strong influence and control over the course of local silversmithing throughout the eighteenth century.[123] These larger shops also served as important training grounds, which further enriched and developed the craft. For example, the silversmiths Jeremiah Elfreth, Anthony Bright, Randall Yetton, and John Hutton, among others, trained with Francis Richardson or his sons in their Philadelphia shop (see nos. 225, 405).

As a result of the fashionable nature of his craft, the silversmith was positioned as an important arbiter of taste in colonial society. The high cost of

domestic silver raised the patron's expectation that it be well designed and executed according to the latest styles (no. 247). The silversmith's role was to supply work that would advertise both his patrons' good taste and his own skill and understanding of fashion. The elaborateness of a silver object, however, and the amount of decoration on it, was largely determined by how much the patron could pay. The cost of a finished piece of silver was determined more by the value of the metal used in its manufacture than by the silversmith's labor, which accounted for approximately a fifth of its price. The merchant Gabriel Thomas recorded in 1698 that "for Silver-Smiths [in Pennsylvania], they have between Half a Crown and Three Shillings an Ounce for working their Silver, and for Gold equivalent."[124]

Upon receiving a commission, the silversmith weighed any silver contributed by the client and credited its value toward the cost of the project. If adequate silver of like purity was available in the shop in a ready-to-be-worked state, the patron's contribution of metal might not be used to fill his order. The raw silver, usually cast in an ingot shape, would be flattened into a hammered or rolled sheet. When of the desired thinness, the sheet could then be bent around a form and its seam soldered, or it could be slowly raised and "beaten" (hammered) and "planished" (smoothed) into the desired shape starting from the center of the form and using a number of specialized hammers, molds, and clamps. Excess portions of the sheet were cut away with metal shears and filed to the desired contours. The shape was then further refined by additional planishing or turning on a lathe and, finally, smoothed by fine abrasion and

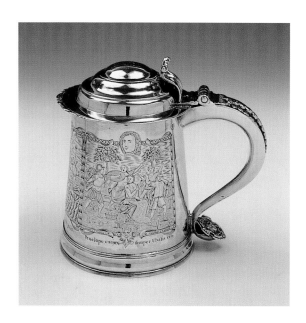

Fig. 208
Tankard, William Vilant,
c. 1725, no. 191.

burnishing. Sheet silver could also be cut or pierced to supply strap handles, or decorative banding could be soldered to the surface of a piece. "Drawn," or pulled, silver wire was also applied for decorative effect. Casting—a process that involved pouring molten silver into wooden or sand-formed molds—was used for making individual elements such as handles, spouts, finials, handle junctures, feet, and decorative appliqués, which would then be soldered to the body of the vessel. Through all these processes the work in progress had to be continually reheated, or annealed, to strengthen the metal. After further refining and buffing of the surface, the completed form was often passed to the engraver, a specialized artisan who applied decorative borders, initial ciphers, cartouche surrounds, or heraldic coats of arms by finely incising, or engraving, lines into the surface.

Because the different techniques and stages of production involved in making a piece of flat silver or hollowware required the specialized skills of casting, forming, soldering, finishing, and engraving, the process lent itself to divisions of labor within the workshop. *The London Tradesman,* published in 1747, describes such divisions and working relationships similar to those found in the larger, more established silver shops in colonial America and, specifically, Philadelphia: "The Goldsmith employs several distinct Workmen, almost as many as there are different Articles in his Shop; for in this great City there are Hands that excel in every Branch, and are constantly employed but in that one of which they are Masters. This gives us an Advantage over many . . . , as they are obliged to employ the same Hands in every Branch of the Trade, and it is im-

possible to expect that a Man employed in such an infinite Variety can finish his Work to any Perfection, at least, not so much as he who is constantly employed in one Thing."[125]

This arrangement resulted in many craftsmen with refined skills and talent working for the master of the shop. Independent craftsmen, particularly engravers, contracted their skills and labor on a daily basis, while journeymen and indentured apprentices worked out their contractual obligations alongside servants and black slaves. Francis Richardson, Sr., and Joseph Richardson, Sr. (1711–1784), his son, both owned slaves who may have worked in their shops. Herford (Herreford), a black man whose name appears repeatedly in the Richardson shop records, was probably trained in at least some aspects of the craft.[126] Unfortunately, records illuminating the work of black-slave craftsmen in Philadelphia silversmithing shops are quite scarce, even though the presence of slaves is noted with some frequency in early documents. Information on silversmiths other than shop masters is generally lacking, for a number of reasons. Among these is the fact that most journeymen, apprentices, and other workers in a shop usually were not allowed to mark or identify their own work. In addition, few workers were able to achieve the economic success that would have allowed them to set up their own shops once free of their apprenticeship obligations and thus establish a name and mark of their own. Finally, it was rare for specialized craftsmen working independently and moving from shop to shop to advertise. One exception is Laurence Hubert, who advertised his skills as an engraver in *The Pennsylvania Gazette* on May 19, 1748: "Engraving

on Gold, Silver, Copper or Pewter, done by Laurence Hubert, from London, at Philip Syng's, Goldsmith, in Front Street."[127]

Indeed, the best engraving on Philadelphia silver is probably the work of French Huguenot or London-trained specialist engravers such as Hubert working in the city's silver shops. Few examples, however, of fully chased and engraved silver objects owned or made in Philadelphia during this early period are known. The "flower'd Cup" mentioned in the inventory of Jonathan Dickinson's best chamber could have been either imported or of local manufacture but has not been identified.[128] The more elaborate engraving tended to closely follow printed design sources from England and Europe. Two surviving tankards made about 1720–25 by the accomplished but little-known Philadelphia silversmith William Vilant (active c. 1725–35), one undecorated and the other lavishly engraved around 1750 by the New York pewterer and engraver Joseph Leddel, illustrate how important engraving was, visually and stylistically, in transforming the decorative aesthetics of a piece and enhancing its symbolic associations (see nos. 190, 191; fig. 208). Leddel's subject matter, a narrative triptych of three scenes from Ovid, is drawn from earlier European and English print sources.[129]

Most local engravers employed simple, fashionable cartouche surrounds or rounded format reversed-initial ciphers for their clients. In 1725, while Joseph Richardson, Sr., was still an apprentice under his father, he asked his friend and fellow Philadelphian Samuel Powell to buy for him "an alphabet Cypher book to Engrave by," "a book of Drafts to Draw by," and a book on how "to Ingrave Snuff boxes" while he was in London (see fig. 209).[130] Ornate cartouches or crested engraving, initials, or coats of arms of owners were often the only surface decoration on early Philadelphia silver and served to unite different forms. Among the most ornately engraved silver pieces, bearing matching cartouche surrounds and a coat of arms, were those produced by several New York and Philadelphia silversmiths for Joshua Maddox, a wealthy and influential member of Philadelphia's political and mercantile circles (see nos. 192, 235, 248; fig. 210).

Silver's malleability made it a medium particularly receptive to and well suited for the styles and decorative elements of European and English baroque classicism. By 1700 American silversmiths had begun to produce simplified architectonic forms and decorative devices that reflected a knowledge of many of the same basic design sources used by their more sophisticated Dutch and English counterparts. Strong, symmetrically balanced shapes drawn from classical elements such as the round or faceted baluster urn and traditional motifs like the reverse scroll, petal gadrooning, cut-card work, applied cast masks, and molded edge and foot appliqués came to be used in Philadelphia's leading silver shops (see nos. 198, 262). Using these basic devices, silversmiths adapted and experimented, developing the forms and decorations that grew to characterize their work. With the exception of some of the earliest straight-sided tankards and canns, most of the silver forms used in Philadelphia houses before mid-century were adaptations of the column or baluster shape drawn from classical architecture. Straight-walled versions may have been inspired by the subtly tapered Doric column (nos.

Fig. 209
Samuel Sympson, *A New Book of Cyphers*, 1739, no. 494; Sugar Bowl, John Leacock, c. 1750–60, no. 230, detail of engraving.

Fig. 210
Tazza, or Footed Salver, Henry
Pratt, c. 1725–40, no. 235.

Fig. 211
Chalice, John East, c. 1707/8,
no. 182b.

185, 199, 200). In their various translations of the shape, different silversmiths placed the maximum swell (or belly) of the baluster form higher or lower, varied the visual rhythm of the S-curved profiles, and augmented the basic design with cast foot rims, borders, spouts, and handles (nos. 195, 206, 212, 213, 251).

By 1700 a good number of wealthy and middle-class Philadelphians were drinking tea, coffee, and chocolate, giving rise to a growing demand for silver teapots, coffeepots, sugar boxes, cream pots, spoon trays, tongs, spoons, and salvers (see no. 445). Craftsmen diversified the forms and decorations found in their shops as they scrambled to compete for business and accommodate the trend (see nos. 215, 216, 220; fig. 146). The Swedish minister Israel Acrelius observed during his travels in Pennsylvania in the late 1740s that these new beverages had become much more widely available: *"Tea* is a drink very generally used. No one is so high as to despise it, nor any one so low as not to think himself worthy of it. . . . It is always drunk by the common people with raw sugar in it. Brandy in tea is called *lese*. Coffee . . . is sold in large quantities, and used for breakfast. Chocolate is in general use for breakfast and supper. It is drunk with a spoon. Sometimes prepared with a little milk, but mostly only with water."[131] While the taste for matching suites of furniture was pronounced during this period in Pennsylvania, large matching silver tea or coffee services did not become popular until well after the Revolution, possibly because of the high costs of such silver assemblages made en suite. In 1748, however, Joseph Richardson, Sr., listed in his account book the pieces he supplied to Anthony Morris of Philadelphia in filling a large order for what was

probably a rare early matched set: "To a tea Pott . . . to fashion, to a weighter . . . to fashion, to a Shugar Dish . . . to fashion, to a Milk Pot . . . to fashion, to a Slop Bowl . . . to fashion."[132]

By the 1730s the salver or "stand," a small footed tray, was often used in conjunction with coffee, tea, or chocolate pots, elevating the pots to display them more impressively and keep the heat away from the surface of the table (fig. 210). Another silver form that developed mostly for display was the caster stand, a footed frame for holding the smaller single casters and cruets that held spices for the table (no. 249, fig. 96). Salvers and caster stands had evolved during the late Baroque toward the end of the seventeenth century in France, Holland, and England to facilitate the display of lavish silver table assemblages. They were imported as well as produced locally for Philadelphia households.

Impressive tankards and small "canns" were used for alcoholic beverages such as ciders and ales. Rum and beer were consumed much more casually and regularly during the period, a time when water purity was questionable. By 1744 more than a hundred licensed public houses, taverns, and coffeehouses were operating in Philadelphia.[133] Alcohol consumption in the home also increased and was viewed by many as a stylish and acceptable aspect of social grace and hospitality (see nos. 189, 196, 205; fig. 101). Punch, a lethally strong, sweet mix of mostly rum or brandy, sugar, and citrus juice, was served in much smaller portions than we are accustomed to today. The quantity held in the smaller silver or imported ceramic punch bowls popular in the early eighteenth century would have been sufficient for serving eight (see nos. 232, 233).[134]

Some of the most impressive silver was commissioned by individuals and presented as gifts to churches (no. 182, fig. 211). Such private gifts provided opportunities for demonstrating piety and largess in a very public way. One Philadelphian to take advantage of the opportunity was Colonel Robert Quary. To augment the impressive silver chalice, paten, and flagon made by John East of London and presented by Queen Anne in 1708 to Christ Church in Philadelphia, he left in his will "Sixty pounds curant mony of this Place to bee Layd out in Silver Plate for the use of the Comunion Table."[135] After Quary's death in 1712, the vestry of the church used his bequest to purchase two imported silver alms plates and to commission the Philadelphia silversmith Philip Syng, Sr., to produce another flagon after the pattern of the first and a baptismal basin. Syng inscribed the new flagon, produced soon after his arrival in the city in September 1714, with an acknowledgment of Quary's generosity and the date of his death. Slightly later, around 1732, another parishioner, Margaret Tresse, donated an alms plate and beaker commissioned from the Philadelphia silversmith Cesar Ghiselin (c. 1663–1733).

Philadelphia's enthusiasm for baroque-inspired patterns and forms in silver is also illustrated by the number of imported examples owned by the city's wealthy elite during the period and by the influence exerted by these imports on both the taste of patrons and the designs of the city's best silversmiths. An extensive list of "Plait Carried to Pennsilvania" by William Penn for use at his Pennsbury estate upon his return to the city from England around 1699 gives an idea of the imported forms used or seen by those in the proprietor's circle:

*1 Extinguisher / 1 little standish with a drawer / 1 sivall runnell [?] marked W:P: / 5 sweet meet spoons / 1 childs drinking cup / 6 spoons with a Cress on them yt are used in the kitching 4 came from / walthamstow 2 wth a Cress 2 wthout / 1 we had before unmarked / 1 marked :E:B: 12 in all / 6 eggs spons 3 marked with ye Childrens names 3 marked :W:P:G 1 gone to / Pennsilvania / 2 cruit tops 2 taisters / . . . 1 large tankard 1 Plaite / 1 Porringer with ears and a cover / 1 Caudle cup with 3 leggs & a porringer to / cover it . . . / 3 tumblers 1 larger 2 lessor / 1 taister 6 spoons 2 forks / 1 paire of snuffers / 1 handle cup . . . / 2 things for Cruit tops / 1 new cup with a couver 2 tankerds . . . / 3 new Chaffen dishes 1 larg / 2 lesser & things to them to / burn Spirits in / 1 large Snuffer pan wth candle / stick in it / 1 Large plait with the Springets arms that Springets Grandmother Pennington / Gave him / 1 little hand Candle stick marked W:P:G: / 1 little [strong?] water bottle marked *G:M:S*.[136]*

Whether a single inherited tankard that an early immigrant family brought with them or a newly acquired silver tea service ordered through a London agent, imported silver was highly prized. It naturally influenced the taste and desire for such forms within the elite class. In some instances, imported silver pieces served as direct prototypes for the work of local silversmiths. In other cases, the influence of imported silver objects was more subtle, affecting the ornament, engraving, or chased details of locally produced objects.

James Logan, Penn's secretary, owned a fine imported English silver service consisting of a teapot on a warming stand, a pair of tea caddies, a cream jug, and a sugar box, which he displayed in

Fig. 212
Offering Plate, Jeremiah Dummer, c. 1685–1700, no. 183.

one of the paneled, built-in "Bouffert" cupboards in this front parlor at Stenton (no. 221, fig. 128). The set was configured en suite in a fashionable baluster-shaped style with faceted sides and sent to Philadelphia by Logan's London agent, but the individual pieces are by different makers. While they vary slightly in scale and execution, they are all united by the finely engraved reversed-initial cipher placed within a scrolled, symmetrically framed cartouche on each piece, probably executed after they arrived in Philadelphia. The Logans entertained their friends Oswald and Lydia Peel and Margaret Wistar at Stenton regularly during the 1730s, and both the Peels and the Wistars commissioned silver tea services from Joseph Richardson, Sr., that are very similar in their faceted forms to Logan's imported set. If not directly influenced by Logan's set, Richardson may have been inspired by similar English-made faceted baluster-shaped examples among the silver he imported and sold in his shop.

John Cadwalader (1677/78–1734), who arrived in Pennsylvania in 1697 among a group of Welsh Quakers granted sizable tracts of land north and west of Philadelphia (in the Welsh Tract), owned a large, impressive silver tankard made by the London silversmith William Penstone in 1712/13 (no. 186, fig. 100). It is one of the earliest imported tankards that can be traced to a Philadelphia owner. Its straight walls, applied midband, and step-profiled dome top reveal the prototypical early English tankard that influenced Philadelphia makers. Francis Richardson, Sr., produced a remarkably similar version for the iron merchant William Branson about 1715–20, including in his version of the form a high scrolled thumbpiece, a shell-shaped terminus on the handle, and applied "rat-tail" beading abutting the hinge mechanism seated on the upper handle (no. 189, fig. 101). His son Joseph Richardson, Sr., was still producing the form around 1745–50, when he made a remarkable diminutive version for Thomas Penrose (1709–1757), a shipbuilder and leading merchant involved in the West Indies trade (no. 196). Placed just above the tankard's midband is an ornately engraved, symmetrical scrolled cartouche enclosing the Penrose coat of arms.

Influences also came from abroad via other colonial cities. A number of the Dutch and English Quaker families who settled in the Delaware Valley had family connections in New York, Boston, or the West Indies (see no. 204). Several carried on lucrative business relationships with merchants in Boston, New York, Charleston, Barbados, and Tortola (West Indies). Samuel Carpenter, Thomas Penrose, Edward Shippen, William Bran-

son, and many of Philadelphia's other leading West Indies traders had regular and close business ties to these cities, and some of them patronized the silversmiths there. The prominent Boston and Philadelphia merchant Edward Shippen, for example, presented an ornately engraved alms plate by the Boston silversmith Jeremiah Dummer, Shippen's neighbor in Boston, to Saint Paul's Church in Philadelphia around 1698–1700 (no. 183, fig. 212). Governor Patrick Gordon of Philadelphia owned a finely cast, ornate pair of double-lipped sauceboats, a form unique among known American examples, made by the New York silversmith Charles Le Roux (no. 246, fig. 137). The shape, described as having *deux anse et deux becs* (two handles and two "noses," or spouts), was popular in the Huguenot silver shops of Louis XIV's France and, later, in London, where it was produced by silversmiths such as James Fraillon (active c. 1706–c. 1728), Benjamin Pyne (active c. 1676–1732), and Paul de Lamerie (1688–1751), among others.[137] The Gordon sauceboats were widely admired in Philadelphia and were valued at more than £30 in Gordon's 1736 inventory.[138] These and other early examples of New York and Boston silver owned by Philadelphia families may have sparked the wider dissemination of ornate Dutch and French Huguenot silver and engraving styles in the city.

The early Dutch and French stylistic influences present in the silvermaking traditions of New York also spread to Philadelphia through Delaware Valley silversmiths who had close associations or had apprenticed with New York makers. The Philadelphia silversmith Johannis Nys (1671–1734), for example,

a French Huguenot whose family had fled France for Holland, eventually arriving in New York, is recorded in baptismal records in the Dutch Church of New York in 1671. While the details of his early apprenticeship and training are unknown, it is known that he married into the family of New York silversmith Henricus Boelen (1684–1755) in 1693.[139] Nys's use of traditional Dutch and French Huguenot decorative elements in his work, such as cast scrollwork, cut-card ornamental appliqués, wire work, baroque masks, and screw-form thumbpieces on his earliest tankards, closely parallels the work of a number of New York silversmiths, confirming his training there.[140] The impressive tankard Nys produced for James and Sarah Read Logan in 1714 (no. 188), with its straight but tapering walls, flat top, sawn scrolled rim, screw-form thumbpiece, and base trim of saw-toothed cut-card work, is closely related to tankards produced by Jacobus van der Spiegel (1668–1708), Bartholomew Schaats (1670–1758), and Henricus Boelen II (1697–1755) of New York.[141]

Nys's exposure to the Dutch and French Huguenot silversmithing traditions in New York is also suggested by a remarkable pair of braziers or "chafing dishes" (used for warming food) that he made for Anthony and Mary Coddington Morris about 1695–99 (no. 261, fig. 142). They incorporate raised, cast, and cutwork techniques and closely follow the form of earlier Dutch braziers, including the intricate pierced fleur-de-lis patterns in their walls and floors. The pair represents one of the most direct transferrals of Dutch and French baroque silver styles to Philadelphia during the initial period of settlement. Nys's training

and stylistic preferences were passed on to the apprentices who trained in his shop, among whom may have been the silversmith Francis Richardson, Sr.[142]

Another early Philadelphia silversmith closely linked to New York Huguenot traditions was Peter David (1707–1755). David's apprenticeship to the New York silversmith Peter Quintard (1699–1762) is entered into the New York apprenticeship records in 1724 as "Registred for Mr. Peter Quintard, the 3rd day of October Anno Dom 1724 / Indenture of Peter David an infant of about fifteen years of agge and an orfen by and with the consent of John David and John Dupuy cherurguien to Peter Quintard, Goldsmith from June 12, 1722 for seven years."[143] David had moved to Philadelphia by 1736 and was actively trading wares with Joseph Richardson, Sr., during 1739. The silver pieces he produced after his move to Philadelphia are closely related to New York examples (see no. 259). For example, David produced a rare, tapered-wall "lighthouse" version of a coffeepot and a square, cut-corner footed salver virtually identical in form and proportion to one produced about 1735–40 for Ralph Assheton of Philadelphia by the New York silversmith Charles Le Roux (see nos. 209, 210; figs. 207, 213). In that David's set is unique among known Philadelphia examples and is thought to have been made for members of the Logan family slightly later than Le Roux's, the Assheton coffeepot and square salver may have served as direct inspirations for his work. Other, later Philadelphia silversmiths continued to have regular interactions with New York makers and to demonstrate in their own work a familiarity with the Dutch and French Huguenot traditions present in that city.[144]

The precious nature of silver and its elegant, often rarified patronage made it a harbinger of developing tastes and fashions in colonial America. Toward mid-century the influences of the growing taste for the Rococo were felt by a number of Philadelphia silversmiths. The baluster form that had tended to dominate silver design began to undergo further experimentation and elaboration. The round and simple pear shapes of earlier tea services evolved into the double-bellied or inverted baluster forms, wherein the widest swell was placed progressively higher, a shift in the perception of balance in design (see no. 219). Canns and tankards followed suit. Their cast handles began to incorporate stacked pairs or conjoined multiples of reversed C-scrolls rather than the single scrolls used in earlier versions. Handles, cast feet, and the finials of lids were increasingly ornamented with appliqués of acanthus scrolls, floral engraving, and asymmetrical volutes. In decorative engraved designs, the symmetrically conceived reversed-initial ciphers and round cartouche surrounds of the Baroque were slowly transformed to include asymmetrical flourishes of rocaille scrollwork and ruffles in their overall compositions (see no. 233). Influenced by a new wave of Huguenot engravers and chasers, surface ornament on silver came to include floral and more pronounced scroll motifs, both chased and in repoussé. As had been the case in the earlier part of the century, the silver pieces produced for Philadelphia's elite during the 1750s provided an early demonstration of the stylistic changes that would form the basis of the colony's coming evolution in taste and fashion.

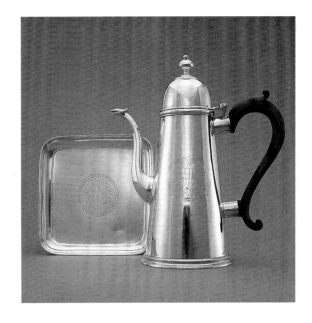

Fig. 213
Coffeepot and salver, Charles
Le Roux, c. 1735–40, no. 209.

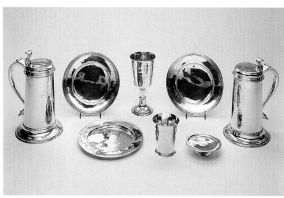

182

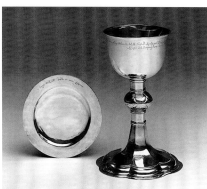

183

184

Silver

182. Ecclesiastical Silver from Christ Church

a. Plates (standing)
Joshua Readshaw (English, active c. 1687–
c. 1728)
London, 1694/95
Inscription: The Gift of / Coll Robert Quary / to
Christ Church in Philadelphia / this 29th 8br
1712 (engraved on top of both plates)
Diameter 9^5/$_8$" (24.4 cm)

b. Flagon, Chalice, and Paten
John East (English, active c. 1689–1734)
London, 1707/8
Inscription: Annæ Reginæ / In Usum Ecclesiæ /
Anglicanæ apud / Philadelphiam / AD / 1708
[(gift) of Queen Anne for the use of the Anglican
Church in Philadelphia AD 1708] (engraved on
body of flagon and chalice)
Silver
Height of flagon 11^1/$_2$" (29.2 cm); height of
chalice 9" (22.9 cm); diameter of paten 5^1/$_8$" (13 cm)

c. Flagon (left)
Philip Syng, Sr. (born Ireland, 1676–1739)
Philadelphia, c. 1714–15
Inscription: The Gift of / Coll Robert Quary / to
Christ Church in Philadelphia / this 29th 8br
1712 (engraved on body)
Silver
Height 11^1/$_2$" (29.2 cm)

d. Beaker and Plate
Cesar Ghiselin (c. 1663–1733)
Philadelphia, c. 1732–33
Inscription: the gift of Magaret Tresse Spinston
[Spinster] / to Christ church in Philadelphia
(engraved on bottom of plate; engraved around
body of beaker without line breaks)
Silver
Height of beaker 4^1/$_4$" (10.8 cm); diameter of
plate 9^3/$_4$" (24.8 cm)

The Rector, Church Wardens, and Vestrymen of
Christ Church, Philadelphia
See also fig. 211.

183. Offering Plate
Jeremiah Dummer (born Massachusetts,
1645–1718)
Boston, c. 1685–1700
Silver
Diameter 10^1/$_8$" (25.7 cm)
On deposit from Saint Paul's Church,
Philadelphia

This plate is thought to have been presented
to Saint Paul's Church by Edward Shippen
sometime after his arrival in Philadelphia from
Boston in 1693.
See also fig. 212.

184. Chalice and Paten
Herman Hermansson (Swedish, 1702–1745)
Gothenburg, Sweden, c. 1718
Inscription: Fahlú Bergslags Schenck: til H • Tre-
fald • Kírkiopo China i Pensylvanien. A 1718 /
/ Assessor och Bergmästare: Herr Anders Swab /
Tag och drick: thetta år min blod (on body of chal-
ice); H: Erick Biörck • P • Fahlú • Fordom Wid
China i Pensylvanien (on bottom of base of chalice,
with hallmark); I N R F S M (around stem)
Silver
Height of chalice 9^1/$_2$" (24.1 cm)
Diameter of paten 6" (15.2 cm)
Old Swedes Church of Trinity Episcopal Parish,
Wilmington, Delaware

This chalice and paten were presented in 1718
to the congregation of Holy Trinity Church at
Christiana (now Wilmington, Delaware) by the
people of Kopparberg, Sweden, a small mining
town. Erik Björk, a former pastor and influential
cleric of the Swedish Church in America, wrote
to the mine master of the town, Anders Svab,
asking that their Swedish "brothers in Christi-
ianity" remember the American congregation
and replace the church's "old and leaden" com-
munion service with a new one.

185. Tankard
Cesar Ghiselin (c. 1663–1733)
Philadelphia, c. 1684–90
Inscription: B w S (engraved on handle)
Silver
Height 7^3/$_4$" (19.7 cm)
Philadelphia Museum of Art. Purchased with
Museum funds. 1956-82-1

Originally owned by Barnabas and Sarah
Wilcox of Philadelphia, who arrived in
Philadelphia from Bristol in 1682.

186. Tankard
William Penstone (English, active after 1694)
London, c. 1712/13
Silver
Height 8^1/$_2$" (21.6 cm)
Philadelphia Museum of Art. Gift of Mr. and
Mrs. Henry Cadwalader. 1991-81-2

John Cadwalader (1677/78–1734), who pur-
chased extensive lands in Merion, in the Welsh
tract of Pennsylvania, and was an early influential
merchant in Philadelphia, brought this tankard
to the city; his only son, Thomas (1707/8–1779),
inherited it when he died.
See fig. 100.

187. Tankard
Johannis Nys (1671–1734)
Philadelphia, c. 1700
Inscription: AH (engraved on handle)
Silver
Height 7^1/$_8$" (18.1 cm)

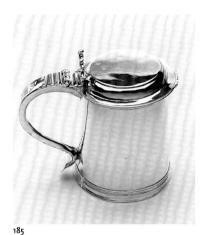

185

187

188

Philadelphia Museum of Art. Gift of William M. Elkins. 1922-86-17

The initials engraved on this tankard are those of Andrew Hamilton, Sr. (1676–1741).

188. Tankard
Johannis Nys (1671–1734)
Philadelphia, 1714
Inscription: JSL (engraved on body in cipher with cartouche surround)
Silver
Height 7¹/₄" (18.4 cm)
Philadelphia Museum of Art. Purchased with Museum funds. 1957-20-1

Originally owned by James and Sarah Read Logan of Philadelphia.
See also fig. 133.

189. Tankard
Francis Richardson, Sr. (born New York, 1681–1729)
Philadelphia, c. 1715–20
Inscription: w ᴮ ᴍ (engraved on handle)
Silver
Height 7" (17.8 cm)
Private Collection

Originally owned by William and Mary Tate Branson of Philadelphia.
See fig. 101.

190. Tankard
William Vilant (active 1725–35)
Philadelphia, c. 1725
Silver
Height 7³/₄" (19.7 cm)
Philadelphia Museum of Art. Purchased with the Joseph E. Temple Fund. 1923-55-1

191. Tankard
William Vilant
Philadelphia, c. 1725
Inscription: L / IM / Joseph Leddel / sculp / 1750 (engraved on handle); Divesque meo bona copia cornu [And the good goddess Abundance is enriched by my horn]; Nobilitas sub amore iacet [Noble birth lies prostrate under love!]; Penelope conjux semper Ulyssis ero [Penelope, wife of Ulysses, I shall be forever!] (engraved around body)
Silver
Height 6⅝" (16.8 cm)
Historic Deerfield, Inc., Deerfield, Massachusetts. 54.483

Engraved by Joseph Leddel of New York, the initials on this tankard are probably his and his wife's. The portraits engraved on the sides of the tankard are accompanied by lines from Ovid's *Metamorphoses* and are identified on the bottom as Philip, Lord Hardwicke; Simon Fraser, Lord Lovat; and Philip, Fourth Earl of Chesterfield.
See also fig. 208.

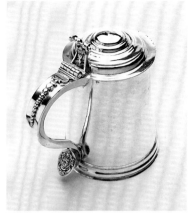

190

191

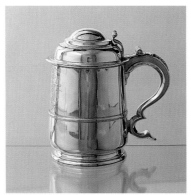

192

192. Tankard
Philip Syng, Jr. (born Ireland, 1703–1789)
Philadelphia, c. 1730–40
Silver
Height 8⁵/8" (21.9 cm)
Yale University Art Gallery, New Haven. Mabel
Brady Garvan Collection. 1930.1194
 Joshua Maddox (1687–1759) of Philadelphia
was the original owner of this tankard, which is
engraved with the Maddox coat of arms.

193. Tankard
Joseph Richardson, Sr. (born Pennsylvania,
1711–1784)
Philadelphia, c. 1740
Inscription: SB (engraved on handle)
Silver
Height 7¹/2" (19.1 cm)
Philadelphia Museum of Art. Gift of Daniel
Blain, Jr. 1991-158-6

194. Tankard
Philip Syng, Jr. (born Ireland, 1703–1789)
Philadelphia, c. 1743
Inscription: I ^W M / 1743 (engraved on handle)
Silver
Height 7¹/8" (18.1 cm)
Philadelphia Museum of Art. Gift of Mr. and
Mrs. Walter M. Jeffords. 1959-2-20
 This tankard bears the initials of its original
owners, Jeremiah and Mary Warder of Phila-
delphia.

195. Tankard
Richard Pitt(s) (active c. 1738–46)
Philadelphia, c. 1740–45
Silver
Height 7⁷/8" (20 cm)
The Dietrich American Foundation

196. Tankard
Joseph Richardson, Sr. (born Pennsylvania,
1711–1784)
Philadelphia, c. 1745–50
Inscription: T ^P S (engraved on handle); IP (also
engraved on handle)
Silver
Height 6¹/8" (15.6 cm)
Private Collection
 Unusual for its small size, this tankard was
originally owned by the Philadelphia shipbuilder
Thomas Penrose (1709–1757) and his wife Sarah
Coates. It is engraved with the Penrose coat of
arms and crest and bears their initials. It also
bears the later initials of James Penrose
(1737–1771), their son.

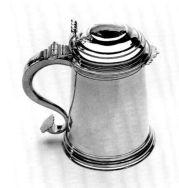

193

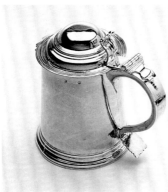

194

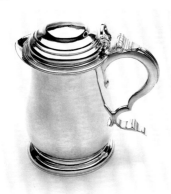

195

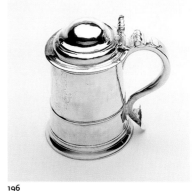

196

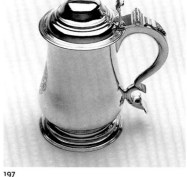

197

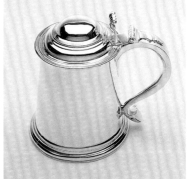

198

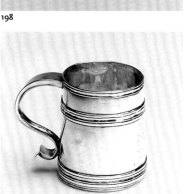

199

197. Tankard
Philip Syng, Jr. (born Ireland, 1703–1789)
Philadelphia, c. 1745–55
Inscription: IEC (engraved on body in cipher)
Silver
Height 8" (20.3 cm)
Philadelphia Museum of Art. Gift of Roland L.
Taylor. 1924-55-1

198. Tankard
Philip Syng, Jr.
Philadelphia, c. 1749–50
Inscription: I S H (engraved on handle)
Silver
Height 7¹/8" (18.1 cm)
Philadelphia Museum of Art. Gift of Mr. and
Mrs. Walter M. Jeffords. 1959-2-19

This tankard is engraved with the initials of
its original owners, Joseph and Hannah
Saunders, who were married about 1749.

199. Cann
Jacobus Van der Spiegel (born New York,
1666–1716)
New York, c. 1690–1700
Silver
Height 3³/4" (9.5 cm)
Philadelphia Museum of Art. Bequest of
Elizabeth Wheatley Bendiner. 1991-79-1

Engraved with the coat of arms of the Welsh
family of Philadelphia, this cann probably
belonged to Samuel Welsh, who died in 1702.

200. Cann
Francis Richardson, Jr. (born Pennsylvania,
1705/6–1782)
Philadelphia, c. 1730
Silver
Height 5¹/4" (13.3 cm)
Lent by the Commissioners of Fairmount
Park, Philadelphia

This cann descended in the Logan family of
Philadelphia. The form of its strap handle,
which is rare in Philadelphia, more often
appears on provincial English and early New
England examples.

201. Cann
Francis Richardson, Jr.
Philadelphia, c. 1730–35
Inscription: I R A (engraved on handle)
Silver
Height 4⁵/8" (11.7 cm)
Philadelphia Museum of Art. Purchased with
Museum funds. 1959-104-1

The initials on the handle are those of John
and Ann Richardson of New Castle County,
Delaware.
See fig. 148.

200

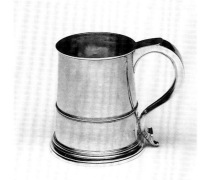
203

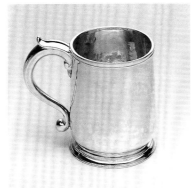
204

205

202. Cann
Joseph Richardson, Sr. (born Pennsylvania,
1711–1784)
Philadelphia, c. 1740–45
Silver
Height 4⁵/8" (11.7 cm)
Philadelphia Museum of Art. Bequest of
Robert R. Logan. 1956-120-5
See fig. 148.

203. Cann
Richard Pitt(s) (active c. 1738–46)
Philadelphia, c. 1740–45
Silver
Height 4¹/2" (11.4 cm)
Philadelphia Museum of Art. Gift of Susanne
Strassburger Anderson, Valerie Anderson
Readman, and Veronica Anderson Macdonald
from the estate of Mae Bourne and Ralph
Beaver Strassburger. 1994-20-67

204. Cann
Joseph Richardson, Sr. (born Pennsylvania,
1711–1784)
Philadelphia, c. 1742–45
Inscription: MC (engraved on handle)
Silver
Height 4" (10.2 cm)
Philadelphia Museum of Art. Gift of Lydia
Thompson Morris. 1925-27-340

The initials on this cann are probably those
of Martha Chalkley, widow of the clergyman
Thomas Chalkley. The cann was made with sil-
ver obtained by melting down Chalkley's per-
sonal silver after his death in Tortola, West
Indies, in 1741.

205. Cann
Philip Syng, Jr. (born Ireland, 1703–1789)
Philadelphia, c. 1750–55
Silver
Height 4⁷/8" (12.4 cm)
Rothman Gallery, Franklin and Marshall
College, Lancaster, Pennsylvania

This cann is engraved with the coat of arms
of George Ross (1730–1779) of Lancaster,
Pennsylvania.

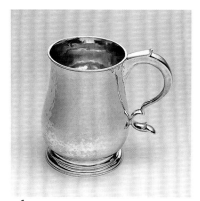

206

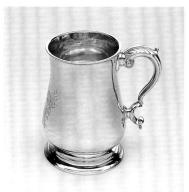

207

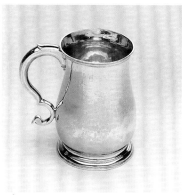

208

206. Cann

Philip Syng, Jr. (born Ireland, 1703–1789)
Philadelphia, c. 1750–55
Inscription: I S H (engraved on handle; eagle crest engraved on body)
Silver
Height 5" (12.7 cm)
Philadelphia Museum of Art. Gift of Walter M. Jeffords. 1956-84-33

207. Pair of Canns

Joseph Richardson, Sr. (born Pennsylvania, 1711–1784)
Philadelphia, c. 1750
Inscription: SL / SLW (engraved on bottom; Logan family crest engraved on body); 1750 (engraved above crest on *a*)
Silver
Height 5¹/8" (13 cm)
Philadelphia Museum of Art
(a) Gift of Walter M. Jeffords. 1958-125-1
(b) Gift of Daniel Blain, Jr. 1991-158-5
　Sarah Logan Wistar's initials are engraved on the bottom of both canns. As rococo design began to influence local styles, it often appeared first on surface decoration, while the earlier baroque shapes were maintained. The form of these canns is consistent with the baroque style, but the engraved cartouche surrounds show the influence of the emerging rococo style.

208. Cann

Joseph Richardson, Sr.
Philadelphia, c. 1750–60
Inscription: IHW / to / RW (engraved on handle)
Silver
Height 5" (12.7 cm)
Philadelphia Museum of Art. Bequest of R. Wistar Harvey. 1940-16-694

209. Coffeepot and Salver

Charles Le Roux (born New York, 1689–1748)
New York, c. 1735–40
Silver, wood
Height 9³/4" (24.8 cm); salver 6¹/4 x 6¹/4" (15.9 x 15.9 cm)
The Metropolitan Museum of Art. Purchase, Friends of the American Wing Fund, Sansbury-Mills Fund, and Mr. and Mrs. Robert G. Goelet, Mr. and Mrs. Robert M. Rubin, Wunsch Foundation, Maxwell H. Gluck Foundation, Louis and Virginia Clemente Foundation Inc., and Anonymous Gifts. 1997.498.1–.2
　This coffeepot and salver originally belonged to Ralph Assheton of Philadelphia; both bear his ornately engraved cipher.
See fig. 213.

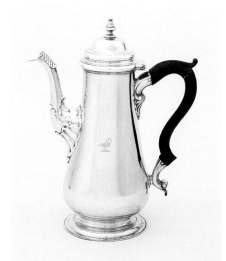

211

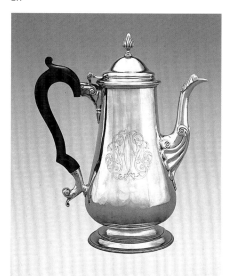

212

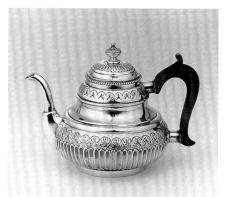

214

210. Coffeepot and Salver
Peter David (born New York, 1707–1755)
Philadelphia, c. 1740–50 (coffeepot); c. 1740 (salver)
Inscription: SL / EF (engraved on bottom of coffeepot)
Silver, wood
(a) Height of coffeepot 10³/4" (27.3 cm)
Philadelphia Museum of Art. Gift of Mr. and Mrs. Henry Cadwalader. 1991-81-1
(b) Salver 6¹/4 x 6¹/4" (15.9 x 15.9 cm)
Private Collection

Peter David's coffeepot, made for the Logan family, is unique among known Philadelphia examples and illustrates the effects of his earlier apprenticeship and training with Peter Quintard (1699–1762) of New York, where the "lighthouse" coffeepot form was more popular.
See fig. 207.

211. Coffeepot
Philip Syng, Jr. (born Ireland, 1703–1789)
Philadelphia, c. 1740–45
Silver, wood
Height 10¹/2" (26.7 cm)
Collection of Mrs. Ruth Nutt

A bird, possibly a swan, is engraved on the body of this coffeepot. The Breck and Emlen families of Philadelphia adopted such crests, and this pot may have belonged to a member of one of these prominent families.

212. Coffeepot
Joseph Richardson, Sr. (born Pennsylvania, 1711–1784)
Philadelphia, c. 1748
Inscription: JMR (engraved on body in cipher)
Silver, wood
Height 9³/4" (24.8 cm)
Sewell C. Biggs Museum of American Art, Dover, Delaware. 94.39

This coffeepot was originally owned by Joseph Richardson and his wife, Mary, and is engraved with their initials.

213. Coffeepot
Philip Syng, Jr. (born Ireland, 1703–1789)
Philadelphia, c. 1750–58
Inscription: T ᴾ S (engraved on body along with the Penrose family coat of arms)
Silver, wood
Height 12" (30.5 cm)
Private Collection

This baluster-shaped coffeepot, a precursor to the pear- or double-bellied forms of the 1760s and 1770s, descended in the Penrose family of Philadelphia.
See fig. 154.

214. Teapot
England, c. 1750
Silver, wood
Height 6¹/2" (16.5 cm)
Philadelphia Museum of Art. Gift of Lois Katherine Rogers in memory of her husband Fred F. Rogers, Jr. 1996-79-2a,b

Descended in the Sandiford family of western New Jersey.

215. Teapot
Joseph Richardson, Sr. (born Pennsylvania, 1711–1784)
Philadelphia, c. 1735–40
Silver, wood
Height 5³/8" (13.7 cm)
The Metropolitan Museum of Art. Bequest of Charles Allen Munn. 1924.109.9

216. Teapot
Joseph Richardson, Sr.
Philadelphia, c. 1740–45
Inscription: G ᴱ M (engraved on bottom)
Silver, wood
Height 5" (12.7 cm)
Collection of Mrs. Ruth Nutt
See fig. 146.

217. Teapot
Joseph Richardson, Sr.
Philadelphia, c. 1740–45
Silver, wood
Height 5³/8" (13.7 cm)
Chester County Historical Society, West Chester, Pennsylvania. 1984.710

This teapot was made for Deborah Morris (1723/4–1793) of Philadelphia.

218. Teapot
Elias Boudinot (1706–1770)
Philadelphia or New Jersey c. 1740–50
Inscription: I ˢ A (engraved on bottom; Stockton family coat of arms engraved on body)
Silver, wood
Height 6¹/2" (16.5 cm)
The New Jersey Historical Society, Newark. 1953.22

Originally owned by the New Jersey judge John Stockton and his wife, Abigail Phillips, this teapot is engraved with the Stockton family coat of arms.

219. Teapot
Joseph Richardson, Sr. (born Pennsylvania, 1711–1784)
Philadelphia, c. 1750–60
Silver, wood
Height 6¹/2" (16.5 cm)
Philadelphia Museum of Art. Gift of Mrs. Thomas J. Curtin. 1969-277-1

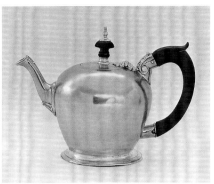

215

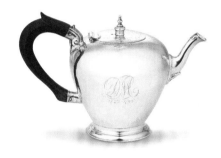

217

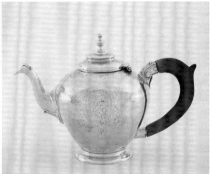

218

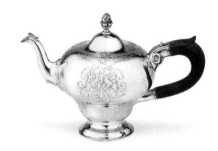

219

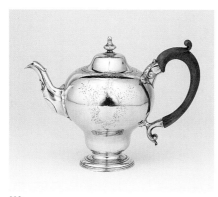

220

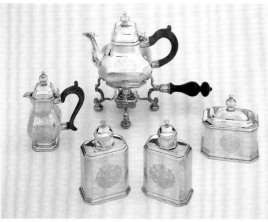

221

222

223

220. Teapot

Philip Syng, Jr. (born Ireland, 1703–1789)
Philadelphia, c. 1750–60
Silver, wood
Height 6¼" (15.9 cm)
Collection of Roy J. Zuckerberg

221. Tea Service

a. Kettle Stand

Benjamin Pyne (English, active after 1676;
died 1732)
London, 1720/21
Silver
Height 5¾" (14.6 cm)
Philadelphia Museum of Art. Gift of Mrs.
Widener Dixon and George D. Widener. 1959-
151-12

b. Kettle

Peter Archambo (English, active c. 1720–67)
England, 1721/22
Silver, wood
Height 8½" (21.6 cm)
Philadelphia Museum of Art. Gift of Mrs.
Widener Dixon and George D. Widener. 1959-
151-9

c. Cream Pot

Peter Archambo
London, 1721/22
Height 5¾" (14.6 cm)
Philadelphia Museum of Art. Gift of Mrs.
Widener Dixon and George D. Widener. 1959-
151-10

d. Sugar Box

Peter Archambo
London, c. 1722
Height 4¼" (10.8 cm)
Philadelphia Museum of Art. Gift of Mrs.
Widener Dixon and George D. Widener. 1959-
151-11

e. Pair of Tea Caddies

John Farnell (English, active after 1714)
London, 1723/24
Silver
Height 5⅛" (13 cm)
Philadelphia Museum of Art. Gift of Mr. and
Mrs. Paul E. Geier in honor of Amey Develin
Geier. 1975-49-1, 2

Originally owned by James Logan, this tea ser-
vice bears his coat of arms and is listed in the
household inventory of Stenton.
See also fig. 128.

222. Tea Canister

Joseph Richardson, Sr. (born Pennsylvania,
1711–1784)
Philadelphia, c. 1736–40
Inscription: OSWALD / AND / LYDIA PEEL; GREEN
TEA (engraved on opposite sides)
Silver
5½ x 2⅝ x 3⅛" (14 x 6.7 x 7.9 cm)
Collection of Roy J. Zuckerberg

This tea canister is one of a pair originally
owned by Oswald and Lydia Peel of Philadelphia
and was probably produced with no. 227 en suite.

223. Spoon Tray

Philip Syng, Jr. (born Ireland, 1703–1789)
Philadelphia, c. 1735–40
Inscription: JAB (engraved on top of tray in
cipher)
Silver
2⅞ x 6½" (7.3 x 16.5 cm)
Collection of Mrs. Ruth Nutt

The initials on this rare spoon tray are proba-
bly those of John and Ann Bartram, who were
married in 1729.

224. Cream Pot

Joseph Richardson, Sr. (born Pennsylvania,
1740–45)
Philadelphia, 1740–45
Inscription: w ᴮ ʀ (engraved on bottom)
Silver
Height 3⅞" (9.8 cm)
Yale University Art Gallery, New Haven. Mabel
Brady Garvan Collection. 1930.1330

225. Cream Pot

John Strangeways Hutton (born New York,
1684–1792)
Philadelphia, c. 1740–45
Inscription: JR (engraved on bottom)
Silver
Height 4¼" (10.8 cm)
Philadelphia Museum of Art. Purchased with
funds given in memory of Sophie E. Pennebaker.
1990-120-1

John Hutton was first recorded as a journey-
man working in the shop of the silversmith
Joseph Richardson, Sr., in 1735. Although he
lived for more than a century, he seems to have
retired from silversmithing in 1747 at age sixty-
three. This cream pot may have been made for
Richardson by Hutton as a part of his training.

226. Cream Pot

Philip Syng, Jr. (born Ireland, 1703–1789)
Philadelphia, c. 1745–55
Inscription: ᴛ ᶜ ᴄ (engraved on bottom)
Silver
Height 4⅜" (11.1 cm)

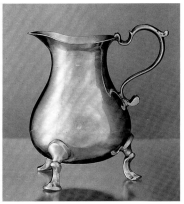

224

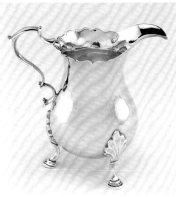

225

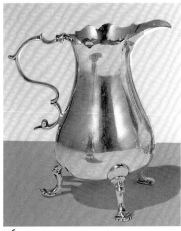

226

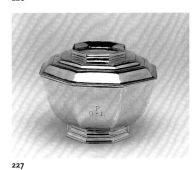

227

Philadelphia Museum of Art. Gift of Mr. and Mrs. Walter M. Jeffords. 1959.2-2

Originally owned by the Cowgill family, who married into the Paul family of Paulsboro, New Jersey.

227. Sugar Bowl
Joseph Richardson, Sr. (born Pennsylvania, 1711–1784)
Philadelphia, c. 1736
Inscription: o P l (engraved)
Silver
Height 3^1/$_2$" (8.9 cm)
Private Collection

Probably produced with no. 222 en suite, this sugar bowl was commissioned by Oswald and Lydia Peel of Philadelphia.

228. Sugar Bowl
Joseph Richardson, Sr.
Philadelphia, c. 1740–45
Silver
Height 4^7/$_8$" (12.4 cm)
Collection of H. Richard Dietrich, Jr.

229. Sugar Bowl
Joseph Richardson, Sr.
Philadelphia, c. 1740–50
Inscription: MW (engraved in double cipher)
Silver
Height 4^3/$_4$" (12.1 cm); diameter 4^3/$_8$" (11.1 cm)
Wyck, Germantown

This sugar bowl descended in the Wistar family of Philadelphia and is engraved with the cipher of its first owner, Margaret Wistar.

230. Sugar Bowl
John Leacock (born Pennsylvania, 1729–1802)
Philadelphia, c. 1750–60
Inscription: DH (engraved in cipher)
Silver
Height 4^1/$_4$" (10.8 cm); diameter 4^1/$_2$" (11.4 cm)
Philadelphia Museum of Art. Gift of Mr. and Mrs. Edward B. Smith, Jr. 1962-40-1a,b
See also figs. 209, 218.

231. Bowl
Joseph Richardson, Sr. (born Pennsylvania, 1711–1784)
Philadelphia, c. 1750
Inscription: MW (engraved in double cipher)
Silver
Height 3^1/$_8$" (7.9 cm); diameter 5^5/$_8$" (14.3 cm)
Wyck, Germantown

This bowl, like no 229, descended in the Wistar family of Philadelphia and is engraved with the cipher of its first owner, Margaret Wistar.

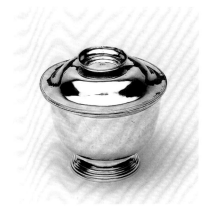

228

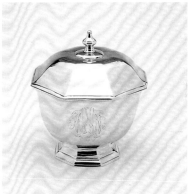

229

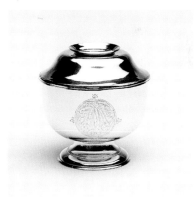

230

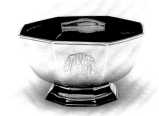

231

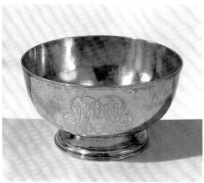

232

233

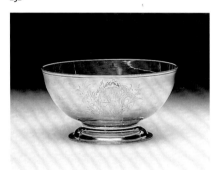

234

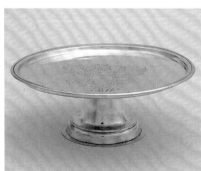

235

232. Punch Bowl

John Leacock (born Pennsylvania, 1729–1802)
Philadelphia, c. 1750–55
Silver
Height 3³/₄" (9.5 cm); diameter 6⁷/₈" (17.5 cm)
Philadelphia Museum of Art. Gift of Daniel
Blain, Jr. 1991-158-3

Sarah Logan Wistar's initials are engraved in a reversed cipher on this punch bowl.

233. Punch Bowl

Philip Syng, Jr. (born Ireland, 1703–1789)
Philadelphia, c. 1752–53
Silver
Height 3³/₈" (8.6 cm); diameter 6⁵/₈" (16.8 cm)
Philadelphia Museum of Art. Gift of Mr. and
Mrs. Walter M. Jeffords. 1959-2-16

Engraved with the Lardner coat of arms impaling the Branson coat of arms, this punch bowl was commissioned by Lynford and Elizabeth Branson Lardner in 1752.

234. Strainer

Philip Syng, Jr.
Philadelphia, c. 1750–55
Silver
Height 1¹/₂" (3.8 cm); length 7³/₈" (18.7 cm)
Philadelphia Museum of Art. Gift of Mr. and
Mrs. Walter M. Jeffords. 1959-2-9

235. Tazza, or Footed Salver

Henry Pratt (born Pennsylvania, c. 1709–1749)
Philadelphia, c. 1725–40
Inscription: I ᴹ ᴹ (engraved on underside of salver;
coat of arms of Joshua Maddox engraved on top)
Silver
Height 3" (7.6 cm); diameter 8¹/₂" (21.6 cm)
Collection of Mrs. Ruth Nutt

This tazza is engraved with the initials of Joshua Maddox of Philadelphia and his wife, Mary Gateaux, who were married in 1725. *See also fig. 210.*

236. Salver

Maker unknown
Philadelphia, c. 1735–45
Inscription: JAB (engraved in cipher)
Silver
Diameter 5³/₄" (14.6 cm)
Philadelphia Museum of Art. Purchased with
Museum funds. 1950-29-3

Originally belonged to John and Ann Bartram.

237. Salver

Joseph Richardson, Sr. (born Pennsylvania,
1711–1784)
Philadelphia, c. 1740–50
Inscription: MW (engraved in double cipher)
Silver
6¹/₂ x 6¹/₂" (16.5 x 16.5 cm)
Wyck, Germantown

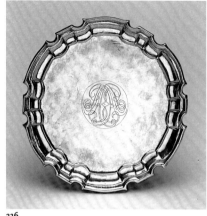

236

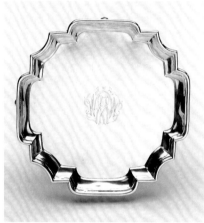

237

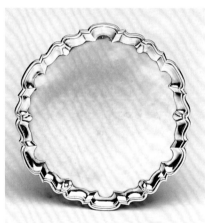

238

Originally owned by Margaret Wistar of Philadelphia, this salver is engraved with her cipher.

238. Salver
Joseph Richardson, Sr.
Philadelphia, c. 1739–40
Inscription: H. Emlen, 1740 (engraved on base)
Silver
Diameter 12¹/₄" (31.1 cm)
Private Collection

This salver was made with no. 239 en suite. It belonged to Hannah Emlen of Philadelphia, who married William Logan in 1740,

239. Salver
Joseph Richardson, Sr.
Philadelphia, c. 1739–40
Inscription: HE (engraved on bottom; crest with image of a bird engraved on center of salver)
Silver
Diameter 4³/₄" (12.1 cm)
Philadelphia Museum of Art. Bequest of Robert R. Logan. 1956-120-4

240. Salver
Joseph Richardson, Sr.
Philadelphia, c. 1740–50
Inscription: MM (engraved on bottom)
Silver
Diameter 9³/₄" (24.8 cm)
Philadelphia Museum of Art. Gift of Dr. and Mrs. Brooke Roberts. 1991-32-1

241. Salver
Jeremiah Elfreth, Jr. (1723–1765)
Philadelphia, c. 1747–50
Silver
Diameter 7¹/₈" (18.1 cm)
Philadelphia Museum of Art. Bequest of Lydia Thompson Morris. 1932-45-5

242. Salver
Philip Syng, Jr. (born Ireland, 1703–1789)
Philadelphia, c. 1750–55
Silver
Diameter 5³/₄" (14.6 cm)
Philadelphia Museum of Art. Gift of Walter M. Jeffords. 1950-110-2

243. Salver
Elias Boudinot (1706–1770)
Philadelphia and New Jersey, c. 1750–55
Silver
Diameter 5³/₄" (14.6 cm)
Collection of Mrs. Ruth Nutt

244. Salver
Philip Syng, Jr. (born Ireland, 1703–1789)
Made in Philadelphia, c. 1750–55
Silver

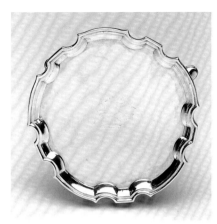
239

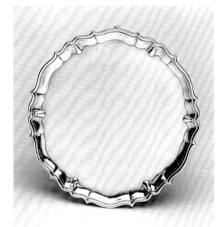
240

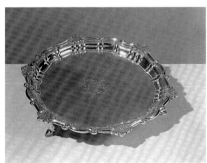
241

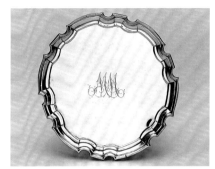
242

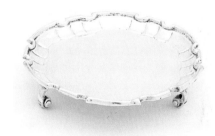
243

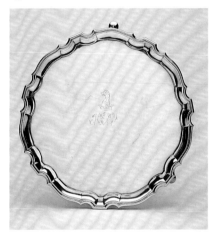
244

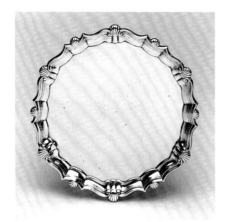

245

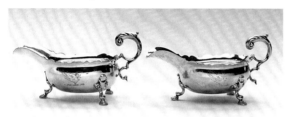

247

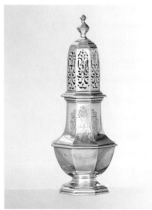

248

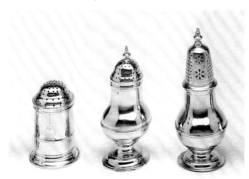

250, 251, 252

Diameter 10³/4" (27.3 cm)
Collection of Roy J. Zuckerberg

245. Salver

Philip Syng, Jr. (born Ireland, 1703–1789)
Philadelphia, c. 1750–58
Silver
Diameter 6⁵/8" (16.8 cm)
Philadelphia Museum of Art. Gift of Dr. and Mrs.
Brooke Roberts. 1991-32-3

For additional salvers, see nos. 209, 210

246. Pair of Sauceboats

Charles Le Roux (born New York, 1689–1748)
New York, c. 1725–35
Silver
(a) Height 3³/4" (9.5 cm); length 9" (22.9 cm)
(b) Height 3⁵/8" (9.2 cm); length 8⁷/8" (22.5 cm)
Philadelphia Museum of Art. Gift of Daniel
Blain, Jr. 1991-158-1, 2

Unique among known American silver sauce-
boats, this pair was commissioned by Patrick Gor-
don, governor of Pennsylvania from 1726 to 1736.
Each is engraved with the Gordon coat of arms.
See fig. 137.

247. Pair of Sauceboats

Joseph Richardson, Sr. (born Pennsylvania,
1711–1784)
Philadelphia, c. 1750–55
Silver
Height 4" (10.2 cm); length 7¹/4" (18.4 cm)
Philadelphia Museum of Art. Purchased with the
Richardson Fund. 1979-1-1, 2

Made for the Pemberton family of Philadelphia,
this pair of sauceboats is engraved with their crest.

248. Caster

Simeon Soumain (1685–1750)
New York, c. 1725–40
Silver
Height 7³/8" (18.7 cm)
Yale University Art Gallery, New Haven. Mabel
Brady Garvan Collection. 1950.788

Joshua Maddox of Philadelphia originally owned
this caster, which is engraved with his coat of arms.

249. Caster Stand and Casters

Samuel Wood (English, c. 1704–1794)
London, 1735/36
Silver, glass
Height 8³/4" (22.2 cm)
Philadelphia Museum of Art. Gift of Lynford
Lardner Starr. 1992-156-1

This caster stand was originally owned by John
Penn. In 1750 Penn sold it to Lynford Lardner of
Philadelphia, who had the stand engraved with the
Lardner/Branson crest. It is one of the earliest docu-
mented caster or cruet stands in colonial America.
See fig. 96.

250. Caster

Philip Syng, Jr. (born Ireland, 1703–1789)
Philadelphia, c. 1740–50
Inscription: PM / to / PC (engraved on bottom)
Silver
Height 3" (7.6 cm)
Philadelphia Museum of Art. Gift of Mr. and
Mrs. Walter Jeffords. 1959-2-8

The initials engraved on this caster are possibly
those of Prudent or Patience Marshall and Patience
Chambers.

251. Caster

Philip Syng, Jr.
Philadelphia, c. 1758
Inscription: s P i (engraved on body)
Silver
Height 4⁵/8" (11.7 cm)
Philadelphia Museum of Art. Gift of Mr. and
Mrs. Walter M. Jeffords. 1959-2-5

The initials of Samuel Potts and Joanna Holland,
who were married in 1758, are engraved on this
caster.

252. Caster

Philip Syng, Jr.
Philadelphia, 1745–55
Inscription: s F s (engraved on bottom)
Silver
Height 5" (12.7 cm)
Philadelphia Museum of Art. Gift of Mr. and
Mrs. Walter M. Jeffords. 1959-2-6

253. Pair of Saltcellars

Joseph Richardson, Sr. (born Pennsylvania,
1711–1784)
Philadelphia, c. 1745
Inscription: A W M (engraved on bottom)
Silver
1¹/8 x 2⁷/8 x 2¹/4" (2.9 x 7.3 x 5.7 cm)
Collection of Roy J. Zuckerberg

These heavy, cast saltcellars are possibly those
ordered by Abraham Wincoop and recorded in
Joseph Richardson's account book in 1745.

254. Pair of Saltcellars

Philip Syng, Jr. (born Ireland, 1703–1789)
Philadelphia, c. 1745–55
Inscription: G R A (engraved on bottom)
Silver
1¹/2 x 2³/4" (3.8 x 7 cm)
Philadelphia Museum of Art. Gift of Mr. and
Mrs. Walter M. Jeffords. 1959-2-13, 14

255. Porringer

Cesar Ghiselin (c. 1663–1733)
Philadelphia, c. 1685–99
Inscription: A M M / HM (engraved on handle);
LM / to / SM (engraved under handle)
Silver

253

254

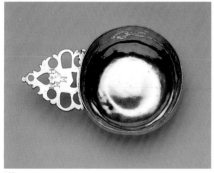

255

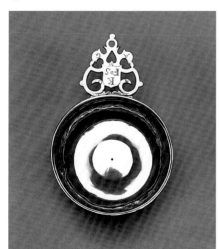

256

Diameter 4" (10.2 cm)
Philadelphia Museum of Art. Gift of Mrs. W. Logan MacCoy. 1957-93-1

It is thought that this porringer originally belonged to Anthony Morris of Philadelphia and his first wife, Mary Jones. The handle pattern is drawn from both French and Dutch silver designs and is found on the earliest local porringers.

256. Porringer
Johannis Nys (1671–1734)
Philadelphia, c. 1714
Inscription: AO / F K s / to / AG (engraved on handle)
Silver
Diameter 5^1/8" (13 cm)
Philadelphia Museum of Art. Purchased with Darley and Special Funds. 1924-27-1

257. Pair of Porringers
Johannis Nys
Philadelphia, c. 1710–25
Inscription: T C B (engraved on handle)
Silver
Diameter 4^5/8" (11.7 cm)
The Dietrich American Foundation

These porringers originally belonged to Thomas and Beulah Coates of Frankford, Pennsylvania, and Philadelphia. Thomas, who died in 1719, was a leading Quaker merchant. Their daughter, Elizabeth Coates Paschall, built the house Cedar Grove in 1748.
See fig. 16.

258. Porringer
Joseph Richardson, Sr. (born Pennsylvania, 1711–1784)
Philadelphia, c. 1738
Inscription: C W C (engraved on handle)
Silver
Diameter 5" (12.7 cm)
Philadelphia Museum of Art. Gift of the heirs of Paul D. I. Maier and Anna Shinn Maier. 1998-161-15

Originally owned by Caspar and Catherine Johnson Wistar of Philadelphia.

259. Porringer
Peter David (born New York, 1707–1755)
Philadelphia, c. 1739–45
Inscription: M S H (engraved on handle)
Silver
Diameter 5" (12.7 cm)
Collection of Roy J. Zuckerberg

With a handle pattern identical to New York examples, David's porringer documents the effect of his earlier apprenticeship to the New York Huguenot silversmith Peter Quintard (1699–1762).

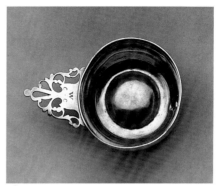

258

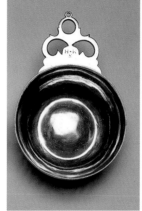

259

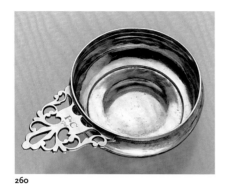

260

260. Porringer

Anthony Bright (active c. 1735–51)
Philadelphia, c. 1740–50
Inscription: PC (engraved on handle)
Silver
Diameter 5" (12.7 cm)
Private Collection. On loan to the Sterling and
Francine Clark Art Institute, Williamstown,
Massachusetts

261. Pair of Braziers

Johannis Nys (1671–1734)
Philadelphia, c. 1695–99
Inscription: A M M (engraved on bases)
Silver, wood
Height 3¹/₄ x 6¹/₈ x 13¹/₄" (8.3 x 15.6 x 33.7 cm)
Philadelphia Museum of Art
(a) Gift of Mr. and Mrs. Elliston P. Morris.
1967-209-1
(b) Bequest of R. Wistar Harvey. 1940-16-700
 These braziers are inscribed with the initials of
the original owners, Anthony Morris and his
third wife, Mary, widow of Thomas Coddington.
See fig. 142.

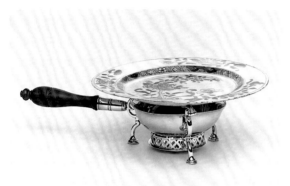

262

262. Brazier

Philip Syng, Sr. (born Ireland, 1676–1739)
Philadelphia, c. 1725–35
Silver, wood
Height 3 x 6 x 11¹/₂" (7.6 x 15.2 x 29.2 cm)
Philadelphia Museum of Art. Gift of William M.
Elkins. 1922-86-20

263. Spoon

England, probably West Country, c. 1680–94
Inscription: ID / 1694 (stipple-engraved on back
of handle)
Silver
Length 8" (20.3 cm)
Philadelphia Museum of Art. Gift of Daniel
Blain, Jr. 1991-158-7
 Originally Jonathan Dickinson's (1663–1722)
or his child's, this spoon descended in the Dick-
inson and Logan families of Philadelphia. The
significance of the 1694 date is unknown, but it
probably marks a birth or a baptism.
See fig. 11.

264

264. Pair of Sucket Forks

Johannis Nys (1671–1734)
Philadelphia, c. 1690–1715
Inscription: H H M (engraved on back of handle)
Silver
Length 6¹/₄" (15.9 cm)
Philadelphia Museum of Art
(a) Gift of Mrs. Alfred Coxe Prime. 1925-6-1
(b) Bequest of J. Stogdell Stokes. 1947-62-1
 Sucket forks were used to serve sweetmeats—
such delicacies as dried or candied fruits or sim-
mered, spiced meats.

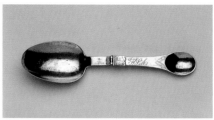

265

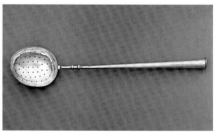

266

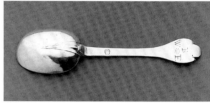

267

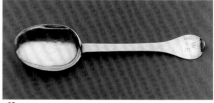

268

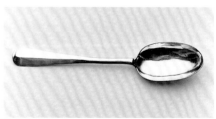

270

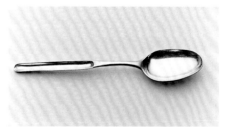

271

265. Folding Pocket Spoon

Cesar Ghiselin (c. 1663–1733)
Philadelphia, c. 1695–1705
Inscription: ᴶ ꜰ ᶜ (engraved on hinge cover)
Silver
Open 7¹/8" (18.1 cm); folded 4" (10.2 cm)
Philadelphia Museum of Art. Purchased with
Museum funds. 1957-56-1

This rare folding spoon may have been used
for measuring medicine. Its engravings are simi-
lar to the vine and floral chased decorations found
on mid- to late seventeenth-century French and
northern European silver.

266. Tablespoon

Johannis Nys (1671–1734)
Philadelphia, c. 1696–1710
Inscription: ᴡ ᴮ ᴇ (engraved on back of handle)
Silver
Length 7³/4" (19.7 cm)
Philadelphia Museum of Art. Purchased with
Museum funds. 1950-29-1

The initials on this tablespoon are perhaps
those of John Bartram's parents, William and
Elizabeth Bartram.

267. Skimming Spoon

Attributed to Philip Syng, Sr. (born Ireland,
1676–1739)
Philadelphia, c. 1700–1710
Silver
Length 17³/8" (44.1 cm)
Lent by the Commissioners of Fairmount Park,
Philadelphia

268. Spoon

Johannis Nys (1671–1734)
Philadelphia, c. 1710–12
Silver
Length 7³/8" (18.7 cm)
Philadelphia Museum of Art. Purchased with
the Richardson Fund. 1995-126-1

269. Spoon

Johannis Nys
Philadelphia, c. 1710–20
Inscription: ɪ ᴰ ᴍ (engraved on back of handle)
Silver
Length 7¹/8" (18.1 cm)
Philadelphia Museum of Art. Gift of Daniel
Blain, Jr. 1991-158-8
See fig. 11.

270. Tablespoon

Cesar Ghiselin (c. 1663–1733)
Philadelphia, c. 1714–20
Silver
Length 8¹/8" (20.6 cm)
Philadelphia Museum of Art. Gift of Daniel
Blain, Jr. 1991-158-9

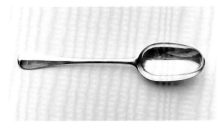

272

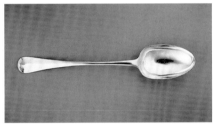

273

274

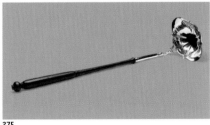

275

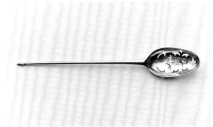

276

271. Marrow Spoon

Francis Richardson, Sr. (born New York,
1681–1729)
Philadelphia, c. 1715–25
Inscription: ɪ ᴱ ʟ (engraved on back of handle)
Silver
Length 6" (15.2 cm)
Philadelphia Museum of Art. Gift of Mr. and
Mrs. George C. Bland. 1977-234-1

272. Spoon

Francis Richardson, Sr.
Philadelphia, c. 1715–25
Inscription: ML (engraved on back of handle)
Silver
Length 7⁷/8" (20 cm)
Philadelphia Museum of Art. Gift of Mrs.
Thomas J. Curtin. 1973-101-1

273. Knife and Fork

Johannis Nys (1671–1734)
Philadelphia, c. 1722
Inscription: VR / SE / 1722 (engraved on back of
fork)
Silver
Length of knife 6¹/8" (15.6 cm); of fork 5¹/4"
(13.3 cm)
The Art Institute of Chicago. Restricted gift of
Robert B. Merrifield and William E. and Martha
Merrifield Steen in memory of their parents,
Frederick W. and Katharine B. Merrifield, and
Enoch and Nora T. Steen. 1990-487.1–2

274. Serving Spoon

Peter David (born New York, 1707–1755)
Philadelphia, c. 1735–40
Inscription: ɪ ᴵ ᴇ (engraved on back of handle
with an unidentifiable crest)
Silver
Length 13⁷/8" (35.2 cm)
Philadelphia Museum of Art. Gift of Walter M.
Jeffords. 1956-84-3

275. Ladle

Philip Syng, Jr. (born Ireland, 1703–1789)
Philadelphia, c. 1740–50
Inscription: ᴘ ᵀ s (engraved on bottom of bowl)
Silver
Length 18¹/2" (47 cm)
Philadelphia Museum of Art. Gift of Mr. and
Mrs. Walter M. Jeffords. 1959-2-10

276. Mote Spoon

Joseph Richardson, Sr. (born Pennsylvania,
1711–1784)
Philadelphia, c. 1745–55
Silver
Length 5¹/2" (14 cm)
Philadelphia Museum of Art. Gift of Mrs.
Thomas J. Curtin. 1974-190-1

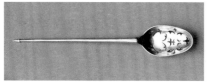
277

278

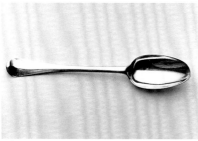
279

280

Mote spoons were used both to strain tea and, using the thin, pointed handle, to clear the clogged spout of a pot.

277. Mote Spoon
America or England, c. 1750–55
Inscription: S (engraved on handle)
Silver
Length 6¹/8" (15.6 cm)
Philadelphia Museum of Art. Bequest of Elizabeth Wheatley Bendiner. 1991-79-9
Originally owned by Robert Strettell, mayor of Philadelphia from 1751 to 1754.

278. Straining Spoon
Philip Syng, Jr. (born Ireland, 1703–1789)
Philadelphia, c. 1745–55
Inscription: HL (engraved on handle)
Silver
Length 8³/8" (21.3 cm)
Philadelphia Museum of Art. Gift of Mr. and Mrs. George C. Bland. 1977-234-2

279. Pair of Teaspoons
Philip Syng, Jr.
Philadelphia, c. 1750–55
Silver
Length 5¹/8" (13 cm)
Philadelphia Museum of Art. Bequest of Robert R. Logan. 1956-120-28, 29

280. Sugar Nippers
Joseph Richardson, Sr. (born Pennsylvania, 1711–1784)
Philadelphia, c. 1745–55
Silver
Length 5¹/2" (14 cm)
Lent by the estate of Mrs. Edward F. Henson

281. Sugar Nippers
Philip Syng, Jr. (born Ireland, 1703–1789)
Philadelphia, c. 1750–55
Inscription: DT (engraved on outside of one bowl)
Silver
Length 4⁵/8" (11.7 cm)
Philadelphia Museum of Art. Gift of Walter M. Jeffords. 1956-84-34

282. Medal of Charles II, King of England
Pieter van Abeele (Dutch, 1608–1684)
Netherlands, c. 1660
Inscription: CAROLUS . II . D[ei] . G[ratia] . MAGNAE . BRIT[anniae] . FRA[nciae] . ET . HIB[erniae] . REX [Charles II, by the grace of God king of Great Britain, France, and Ireland] (legend on obverse); IN NOMINE MEO EXALTABITUR CORNU EIUS . PSAL[mo] . 89 . [In my name shall his horn be exalted; Psalm 89:24] (legend on reverse)
Silver

281

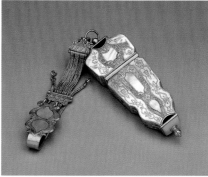
283

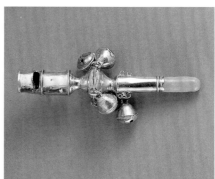
284

285

Diameter 2³/₄" (7 cm)
Collection of Joseph and Jean McFalls
 This medal commemorates King Charles II
(1630–1685), descended in the Markoe family of
Philadelphia, who had close ties to Charles II.
The 1736 inventory of Governor Patrick Gordon
lists a similar medal.
See fig. 3.

283. Etui
German or French, c. 1720–40
Silver, gilt, mother of pearl
Length of case 4¹/₂" (11.4 cm)
Congregation Mikveh Israel, Philadelphia
 This etui, or sewing case, descended in the
Gratz family of Philadelphia.

284. Child's Whistle and Bells
Attributed to Joseph Richardson, Sr. (born
Pennsylvania, 1711–1784)
Philadelphia, c. 1740–50
Silver, gilt, coral
Length 4⁷/₈" (12.4 cm)
Collection of H. Richard Dietrich, Jr.
 Much of the original mercury-gilt surface of
this whistle has been preserved.

285. Child's Whistle and Bells
John Leacock (born Pennsylvania, 1729–1802)
Philadelphia, c. 1756–58
Inscription: s. MORRIS (engraved on side of
whistle)

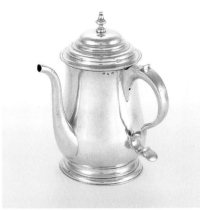

286

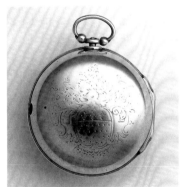

287

Silver, coral
Length 5¹/₄" (13.3 cm)
Philadelphia Museum of Art. Gift of Mrs.
Thomas D. Thacher. 1970-81-1
 Samuel Morris (1734–1812), the influential
great grandson of the city's second mayor,
Anthony Morris II (1654–1721), commissioned
this ornate whistle for either his first son,
Samuel, born 1756, or his second child, Sarah,
born 1758.

286. Spout Cup
Philip Syng, Jr. (born Ireland, 1703–1789)
Philadelphia, c. 1740–50
Inscription: T ᴺ ᴇ (engraved on bottom)
Silver
Height 6³/₄" (17.1 cm)
Collection of Mrs. Ruth Nutt
 Spout cups were used to feed infants and the
sick or elderly. The initials on this cup are possi-
bly those of Thomas Newbold (died 1741) and
Edith Coate, who were married in 1724.

287. Pocket Watch
England, c. 1751
Silver, enamel, steel
Diameter 2¹/₄" (5.7 cm)
Collection of Joseph and Jean McFalls
 This watch bears the ornately engraved crest
of Isaac Paschall of Philadelphia.

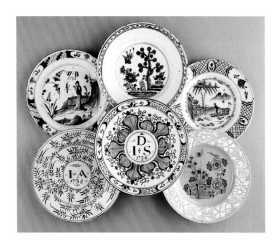

Fig. 214
Plates, 1715–60, nos. 363, 355, 347
(top row, left to right); nos. 364,
366, 346 (bottom row, left to right).

Base Metals, Glass, and Ceramics

Compared to the large numbers of furniture craftsmen and silversmiths working in the Delaware Valley prior to 1758, makers of iron, brass, copper, pewter, glass, and ceramics were relatively few. While there were some craftsmen producing simple utilitarian wares early on, aspects of the manufacture of these goods did not easily lend themselves to the limiting production dynamics of smaller shops. A few potters supplied basic redware cooking and storage vessels, and blacksmiths produced simple domestic goods and fittings for the early shipbuilding enterprises, but expanded production of iron, glass, and ceramics required a larger number of workers; more tools, furnaces, and kilns; stockpiles of raw materials; and specialized, often complex technologies. If indeed enough skilled labor could be found to establish a local foundry, glassworks, or pottery, its success depended on the ability to compete with imported merchandise, which required an extensive initial outlay of capital. In the uncertain climate of early settlement, such ventures were too risky financially.

Penn and the Free Society of Traders viewed craftsmen and industries that could supply Pennsylvanians with local goods in place of imported ones as essential to the long-term success of the colony. Yet despite several efforts and optimistic investments, a few small brickyards utilizing local clays along the Delaware River were their only successes. In 1683, for example, the Free Society of Traders sponsored Joshua Tittery, "a broad glass-maker" from New Castle, England, to establish a glasshouse in Philadelphia. Unsuccessful in this enterprise, he abandoned it and became a potter, operating a small shop along the river by the time of his death in 1708. No surviving examples from his endeavors in either medium are known today.[145]

The English crown initially placed few controls over the colonial manufacture of iron, glass, and ceramics, but none of the local productions threatened England's supremacy in the American market (see no. 309). England viewed Pennsylvania and most of the other American colonies as lucrative markets for their exports and fashioned the type, cost, and quality of many products to capitalize on American demand. As a result, England allowed the production of raw iron, utilitarian glass, and basic redware and stoneware but discouraged any competing production of finished iron, base metals, and finer glass or ceramic tableware by saturating colonial markets with its own products.[146]

Iron

England also viewed the colonies as important sources of raw materials and thus encouraged the colonial manufacture and export of iron in its cast ingot form. The Delaware Valley's abundant supplies of bog iron and iron ore, limestone, water power, and wood for fuel enabled the creation of a prosperous iron industry.[147] The earliest known ironworks, Pool Forge, and the earliest iron furnace, Coalbrookdale Furnace, were established in Lebanon County, near Pottstown, by Thomas Rutter in 1720. Employing skilled workers from

Germany and England, Rutter's manufactory produced high-quality raw ingot and finished cast-iron products. In 1717 iron from Rutter's furnace was noted by Jonathan Dickinson as valued by "all smiths here, who say that the best of Swedes iron doth not exceed it."[148] That same year, Samuel Nutt established the Coventry Forge about thirty miles above Philadelphia on the Schuylkill in Chester County. Redding Furnace, established nearby about 1720–26 on French Creek, Chester County, was one of the many iron investments of William Branson. In 1730 Branson also owned a furnace located on the upper end of Chestnut Street, one of the earliest established in Philadelphia. In 1728 a group of prominent Philadelphia businessmen that included James Logan, William Allen, Joseph Turner, and Anthony Morris formed a joint investment company and founded Durham Furnace in Bucks County (see nos. 304, 314; fig. 127). The tidewater counties of West Jersey, rich in iron deposits, also were the sites of early furnaces (see no. 317), and a number of other furnaces and foundries dotted the local landscape, encouraging competition.[149]

Unlike fine steel cutlery, cast-metal cooking pots, and refined white-work metal goods, the local manufacture of wood-burning cast-iron stoves, stove plates, and firebacks was not restricted by the British crown because these products did not compete with British exports; in England, coal or peat was used for heating (see no. 298).[150] One of the greatest restrictions on the expansion and diversification of the iron and steel industries in early Pennsylvania was the Iron Act of 1749, which prevented the building of steel furnaces and rolling and splitting mills for the processing of

sheet metals.[151] Despite these impediments, local iron founders and blacksmiths transformed raw materials into a wide range of quality utilitarian goods (see no. 306). The styles of these wares closely followed imported prototypes. Because their alloys vary widely and basic forms were often maintained relatively unchanged, accurately dating local iron products is often problematic.

Brass, Copper, and Pewter

The colonial production of brass, copper, pewter, and their various alloys was faced with competition from superior-quality English, Dutch, and German wares, making it difficult for the smaller local workshops to compete (see no. 292).[152] The shipbuilding industry, however, required braziers to produce specialized fittings and tools, and it may have been this need that brought some of the earliest finish-metal craftsmen to Philadelphia. The "Minutes of the Common Council of 1717" list Peter Steel and James Winstanley as "braziers," Austin Paris and Thomas Paglan as "founders," and more than fourteen whitesmiths and blacksmiths as taxpayers in the city.[153] In addition, the need for lighting, cooking, and heating brought a range of locally produced utilitarian and decorative metal objects into early Pennsylvania households. By 1723 John Hyatt, an Englishman, was carrying on the trade of brass founder at his shop on Front Street near Market Street. Caspar Wistar started a successful brass-button manufactory in the city soon after his arrival from Germany in 1717 (see no. 383). Later, John Stow, a brass founder who would play a role in the recasting of the cracked State House bell, advertised that he made and sold "all manner of brass work."[154] Des-

pite these and other early efforts, however, domestic production of brass was unable to compete with the cheaper, superior, and more abundant imported goods, which continued to dominate the Pennsylvania market (see nos. 302, 310, 311). A number of Philadelphia merchants, upholsterers, and furniture craftsmen offered their customers a wide variety of imported brass pulls, locks, hinges, and other decorative fittings, relying largely on producers in Bristol and Birmingham, England, to supply the demand.[155]

As with silver, the commissioning of private gifts for churches resulted in particularly impressive imported and domestic brass, pewter, and iron furnishings, presented as a pious gesture while at the same time allowing the donors to publically demonstrate their generosity and taste. Henry Pratt of Philadelphia—probably the same Pratt who as a silversmith enjoyed prominent patronage in Philadelphia during the 1730s and 1740s—presented a massive, ornate Dutch brass chandelier to the chapel of Codrington College, Saint John's Parish, Barbados (no. 297, fig. 215).[156] The rural congregation of the German Reformed church of Pikes Township, Chester County, acquired a finely engraved pewter flagon, alms plate, and baptismal basin about 1757, either through an individual gift or by subscription of the congregants (no. 321). Decorated with ornate, baroque-inspired imagery and cartouche surrounds, an inscription in German decorating the alms plate is a proverb from the Book of Matthew (6:3) that instructs not to give for show.[157]

During the first half of the eighteenth century, pewter, an alloy composed principally of tin, with varying amounts of

Fig. 215
Chandelier, c. 1700–1730, no. 297.

copper, lead, bismuth, and antimony, was used extensively for the local production of objects for the table and was to be found in households at all economic and social levels. The large quantity of pewter kept in some households can be surprising. In 1716 Joseph Hoskins of Chester kept in the "Buttery" of his house eight pewter quarts, four pewter tankards, five pewter salts, two mustard pots, one half pint, two "gills" (measures), one half gill, eight dozen pewter plates, seven large pewter dishes, eleven smaller pewter dishes, three pewter basins, three dozen old pewter plates, eight pewter porringers, and one old pewter basin.[158] In Philadelphia pewter was used alongside silver or for everyday use in wealthier households and was probably the "best" ware in middle-range households, while simpler turned "treen" (wooden) or earthernware vessels were used in poorer households. In addition to her various glass, ceramic, and silver tableware, Elizabeth Coates Paschall, the wealthy dry-goods merchant, had "2 doz. & 11 Pewter Plates," a "Pewter Turene," "a Pewter water Dish," and "a Pewter Bason [and] old Coffe Pott."[159]

Pewter's softness and low melting point made it susceptible to damage through heat and the wear and tear of regular use. As a result, relatively few examples that can be traced to the earliest local pewterers survive. While surviving documents confirm that craftsmen working in the metal were operating in early Philadelphia, most of the surviving pewter objects used in Pennsylvania prior to 1755 were imported from England or Germany. In 1697 alone, nearly fifty tons of imported English pewter arrived in the colonies, and this amount increased steadily as the population of Pennsylvania grew throughout the

1760s.[160] One of the largest surviving suites of imported English pewter, much of it by the London pewterer Richard King (active 1729–45), was owned by James Logan. At Stenton, Logan maintained a "Pewter Press" in which were displayed dozens of plates, "Old Water Plates & Bason," and miscellaneous other forms (see no. 47, fig. 132).[161] Pewter, like silver, lent itself to decorative engraving such as armorial crests and ciphers. A number of German and English Protestant churches owned pewter communion services, comprised of both locally produced and imported pieces (no. 319).

Local retailers offered pewter among their imported wares and may also have sold the products of local makers. A rare advertisement by a Philadelphia pewterer, Cornelius Bradford (active Philadelphia, c. 1752–70), placed on May 3, 1753, reflects the variety of forms available: "Cornelius Bradford, Pewterer in Second Street, Makes and Sells wholesale and retale, Pewter Dishes, Plates, Tankards, Quart and Pint Muggs, Basons, Porringers, Tea Potts, Cullenders, Spoons and all other sorts of Pewter. Said Bradford Makes WORMS of any Size for Distilling, as also Cranes. Where all Persons may have Pewter mended at a reasonable Price, or old pewter exchanged for new."[162] Such variety was not exclusive to Philadelphia but was also available to those in the outlying communities. Until his death in 1729, the shopkeeper Nathaniel Newlin of Concord, Chester County, offered his clients a good assortment of pewter forms, including plates, basins, cups, and porringers.[163]

Pewter objects were formed by casting the molten metal in molds, usually made of brass or bronze. The forms of

much of the earliest pewter produced in America have close ties to English and European examples, suggesting that molds may have been imported or that imported objects were used to create molds. Once cast, the form could be scraped clean of its seams, refined by turning on a lathe, and its separately cast parts soldered together. Planishing, or lightly hammering, the surface of pewter objects hardened and strengthened the metal but was rarely done over the entire surface. Because pewter molds were expensive and difficult to obtain, craftsmen tended to use them repeatedly, combining and adapting the individual shapes into the various forms they offered in their shops. This long-term use of molds meant that many pewterers maintained the same, relatively unchanged forms and styles longer than did some other types of metal craftsmen.

Simon Edgell (c. 1688–1742) is the earliest Philadelphia pewterer whose work has survived. Trained in England, he was admitted to the Pewterer's Company of London in 1709 (nos. 300, 301). While it is not known in exactly what year he left for America, he is recorded as being in Philadelphia by 1713. Admitted to the city as a freeman of Philadelphia in 1717, he purchased property on High (now Market) Street in 1718, where he carried on the trade of pewterer and offered a general line of merchandise. The inventory of his shop, taken at the time of his death, contains a large quantity of finished pewter, including 125 teapots, 177 tankards, 1,635 "Dishes," and 1,936 porringers, basins, and small cups.[164] Surviving examples of Edgell's work demonstrate the refined skill and accurate understanding of baroque-inspired metal forms that could be found among local pewterers.

Glass

Imported window, mirror, and table glass dominated the market in early Pennsylvania (nos. 322, 323, 332–337). Merchant and household inventories include lists of imported glass tableware and expensive decorative glass such as various "Branches," sconces, and other forms of lighting. Both simple utilitarian objects and more ornately decorated luxury items could be acquired (see no. 324). While most of the early imported glassware was made in England, Bohemian blown- and cut-glass tableware also entered the colony through the contacts many Germanic settlers in Pennsylvania maintained with the Old World. Benjamin Moulder of Chichester, Chester County, owned "8 Dutch glasses" in 1731.[165] In 1713 Mary Dickinson was sent a "German Cutt Glass kinester for Tea on the Tea table."[166] Bohemian "painted" or "japanned" "Glass China"— blown white opaque or clear glass with enameled decorations—was often executed in patterns imitating the more expensive and scarcer Chinese porcelains and was a popular import in Pennsylvania (see nos. 334–336 and nos. 354, 374; fig. 216).[167]

Fashionable serving styles emulated by early Philadelphians called for specialized glass forms. There were case bottles for the storage of wine and spirits, and special decanters, punch bowls, tumblers, canns, mugs, glasses, and cups for serving them at table (nos. 323, 325). During the 1750s Elizabeth Coates Paschall both owned and offered for sale through her dry-goods store a wide range of glass tableware, including forms such as "2 large & 2 Small Decanters / 2 large water Glasses & 2 half pint Tumblers / 12 wine Glasses / . . . Glass

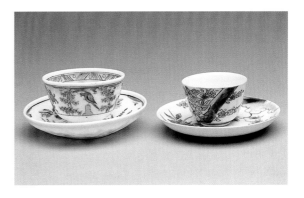

Fig. 216
Bohemian glass cup and saucer, c. 1745–60, no. 335; Chinese export porcelain cup and saucer, c. 1740–55, lent by the Commissioners of Fairmont Park, Philadelphia.

Fig. 217
Tobacco Box, Thomas Shaw,
1756, no. 439.

Mugg . . . 2 glass Salts, Conch, Canister / large tea pot," and "a Glass Sillabub Pott & Sundry other glass ware."[168] The early scientific and medical community in Philadelphia also bought imported glass for "Cheymical Glasses," "medicines," "viols," and the glass apparatus and tubes used in volumetric measurements, pharmacology, and early experiments in electricity.[169]

German craftsmanship and technologies influenced and enabled the development of a glassmaking industry in Pennsylvania. The first successful glassworks in the Delaware Valley, Wistarburgh, was established by the German immigrant Caspar Wistar (1696–1752) in Salem County, New Jersey, in 1739. The factory was located near Alloway and employed German-trained workmen. Several examples of the glass produced there bear a close resemblance, both stylistically and technologically, to Bohemian prototypes (no. 330). Wistar, who emigrated in 1717 from the Hilsbach region of Germany, arriving in Philadelphia at the age of twenty-two, had first established a brass-button manufactory in the city. Alongside this lucrative enterprise he maintained a dry-goods store where he sold a range of imported German-made goods, acquired through earlier Old World contacts he had cultivated and maintained. His regular correspondence with colleagues in Germany may have made him aware of the talents and skills of a number of German glassblowers and craftsmen who wished to emigrate, and his experience in his shop would have demonstrated the popularity of imported glassware locally. His business prowess had provided him with substantial capital for additional investments. Granted permission in 1724 "to Trade and to buy and hold

Lands in the Province" by the Pennsylvania Council, Wistar acquired lands in New Jersey in 1738 and arranged to sponsor four German glassblowers— Martin Halter, William Wentzel, Simeon Griesmeyer, and Caspar Halter—who arrived in September of that year.[170] Substantial capital was required to establish the necessary buildings and kilns and to harvest the surrounding woodlands to supply fuel for firing, but by late in 1739 the factory was operational, producing a range of simple wine bottles, tableware, and cylinder-formed window glass (nos. 327–331; see also 439, fig. 217). Pennsylvanians patronized the factory immediately and were fascinated by the dramatic firing and heating processes that glassmaking required.

Through Wistar's close associations with Benjamin Franklin, who was interested in the chemical and alchemic aspects of glassmaking, Wistarburgh was called upon in 1746 to produce the long cylindrical glass tubes necessary to generate the static electricity the inventor required for his early experiments, which Franklin had previously had to import. Franklin wrote to a friend that his "house was continually full for some time, with people who came to see these new Wonders . . . to divide a little [of] this Incumbrance among my Friends, I caused a Number of similar Tubes to be blown at our Glasshouse."[171] Speaking of the extent and nature of the factory's operations, he observed that the main furnace was "about 12 foot long, 8 wide, 6 high, has no Grate, the Fire being made on its Floor . . . On each side in the Furnace is a Bench or Bank of the same Materials with the Furnace on which the Pots of Metal stand, 3 or 4 of a side," and noted in another letter that "Our glasshouse consumes Twenty-four Hundred Cords

of Wood per Annum tho' it works but Seven Months in the Year. . . . The Cutting, Hauling, Splitting and Drying of this Wood, employs a great many hands, and is the principal Charge."[172]

Ceramics

The small number of ceramic objects surviving from the earliest periods of settlement in the Delaware Valley provide a very incomplete picture of what types of wares were used and what local attempts were made to produce them.[173] Gabriel Thomas commented on the local demand for ceramics in 1698, noting that "Potters have Sixteen Pence for an Earthen Pot which may be bought in England for Four Pence."[174] However, few complete examples of these simple utilitarian redwares are known. Based upon archaeological evidence, imported Dutch tin-glazed utilitarian white faience and earthenware, English white stonewares and earthenwares, and German salt-glazed stonewares were present in limited quantities in the trading and farming communities of the Delaware Valley prior to Penn's arrival (see no. 342). The demand for these imported ceramic goods undoubtedly inspired the several early attempts to establish potteries in the area. As early as 1684 a pottery was established near Burlington, New Jersey, by the Englishman Daniel Coxe, who was proprietor and royal governor of West Jersey. In 1688 Coxe wrote that the pottery, managed by his agent John Tatham and his son Daniel Coxe, Jr., "hath likewise at Burlington two houses and kill with all necessary materialls and implements with divers servants who have made a greate progresse in a Pottery of White and China ware about 1200 li [pounds] worth

being already made and vended in the Country neighbour plantations and the Islands of Barbados Jamaica &C and well managed will probably bee very Advantagious to ye Undertakers . . . haveing expended thereon to bring it to perfection allmost 2000 li."[175] While no examples from this early manufactory are known to have survived, it is thought that its productions were of the white stoneware type and that they probably resembled the popular wares produced in Staffordshire, England.

Simple black manganese-glazed utilitarian wares and heavy-bodied redware cups, bowls, and plates with combed, "scroddled" (swirled), or trailed slip decorations—sometimes in their complete and undamaged form—have been recovered by archaeologists at local sites dating to about 1730–50. Probably produced by English and Germanic potters working in Philadelphia and the surrounding area by this period, and fired at low temperatures, they were fragile in comparison to stoneware, which required higher firing temperatures. Popular and affordable, and largely utilitarian in nature, these simple wares were relatively inexpensive and could be more easily replaced if broken. While large quantities of utilitarian jugs, storage crocks, plates, bowls, and cups were produced, few complete surviving examples can be firmly dated (see no. 362).

Philadelphia's appetite for finer tableware called for a wider range of more refined types of ceramics than were available locally, and the demand for imported wares continued. Dutch, English, and Chinese ceramics probably made up the majority of the early imports (see no. 343). Groups of fine ceramics were displayed on mantelpieces, "Scritiore Heads," or the tops of high chests (see

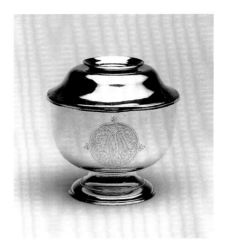

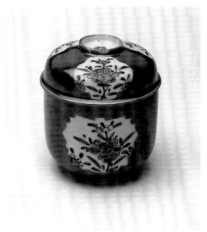

Fig. 218
Sugar Bowl, John Leacock,
c. 1750–60, no. 230; Covered Bowl,
c. 1730–50, no. 360.

fig. 182), often together with glass. Job Harvey of Darby, Pennsylvania, for example, in 1750 displayed "on the Mantle piece China and Delf ware and Sundry Glasses."[176] By far the most valuable of the early imported ceramics would have been the fine Chinese porcelains brought to Philadelphia through Holland and England's trade with the West Indies. Following the practice popular among the wealthy English and Dutch owners of exotic porcelains, families such as that of William Penn owned custom-produced patterns that bore their armorial crests (nos. 353, 354; fig. 21). Chinese porcelains receive special mention in household inventories from the period, attesting to their rarity and value. John Busby, a Philadelphia weaver who died in 1699, owned over thirty pieces of ceramics in his small but stylish household.[177] Many pieces of porcelain were kept even after they had been damaged, and surviving examples often exhibit carefully executed repairs (see no. 339). Mayor Edward Shippen of Philadelphia had "some broken China & earthenware" in his desk in 1711.[178]

Henry Waddy, also of the city, owned "1 Japan dish crackt, 3 china plates, 1 Japan bowl, 1 china cup and 1 china dram cup" at the time of his death in 1694.[179]

Several of the city's early merchants, such as Isaac Norris, Jonathan Dickinson, Samuel Carpenter, and James Logan, continued to import fine Chinese porcelains, Dutch "Blew and white," and English "Burnt" china wares into the city through their contacts with London and the West Indies trade (see no. 342). London auctions of imported goods, first held by the Vereenigde Oost Indische Compagnie (Dutch East India Company) in 1703–4, provided speculative agents and English traders with wares they could distribute to merchants in the colonies.[180] Thomas Penrose, a Philadelphia merchant and shipowner who had cargoes arriving regularly from Holland, England, and Barbados, entered large amounts of "Burnt" china, "Enameled ware," blue and white china, and "Delphtware" in his ledgers between 1738 and 1751 (see nos. 230, 360; fig. 218).[181] In 1735 Philadelphia was active

in trading imported "China ware" and "India" goods with other colonial ports such as Charleston, South Carolina, sending out twenty-two ships carrying Chinese porcelains during that year alone (see no. 374).[182]

Merchants and agents helped Pennsylvanians acquire ceramics from English potteries through custom orders (see no. 368). To commemorate the commissioning and launching of the *Charming Peggy,* a sixty-ton brigantine built in Philadelphia about 1750–51, its owners commissioned from Lambeth, England, a tin-glazed earthenware punch bowl picturing the ship and presented it to the ship's first master, Randle Wilson (no. 371). In 1738 a group of Chester County Quaker families acquired sets of English blue-and-white earthenware plates of various patterns with customized initials and the date the piece was ordered incorporated into their design (fig. 214). A number of Quaker families in Chester County owned Dutch or English "Delpht" wares, suggesting the presence of an active merchant or agent-importer in the county.[183]

Base Metals

288. Group of Roman Coins
Roman, c. 125 B.C.–A.D. 350
Bronze, silver
Diameter of largest coin 3/4" (1.9 cm)
Private Collection
Lynford Lardner of Philadelphia owned this group of coins by 1744.
See fig. 99.

289. Refractive Sundial
Christopher Schissler (German, active c. 1556–c. 1602)
Augsburg, Germany, 1578
Inscription: CHRISTOPHORUS SCHISSLER GEO-METRICUS AC ASTRONOMICUS ARTIFEX AUGUSTAE VINDELICORUM FACIEBAT ANNO 1578 [Christopher Schissler, skilled geometer and astronomer, made (this) at Augsburg in 1578] (engraved on border of bottom of bowl)
Copper, silver, brass, gilt
Diameter 12" (30.5 cm)
American Philosophical Society, Philadelphia. 58-66
This sundial is thought to have been brought to Pennsylvania in about 1691 by the mystic pietist Johannes Kelpius (1673–1708) of Germantown. It was subsequently owned by Christopher Witt and Benjamin Franklin. Franklin later presented this important scientific instrument to the American Philosophical Society.
See fig. 71.

290. Helmet
Sweden, c. 1650–80
Iron
9 x 13 1/2 x 10 3/4" (22.9 x 34.3 x 27.3 cm)
The Historical Society of Pennsylvania, Philadelphia. R-1
This early helmet was discovered during archaeological excavations near Philadelphia.
See fig. 29.

291. Surveyor's Compass
James Ramsay (active late seventeenth century)
Dublin, c. 1670–80
Brass, iron, glass
Diameter 5 5/8" (14.3 cm)
The Historical Society of Pennsylvania, Philadelphia. Gift of the Chicago Historical Society, 1981.40

John Ladd, assistant to William Penn's surveyor-general, Thomas Holme, used this compass to plot and lay out the earliest map of the city of Philadelphia, published in 1683.
See fig. 35.

292. Brazier
Netherlands or England, c. 1680–1700
Copper
Height 3 3/8" (8.6 cm); diameter 4 3/4" (12.1 cm)
Philadelphia Museum of Art. Gift of Mr. and Mrs. John W. Brock. 1916-368

293. Candlestick
Spain or Portugal, c. 1680–1700
Brass, iron
Height 9 1/2" (24.1 cm)
Private Collection
This early candlestick descended in the Mendenhall family of Chester County, Pennsylvania.

294. Perpetual Calendars
Netherlands or England, c. 1680–1700
Brass, silver
Diameter 2 3/4" (7 cm)
Wyck, Germantown
It is thought that Caspar Wistar of Philadelphia owned these pocket-size calendars.

295. Weather Vane
Probably Chester County, Pennsylvania, 1699
Iron
33 x 15 1/4" (83.8 x 38.7 cm)
The Historical Society of Pennsylvania, Philadelphia. Gift of Reese Wall Flower, 1864.X-35.
This weather vane stood atop the first mill on Chester Creek, south of Philadelphia. The mill was established as a joint business venture of William Penn, Samuel Carpenter, and Caleb Pusey.
See fig. 41.

296. Andirons
Probably the American colonies, c. 1700–1725
Iron, brass
Height 20" (50.8 cm)
Private Collection

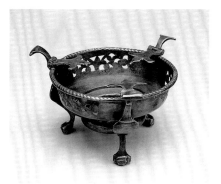

292

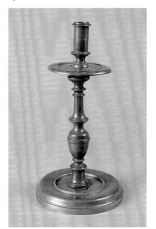

293

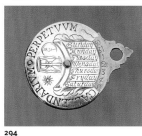

294

294

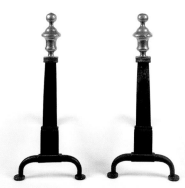

296

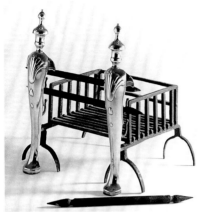

298

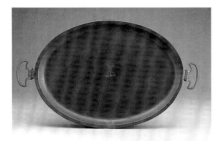

299

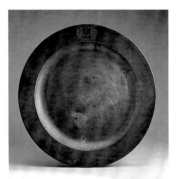

299

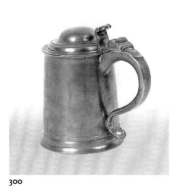

300

297. Chandelier
Netherlands, c. 1700–1730
Inscription: The gift of Mr. Henry Pratt and St. John's Parish (engraved on body below chandelier's arms)
Brass, iron
Height 37" (94 cm); diameter 43" (109.2 cm)
Philadelphia Museum of Art. Gift of Mrs. Henry W. Breyer, Sr. 1958-119-1

This chandelier is thought to have been commissioned and presented to Saint John's Parish by the Philadelphia silversmith Henry Pratt, who had ties to the West Indies trade.
See fig. 215.

298. Hearth Grate
England, probably London, c. 1720–40
Brass, iron
20 x 18¹/8 x 16¹/8" (50.8 x 46 x 41 cm)
Winterthur Museum, Winterthur, Delaware. Bequest of Henry F. du Pont. 63.643a–f

299. Group of Pewter Tableware
Various Makers
England, c. 1720–45
Pewter
Diameter of largest plate 20³/4" (52.7 cm)
Lent by the Commissioners of Fairmount Park, Philadelphia

This group of imported pewter tableware, engraved with the Logan crest or reversed cipher, originally belonged to James Logan and was used at Stenton. It was listed with the pewter press (no. 47) in the 1754 inventory of the house.

300. Tankard
Simon Edgell (born England, c. 1688–1742)
Philadelphia, c. 1725–30
Pewter
Height 6⁷/8" (17.5 cm)
Collection of H. Richard Dietrich, Jr.

301. Tankard
Simon Edgell
Philadelphia, c. 1725–30
Inscription: AM (engraved on body)
Pewter
Height 6³/4" (17.1 cm)
Winterthur Museum, Winterthur, Delaware. Bequest of Henry F. du Pont 65.553

According to tradition, the initials engraved on this tankard are those of Ann Michner of Philadelphia.

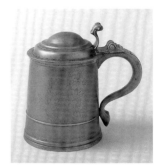

301

302

305

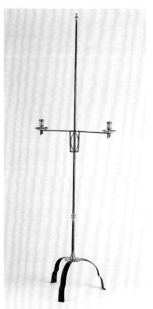

306

302. Andirons
England or America, c. 1725–40
Brass, iron
Height 19⁷/8" (50.5 cm)
Collection of H. L. Chalfant

303. Sundial
Philip Roman (died 1729)
Chester County, Pennsylvania, 1726
Copper
Diameter 5⁵/8" (14.3 cm)
Chester County Historical Society, West Chester,
Pennsylvania. 1992.645
See fig. 51.

304. Fireback
Durham Furnace (active 1727–91)
Durham Creek, Bucks County, Pennsylvania,
c. 1728
Inscription: JL / 1728
Iron
27¹/2 x 18¹/2" (69.9 x 47 cm)
Stenton, Philadelphia

James Logan was one of the founding part-
ners of Durham Furnace, one of the earliest fur-
naces in Pennsylvania. This fireback, customized
with Logan's initials, is one of several produced
for his use at Stenton.
See fig. 127.

305. Folding Sundial
Probably England, 1730–35
Inscription: Ch. Swaine (scratched on bottom);
Abraham Bath (engraved on top of base)
Brass
Diameter 4³/8" (11.1 cm)
Private Collection

Charles Swaine led the earliest American voy-
age in search of the Northwest Passage, which
was sponsored by the Library Company of Phila-
delphia. He embarked from Philadelphia on the
ship *Argo* in 1753. Abraham Bath of London is
probably the maker of this sundial.

306. Standing Candle Holder
Probably Philadelphia, c. 1730–50
Iron, brass
Height 69¹/4" (175.9 cm)
Collection of H. Richard Dietrich, Jr.

307. Seal
Philip Syng, Sr. (born Ireland, 1676–1739)
Made for the Library Company of Philadelphia,
c. 1731–33
Brass

307

308

309

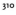
310

Diameter 2¹/4" (5.7 cm)
The Library Company of Philadelphia

This seal was used to record and certify the
memberships of early subscribers to the Library
Company of Philadelphia. The motto around the
perimeter of the seal, *Communiter bona profun-
dere deum est,* translates as "To lavish the public
with good things is divine."

308. Andirons
Philadelphia, c. 1735–45
Iron, brass
Height 22" (55.9 cm)
Collection of Joseph and Jean McFalls

These andirons descended in the Lockerman
family of Delaware.

309. Plate Warmer
England or America, c. 1737–50
Inscription: HMR (engraved on body)
Pewter
Height 21¹/4" (54 cm); diameter 9¹/2" (24.1 cm)
Philadelphia Museum of Art. Gift of Mrs.
Clarence C. Zantzinger. 1957-11-1

This plate warmer descended in the Roberts
family of Philadelphia. Its engraved cipher
stands for Hugh Roberts (1706–1786) and his
wife, Mary Calvert, who were married in 1737.
Roberts served in various official Philadelphia
city posts during the 1740s and early 1750s.

310. Candlesticks (4)
England, c. 1735–50
Brass
7⁷/8" (20 cm)
Herbert Schiffer Antiques

311

311. Pair of Candlesticks
England, c. 1740–50
Brass
Height 9⅞" (25.1 cm)
Collection of Jay Robert Stiefel

312. Toasting Fork
Southeastern Pennsylvania, c. 1740–55
Iron
Length 54½" (138.4 cm)
Philadelphia Museum of Art. Gift of Mr. and
Mrs. J. Stogdell Stokes. 1933-70-4

313. Hearth Shovel
England or America, c. 1740–55
Brass, iron
Length 28¾" (73 cm); width 5¼" (13.3 cm)
Private Collection

314. Stoveplate
Durham Furnace (active 1727–91)
Durham Creek, Bucks County, Pennsylvania, 1741
Inscription: CAIN . SEINEN . BRUTER . AWEL . TOT .
SCHLUG [Cain killed his brother Abel] / 1741
(on front)
Iron
26½ x 26¾" (67.3 x 67.9 cm)
Philadelphia Museum of Art. Purchased with
Museum funds. 1899-1142

315. Seven Plate, or Franklin, Stove
Attributed to Warwick or Mount Pleasant furnace,
Chester or Berks County, Pennsylvania, c. 1742–48
Iron
31½ x 27½ x 35¾" (80 x 69.9 x 90.8 cm)
Mercer Museum of the Bucks County Historical
Society, Doylestown, Pennsylvania. 4519, 4555-9
See fig. 61.

316. Gorget
England, c. 1745–55
Inscription: GR (engraved in cipher)
Mercury-gilded copper
Width 6¼" (15.9 cm)
Philadelphia Museum of Art. Gift of an anony-
mous donor in memory of Elizabeth Wheatley
Bendiner. 1991-75-14

This gorget, which bears the cipher of King
George II, was presented to Robert Strettell,
mayor of Philadelphia. Gorgets were worn loose-
ly around the neck, and were often presented as
tokens of friendship or for loyal service. Also
known as colletins, they are vestiges of the earli-
er armor worn between the breastplate and hel-
met to protect the neck.

317. Fireback
Oxford Furnace (active 1742–1882)
Warren County, New Jersey, c. 1746
Iron

312 313

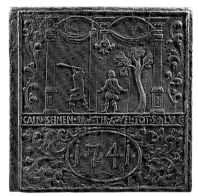

314

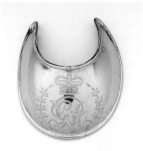

316

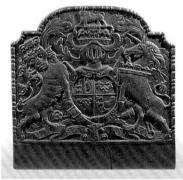

317

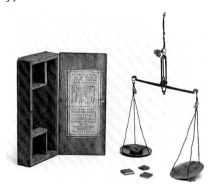

318

34³/4 x 35" (88.3 x 88.9 cm)
Philadelphia Museum of Art. Gift of John T.
Morris. 1900-17

Bearing the arms of England, this fireback
was one of several produced for Hope Lodge,
in Whitemarsh, Pennsylvania, built by Samuel
Morris (1708/9–1770) from 1743 to 1748.

318. Set of Scales and Weights
Probably England, c. 1735–55
Labeled and sold by Joseph Richardson, Sr., in
Philadelphia, c. 1751–56
Iron, brass, lead; wooden case
Box 1¹/4 x 7 x 3¹/4" (3.2 x 17.8 x 8.3 cm)
Philadelphia Museum of Art. Gift of Henry P.
McIlhenny. 1961-181-1

Imported boxed scales such as these were
sold in great numbers by Joseph Richardson,
Sr. This set, believed to have been used by the
silversmith, contains additional weights struck
with his mark.

319. Covered Chalice
Johann Heyne (active 1752–81)
Lancaster, Pennsylvania, c. 1753
Inscription: R . K 1753 JE . M (engraved
around body)
Pewter
Height 10¹/2" (26.7 cm)
Hershey Museum, Hershey, Pennsylvania.
79.2.61a–b

320. Sundial
Edward Duffield (1720–1801)
Philadelphia, 1757
Signature: E. Duffield Philadel.ᴬ Latᴰ 40.
(engraved on top of base)
Copper
5 x 8¹/8 x 8¹/8" (12.7 x 20.6 x 20.6 cm)
Private Collection

321. Group of Ecclesiastical Pewter

a. Flagon
Cologne, Germany, 1757
Inscription: VOR DIE RE / FORMIRTE / GEMEINE
DE / KIRCH IN PEI / TAUNSCHIP / ANNO 1757 [For
the Reformed congregation church in Pikes
Township in the year 1757] (engraved on body)
Pewter
Height 9¹/8" (23.2 cm)
East Vincent United Church of Christ, Spring
City, Chester County, Pennsylvania

b. Basin
John Townsend (English, active 1748–1801)
London, c. 1757
Inscription: VOR DIE REFORMIRTE GEMEINE DE
KRCH / IN PEICKS TOWN SHIP / 1757 [For the

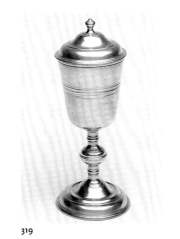

319

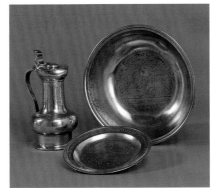

320

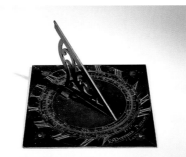

321

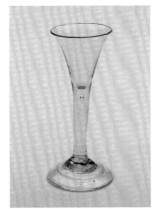

322

Reformed congregation church in Pikes Town-
ship in the year 1757]; WER GLABBT UND
GETAUFT / WIRD DER WIRD SELIG / WERDEN M
16 [Whoever believes and is baptized will be
saved (but whoever does not believe will be
condemned), Matthew 16:16] (engraved below
an unidentified crest of lions flanking a
crowned shield)
Pewter
Diameter 11¹/2" (29.2 cm)
East Vincent United Church of Christ, Spring
City, Chester County, Pennsylvania

c. Plate
Cornelius Bradford (active 1752–85)
Philadelphia, c. 1757
Inscription: VOR DE REFORMIRTE GEMEINE DE
KRCH IN PEICKS TAUNSCHIP CHESTER COUNTY
ANNO 1757 [For the Reformed congregation in
Pikes Township, Chester County, in the year
1757] (engraved on rim); WANNDUALL MOSEN /
GIBST. SO LAS DEINE LIN / CKE HAND NICHT
WISSEN / WAS DIE RECHTE THUT / MATH. 6 V 3
[When you give alms, do not let your left hand
know what your right hand is doing, Matthew
6:3] (engraved on front above image of a che-
rub's head)
Pewter
Diameter 8" (20.3 cm)
East Vincent United Church of Christ, Spring
City, Chester County, Pennsylvania

This group of ecclesiastical pewter was presented
around 1757 to the Reformed Lutheran Church
of Pikes Township, Chester County, Pennsyl-
vania.

Glass

322. Wineglass
England, c. 1740
Glass
Height 6¹/2" (16.5 cm)
Philadelphia Museum of Art. Bequest of R.
Wistar Harvey. 1940-16-420

Descended in the Wistar family of German-
town.

323. Decanters
England, c. 1720–30
Glass
(a) Height 8³/4" (22.2 cm)
(b) Height 11⁵/8" (29.5 cm)
Lent by the Estate of Anthony Stoudt
See fig. 144.

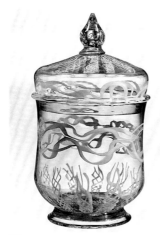

324

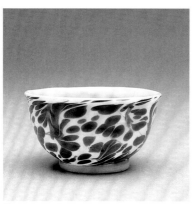

325

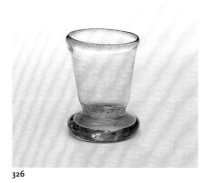

326

324. Covered Beaker

England, c. 1725–45
Glass
Height 8¹/8" (20.6 cm); diameter 5" (12.7 cm)
Winterthur Museum, Winterthur, Delaware. Gift
of Mr. and Mrs. Lewis Rumford II. 79.62a,b

First owned by Mary Lefevre (1715–1774) of
Philadelphia, this covered beaker is one of the
earliest pieces of imported English glass with a
documented history of ownership in Philadelphia.
In 1739 Mary Lefevre married Caspar Wistar's
nephew David Deshler.

325. Teabowl

Southern Germany or Switzerland, c. 1750
Glass
Height 1¹/8" (2.9 cm); diameter 3" (7.6 cm)
Philadelphia Museum of Art. Bequest of
Constance A. Jones. 1988-27-63

326. Salt Dish

Attributed to Caspar Wistar (born Germany,
1696–1752)
Wistarburgh Glassworks (active 1739–77) near
Alloway, Salem County, New Jersey, c. 1745–55
Glass
Height 2¹/4" (5.7 cm)
Philadelphia Museum of Art. Gift of the heirs of
Paul D. I. Maier and Anna Shinn Maier. 1998-161-3

This salt dish descended in the family of its
maker, Caspar Wistar.

327. Storage Jar

Attributed to Caspar Wistar
Wistarburgh Glassworks, c. 1745–60
Glass
5¹/2 x 4¹/4 x 4³/4" (14 x 10.8 x 12.1 cm)
Philadelphia Museum of Art. Purchased with the
Elizabeth Wandell Smith Fund and the Marie
Josephine Rozet Fund. 1996-97-1

328. Covered Bowl

Attributed to Caspar Wistar
Wistarburgh Glassworks, c. 1739–50
Glass
Height 7¹/4" (18.4 cm); diameter 4⁷/8" (12.4 cm)
Winterthur Museum, Winterthur, Delaware.
Museum Purchase, funds provided by Henry F.
du Pont. 59.30.2a,b

329. Whimsey Figure

Attributed to Caspar Wistar
Wistarburgh Glassworks, c. 1740–55
Glass
3³/8 x 2 x 4" (8.6 x 5.1 x 10.2 cm)
Philadelphia Museum of Art. Gift of the heirs
of Paul D. I. Maier and Anna Shinn Maier.
1998-161-1

This whimsey figure descended in the family
of its maker, Caspar Wistar.

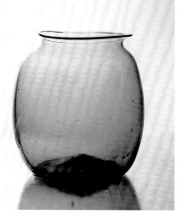

327

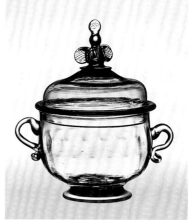

328

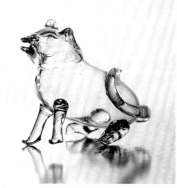

329

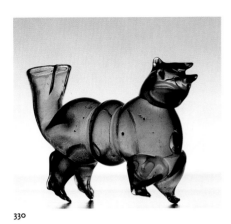

330

330. Whimsey Bottle
Attributed to Caspar Wistar
Wistarburgh Glassworks, c. 1740–55
Glass
5 x 7¹/4 x 2³/4" (12.7 x 18.4 x 7 cm)
Wyck, Germantown

The design of this figural bottle has precedents in both early Persian and Middle German glassblowing traditions. In Germany the form was known as a *Schnapshund* and was used to serve spirits.

331. Bottle
Caspar Wistar
Wistarburgh Glassworks, c. 1739–77
Inscription: RW (impressed on body)
Glass
Height 8¹/2" (21.6 cm)
Collection of Mr. and Mrs. William S. Hyland

Descended in the Wistar family.

332. Bottle
England, c. 1752
Inscription: Wm / Savery / 1752 (impressed on body)
Glass
Height 8³/4" (22.2 cm)
Philadelphia Museum of Art. Gift of Robert L. McNeil, Jr. 1966-29-1

This bottle bears the impressed seal of the Philadelphia cabinetmaker William Savery.

333. Wineglass
England, c. 1740
Glass
Height 5⁵/8" (14.3 cm)
Philadelphia Museum of Art. Gift of the heirs of Paul D. I. Maier and Anna Shinn Maier. 1998-161-13

334. Candlesticks (2)
Bohemia, c. 1745–55
Glass; polychrome decoration
Height 7" (17.8 cm); 6¹/2" (16.5 cm)
Collection of Mr. and Mrs. Robert L. Raley

335. Cups and Saucers
Bohemia, c. 1745–60
Glass; enamel decoration
Height of cups 1⁵/8" (4.1 cm), 1⁷/8" (4.8 cm); diameter 2⁷/8" (7.3 cm), 3" (7.6 cm)
Diameter of saucers 4¹/2" (11.4 cm), 4⁷/8" (12.4 cm)
Philadelphia Museum of Art. Bequest of Constance A. Jones. 1988-27-64, 65, 66, 67

336. Tankards
Bohemia, c. 1745–60
Glass; enamel decoration

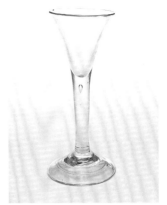

333

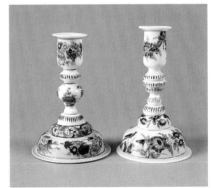

334

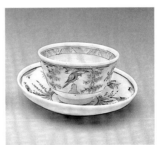

335

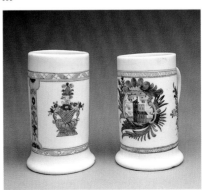

336

331

332

Height of largest tankard 7" (17.8 cm)
Philadelphia Museum of Art. Bequest of
Constance A. Jones. 1988-27-55, 56

337. Whirl Beaker
Bohemia, c. 1745–55
Enameled glass
Height 8⁵/8" (21.9 cm)
Private Collection
 This beaker originally belonged to the first
librarian of the Library Company of Philadelphia,
Louis Timothée.
See fig. 72.

Ceramics

338. Skyphos
Apulia, South Italy, c. 340–320 B.C.
Terracotta
Height 4³/8" (11.1 cm); diameter 4" (10.2 cm)
Lent by the Commissioners of Fairmount Park,
Philadelphia
 This Greek skyphos was owned by James Logan
of Philadelphia, who included it among his "cu-
riosities." It was thought to have been sent to Logan
by Peter Collinson and members of the Royal
Society in London sometime around 1738–40.
See fig. 131.

339. Covered Jar
China, made for export, c. 1680–1720
Porcelain
Height 7¹/8" (18.1 cm); diameter 5⁵/8" (14.3 cm)
Lent by the Commissioners of Fairmount Park,
Philadelphia
 Originally owned by James Logan, this rare
Chinese export cannister, probably used for the
storage of sweetmeats, was damaged at some
early date. It was repaired carefully, possibly by a
local silversmith, using solid silver bands
attached around its body.

340. Charger
China, made for export, c. 1680–1720
Porcelain
Diameter 14" (35.6 cm)
Lent by the Commissioners of Fairmount Park,
Philadelphia
 Originally owned by James Logan of Phila-
delphia.
See fig. 129.

339

341

342

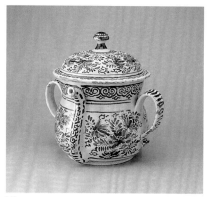

343

341. Charger
China, made for export, c. 1710–30
Porcelain
Diameter 15¹/2" (39.4 cm)
Lent by the Commissioners of Fairmount Park,
Philadelphia
 Originally owned by Isaac Norris I (1671–1735)
of Philadelphia.

342. Punch Bowl and Cover
Netherlands, c. 1690–1730
Tin-glazed earthenware
Height 11¹/2" (29.2 cm); diameter 14" (35.6 cm)
Ex-Collection Titus C. Geesey

343. Posset Pot
Netherlands, c. 1700–1720
Tin-glazed white earthenware
Height 10¹/2" (26.7 cm)
Collection of Joseph and Jean McFalls

344. Tile Fragments
Netherlands, c. 1700–1730
Tin-glazed white earthenware
Each original tile approximately 5¹/8 x 5¹/8"
(13 x 13 cm)
The Atwater Kent Museum, Philadelphia
 Excavated from Budd's Long Row in Philadel-
phia, these fragments only hint at the character
of this early row of small dwellings along the
waterfront.

345. Tile Fragments (4)
Netherlands, c. 1715–30
Tin-glazed white earthenware
Each original tile approximately 5¹/8 x 5¹/8"
(13 x 13 cm)
Stenton, Philadelphia. Gift of Mrs. William
Heatley
 These tiles were among the types acquired for
use at Stenton by James Logan.

346. Plate
England, c. 1755–60
White earthenware
Diameter 8⁷/8" (22.5 cm)
Philadelphia Museum of Art Purchase. 1906-207

347. Plate
England, c. 1720–40
White earthenware
Diameter 8⁵/8" (21.9 cm)
Philadelphia Museum of Art. Bequest of
Emmeline Reed Bedell. The Bradbury Bedell
Memorial. 1921-3-96
 Originally belonged to Elizabeth Coates
Paschall and used at Cedar Grove.

344

345

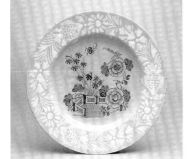

346

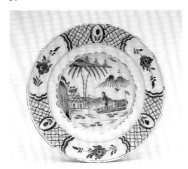

347

348

348. Tile
Netherlands, c. 1720–50
Tin-glazed white earthenware
Original tile 5¹/8 x 4⁵/8" (13 x 11.7 cm)
Philadelphia Museum of Art. Gift of the heirs of
Paul D. I. Maier and Anna Shinn Maier. 1998-162-3

This tile descended in the Morris and Wistar
families of Philadelphia and may have been used
at Harriton (built c. 1704) or Cedar Grove (built
c. 1748).

349. Plate
China, made for export, c. 1720–40
Porcelain
Diameter 9" (22.9 cm)
Lent by the Commissioners of Fairmount Park,
Philadelphia

Originally belonged to Charles Norris of
Philadelphia.

350. Plates (6)
China, made for export, c. 1720–40
Porcelain
Diameter 9¹/8" (23.2 cm)
Lent by the Commissioners of Fairmount Park,
Philadelphia

One of a group of six, this plate was originally
owned by James Logan. Similar plate fragments
have been found on the grounds of Stenton.

351. Plate
China, made for export, c. 1720–40
Porcelain
Diameter 8⁷/8" (22.5 cm)
Lent by the Commissioners of Fairmount Park,
Philadelphia

Originally owned by James Logan, this plate
is a Chinese copy of Imari porcelain, a type of
Japanese porcelain made for export.

352. Tankard or Jug
Germany, 1720–45
Salt-glazed stoneware; incised
Height 8¹/8" (20.6 cm)
Philadelphia Museum of Art. Purchased with
Museum funds. 1976-856

353. Cann
China, made for export, c. 1725–40
Porcelain
Height 5" (12.7 cm)
Edward A. and Judi V. Eckenhoff

This cann is embellished with the full armo-
rial crest of the Penn family; it may have been a
part of the extensive furnishings of Pennsbury.
See fig. 21.

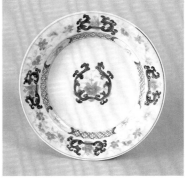

349

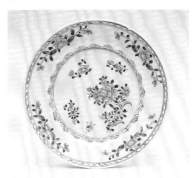

350

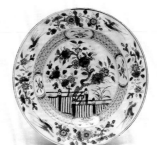

351

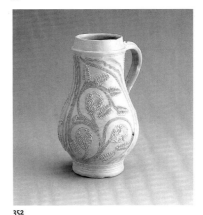

352

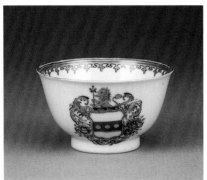

354

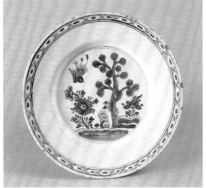

355

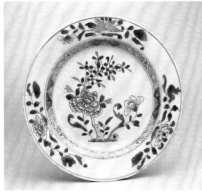

356

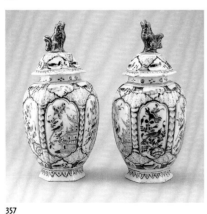

357

354. Cup

China, made for export, c. 1725–40
Porcelain
Height 1³/4" (4.4 cm); diameter 3" (7.6 cm)
Collection of Bruce C. Perkins

This cup bears the abbreviated Penn family crest as used by Thomas Penn and John Penn, William Penn's son and grandson.

355. Plate

England, c. 1730–50
Earthenware
Diameter 9¹/8" (23.2 cm)
Philadelphia Museum of Art. Gift of Edward W. Bok. 1928-66-13

Originally owned by Elizabeth Coates Paschall and used at Cedar Grove.

356. Plate

China, made for export, c. 1730–50
Porcelain
Diameter 9¹/4" (23.5 cm)
Philadelphia Museum of Art. Gift of Lydia Thompson Morris. 1928-7-44(13)

Originally owned by Elizabeth Coates Paschall and used at Cedar Grove.

357. Pair of Covered Vases

Netherlands, c. 1730–50
Tin-glazed earthenware
Height 10⁷/8" (27.6 cm); diameter 5⁵/8" (14.3 cm)
Philadelphia Museum of Art. Gift of Haas Community Funds. 1968-118-39

358. Candlestick

China, made for export, c. 1735–50
Porcelain; underglaze decoration
Height 8" (20.3 cm)
Philadelphia Museum of Art. Purchased from the Annual Membership Fund. 1921-29-2

Descended in the Paschall and Morris families of Philadelphia.

359. Teapot

China, made for export, c. 1735–55
Porcelain; enamel decoration
Height 5" (12.7 cm)
Philadelphia Museum of Art. Gift of the nephews of Mrs. Morris Hawkes. 1948-62-107a,b

360. Covered Bowl

China, made for export, c. 1730–50
Porcelain; enamel decoration
Height 5¹/8" (13 cm); diameter 4⁷/8" (12.4 cm)
Philadelphia Museum of Art. The Bloomfield Moore Collection. 1882-1383

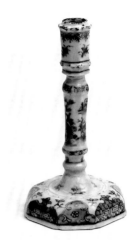

358

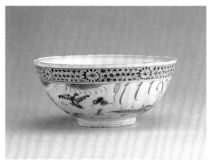

359

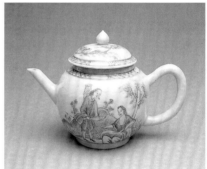

361

362

Chinese export porcelain with a brown-glazed ground, known as Batavian ware, was popular in the Delaware Valley and is frequently found in archaeological excavations at early waterfront sites in Philadelphia.
See fig. 218.

361. Punch Bowl
China, made for export, 1730–50
Porcelain
Height 3³/4" (9.5 cm); diameter 8³/8" (21.3 cm)
Philadelphia Museum of Art. Given by Miss Lydia Thompson Morris. 1928-7-43
Originally owned by Elizabeth Coates Paschall and used at Cedar Grove.

362. Charger
Philadelphia, c. 1730–60
Red earthenware; slip decoration
Diameter 15³/4" (40 cm)
Philadelphia Museum of Art. Purchased with the Baugh-Barber Fund. 1992-59-1

363. Plate
England, 1738
Inscription: WB / 1738 (front)
White earthenware
Diameter 8³/4" (22.2 cm)
Chester County Historical Society, West Chester, Pennsylvania. 1984.1050
Originally owned by William Beverley of Kennett Square, Chester County, Pennsylvania.

364. Plate
England, c. 1738
Inscription: IA / 1738 (front)
White earthenware
Diameter 8³/4" (22.2 cm)
Philadelphia Museum of Art. Gift of Mrs. Stoney McLinn. 1970-78-1
Originally owned by John Allen (died 1771) of London Grove Township, Chester County, Pennsylvania.

365. Plate
England, c. 1738
Inscription: T ᴳ D / 1738 (front)
White earthenware
Diameter 8³/4" (22.2 cm)
Collection of Joseph and Jean McFalls
This plate descended in the family of Thomas and Dinah Gregg of Kenneth Meeting, Chester County, Pennsylvania.
See fig. 103.

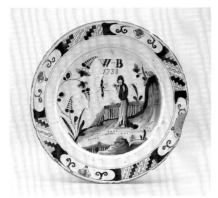

363

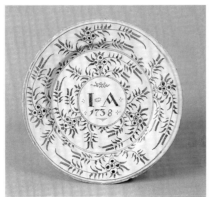

364

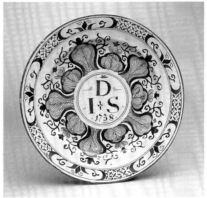

366

368

366. Plate
England, c. 1738
Inscription: I ᴰ s / 1738 (front)
White earthenware
Diameter 9" (22.9 cm)
Philadelphia Museum of Art. Gift of Richard Hartshorne, Nancy Hartshorne Bell, John Fritz Hartshorne, and Penelope Hartshorne Batcheler. 1992-35-1
This plate was probably made for John Dixon and Sarah Hollingsworth, who were married in 1724. Dixon emigrated from Sego Parish, Armagh, Ireland, and settled in Chester County.

367. Apothecary Jars
Netherlands, c. 1740–43
Tin-glazed white earthenware
Height of smallest jar 3³/4" (9.5 cm); diameter 2¹/4" (5.7 cm)
Height of largest jar 7¹/2" (19.1 cm); diameter 3¹/2" (8.9 cm)
The Moravian Museum of Bethlehem, Pennsylvania, a member of Historic Bethlehem Partnership. D1-2, 5, 12, 14, 21, 25
These apothecary jars are part of a larger set ordered from Holland for the apothecary of the Moravian Brethren at Bethlehem, Pennsylvania, in 1743.
See fig. 27.

368. Inkwell
Staffordshire, England, c. 1690–1710
Glazed earthenware
4³/8 x 6¹/8 x 4³/4" (11.1 x 15.6 x 12.1 cm)
Brinton House Association, West Chester, Pennsylvania
Descended in the Brinton family of Chester County, Pennsylvania.

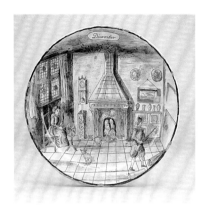

369

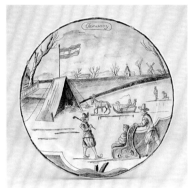

369

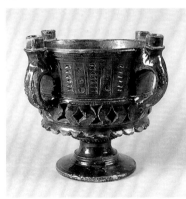

370

369. Plates (2)

Netherlands, c. 1735–45
Tin-glazed white earthenware
Diameter 9¹/4" (23.5 cm)
Collection of Joseph and Jean McFalls

These plates, decorated with allegorical scenes depicting the months of the year, are from a set of twelve thought to have been brought to Dover, Delaware, from New York by Vincent Lockermann in 1745.

370. Footed Bowl

Northern Europe, 1740–60
Tin-glazed white earthenware
Height 9¹/4" (23.5 cm); diameter 12¹/4" (31.1 cm)
Philadelphia Museum of Art. Titus C. Geesey Collection. 1969-284-32

371. Punch Bowl

Lambeth, England, c. 1750
Inscription: Success to the Charming Peggy (of Philadelphia) and Randle Wilson Master (front)
Earthenware
Height 3¹/2" (8.9 cm); diameter 87/8" (22.5 cm)
Philadelphia Museum of Art. Gift of Mr. and Mrs. J. Wells Henderson. 1976-188-1

The *Charming Peggy*, a ship commissioned and built in Philadelphia in 1750, was owned by John Devereux of Philadelphia and Stephen and William Bayard of New York.

372. Covered Tureen

Staffordshire, England, 1755–60
Salt-glazed stoneware
7³/4 x 10³/8 x 7¹/2" (19.7 x 26.4 x 19.1 cm)
Philadelphia Museum of Art. Purchased with the Elizabeth Wandell Smith Fund. 1930-127-1

373. Plate

England, c. 1749
Inscription: I ᴮ M / 1749 (bottom)
White earthenware
Diameter 8¹/4" (21 cm)
Collection of Joseph and Jean McFalls

Originally owned by James Brinton and his wife, Mary Ford, of Sadsbury, Chester County.

374. Cups and Saucer

China, made for export, c. 1750–55
Decorated in England or Germany
Porcelain, enamel decoration
Height of cups 1³/4" (4.4 cm); diameter 3¹/8" (7.9 cm)
Height of saucer 1¹/8" (2.9 cm); diameter 6" (15.2 cm)
Philadelphia Museum of Art. Gift of Lydia Thompson Morris. 1928-7-44 (18, 19, 23)

These cups and saucer originally belonged to Elizabeth Coates Paschall and were used at Cedar Grove.

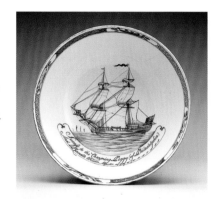

371

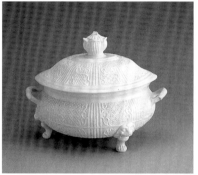

372

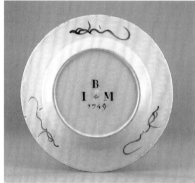

373

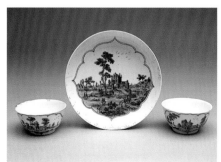

374

Textiles, Clothing, and Personal Adornment

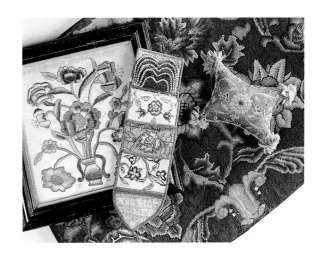

Fig. 219
Needlework chair cushion, picture,
needle case, and needle cushions
(nos. 382, 385, 387, 392).

Textiles, for both personal apparel and household decorations, were among the most valuable possessions listed in household inventories of the early eighteenth century. Because they were so desirable, both utilitarian and finer textiles served, like silver, as trading commodities during the earliest years of settlement in Pennsylvania. In 1684 Joris Wertmuller, a Swiss immigrant, advised those coming to the colony to "see that you are well supplied with clothes and linen, and it will be better than to have money, since what I bought in Holland for ten guldens, I here sold again for thirty guldens."[184] James Logan, along with many other Pennsylvania merchants, ordered large quantities of English woolen blankets for trading with the Indians.[185] Merchants traded heavily in textiles, and vendue auctions on the docks regularly included speculative cargoes of fine fabrics brought into Philadelphia by English, Dutch, and French ships.

The high cost and relative scarcity of textiles and clothing resulted from their labor-intensive production and from the colony's dependence on their importation. There was some scattered local manufacture of textiles during the period of initial settlement. Gabriel Thomas noted in 1698 that in Germantown they made "very fine German Linen, such as no Person of Quality need be asham'd to wear; and in several places, they make very good Druggets, Crapes, Camblets, and Serges, besides other Woollen Cloathes, the Manufacture of all which daily improves."[186] The quality of imported Irish linen and its widespread availability in Pennsylvania, however, made it difficult for domestic linen manufacturers to compete, and the scope of their production was thus limited during the earliest period of settlement. Along with linen and wool production there were some early, isolated investigations into and attempts to establish the culturing and production of silk in Pennsylvania. John Bartram, James Logan, and Susanna Wright were among several who corresponded and exchanged books on the subject, and Wright's experiments in the 1730s and 1740s with silk-worm culture and silk spinning at her farm on the Susquehanna River near Columbia, Pennsylvania, are thought to have produced limited quantities of plain woven fabric (see no. 407).[187]

Despite the moral apprehensions voiced in 1719 by the Philadelphia Yearly Meeting of the Society of Friends, repeated in later years, concerning the lack of "moderation and plainess in gesture, speech, apparel, or furniture of houses," most Pennsylvanians wanted to own the best clothing and household textiles they could afford.[188] In both rural and urban society, personal attire became one of the many symbols of status. Often, very specific dress was required for public occasions such as religious observances, celebratory fêtes, and the gala society balls held regularly by the Philadelphia Dancing Assembly (nos. 398, 399; fig. 97).[189] While few garments survive from the years prior to 1758 without repairs or later alterations, early portraiture provides vivid evidence that many individuals from Philadelphia and rural Pennsylvania towns were able to emulate European and English fashions closely (no. 443).

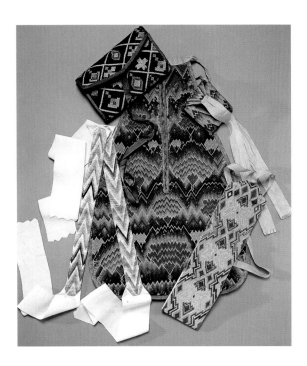

Fig. 220
Needlework pocket, garters, needle
cases (nos. 401, 404, 388); wallet
(lent by the Commissioners of
Fairmount Park).

Their inventories suggest that a good
number of them maintained surpris-
ingly large wardrobes of both imported
and domestically produced, finely made,
richly trimmed garments. The 1736
inventory of Governor Patrick Gordon,
for example, listed more than £50 in
personal attire, including "A Suite of
blew Cloth laced with Gold / A Sute of
Scarlet Cloth trimm'd with Silver / An
old black velvet Coat & Breeches trim'd
wth Gold / . . . A red Wastcoat the body
lind with Furr / . . . Two old Banyan
Coats / . . . A strip'd silk night gown &
silk netted sash / A red velvet Cap."¹⁹⁰

Connections with traders involved in
Dutch enterprises in the East and West
Indies brought a surprising range of In-
dian, Spanish, Italian, French, and En-
glish textiles to Philadelphia through
their English and European agents (see
no. 375). Table carpets; silks and "painted"
(printed) cottons from the Orient; Italian
and French plushes, brocades, and vel-
vets; "Russia" leathers; and English silks,
calicoes, fustians, calamancoes (glossy
woolen fabric of satin weave with striped
or checkered designs), moreens (strong
fabric of wool or cotton with a plain glos-
sy or moiré finish), and damasks are
only a small sampling of the array of
goods offered by local merchants. The
Philadelphia dry-goods merchant George
Smith's advertisement of the imported
fineries he carried in his Front Street
shop is typical for the time:

*Just imported from London . . . English
and Russia duck, oznabrigs, Pomerania
linens, Irish and Russia sheeting . . . strip'd
hollands and cottons, Irish linens, tan-
dems, . . . garlix, bag hollands, single and
double silesias, holland whited long lawns,
pistol lawns, broad lawns, fine clear lawns
in pieces and patches, spotted and flower'd*

*ditto, cambricks in peices and patches, . . .
mislins, diaper and damask table cloaths
printed linens, and cotton yard wide linen
handkerchiefs, light and dark ground cali-
coes, superfine light and dark ground chints
in patterns for bed curtains, and gowns,
white India demity, white, pink, blue, green
and cloth colour'd English and India dam-
asks, white and cloth colour'd sattens,
black padusoys, black velvet, scarlet, green,
and spotted shag ditto, black and cloth
colour'd China grogoroons, and taffaties,
black ell wide Persians, strip'd ditto, half
yard ditto, China handkerchiefs, bordored
bandanoes, silk and cotton romal lungees,
superfine broad cloths in pieces and suits,
buttons and mohair, womens scarlet and
cloth colour'd cloaks, boyl'd camblets, cam-
blettees, calimanicoes, starrets, florettas,
serpintins, poplins, silk, cards, allopeens,
black crape, duroys, scarlets, and black ever-
lasting, worked damasks, London and Bris-
tol shalloons and tammies, felt and castor
hats . . . woorsted and silk pieces in patterns
for breeches . . . cotton and silk laces.*¹⁹¹

For household decorations, bedding,
and upholsteries, a full range of richly
decorated imported textiles was available.
The role of the upholsterer, who supplied
the textiles and trims for decorations
en suite and "fitted up" such fabrics for
household interiors, grew in importance.
Many of the earliest surviving seating
furniture had loose cushions, or "Squabs,"
that rested on the chair seats (no. 147).
Job Adams, recently from London, ad-
vertised in 1732 his ability to supply
such seating cushions, stating that he
sold "all Sorts of Upholders Goods, viz.
Beds and Beding, Easy Chairs, Settees,
Squabs and Couches, Window-Seat
Cushions Russia Leather Chairs, with all
sorts of Upholders Goods, at reasonable
Rates."¹⁹²

Among the most ambitious and expensive household furnishings undertaken by upholsterers during the period were beds. A full range of beds—from the simplest "pallet" mattresses or low post-frame "field" beds to the grandly trimmed and fitted out four-post tester, or canopied, beds modeled after the state beds of England and Europe— were to be found in early Pennsylvania households. The ornately decorated larger post beds fully fitted out with textile hangings were by far the most highly valued of the furnishings included in early household inventories. Employing simplified versions of designs developed by Daniel Marot and other European and English designers, Philadelphia's elite merchant class coordinated the color, trim, and patterns of the hangings in their most important bed chambers (no. 171, fig. 110). A complete set of bed "furniture" for ornate four-post beds with tester frames consisted of a head cloth, tester valance, floor valance, quilt or coverlet, and four corner bed curtains in addition to the mattress, foundation linens, bolsters, and pillows (no. 380). Tapes, trims, tassels, and ribbons were added to the most ornate examples. In 1741 Thomas and Margaret Fraeme,

William Penn's son-in-law and daughter, had richly decorated, coordinated suites of bed hangings in several of the chambers in their Philadelphia house, including "a sett of Mohair Hangings and Vallends for a Bed and Windows for a Room," "a sett of blue Callimanco Bed Curtains," "a Suit of Damask Curtains for a Bed & 2 Windows," and "a sett of fine Broad Cloth Curtains."[193]

In 1745 the Philadelphia upholsterer Peter Hall advertised his extensive offerings of goods and services as well as his ability to "teach any Person to draw Draughts in a short Time for Flourishing or Embroidering."[194] From the earliest period of settlement, fine needleworking skills were promoted and admired as an integral part of a young woman's education and training (nos. 394–396). The skills necessary to execute the various intricate stitches involved in needleworking were taught by hired schoolmistresses who were quite adept in the art. One of the most talented and influential of these early teachers and artists was Elizabeth Marsh (born England, 1683–c. 1741). Marsh taught a number of the daughters of Philadelphia's most influential families, including Sarah Logan, Margaret Wistar, and Elizabeth

Hudson (nos. 381, 384, 386).[195] Produced as special gifts, needlework samplers were both a regular part of a girl's education in the "womanly arts" and a testament to the maker's skill and devotion. Needlework projects and finely worked household linens were also accumulated as a part of a young woman's dowry. Samplers of the quality executed by Marsh, her daughter Ann, and their pupils, along with other types of finely stitched textile decorations produced in Pennsylvania, demonstrate the important role ornamental textiles played in the lives of many of the colony's women (see no. 393). A number of surviving examples of Pennsylvania needlework illustrate the close stylistic ties between locally produced patterns and earlier English and northern European traditions (see no. 376). Some of the more ornate needlework produced locally, such as the "Case of Gom Flowers and a piece of Needle Work" kept in the back parlor of the Philadelphia house of Alexander Wooddrop, or the "Crocadile in Needle Work by Mrs. Graeme" of Graeme Park, Bucks County, must also have served as interesting and at times amusing conversation pieces.[196]

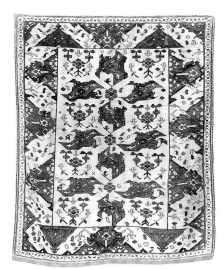

375

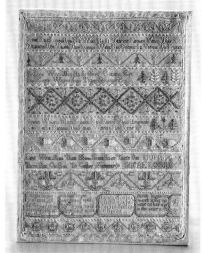

376

378

379

Textiles, Clothing, and Personal Adornment

375. Carpet
Anatolia, Turkey, c. seventeenth–eighteenth century
Wool
74 x 64" (188 x 162.6 cm)
Philadelphia Museum of Art. The John D. McIlhenny Collection. 1943-28-3

376. Needlework Picture
England, c. 1680–1710
Silk, wool
12^{1}/4 x 17^{1}/4" (31.1 x 43.8 cm)
Lent by the Commissioners of Fairmount Park, Philadelphia
This needlework picture is thought to have been owned by James Logan of Philadelphia.

377. Stomacher
France or England, c. 1690–1735
Silk, linen, metallic thread
Length 12" (30.5 cm); width 9" (22.9 cm)
Philadelphia Museum of Art. Gift of Mrs. William H. Noble, Jr. 1972-110-13
See fig. 15.

378. Petticoat
Philadelphia, c. 1710–30
Silk, wool
Waist 24" (61 cm); length 35^{1}/2" (90.2 cm)
Philadelphia Museum of Art. Gift of Elizabeth C. and Frances A. Roberts. 1900-49
Descended in the Roberts family of Haverford Township, Pennsylvania.

379. Patch Box
Francis Richardson, Sr. (born Pennsylvania, 1681–1729)
Philadelphia, c. 1715
Inscription: EB (engraved on base)
Silver
5/8 x 2 x 2^{5}/8" (1.59 x 5.1 x 6.7 cm)
Philadelphia Museum of Art. Purchased with the Joseph E. Temple Fund. 1921-56-1a,b

380. Quilt
Attributed to Elizabeth Coates Paschall (born Pennsylvania, 1702–1767)
Philadelphia, c. 1720–30
Silk, printed cotton, wool
100^{3}/8 x 101^{1}/4" (255 x 257.2 cm)
Philadelphia Museum of Art. Bequest of Lydia Thompson Morris. 1932-45-124

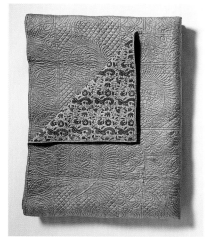

380

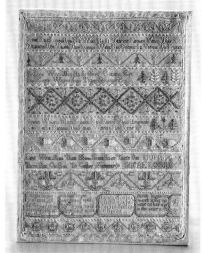

381

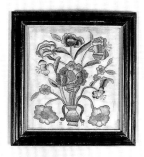

382

383

381. Needlework Sampler
Sarah Logan (born Pennsylvania, 1715–1744)
Philadelphia, c. 1725
Inscription: sarah logan her / work in the 10 /
year of her age / in the year 1725 / Sarah Logan /
was born 9 of th 8mo 1715 15 mi / after 4 in the
af / ter noon; william logan / was born ye 14 of /
ye 3mo 1718 30 mi / after 5 in ye morn; this
work in han / my friends may hav / when i am
dead an / laid in grave
Silk, wool
12 x 9" (30.5 x 22.9 cm)
Lent by the Commissioners of Fairmount Park,
Philadelphia

382. Needlework Picture
Ann Marsh (born England, 1717–1797)
Philadelphia, c. 1730–39
Inscription: Ann Marsh her work 173-. / Oh
time, time why dost thou leave us this, / When
she that wrought thy showy surface / Is moul-
dering into dust (on back of frame)
Silk, linen
Framed (in original frame) 10¹/₂ x 10"
(26.7 x 25.4 cm)
Chester County Historical Society, West Chester,
Pennsylvania. 1985.524

383. Buttons
Attributed to Caspar Wistar (born Germany,
1696–1752)
Philadelphia, c. 1730–40
Brass
Diameter 7/8" (2.22 cm)
Philadelphia Museum of Art. Gift of Thomas
Wistar, Jr. 1987-48-1, 2

384. Needlework Sampler
Attributed to Elizabeth Hudson (born
Pennsylvania, 1721–1783)
Philadelphia, 1737
Inscription: Elizabeh / Hudson / her / Samplar
/ Workd in / the 15 year / of her age 1737 (lower
right corner)
Silk, linen
15¹/₂ x 11¹/₄" (39.4 x 28.6 cm)
Philadelphia Museum of Art. Purchased with
funds contributed by Robert L. McNeil, Jr.
1966-149-1

385. Needle Cushion
Attributed to Ann Marsh (born England,
1717–1797)
Philadelphia, c. 1737–50
Silk, metallic thread, cotton
Width 5" (12.7 cm); diameter 3¹/₂" (8.9 cm)
Chester County Historical Society, West Chester,
Pennsylvania. 1985.524.3

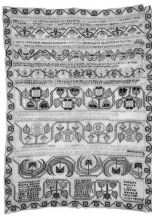
384

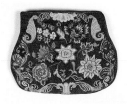
385

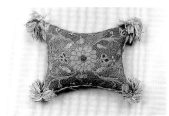
387

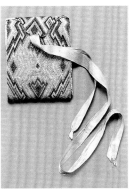
388a

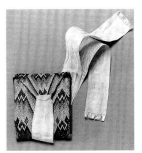
388b

386. Pair of Needlework Sconces
Margaret Wistar (born Pennsylvania,
c. 1728/29–1793)
Germantown, Pennsylvania, 1738
Inscription: Margaret Wistar her work / in the
9 year of her age 1738
Silk
(a) Framed (in original frame) 17¹/₈ x 10¹/₄"
(43.5 x 26 cm)
Wyck, Germantown
(b) Unframed 16³/₈ x 9⁵/₈" (41.6 x 24.4 cm)
Private Collection
See fig. 106.

387. Chair Cushions (2)
Attributed to Ann Marsh (born England,
1717–1797)
Philadelphia, c. 1740–50
Cotton, lamb's wool, silk
Floral cushion (pictured) 4³/₄ x 21³/₄ x 16¹/₂"
(12.1 x 55.2 x 41.9 cm)
Flame-stitched cushion 6 x 16³/₈ x 15⁵/₈"
(15.2 x 41.6 x 39.7 cm)
Chester County Historical Society, West Chester,
Pennsylvania. 1985.524.2, 1993.2443

388. Two Needle Cases
Philadelphia, c. 1740–50
Silk, wool, linen
Length 7" (17.8 cm); width 2¹/₂" (6.4 cm)
Lent by the Commissioners of Fairmount Park,
Philadelphia
 These needle cases descended in the Logan
and Norris families of Philadelphia.

389 & 390

391

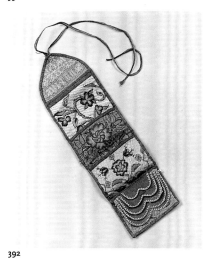

392

389. Book Covers
Deborah Morris and Ann Bettle
Philadelphia, c. 1740–50
Wool, linen
Morris cover 6³/8 x 3³/4 x 2³/8" (16.2 x 9.5 x 6 cm);
Bettle cover 5³/4 x 3¹/4 x 2" (14.6 x 8.3 x 5.1 cm)
Chester County Historical Society, West Chester,
Pennsylvania. 1987.732, 1995.529

390. Bible with Needlework Cover
Philadelphia, c. 1740–50
Paper, leather, wool, linen
11¹/8 x 4³/8 x 9¹/4" (28.3 x 11.1 x 23.5 cm)
Philadelphia Museum of Art. Bequest of Lydia
Thompson Morris. 1932-45-135-a,b
This Bible, which descended in the Morris
family of Philadelphia, was covered using a frag-
ment of an earlier set of needlework seat covers.

391. Lambert Family Coat of Arms
Philadelphia or Connecticut, c. 1745–55
Silk, metallic thread, linen (in original frame)
Unframed 5³/8 x 5³/8" (13.7 x 13.7 cm)
Collection of Jay Robert Stiefel
This rare embroidered coat of arms and crest is
thought to have descended in the Lambert family
of New Jersey and Connecticut. Hannah Lambert
married Dr. Thomas Cadwalader of Philadelphia
in 1738, uniting two influential Quaker families.

392. Needle Case
Ann Marsh (born England, 1717–1797)
Philadelphia, c. 1745–55
Silk
Length 12¹/4" (31.1 cm); width 3³/4" (9.5 cm)
Chester County Historical Society, West Chester,
Pennsylvania. 1993.2444
Ann Marsh taught needlework to the daugh-
ters of many prominent Philadelphians, as did
her mother, Elizabeth Marsh (1683–c. 1741).

393. Unfinished Sampler
Mary Richardson (born 1735)
Philadelphia, 1749
Inscription: Mary Richardson Daughter of Joseph
and Mary Richardson was born the twenty-fifth
day of the fifth month 1735 and this in the year
1749 Martha Cherry Mistress
Silk on canvas
16¹/2 x 12³/4" (41.9 x 32.4 cm)
Philadelphia Museum of Art. Gift of Henry
Lyne, Jr. 1968-175-4

394. Needlework Pictures (2)
Sarah Logan Wistar (born Pennsylvania,
1738–1815)
Philadelphia, 1752
Silk, silk moiré
9¹/2 x 7" (24.1 x 17.8 cm)

393

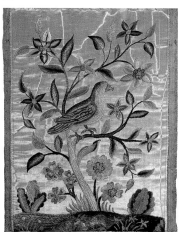

394

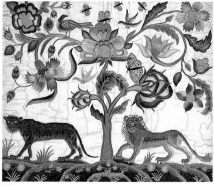

395

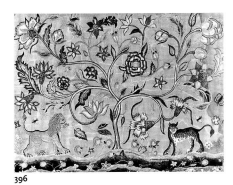

396

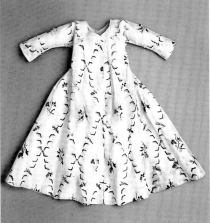

397

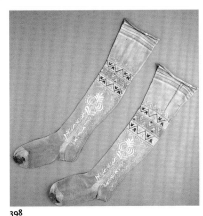

398

Winterthur Museum, Winterthur, Delaware.
Museum Purchase. 64.120.1a–d, .2a–d

395. Needlework Picture
Philadelphia, c. 1754–58
Silk, silk moiré
13¹/₂ x 18" (34.3 x 45.7 cm)
Private Collection

396. Needlework Picture
Mary King
Philadelphia, 1754
Signature: Mary King 1754
Silk, metallic thread, beads, silk moiré
18¹/₄ x 24¹/₈" (46.4 x 61.3 cm)
Winterthur Museum, Winterthur, Delaware.
Bequest of Henry F. du Pont. 66.978

397. Child's Dress
Philadelphia, c. 1730–40
Block-printed cotton, silk
Length 25" (63.5 cm)
Stenton, Philadelphia. Gift of Miss Frances A.
Logan
 Descended in the Logan and Norris families
of Philadelphia.

398. Pair of Stockings
France or England, c. 1740–55
Silk
Top edge to heel 19³/₄" (50.2 cm); heel to toe
8¹/₄" (21 cm)
Philadelphia Museum of Art. Gift of Miss Helen
Hamilton Robins. 1933-47-2a,b
 These stockings were worn by Martha
Ibbetson, who married George Gray (1725–1800)
of Gray's Ferry in 1752.

399. Dress
Fabric probably English, c. 1740–50, with later
alterations
Silk
Height 55" (139.7 cm)
Philadelphia Museum of Art. Gift of Ronald, Ken-
neth, and Louis Schloesser and David Akers in me-
mory of Mildred Schloesser Hobson. 1995-98-8
See fig. 97.

400. Man's Dressing Coat
Fabric English, c. 1745–55, with later alterations
Silk
Height 45¹/₂" (115.6 cm); chest 38¹/₂" (97.8 cm)
Philadelphia Museum of Art. Gift of an anony-
mous donor in memory of Elizabeth Wheatley
Bendiner. 1991-75-24
 Philadelphia mayor Robert Strettell was the
original owner of this dressing coat, or banyan.

401. Pocket
Philadelphia, c. 1745–55
Wool, linen, silk

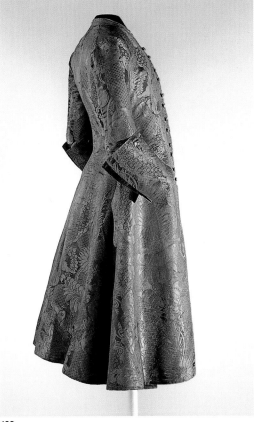

400

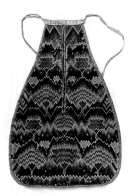

401

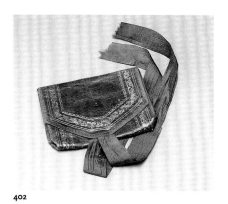

402

403

404

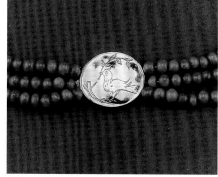

405

407

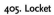

407

Length 16 1/2" (41.9 cm); width 11 1/2" (29.2 cm)
Philadelphia Museum of Art. Gift of Mrs.
Hampton L. Carson. 1930-30-36

402. Wallet
France or Italy, c. 1730–50
Leather, silk
Folded 3 5/8 x 4 7/8" (9.2 x 12.4 cm)
Lent by the Commissioners of Fairmount Park,
Philadelphia
 This wallet is thought to have been owned by
James Logan or his son William.

403. Necklace
Francis Richardson, Sr. (born New York,
1681–1729)
Philadelphia, c. 1720
Inscription: SC (engraved with primrose on back)
Gold, coral beads
Length of clasp 1 1/8" (2.9 cm)
Winterthur Museum, Winterthur, Delaware.
Gift of Henry F. du Pont, 58.120.3; Museum
Purchase, 58.139 (coral beads)

404. Garters (2)
Philadelphia, c. 1735–55
Silk
Needlework 11 3/4 x 1 1/8" (29.8 x 2.9 cm)
Philadelphia Museum of Art. Gift of Clarence
Brinton in memory of Octavia E. F. Brinton.
1936-12-7a,b

405. Locket
Attributed to Randall Yetton (active 1736–44)
Philadelphia, c. 1740
Silver
3/4 x 1 1/4 x 1/8" (1.9 x 3.2 x 0.32 cm)
The Art Institute of Chicago. Restricted gift of
Mr. and Mrs. Robert A. Kubicek. 1978.299

406. Buckle
Philip Syng, Jr. (born Ireland, 1703–1789)
Philadelphia, c. 1740–50
Gold, steel
1 5/8 x 1 1/4 x 1/4" (4.1 x 3.2 x .64 cm)
Winterthur Museum, Winterthur, Delaware.
Gift of Lammot du Pont Copeland. 68.304
See fig. 155.

407. Bag and Contents
Silk fragments attributed to Susanna Wright
(born Pennsylvania, 1697–1784)
Wrights Ferry, Pennsylvania, c. 1740–50
Silk, wood
Inscription: HOPE; GOD IS OUR GUIDE (stitched
on opposite sides of bag)
Bag 7 x 3" (17.8 x 7.6 cm)
Von Hess Foundation: Wright's Ferry Mansion,
Columbia, Pennsylvania. 83.18.247

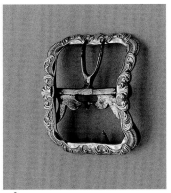

408

408. Shoe Buckle
Joseph Richardson, Sr. (born Pennsylvania, 1711–1784)
Philadelphia, c. 1740–50
Gold
Length 1⁷/8" (4.8 cm); width 1³/4" (4.4 cm)
Yale University Art Gallery, New Haven. Mabel Brady Garvan Collection. 1931.645

409. Wallet
Hannah Logan (born Pennsylvania, 1720)
Philadelphia, 1744
Inscription: John Smith's Pocket Book 1744
Wool, linen, silk
Length 7" (17.8 cm); width 3¹/2" (8.9 cm)
Stenton, Philadelphia
　Hannah Logan, James Logan's younger daughter, made this wallet for John Smith (1722–1771) of Burlington, New Jersey, whom she married in 1748.

410. Fan
Germany or France, c. 1745–55
Ivory, paper, straw, paste brilliant
Closed 11⁷/8" (30.2 cm)
Philadelphia Museum of Art. Gift of the heirs of Paul D. I. Maier and Anna Shinn Maier. 1998-162-25.
　Samuel Morris (1734–1812) presented this fan to Rebecca Wistar (1735/36–1791), Caspar Wistar's daughter, before their marriage on December 11, 1755.
See fig. 98.

411. Wallet
Attributed to Margaret Wistar (born Pennsylvania, c. 1728/29–1793)
Germantown, Pennsylvania, c. 1750
Inscription: Caspar Wistar
Wool, linen
Closed 7 x 5" (17.8 x 12.7 cm)
Wyck, Germantown

412. Cuff Links
Daniel Dupuy, Sr. (1719–1807)
Philadelphia, c. 1750–55
Inscription: ED (engraved on front)
Gold
Length 3/8" (0.95 cm)
Philadelphia Museum of Art. Gift of Mrs. M. Basil B. Rolfe. 1962-95-1a,b; 2a,b
　Made for Eleanor Cox, who married Daniel Dupuy in 1746.

413. Chain
Netherlands or France, c. 1670–90
Silver
Length 39" (99.1 cm)
Private Collection
　Descended in the Firth and Mendenhall families of Chester County, Pennsylvania.

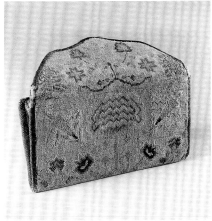

409

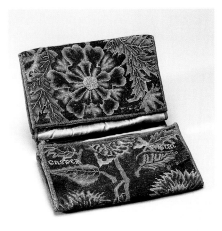

411

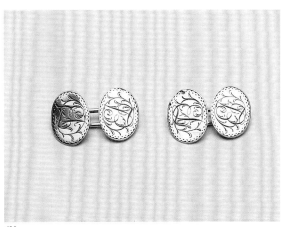

412

413

Miscellaneous Objects

414

414. Personal Ornaments
Susquehannock Indians, c. 1625
Diameter of disk 2¹/₄" (5.7 cm)
The State Museum of Pennsylvania,
Pennsylvania Historical and Museum
Commission

These objects were recovered from Susquehannock village sites located on the banks of the Susquehanna River in York and Lancaster counties.

415. Group of Ornaments and Ceremonial Gifts
Delaware or Lenape Indian tribes
Made in New Sweden, Delaware Valley, c. 1640–53
Animal skins, shells, bones, glass beads, metal, wood
Length of club 15¹/₄" (38.7 cm); bag 34¹/₂" (87.6 cm); tumpline 18¹/₂" (5.5 m)
Skokoloster Castle, Hallwyl Museum, Stockholm

These artifacts are some of the ceremonial gifts presented to Johan Printz, the colonial governor of New Sweden from 1642 to 1653, upon his last departure from the colony in 1653.
See fig. 28.

416. Wampum Belt
Delaware or Iroquois Indian tribes
Delaware Valley, c. 1670–82
Animal hide, glass, shell beads
5³/₄ x 26" (14.6 x 66 cm)
The Historical Society of Pennsylvania, Philadelphia. Gift of Granville John Penn. 1857.3

Tradition has it that this belt was the one presented to William Penn by Delaware Indian leaders at the signing of the Shackamaxon treaty in 1682.
See fig. 33.

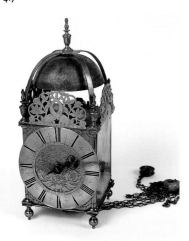

417

417. Slate Book
England or France, c. 1695
Inscription: SY (engraved on top clasp); 1695 (engraved on bottom clasp)
Leather, slate, wood, brass
4¹/₈ x 2³/₄ x ⁵/₈" (10.5 x 7 x 1.6 cm)
Lent by the Commissioners of Fairmount Park, Philadelphia

Descended in the Yeates and Logan families of Philadelphia, this slate book bears the initials of its first owner, Sarah Yeates.

418. Lantern Clock
Peter Stretch (born England, 1670–1746)
England, c. 1691–1701
Signature: Peter Stretch Leek
Brass, iron
14⁵/₈ x 6 x 6" (37.1 x 15.2 x 15.2 cm)
Collection of Robert A. Erlandson, Towson, Maryland

418

420

421

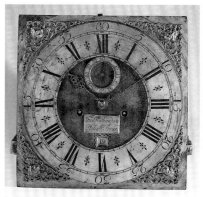

422

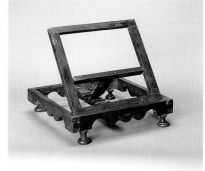

423

The Philadelphia clockmaker Peter Stretch was a native of Leek in Staffordshire County, England. This is thought to be an example of his early work, made before he emigrated.

419. Armorial Plaque of William and Mary
Probably England, c. 1695–1710
Oak
13 x 18 x 3" (33 x 45.7 x 7.6 cm)
The Rector, Church Wardens, and Vestrymen of Christ Church, Philadelphia
This crest is thought to be one presented by the Crown to the first congregation of Christ Church in Philadelphia, where it decorated the governor's pew.
See fig. 46.

420. Face of a Clock
Abel Cottey (born England, 1655–1711)
Philadelphia, c. 1700–1711
Signature: Abel Cottey Philadelphia
Brass
11¹/8 x 11¹/8" (28.3 x 28.3 cm)
Collection of Philip H. Bradley
Cottey, who arrived in 1682, was one of the earliest clockmakers in Philadelphia. No complete clockworks in their original cases from the Cottey workshop are presently known. This fragmentary brass clockface provides a glimpse of his work.

421. Hourglass
England or Europe, c. 1710–40
Glass, wood, sand
Height 6¹/2" (16.5 cm); diameter 3¹/2" (8.9 cm)
Philadelphia Museum of Art. Gift of Mrs. William D. Frishmuth. 1910-85

422. Face of a Clock
Attributed to Francis Richardson, Jr. (born Pennsylvania, 1705–1782)
Philadelphia, c. 1715–25
Signature: Francis Richardson, Philada Fecit (engraved on dial)
Brass, iron
12 x 12" (30.5 x 30.5 cm)
Philadelphia Museum of Art. Purchased with the Fanny Magee Fund. 1925-60-1
Francis Richardson, Jr., worked as a silversmith, clockmaker, and merchant and is known to have fashioned silver objects for his brother Joseph, also a silversmith. The working relationship between the two brothers is apparent in this clock, as Joseph probably engraved the name of his brother on the face. Joseph is known to have engraved clockfaces for other makers, such as John Wood, who paid Joseph for "Ingraving 6 name pieces" and "5 clock faces."

424

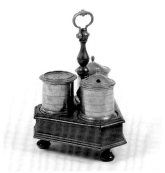
425

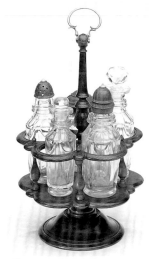
426

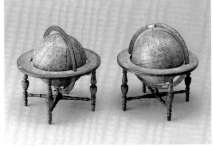
427

423. Book Stand
Southeastern Pennsylvania, c. 1715–30
Walnut
Closed 3 x 13¹/4 x 12¹/2" (7.6 x 33.7 x 31.8 cm)
Collection of Joseph and Jean McFalls
This book stand originally belonged to John Gregg, whose house was on the border of New Castle and Chester counties.

424. Woodworker's Template
Chester County, Pennsylvania, c. 1725–30
Poplar
11¹/8 x 17/8 x ¹/8" (28.3 x 4.8 x .32 cm)
Collection of Joseph and Jean McFalls
This template was recovered from behind a mantel in the Bartholomew Coppock House (built c. 1696–1700) in Chester County.

425. Inkstand
England or the Netherlands, c. 1720–35
Walnut, brass
8³/4 x 9¹/2" (22.2 x 24.1 cm)
Collection of Joseph and Jean McFalls
According to tradition, James Logan gave this inkstand to the Neagle family to thank them for allowing him to stay in their home while Stenton was being built.

426. Caster Stand and Casters
Probably England, c. 1720–40
Mahogany, glass, tin
Height 10¹/2" (26.7 cm)
Philadelphia Museum of Art. Gift of the heirs of Paul D. I. Maier and Anna Shinn Maier. 1998-162-2
Descended in the Paschall, Wistar, and Morris families of Philadelphia.

427. Pair of Globes
Richard Cushee (active 1729–31)
London, 1731
Signature: A New Globe of the Earth by R. Cushee 1731
Paper, wood
Height 4¹/2" (11.4 cm); diameter 4¹/4" (10.8 cm)
Philadelphia Museum of Art. Bequest of Henrietta Morris Bonsal. 1955-97-36, 37
Descended in the Morris family of Philadelphia.
See also fig. 52.

428. Pair of Flintlock Pistols
Pierre Peyret (French, 1712–1776)
France, c. 1740
Walnut, silver, steel, gilt, horn
Length 15" (38.1 cm)
Private Collection

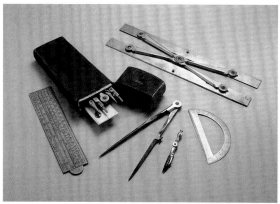

429

These imported pistols originally belonged to the prominent Philadelphian Samuel Morris (1734–1812), who served as sheriff of the city from 1752 to 1755 and from 1758 to 1759. *See fig. 17.*

429. Draftsman's Tools
England, c. 1730–50
Brass, iron, shagreen case
8¹/8 x 2⁵/8 x 1" (20.6 x 6.7 x 2.5 cm)
Lent by the Commissioners of Fairmount Park, Philadelphia

These tools are thought to have belonged to James Logan of Philadelphia. Logan's interest in architecture, and his knowledge of mathematics and geometry, led to his experiments in drafting and design on projects such as Stenton, and in designing a building to house his library.

430. Watch Hutch
Southeastern Pennsylvania, c. 1735–55
Cherry, glass
6⁵/8 x 4 x 1⁷/8" (16.8 x 10.2 x 4.8 cm)
Collection of H. L. Chalfant

431. Figure of a Dog
England or Europe, 1742
Alabaster
Height 3¹/2" (8.9 cm)
Private Collection

Descended in the Mendenhall family of Chester County, Pennsylvania.

432. Electrical Apparatus
Philadelphia, c. 1742–47
Walnut, iron
59 x 28 x 24" (149.9 x 71.1 x 61 cm)
The Library Company of Philadelphia

This apparatus was used by Benjamin Franklin in his experiments with electricity and was presented to the Library Company of Philadelphia around 1745. Franklin commissioned several of these generating wheels for his associates in order to accommodate the requests of the curious for demonstrations of the phenomenon of electrical energy.
See fig. 60.

433. Marble Samples
Gathered in Italy and France, c. 1740–50
Marble, in paper wrappers
Largest sample 2¹/4 x 3" (5.7 x 7.6 cm)
Lent by the Commissioners of Fairmount Park, Philadelphia

Originally owned by James Logan of Philadelphia.
See fig. 130.

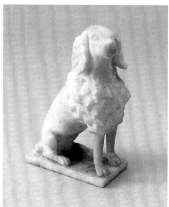

431

430

434

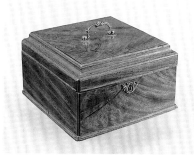

435

436

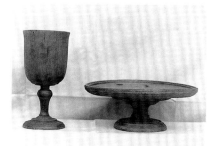

438

434. Fly-Fishing Wallet
Philadelphia, c. 1740–50
Leather, paper, iron hooks, feathers, silk, wool
1³/4 x 5³/8 x 3⁵/8" (4.4 x 13.7 x 9.2 cm)
Lent by the Commissioners of Fairmount Park,
Philadelphia
 This fly-fishing wallet descended in the Logan
family and is thought to have been owned by both
James Logan and his son William. Both were
early members of the Colony in Schuylkill, a gen-
tlemen's fishing club founded in 1732.
See also fig. 108.

435. Tea Chest
Made in England or America, c. 1740–55
Mahogany
6¹/2 x 10³/4 x 10³/4" (16.5 x 27.3 x 27.3 cm)
Philadelphia Museum of Art. Gift of Daniel
Blain, Jr. 1997-67-1a

436. Salver
Philadelphia, c. 1745–55
Mahogany
Diameter 10³/8" (26.4 cm)
Private Collection

437. Door
From the Millbach House, Millbach, Lebanon
County, Pennsylvania, built c. 1752–53
Walnut, iron
77 x 38" (195.6 x 96.5 cm)
Philadelphia Museum of Art. Gift of Mr. and
Mrs. Pierre S. du Pont and Mr. and Mrs. Lammot
du Pont. 1926-74-1
See fig. 164.

438. Chalice and Paten
Lancaster County, Pennsylvania, c. 1750–60
Walnut
Height of chalice 8⁵/8" (21.9 cm); diameter 4¹/2"
(11.4 cm)
Height of paten 3⁷/8" (9.8 cm); diameter 10¹/4"
(26 cm)
Collection of Mr. and Mrs. Clarence Spohn
 This chalice and paten were probably used
by the Moravian brethren at Snow Hill, York
County, Pennsylvania, or at Ephrata Cloister in
Ephrata, Pennsylvania.

439. Tobacco Box
Thomas Shaw
London, 1756
Engraved steel
7/8 x 5¹/8 x 2³/8" (2.2 x 13 x 6 cm)
The Corning Museum of Glass
 Engraved with images of kilns and glass-
making tools, this box originally belonged to
glassmaker Richard Wistar, Caspar Wistar's son.
See fig. 217.

Paintings, Drawings, and Prints

440. *Portraits of Hannah and William Penn*
Francis Place (born England, 1647–1728)
England, c. 1696
Pastel on paper
Portrait of Hannah 9⁷/8 x 8¹/8" (25.1 x 20.6 cm)
Portrait of William 11⁷/8 x 8¹/4" (30.2 x 21 cm)
The Historical Society of Pennsylvania,
Philadelphia. 1957.7, 8
 William Penn married his second wife,
Hannah Callowhill, in 1695/96. These portraits
were probably executed around the time of their
marriage.
See figs. 30, 40.

441. *Jupiter Visits Semele in All His Glory*
Unknown Dutch or Flemish artist
Netherlands, late seventeenth–early eighteenth
century
Engraving
7³/4 x 9⁷/8" (19.7 x 25.1 cm)
From an unidentified bilingual (Latin and En-
glish) edition of Ovid's *Metamorphoses*
Philadelphia Museum of Art. Gift of R. Emmett
Murphy. 1998-182-4
 This print is part of a group of twelve engrav-
ings of classical subjects owned by the merchant
Benjamin Godfrey of Philadelphia. The prints
were compiled by Godfrey from a version or ver-
sions of Ovid's *Metamorphoses*. Jan Wandelaar,
Phillip van Gunst, and Martin Bouche are
among the artists of the twelve prints. Godfrey's
household inventory of his parlor lists "12 Old
Roman prints."

442. *Portrait of Johannes Kelpius*
Christopher Witt (born England, 1675–1765)
Germantown, Philadelphia County, c. 1705
Inscription: Johannes Kelpius (top)
Watercolor on paper
9¹/8 x 6³/8" (23.2 x 16.2 cm)
The Historical Society of Pennsylvania,
Philadelphia. 1882.1
 This portrait of the mystic pietist Johannes
Kelpius (1673–1708) is thought to be the earliest
portrait painted in the colony.
See fig. 76.

443. *Portrait of Mary Yeates*
Attributed to Gerardus Duyckinck I (1695–c. 1746)
Delaware Valley, c. 1719
Oil on canvas
31 x 26" (78.7 x 66 cm)
Private Collection
 Mary Yeates, an early resident of the Delaware
Valley, was connected by marriage to the painter

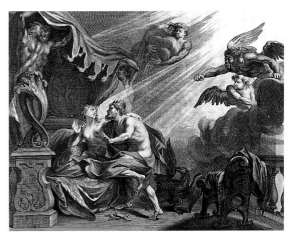

441

443

445

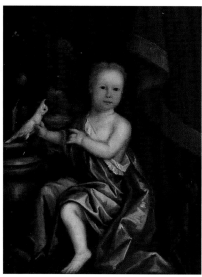

449

Gerardus Duyckinck I. Her father was married to Elisabeth Rodenbergh, whose stepfather was Johannes van Brugh, a relative or a friend of Duyckinck's. Van Brugh's son sold land to Mary's husband, George Yeates.

444. *The South East Prospect of the City of Philadelphia*
Peter Cooper (English, c. 1698–1725)
Philadelphia, c. 1720
Oil on canvas
20 x 87" (50.8 x 221 cm)
The Library Company of Philadelphia
 The Philadelphia Common Council recorded that Peter Cooper was admitted a freeman of the city in May 1717.
See figs. 25, 115.

445. *Tea Drinkers*
Unknown artist, possibly Richard Collins (English, died 1732)
England, c. 1725
Oil on canvas
28 x 24¹/2" (71.1 x 62.2 cm)
The Colonial Williamsburg Foundation, Williamsburg, Virginia. 1954-654
 This painting illustrates a variety of silver and ceramic forms used for serving tea. Although the painting is English, similar objects were produced by a number of Philadelphia silversmiths (see nos. 221, 222, 227).

446. *Bacchus and Ariadne*
Gustavus Hesselius (born Sweden, 1682–1755)
Philadelphia, c. 1725
Oil on canvas
24¹/2 x 32³/8" (62.2 x 82.2 cm)
The Detroit Institute of Arts. Gift of Dexter M. Ferry, Jr. 1948.1
See fig. 80.

447. *Portrait of Charles Norris*
Gustavus Hesselius
Philadelphia, c. 1728–35
Oil on canvas
Framed 18¹/4 x 16" (46.4 x 40.6 cm)
Lent by the Commissioners of Fairmount Park, Philadelphia
 Charles Norris (1712–1766) was a prominent Philadelphia merchant who owned a large three-story Georgian mansion on Chestnut Street between Fourth and Fifth streets.
See fig. 104.

448. *Portrait of James Logan*
Attributed to Gustavus Hesselius
Philadelphia, c. 1728–35
Oil on canvas
31¹/2 x 25¹/2" (80 x 64.8 cm)

The Historical Society of Pennsylvania, Philadelphia. Bequest of Miss Maria Dickinson Logan. 1939.3
See fig. 53.

449. *Portrait of Elizabeth Graeme*
Attributed to Gustavus Hesselius
Philadelphia, c. 1730–35
Inscription: Miss Eliz[abeth Graeme] (in pencil on back of frame)
Oil on canvas
33 x 24³/4" (83.8 x 62.9 cm)
The Schwarz Gallery, Philadelphia
 This portrait was probably commissioned by the sitter's father, Dr. Thomas Graeme.

450. *Portrait of Thomas Lawrence*
Attributed to John Watson (born Scotland, 1685–1768)
New York or New Jersey, c. 1719–30
Oil on canvas
45¹/4 x 36¹/2" (114.9 x 92.7 cm)
The Historical Society of Pennsylvania, Philadelphia. Gift of Mrs. Richard Penn Lardner. 1887.2
 A merchant and mayor of Philadelphia, Thomas Lawrence (1689–1754) figured prominently in the development of maritime commerce in the city.
See fig. 81.

451. *The Rice Bird*
Mark Catesby (born England, 1682–1749)
London, 1731–43
Hand-colored etching
10¹/8 x 14" (25.7 x 35.6 cm)
From *The Natural History of Carolina, Florida, and the Bahama Islands,* volume I
Philadelphia Museum of Art. Purchased with the Thomas Skelton Harrison Fund. 1961-86-56

452. *Nature Prints of Leaves*
Joseph Breintnall (died 1746)
Philadelphia, c. 1731–44
Ink on paper
12¹/4 x 15³/8" (31.1 x 39.1 cm)
The Library Company of Philadelphia
See fig. 68.

453. *Elevation of the State House*
Attributed to Andrew Hamilton (born Scotland, 1676–1741) or Edmund Woolley (probably born England, c. 1695–1771)
Philadelphia, 1732
Ink on paper
13 x 28¹/2" (33 x 72.4 cm)
The Historical Society of Pennsylvania, Philadelphia. Jonathan Dickinson Papers
 Presented to the Pennsylvania Assembly in 1732, this drawing shows the appearance of the

State House prior to 1750, when construction on the tower and belfry began.
See fig. 116.

454. Portrait of David and Phila Franks
Unknown artist
New York, c. 1735
Oil on canvas
45¹/₂ x 36" (115.6 x 91.4 cm)
American Jewish Historical Society, Waltham, Massachusetts, and New York. Gift of Captain N. Taylor Phillips. 1907.4.6

David Franks (1720–1794), brother of Phila Franks (1722–1811) and a member of the Jewish faith, arrived in Philadelphia soon after this portrait was painted and became one of the most prominent and influential merchants in the city.
See fig. 45.

455. Portrait of Tishcohan
Gustavus Hesselius (born Sweden, 1682–1755)
Philadelphia, 1735–37
Inscription: Tishcohan (upper left)
Oil on canvas
33 x 25" (83.8 x 63.5 cm)
The Historical Society of Pennsylvania, Philadelphia. Gift of Granville Penn. 1834.1
See fig. 77.

456. Portrait of Lapowinsa
Gustavus Hesselius
Philadelphia, c. 1735–37
Inscription: Lapowinsa (upper left)
Oil on canvas
33 x 25" (83.8 x 63.5 cm)
The Historical Society of Pennsylvania, Philadelphia. Gift of Granville Penn. 1834.3
See fig. 78.

The portraits of Delaware Indian chiefs Tishcohan and Lapowinsa were probably commissioned by John and Thomas Penn. Both chiefs were signers of the Walking Purchase treaty, an attempt to settle a land dispute between the Penns and the Delaware, or Lenni-Lenape, Indians. The Penn records indicate that on June 12, 1735, John Penn directed that £16 be "Paid on his Order to Hesselius the Painter," probably in payment for these two paintings.

457. Portrait of Tench Francis
Robert Feke (born New York, c. 1707–c. 1751)
Philadelphia, 1746
Signature: R. Feke / Pinx 1746 (lower right)
Oil on canvas
49 x 39" (124.5 x 99.1 cm)
The Metropolitan Museum of Art. Maria DeWitt Jesup Fund. 1934.153
See fig. 84.

458. Sketch for the Library Building
James Logan (born Ireland, 1674–1751)
Philadelphia, 1748
Ink on paper
85/8 x 13¹/₈" (21.9 x 33.3 cm)
The Historical Society of Pennsylvania, Philadelphia

459. Drawing of a Bird
Attributed to John Bartram (born Pennsylvania, 1699–1777)
Philadelphia, c. 1748
Ink on paper
9¹/₈ x 73/8" (23.2 x 18.7 cm)
Private Collection

This drawing was presented by Bartram to Nereus Mendenhall of Chester County, Pennsylvania, in 1748, before Mendenhall's departure with a group of Quakers to North Carolina.
See fig. 56.

460. Portrait of Elizabeth Branson Lardner
Robert Feke (born New York, c. 1707–c. 1751)
Philadelphia, 1749
Oil on canvas
43¹/₂ x 36" (110.5 x 91.4 cm)
Private Collection

Elizabeth's husband, Lynford Lardner, recorded in his account book and daybook (now in the Rosenbach Museum and Library, Philadelphia) on November 15, 1749, "Paid Phyke Face Painter for my own & Wife's Picture." Her father, William Branson, was an influential Philadelphia businessman with interests in several ironworks, including Reading Furnace in Berks County, Pennsylvania.
See fig. 74.

461. Portrait of Lynford Lardner
John Hesselius (born Pennsylvania, 1728?–1778)
Philadelphia, 1749
Signature: Jnᵒ Hesselius pinx (center right)
Inscription: Lynford Lardner AEtats 34/Jnᵒ Hesselius pinxᵗ 1749 (on the back)
Oil on canvas
39¹/₄ x 32" (99.7 x 81.3 cm)
Private Collection

On January 18, 1749, Lardner recorded in his account book and daybook that he paid Hesselius £6 for his portrait.
See fig. 95.

462. Portrait of Benjamin Lay
William Williams (born England, 1727–1791)
Philadelphia, c. 1750
Inscription: BENJAMIN LAY (on the back)
Oil on red walnut panel
153/8 x 143/8" (39.1 x 36.5 cm)
National Portrait Gallery, Smithsonian Institution. Gift of the James Smithson Society. NPG.79.171
See fig. 91.

451

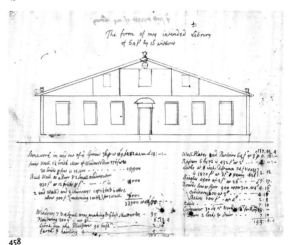
458

463. The Duché House
Unknown artist
Philadelphia, c. 1750–60
Oil on canvas
28¹/₂ x 22³/₄" (72.4 x 57.8 cm)
The Library Company of Philadelphia

The Duché House was built about 1750–60, either for Colonel Jacob Duché or for his son Jacob, a reverend. The rooftop balustrade and the imported English urns on the roof echo those used in the construction of Christ Church and were also prescribed by James Logan in his drawings for his library buildings.

464. Portrait of Elizabeth Chew
John Wollaston (born England, c. 1710–after 1775)
Philadelphia, c. 1752
Oil on canvas
50 x 40" (127 x 101.6 cm)
Chester County Historical Society, West Chester, Pennsylvania. PTG 156

465. Portrait of Joseph Turner
John Wollaston
Philadelphia, c. 1752
Oil on canvas
49¹/₄ x 39¹/₄" (125.1 x 99.7 cm)
Chester County Historical Society, West Chester, Pennsylvania. PTG 157
See fig. 85.

466. Portrait of Margaret Oswald
John Wollaston
Philadelphia, c. 1752
Oil on canvas
50¹/₄ x 40¹/₂" (127.6 x 102.9 cm)
Cliveden, a co-stewardship property of the National Trust for Historic Preservation. Germantown, Pennsylvania. NT.72.41.8
See fig. 86.

467. Self-Portrait
John Meng (born Pennsylvania, 1734–c. 1754)
Germantown, Philadelphia County, c. 1752–54
Oil on canvas
43¹/₄ x 32¹/₂" (109.9 x 82.6 cm)
The Historical Society of Pennsylvania, Philadelphia. Gift of Charles S. Ogden. 1896.9

468. The Analysis of Beauty
William Hogarth (English, 1697–1764)
London, 1753
Engraving
15³/₈ x 19⁷/₈" (39.1 x 50.5 cm)
From The Analysis of Beauty, plate 1
Philadelphia Museum of Art. Gift of Boies Penrose. 1940-11-82

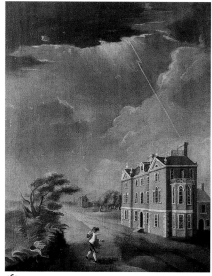
463

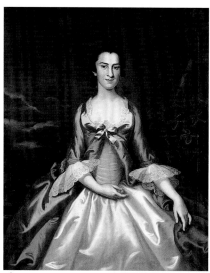
464

469. An East Prospect of the City of Philadelphia
George Heap (c. 1715–1752) and Nicholas Scull (born Pennsylvania, 1687–1761)
Engraved by Gerard Vandergucht (English, active c. 1753)
London, c. 1751–53
Engraving
Four plates, each 21¹/₄ x 20¹/₈" (54 x 51.1 cm)
The Episcopal Academy, Merion, Pennsylvania

Similar to larger portfolio cartography, this impressive engraved view of the city at mid-century required four large plates. An advertisement for subscriptions to this series appeared in The Pennsylvania Journal and The Pennsylvania Gazette from September 28 to December 26, 1752.
See fig. 47.

470. Portraits of Johanna Ingerheidt Schmick and John Jacob Schmick, Sr.
John Valentine Haidt (born Danzig, 1700–1780)
Bethlehem, Pennsylvania, c. 1754
Oil on canvas
Portrait of Johanna 26¹/₄ x 20¹/₂" (66.7 x 52.1 cm)
Portrait of John 26³/₈ x 20¹/₂" (67 x 52.1 cm)
The Moravian Historical Society, Nazareth, Pennsylvania. 748, 749
See fig. 87.

471. Portrait of George Ross
Benjamin West (born Pennsylvania, 1738–1820)
Lancaster, Pennsylvania, c. 1755–56
Oil on canvas
42¹/₂ x 33¹/₂" (108 x 85.1 cm)
Rothman Gallery, Franklin and Marshall College, Lancaster, Pennsylvania. 2496

472. Rebecca at the Well
Benjamin West
Philadelphia or Lancaster, Pennsylvania, c. 1755–57
Inscription: One of the first attempts at historical composition by Benjⁿ West. while in Philadelphia 1757 (pen and brown ink)
Pen and ink, black wash over black chalk on paper
13⁵/₈ x 20⁵/₈" (34.6 x 52.4 cm)
The Pierpont Morgan Library, New York. 1970.11:1
See fig. 88.

473. The Death of Socrates
Benjamin West
Lancaster, Pennsylvania, c. 1756
Signature: [] Henry / B West [pi]nxit (on step, lower left; part of signature lost through cleaning)
Oil on canvas
34 x 41" (86.4 x 104.1 cm)
The Historical Society of Pennsylvania, Philadelphia. 1989.52
See fig. 90.

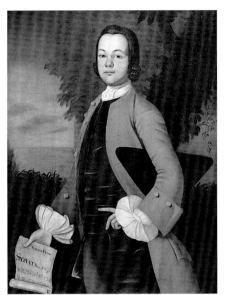

467

468

474. *Achilles among the Daughters of Lycomedes*
Henry Benbridge (born Pennsylvania, 1743–1812)
Philadelphia, c. 1756–60
Oil on canvas
26¼ x 42¼" (66.7 x 107.3 cm)
Philadelphia Museum of Art. Purchased with the
J. Stogdell Stokes Fund, the Edith H. Bell Fund,
and the Katharine Levin Farrell Fund. 1990-88-1

**475. *A South-East Prospect of Pennsylvania
Hospital***
Engraved by Henry Dawkins (born England,
active c. 1753–86) and John Steeper (active
1755–62) after sketches by John Winter (active
1739–71) and Montgomery
Printed by Robert Kennedy in Philadelphia, 1761
Engraving with watercolor
8⅜ x 13¾" (21.3 x 34.9 cm)
Collection of Jay and Terry Snider
See fig. 65.

476. *Portrait of Benjamin Franklin*
Mason Chamberlin (born England, 1727–1787)
London, 1762
Oil on canvas
50⅜ x 40¾" (128 x 103.5 cm)
Philadelphia Museum of Art. Gift of Mr. and
Mrs. Wharton Sinkler. 1956-88-1
See fig. 59.

477. *A South East View of Christ Church*
Charles Willson Peale (born Maryland,
1741–1827)
Philadelphia, 1787
Engraving
Framed 11¼ x 8½" (28.6 x 21.6 cm)
Collection of Robert S. Teitelman
 Although this image was created about forty-
three years after the construction of Christ
Church was completed, it is one of the earliest
detailed images of its exterior. Commissioned by
Columbian Magazine, this engraving appeared in
a supplement to the periodical's first volume.
The design of Christ Church is attributed to
Dr. John Kearsley (1684–1772).
See fig. 114.

478. *Slate Roof House*
Attributed to William Strickland (born New
Jersey, 1788–1854)
Philadelphia, c. 1825–45
Ink wash on card
6⅝ x 8⅜" (16.8 x 21.3 cm)
The Schwarz Gallery, Philadelphia
See fig. 117.

479. *Old London Coffee House*
Attributed to David Johnston Kennedy (born
Scotland, 1816/17–1898)

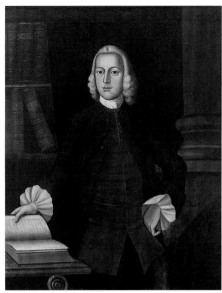

471

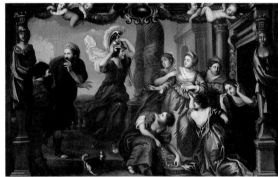

474

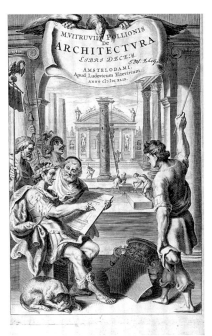

482

Philadelphia, c. 1836–70
Ink on paper
Image 4³/8 x 6³/8" (11.1 x 16.2 cm)
Private Collection
See fig. 43.

480. Carpenter's Mansion

Attributed to David Johnston Kennedy
Philadelphia, c. 1836–70
Ink on paper
4³/8 x 6¹/4" (11.1 x 15.9 cm)
Private Collection
See fig. 120.

Manuscripts, Maps, and Printed Works

481. Euclid's *Elemental Geometry*

Translated into Arabic by Nāsir-al-Dīn
Printed in Rome, 1594
Open 13 x 17³/4" (33 x 45.1 cm)
The Library Company of Philadelphia
 By the time he was thirteen, the gifted linguist
James Logan had learned Latin, Greek, and some
Hebrew. Logan added this Arabic copy of Euclid,
marked with his own notes in Arabic and Latin,
to his library at Stenton in 1725.
See fig. 2.

482. Vitruvius's *De Architectura*

Edited by Guillaume Philandrier et al.
Printed in Amsterdam, 1649
Open 12¹/4 x 16¹/8" (31.1 x 41 cm)
The Library Company of Philadelphia
 This copy was originally owned by James
Logan of Philadelphia.

483. Map of New Sweden

Peter Mårtensson Lindeström (born Sweden,
1632–1691)
Stockholm, c. 1654–56
Watercolor on vellum
21¹/2 x 11³/4" (54.6 x 29.8 cm)
The Royal Library of Stockholm

484. A Letter from William Penn, Proprietary and Governour of Pennsylvania in America, to the Committee of the Free Society of Traders

William Penn (born England, 1644–1718)
Printed by Andrew Sowle in London, 1683
11³/4 x 8" (29.8 x 20.3 cm)
Private Collection
See figs. 20, 32.

485. Philosophiæ Naturalis Principia Mathematica

Sir Isaac Newton (English, 1642–1727)
Printed in London, 1687
Open 9⁷/8 x 15" (25.1 x 38.1 cm)
The Library Company of Philadelphia

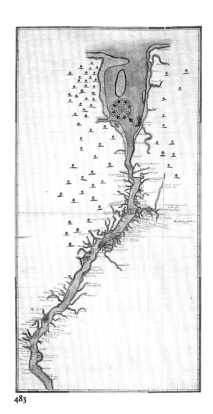

483

James Logan made notations in Latin in this 1709 addition to his library at Stenton.
See fig. 54.

486. *Zonder Kruys Geen Kroon* (No Cross, No Crown)
William Penn (born England, 1644–1718), translated into Dutch by William Séwel (1653–1720)
Published by Jacob Claus in Amsterdam, 1687
5³/8 x 3" (13.7 x 7.6 cm)
Private Collection
This copy was originally owned by William Penn.
See fig. 31.

487. *A Mapp of Ye Improved Part of Pensilvania in America*
Thomas Holme (born England, 1624–1695)
Engraved by George Willdey
London, c. 1700
Hand-colored engraving
12¹/8 x 18" (30.8 x 45.7 cm)
Collection of Jay and Terry Snider

488. Charter for the City of Philadelphia
William Penn (born England, 1644–1718)
Philadelphia, 1701
Ink on vellum with a wax seal
With hanging seal 41 x 26¹/2" (104.1 x 67.3 cm)
City of Philadelphia, Department of Records, City Archives, RG 60, Office of the Mayor, City Charter, 1701
Granted by Penn as a result of growing anti-proprietary sentiments, the Charter of 1701 decentralized Penn's authority, conveying limited powers of government to a mayor, aldermen, and councilmen.
See fig. 39.

489. *Kort Beskrifning om Provincien Nya Swerige uti America, som nu Fortjden af the Engelske Kallas Pensylvania* [Short description of the province of New Sweden, now called by the English, Pennsylvania in America]
Tomas Campanius Holm (born Sweden, c. 1670–1702)
Printed in Stockholm, 1702
7⁷/8 x 6" (20 x 15.2 cm)
The Dietrich American Foundation
See figs. 19, 26.

490. Estate Inventory for the Silversmith Francis Richardson, Sr.
Recorded by John Cadwalader and Edward Roberts in Philadelphia, 1729
Ink on paper
12⁷/8 x 7³/4" (32.7 x 19.7 cm)
Register of Wills, City of Philadelphia, 1729, Will no. 127.

491. Shipbuilding Journal
Thomas Penrose (born Pennsylvania, 1709/10–1757)
Philadelphia, c. 1730–55
Ink on paper, vellum binding
7¹/2 x 5" (19.1 x 12.7 cm)
Private Collection

492. *America Septentrionalis, or A Map of the British Empire in America with the French and Spanish Settlements Adjacent thereto*
Henry Popple (English, died 1743)
Engraved by William Henry Toms (English, c. 1700–c. 1750) and R. W. Searle
Printed by S. Harding in London, 1733
Hand-colored engraving
96 x 90" (243.8 x 228.6 cm)
The Dietrich American Foundation
See fig. 1.

493. Ship Manifests
Bartholomew Penrose (1708–1758)
Philadelphia, 1735–56
Ink on paper, leather binding
4¹/2 x 9¹/2" (11.4 x 24.1 cm)
Private Collection
See fig. 42.

494. *A New Book of Cyphers, More Compleat and Regular Than Any Ever Publish'd*
Samuel Sympson
Printed in London, 1739
7³/4 x 4⁵/8" (19.7 x 11.7 cm)
The Ryerson and Burnham Libraries, The Art Institute of Chicago. D18.19 S99
See fig. 209.

495. *A Catalogue of Books Belonging to the Library Company of Philadelphia*
Printed by Benjamin Franklin in Philadelphia, c. 1741
Open 6¹/8 x 7⁷/8" (15.6 x 20 cm)
The Library Company of Philadelphia
While this is the earliest surviving catalogue of the holdings of the Library Company, Franklin also printed earlier, broadside additions of the library's holdings in 1733 and 1735. Subscribers to the Library Company could suggest books to add to the circulating collections, which were purchased by agents such as Peter Collinson in London.
See fig. 63.

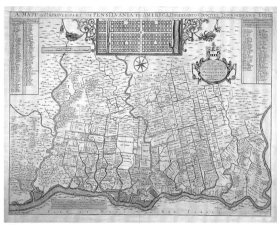
487

490

491

496

497

498

503

496. *Das Neue Testament Unsers Herrn und Henlandes Jesu Christi . . .* (The New Testament)
Printed by Christopher Sauer [Christoph Saur] (born Germany, 1695–1758)
Germantown, Philadelphia County, 1743
10¹/8 x 8¹/4" (25.7 x 21 cm)
Philadelphia Museum of Art. Gift of J. Stogdell Stokes. 1936-19-6a

497. Cicero's *Cato Major*, or *Discourse of Old-Age*
Translated by James Logan
Printed by Benjamin Franklin in Philadelphia, 1744
8¹/2 x 57/8" (21.6 x 14.9 cm)
Private Collection

Franklin concluded his printer's note with the endorsement: "I shall add to these few Lines my hearty Wish, that this first Translation of a *Classic* in this *Western World,* may be followed with many others, performed with equal Judgment and Success; and be a happy Omen, that *Philadelphia* shall become the Seat of the *American* Muses."

498. *A Treaty Held at the Town of Lancaster, in Pennsylvania, . . . with the Indians of the Six Nations, in June, 1744*
Printed by Benjamin Franklin in Philadelphia, 1744
13¹/4 x 7³/4" (33.7 x 19.7 cm)
Private Collection

499. *Franklin's Stove*
James Turner (active 1744–59) after Lewis Evans (c. 1700–1756)
Printed by Benjamin Franklin in Philadelphia, c. 1744
Unfolded page 8¹/8 x 163/8" (20.6 x 41.6 cm)
From *An Account of the New Invented Pennsylvanian Fire-Places*
The Library Company of Philadelphia
See fig. 62.

500. *An Essay on the West-India Dry-Gripes*
Thomas Cadwalader (born Pennsylvania, 1707/8–1779)
Printed by Benjamin Franklin in Philadelphia, c. 1745
8¹/4 x 5¹/4" (21 x 13.3 cm)
Library of the College of Physicians of Philadelphia
This is the first medical tract printed in America.
See fig. 70.

501. Map of the Allegheny Ridge
John Bartram (born Pennsylvania, 1699–1777)
Philadelphia, c. 1745–47
Inscription: Mr. Bartram's Map very curious (on the back in Benjamin Franklin's hand)
Ink on paper

12¹/₄ x 15" (31.1 x 38.1 cm)
American Philosophical Society, Philadelphia
See fig. 57.

502. *Poor Richard Improved*
Benjamin Franklin (born Boston, 1706–1790)
Printed in Philadelphia, 1750
7 x 37/8" (17.8 x 9.8 cm)
Private Collection

Poor Richard's Almanack is the name commonly used for the almanacs issued from 1732 to 1757 by Benjamin Franklin, whose pen name for this series was Richard Saunders. Before 1747 the almanacs were called *Poor Richard;* later editions were called *Poor Richard Improved.*
See fig. 49.

503. Record of Circumcisions, Congregation Mikveh Israel
Philadelphia, c. 1750
Ink and watercolor on paper
6¹/₄ x 4" (15.9 x 10.2 cm)
Congregation Mikveh Israel, Philadelphia

504. List of Yehidim (Elders), Congregation Mikveh Israel
Philadelphia, c. 1750–70
Ink on paper
11 x 8¹/₂" (27.9 x 21.6 cm)
Congregation Mikveh Israel, Philadelphia
See fig. 44.

505. *Some Account of the Pennsylvania Hospital; From Its First Rise, to the Beginning of the Fifth Month, Called May, 1754*
Benjamin Franklin (born Boston, 1706–1790)
Printed by Benjamin Franklin and David Hall in Philadelphia, 1754
10¹/8 x 8" (25.7 x 20.3 cm)
Library of the College of Physicians of Philadelphia

506. Birth and Baptismal Certificate of Michael Heller
Unknown artist
Bucks or Northampton County, Pennsylvania, 1757
Ink and pigment on paper
13¹/₂ x 17¹/₄" (34.3 x 43.8 cm)
Private Collection

505

506

Notes

1. While these early boxes have traditionally been referred to as "bible boxes," none of the early inventories I examined listed them as such or included a Bible in the itemized contents. Entries for textile chests, on the other hand, regularly include the contents and often list Bibles and other books. For chests or boxes, see Margaret B. Schiffer, *Chester County, Pennsylvania, Inventories, 1684–1850* (Exton, Pa.: Schiffer Publishing, 1974), pp. 101, 132.

2. The sides of these interior compartments were often set into the box at a slant, a feature found on early Germanic and northern European examples.

3. See Schiffer, *Chester County, Pennsylvania, Inventories,* p. 109.

4. These early straight stile feet were later often broken off or purposely removed and replaced with turned feet. Also, bracket-form foot facings were sometimes added quite early to these stile feet, updating the form to the then-preferred fashion. Some case furniture was originally constructed with turned feet at the front and stile back posts as rear supports.

5. Ruth Matzkin, "Inventories of Estates in Philadelphia County, 1682–1710" (master's thesis, University of Delaware, 1959), pp. 108–9.

6. The chest of drawers probably evolved from the chest over drawers, but no clearly documented progression or evolution can be identified in the surviving Pennsylvania case furniture. Both forms continued to be made concurrently during the early eighteenth century.

7. See, for example, Reinier Baarsen, "The Court Style in Holland," in Baarsen et al., *Courts and Colonies: The William and Mary Style in Holland, England, and America* (Washington, D.C.: Cooper-Hewitt Museum, 1988), pp. 24–28.

8. Panel and molded chests of drawers from Boston, particularly the group from the Ralph Mason/Henry Messenger shops (c. 1690–1720), provide interesting comparisons to this lone Philadelphia version. For examples, see Robert F. Trent, "The Chest of Drawers in America, 1635–1730: A Postscript," *Winterthur Portfolio,* vol. 20, no. 1 (Spring 1985), pp. 42–47.

9. Two related examples of case furniture that include similar dowel-attached Spanish feet are known: an early two-part secretary bookcase of walnut in a private collection, and a small three-drawer chest in the collection of the Winterthur Museum, Delaware.

10. A similar chest, also signed by Beake, is in the collection of the Dietrich American Foundation, Philadelphia.

11. For examples of these European and English prototypes, see Baarsen et al., *Courts and Colonies,* pp. 26–27, and Peter Thornton, *Authentic Decor: The Domestic Interior, 1620–1920* (London: Weidenfeld and Nicolson, 1984), pp. 14–87.

12. See Benno Forman, "The Chest of Drawers in America, 1635–1730: The Origins of the Joined Chest of Drawers," *Winterthur Portfolio,* vol. 20, no. 1 (Spring 1985), pp. 17–25. For other examples of European and English prototypes of cabinets on stand, see Baarsen et al., *Courts and Colonies,* illustrations on pp. 153, 155, 157.

13. Register of Wills, City of Philadelphia, Margaret Beardsley, 1700, Will no. 42.

14. William MacPherson Hornor, Jr., *Blue Book of Philadelphia Furniture: William Penn to George Washington* (1935; repr. Washington, D.C.: Highland House Publishers, 1977), p. 30.

15. The arch created by the facing S-scrolled ogees is similar to the pointed arch from ancient Islamic, Persian, and other Eastern traditions. These exotic motifs traveled across Europe with early Portuguese traders and later through the imports of the Dutch East India Company, founded in 1602. Exotic ceramics, textiles, metalwork, and furniture influenced European patterns and motifs. These same influences would eventually affect American taste through immigrants' memories of Dutch and English versions. See Christiaan J. A. Jörg, "The Dutch Connection: Asian Export Art in the Seventeenth and Eighteenth Centuries," *Antiques,* vol. 153, no. 3 (March 1998), pp. 438–47.

16. See Beatrice B. Garvan in Philadelphia Museum of Art, *Philadelphia: Three Centuries of American Art* (Philadelphia: Philadelphia Museum of Art, 1976), pp. 25–27.

17. Inventory of Caspar Wistar, April 13, 1752, Wistar Family Papers, mss. 727, The Historical Society of Pennsylvania, Philadelphia; quoted by Garvan in *Philadelphia: Three Centuries of American Art,* pp. 25–26.

18. Inventories from the period indicate that the tops of high chests, secretary desks, and other large case pieces, as well as mantelpieces, were often used to display expensive imported ceramics in the households that could afford such luxuries.

19. Register of Wills, City of Philadelphia, John Tatham, 1700, Will no. 25; Elizabeth Tathum, 1701, Will no. 59; quoted in Cathryn J. McElroy, "Furniture in Philadelphia: The First Fifty Years," in *American Furniture and Its Makers,* Winterthur Portfolio, vol. 13, ed. Ian M. G. Quimby (Chicago and London: The University of Chicago Press for the Henry Francis du Pont Winterthur Museum, 1979), p. 68.

20. *The Pennsylvania Gazette,* no. 1462, December 30, 1756; reproduced in Alfred Coxe Prime, *Colonial Craftsmen of Pennsylvania: Reproductions of Early Newspaper Advertisements from the Private Collection of Alfred Coxe Prime* (Philadelphia: Pennsylvania Museum and School of Industrial Arts, 1925), p. 18. See also Mary Ellen Hayward, "The Elliotts of Philadelphia: Emphasis on the Looking Glass Trade, 1755–1810" (master's thesis, University of Delaware, 1971), p. 29.

21. Register of Wills, City of Philadelphia, William Till, 1711, Will no. 216; quoted in Benno M. Forman, "Furniture for Dressing in Early America, 1650–1730: Forms, Nomenclature, and Use," *Winterthur Portfolio,* vol. 22, nos. 2/3 (Summer/Autumn 1987), p. 157.

22. Register of Wills, City of Philadelphia, Jonathan Dickinson, 1722, Will no. 251 quoted in Forman, "Furniture for Dressing in Early America," p. 157. Dickinson's inventory is reproduced in Harrold E. Gillingham, "Notes and Documents: The Estate of Jonathan Dickinson (1663–1722)," *Pennsylvania Magazine of History and Biography,* vol. 59, no. 4 (October 1935), pp. 422–28.

23. For an illustration of a Pennsylvania example with a fitted drawer, now in a private collection, see Forman, "Furniture for Dressing in Early America," p. 162.

24. William Penn Cash Book, 1701, American Philosophical Society, Philadelphia; quoted by Garvan in *Philadelphia: Three Centuries of American Art,* p. 13.

25. William Trent Ledger, 1703–9, p. 202, The Historical Society of Pennsylvania, Philadelphia; quoted by Garvan in *Philadelphia: Three Centuries of American Art,* p. 13

26. These drawers may have been used to store larger portfolio-format maps or navigational charts; their width and depth would certainly have accommodated them.

27. For examples of these cabinets on stands, see Baarsen et al., *Courts and Colonies,* pp. 153 and 157, nos. 102 and 107. The arrangement of the interior of the Evans desk in compartments also appears frequently in a smaller case form, the Pennsylvania "spice box."

28. The overall form of the desk relates closely to an inlaid cedar and walnut fall-front desk attributed to New York and with a provenance relating it to the Dutch Brinckerhoff family of Flushing; this desk is now in the collections of the

Museum of the City of New York. For the New York desk, see Baarsen et al., *Courts and Colonies*, p. 154; for the Philadelphia desk, see McElroy, "Furniture in Philadelphia," p. 76.

29. Register of Wills, City of Philadelphia, Joseph Redman, 1722, Will no. 257; quoted in Hornor, *Blue Book of Philadelphia Furniture*, p. 21.

30. A similar desk, of walnut, is in the collection of Wyck, the Germantown house of Caspar Wistar, and survives with a provenance documenting ownership to Wistar.

31. Richard Hill Cash Accounts, 1729–42, The Historical Society of Pennsylvania, Philadelphia; quoted in Arthur W. Leibundguth, "The Furniture-Making Crafts in Philadelphia, c. 1730–c. 1760" (master's thesis, University of Delaware, 1964), p. 9.

32. *The Pennsylvania Gazette*, June 14, 1739; quoted in Leibundguth, "The Furniture-Making Crafts in Philadelphia," pp. 14–15.

33. Surviving Philadelphia inventories dating before 1730 indicate that around two-thirds of the households owning clocks in this early period left estates valued at £400 or more, a large sum for this period of time. See McElroy, "Furniture in Philadelphia," p. 78.

34. In 1722 Joseph Redman's countinghouse had on hand "284 hour & ½ hour glasses." See Hornor, *Blue Book of Philadelphia Furniture*, p. 21.

35. This clock is now in the collections of the Library Company of Philadelphia, inv. no. 4.

36. The Graham clock descended in the Wistar and Morris families of Philadelphia and might be the same clock listed in the 1752 inventory of Caspar Wistar's house on Market Street between Second and Third streets. Inventory of Caspar Wistar, April 13, 1752, Wistar Family Papers, mss. 727, The Historical Society of Pennsylvania, Philadelphia. The cabinetmaker responsible for its clock case is presently unknown. Examples of slightly later Philadelphia-made cases with sarcophagus tops, housing clockworks by Peter Stretch, have survived with their applied fretwork partially intact and have been restored by their present owners. The fretwork and case of the Graham clock are the best preserved among the early case clocks presently known. It and the surviving examples made by Stretch have served as reference points when other Pennsylvania clock cases required restoration of their fretwork.

37. This decorative treatment may have been an attempt to approximate the effect of ornate sawn tortoiseshell and wood veneers seen in French, Dutch, and English "boulle"-work marquetry.

38. Quoted by Garvan in *Philadelphia: Three Centuries of American Art*, pp. 15–16.

39. See Martha Gandy Fales, *Joseph Richardson and Family: Philadelphia Silversmiths* (Middletown, Conn.: Wesleyan University Press, 1974), p. 23.

40. See Hornor, *Blue Book of Philadelphia Furniture*, p. 15.

41. See ibid., p. 87.

42. See Lee Ellen Griffith, "The Pennsylvania Spice Box—Paneled Doors and Secret Drawers," in *Catalog for the Chester County Antiques Show* (West Chester, Pa.: Chester County Historical Society, 1987).

43. Register of Wills, City of Philadelphia, Martha Waite, 1720, Will no. 210.

44. Schiffer, *Chester County, Pennsylvania, Inventories*, p. 122.

45. The contents of the box were inventoried in 1810–12 by a later member of the Shinn family. While much of the contents are later than the 1745–50 date of the box's manufacture, they are probably a good reflection of the types of objects found in such boxes earlier.

46. Register of Wills, City of Philadelphia, James Sandelands, 1708, Administration File no. 29, Book B, p. 62; quoted in Hornor, *Blue Book of Philadelphia Furniture*, p. 10.

47. The earliest Chester County example with an inlaid date is a small chest of drawers with the date 1706 (no. 25). See Margaret Berwind Schiffer, *Furniture and Its Makers of Chester County, Pennsylvania* (Exton, Pa.: Schiffer Publishing, 1978), plate 118.

48. For examples, see Baarsen et al., *Courts and Colonies*, illustrations on pp. 13, 107, 119, 230–39.

49. See Lee Ellen Griffith, "Line and Berry Inlaid Furniture: A Regional Craft Tradition in Pennsylvania, 1682–1790" (Ph.D. diss., University of Pennsylvania, 1988), pp. 157–82.

50. Chester County makers continued to use oak and chestnut as secondary woods long after cabinetmakers in Philadelphia and elsewhere were using poplar, cedar, and white pine. Whether this was because these woods were abundant in the area or because local craftsmen wished to maintain tradition, or a combination of the two, is not known.

51. Griffith, "Line and Berry Inlaid Furniture," pp. 91–114, esp. pp. 93–99.

52. See McElroy, "Furniture in Philadelphia," pp. 67–68.

53. While it is rare in Delaware Valley folding tables to find the turned-leg arrangement of opposing baluster or vase-shaped turnings separated by a ring or ball as is common in New England examples, a few early slab tables from the region do have such turned legs and may be the result of Boston-trained turners working in Philadelphia prior to 1730. The leg patterns preferred by local turners seem to have varied—vertical compositions of baluster-vase-over-ring(s)-over-vase or ball-over-block-over-foot, which is usually a ball or a half ball. This symmetrical arrangement of flanking devices with a central ring or ball was commonly used for turned horizontal stretchers on locally produced tables and chairs.

54. No Philadelphia examples of slate tables from this period are known. Boston examples of "mixing" and dressing tables are rare but may provide some hint as to the form of those produced in Philadelphia. The Boston examples have imported Swiss slate- and marquetry-decorated, octagonal wood-framed tops on turned-leg frames. For illustrations, see Winslow Ames, "Swiss Export Table Tops," *Antiques*, vol. 80, no. 1 (July 1961), pp. 46–49.

55. Peter Kalm, *The America of 1750: Peter Kalm's Travels in North America*, English edition, rev. and ed. Adolph B. Benson, vol. 1 (New York: Dover Publications, 1966), p. 46; see also Hornor, *Blue Book of Philadelphia Furniture*, p. 61.

56. James Logan owned a group of European marble samples that illustrated the range of stone used in ancient Greek and Roman architecture and sculpture; a sample of this Spanish marble was included among this group of "curiosities." See no. 429.

57. See, for example, the engraved table designs of Gerbrandt van der Eeckhout (1621–1674) of Rijksprentenkabinet, Rijksmuseum, Amsterdam. For later examples, see Thomas Johnson, *A New Book of Ornament* (London, 1762).

58. Leibundguth, "The Furniture-Making Crafts in Philadelphia," p. 91.

59. This dovetail mortise, which is the joint most often employed in later, Revolutionary-period tea tables, first appears in Philadelphia on tables made c. 1730–40. The flat, iron reinforcing "spiders" often attached to the underside of later versions do not seem to have been employed as a structural device on any of the early examples.

60. See Hornor, *Blue Book of Philadelphia Furniture*, p. 95. The Hall citation is corroborated by a receipt to Philip Redman in the collection of the Historical Society of Pennsylvania, Philadelphia. See also no. 39.

61. An account book of Lynford Lardner lists "to a set of chairs and SQ. tea tray Table from Harrison, Dublin," Account Book and Day Book of Lynford Lardner, 1748–51, p. 38, entry for May 14, 1749, private collection.

62. Quoted in Hornor, *Blue Book of Philadelphia Furniture*, caption for plate 74, opposite p. 64.

63. For Harding, see Garvin in *Philadelphia: Three Centuries of American Art*, p. 42. More recent research on a group of furniture carvings attributed to Harding has been undertaken by Luke Beckerdite.

64. One exception is a shaped, block-front version illustrated in Hornor, *Blue Book of Philadelphia Furniture*, plate 25, opposite p. 33; it is now in a private collection. Other, turret-corner versions examined were imported or could not be firmly documented to the period before 1758.

65. *Minutes and Proceedings of the Assembly and Supreme Executive Council of the Colony of Pennsylvania*, ed. Theo Finn (Harrisburg, Pa., 1853), vol. 3, book 12, pp. 12–13; quoted in Hornor, *Blue Book of Philadelphia Furniture*, p. 63.

66. Register of Wills, City of Philadelphia, Patrick Gordon, 1736, Will no. 1; quoted in Hornor, *Blue Book of Philadelphia Furniture*, p. 63.

67. Hornor, ibid., p. 64, cites several specific mentions of gaming tables in taverns during the period, but the documents he cites could not be located.

68. Register of Wills, City of Philadelphia, Christopher Taylor, 1685, Will no. 26; quoted in part in McElroy, "Furniture in Philadelphia," p. 62.

69. Register of Wills, City of Philadelphia, James Claypoole, 1688, Will no. 34. See also Hornor, *Blue Book of Philadelphia Furniture*, p. 17.

70. Schiffer, *Chester County, Pennsylvania, Inventories*, p. 202.

71. Both these chairs are thought to have originally belonged to Robert Pearson, an English Quaker who immigrated to the Delaware Valley around 1680 and settled in Crosswicks Creek, Burlington County, New Jersey. Chair no. 112 is thought to have been made, probably in a Philadelphia shop, sometime in the decade 1690–1700, as Pearson died in 1703–4. See Garvan in *Philadelphia: Three Centuries of American Art*, p. 9; see also Benno Forman, *American Seating Furniture, 1630–1730: An Interpretive Catalogue* (New York and London: W. W. Norton and Company, 1988), pp. 220–21, cat. no. 48. The other chair is in the collection of the Winterthur Museum, Delaware. Forman's research on these chairs is the most complete to date. He cites

another chair with twist-turned elements, possibly of Philadelphia origin (p. 222, fig. 111).

72. Again, the research of Benno Forman on the early Pennsylvania forms of wainscot chairs remains the most comprehensive and accurate. See Forman, *American Seating Furniture*, pp. 133–43, 145–46, 148–63, 168–69, 175–79.

73. In 1708 Ralph and Elizabeth Fishbourn's six chairs in the outer parlor of their house in Chester, Pennsylvania, were described as "1/2 doz of oaken Chaires"; in 1709 they were referred to as "6 Wainscot chairs." In 1716 John Hoskins, another resident of Chester, owned a "Seald arme chear" valued at 10s. See Schiffer, *Chester County, Pennsylvania, Inventories*, pp. 107, 300, 301.

74. The Swedish and Germanic influences found in these chairs may have originated in the Delaware Valley settlements that predated the arrival of Penn, surviving in the areas in which a single ethnic craftsman or concentrations of those populations settled. One craftsman working in these traditions in the region as early as 1683 was a Swede named Broer Sinnexen. His 1708 inventory lists a surprising number of planes, augers, drawknives, and other tools of the type necessary to make paneled chairs. See Forman, *American Seating Furniture*, pp. 141–42.

75. Many of the early Quaker meetinghouses in Chester County towns such as London Grove and New Garden had sizable numbers of Welsh and Irish members.

76. Forman, *American Seating Furniture*, pp. 140–41, 164.

77. Forman, *ibid.*, p. 136, fig. 60, cites and illustrates a chair from the Limburg region of the Netherlands that shows close parallels.

78. Ibid., pp. 172–74.

79. Popular in the courts of Louis XIV and later William and Mary, suites of four of these stools *(tabourets)* were often included in throne rooms for seating honored attendants to the king or queen, particularly ladies; the form was later adopted by the merchant and aristocratic classes. See John Gloag, *A Short Dictionary of Furniture* (London: George Allen and Unwin, 1969), p. 660; see also Baarsen "The Court Style in Holland," p. 12.

80. Register of Wills, City of Philadelphia, Jonathan Dickinson, 1722, Will no. 251; see Gillingham, "The Estate of Jonathan Dickinson," p. 424.

81. Research File 1971-91-1, Department of American Art, Philadelphia Museum of Art. See also Hornor, *Blue Book of Philadelphia Furniture*,

pp. 49, 199.

82. "6 1/2 yrds of Iron Chain for a couch" were listed in Caleb Emlen's shop inventory of 1748; see Hornor, *Blue Book of Philadelphia Furniture*, p. 58.

83. See, for example, Schiffer, *Chester County, Pennsylvania, Inventories*.

84. See Hornor, *Blue Book of Philadelphia Furniture*, p. 17.

85. Registrar of Wills, City of Philadelphia, Jonathan Dickinson, 1722, Will no. 251; see Gillingham, "The Estate of Jonathan Dickinson," p. 424; see also Hornor, *Blue Book of Philadelphia Furniture*, p. 25.

86. For an early paneled version with inlay relating it to the known Chester County group, see Forman, *American Seating Furniture*, p. 169, plate 29.

87. Papers of James Logan, miscellaneous bills and receipts, 1712, 1717, 1719, The Historical Society of Pennsylvania, Philadelphia; see Hornor, *Blue Book of Philadelphia Furniture*, pp. 3, 4, 226.

88. Reproduced in Prime, *Colonial Craftsmen of Pennsylvania*, p. 6.

89. The settee's provenance has long been in question. It was published early on as having belonged to James Logan and as having been a part of the furnishings at Stenton. However, because of the line of descent in the Logan family, the Dickinson and Norris family lines are intermixed with it through early marriages and therefore confused. Much of the Logan material was further scattered and inaccurately identified by a family member, Maria Dickinson Logan, whose best efforts at identifying and preserving much of the family's most significant early material unfortunately and irrevocably confused the identities of many of the surviving examples.

90. The only other pre-1760 Philadelphia sofa located while researching this catalogue is in the collection of the Winterthur Museum; see Joseph Downs, *American Furniture: Queen Anne and Chippendale Periods* (New York: Macmillan, 1952), plate 269. Its stretchers, and possibly elements of its frame, have been restored.

91. Similar easy chairs with Spanish feet and base stretchers are found in colonial Boston. Their absence among known Philadelphia survivals is curious, given the regular cross-fertilization in the early furniture traditions of the two cities.

92. Quoted in R. W. Symonds, "English Caned Chairs—Part 1," *Connoisseur*, vol. 127, no. 520 (March 1951), p. 13.

93. The inventory of Pennsbury in 1687 included "2 gret arme Cane Chayres" in the "Paller" and "2 small Ceane Chayres" in the "Paller Chamber"; see Hubertis M. Cummings, "An Account of Goods at Pennsbury Manor, 1687," *Pennsylvania Magazine of History and Biography,* vol. 86, no. 4 (October 1962), pp. 397–416, esp. pp. 408, 411. Many imported cane chairs were ordered by wealthier Philadelphians through English business associates or their London agents. In 1718 James Logan ordered "8 handsome put plain new fashioned Cane Chairs . . . & 2 Arm Chairs of ye same for a chamber" through his London agent, John Askew. Later in the same year he purchased "2 fine Walnut Chairs & 1 Elbow ditto . . . 9 black Chairs . . . 1 black couch . . . 6 Cane Chairs . . . & 1 Elbow [chair]" from the cargo of the *Richmond,* a ship that had just arrived in Philadelphia from London; see McElroy, "Furniture in Philadelphia," p. 65.

94. See Forman, *American Seating Furniture,* which provides the most extensive recent work on the differentiation of regional types of early American seating furniture. See also John Kirk, *American Furniture and the British Tradition to 1830* (New York: Alfred A. Knopf, 1982).

95. On most caned chairs produced in Philadelphia, as is seen in no. 137, the upper scroll of the foot terminates in the crisply undercut straight edge of the squared block of the leg above. Imported English and Boston caned chairs have slightly rounded lower edges on the leg blocks over the feet, which provide a less well defined transition between these elements.

96. A close associate of Penn, Shippen later became the first mayor of the city under the Charter of 1701.

97. Both Shippen and Stapleford had close business associations with Thomas Fitch (c. 1669–c. 1736), another Boston chairmaker who may have been one of the main suppliers of the Boston-type leather, caned, and carved-crest chairs brought to Philadelphia in large numbers as venture cargo. See Forman, *American Seating Furniture,* pp. 292–95.

98. Peter Baynton, a Philadelphia merchant who traded heavily with London merchants and who was also involved in the speculative West Indies trade that traveled along the American coast, advertised during the 1720s and 1730s that he had both English and Boston chairs for sale. His advertisement in *The Pennsylvania Gazette* on June 13, 1734, stated: "Lately Imported from London and elsewhere . . . Cane Chairs of many sorts and Couches, red Leather Chairs and fine Rush-Bottom ditto, Looking Glasses." As his later advertisements would clarify, the "elsewhere"

was Boston. See Leibundguth, "The Furniture-Making Crafts in Philadelphia," pp. 37–38.

99. Plunkett Fleeson, an upholsterer, was one of the most visible local competitors, advertising in 1742 that he had "Several Sorts of good Chair-frames, black and read leather Chairs, finished cheaper than any made here, or imported from Boston," *The Pennsylvania Gazette,* September 23, 1742; reproduced in Prime, *Colonial Craftsmen of Pennsylvania,* p. 4. See also Leibundguth, "The Furniture-Making Crafts in Philadelphia," pp. 37–38, and *The Pennsylvania Gazette,* May 10, 1744.

100. Scored decorative turning lines are often found in Philadelphia turned work, particularly in the products of Germanic craftsmen.

101. In some of the designs of turned Delaware Valley furniture prior to 1725, the facing or opposing composition of vase-shaped or baluster turning typical of New England is sometimes found (see no. 49). This may be a result of early cross-fertilization between Boston and Philadelphia brought about by the business dealings of merchants and the movement of craftsmen.

102. Forman, *American Seating Furniture,* pp. 340–48. Forman's work remains the most extensive and accurate on the differences between chairs from Boston and those from Philadelphia.

103. For example, John Jones, a Philadelphia merchant, owned "12 Russia chairs" and "5 walnut ditto" in 1708; see Forman, *American Seating Furniture,* p. 294. Charles Plumley, the cabinetmaker, had "6 leather chairs" among the contents of his household the same year; Plumley's inventory is reproduced by Forman, pp. 371–72; see also p. 295.

104. Edward S. Cooke, Jr., ed., *Upholstery in America and Europe from the Seventeenth Century to World War I* (New York and London: W. W. Norton and Company, 1987), p. 46.

105. Recent analytical tests conducted on a number of early Philadelphia chairs whose finishes survive suggest that these painted black finishes were common; they may have been intended to imitate lacquered, "japanned," or ebonized surfaces.

106. Many of these chairs make use of a range of mixed hardwoods in their frames, often combining maple, ash, and sometimes oak or chestnut, which was utilized in their seat rails. In many cases craftsmen united these mixed woods by applying a dark stain or paint to the surface. Versions with both rush-matted and upholstered seats have been documented.

107. Forman, *American Seating Furniture,* pp. 327–28.

108. Ledger of Solomon Fussell, 1751–57, Stephen Collins Papers, Library of Congress, Washington, D.C.; quoted in Leibundguth, "The Furniture-Making Crafts in Philadelphia," p. 55.

109. Receipt Book of John Wistar, 1739–46, Wistar Papers, Joseph Downs Memorial Library, Winterthur Museum, Delaware; quoted in Leibundguth, "The Furniture-Making Crafts in Philadelphia," p. 49. See also Garvan, *Philadelphia: Three Centuries of American Art,* pp. 50–52.

110. See Benno M. Forman, "Delaware Valley 'Crookt Foot' and Slat-Back Chairs: The Fussell-Savery Connection," *Winterthur Portfolio,* vol. 15, no. 1 (Spring 1980), pp. 41–64, esp. pp. 42, 44.

111. Ibid., pp. 43, 45.

112. Ibid., p. 43.

113. Ibid, p. 41.

114. These dovetail leg-mortise joints, which were exposed on the front face of the seat rail, were hidden with applied veneers, usually of walnut. Because this type of joint was inherently weak when used in compass-seat frames, it loosened as the chair was used, causing damage to the seat-rail veneers. This may explain why this early leg-joinery technique was quickly replaced by the fully rounded mortise, often wedged, which by 1740 had become the preferred method of leg-to-seat-frame joinery employed by Philadelphia chairmakers in compass-seat chairs.

115. For silver and silversmiths in colonial society, see Graham Hood, *American Silver: A History of Style, 1650–1900,* American Decorative Arts Series (New York, Washington, and London: Praeger Publishers, 1971), pp. 12–15.

116. See John P. Burnham, "You Shall Not Crucify Man on a Cross of Gold, Silver, and Money in America," in *Silver in American Life: Selections from the Mabel Brady Garvan and Other Collections at Yale University,* ed. Barbara McLean Ward and Gerald W. R. Ward (New York: The American Federation of Arts, 1979), pp. 10–14.

117. While no known early Philadelphia silversmiths used the series of standard assay and makers' strike marks found in many of the guilds, local craftsmen would often strike the same mark in close configuration three or four times on a completed form to approximate the appearance of the strikes on imported wares. For illustrations and further discussion of the use of strike marks, see Fales, *Joseph Richardson and Family,* pp. 9–16, and Louise Conway Belden, *Marks of American Silversmiths in the Ineson-Bissell Collection* (Charlottesville, N.C.: University Press of Virginia, 1980).

118. See Morrison H. Heckscher and Leslie Greene Bowman, *American Rococo, 1750–1775: Elegance in Ornament* (New York: The Metropolitan Museum of Art), pp. 74–75, where the problem of accurately identifying makers in light of shop practices is discussed.

119. See Fales, *Joseph Richardson and Family*, pp. 17–23; quotation on p. 22. There are records of an earlier buying trip abroad made by Francis Richardson, Sr., who went to London in 1719. During the trip he established contacts with a number of English merchants from whom he purchased jewelry, hardware, textiles, looking glasses, tea tables, and other goods to sell in his Philadelphia shop. His surviving account books note the local sales of these imported luxuries along with his own products during the 1720s. In exchange, Richardson received from his customers several forms of payment, including a variety of bartered services, household goods, and older silver or gold objects to be scrapped and reworked in his shop. Richardson's sons, Francis, Jr., and Joseph, Sr., expanded their father's diverse offerings.

120. While testing by spectroscopy may provide some information on alloy content to aid in differentiating American from foreign manufacturers, the inconsistencies in the alloy content of metals used in these small articles are greater and have not been well studied.

121. For a detailed discussion of the American silversmith's status and role in society during the early eighteenth century, see Barbara McLean Ward, "'The Most Genteel of Any in the Mechanic Way': The American Silversmith," in *Silver in American Life*, pp. 15–22.

122. See Heckscher and Bowman, *American Rococo, 1750–1775*, pp. 74–75.

123. For these silversmithing dynasties, see Garvan in *Philadelphia: Three Centuries of American Art*, pp. 17–20, 44–45.

124. Gabriel Thomas, *An Historical and Geographical Account of the Province and Country of Pensilvania . . .* (London, 1698); reproduced in Albert Cook Myers, ed., *Narratives of Early Pennsylvania, West New Jersey, and Delaware, 1630–1707* (New York: Charles Scribner's Sons, 1912), p. 327.

125. R[obert?] Campbell, *The London Tradesman: Being a Compendious View of All the Trades, Profession, Arts, Both Liberal and Mechanic, Now Practiced in the Cities of London and Westminster . . .* (London: T. Gardner, 1747; repr. New York: Augustus M. Kelley, Publishers, 1969), p. 142.

126. Fales, *Joseph Richardson and Family*, pp. 20, 66. Francis Richardson, Sr., left his son Joseph, Sr., his tools and "my negro boy named Herreford . . . provided he . . . carry on my trade" upon his death in 1729.

127. Quoted by Garvan in *Philadelphia: Three Centuries of American Art*, p. 52. Unfortunately, no signed engraving on silver from this early period has yet been identified.

128. Register of Wills, City of Philadelphia, Jonathan Dickinson, 1722, Will no. 251; see Gillingham, "The Estate of Jonathan Dickinson," p. 424.

129. Henry Flynt and Martha Gandy Fales, *The Heritage Foundation Collection of Silver; with Biographical Sketches of New England Silversmiths, 1625–1825* (Old Deerfield, Mass.: The Heritage Foundation, 1968), pp. 61–63.

130. Fales, *Joseph Richardson and Family*, p. 54.

131. Israel Acrelius, *A History of New Sweden; or, The Settlements on the River Delaware*, Memoirs of the Historical Society of Pennsylvania, vol. 11, trans. and ed. William M. Reynolds (Philadelphia: The Historical Society of Pennsylvania, 1874), p. 164.

132. Fales, *Joseph Richardson and Family*, p. 292.

133. See Peter Thompson, *Rum Punch and Revolution: Taverngoing and Public Life in Eighteenth-Century Philadelphia* (Philadelphia: University of Pennsylvania Press, 1999), p. 27.

134. Punch recipes from the period are often prescribed for the smaller bowls of this type. For food and drink in colonial Philadelphia, see Mary Anne Hines, Gordon Marshall, and William Woys Weaver, *The Larder Invaded: Reflections on Three Centuries of Philadelphia Food and Drink* (Philadelphia: Library Company of Philadelphia and The Historical Society of Pennsylvania, 1987).

135. See Garvan in *Philadelphia: Three Centuries of American Art*, p. 19.

136. William Penn's Cash Book, 1699–1701, American Philosophical Society, Philadelphia; transcribed in Clare Lise Cavicchi, *Pennsbury Manor Furnishing Plan* (Philadelphia: The Pennsbury Society, 1988), p. 174.

137. Double-handled "butter boats" of this form were produced in ceramic in Holland, France, England, and Scandinavia during the period.

138. Register of Wills, City of Philadelphia, Patrick Gordon, 1736, Will no. 1. The Gordon sauceboats were later purchased by Isaac Norris, Jr. (1701–1766), where they were described as "2 Sauce Boats, [bo't of Gov'r Gordon's Ex] Stamp (CR) Bottom Neat[work] 28.10," Norris Papers, Isaac Norris, 1957 Inventory of Silver, The Historical Society of Pennsylvania, Philadelphia; quoted in Jack Lindsey, "Royal Gravy: Governor Patrick Gordon's Silver Sauceboats," *Antiques*, vol. 151, no. 1 (January 1997), p. 199.

139. See Garvan, *Philadelphia: Three Centuries of American Art*, pp. 7–8.

140. By 1695 the economy of Philadelphia was undergoing massive expansion, and a number of New York Dutch families made the move south to take advantage of the greater opportunities. It was probably during this time that Nys arrived in Philadelphia.

141. Logan entered the purchase of this tankard in his account soon after the couple's marriage, noting, "Sundry Acco^ts D^rs to Cash / Household goods for a Tankard 32 ounces . . . £11.19.5 . . . paid Jn^o Denys for making them £3.^12," Logan Account Book, 1712–20, p. 96, The Historical Society of Pennsylvania, Philadelphia. Photocopy available from Stenton, Germantown, Pennsylvania.

142. Fales, *Joseph Richardson and Family*, pp. 8–9. Nys and Richardson had many close associations from 1719 to 1722, at just the time the younger craftsman would have been establishing a shop. Similarities in their work and their marks suggest an apprenticeship association.

143. Quoted by Garvan in *Philadelphia: Three Centuries of American Art*, p. 45.

144. Some of these relationships were more successful than others. In 1734 Francis Richardson, Jr., posted an offer for a "Reward for runaway apprentice, Isaac Marceloe, formerly with William Heurtin, Goldsmith of New York," *American Mercury*, February 18, 1734; quoted in Fales, *Joseph Richardson and Family*, p. 23.

145. See Hornor, *Blue Book of Philadelphia Furniture*, p. 271.

146. See Heckscher and Bowman, *American Rococo, 1750–1775*, p. 219.

147. In 1698 the merchant Gabriel Thomas noted that "there is likewise Iron-Stone or Oar, (lately found) which far exceeds that in England, being Richer and less Drossy; some Preparations have been made to carry on an Iron-Work." Thomas, *Account of the Province and Country of Pensilvania;* see Myers, *Narratives of Early Pennsylvania*, p. 320.

148. J. Thomas Scharf and Thompson Westcott, *History of Philadelphia, 1609–1884*, vol. 3 (Philadelphia: L. H. Everts and Co., 1884), p. 2249; see

also Leibundguth, "The Furniture-Making Crafts in Philadelphia," pp. 68–70.

149. Henry C. Mercer, *The Bible in Iron: Pictured Stoves and Stoveplates of the Pennsylvania Germans*, 3rd ed., rev. and enl. Horace M. Mann, with additions by Joseph E. Sandford (Doylestown, Pa.: The Bucks County Historical Society, 1961), pp. 104–10.

150. While the majority of Pennsylvanians heated their homes with wood, some burned charcoal, coal, or marsh peat. Elizabeth Coates Paschall owned "an Iron Grate & Hearth with brass Fronts," Register of Wills, City of Philadelphia, Elizabeth Paschall, 1768, Will no. 210.

151. One of the inspirations behind the Iron Act may have been the desire to suppress two early plating and steel furnaces founded in 1746, one by John Hall at Byberry and the other, slightly later, by Daniel Offley in Philadelphia. For these furnaces, see Leibundguth, "The Furniture-Making Crafts in Philadelphia," p. 71.

152. A 1712 London political pamphlet attests to the expansion of the export trade in elaborate brass and copper goods: "The extraordinary late Improvement and Nicety in all Sorts of Brass Wares, great and small, in and about London, Birmingham, and divers other Parts of England; and the Capacity and Genius of the English Artificers, is obvious to every common Understanding in England, but has acquired a singular Reputation Abroad, particularly in France, where our English Watches, Clocks, Locks, Buckles, Buttons, and all Sorts of English Brass Toys, are in great esteem, and in Case of Peace we may expect an extraordinary Accession to the Consumption of our Brass Wares." Quoted in Charles Saumarez Smith, *Eighteenth-Century Decoration: Design and the Domestic Interior in England* (New York: Harry N. Abrams, 1993), p. 49.

153. "Records and Minutes of the Common Council of Philadelphia, 1717," October 9, 1717, Archives, City of Philadelphia; transcription available in the Brass and Copper research file, Department of American Art, Philadelphia Museum of Art.

154. See Leibundguth, "The Furniture-Making Crafts in Philadelphia," p. 72. Stow recast the cracked English bell in the State House in 1751, gaining notoriety and important connections through his involvement in this public work. A brass back plate for a bale handle bearing Stow's mark is in the collection of the Winterthur Museum, Delaware.

155. See, for example, a list of such fittings purchased by the cabinetmaker Stephen Armitt from the merchant Thomas Penrose: Leibundguth, "The Furniture-Making Crafts in Philadelphia," p. 87.

156. Several of Pratt's prominent clients were wealthy Philadelphia merchants involved in the West Indies trade who regularly visited Barbados and may have attended services at the parish.

157. Donald M. Herr, *Pewter in Pennsylvania German Churches*, The Pennsylvania German Society, vol. 29 (Birdsboro, Pa.: The Pennsylvania German Society, 1995), pp. 46–49. Herr's comprehensive survey of early ecclesiastical pewter in Pennsylvania has added immeasurably to the field.

158. Schiffer, *Chester County, Pennsylvania, Inventories*, p. 197.

159. Register of Wills, City of Philadelphia, Elizabeth Paschall, 1768, Will no. 210.

160. Garvan, *Philadelphia: Three Centuries of American Art*, p. 93.

161. Register of Wills, City of Philadelphia, James Logan, 1752, Will no. 314. Transcription available in the Stenton research file, Department of American Art, Philadelphia Museum of Art.

162. *The Pennsylvania Journal or Weekly Advertiser*, May 3, 1753; quoted in Herr, *Pewter in Pennsylvania German Churches*, p. 129.

163. Schiffer, *Chester County, Pennsylvania, Inventories*, p. 362.

164. For pewter listed in the inventory of Simon Edgell, see Ledlie Irwin Laughlin, *Pewter in America: Its Makers and Their Marks*, vol. 2 (Boston: Houghton Mifflin Company, 1940), p. 155.

165. Schiffer, *Chester County, Pennsylvania, Inventories*, p. 154.

166. Arlene Palmer, *Glass in Early America: Selections from the Henry Francis du Pont Winterthur Museum* (Winterthur, Del.: Winterthur Museum), p. 121.

167. Ibid., pp. 120–21.

168. Register of Wills, City of Philadelphia, Elizabeth Paschall, 1768, Will no. 210.

169. See Schiffer, *Chester County, Pennsylvania, Inventories*, pp. 154–59.

170. Wistar's rise within the power circles of the city was furthered by his conversion to Quakerism in 1725 and his marriage to Catherine Johnson, who was from a prominent Germantown family. For Wistar, see Arlene M. Palmer, *The Wistarburgh Glassworks: The Beginning of Jersey Glassmaking* (Alloway, N.J.: Alloway Township Bicentennial Committee, 1976), pp. 2–5. Caspar

Wistar operated his glassworks until his death in 1752, at which time his son Richard took over the business, operating it until it closed in 1777.

171. Quoted in Palmer, *The Wistarburgh Glassworks*, p. 18.

172. Benjamin Franklin to Thomas Darling, March 27, 1747, and Franklin to Darling, February 10, 1746/47; see Leonard W. Labaree, ed., *The Papers of Benjamin Franklin*, vol. 3 (New Haven: Yale University Press, 1961), pp. 109, 114–15; quoted in Palmer, *The Wistarburgh Glassworks*, pp. 5–6.

173. Most of the earliest evidence of the domestic production and use of glass and ceramics in the region has been recovered through archaeological investigations. The largest repositories of archaeological records and artifacts from Philadelphia sites are held at the Atwater Kent Museum, Philadelphia, and the State Museum in Harrisburg, Pennsylvania.

174. Thomas, *Account of the Province and Country of Pensilvania*; see Myers, *Narratives of Early Pennsylvania*, p. 327.

175. See John Spargo, *Early American Pottery and China* (Rutland, Vt.: Charles E. Tuttle Company, 1974), p. 56. For more information on the earliest potteries in Philadelphia, see Harrold E. Gillingham, "Pottery, China, and Glass Making in Philadelphia," *Pennsylvania Magazine of History and Biography*, vol. 54, no. 214 (April 1930), pp. 97–129.

176. Schiffer, *Chester County, Pennsylvania, Inventories*, p. 176.

177. Jean McClure Mudge, *Chinese Export Porcelain in North America* (New York: Clarkson Potter, 1986), p. 109.

178. Hornor, *Blue Book of Philadelphia Furniture*, p. 21.

179. Mudge, *Chinese Export Porcelain*, p. 109.

180. For illustrations of these wares, see ibid., p. 150.

181. Penrose Family Ledgers, The Historical Society of Pennsylvania, Philadelphia.

182. Mudge, *Chinese Export Porcelain*, pp. 123–25.

183. For this Chester County group, see Lee Ellen Griffith, "Chester County Historical Society's '1738' Delft Plates," in *Chester County Historical Society Antiques Show, May 1988* (West Chester: Chester County Historical Society, 1988), pp. 5–11.

184. Joris Wertmuller to Benedict Kunts, March 16, 1684; quoted in Grant Miles Simon, "Houses and Early Life in Philadelphia," in *Historic Philadelphia from the Founding until the Early Nineteenth*

Century, Transactions of the American Philosophical Society, vol. 43, part 1 (Philadelphia: American Philosophical Society, 1953), p. 280, note 2.

185. In 1714, Logan specified "Striped Blankets that are white like other Blankets only towards the ends they have generally four broad Stripes as each 2 red and 2 blue or black"; see Florence M. Montgomery, *Textiles in America, 1650– 1870: A Dictionary Based on Original Documents* (New York: W. W. Norton and Company, 1984), p. 170.

186. Thomas, *Account of the Province and Country of Pensilvania;* see Myers, *Narratives of Early Pennsylvania,* pp. 331–32.

187. John F. Watson, *Annals of Philadelphia, and Pennsylvania, in the Olden Time,* rev. and enl. Willis P. Hazard, vol. 1 (Philadelphia: Edwin S. Stuart, 1887), pp. 560–61. Watson's manuscript for his original publication, now in the collection of the Library Company of Philadelphia, has tipped into its pages a plain swatch of light blue

silk noted as having been produced by Wright.

188. See Leibundguth, "The Furniture-Making Crafts in Philadelphia," p. 35.

189. The Dancing Assembly, inaugurated in Philadelphia in 1748, was supported by subscription. The festive gatherings the Assembly sponsored grew to be among the most important social events of the city's elite class.

190. Register of Wills, City of Philadelphia, Patrick Gordon, 1736, Will no. 1.

191. *Pennsylvania Journal and Weekly Advertiser,* May 11, 1749. The different names for cloth and technical variations of weaves were often subjectively applied to imported linens, cottons, wools, and silks, causing confusion among buyers and merchants alike during the period; see Montgomery, *Textiles in America,* p. xiii.

192. *American Weekly Mercury,* May 18, 1732; reproduced in Prime, *Colonial Craftsmen of Pennsylvania,* p. 3.

193. Hornor, *Blue Book of Philadelphia Furniture,* p. 71.

194. *The Pennsylvania Gazette,* April 4, 1745; reproduced in Prime, *Colonial Craftsmen of Pennsylvania,* p. 4.

195. Betty Ring, *Girlhood Embroidery: American Samplers and Pictorial Needlework, 1650–1850,* vol. 2 (New York: Alfred A. Knopf, 1993), pp. 330–60. Ring's research and publications are the most extensive on the subject, and her pioneering work on the early needleworker Elizabeth Marsh has led to a much more accurate understanding of the earliest surviving examples of needlework from Pennsylvania.

196. Hornor, *Blue Book of Philadelphia Furniture,* p. 65; see also Richard L. Bushman, *The Refinement of America: Persons, Houses, Cities* (New York: Alfred A. Knopf, 1992), pp. 86–87.

Appendix 1

Craftsmen Active in the Delaware Valley,

1680–1758

Furniture Craftsmen

This list is founded on the work done by William MacPherson Hornor, Jr., in his *Blue Book of Philadelphia Furniture: William Penn to George Washington* (Philadelphia, 1935) and that of Arthur W. Leibundguth in his master's thesis, "The Furniture-Making Crafts in Philadelphia, c. 1730–c. 1760" (University of Delaware, 1964). It has been augmented by information compiled from various sources, including unpublished manuscripts and records, while researching this exhibition and catalogue. Only craftsmen for whom there exist specific records confirming their dates and occupation are included. Where possible, life or active dates are listed. "Documented references" are the years when a craftsman is mentioned in such documents as court and tax records, shop and apprenticeship records, newspaper accounts and advertisements, extant craftsman and patron receipts, correspondence, account books, and, in some cases, signatures on labeled and dated objects. Wood craftsmen from allied trades—house or ship carpenters, other craftsmen working in the building trades, wheelwrights, coopers—and upholsterers have not been included. While this list remains incomplete, it is hoped that it will serve to inspire future research and lead to the identification of other craftsmen working in the Delaware Valley during the late seventeenth century and the first half of the eighteenth century.

Name	Profession	Life Dates	Documented References
Thomas Ackley	Chairmaker, turner	1752, 1761, 1760	
Joseph Allen	Joiner	1749, 1755, 1783	
Joseph Armitt	Cabinetmaker, joiner	died 1747	1724, 1738, 1748, 1742
Stephen Armitt	Joiner	1705–1752	1731, 1733, 1741, 1743, 1743/44, 1739, 1762
John Atkinson	Turner		1748, 1750, 1722
Samuel Austin	Joiner	died 1767	1729, 1730, 1737, 1746, 1748, 1760
Joshua Baker	Joiner		
Benjamin Barton	Chairmaker		
Robert Barton	Cabinetmaker, chairmaker		1739
James Bartram	Cabinetmaker, joiner	active 1725–30	
William Bates	Carpenter		1683
Peter Baynton	Joiner	died 1742	1710, 1723, 1725–26

Name	Profession	Life Dates	Documented References
William Beake, Jr.	Joiner		1694, 1711
Thomas Bedson	Joiner		
John Bird	Joiner		1710–11, 1715–17
Robert Black	Joiner		1720
Edward Blake	Turner		1681
Thomas Boyer	Turner		1697
Patrick Brannen	Chairmaker, joiner		
William Branson	Joiner		1712, 1718–19
John Brientnall	Chairmaker, joiner		1747, 1748
Charles Bush	Cabinetmaker, joiner		1739
William Bywater	Joiner		1769
David Cane	Cabinetmaker, joiner		
Joseph Carbut	Chairmaker		
Joshua Cart	Joiner	died 1716	
William Carter	Turner		1681
Arnold Cassell	Joiner		
Nicholas Cassell	Joiner		
Benjamin Chandlee	Clockmaker	1685–1745	1701
Benjamin Chandlee, Jr.	Clockmaker		1750
David Chambers	Chairmaker		1748
Joseph Chatham (Chattam)	Cabinetmaker, chairmaker		1715, 1748, 1754
James Chick	Joiner	died 1699	1694–95
Walter Clark	Chairmaker		
George Claypoole, Sr.	Cabinetmaker, joiner	born 1706	1738, 1739, 1744, 1746, 1748, 1754, 1755, 1756, 1758, 1762
George Claypoole, Jr.	Cabinetmaker, joiner	1730–1793	1775, 1783, 1786
Joseph Claypoole	Cabinetmaker, joiner	died 1744	1683, 1708, 1713, 1717–19, 1724, 1729, 1733, 1738, 1743
Josiah Claypoole	Cabinetmaker, joiner		1740, 1738, 1739, 1743
Nathaniel Clemens	Joiner	1715/16	
Johannes Clemm (Klemm, Clemon)	Joiner	1690–1762	
Henry Clifton	Chairmaker, joiner		1745, 1748, 1750, 1758, 1759
Richard Clone	Joiner		1683
John Coats	Joiner		1721
Thomas Coburn	Carpenter		1682
Abraham Coffin (Coffen)	Cabinetmaker		1682
William Cook	Joiner		
Abel Cottey	Clockmaker	died 1711	1682, 1706
John Cowper	Clockmaker		1716
Israel Coxe	Joiner		1717
James Cresson	Chairmaker, joiner	born 1709	
Jeremiah Cresson	Chairmaker, joiner		
Solomon Cresson	Chairmaker, turner		1696
Richard Cripps	Joiner		1716

Name	Profession	Life Dates	Documented References
William Crisp	Cabinetmaker, carver		
John Croslwhitt	Joiner	died 1715	1708–9, 1714
Abraham Darlington		1723–1799	
James Davis	Joiner		
William Davis	Chairmaker		1748, 1767
Nathaniel Dowdney	Cabinetmaker		
Edward Drinker		1680–1783	1745
John Drinker	Cabinetmaker		1692, 1745
Robert Eachus	Joiner		
Bernard Eaglesfield	Joiner	died 1732	1722–23, 1735
John Earle	Joiner		
John Elliott, Sr.	Cabinetmaker	1713–1791	1755–58, 1786
John Elton	Joiner, turner		1772
Lambert Emerson	Joiner, looking glass maker		1738, 1745
Caleb Emlen	Chairmaker, joiner	1699–1748	1745, 1746, 1748
John Emmery	Cabinetmaker, joiner		
Edward Evans	Joiner	1679–1754	1701, 1703, 1707, 1714, 1715, 1719
Joseph Evett	Joiner		
John Eyers	Joiner		
Thomas Farmberough	Chairmaker		1681
John Farmer	Clock- and watchmaker		1693
John Fellows (Fellowes)	Cabinetmaker	died 1694	1682
William Fisher, Sr.	Joiner		1685
Daniel Flower	Carpenter, joiner		1709–10, 1719
Enoch Flower	Joiner		1748, 1756
Henry Flower	Cabinetmaker		1736
John Fordham	Joiner		1731
William Fordham	Joiner		
Alexander Foreman	Turner		1717, 1718
John Foster	Chairmaker		
Moses Foster	Chairmaker		
John Freeman	Chairmaker		
Henry Frogly	Joiner	died 1722	1717, 1718
Solomon Fussell	Chairmaker	c. 1704–1762	1738–50 (chairmaker) 1751–62 (general merchant)
Nicholas Gale	Chairmaker		
Thomas Gamble	Joiner		1722
Thomas Gant	Joiner		1748
Johannes Gebharde	Turner		
William George	Clockmaker		1716
James Gillingham	Cabinetmaker, joiner		1775, 1771
John Gillingham	Cabinetmaker, joiner	died 1793	1740, 1745, 1755, 1782, 1783, 1786, 1792
Aaron Goforth, Sr.	Joiner		1711
Aaron Goforth, Jr.	Joiner		1711

Name	Profession	Life Dates	Documented References
Richard Gove	Carver, joiner	died 1710	1687, 1688, 1694, 1699, 1707
John Haines	Joiner		
Joseph Hall	Joiner		1760, 1745/46, 1749, 1770
Samuel Harding	Carver	died 1758	1751
Daniel Harrison	Joiner		
John Harrison, Jr.		died 1760	
Joseph Harrison			1719
William Hayes	Chairmaker		
Joshua Hazlenut	Carver		
John Head	Joiner	died 1754	1717, 1726, 1754
Samuel Head	Joiner		
Andrew Henry	Joiner		
John Hill	Joiner		
Michael Hilton	Joiner		1741
Abraham Hooper	Cabinetmaker	died 1707	1681, 1682, 1694, 1699
John Howard	Joiner		
Thomas Howard	Cabinetmaker, joiner	died 1748	
Robert Hubbard	Joiner		1717
John Hudson	Chairmaker, turner		1715, 1718, 1717
Thomas Hulbart	Joiner	died 1710	
Joseph Humfrits	Joiner		1717
Samuel Hurford	Joiner		1739–40
Isaac Jackson	Clockmaker		1725, 1734
John Jackson	Clockmaker		1746
James James	Cabinetmaker, joiner		1751–55, 1756, 1758
David John	Joiner		1722
Philip John	Joiner	died 1741	
Daniel Jones	Chairmaker		1739
Edmund Jones	Cabinetmaker, joiner		1717, 1718
John Jones	Joiner		1691, 1744
Joseph Jones	Joiner		1745–47
Joseph Jueson	Turner		1717
Johann Keim	Turner	died 1754	1707
Garratt Ketletas	Joiner		
Joseph Kingston	Joiner		
John Knowles	Joiner		1708
Giles Laurence	Cabinetmaker, joiner		
Jacob Levering	Joiner	died 1753	1683, 1717
Thomas Lloyd, Jr.	Joiner		1722–23
John Maddock	Joiner		1683
William Mason	Turner		1717, 1720
Samuel Matthews	Joiner	died 1775	1755, 1760
William Maugridge	Joiner		1732

Name	Profession	Life Dates	Documented References
Thomas Maule	Joiner		1748, 1749, 1754, 1755
James McCall	Joiner		
William Meredith	Joiner		1723, 1796
John Miller	Joiner		1708
George Miller	Joiner		
John Milton	Joiner		1717
Henry Mitchell	Joiner		1707, 1710
Robert Moon	Joiner		
Robert Moore	Cabinetmaker, chairmaker		
William Moor(e)	Joiner		1717
William Morgan	Turner		
Robert Mullard	Carver		1717, 1722
John Nash	Joiner		1717, 1718
Edward Nichols	Turner		
Benjamin Ogden	Chairmaker, joiner		
Hugh O'Neal	Chairmaker, turner		1739–40
Patrick O'Neal	Chairmaker		
Thomas Oppy	Joiner		1716
John Page	Turner		1745–46, 1748
Moses Parker	Joiner		1717
Charles Plumley	Cabinetmaker, carver, chairmaker, turner	died 1708	1706, 1707
Abraham Pratt	Joiner		1690
William Pyle			
Daniel Quare	Clockmaker	1648–1724	1681
Caleb Ransted	Chairmaker, joiner, turner		
Jonathan Read	Joiner		
Henry Rigby	Cabinetmaker, joiner		1745/46, 1749
David Rittenhouse	Clockmaker		1769/71, 1789
David Robert	Joiner		1708
Matthew Robinson	Turner	died 1736	1698, 1718
Peter Rose	Joiner		1742, 1761, 1745–1746/7
James Russell	Chairmaker		1754
Richard Sanders	Carpenter, joiner		1719, 1730
Christopher Sauer	Cabinetmaker, clockmaker	1693–1758	1726
Joseph Saull	Chairmaker		
William Savery	Cabinetmaker, chairmaker	1721/22–1787	1741, 1742, 1767, 1769, 1774, 1775, 1783, 1786, 1787
John Scott	Joiner		
Robert Scott	Joiner		
Edward Scull, Jr.	Joiner		1716, 1717
Samuel Shepard	Joiner	died 1717	1707
Josiah Sherald	Chairmaker		1762
John Sherburne	Joiner		

Name	Profession	Life Dates	Documented References
George Shiers	Joiner		1719
Isaac Shoemaker	Turner	born 1669	1695–96
Jacob Shoemaker, Sr.	Cabinetmaker, turner		1714–16
Jacob Shoemaker, Jr.	Turner		1743, 1765
Jonathan Shoemaker	Cabinetmaker, joiner	died 1793	1760, 1758, 1757
Peter Shoemaker	Turner		1685, 1696, 1704, 1707
Thomas Shugars (Sugar)	Carpenter, turner		1739, 1740, 1741, 1742
Edward Skull	Joiner		
Henry Sleighton	Turner		1681
Samuel Smith	Joiner		
Jedidiah Snowden	Cabinetmaker, chairmaker	died 1797	1748/9, 1750–62, 1773, 1786
Edward Stanton	Joiner		died 1689
Thomas Stapleford	Joiner	died 1739	1712, 1714, 1717–19, 1728, 1729, 1735, 1738
James Steele	Joiner		1735
Peter Stretch	Clockmaker	1670–1746	1702, 1710, 1711, 1717, 1722, 1733, 1737
Samuel Stretch	Clock- and watchmaker	died 1732	
Thomas Stretch	Clockmaker	died 1765	1753, 1759, 1761
William Stretch	Clockmaker	died 1748	
William Sutor	Turner		
Benjamin Swan	Chairmaker		
Daniel Swan	Chairmaker		
Robert Tate	Joiner	died 1727–28	1697, 1721
Joseph Tatnall	Carpenter		1735
Daniel Teese	Chairmaker		
Evan Thomas	Joiner		1714, 1717, 1722
Isaac Thomas	Clockmaker		1721–1802
John Tibbye	Joiner	died 1688	1681
William Till	Joiner	died 1711	1701, 1707, 1710
Benjamin Trotter	Chairmaker, joiner	1699–1768	1751, 1759, 1760, 1761, 1768
Francis Trumble	Cabinetmaker, chairmaker	c. 1716–1798	1740, 1741–45, 1754, 1755–56, 1759, 1760, 1761, 1769, 1776–78, 1783, 1786, 1796
William Trumble	Cabinetmaker		
John Valecott	Cabinetmaker		1682
Joseph Waite	Carver		
John Walker	Joiner		1688
Jonathan Wamsley	Cabinetmaker		
Anthony Ward	Joiner		1715
William Warner	Turner		
Joseph Watkins	Joiner		1745

Name	Profession	Life Dates	Documented References
John Wetefield (Widdifield?)			1713
John Widdifield	Joiner	died 1720	1707–8
James Wilkins	Joiner		1717
John Williams	Joiner		
Samuel Williams	Joiner		1769, 1773, 1783, 1786
Joseph Wills	Clockmaker	c. 1700–1759	
George Wil(l)son	Joiner	died 1748	1724, 1727, 1736–48
Thomas Willson	Joiner		1714
James Wilson	Joiner		1753–56
Jacob Wismar	Joiner		
Christopher Witt	Clockmaker	1675–1765	
John Wood, Sr.	Clockmaker	died 1761	1734, 1745, 1747, 1750
John Wood, Jr.	Clockmaker	1736–1793	1760–93
Edmund Wooley	Joiner		1716
Edward Wright	Joiner		

Silversmiths and Related Craftsmen

Two early lists of Philadelphia silversmiths consulted in compiling the names of colonial Philadelphia silversmiths that appear here were Maurice Brix's *List of Philadelphia Silversmiths and Allied Artificers from 1682 to 1850* (Philadelphia, 1920) and Stephen G. C. Ensko's *American Silversmiths and Their Marks* (New York, 1927). Information gathered from primary documents while researching this catalogue has been used to confirm, expand, and update these earlier lists. It has been augmented by information complied from various unpublished manuscripts and records, as well as published sources relating to silversmithing in colonial Pennsylvania. Only craftsmen for whom there exist specific confirmation records as to their dates and occupation are included. Where possible, life dates or active dates are listed. "Documented references" dates are the years when a craftsman is mentioned in the types of documents listed in the introduction to the list of furniture craftsmen. Again, this work remains incomplete, but it is hoped that it will serve to encourage further research and lead to the identification of other silversmiths working in early Philadelphia.

Name	Profession	Life Dates	Documented References
James Allen	Goldsmith		advertised 1720
John Bayly	Goldsmith		first advertised 1754
Joseph Best	Goldsmith		advertised 1723
Elias Boudinot	Silversmith	1705–1770	advertised 1747–49
Anthony Bright	Silversmith	died 1749	advertised 1739
Michael Cario	Jeweler		advertised 1736–48
William Carter	Watchmaker	died 1738	arrived 1683
Peter David	Goldsmith	1707–1755	advertised 1738–39
Charles Dulins, Jr.	Jeweler		advertised 1751–57
Daniel Dupuy, Sr.	Silversmith	1719–1807	advertised 1745
Jeremiah Elfreth	Silversmith	1723–1765	

Name	Profession	Life Dates	Documented References
William England	Goldsmith		1717
Henry Flower	Watchmaker		advertised 1753–55
William Fraser	Silversmith		cited 1738
Cesar Ghiselin	Gold- and silversmith	c. 1663–1733	arrived 1681, 1734
William Ghiselin	Goldsmith		advertised 1750–62
Thomas Gibbons	Watchmaker		advertised 1751–52
Jeramiah Goforth	Silversmith		cited 1700
William Graham	Watchmaker		advertised 1733
Thomas Hammesley	Goldsmith		cited 1756
David Harper	Goldsmith		advertised 1755–56
Alexander Hemphill	Goldsmith		cited 1741
William Hollingshead	Gold- and silversmith		1754, advertised 1757–74
Laurence Hubert	Engraver		advertised 1748–51
Bouman Hunlocle	Goldsmith		advertised 1748–51
Edward Hunt	Goldsmith		cited 1717, 1720
John Strangeways Hutton		1684–1792	
Theodorus Karbin	Jeweler		advertised 1758
Samuel Leach	Engraver		advertised 1741
John Leacoch	Silversmith		advertised 1748–1796
John Leacock	Goldsmith		advertised 1751–67
John Lyng	Silversmith		advertised 1734
Isaac Marceloc	Silversmith		advertised 1735
John Naglee	Gold- and silversmith	died 1780	cited 1748–55
Johannis Nys	Silversmith	1671–1734	
William Paschall	Silversmith	died 1696	
Joseph Pattison	Turner in metals		advertised 1751
Richard Pitt(s)	Silversmith		active c. 1738–46
Henry Pratt	Gold- and silversmith	1709–1749	
Francis Richardson, Sr.	Silversmith	1681–1729	
Francis Richardson, Jr.	Goldsmith, clockmaker	1705/6–1782	
Joseph Richardson, Sr.	Silversmith	1711–1784	advertised 1744-84
Alexander Robertson	Silversmith	died 1751	
Emanuel Rouse	Watchmaker		advertised 1747–68
John Sacheverel	Engraver		advertised 1733
James Saint-Maurice	Silversmith		advertised 1748
Samuel Soumain	Goldsmith	died 1738	advertised 1734
Philip Syng, Sr.	Silversmith	1676–1739	arrived 1714
Philip Syng, Jr.	Silversmith	1703–1789	arrived 1714
Christopher Tuthill	Goldsmith		advertised 1730
"Mr." Vanderhaul	Goldsmith		cited 1740–41
William Vilant	Goldsmith		cited 1725
Charles Webb	Jeweler		advertised 1738
Randall Yetton (Yeaton)	Silversmith		advertised 1739

Appendix II

Peter Kalm's List of Woods Available around Philadelphia

Peter Kalm, the Swedish botanist who traveled extensively in the American colonies from September 1748 to February 1751, included in his travelogue a list of the woods to be found in the vicinity of Philadelphia. This list is reproduced here, along with Kalm's prefatory comments, as it appears in *The America of 1750: Peter Kalm's Travels in North America,* English edition, rev. and ed. Adolph B. Benson, vol. 1 (New York: Dover Publications, 1966), pp. 37–39:

To satisfy the curiosity of those who are willing to know how the woods look in this country and whether or no[t] the trees in them are the same as those found in our forests, I here inserted a small catalogue of those which grow wild in the woods nearest to Philadelphia. I exclude such shrubs as do not attain any considerable height. I shall put that tree first in order which is most plentiful and so on with the rest, and therefore trees which I have found but single, though near the town, will be last.

1. *Quercus alba,* the white oak in good ground.
2. *Quercus nigra,* or the black oak.
3. *Quercus Hispanica,* the Spanish oak, a variety of the preceding.
4. *Juglans alba,* hickory, a kind of walnut tree, of which three or four varieties are to be met with.
5. *Rubus occidentalis,* or American blackberry shrub.
6. *Acer rubrum,* the maple tree with red flowers, in swamps.
7. *Rhus glabra,* the smooth leaved sumach, in the woods, on high glades and old corn fields.
8. *Vitis labrusca* and *vulpina,* grape vines of several kinds.
9. *Sambucus Canadensis,* American elder tree, along the hedges and on glades.
10. *Quercus phellos,* the swamp oak, in morasses.
11. *Azalea lutea,* the American upright honey-suckle, in the woods in dry places.
12. *Cratœgus Crus galli,* cockspur thorn (the Virginia azarole), in woods.
13. *Vaccinium ,* a species of whortleberry shrub.
14. *Quercus prinus,* the chestnut oak in good ground.
15. *Cornus florida,* the cornelian cherry, in all kinds of soil.
16. *Liriodendron tulipifera,* the tulip tree, in every kind of soil.
17. *Prunus Virginiana,* the wild cherry tree.
18. *Vaccinium ,* a frutex swamp whortleberry, in good ground.
19. *Prinos verticillatus,* the winterberry tree in swamps.
20. *Platanus occidentalis,* the water-beech.
21. *Nyssa aquatica,* the tupelo tree; on fields and mountains.
22. *Liquidambar styraciflua,* sweet gum tree, near springs.
23. *Betula alnus,* alder, a variety of the Swedish; it was here but a shrub.
24. *Fagus castanea,* the chestnut tree, on corn fields, pastures and on wooded hills.

25. *Juglans nigra,* the black walnut tree, in the same place with the preceding tree.

26. *Rhus radicans,* the twining sumack, climbed up the trees.

27. *Acer negundo,* the ash-leaved maple, in morasses and swampy places.

28. *Prunus domestica,* the wild plum tree.

29. *Ulmus Americana,* the white elm.

30. *Prunus spinosa,* sloe shrub, in low places.

31. *Laurus sassafras,* the sassafras tree, in a loose soil mixed with sand.

32. *Ribes nigrum,* the currant tree, grew in low places and in marshes.

33. *Fraximus excelsior,* the ash tree in low places.

34. *Smilax laurifolia,* the rough bind-weed with the bay leaf, in woods and near fences.

35. *Kalmia latifolia,* the American dwarf laurel, on the northern side of hills.

36. *Morus rubra,* the mulberry tree on fields, hills and near the houses.

37. *Rhus vernix,* the poisonous sumach, in wet places.

38. *Quercus rubra,* the red oak, but a peculiar variety.

39. *Hamamelis Virginica,* the witch hazel.

40. *Diospyros Virginiana,* the persimmon.

41. *Pyrus coronaria,* the anchor tree.

42. *Juniperus Virginiana,* the red juniper, in a dry poor soil.

43. *Laurus æstvalis,* spice-wood in a wet soil.

44. *Carpinus ostrya,* a species of horn-beam in good soil.

45. *Carpinus betulus,* a hornbeam, in the same kind of soil with the former.

46. *Fagus sylvatica,* the beech, likewise in good soil.

47. *Juglans cinerea,* a species of walnut tree on hills near rivers, called by the Swedes "butternutsträ."

48. *Pinus Americana,* Pennsylvania fir tree; on the north side of mountains and in valleys.

49. *Betula lenta,* a species of birch on the banks of rivers.

50. *Cephalantus occidentalis,* button wood, in wet places.

51. *Pinus tœda,* the New Jersey fir tree, on dry sandy heaths.

52. *Cercis Canadensis,* the sallad tree, in good soil.

53. *Robinia pseudacacia,* the locust tree, on the corn fields.

54. *Magnolia glauca,* the laurel-leaved tulip tree, in marshy soil.

55. *Tilia Americana,* the lime tree, in good soil.

56. *Gleditsia triacanthos,* the honey locust tree, or three thorned acacia, in the same soil.

57. *Celtis occidentalis,* the nettle tree, in the fields.

58. *Annona muricata,* the custard apple, in a fertile soil.

Selected Bibliography

Adair, William. *The Frame in America, 1700– 1900: A Survey of Fabrication Techniques and Styles.* Washington, D.C.: American Institute of Architects Foundation, 1983.

Avery, C. Louise. *Early American Silver.* New York and London: Century Company, 1930.

Baird, Charles W. *History of the Huguenot Emigration to America.* Vol. 2. New York: Dodd, Mead, and Company, 1885.

Belknap, Henry Wyckoff. *Artists and Craftsmen of Essex County, Massachusetts.* Salem, Mass.: The Essex Institute, 1927.

Beurdeley, Michel. *Porcelain of the East India Companies.* Trans. Diana Imber. London: Barrie and Rockliff, 1962.

Bigelow, Francis Hill. *Historic Silver of the Colonies and Its Makers.* New York: Macmillan, 1917.

Bishop, J. Leander. *A History of American Manufactures from 1608 to 1860.* 2 vols. Philadelphia: Edward Young and Company, 1864.

A Brief Essay on the Copper and Brass Manufactures of England . . . London, 1712.

Buhler, Kathryn C. *American Silver, 1655–1825, in the Museum of Fine Arts, Boston.* 2 vols. Boston: Museum of Fine Arts, 1972.

Buhler, Kathryn C., and Graham Hood. *American Silver: Garvan and Other Collections in the Yale University Art Gallery.* Vol. 1, *New England.* New Haven and London: Yale University Press, 1970.

———. *American Silver: Garvan and Other Collections in the Yale University Art Gallery.* Vol. 2, *Middle Colonies and the South.* New Haven and London: Yale University Press, 1970.

Campbell, R. *The London Tradesman: Being a Compendious View of All the Trades, Professions, Arts, both liberal and Mechanic, now practiced in the Cities of London and Westminster.* London, 1747. Reprint, New York: Augustus M. Kelley Publishers, 1969.

Cary, John. *An Essay on the State of England.* Bristol, 1695.

Chambers, Ephraim. *Cyclopaedia; or, An Universal Dictionary of Arts and Sciences.* 2 vols. 4th ed., London: D. Midwinter, 1741.

Chippendale, Thomas. *The Gentleman and Cabinet-Maker's Director.* 3d ed., 1762. Reprint, New York: Dover Publications, 1966.

Comstock, Helen. *American Furniture: Seventeenth, Eighteenth, and Nineteenth Century Styles.* Exton, Pa.: Schiffer Publishing, 1962.

Cooke, Edward S., Jr., et al. *Upholstery in America and Europe from the Seventeenth Century to World War I.* Ed. Edward S. Cooke, Jr. New York and London: W. W. Norton and Company, 1987.

Cooper, Wendy A. *In Praise of America: American Decorative Arts, 1650–1830; Fifty Years of Discovery Since the 1929 Girl Scouts Loan Exhibition.* New York: Alfred A. Knopf, 1980.

Cope, Gilbert, and Henry Graham Ashmead, eds. *Historic Homes and Institutions and Genealogical and Personal Memoirs of Chester and Delaware Counties, Pennsylvania.* 2 vols. New York and Chicago: Lewis Publishing Company, 1904.

Cox, Warren E. *The Book of Pottery and Porcelain.* 2 vols. New York: Crown Publishers, 1944.

Crom, Theodore R., ed. *An Eighteenth Century English Brass Hardware Catalogue.* Hawthorne, Fla.: Theodore R. Crom, 1994.

Cummings, Abbott Lowell, comp. *Bed Hangings: A Treatise on Fabrics and Styles in the Curtaining of Beds, 1650–1850.* Boston: Society for the Preservation of New England Antiquities, 1961.

Cummings, Hubertis M. "An Account of Goods at Pennsbury Manor, 1687." *Pennsylvania Magazine of History and Biography,* vol. 86, no. 4 (October 1962), pp. 397–416.

Dam, Jan Daniel van, and Pieter Jan Tichelaar. *Dutch Tiles in the Philadelphia Museum of Art.* Philadelphia: Philadelphia Museum of Art, 1984.

Davenant, Charles. *An Essay on the East India Trade.* London, 1696.

Defoe, Daniel. *The Complete English Tradesman.* London: Charles Rivington, 1726.

Denker, Ellen Paul. *After the Chinese Taste: China's Influence in America, 1730–1930.* Salem, Mass.: Peabody Museum of Salem, 1985.

Diderot, Denis, et al. *Encyclopédie; ou Dictionnaire raisonné des sciences, des arts et des métiers, par une société de gens de lettres.* 17 vols. Paris, 1751–65.

Downs, Joseph. *American Furniture, Queen Anne and Chippendale Periods, in the Henry Francis du Pont Winterthur Museum.* New York: Macmillan, 1952.

Failey, Dean F., Robert J. Hefner, and Susan E. Klaffky. *Long Island Is My Nation: The Decorative Arts and Craftsmen, 1640–1830.* Setauket, N.Y.: Society for the Preservation of Long Island Antiquities, 1976.

Fairbanks, Jonathan L., and Robert F. Trent. *New England Begins: The Seventeenth Century*. 3 vols. Boston: Museum of Fine Arts, 1982.

Fales, Martha Gandy. *Early American Silver for the Cautious Collector*. New York: Funk and Wagnalls, 1970.

———. *Joseph Richardson and Family: Philadelphia Silversmiths*. Middletown, Conn.: Wesleyan University Press for The Historical Society of Pennsylvania, 1974.

Fernow, Berthold, trans. and comp. *Documents Relating to the History of the Dutch and Swedish Settlements on the Delaware River*. Documents Relative to the Colonial History of the State of New York, vol. 12. Albany, N.Y.: Argus Company, 1877.

Forman, Benno M. "Delaware Valley 'Crookt Foot' and Slat-Back Chairs: The Fussell-Savery Connection." *Winterthur Portfolio*, vol. 15, no. 1 (Spring 1980), pp. 41–64.

———. "The Chest of Drawers in America, 1635–1730: The Origins of the Joined Chest of Drawers." *Winterthur Portfolio*, vol. 20, no. 1 (Spring 1985), pp. 1–30.

———. *American Seating Furniture, 1630–1730: An Interpretive Catalogue*. New York and London: W. W. Norton and Company, 1988.

Fourest, H.-P. *Delftware: Faience Production at Delft*. Trans. Katherine Watson. New York: Rizzoli, 1980.

Gloag, John. *Georgian Grace: A Social History of Design from 1660–1830*. London: A. and C. Black, 1956.

Godden, Geoffrey A. *Oriental Export Market Porcelain and Its Influence on European Wares*. London, Toronto, Sydney et al.: Granada, 1979.

Goodman, W. L. "Tools and Equipment of the Early Settlers in the New World." *The Chronicle of the Early American Industries Association*, vol. 29, no. 3 (September 1976), pp. 40–51.

Griffith, Lee Ellen. *The Pennsylvania Spice Box: Paneled Doors and Secret Drawers, An Essay and Catalogue*. Ed. Ann Barton Brown and Roland H. Woodward. West Chester, Pa.: Chester County Historical Society, 1986.

Hamilton, Henry. *The English Brass and Copper Industries to 1800*. 2nd ed. New York: Augustus M. Kelley, 1967.

Hayward, Mary Ellen. "The Elliotts of Philadelphia: Emphasis on the Looking Glass Trade, 1755–1810." Master's thesis, University of Delaware, 1971.

Heckscher, Morrison H. *In Quest of Comfort: The Easy Chair in America*. New York: The Metropolitan Museum of Art, 1971.

Hinckley, F. Lewis. *Directory of the Historic Cabinet Woods*. New York: Crown Publishers, 1960.

Hood, Graham. *American Silver: A History of Style, 1650–1900*. New York, Washington, and London: Praeger Publishers, 1971.

Hopkins, Thomas Smith, and Walter Scott Cox, comps. *Colonial Furniture of West New Jersey*. Haddonfield, N.J.: The Historical Society of Haddonfield, 1936.

Hornor, William MacPherson, Jr. *Blue Book of Philadelphia Furniture: William Penn to George Washington*. 1935. Reprint, Washington, D.C.: Highland House Publishers, 1977.

Hornsby, Peter. *Collecting Antique Copper and Brass*. Ashbourne, England: Moorland Publishing Company, 1989.

Hutton, William. *An History of Birmingham, to the End of the Year 1780 . . .* Birmingham, England: Pearson and Rollason, 1781.

Jacobs, Carl. *Guide to American Pewter*. New York: McBride Company, 1957.

Jobe, Brock. "The Boston Furniture Industry, 1720–1740." In *Boston Furniture of the Eighteenth Century*. Boston: The Colonial Society of Massachusetts, 1974, pp. 3–48.

Johnson, Amandus. *The Swedish Settlements on the Delaware, 1638–1664*. 2 vols. 1911. Reprint, Baltimore: Genealogical Publishing Company, 1969.

Kane, Patricia E. *300 Years of American Seating Furniture: Chairs and Beds from the Mabel Brady Garvan and Other Collections at Yale University*. Boston: New York Graphic Society, 1976.

Kauffman, Henry J. *American Copper and Brass*. Camden, N.J.: Thomas Nelson, 1968.

———. *The Colonial Silversmith: His Techniques and His Products*. Camden, N.J.: Thomas Nelson, 1969.

Kauffman, Henry J., and Quentin H. Bowers. *Early American Andirons and Other Fireplace Accessories*. Nashville: Nelson, 1974.

Kindig, Joseph K., III. *The Philadelphia Chair, 1685–1785*. York, Pa.: Historical Society of York County, 1978.

Kirk, John T. "Sources of Some American Regional Furniture, Part I." *Antiques*, vol. 88, no. 6 (December 1965), pp. 790–98.

———. *American Chairs: Queen Anne and Chippendale*. New York: Alfred A. Knopf, 1972.

———. *American Furniture and the British Tradition to 1830*. New York: Alfred A. Knopf, 1982.

Langley, Batty. *The City and Country Builder's and Workman's Treasury of Designs*. London, 1740. Reprint, New York: Benjamin Blom, 1967.

Laughlin, Ledlie Irwin. *Pewter in America: Its Makers and Their Marks*. 3 vols. Vols. 1–2. Boston: Houghton Mifflin Company, 1940. Vol. 3. Barre, Mass.: Barre Publishers, 1971.

Leibundguth, Arthur W. "The Furniture-Making Crafts in Philadelphia, ca. 1730–ca. 1760." Master's thesis, University of Delaware, 1964.

"Letters of William Penn." *Pennsylvania Magazine of History and Biography*, vol. 33, no. 4 (1909), pp. 423–31.

Lockwood, Luke Vincent. *Colonial Furniture in America*. New York: Charles Scribner's Sons, 1901.

Lunsingh Scheurleer, T. H. "The Dutch and Their Homes in the Seventeenth Century." In *Arts of the Anglo-American Community in the Seventeenth Century*. Winterthur Conference Report, 1974. Ed. Ian M. G. Quimby. Charlottesville, Va: University Press of Virginia for the Henry Francis du Pont Winterthur Museum, 1975, pp. 13–42.

Lynes, Wilson. "Slat-Back Chairs of New England and the Middle-Atlantic States: A Consideration of Their Derivation and Development, Part II." *Antiques*, vol. 25, no. 3 (March 1934), pp. 104–7, 116.

McElroy, Cathryn J. "Furniture of the Philadelphia Area: Forms and Craftsmen before 1730." Master's thesis, University of Delaware, 1970.

Matzkin, Ruth. "Inventories of Estates in Philadelphia County, 1682–1710." Master's thesis, University of Delaware, 1959.

Mercer, Henry C. *The Bible in Iron: Pictured Stoves and Stoveplates of the Pennsylvania Germans*. 3rd ed., rev. and enl. Ed. Joseph E. Sandford. Doylestown, Pa.: The Bucks County Historical Society, 1961.

Miles, Ellen G., et al. *American Paintings of the Eighteenth Century*. Washington, D.C.: National Gallery of Art, 1995.

Minchinton, W. E., ed. *The Trade of Bristol in the Eighteenth Century*. Bristol Record Society's Publications, vol. 20. Bristol, England: Bristol Record Society, 1957.

———. *The Growth of English Overseas Trade in the Seventeenth and Eighteenth Centuries*. London: Methuen and Company, 1969.

Minutes of the Common Council of the City of Philadelphia, 1704 to 1776. Philadelphia: Crissy and Markley, 1847.

Monkhouse, Christopher P., Thomas S. Michie, and John M. Carpenter. *American Furniture in Pendleton House*. Providence, R.I.: Museum of Art, Rhode Island School of Design, 1986.

Monmouth Museum. *New Jersey Arts and Crafts: The Colonial Expression*. Catalogue entries by Charles T. Lyle and Milton J. Bloch. Freehold, N.J.: Monmouth County Historical Association, 1975.

Montgomery, Charles F. *A History of American Pewter*. New York and Washington: Praeger Publishers, 1973.

Montgomery, Florence M. *Textiles in America, 1650–1870: A Dictionary Based on Original Documents . . .* New York: W. W. Norton and Company, 1984.

Morse, Hosea Ballou. *The Chronicles of the East India Company Trading to China, 1635–1834*. 5 vols. Oxford: Clarendon Press, 1926–29.

Moxon, Joseph. *Mechanick Exercises; or, The Doctrine of Handy-Works Applied to the Arts of Smithing, Joinery, Carpentry, Turning, Bricklaying*. 2 vols. London: Joseph Moxon, 1677–83.

Mulholland, James A. *A History of Metals in Colonial America*. University, Ala.: The University of Alabama Press, 1981.

Murdoch, Tessa. "The Huguenots and English Rococo." In *The Rococo in England: A Symposium*. Ed. Charles Hind. London: Victoria and Albert Museum, 1986, pp. 60–81.

Newark Museum. *Early Furniture Made in New Jersey, 1690–1870: An Exhibition, October 10, 1958–January 11, 1959*. Newark, N.J.: Newark Museum, 1958.

Noël Hume, Ivor. *A Guide to Artifacts of Colonial America*. New York: Alfred A. Knopf, 1970.

Nutting, Wallace. *Furniture of the Pilgrim Century, 1620–1720; Including Colonial Utensils and Hardware*. Framingham, Mass., and Boston: Old America Company, 1921.

———. *Furniture Treasury (Mostly of American Origin): All Periods of American Furniture with Some Foreign Examples in America*. 3 vols. Framingham, Mass.: Old America Company, 1928–33.

Park, Helen. *A List of Architectural Books Available in America before the Revolution*. Rev. ed. Los Angeles: Hennessey and Ingalls, 1973.

Parry, J. H. *Trade and Dominion: The European Overseas Empires in the Eighteenth Century*. New York and Washington: Praeger Publishers, 1971.

Philadelphia Museum of Art. *Philadelphia: Three Centuries of American Art*. Philadelphia: Philadelphia Museum of Art, 1976.

———. "Philadelphia Silver, 1682–1800." *The Philadelphia Museum Bulletin*, vol. 51, no. 249 (Spring 1956).

Pomfret, John E., and Floyd M. Shumway. *Founding the American Colonies, 1583–1660*. New York, Evanston, Ill., and London: Harper and Row, 1970.

Prime, Alfred Coxe. *Colonial Craftsmen of Pennsylvania: Reproductions of Early Newspaper Advertisements from the Collection of Alfred Coxe Prime*. Philadelphia: Pennsylvania Museum and School of Industrial Art, 1925.

Pye, David. *The Nature and Art of Workmanship*. London: Cambridge University Press, 1968.

Quimby, Ian M. G., ed. *Ceramics in America*. Charlottesville, Va.: University Press of Virginia for the Henry du Pont Winterthur Museum, 1973.

———. *The Craftsman in Early America*. New York and London: W. W. Norton and Company for the Henry du Pont Winterthur Museum, 1984.

Rackham, Bernard. "Early Dutch Maiolica and Its English Kindred." *Burlington Magazine*, vol. 33, no. 187 (October 1918), pp. 116–23.

Raymond, Robert. *Out of the Fiery Furnace: The Impact of Metals on the History of Mankind*. University Park, Pa., and London: The Pennsylvania State University Press, 1986.

Rogers, Meyric R. *American Interior Design: The Traditions and Development of Domestic Design from Colonial Times to the Present*. New York: W. W. Norton and Company, 1947.

Roth, Rodris. *Tea Drinking in 18th-Century America: Its Etiquette and Equipage*. Contributions from the Museum of History and Technology, Paper 14 (*United States National Museum Bulletin*, vol. 225). Washington D.C.: Smithsonian Institution, 1961.

Sack, Albert. *Fine Points of Furniture: Early American*. New York: Crown Publishers, 1950.

Salaman, R. A. *Dictionary of Tools Used in the Woodworking and Allied Trades, c. 1700–1970*. London: George Allen and Unwin, 1975.

Salmon, William. *Polygraphice; or, The Art of Drawing, Engraving, Etching, Limning, Painting, Washing, Varnishing, Colouring, and Dying . . .* London: E. T. and R. H. for Richard Jones, 1672.

Santore, Charles. *The Windsor Style in America: A Pictorial Study of the History and Regional Characteristics of the Most Popular Furniture Form of Eighteenth-Century America, 1730–1830*. Ed. Thomas M. Voss. Philadelphia: Running Press, 1981.

Schiffer, Margaret Berwind. *Furniture and Its Makers of Chester County, Pennsylvania*. Philadelphia: University of Pennsylvania Press, 1966.

———. *Chester County, Pennsylvania Inventories, 1684–1850*. Exton, Pa.: Schiffer Publishing, 1974.

Schiffer, Peter, Nancy Schiffer, and Herbert Schiffer. *The Brass Book: American, English, and European; Fifteenth Century through 1850*. Exton, Pa.: Schiffer Publishing, 1978.

Schumpeter, Elizabeth Boody. *English Overseas Trade Statistics, 1697–1808*. Oxford: Clarendon Press, 1960.

Shepherd, Raymond Voigt. "James Logan's Stenton: Grand Simplicity in Quaker Philadelphia." Master's thesis, University of Delaware, 1968.

Shoemaker, Thomas H. "A List of the Inhabitants of Germantown and Chestnut Hill in 1809." *Pennsylvania Magazine of History and Biography*, vol. 15, no. 4 (1891), pp. 449–80.

Shuster, Elwood Delos. *Historical Notes of the Iron and Zinc Mining Industry in Sussex County, New Jersey*. Franklin, N.J.: Elwood Delos Shuster, 1927.

Simpson, Marc. *"All That Glisters": Brass in Early America*. New Haven: Yale Center for American Art and Material Culture, 1979.

Singleton, Esther. *The Furniture of Our Forefathers*. 8 pts. in 2 vols. New York.: Doubleday, Page, and Company, 1900.

Skerry, Janine E. "The Philip H. Hammerslough Collection of American Silver at the Wadsworth Atheneum, Hartford, Connecticut." *Antiques*, vol. 126, no. 4 (October 1984), pp. 852–59.

Smith, Helen Evertson. *Colonial Days and Ways as Gathered from Family Papers*. New York: The Century Company, 1900.

Snyder, Martin P. *City of Independence: Views of Philadelphia Before 1800*. New York: Praeger Publishers, 1975.

Stocker, Harry Emilius. *Moravian Customs and Other Matters of Interest*. Bethlehem, Pa.: Times Publishing Company, 1919.

Stockwell, David. "Irish Influence in Pennsylvania Queen Anne Furniture." *Antiques*, vol. 79, no. 3 (March 1961), pp. 269–71.

Swain, Charles V. "Interchangeable Parts in Early American Pewter." *Antiques,* vol. 83, no. 2 (February 1963), pp. 212–13.

Swank, Scott T., et al. *Arts of the Pennsylvania Germans.* Ed. Catherine E. Hutchins. New York: W. W. Norton and Company for the Henry Francis du Pont Winterthur Museum, 1983.

Swanton, John R. *The Indian Tribes of North America.* Smithsonian Institution Bureau of American Ethnology Bulletin, vol. 145. Washington, D.C.: United States Government Printing Office, 1952.

Symonds, R. W. "Charles II: Couches, Chairs, and Stools, 1660–1670—Part I." *Connoisseur,* vol. 93, no. 389 (January 1934), pp. 15–23.

———. "Charles II: Couches, Chairs, and Stools, 1670–1680—Part 2." *Connoisseur,* vol. 93, no. 390 (February 1934), pp. 86–95.

———. "Cane Chairs of the Late Seventeenth and Early Eighteenth Centuries." *Connoisseur,* vol. 93, no. 391 (March 1934), pp. 173–81.

———. "Turkey Work, Beech, and Japanned Chairs." *Connoisseur,* vol. 93, no. 392 (April 1934), pp. 221–27.

———. "The Export Trade of Furniture to Colonial America." *Burlington Magazine,* vol. 77, no. 452 (November 1940), pp. 152–63.

———. "English Cane Chairs—Part I. *Connoisseur,* vol. 127, no. 520 (March 1951), pp. 8–15.

———. "English Cane Chairs—Part 2. *Connoisseur,* vol. 127, no. 521 (May 1951), pp. 83–91.

Thornton, Peter. "Back-Stools and Chaises à Demoiselles." *Connoisseur,* vol. 185, no. 744 (February 1974), pp. 98–105.

———. *Seventeenth-Century Interior Decoration in England, France, and Holland.* New Haven and London: Yale University Press, 1978.

———. *Authentic Decor: The Domestic Interior, 1620–1920.* New York: Viking, 1984.

Trent, Robert F. "The Chest of Drawers in America, 1635–1730: A Postscript." *Winterthur Portfolio,* vol. 20, no. 1 (Spring 1985), pp. 31–48.

Valenstein, Suzanne G. *A Handbook of Chinese Ceramics.* New York: The Metropolitan Museum of Art, 1975.

Wallace, Philip B. *Colonial Houses: Philadelphia, Pre-Revolutionary Period.* New York: Bonanza Books by arrangement with Architectural Book Publishing Company, 1931.

Ward, Barbara McLean, and Gerald W. R. Ward, eds. *Silver in American Life: Selections from the Mabel Brady Garvan and Other Collections at Yale University.* New York: David R. Godine, 1979.

Ward, Gerald W. R. *American Case Furniture in the Mabel Brady Garvan and Other Collections at Yale University.* New Haven: Yale University Art Gallery, 1988.

Warren, David B. *Bayou Bend: American Furniture, Paintings, and Silver from the Bayou Bend Collection.* Houston: The Museum of Fine Arts, 1975.

Warren, David B., Katherine S. Howe, and Michael K. Brown. *Marks of Achievement: Four Centuries of American Presentation Silver.* Houston: The Museum of Fine Arts, 1987.

Weslager, C. A., and A. R. Dunlap. *Dutch Explorers, Traders, and Settlers in the Delaware Valley, 1609–1664.* Philadelphia: University of Pennsylvania Press, 1961.

Whisker, James Biser. *Pennsylvania Workers in Brass, Copper, and Tin, 1681–1900.* Lewiston, N.Y., Queenston, Ontario, and Lampeter, Wales: The Edwin Mellen Press, 1993.

Wilcoxen, Charlotte. "Dutch Majolica of the Seventeenth Century." *American Ceramic Circle Bulletin,* vol. 3 (1982), pp. 17–28.

Wills, Geoffrey. *The Book of Copper and Brass.* Feltham [London]: Country Life Books, 1968.

Wolsey, S. W., and R. W. P. Luff. *Furniture in England: The Age of the Joiner.* London: Arthur Barker, 1968.

Index of Names

Ackley, Thomas 247
Acrelius, Israel 113, 180
Adams, Job 220
Alison, Francis 46
Allen, James 253
Allen, John 217
Allen, Joseph 247
Allen, Nathaniel 97, 116
Allen, William 59, 201
Anne (queen of England) 181, 184
Archambo, Peter 87, 190
Armitt, Joseph 116, 173, 247
Armitt, Stephen 101, 247
Askew, John 115
Assheton, Ralph 93, 167, 183, 188
Atkinson, John 247
Austin, Samuel 247
Baker, Joshua 247
Baltzell, E. Digby 44
Barclay family 174
Barton, Benjamin 247
Barton, Robert 247
Bartram, Ann 190, 192
Bartram, Elizabeth 153
Bartram, James 153, 247
Bartram, John 37, 38–40, 41, 42,
 43, 45, 46, 48, 49, 117, 153, 190,
 192, 219, 233, 238
Bates, William 248
Bath, Abraham 209
Bayard, Stephen 218
Bayard, William 218
Bayly, John 253
Baynton, Peter 248
Beake, William, Jr. 97, 130, 142, 248
Beardsley, Margaret 131
Bedson, Thomas 248
Benbridge, Henry 235

Benezet, Anthony 26
Bernini 22
Best, Joseph 253
Bettle, Ann 224
Beverley, William 217
Biddle family 32
Bird, John 248
Björk, Erik 184
Black, Robert 248
Blake, Edward 248
Boelen, Henricus 182
Boelen, Henricus II 182
Bouche, Martin 231
Boudinot, Elias 189, 193, 253
Bowles, Sarah 141
Boyer, Thomas 248
Braddock 30
Bradford, Cornelius 202, 211
Bradford, William 78
Brannen, Patrick 248
Branson, Elizabeth 50, 60, 69, 192,
 233
Branson, Mary Tate 185
Branson, William 69–70, 103, 110,
 182, 185, 201
Branson, William (joiner) 248
Breck family 189
Brientnall, John 248
Breintnall, Joseph 45–46, 232
Bright, Anthony 177, 196, 253
Brinton, James 218
Brinton, Mary Ford 218
Brinton, William II 78
Brinton family 217
Budd, John 134, 160, 248
Budd, Thomas 134
Burke, Edmund 71
Burnet, William 58

Busby, John 206
Bush, Charles 248
Bywater, William 248
Cadwalader, Hannah Lambert 224
Cadwalader, John 72, 182, 184, 237
Cadwalader, Thomas 47, 184, 224,
 238
Calvert, Charles 23
Calvert, Mary 209
Campbell, Colin 80
Campbell, Robert 98, 107
Cane, David 248
Carbut, Joseph 248
Cario, Michael 253
Carlyle family 139
Carpenter, Samuel 26, 78, 81, 82,
 117, 167, 182, 206, 207
Carpenter family 32
Cart, Joshua 248
Carter, William (turner) 248
Carter, William (watchmaker) 253
Cassell, Arnold 248
Cassell, Nicholas 248
Catesby, Mark 232
Chads, John 78
Chalkley, Martha 187
Chalkley, Thomas 93, 187
Chamberlin, Mason 235
Chambers, David 248
Chambers, Patience 194
Chandlee, Benjamin, Jr. 99, 248
Chandlee, Benjamin, Sr. 98, 99,
 146, 248
Chandlee, Sarah Cottey 99
Charles II (king of England) 3, 17,
 18, 19, 199
Chatham (Chattam), Joseph 248
Chew, Elizabeth 234

Chick, James 248
Clark, Walter 248
Claus, Jacob 237
Claymore, Robert 146
Claypoole, George, Jr. 248
Claypoole, George, Sr. 98, 135, 248
Claypoole, James 113, 157
Claypoole, Joseph 97, 98, 135, 143,
 248
Claypoole, Josiah 97, 135, 143, 248
Claypoole family 97
Clayton, John 39
Clemens, Nathaniel 248
Clemm (Klemm, Clemon),
 Johannes Gottlob 175, 248
Clifton, Henry 102, 137, 248
Clone, Richard 100, 158, 248
Coate, Edith 199
Coates, Beulah 195
Coates, Sarah 186
Coates, Thomas 195
Coats, John 248
Coburn, Thomas 248
Cockfield, Joshua 116
Coddington, Mary 94, 182, 196
Coddington, Thomas 196
Coffin (Coffen), Abraham 95, 248
Collins, Richard 232
Collinson, Peter 41, 43, 46, 86, 88,
 214
Cook, William 248
Cooper, Peter 31, 80, 232
Coppock, Bartholomew 129, 229
Cottey, Abel 98, 99, 136, 229, 248
Cottey, Sarah 99
Courtin, Antoine de 71
Cowgill family 191
Cowper, John 248

Photography Credits

The American College of Physicians, Philadelphia: fig. 70; no. 505

American Jewish Historical Society, Waltham, Massachusetts: fig. 45

American Philosophical Society, Philadelphia: figs. 57, 71

American Swedish Historical Museum, Philadelphia: fig. 4

Amico Studios, Allentown, Pennsylvania: fig. 27

The Art Institute of Chicago: fig. 209; no. 405

Gavin Ashworth: figs. 1, 12, 18, 29, 33, 35, 41, 46, 50–52, 54, 60, 62–64, 68, 76, 81, 83, 85, 86, 90, 103, 105, 107, 108, 116, 127, 132, 135, 138, 141, 143, 145, 149, 150, 158–60, 164, 165, 169, 171, 173, 175, 177–79, 184, 186–89, 192, 193, 195, 199, 200, 201, 204, 205; nos. 1–7, 9, 10, 12, 13, 17–19, 27, 29, 32, 50–53, 61, 71, 75, 83, 87, 89–91, 96–98, 101, 103, 108, 111, 117, 123, 125, 126, 130, 135, 138–41, 143, 145, 147, 149, 151, 155, 157, 159, 161, 163, 176, 177, 292, 294, 299, 300, 302, 306–9, 311, 320, 326, 327, 329–32, 339, 341–43, 345, 352, 357, 361, 363, 368, 369, 371–73, 376, 381, 382, 385, 387, 388, 389, 392, 397, 398, 402, 409, 411, 417, 420–25, 427, 429–31, 434–36, 458, 463, 464, 467, 482

The Brooklyn Museum, New York: fig. 92

Will Brown: figs. 93, 161; nos. 8, 55, 76, 114, 121, 166, 178, 443

The Colonial Williamsburg Foundation, Williamsburg, Virginia: figs. 37, 194; nos. 69, 445

The Corning Museum of Glass, Corning, New York: fig. 217

Tom Crane: figs. 73, 111, 112, 122, 124, 125, 126, 136

Christie's Inc.: figs. 168, 196; no. 284

The Detroit Institute of Arts: fig. 80

Rick Echelmeyer: fig. 66

Herman Farrer: fig. 21

Franklin and Marshall College, Lancaster, Pennsylvania: nos. 205, 471

Donald M. Herr and Jonathan Charlers: no. 321

The Historic American Building Survey, Library of Congress, Washington, D.C., survey no. PA-1649: fig. 123

Historical Deerfield, Inc., Deerfield, Massachusetts: fig. 208; no. 191

The Historical Society of Pennsylvania, Philadelphia: figs. 30, 40, 53, 75, 77, 78, 82, 89

The Library Company of Philadelphia: figs. 25, 38, 113, 115

The Mercer Museum of the Bucks County Historical Society, Doylestown, Pennsylvania: fig. 61

The Metropolitan Museum of Art, New York: (Schecter Lee) figs. 84, 213; nos. 158, 180, 215; (Richard Creek) fig. 172

The Moravian Historical Society, Nazareth, Pennsylvania: fig. 87

Museum of Fine Arts, Boston: no. 131

National Museum of American Jewish History, Philadelphia: nos. 283, 503

National Portrait Gallery, Smithsonian Institution, Washington, D.C.: fig. 91

The Newark Museum, Newark, New Jersey: fig. 183; no. 116

Thomas R. Nutt: figs. 146, 210; nos. 211, 223, 235, 243, 286

Pennsylvania Academy of the Fine Arts, Philadelphia: fig. 79

Pennsylvania State Museum, Harrisburg, Pennsylvania: no. 414

The Pierpoint Morgan Library, New York: fig. 88

Lynn Rosenthal: figs. 2, 15, 19, 20, 26, 31, 32, 39, 42–44, 49, 56, 65, 66, 72, 97–99, 114, 118, 120, 129, 134, 174; nos. 293, 322, 325, 334–36, 344, 346, 347, 349–51, 355, 356, 359, 364, 366, 374, 378, 380, 384, 390, 391, 393, 400, 401, 404, 441, 451, 468, 487, 490, 491, 496–98

The Royal Library, National Library of Sweden: no. 483

The Schwarz Gallery, Philadelphia: no. 449

Skokloster Castle, Hallwyl Museum, Skokloster, Sweden: fig. 28

Sotheby's: fig. 23; no. 395

Robert C. Smith: fig. 119 (reproduced from Robert C. Smith, "Two Centuries of Philadelphia Architecture, 1700–1900," in Historic Philadelphia from the Founding until the Early Nineteenth Century, Transactions of the American Philosophical Society, vol. 43, pt. 1 [Philadelphia: American Philosophical Society, 1953], p. 291, fig. 3).

The Sterling and Francine Clark Art Institute, Williamstown, Massachusetts: no. 260

Barbara H. Taylor: no. 418

Tryon Palace Historic Sites and Gardens, New Bern, North Carolina: no. 73

United States Department of State, Washington, D.C.: no. 86

Winterthur Museum, Garden & Library, Winterthur, Delaware: figs. 6, 121, 153, 155, 158, 181; nos. 298, 301, 324, 328, 394, 396, 403

Graydon Wood: figs. 3, 7, 8, 10, 11, 13, 14, 16, 17, 22, 24, 34, 47, 48, 58, 59, 69, 74, 94–96, 100, 101, 104, 106, 118, 128, 130, 131, 133, 137, 140, 142, 144, 147, 148, 151, 152, 154, 156–58, 162, 163, 167, 170, 176, 182, 185, 190, 191, 197–99, 202, 207, 209, 211, 212, 215, 218; nos. 14,

21–25, 35, 37, 39, 46, 48, 49, 54, 56, 59, 62, 64, 66, 67, 77–82, 85, 92–94, 99, 100, 102, 104, 107, 108, 110, 112, 115, 118, 120, 124, 129, 133, 136, 148, 157, 165, 170, 172, 173, 175, 182–85, 187, 188, 190, 193–200, 203, 204, 206–8, 214, 217–22, 225–34, 236–42, 244, 245, 247, 250–56, 258, 259, 262, 264–68, 270–72, 274–81, 285, 287, 296, 305, 310, 312–14, 316–19, 326, 333, 348, 354, 358, 362, 370, 375, 379, 383, 412, 413, 426, 474, 506

Wright's Ferry Mansion, Columbia, Pennsylvania: fig. 110; nos. 33, 43, 407
Yale University Art Gallery, New Haven, Connecticut: nos. 192, 224, 248, 273, 408
Carson T. Zullinger: no. 212